Photographers in North Carolina

THE FIRST CENTURY, 1842–1941

Photographers in North Carolina

THE FIRST CENTURY, 1842–1941

COMPILED BY STEPHEN E. MASSENGILL

With Essays by

H. G. Jones, Jesse R. Lankford Jr., & Stephen E. Massengill

Office of Archives and History
North Carolina Department of Cultural Resources
Raleigh

In association with the North Caroliniana Society
Chapel Hill

CONTENTS

ACKNOWLEDGMENTS

Individuals who assisted in the preparation of this publication include the following: Rachael Abernathy, John Ansley, William Charles Austin, Don Bailey, Durwood Barbour, Mary M. Barden, Mary Barnes, Bill Bennett, Jennifer Bean Bower, Beverly Brannon, Cynthia Bright, Randle E. Brim, Dick Brown, Sheila Bumgarner, Tom Butchko, Earl Butler, Bill Carter, J. Stephen Catlett, Bruce S. Cheeseman, Donna Christenson, Brent Clayton, Alvis B. and Emma Jean Clegg, Tim Cole, James Vann Comer, Rebecca Telfair Horton Cone, Pat Connell, Vinia Conte, Peggy Cook, Margaret Cotrufo, Alice and Jerry Cotten, Guy Cox, John S. Craig, Victor Crawford, Jefferson Currie, J. Marshall Daniel, Ruth Daniel, Dennis Daniels, William H. Dartt, Sarah Downing, Rebecca Leach Dozier, John Durham, Melissa Eller, William R. Erwin Jr., Andrew Eskind, Gene G. Floyd, Chris E. Fonvielle Jr., Peggy Gardner, Helen Garner, John B. Green III, Leigh Holeman Gunn, Jason Harpe, Mary Emma Harris, Jan Hensley, Jennie W. Hightower, Karl G. Hudson Jr., Bill Hutchins, Earl Ijames Jr., Khristine E. Januzik, Sherman Jenkins, Goldie Johns, Carol Johnson, Jane Johnson, Barney L. Jones Jr., H. G. Jones, Victor T. Jones Jr., Amy Jordan, Mary Lib Clark Joyce, Whit Joyner, Roger Kammerer, Paul E. Kardulis Jr., Donna Kelly, Bill Kendall, Jesse R. Lankford Jr., Ralph E. Lentz II, Keith Longiotti, Michael McCue, Cheryl McLean, Linda March, Louis Martin, James A. Marusek, Greg Mast, Chris Meekins, Hardy Mills, Rencher Moore, Richard Murdoch, Elizabeth Reid Murray, Jean Newell, John H. Oden III, Brenda O'Neal, Reid A. Page Jr., Roy Parker Jr., Peter E. Palmquist, Laura Peace, Don Pendergraft, Phil Perkinson, Miles Philbeck, Scott Pickett, Amarette P. Pierce, Jan Plemmons, Sarah M. Pope, Benjamin Porter, Molly Rawls, William R. Reaves, Zoe Rhine, Lynn Richardson, Frances Osborn Robb, Sarah Robinson, Jerry R. Roughton, Stephen M. Rowe, Jean Sanderson, Janet Seapker, Ellennore Eddy Smith, Bryan T. Smithey, Florence W. Stevens, George Stevenson, Kenneth Strawbridge, John C. Sykes III, Harvey S. Teal, Beverly Tetterton, David V. Tinder, Robert M. Topkins,

Susan Trimble, Chad Tucker, Grace Turner, John Warner, Micky Weeks, Alan L. Westmoreland, Barnetta M. White, Lynn and Mark White, J. Mack Wicker, Roy E. Wilder Jr., Tom Wise, Barbara Poythress Wolfe, A. S. Woodlief, and Ann Wright.

The compiler utilized the following institutions and miscellaneous sources in the preparation of this publication: Alamance County Public Library; Cedar Grove Cemetery, New Bern; Cumberland County Public Library; Duke University Rare Book, Manuscript, and Special Collections Library, Durham; Durham County Public Library; East Carolina University Special Collections; Elmwood Cemetery, Henderson; Forsyth County Public Library; George Eastman House Photographers' Database; Georgia State Archives; Greensboro Historical Museum; Greensboro Public Library; Mary Love Cemetery, Hamlet; Institute of Photographic Research, Bryan, Texas; Lee County Genealogical and Historical Society; Library of Congress, Prints and Photographs Division, Washington, D.C.; McCown-Mangum House, West Point on the Eno, Durham; Maplewood Cemetery, Durham; Mars Hill College; Museum of Early Southern Decorative Arts, Winston-Salem; Museum of the Albemarle, Elizabeth City; New Hanover County Museum; New Hanover County Public Library; North Carolina Collection, Wilson Library, University of North Carolina at Chapel Hill; State Library of North Carolina, Raleigh; Oakdale Cemetery, Wilmington; Oakwood Cemetery, Raleigh; Outer Banks History Center, Manteo; Pack Memorial Library, Asheville; Person County Museum, Roxboro; Pope House Museum, Raleigh; Public Library of Charlotte and Mecklenburg County; Reynolda House, Winston-Salem; South Carolina State Archives; Southern Highlands Research Center, Ramsey Library, University of North Carolina, Asheville; Southern Historical Collection, Wilson Library, University of North Carolina at Chapel Hill; Tufts Archives, Given Memorial Library, Pinehurst; and Wilson County Public Library.

Illustrating North Carolina, 1842–1941

H. G. Jones

Billions of words have been written about North Carolina since Europeans first sighted our shores nearly five centuries ago, and research continually adds to our knowledge of both ourselves and the aboriginals who stared disbelievingly as Verrazzano's strange ship bobbled in the water only a few miles from their familiar surroundings at Cape Fear. Until the 1840s, however, with the exception of a few drawings and paintings, only *words* provided mental images of the natural and human dimensions of North Carolina and its people. To be understood, words—whether heard or read—are converted into pictures in our mind. Today, if I write about growing up on a tenant farm during the Great Depression, I describe events, tasks, people, and emotions as my mind has recorded them—a sort of visual documentary through my own eyes. But if I do that only through words, no matter how hard I try, the images that I attempt to portray through my words are never "seen" by readers as I intended them. To make matters worse, each reader "sees" a *different* picture, for language is converted into images limited by our unique experiences. Almost every word has myriad meanings, depending upon what we have seen, felt, or imagined, and our world is circumscribed by those experiences. Our imagination, therefore, is limited to association with something that our minds can "see."

With our heavy dependence upon the writers of history, it is not surprising that we know a great deal about those who used words to describe the past. In my book *For History's Sake* (1966), I sought to put verbal flesh on the literary bones of the early historians, and more recently all of them have been accorded biographies in articles or books. The names of George Chalmers, Hugh Williamson, François-Xavier Martin, Archibald Debow Murphey, Joseph Seawell Jones, John Hill Wheeler, David Lowry Swain, Francis Lister Hawks, John Wheeler Moore, William Laurence Saunders, Walter Clark, and Samuel A'Court Ashe, among others, are well known as early historians of North Carolina. Even better known—and deservedly so—are twentieth-century historians of the state, names such as Robert D. W. Connor, Joseph G. deR. Hamilton, William K. Boyd, Albert Ray Newsome, Christopher Crittenden, Adelaide Fries, David Leroy Corbitt, Hugh Talmadge Lefler, William Stevens Powell, Alan D. Watson, and Thomas C. Parramore. These and others have added factual and verbal richness to the land in which we live and the people who preceded us. Their words have also given us mental images, for historians have done their best to describe people and their times verbally. Without those words, we would know virtually nothing of our past. Deservedly, therefore, their biographies are known. Yet, the fact remains that even the best writings furnish us only with words.

It has been with no lack of appreciation for the written histories of our state that for half a century a

few Tar Heels have sought to add a powerful dimension to the understanding of North Carolina's past. Except for those rare drawings and paintings referred to previously, North Carolinians have few "creations of a moment" with which to "see" people, places, and events of the colonial and early federal periods. With the introduction of daguerreotypers into the state in the 1840s, however, *visual* images multiplied, first of persons and later of scenes. Words were no longer the only means of "picturing" history. We could now truly "see" the past—at least slivers of it.

The power of the photograph, whether a daguerreotype or digital image, has seldom been sufficiently emphasized by the writers of history. Pictures have been used as props for, or as accompaniment to, the written word. Furthermore, until the twentieth century little effort was made to systematically collect and preserve images that had survived their own chemical instability and the adverse effects of atmosphere and handling. Fortunately, nearly a century ago a few manuscript collectors such as Connor, Boyd, and Hamilton recognized the value of photographic images and often brought them to their repositories as supplements to written records. More recently, the North Carolina State Archives, the North Carolina Collection, and several other repositories, finally recognizing the importance of images in understanding the past, have provided professional personnel and instituted collection policies and preservation procedures. Today millions of images relating to North Carolina are preserved in repositories in the state. Thousands more, particularly those made in the state during the Civil War and in association with federal governmental initiatives such as the New Deal agricultural programs, are housed in the Library of Congress, the National Archives, and other federal, state, local, and private collections.

Even so, few assiduous researchers have actually seen more than a fraction of the number of images available in photographic archives. Consequently, the same views are used time and time again in books, magazines, and newspapers. Without sensing the importance of visual aids, too many authors and publishers conduct only cursory searches and reuse images already familiar to readers of history. Exceptions have appeared in books of a nostalgic nature and a few pictorial works with limited readership.

This relative neglect of North Carolina's pictorial record accounted for my own determination to bring into the public domain through *North Carolina Illustrated, 1526–1984* (1983) nearly twelve hundred images, few of which were familiar to the casual reader. In seeking to document visually the unique character—the collective soul—of the state, my search took me through hundreds of thousands of images in the State Archives and other repositories within the United States and, with the help of colleagues, through collections in Australia, Bermuda, Canada, China, East Germany, England, France, Iran, Italy, Japan, Scotland, Spain, Switzerland, and the Vatican. The selection process was brutal. The resulting number of office-machine copies was gradually reduced to about 10,000, then to 2,000, and eventually to 1,158. In all, about two hundred repositories and individuals furnished pictures that survived repeated culling. Except for images of paramount importance (for example, a few pictorial landmarks such as John White's drawings), the selection process emphasized views never before seen, or seldom seen, by North Carolinians. No illustrated history covering the full 460-year sweep beginning with Verrazzano's sightings in 1526 had previously been attempted, but the eleven years of labor and the cost of the enormously expensive project were more than offset by a byproduct of the undertaking—the addition of prints and negatives to the State Archives and the North Carolina Collection. Even more importantly, the book added hundreds of previously hidden images, accompanied by credit lines showing their source, to the published record. For each selection, in addition to a reproducible print, written permission for publication was obtained from its owner, and a credit line was added to each caption so that future users can go directly to the source for a copy and publication permission. To hold the size of the book to fewer than five hundred pages and its price to twenty-five dollars, many of the images were reproduced in miniature. One critic, who complained about the "postage stamp size" of some of the pictures, failed to understand that the main purpose of *North Carolina Illustrated (NCI)* was to bring to light unseen or seldom-seen images, together with an acknowledgment of their sources, so that they might become familiar landmarks in our state's colorful history. Now, nearly two decades later, it is not unusual for publishers to order copies from repositories by citing the picture numbers in *NCI*. The project was completed long before the availability of fax, e-mail, word processors, the Internet, scanners, and digital photography.

Pictorial local histories began to appear in greater numbers during the 1980s. Several publishers, most of them outside the state, recognized the marketability of such books, and amateurs and a few professionals added richly to the pictorial record by collecting photos and writing accompanying text and captions. The introduction of new images into the public domain led to the placement of many of the photographs or negatives

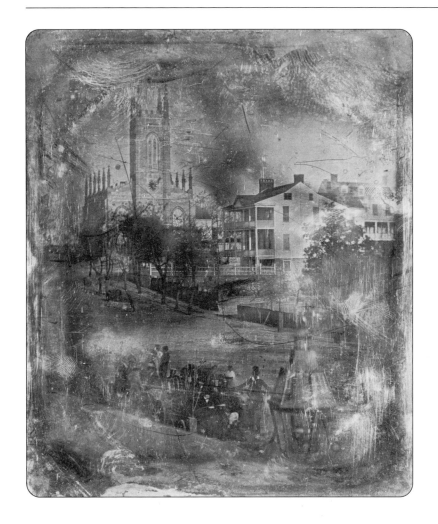

John Hemmer subsequently contributed enormously to the preservation of the visual image of North Carolina's twentieth century. To emphasize the central role of photography in the history of the state, three organizations—the North Carolina Literary and Historical Association, the Federation of North Carolina Historical Societies, and the North Caroliniana Society—cosponsored conferences in 2001 and 2002 titled "Imaging North Carolina."

If the visual records of the past are so important, why is it that we know so little about the men and women who made them? Why do we not know the first name of "Dr. Davis," who introduced the daguerreotype to the citizens of Halifax in 1842? Or more than the name of Charles Doratt, who offered his services to the General Assembly six years later? Or Melvina Thompson Ramsaur, pioneer amateur photographer in Lincoln County? Or Horace Davis, a black man who worked in both New Bern and Raleigh? If a picture is worth a thousand words, why have we ignored the men and women who provided us with a rich heritage of visual images that more accurately transmit history to the mind of the reviewer-reader? Why have we overlooked those who painted, drew, or took the pictures that are worth untold thousands of words?

Instead of trying to answer the unanswerable, *Photographers in North Carolina: The First Century, 1842–1941* seeks to fill a void in our collective memory by putting into print—in words, to be sure, but accompanied by a sampling of pictures—the abbreviated story of powerful image-makers whose works, when seen by North Carolinians, alter impressions conveyed by the written word. Stephen E. Massengill's "Biographical Directory of Photographers in North Carolina, 1842–1941" is the result of three decades of fascination with the men and women who produced the pictorial record

in repositories capable of preserving them and making them available for public use. Another late-twentieth-century genre, the coffee-table book, likewise introduced some historic images, and their tendency to emphasize handsome contemporary photography will provide images for historians of the twenty-first century and beyond.

By means of several interesting coincidences, 1941—the end of the first century of photography in North Carolina—ushered in a new iconographic era. The humanistic images from the camera of Bayard Wootten and the architectural views captured by Frances Benjamin Johnston had recently appeared in lavish volumes; the rural images of Farm Security Administration contract photographers such as Dorothea Lange, Arthur Rothstein, and Marion Post Wolcott were beginning to shape the public memory of the Great Depression; and public appeal for photography was magnified by wartime events. That same year Hugh Morton, the single most influential image-maker in the history of the state, sold his first professional photograph. Morton and other talented photographers such as Aycock Brown and

of North Carolina. Initially a hobby, the project grew as Massengill searched the State Archives (the largest photographic collection in the state, now numbering nearly a million images). Other iconographic archivists and collectors such as Jerry Cotten of the North Carolina Collection at the University of North Carolina at Chapel Hill, Jennifer Bean Bower of the Museum of Early Southern Decorative Arts in Winston-Salem, and Shelia Bumgarner of the Public Library of Charlotte and Mecklenburg County shared their independent findings, lengthening the list. The biographical directory currently identifies more than 2,500 image-makers, many of whose names appear only in yellowing censuses, newspaper advertisements, or town directories. Even with scant information, publication of their names will, at a minimum, record them for posterity and, at best, stimulate further research to reveal more about their influence on our state's history.

This book is being published at a propitious time, for with the advent of digitization, photography as known in the past century and a half will soon become a rare art, practiced by only a few artisans. Traditional photographs may become as rare as books printed by handset type on handmade paper. Without reading the story of North Carolina's early image-makers, future generations may never know about the painstaking experimentation involved in capturing living history before traditional photography is replaced by electronic techniques and gadgetry. For that reason, Jesse Raymond Lankford Jr. contributes an instructive essay titled "'Creations of a Moment': Early Photographic Types," which traces the evolution of image-making. And, to bring to life the biographical listing that follows, Massengill provides an essay that places a selected number of early photographers in their geographic settings.

This book, like any directory containing more than two thousand names, does not pretend to be complete. However, to wait until such a roster is deemed "complete" would be to postpone its publication eternally. Its very publication is designed to elicit additional information from its users and readers. Bureaucracies change with the winds of politics (for example, the agency publishing this book has been called a commission, department, division, and office within the past two-thirds of a century), but the State Archives will remain a functional agency regardless of future reorganizations. Readers are urged to communicate to Lankford, Massengill, and their successors new information that can be recorded for use in a revised edition of this book, which presents itself as a beginning, not the end, of the story of photography in North Carolina.

H. G. JONES, a native of Caswell County and a Navy veteran of World War II, received his Ph.D. degree from Duke University and taught at colleges in North Carolina and Georgia before becoming State Archivist of North Carolina in 1956. From 1968 to 1974 he was director of the State Department of Archives and History, after which he moved to the University of North Carolina at Chapel Hill, where he was curator of the North Carolina Collection and adjunct professor of history until 1993. Since that time he has been Thomas Whitmell Davis Research Historian in Wilson Library and secretary-treasurer of the North Caroliniana Society, which he founded in 1975. Dr. Jones has served as president of the Society of American Archivists, secretary of the American Association for State and Local History (AASLH), and commissioner of the National Historical Publications and Records Commission (NHPRC). Among his honors are the AASLH's Award of Distinction, the NHPRC's Distinguished Service Award for Documentary Publication and Preservation, the North Carolina Award for Public Service, and the North Carolina Humanities Council's John Tyler Caldwell Award for lifetime service to the humanities.

Dr. Jones's books include *For History's Sake* (1966) and *North Carolina History: An Annotated Bibliography* (1995), but it was his *North Carolina Illustrated, 1524–1984* (1983)—the first comprehensive pictorial history of the state, with 1,158 illustrations, most of them previously unpublished—that convinced Dr. Jones of the enormous importance of visual images in interpreting North Carolina's past. That conviction led to two statewide conferences titled "Imaging North Carolina," and it was from the seed sowed at those conferences that this book on North Carolina's pioneer photographers grew.

"Creations of a Moment"

EARLY PHOTOGRAPHIC TYPES

Jesse R. Lankford Jr.

Photographs have long been appreciated for their power to make time stand still. The ability to freeze a moment forever—to evoke memories of loved ones or of events gone by—is indeed awe inspiring. Photographs are a blend of art and science, possessing the capacity to hold an image forever in time through the interaction of chemistry and light. In his book *The Pencil of Nature*, English scientist and scholar William Henry Fox Talbot (1800–1877) described his desire to permanently capture images produced by the camera obscura—images he called "fairy pictures, creations of a moment." It was these delicate, fleeting images that inspired Talbot to render permanent what was wrought by "the pencil of nature" and not the hand of man.[1]

The camera has the potential to record faithfully its subject in exact detail. This is not to say that the camera does not lie. Indeed it does, or, more accurately, it can be made to lie. This is especially true in the present age of digital photography and photo-editing software. From the historian's point of view, the subject and authenticity of an image are far more important than its artistic qualities. Like the facts upon which history is based, photographs must be analyzed and authenticated. Recognizing and examining photography's historical types are key elements in this evaluation.

With this necessity in mind, some background about the development of the photographic science needs to be provided. Along the way, some of the key players will be discussed, and many important photographic types will be examined. Most of the types were available to North Carolina photographers during the nineteenth and early twentieth centuries.

An introduction to early photography begins with a brief look at the concept of the camera obscura. The name is from Latin and literally means "dark room." The principle of the camera obscura has existed since the late Renaissance. Light entering a small hole in the wall of a dark room forms on the opposite wall an inverted image of what exists outside the room. In the nineteenth century, a camera obscura was comprised of a lens fitted in a framed box. The opposite end of the box contained a pane of frosted glass. The image was reflected upward and could be seen outside the box as it was cast upon the glass. An Englishman by the name of William Wollaston (1766–1828) invented the "camera lucida" in 1807. The device was a portable brass rod that suspended a glass prism at eye level. The operator, looking through a peephole centered over the edge of the prism, saw the subject and the drawing paper at the same time. The artist's pencil was guided, in effect, by a virtual image.[2]

Neither the camera obscura nor the camera lucida could render an exact duplicate of reality. Simply drawing with the "pencil of man" was not adequate. Only permanently capturing the image produced by the "pencil of nature" would do. This idea burned brightly in the minds of several men during the early part of the

nineteenth century. Between 1827 and 1839, the work of three individuals was crucial in the development of photography. They were Joseph Nicephore Niépce (1765–1833), Louis Jacques Mandé Daguerre (1787–1851), and the aforementioned William Henry Fox Talbot. The name of a fourth individual—Hippolyte Bayard (1801–1887)—should also be added to this list.[3]

Nicephore Niépce descended from a family of French inventors. He was interested in improving the process of lithography, which was a primary means of producing multiple prints. Niépce proposed replacing the heavy stones used in the lithographic process with coated metal plates. For his experiments he needed drawings, but, having little artistic skill, he was determined to produce illustrations using light. Niépce knew that bitumen of Judea would harden in light, so he coated a sheet of metal with it. His first exposures were produced using an etching made translucent when waxed. Where light passed through the paper, the bitumen hardened. Where the ink lines of the etching blocked light, the bitumen remained soluble. After the plate was exposed, it was washed in a solvent. The unexposed and unhardened areas washed away. The plate was then bathed in acid, after which it was inked and printed to produce a photographic reproduction of the original. Niépce called this process "heliography."[4]

Niépce decided to try the technique directly in the camera obscura. The exposure took all day, but in 1827

ABOVE LEFT: Pencil drawing depicting Nicephore Niépce. Reproduced in Helmut Gernsheim, *A Concise History of Photography* (New York: Grosset and Dunlap, 1965), 14. **ABOVE RIGHT:** Daguerreotype of Louis Jacques Mandé Daguerre by J. E. Mayall, 1846. Reproduced in Gernsheim, *A Concise History of Photography*, 10. **BELOW:** Portrait daguerreotype of William Henry Fox Talbot. Reproduced in Gernsheim, *A Concise History of Photography*, 8.

he did manage to get a permanent image of a view outside his window. He later produced a photograph depicting a set table (see right). That same year Niépce traveled to Paris and visited Louis Daguerre, a painter of scenes and co-inventor of the "Diorama," a display of views painted on canvas, then illuminated by projected light. Daguerre, like Niépce , had been trying to fix the images that he painted using the camera obscura. In 1829, two years after their meeting, Daguerre and Niépce signed a partnership agreement that was to last for ten years. Upon Niépce's death in 1833, his son Isidore succeeded to the partnership but contributed little to the agreement, and Daguerre pressed on alone.[5]

Daguerre worked with silver salts that changed color in light rather than with organic compounds such as bitumen that changed hardness in light. By 1837 he had learned to make highly successful photographs. A copper sheet was coated with silver; the silver surface was then well cleaned and polished mirror-bright. Daguerre then sensitized the plate by putting it silver side down over a box containing iodine at room temperature. The sensitized plate was then placed in a

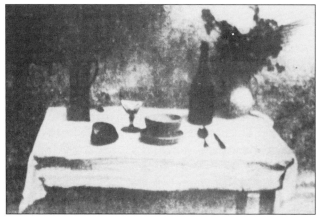

Set Table (ca. 1827), by Nicephore Niépce. A. Davanne and Maurice Burquet, *Le Musée retrospectif de la photographie à l'Exposition Universelle de 1900* (Paris, 1903). Reproduced in Beaumont Newhall, *The History of Photography: From 1839 to the Present Day* (New York: Museum of Modern Art, 1982), 15.

camera obscura and exposed. The exposed plate was then removed from the camera. A latent image was present, but nothing could be detected. The plate was then placed in a closed box and exposed to mercury heated to 167 degrees Fahrenheit. The mercury vapor

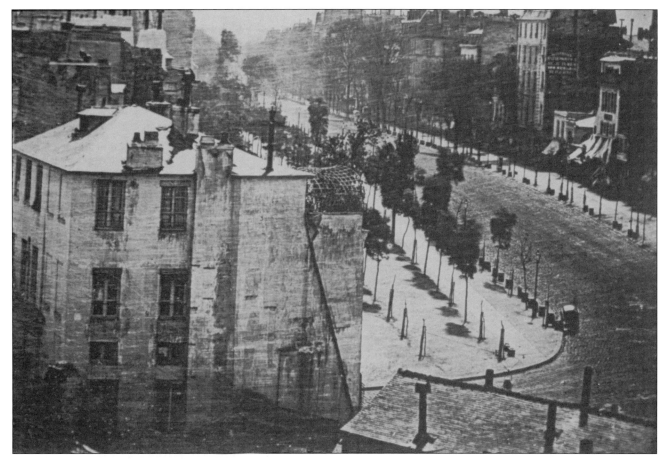

Daguerreotype of the Boulevard du Temple, Paris, ca. 1838, by Daguerre. Original held by Bayerisches Nationalmuseum, Munich, Germany. Reproduced in Newhall, *History of Photography*, 17.

formed an amalgam with the silver. The plate was then immersed in a strong solution of common salt to halt development. Finally, the plate was washed in water, dried, and mounted under glass to protect the image.[6]

Daguerre initially planned to patent his work and sell license rights. Instead, he assigned his rights to the process to the French government in exchange for a lifetime pension. The government then made the process available throughout the world with no fees attached. The daguerrean process was announced to the public on August 19, 1839. Daguerre wrote a 79-page instructional booklet that went through thirty-nine editions and numerous translations. It provided the exact details of the daguerreotype process, as well as Niépce's heliographic procedures.[7]

The daguerreotype spread quickly to America. Full accounts of the process were carried to the United States by the steamship *British Queen*, which docked in New York City on September 20, 1839.[8] The United States soon became the acknowledged center for skilled "operators" familiar with the process. (But the daguerrean art was not practiced in North Carolina until the early 1840s.) Among prominent Americans involved in making daguerreotypes was Samuel F. B. Morse (1791–1872), the inventor of the telegraph. Morse actually visited Daguerre in France and was privileged to view his work prior to the first public announcement of the process. Morse briefly made a living preparing daguerreotypes, and he taught the art to Mathew B. Brady (ca. 1823–1896), who in time became a renowned photographer of the American Civil War. Alexander S. Wolcott (1804–1844), a resident of New York City, is credited with making the first portrait daguerreotype on October 7, 1839. Wolcott soon devised a system by which a beam of light could be focused on the sitter, thereby shortening exposure time and introducing practical portrait photography.[9] (See pages 7, 18, 77, 167, and 212 for examples of daguerreotypes.)

America's greatest contribution to the daguerreotype involved the refinement of the process. When first introduced, the daguerreotype was used chiefly for landscapes. But American photographers were able consistently to shorten exposure times to produce first-rate portraits. This was done by using mirrors to concentrate light on a subject, by developing new chemistry called "quicks" to increase the sensitivity of the plates, and by improving the quality of camera lenses. Additional refinements included the use of sodium thiosulfate, or "hypo," to more effectively reduce silver salts in the development of the image. The introduction of a process known as "gold toning" to increase the durability and tonal range of the finished plates was another significant accomplishment.

These improvements helped create a new occupation, the professional portrait photographer, or "daguerreotypist."[10]

The daguerreotype reigned supreme in the United States until well into the 1850s. By 1853 there were eighty-six galleries in New York City alone, with Mathew Brady's among the largest. Daguerreotypes were encased in leather or plastic enclosures known as "union cases." Despite its popularity, the daguerreotype was destined to fall from its preeminent position. It did not lend itself readily to duplication. It was fragile, chemically complex, and expensive to produce. By 1864 the profession of "daguerreotypist" was no longer listed in most American business directories.[11]

While Americans and the French were preoccupied with the daguerreotype, an Englishman concurrently pursued a different photographic approach. The daguerreotype is a one-of-a-kind product, but William Henry Fox Talbot almost simultaneously developed what he called a "photogenic drawing" process. Talbot heard of Daguerre's work and was stunned by the news. He thought that he was alone in pursuing the capture of a permanent image. In January 1839 he rushed samples of his work to the British Royal Society in order to claim priority over Daguerre. While Talbot originally called his process "photogenic drawing," Sir John F. W. Herschel (1792–1871), distinguished English scientist, can be thanked for suggesting that the process be called "photography."[12]

By 1841 Talbot had further refined his process and named it the "calotype," meaning "beautiful picture" in Greek. Talbot's work is critically important because he succeeded in devising the concept of the negative/positive process so well known at present. The calotype is a paper negative. A sheet of paper was bathed in silver nitrate and potassium iodide. The paper was then washed in a mixture of gallic acid and silver nitrate. Next, the paper was exposed in the camera and bathed again in a solution of gallic acid and silver nitrate. The image was then "fixed" in a hypo solution to produce a negative. Finally, the negative was used to make a print on salt paper. (See page 84 for an example of a salt print.) The fibers of salt paper are often visible, and the prints are weak and subject to fading. There is no glossy finish. In 1841 Talbot secured a royal patent on the calotype. In 1844 he published a book titled *The Pencil of Nature*, which was illustrated with twenty-four original calotypes with text explaining the significance of each picture.[13]

Although the calotype was popular in Europe, it never really caught on in the United States. Few, if any, North Carolinians are known to have employed the

process. Although the calotype never enjoyed widespread popularity, the concept of the negative/positive process was widely accepted. By 1851 another Englishman, Frederick Scott Archer (1813–1857), developed a method of sensitizing glass plates with silver salts suspended in a collodion emulsion. Within a decade, collodion wet-plate photography replaced the daguerreotype and calotype processes. Talbot filed a lawsuit in 1854 to protect his patent, arguing that the use of the collodion negative/positive system infringed on his patent. The court did not agree.[14]

Collodion is a solution of nitrocellulose in alcohol and ether. When dry, it is impervious to water. Light-sensitive silver is suspended in the collodion emulsion. The plate was exposed while still wet inside the camera. It was then developed in pyrogallic acid, fixed in hypo, washed, and dried. All these steps had to be performed quickly before the collodion dried. The process tied the photographer to the darkroom and its chemicals. Initially, salt-paper prints were used in conjunction with wet-plate negatives, but in 1851 a Frenchman, Louis Désiré Blanquart-Evrard (1802–1872), devised a new printing paper known as "albumen paper," which

was coated with egg white. Prints produced in this process usually varied in tone from yellow to sepia. The finish was somewhat glossy—especially with regard to albumen prints made after 1879, which were burnished by a system of rollers. Albumen paper was the dominant type of printing paper up to the 1890s. With albumen prints, brush strokes are often visible where they were picked up from the collodion negative.[15]

The "ambrotype" is a variation of the collodion negative. James Ambrose Cutting (1814–1867) of Boston invented it in 1854. Cutting obtained U.S. patents and vigorously prosecuted photographers who used his techniques without securing licenses. The ambrotype is a thin collodion negative with a black backing that reverses polarity and makes the image appear positive. It was cheaper and easier to produce than the daguerreotype. Yet, when mounted behind glass and placed in an ornate case, it possessed much of the appeal characteristic of the daguerreotype. Ambrotypes were often retouched and tinted by the photographer. They were sometimes prepared on dark-colored blue or crimson glass, eliminating the need for a black backing to make the image appear positive.[16]

The Mathew Brady ambrotype of John W. Draper. **LEFT:** the ambrotype photographed with white paper as a backing, showing the negative character of this form of photograph. **RIGHT:** the same ambrotype photographed against a piece of black velvet. Image courtesy John W. Draper, Morgantown, W. Va. Reproduced in Robert Taft, *Photography and the American Scene: A Social History, 1839–1889* (New York: Dover Publications, 1938), 125.

The popularity of the ambrotype was short-lived, even more so than the daguerreotype. A similar process that did not require the use of fragile glass soon superseded it, and by 1863 the ambrotype had yielded its popularity to the tintype. The word "tintype" is a misnomer. The metal used is actually black japanned sheet iron. It is a collodion negative made positive by the black backing of the metal plate. Like the daguerreotype and the ambrotype, the finished product is a camera original, and it is laterally reversed. Prof. Hamilton L. Smith (1818–1903) of Kenyon College in Ohio perfected the process in 1856. Smith sold his patent to Peter Neff (1827–1903), who popularized the process and manufactured plates known as "melainotypes." Victor M. Griswold (1819–1872) operated a rival firm; because the tintype process involved the use of iron, he called his plates "ferrotypes."

During the Civil War the tintype was the frequent choice of photographers and soldiers in the field. They were cheap and durable and could be mounted in albums, carried in a pocket, and sent through the mail. They were often hand-tinted. Operators soon learned to use multilensed cameras to make multiple exposures on one plate. Tintypes were a distinctively American form of photography, appealing to the common man. They remained in use until the early part of the twentieth century.[17] (See pages 120, 133, and 209 for examples of tintypes.)

The next major form of imaging was the card photograph. In 1854 André Adolphe Eugène Disderi (1819–ca. 1890), court photographer to Napoleon III, patented the carte-de-visite in France. This was a photograph mounted on 2½-by-4-inch card stock. To make a card photograph, a wet-plate collodion negative was placed in a camera equipped with multiple lenses—usually four. The plate holder was moved from side to side, producing eight images on the negative. The negative was then printed, usually on albumen paper. The print was cut into eight separate portraits, each of which was mounted on specially prepared boards. The carte-de-visite became quite the fad, spreading from Paris to London and then to the United States.[18] (See page 207 for an example of a carte-de-visite.)

A major supplier of mass-produced card photographs was the E. and H. T. Anthony Company of New York City. The Anthony firm was capable of making 3,600 cartes-de-visite per day. The card photos were sold in nearly every shop and were used until the early part of the twentieth century. They were popular for portraits of generals, entertainers, and politicians—virtually anyone of notoriety. They gave rise to an American tradition—the family album. Few fashionable Victorian homes were without a photograph album

containing card photographs and tintypes. By 1866 the carte-de-visite format began to give way to larger-sized card photos. The most popular size was the "cabinet card," which measured 6½ by 4½ inches and was nothing more than an oversized carte-de-visite.[19] (See pages 37, 58, 74, 83, 93, 136, 144, 145, 161, 170, 181, and 215 for examples of cabinet cards.)

Another popular form of photography was the stereograph, which imparts the illusion of depth to a picture. Stereographs, like card photographs, were a format and not a technical process. Many different photographic processes were used to produce stereographs, including daguerreotypes, ambrotypes, wet-plate glass positives, mounted salt prints, albumen prints, and bromide prints. Regardless of the process used, stereographs were formed by mounting two images side by side. These were most commonly made with cameras containing two lenses 2½ inches apart—approximately the average distance between the pupils of the eyes. After the negative was printed, the print was cut in two, reversed, and mounted. Although stereographs involve two photographs taken simultaneously, careful examination reveals that the two images are not identical. This is most apparent along the borders of the pictures. The two parallel but not identical images, when viewed side by side through a special device created for that purpose, create the illusion of depth in a single picture, much like the 3-D effect produced by the modern View-Master. Physician, educator, and author Oliver Wendell Holmes (1809–1894) advocated the creation of a national library of stereographs. He helped popularize the format by his 1861 design of a practical viewer. The types of mounted prints used for stereographs vary according to the type of printing paper used at the time. Stereographs remained popular through the 1920s.[20] (See pages 156, 193, and 203 for examples of stereographs.)

The wet collodion process was used to produce lantern slides and glass stereographs, which, unlike card stereographs, were viewed by transmitted light instead of reflected light. The glass collodion stereos gave a much more realistic stereoscopic effect than did card photographs.[21]

The next significant advance in photography beyond the various collodion processes was the gelatin dry-plate glass negative. Dr. Richard Leach Maddox (1816–1902), a British physician, conducted experiments that led to the creation of the gelatin dry plate in 1871. Advantages afforded by this process were considerable. Collodion negatives had to be developed while they were still wet and had to be prepared and sensitized by the photographer. The dry plate required none of these inconveniences because they were prepared in a factory

LEFT: Dry-plate negative by Albert Barden, showing the Yarborough House in Raleigh. Courtesy A&H. **BELOW:** Nitrate negative made by Albert Barden in Raleigh. Courtesy A&H.

and exposed in the field or studio and developed later. That characteristic helped free the photographer from the darkroom. Despite the many advantages, the new gelatin glass plates did not come into widespread use until 1883. Their refinement undoubtedly expanded the amateur market. Gone were the silver-nitrate stains on the photographer's hands.[22]

In 1880 a little-known bank clerk who began the manufacture of quality plates boosted the dry-plate business. His name was George Eastman (1854–1932). At first Eastman sold his plates through the E. and H. T. Anthony Company, but by 1885 he and the Anthony Company were no longer on friendly terms, and they were soon suing each other over patents connected with bromide paper. That ill will would play a role in the development of flexible film. Gelatin dry plates, for all their positive points, had an equal number of disadvantages. Being glass, they were cumbersome, heavy, and subject to breakage. In addition, the emulsion became erratic and less dependable with age. George Eastman was determined to find a new film medium to replace glass.

Initially Eastman worked with a gelatin emulsion, using paper as the film base. This was known as stripping film, because the emulsion was heated and the gelatin negative was removed, or "stripped," from the paper base. It was then transferred to a glass plate and eventually printed. Unfortunately, images often were torn in the process of removal.[23]

In contrast to Eastman, Hannibal Goodwin (1822–1900) of Newark, New Jersey, developed a transparent flexible plastic base for film. It eliminated the delicate operation of stripping the emulsion from a paper base. In 1887 Goodwin applied for a patent for his film base. There were excessive delays, and the patent was not awarded until 1898. Meanwhile, the Eastman Company developed a similar process and began selling its brand of flexible nitrate film. Eastman's old rival, now known as ANSCO, purchased Hannibal Goodwin's patent and filed a lawsuit against Eastman in 1889. After years of

legal maneuvers, a federal court in 1914 ruled against Eastman, and ANSCO was awarded five million dollars in damages.[24]

In the long run, the decision proved to be only a minor setback for Eastman. His introduction of what he coined the "Kodak" system revolutionized photography. If the gelatin dry plate had unlocked the door for amateurs, the Kodak roll-film camera of 1888 swung the door wide open. "You Press the Button, We Do the Rest" was the Kodak slogan. The American public was more than willing to press the button on this new camera, which was packed with 100 exposures and sold for twenty-five dollars; Eastman's company then printed the resulting film. The Kodak system in many ways personifies the birth of contemporary photography. The picture made by the Kodak of 1888 and its successor the "Brownie" camera of 1895 was circular when printed. This was because the lenses used in both

devices were of low precision and were sharp only in the center. The camera was simply aimed and the shutter clicked. Artistic composition often left much to be desired.[25]

The advantages of flexible roll film over dry plates are quite obvious. The era of the "snapshot" had arrived with roll film and the Kodak. Nitrate film in roll form quickly became the standard medium of both the professional and amateur photographer. In 1913 nitrate film was likewise manufactured in sheet form. Despite the widespread appeal of flexible-based film, many professional photographers were slow to abandon the glass-plate negative, which was still being used as late as the 1920s.

In 1934 another significant change in film bases occurred. Because nitrate was chemically unstable and was highly flammable, diacetate film was introduced. By 1939, nitrate film in sheet form was abandoned in

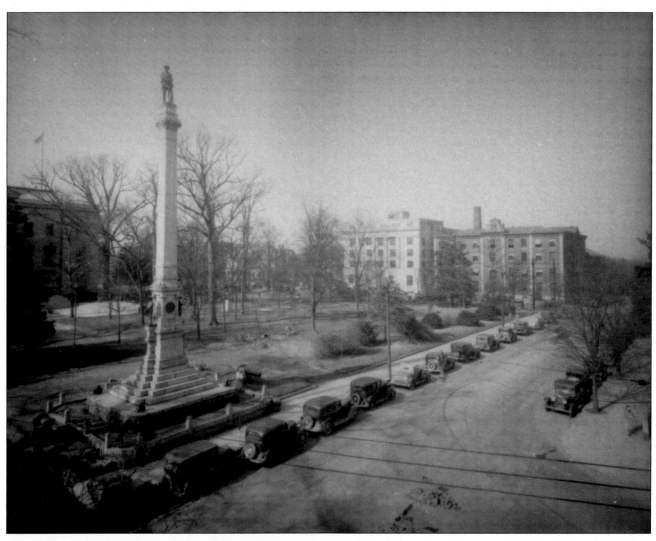

Diacetate negative by Albert Barden showing the Confederate Monument on Hillsborough Street, Raleigh. Courtesy A&H.

favor of diacetate. Roll nitrate film continued to be manufactured until 1951, however. Diacetate base is commonly known as "safety" film because it does not ignite until the temperature reaches nearly 600 degrees Fahrenheit.[26]

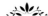

ANOTHER HISTORICAL TYPE being produced by photographers from 1866 to the early 1900s was the "carbon print," which consisted of images secured on matte paper that had been treated with carbon pigments suspended in bichromated gelatin. The image, an extremely permanent print, featured a degree of "relief" and sometimes resembled an engraving. From 1880 until the early 1900s, platinum prints were another historical type, though less widespread. These images were secured on paper impregnated with platinum. Platinum is inert and therefore more stable than silver prints. The prints exhibit a soft silver-gray tone and sometimes are referred to as "platinotypes." Between 1885 and 1910, "cyanotype" prints were produced. Their color ranged from a deep Prussian blue to a violet blue. Cyanotypes exhibit a great deal of contrast and can be produced on paper or cloth as blueprints. They are based on light-sensitive ferric salts rather than silver. They are exposed to light under a negative, then simply washed in water to develop out in blue and white. Introduced in 1842, they did not become popular until the 1880s, when their low cost and ease of processing appealed to amateur photographers. "Crayon photographs" came into vogue during the late nineteenth and early twentieth centuries. These photographic enlargements were "retouched" to make them look like actual portraits painted or drawn by artists, a process carried out through the use of crayons, manual brushes, and air brushes.[27]

"Crystoleums" are one of the lesser-known variations of the albumen print process. They were made as early as 1883 and were still being prepared as late as 1912. A crystoleum was intended to look like a framed painting on glass. It was made by taking an albumen print and pasting it face down to the back of a concave glass. When dry, the print was made transparent by rubbing away most of the paper backing and then applying wax. All the fine details in the print were colored by hand.

During the 1880s and 1890s two kinds of emulsion papers flourished: "printing-out papers" and "developing-out papers." Printing-out papers were placed in contact with the negative and exposed to a bright light. A visible image was formed directly by exposure. Developing-out papers could be produced

ABOVE: Carbon print of Benjamin Disraeli. Courtesy Rare Book, Manuscript, and Special Collections Library, Duke University. **BELOW:** Developing-out paper. Courtesy Special Collections, University of Kentucky Libraries. Reproduced in Mary Lynn Ritzenthaler, Gerald J. Munoff, and Margery S. Long, *Archives & Manuscripts: Administration of Photographic Collections* (Chicago: Society of American Archivists, 1984), 46.

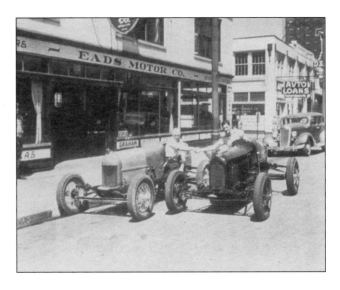

much more quickly. Introduced around 1880, developing-out papers eventually triumphed in popularity. Rather than requiring exposure in bright sun or bright light, they required only a few seconds of strong artificial light, and the resulting prints were developed out chemically. Most of these prints are now called bromides, a reference to their chemistry.[28]

From the beginning of photography, there was a quest to produce images in color. Levi Hill (1816–1865) of New York even attempted to create a daguerreotype capable of capturing natural color. But it was not until 1907 that the Lumiere brothers of France marketed the first commercially successful color photographs. They were known as "autochromes" and were available for about thirty years. The autochrome process employed a screen of microscopic primary color filters in the form of orange, green, and violet grains of starch laid upon a single glass plate coated with panchromatic emulsion. Following exposure, the image was developed as a positive and, projected or viewed by transmitted light, appeared as a color image. An autochrome was often displayed in a viewing device known as a "diascope." Many other types of color photography relied upon the principles of a screen and tricolor separation, as employed in the autochrome process. All of the early color processes have one thing in common: they were more long-lived than the chromogenic color processes used at present.[29]

⚜

WHY IS IT USEFUL to study the historical types of photography? Consider the matter of a photograph that appeared in *North Carolina Illustrated*, a pictorial history of the state by H. G. Jones. The photo depicts two members of the Waynick family of Rockingham County, one of whom appears to be a left-handed banjo player. A letter that was written in 1986 by a man who purchased a copy of the book inquired if the banjo player was "really left-handed?" The answer is no. The photograph is a tintype and is laterally reversed. The banjo player is actually right-handed. To further illustrate this point, for years historians and movie directors assumed that the infamous outlaw Billy the Kid was left-handed, so he was often referred to as "The Left-handed Gun." For decades no one bothered to take into account the characteristics of a tintype of Billy—which likewise is laterally reversed.[30]

Finally, let's return for a moment to the fourth individual mentioned in the development of photography. Hippolyte Bayard was a clerk for the French government who invented a direct positive camera original process at the same time Louis Daguerre was being touted as the inventor of photography. Bayard received little notice for his work, even though he exhibited his photographs on the streets of Paris. In a photograph titled *Self-Portrait as a Drowned Man*, Bayard symbolically posed himself in frustration at his failure to achieve the notoriety—and the accompanying financial rewards—enjoyed by Daguerre.[31]

In the evolution of photography and its various historical types, each photographic process built upon the successes or failures of its predecessor. Ultimately they all succeeded in one way or another to accomplish Talbot's original dream of capturing permanently the "creations of a moment."

NOTES

1. William Henry Fox Talbot, *The Pencil of Nature* (New York: Da Capo Press, 1969), "Brief Historical Sketch of the Invention of the Art," unpaged.
2. Robert Taft, *Photography and the American Scene: A Social History, 1839–1889* (New York: Dover Publications, 1938), 6; Beaumont Newhall, *The History of Photography: From 1839 to the Present Day* (New York: Museum of Modern Art, 1982), 9–10, 11.
3. Newhall, *History of Photography*, 13–25.
4. Newhall, *History of Photography*, 13–15.
5. Taft, *Photography and the American Scene*, 4–5; Newhall, *History of Photography*, 18.

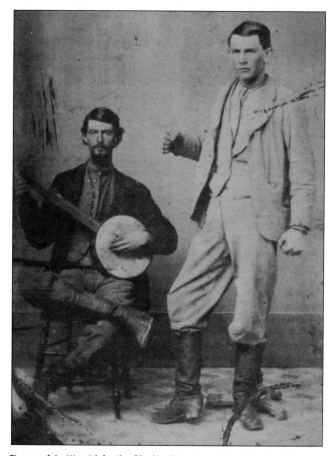

Tintype of the Waynick family of Rockingham County. Reproduced in H. G. Jones, *North Carolina Illustrated, 1524–1984* (Chapel Hill: University of North Carolina Press, 1983), 301.

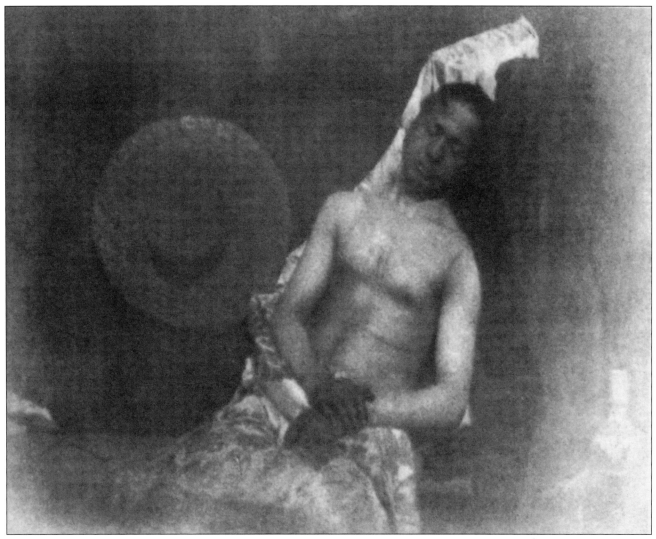

Hippolyte Bayard in *Self-Portrait as a Drowned Man*, 1840. Original held by Société Française de Photographie, Paris. Reproduced in Newhall, History of Photography, 25.

6. Taft, *Photography and the American Scene*, 6–8; Newhall, *History of Photography*, 18.

7. Newhall, *History of Photography*, 18–19; Taft, *Photography and the American Scene*, 5.

8. Taft, *Photography and the American Scene*, 13–14.

9. Taft, *Photography and the American Scene*, 9–12, 33–36.

10. Taft, *Photography and the American Scene*, 35, 44, 120.

11. Newhall, *History of Photography*, 34.

12. Taft, *Photography and the American Scene*, 29, 103–104.

13. Newhall, *History of Photography*, 43.

14. Newhall, *History of Photography*, 54–56.

15. Newhall, *History of Photography*, 59–60.

16. Taft, *Photography and the American Scene*, 123–124; Newhall, *History of Photography*, 62–63.

17. Newhall, *History of Photography*, 63.

18. Taft, *Photography and the American Scene*, 139; Newhall, *History of Photography*, 64.

19. Mary Lynn Ritzenthaler, Gerald J. Munoff, and Margery S. Long, *Archives & Manuscripts: Administration of Photographic Collections* (Chicago: Society of American Archivists, 1984), 41–43 (hereafter cited as Ritzenthaler, Munoff, and Long, *Administration of Photographic Collections*); Newhall, *History of Photography*, 64–66; Taft, *Photography and the American Scene*, 141.

20. Robert A. Weinstein and Larry Booth, *Collection, Use, and Care of Historical Photographs* (Nashville: American Association for State and Local History, 1977), 186–189; Ritzenthaler, Munoff, and Long, *Administration of Photographic Collections*, 37–42.

21. Ritzenthaler, Munoff, and Long, *Administration of Photographic Collections*, 37–41.

22. Ritzenthaler, Munoff, and Long, *Administration of Photographic Collections*, 43–44.

23. Reese V. Jenkins, *Images & Enterprise: Technology and the American Photographic Industry, 1839–1925* (Baltimore and London: The Johns Hopkins University Press, 1975), 66–95, passim.

24. Taft, *Photography and the American Scene*, 391–402.

25. Newhall, *History of Photography*, 129; Ritzenthaler, Munoff, and Long, *Administration of Photographic Collections*, 44–45.

26. Ritzenthaler, Munoff, and Long, *Administration of Photographic Collections*, 45–46; Taft, *Photography and the American Scene*, 188–194.

27. Ritzenthaler, Munoff, and Long, *Administration of Photographic Collections*, 35, 36, 49.

28. Weinstein and Booth, *Collection, Use, and Care of Historical Photographs*, 184–186.

29. Newhall, *History of Photography*, 269–272; Ritzenthaler, Munoff, and Long, *Administration of Photographic Collections*, 50–54.

30. Jake Page, "Was Billy the Kid a Superhero—or a Superscoundrel?" *Smithsonian* 21 (1991): 137–148; John E. Perkins to the North Carolina Department of Archives and History, February 3, 1986, copy in possession of author.

31. Newhall, *History of Photography*, 25.

JESSE R. LANKFORD JR., a native of Winston-Salem, holds a B.A. in history (cum laude) and an M.A. in American history from Western Carolina University, as well as a Master of Public Affairs degree from North Carolina State University. He began his archival career in 1969 as a records analyst for the South Carolina Department of Archives and History and joined the archival staff of the North Carolina Office of Archives and History in 1972. In 1974 he was named iconographic archivist for the agency's Archives and Records Section, and in 1986 he was named assistant state archivist and supervisor of the agency's Archival Services Branch. In 2000 Lankford, continuing as assistant state archivist, became supervisor of the newly created Special Collections Branch of the Archives and Records Section. In 2004 he was promoted to State Archivist and Records Administrator.

In 1995 Lankford received the "Order of the Longleaf Pine" award for service to the state of North Carolina. He is a member of numerous professional organizations and committees and has served as chairman of a number of them. He also serves as an adjunct associate professor in the public history program at North Carolina State University. He has published numerous book reviews and has edited several statistical reports for the National Association of Government Archives and Records Administrators.

Photographers in North Carolina, 1842–1941

Stephen E. Massengill

In 1839 French artist Louis J. M. Daguerre announced the development of the daguerreotype, one of the earliest and most successful forms of photography. Daguerre's process, through which images were secured on silvered copper plates exposed directly inside the camera, produced sharp and accurate pictures with a mirrorlike surface. The art spread quickly across the Atlantic and then from the northeastern United States to the Midwest and South.

Most of the early traveling artists were based in the North, and during the winter months they often traveled in the South. That winter migration represented a continuation of a tradition followed by northern portrait painters in earlier times. The itinerant artists most often appeared from about December to May—most likely to capture the Christmas trade and to escape the colder climate at home. The daguerreotypers occasionally sought well-to-do clients at resorts in the summertime and also visited cities and towns during court week, when a large number of citizens would be present to conduct business.

The pioneer itinerant daguerreotypers traveled mostly in wagons and by stagecoach and followed the main north-south roads through North Carolina. The leading transportation arteries included the road that connected Warrenton, Raleigh, and Fayetteville and the highway that linked Virginia to Charlotte via Greensboro and Salisbury. Some operators may have traveled by rail or sailed aboard ships into Wilmington, New Bern, and Beaufort. Thus, the leading centers for photographic activity in the state included the more populated centers of transportation—Wilmington, Fayetteville, Raleigh, New Bern, Hillsborough, Greensboro, Salisbury, and Charlotte.

The earliest itinerants in North Carolina set up makeshift studios in hotels, courthouses, or other public buildings; on the second floor of business buildings; and sometimes in private residences. The duration of their stay in any given area was usually brief, varying from a week to a few months. Most of the artists published advertisements in local newspapers. Some of the advertisements included colorful poetic verses that described the new art or the artist's gallery. The average price of cased daguerreotype images ranged from three to ten dollars, depending on the size of the image and the quality of the case. To increase their income, some artists offered instruction in the new art; others sold photographic supplies. Many of them peddled encasements such as frames, pins, and lockets. A goodly number of daguerreotypers made house calls in order to make portraits of sick and deceased persons. Other than those occasional visits to the homes of the ill, photographic artists recorded few images outside of their studios. Only a handful of operators advertised the execution of outdoor views, preferring the convenience and consistency of portraiture in their own galleries. The majority of the artists practiced their occupation for only a brief time and moved on to

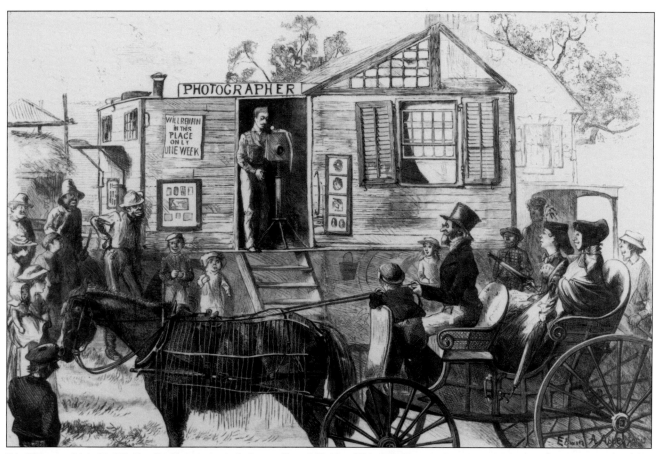

This 1871 engraving is titled *The Traveling Photographer in the Country*. *Harper's Weekly* published the illustration in its December 16, 1871, issue. Illustration courtesy N.C. Office of Archives and History (A&H), Raleigh.

other professions. A few of the more talented photographers, who were also keen businessmen, fashioned careers out of the new art.

The following paragraphs include brief sketches of a number of pioneer photographers who operated in North Carolina between 1842 and the start of the Civil War and made significant contributions toward the advancement of the art in the state. All of the earliest photographers in North Carolina were itinerants.

Possibly the first operator to find his way into North Carolina was an itinerant named Dr. Davis, who worked at Halifax in May 1842. He was likely one of three Davis brothers—Ari, Asahel, and Daniel—who were early daguerreotypers in Boston. Dr. Davis worked out of William Pride's hotel in Halifax and offered daguerreotype miniatures for six dollars each. He advertised that he would "be happy to wait upon the ladies and gentlemen, and explain the principles of this curious art to sitters."[1]

Among the first photographers to visit Raleigh was T. H. Smiley, who had been a student of Samuel F. B. Morse in Philadelphia in 1840. Smiley opened a gallery at the home of Dr. Fabius J. Haywood

on the corner of Fayetteville and Morgan Streets in late December 1842 and remained there through March 1843.[2] A few months later, Raleigh received a visit from artist Henry B. Stringfellow Jr., who opened and briefly occupied studios in the capital city and at the Planter's Hotel in Fayetteville. In November 1843 Stringfellow paid a return visit to Raleigh, where he set up quarters over Benjamin B. Smith's store.[3]

One of the first of the pioneer itinerants to offer hand-colored daguerreotype miniatures to the North Carolina public was James Joyner. In June 1843 Joyner operated a temporary gallery at a dwelling near the residence of Judge Frederick Nash on Margaret Street in Hillsborough. Joyner's stay was brief in North Carolina, but he returned to the state in November 1843, setting up his business at New Bern.[4]

One of the leading operators in New York appeared in Fayetteville and Wilmington in 1845 and 1846. Samuel Dwight Humphrey (1823–1883), prominent daguerreotyper and later a photographic editor, along with J. L. Bryan, a partner, comprised the firm of Humphrey and Company, which occupied Brick Row near Briggs's Hotel in Fayetteville beginning in late

1845. By the summer of 1846, Humphrey opened an office on Front Street in Wilmington. Humphrey, like many of the picture takers of the era, supplemented his income by offering instruction in the art for a modest fee and selling photographic apparatus and supplies.[5]

A local portrait painter who turned to the art of the daguerreotype was Dr. Charles Doratt, who arrived in Raleigh from New York in 1840 as copartner in and instructor at the Raleigh Institute, a day school for boys. Doratt later offered private art instruction and painted portraits on commission. By 1844 he had introduced photography into his studio. In the autumn of 1846 Doratt offered his talents to members of the General Assembly, boasting that "His portraits, combining the latest improvements, with the best materials, cannot be surpassed either in distinctness of outline, or in correctness of resemblance."[6] Doratt took a wedding picture of Capt. William J. Clarke and writer Mary Bayard Devereux Clarke in 1848, shortly after the former returned from service in the Mexican War.

Another artist who visited North Carolina and subsequently became well known in the photographic world was Samuel Broadbent (1810–1880). Broadbent was a painter of portraits, particularly miniatures, who learned the daguerreotype art from his friend Samuel F. B. Morse in New York City. During the 1840s Broadbent traveled south during winters and later opened his own studio in Philadelphia. He made stops in Fayetteville and Raleigh in April and May 1848.[7]

One unusual team of daguerreotypers may have included the first woman to be involved in the photographic trade in North Carolina. Dr. John W. F. Wilde (b. ca. 1803), a resident of Baltimore, and his daughter Augusta (b. ca. 1832) were itinerant operators in the state between 1849 and 1853, with known stops in Hillsborough, Greensboro, Charlotte, and Asheville. They opened a gallery in Greensboro in March 1851, and their announcement in the *Greensboro Patriot* pointed out the benefits afforded by the presence of a female assistant: "To Ladies, our advantages present strong claims, as they [female subjects] are assisted (in a separate apartment) in their toilette, and prepared for sitting by Miss Wilde, whose experience and success with children produce gratifying results and whose style of coloring is unequaled—both which duties are exclusively within the province of a female. . . ."[8]

Alexander Starrett (b. ca. 1807), a native of Guilford County, was an artist who periodically practiced photography in Greensboro between 1848 and 1857. Starrett rented rooms at William Gott's hotel there and also worked out of an upstairs building opposite the Bland House.[9]

One traveling daguerreotyper who had made previous visits to North Carolina returned to the state in the fall of 1850 with a new innovation in the profession that he claimed would improve the quality of the art. John S. Woodbridge opened a "Skylight Daguerrean Gallery" on Craven Street in New Bern, near Pollock Street. At his own expense, he constructed a "MAMMOTH SKYLIGHT"—which he claimed was the only one in North Carolina. He equipped his studio with a very large-sized camera that, along with his overhead window, he boasted, would produce images "in a Style heretofore unknown in this section of the state."[10]

A team of itinerant photographers by the name of Weeks (Dr. George H.) and Griffin made a whirlwind tour of the state during the early months of 1851. The two men entered North Carolina from Farmville, Virginia, and made appearances in Tarboro, Raleigh, Greensboro, and Salisbury. Weeks and Griffin styled their operation a "Locomotive Daguerrean Gallery" while they were in Raleigh, but in Greensboro they erected a skylight gallery at Col. William Gott's hotel. They resorted to light doggerel in advertising their services:

> All thanks to him who made the sun
> For all the wonders we have done,
> We talk by lightning, ride by steam,
> And paint by Sol's unerring beam.

While in Greensboro Dr. Weeks claimed to have discovered a process that produced an "Ivory Daguerreotype." The resulting image was less glossy in appearance and was plainer and more distinct. By September 1851 Weeks was located at Greeneville, Tennessee.[11]

Jesse H. Whitehurst (ca. 1820–1875), one of the foremost pioneer daguerreotypers and promoters of the art, is believed to have opened the first permanent gallery in North Carolina at Wilmington in January 1853. During the 1840s and 1850s the Virginia native operated a chain of studios between New York City and Wilmington, including establishments at Baltimore, Washington, Richmond, Lynchburg, Petersburg, and Norfolk. The artist surrounded himself with talented photographers and painters and secured Benjamin F. Harrison (b. 1824), reputed to be the best daguerreotyper in North Carolina, to oversee his Wilmington operation. Whitehurst's Wilmington gallery was located in Mozart Hall above Hart and Polley's store on Front Street. Whitehurst advertised the sale of

"WORLD'S FAIR PREMIUM DAGUERREOTYPES" in honor of the numerous medals he had won at various fairs and expositions. The Whitehurst firm was probably the first of its kind to offer stereographs to North Carolina consumers. In the summer of 1854 Whitehurst had his studio "thoroughly overhauled, and furnished in the best style." He boasted that those improvements would enable his gallery to produce "a Picture superior to those very black or pale likenesses usually taken by itinerant operators with ordinary light." Whitehurst also resorted to money-making schemes, such as a heavily advertised lottery he operated in 1854 to promote business. For unknown reasons, he closed his Wilmington branch in January 1855.[12]

C. B. and T. J. Havens (relationship not determined) dominated the photographic business in Raleigh during much of the 1850s. In 1854 C. B. Havens formed a partnership with painter Oliver Perry Copeland (1816–after 1876) and opened a studio in the newly erected brick building of William J. and A. S. Lougee on Fayetteville Street. Havens believed he could produce likenesses equal to any in the United States with his "SPLENDID SKYLIGHT" and "updated instruments."[13] Later in the decade T. J. Havens formed successful partnerships with talented artists M. M. Mallon and Joshua P. Andrews, who at different times expertly applied color to Havens's images.[14]

Oliver P. Copeland, a native of Suffolk, Virginia, moved to North Carolina after 1840 to engage in painting and teach art. Following his 1854 association with C. B. Havens, Copeland augmented his portrait-painting studio with daguerreotype apparatus. In a lengthy 1855 newspaper advertisement, he described in verse the two art forms available at his gallery:

> Come, Ladies fair, and Gentlemen, who want a
> likeness true
> Come to my Portrait Gallery, and I will give it you;
> I'll paint your portraits large as life, and very cheap
> will make 'em.
> I also take daguerreotypes, and take 'em in a hurry,
> And if you'll come and sit for one, I'll not your
> patience worry....

Copeland was practicing his profession in Oxford by 1858. He returned to Virginia in 1861 and worked as a photographer in the Tidewater region in the 1870s.[15]

The development of the *ambrotype*, a thin collodion negative on glass, led to the steady decline of the daguerreotype in the mid- to late 1850s. After the new photographic medium was developed, fixed, and dried, it was backed by a dark background and viewed by reflected light, producing a positive image. The ambrotype became the fashionable form of photography for the next few years. It was easier and less expensive to produce than a daguerreotype, and it lacked the irritating glare associated with its predecessor. By 1856 most of the prominent daguerreotypers in the state had adopted the new technology, although many continued to offer the old process.

Esley Hunt (b. 1824), a native of Tennessee, was among the first ambrotype artists in North Carolina; he operated a business at Chapel Hill in 1856. One of his advertisements in the *Hillsborough Recorder* pointed out the superiority of the new art form, which he called "The latest and greatest Discovery of the Age." "E. Hunt would inform the public," the notice declared, "that he has opened rooms permanently in Chapel Hill, where he is prepared to execute these beautiful pictures in the highest style of the art. The Ambrotype is taken on glass, without being reversed. . . . It can be seen in any light without reflection as it is free from the polish of the silver plate. . . ." By 1859 Hunt had established a gallery in Raleigh, where he collaborated with artist and portraitist Joshua P. Andrews during the early years of the Civil War.[16]

Jesse L. Cowling (ca. 1832–1864) migrated from Norfolk, Virginia, to New Bern in 1856 and by the summer of that year was offering ambrotypes to local citizens from his studio on Craven Street above Jonathan Whaley's store. In a newspaper advertisement Cowling boasted that his firm was "one of the best in the state for [the photograph] business. We have plenty of light and can operate in all kinds of weather." "The ambrotype," Cowling explained, "is made on Glass—is a new and beautiful style of Picture, and colored equal to an oil painting. . . ." [It] "is taken in about one-fourth of the time required for the Daguerreotype, and it is believed that they cannot possibly fade. . . ." Cowling remained in New Bern during the Civil War and died there during the yellow fever epidemic of 1864.[17]

Another Virginian who excelled as a maker of ambrotypes and who subsequently became one of the best-known photographers in North Carolina was John W. Watson (1828–1889). He launched his career in Richmond about 1851 and within four years had become a traveling daguerreotyper. Watson was located for brief periods at Hillsborough, Tarboro, New Bern, Beaufort, and Athens, Georgia. By 1857 he had decided to locate permanently in New Bern. He updated his old temporary quarters on Craven Street and began producing ambrotypes, as well as a new style of

photograph known as the *melainotype*, popularly known as the *tintype*.[18] The tintype was developed during the ambrotype period and was a modification of that process. The collodion negative was secured on black japanned iron, rather than on glass coated with dark color or backed with a black material. The tintype became very popular, especially during the Civil War, because it was more durable than the other two preexisting media. Watson remained in New Bern until the town was occupied by Union forces in March 1862. He relocated his business to Raleigh in the fall of 1865, and he became the leading photographer during the following two decades in the capital city.[19]

David Lowry Clark (1824–1915) was another skillful portrait painter who turned to the photographic art to enhance his work. Clark, yet another Virginia native, was a student of the renowned British-born American master Thomas Sully in Philadelphia in 1846. Clark traveled extensively throughout the South as an itinerant portraitist in the 1850s. He settled in High Point in the mid-1850s and by 1858 began taking pictures with a new type of camera that involved a novel enlargement process perfected by Baltimore inventor David A. Woodward (1823–1909); the device utilized the sun's rays to fix an image on light-sensitive paper or canvas rather than on a metallic or glass surface. Woodward's "solar camera" was part of a nationwide trend in the late 1850s toward the use of paper photographs and the decline of the ambrotype. Paper prints could be made larger than the old forms, and a number of prints could be obtained from a single negative. With his solar camera, Clark could take an almost perfect likeness of a subject or make a copy from a daguerreotype or an ambrotype. He then could enlarge it and correctly expose it on sensitized paper or canvas. Just prior to the Civil War Clark was affiliated with photographer Calvin A. Price (ca. 1821–1872) at High Point.[20]

Cornelius Murrett Van Orsdell (1832–1883) journeyed from Virginia to Fayetteville in 1859—about the time paper prints were coming into fashion. Like David Clark, Van Orsdell acquired a Woodward solar camera, which he claimed would make life-sized hand-colored photographs that were more beautiful and less costly than oil paintings. His gallery was located on Hay Street in Fayetteville. After 1862 Van Orsdell moved to Wilmington, where he enjoyed a prosperous career after the war.[21]

One of the first female amateur photographers in the state was New York native Melvina Thompson Ramsaur (ca. 1818–1890). She married Lincoln County native Dr. Alexander Ramsaur, and by 1847 the couple was residing at Woodside, a beautiful Federal-style plantation house located a few miles west of Lincolnton. Following her husband's death in 1856, Mrs. Ramsaur took up the art of photography. She produced ambrotype portraits of family members and secured outdoor views of the grounds of Woodside. Mrs. Ramsaur used the springhouse on the plantation as her darkroom. She likely learned her photographic skills from an itinerant artist or took lessons in a northern studio.[22]

Americans experienced a "golden era of portraiture" in the two decades before the Civil War. A variety of social influences stimulated an intense public hunger for art, and the nascent art of the portrait taker rode that wave of popularity. In relatively isolated North Carolina, itinerant photographers and, later, talented permanent operators gave local residents, especially those who resided in towns and along transportation routes, the opportunity to acquire the new art forms. Surviving images from the pre-Civil War daguerreotype era accurately document and help to define the faces and fashions of that period. United States census data demonstrate the dramatic growth of photography in the nation and in North Carolina between 1840 and 1860.[23]

Although the Civil War stimulated interest in the medium of photography as such accomplished cameramen as Mathew B. Brady, Timothy H. O'Sullivan, Alexander Gardner, and George N. Barnard brought powerful images of the battlefield into the homes of the American public, the war interrupted or ended the careers of most photographers in North Carolina. During the war years, when photographic supplies and equipment became scarce in the South, there were only a few dozen operators in the state. In addition to Jesse L. Cowling, Esley Hunt, and John W. Watson, the leaders were E. T. Barry and William Batchelor in Wilmington; J. Newton Bryson in Asheville; David L. Clark in High Point; Levi Crowl (1820–1890) in Wilmington; William P. Hughes (b. ca. 1835)—an itinerant in the state—O. J. Smith, and others in New Bern during the Union occupation; Cornelius M. Van Orsdell in Fayetteville and Wilmington; and Alanson E. Welfare (1824–1883) in Salem.[24]

Two new photographic formats that were products of the wet-plate process began to replace the ambrotype in the 1860s. The first type, the aforementioned tintype, became the most prevalent form of inexpensive images during the war years. The second was called the *carte-de-visite*—a card photograph mounted on cardboard stock about the size of a calling card. The latter became the leading form of photograph in the United States during the 1860s and early 1870s, and its popularity led to the development of the family photograph album.

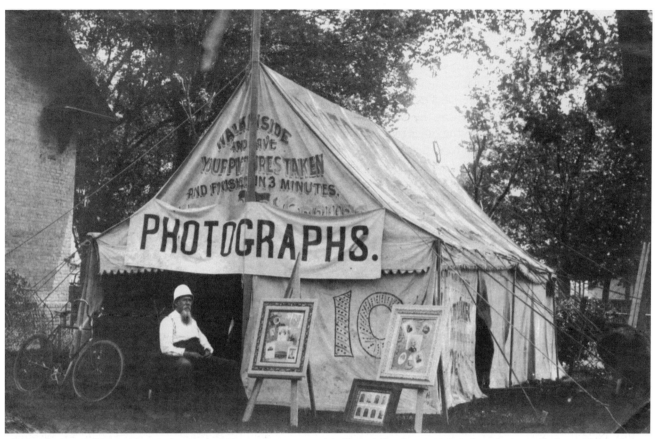

John F. Engle was a well-known itinerant photographer before settling permanently in Elizabeth City about 1892. He is shown here seated in front of the tent he pitched during his travels in eastern North Carolina. Photograph courtesy Florence W. Stevens, Elizabeth City.

Commercial photography underwent a resurgence in the postwar period, and the number of professionals increased at a steady rate in the late 1860s and throughout the 1870s.[25] Many new operators entered the field, but only a handful of the antebellum artists continued or resumed the practice of photography during the postwar years. These pre-war professionals included Clark in High Point; John F. Engle (1824–1908), an important itinerant; Edward W. Herndon (1839–1886) in Asheville; William P. Hughes in Greensboro; Hunt in Fayetteville; Calvin A. Price in Goldsboro and Fayetteville; William Shelburn (1834–1911) in Raleigh and Durham, Van Orsdell in Wilmington; Watson in Raleigh; and Alanson E. Welfare in Salem.

Among the artists of the period were itinerants as well as resident practitioners. As the population of the state grew and towns and cities emerged, the number of resident operators increased. The most renowned artists tended to reside in the state's larger towns. Most of them specialized in portraiture, but some also made outdoor views and sold them as stereographs, an increasingly popular medium of the period. The most successful newcomers to the field of photography between the end of the Civil War and the end of the nineteenth century are listed at right.

Lewis W. Andrews (1837–1901), Greensboro

Arthur F. Baker (1857–1936), Hendersonville

Henry Baumgarten (1839–1918), Charlotte

Henry Cronenberg (1856–1914), Wilmington

Edward Gerock (1845–1906), New Bern

Thomas H. Lindsey (1849–1927), Asheville

Henry A. Lineback (1839–1932), Salem and Winston

Archibald McIntosh (1837–1912), Hickory

Rufus Morgan (1846–1880), New Bern and as an itinerant

Charles W. Rochelle (1854–1913), Durham

Edward F. Small (1844–1924), as an itinerant

William J. Stimson (1860–1929), Statesville

Nat W. Taylor (1852–1904), Asheville

James H. Van Ness (1841–1925), Charlotte

Cyrus P. Wharton (1852–1929), Greensboro and Raleigh

Francis M. Winstead (1850–1914), Wilson

Charles W. Yates (1839–1915), Wilmington

William H. Zoeller (1864–1936), Elizabeth City[26]

While daguerreotypes, ambrotypes, and tintypes generally were reserved for portraits, North Carolina photographers during the 1870s began using negatives and the resulting prints to produce outdoor scenes in the form of stereographs and larger-format prints. These photographs became popular modes of entertainment in the nineteenth century. Operators such as J. H. Blakemore (b. 1832), John F. Engle, Thomas H. Lindsey, Rufus Morgan, Alexander Orr Jr., William T. Robertson (1845–1895), Nat W. Taylor, Balduin Von Herff, E. S. Wormell (b. ca. 1838), and Charles W. Yates increasingly took the camera outside to capture interesting views of the Tar Heel landscape.

Rufus Morgan was one of the state's foremost stereograph artists. A native of Virginia, he settled in North Carolina after the Civil War and married Mary Devereux Clarke, the only daughter of Col. William J. Clarke and Mary Bayard Devereux Clarke. By 1869 Morgan was headquartered at New Bern, where he offered the public porcelain pictures, as well as stereographs. In order to obtain additional business, he subsequently crisscrossed the state, taking views and portraits. Between 1872 and 1875 Morgan published a popular series of stereographs that included some of the earliest recorded scenes of Asheville and vicinity, New Bern and vicinity, Charlotte, Wilmington, and Raleigh. By the mid-1870s Morgan began to realize that the photography business alone would not provide enough income to support his family. He began to experiment in the beekeeping and fruit industry while in the Old Fort area of McDowell County. In January 1879 Morgan left his family in New Bern and traveled to near San Diego, California, to engage full time in the bee industry. Before he could establish a successful business he died unexpectedly in southern California on April 5, 1880, after eating poisonous mushrooms.[27]

White men tended to dominate the profession, but that tendency began to change as the nineteenth century drew to a close. Although women had been assisting in photographic galleries during earlier times, they were slow to take up the profession in North Carolina. Correspondence from Mary Custis Lee, wife of Robert E. Lee, to Mary Bayard Clarke in 1867 mentions a photographer named Mrs. D. W. Jones in Smithfield.[28] No further information could be located about this woman. Forsyth County women Susan Elizabeth James (1848–1933) and Emma Fischer Cain (1864–1924) were active as early photographic assistants during the 1870s and 1880s. James was associated with Henry A. Lineback at Salem for six years before the two were married in 1876; Cain was employed in the gallery of Sylvester E. Hough (b. 1849) in Winston.[29]

The first commercial female photographer in the state was likely Mrs. H. H. Davisson, who began work at Oxford in 1882. She opened her business above the store of Grandy and Brother on Main Street and boasted that she received instruction from some of the finest "masters of the art." She announced to the local citizens that she had moved her operations to "the wide awake town of Oxford and hopes to merit by good work and attention to business, the patronage of the town and surrounding country." Davisson claimed to have one of the earliest photographers of Washington City as her associate.[30] No additional information has been located concerning Mrs. Davisson's photographic endeavor, and it is doubtful that she remained in Oxford for an extended period of time.

As the nineteenth century drew to a close, women increasingly began to step behind the camera. Some of these pioneers in the trade included Bessie S. Alderman (1871–1939) in Greensboro, Florence M. Branagan (1872–1942) in Asheville, Estelle Cox (b. 1875) in Asheville, Mamie Gilliam (1866–1942) in Morganton, Annie B. Leonard (b. 1879) in Greensboro, sisters Sue S. (b. 1868) and Tetlulah Robbins (b. 1872) in Lexington, Miss R. E. Scott in Wilmington, and Sallie C. Vaughn (b. 1877) in Burlington. A Wilmington newspaper had this reaction to Miss Scott's occupation: "A lady photographer is something new to Wilmington, but it is an innovation that will be appreciated by the public. The fair sex succeed at everything else they undertake, why shouldn't they make successful picture artists."[31] Many of these artists worked as apprentices for male photographers or were wives or daughters of cameramen. Bessie Alderman was married to prominent Greensboro photographer Sidney L. Alderman, while Annie Leonard was the daughter of Greensboro operator Joseph A. Leonard (1853–1912). Award-winning Asheville artist Ignatius W. Brock (1868–1950) taught the trade to Estelle Cox.[32]

African American photographers were a rarity in late-nineteenth-century North Carolina. During the period, they performed odd jobs in the studios of white photographers. A young African American man named Frank Manly (b. ca. 1851) worked in an unidentified studio in Raleigh in 1870.[33] Another man of color named Julius Johnston (b. ca. 1860) assisted Nat Taylor with his operation in Asheville in 1880.[34] By 1870 a few African American men had begun to serve as apprentices under white photographers. One such individual was Horace Davis (b. ca. 1851), who practiced his trade in an unidentified gallery at New Bern in 1870 and was perhaps the first of his race to work as a photographer in the state. By 1880 Davis was operating his own studio in Raleigh, and it may have been the first permanent gallery run by a nonwhite. He was proprietor

of Oak City Photograph Gallery on Hargett Street, east of Wilmington Street.[35] Records do not reveal how long Davis operated this business. Two mulattoes were engaged as itinerants in North Carolina during the 1870s and 1880s: John F. Lee (ca. 1850–1888) was active in Edenton in the 1880s, and William F. Sturgis (b. ca. 1840) traveled with his camera to Durham, Windsor, and Edenton between 1877 and 1881. Sturgis, a native of New York, worked in South Carolina prior to traveling through North Carolina and subsequently moved to Baltimore.[36] Henry H. Hayden (1872–1934) worked in Charlotte between 1897 and 1899, and Harris Hogan (b. 1857) was active in Greensboro by 1900.[37]

The fluctuating economy of the period profoundly affected the photographic trade. Photographers increasingly formed and re-formed partnerships to keep their businesses afloat; such partnerships commonly involved fathers and sons or brothers. Uncertain financial conditions forced others to abandon the profession. Some operators in smaller markets were compelled to engage in other business enterprises to supplement their earnings from photography.

The North Carolina General Assembly first included photographers in the state's tax legislation in 1857 when it assessed a tax of "ten dollars in every county in which they may take likenesses." In 1859 the state government levied a tax of 1 percent on every $500 annual income of resident photographers and directed that itinerant operators pay $10.00 for each county in which they undertook their business. In 1873 the tax imposed for the privilege of working as an itinerant photographer was reduced to $5.00 per county. Four years later traveling photographers had a choice of paying $5.00 in each county in which they were employed or obtaining an annual license from the state treasurer for $25.00. Although the amounts of the tax and license fee fluctuated, the law remained in effect until 1899, when the legislature imposed an annual license tax of $5.00 on every photographer. The license was good in every county of the state, and the amount remained constant during the first two decades of the twentieth century. By 1931 there was a $25.00 license fee for photographers who made more than $1,000 during the preceding year. Operators with receipts under $1,000 paid only $12.50 to the state. By 1935, in addition to the state license fee, cities and towns were empowered to levy a tax not to exceed $25.00 on photographers.[38]

Two important innovations in the art of photography—the gelatin dry-plate developing process and, subsequently, flexible film—occurred during the period and enabled practitioners to achieve markedly increased productivity and efficiency. Those improvements were not adopted as standards in the United States until the 1880s, however. Indeed, large numbers of older professionals continued to utilize the outdated traditional technologies.

By the end of the nineteenth century the art of photography had blossomed into a respected profession. The number of people engaged in this business more than doubled in North Carolina between 1890 and 1900.[39] Although traveling operators were still prevalent, the number of resident photographers increased as the population of the state and its towns and cities grew. By 1900 more women and African Americans were participating in the trade.

At the dawn of the twentieth century one of the more famous photographs in the state's history was taken by an amateur photographer. John T. Daniels, an employee of the United States Life-saving Service in Dare County, North Carolina, captured on a glass-plate negative an image of the first flight of a heavier-than-air powered aircraft on the windswept Outer Banks on December 17, 1903. The Wright brothers had pre-focused, pre-loaded, and positioned a box camera, mounted on a tripod, to face the spot where the airplane would become airborne and instructed Daniels to squeeze a bulb to trip the camera's shutter at the appropriate moment. The result was a successful image of the Wright Flyer, with Orville aboard, flying a few feet off the ground, with Wilbur standing alongside the right wing. It was the only photograph ever taken by the lifesaver.[40]

At the turn of the twentieth century, professional photographers were confronted with an explosion of amateur photographers. With the development of the Kodak camera, individuals were increasingly taking their own photographs and sending the undeveloped flexible film back to the factory to have it developed into prints. Commercial photographers continued to have a steady business of making portraits in their studios but also began serving the amateurs by offering film-developing and photo-finishing services. A few of the more important amateur photographers have been included in the directory.

During the first quarter of the twentieth century, professional photographers also began to take advantage of the public's desire for picture postcards of family members and views of hometown subjects. Photographers captured images of public buildings, main streets, schools, churches, colleges, post offices, railroad depots, and parades and published thousands of them as postcards. North Carolinians mailed millions of these cards to relatives and friends as a part of the national craze for receiving and collecting "penny

postcards." Some of the best real-photo and commercial postcard artists in North Carolina included Thomas R. Draper (1868–1940) in Beaufort County, E. C. Eddy (1882–1969) in Southern Pines, the Felch sisters (Dora and Edith) in Sanford, Frank Marchant (1872–1942) in Hamlet, D. Victor Meekins (1897–1964) in Dare County, Edmond L. Merrow (ca. 1861–1922) in Pinehurst, John E. Spencer (b. 1865) in Rockingham,

H. Lee Waters (1902–1997) in Lexington, and Bayard Wootten (1875–1959) in New Bern. (For a fuller listing of photographic artists and companies known to have produced picture postcards in North Carolina, see Appendix 3.)

Many of the more prominent photographers in North Carolina during the early decades of the twentieth century are listed below.

Sidney L. Alderman (1860–1931), Greensboro and High Point
William H. Baker (1870–1939), Washington
Ewart M. Ball (1895–1937), Asheville
Arthur F. Barber (1889–1980), Hendersonville
Albert Barden (1888–1953), Raleigh
William A. Barnhill (1888–ca. 1988), Asheville
John D. Brinkley (1862–1939), Oxford and Henderson
Ignatius W. Brock (1866–1950), Asheville
James W. Denmark (1896–1956), Raleigh
Joseph C. Ellington (1871–1965), Raleigh
Charles A. Farrell (1893–1977), Greensboro
Robert W. Foister (b. 1888), Chapel Hill
Lee Greer (1870–1943), Wilmington
Charles M. Hardin (1868–1940), Hickory
John H. Hemmer (1892–1981), Pinehurst
Luther L. Higgason (1885–1934), Asheville
Waller Holladay (b. ca. 1875), Durham
Katie L. Johnson (1874–1964), Durham
James Edward Jones (1865–1942), High Point
George Masa (1881–1933), Asheville
Ben V. Matthews (1887–1939), Winston-Salem
Alexander A. Miller (1857–1936), Goldsboro

William J. Moon (b. ca. 1872) and wife Mary E. Moon (b. ca. 1884), Charlotte
William M. Morse (1867–1932), Charlotte
Erastus A. Parker (1857–1935), Kinston and Greenville
George E. Paton, Octavia Paton Allen, and Noel E. Paton (Paton Studios), Fayetteville
Herbert W. Pelton (1879–1961), Asheville
Ottis J. Rader (1868–1935), Charlotte
William A. Roberts (1872–1943), Greensboro
R. Henry Scadin (1861–1923), western North Carolina
Charles V. Sellers (1870–1941), Burlington
George D. Sherrill (1879–1931), Waynesville
Henry A. Siddell (b. ca. 1882), Raleigh
Benjamin A. Stimson (1893–1969), Statesville
James E. Strawbridge (1894–1964), Durham
Manly W. Tyree (1877–1916) in association with Cyrus P. Wharton, Raleigh
James H. Van Ness Jr. (1878–1928), Charlotte
James C. Webb (1876–1938), Washington and Rocky Mount
Lloyd E. Webb (1879–1937), Morganton
Bayard Wootten, New Bern and Chapel Hill

More African Americans and women began to enter the profession in the twentieth century. Some of the leading male African American photographers in North Carolina who deserve mention include Fred D. Anders (1905–1975) in Fayetteville, Corel B. Campbell in Raleigh, Edward D. Devereaux (b. 1892) in Rocky Mount, Colvin M. Edwards (1903–1989) in Charlotte, Tod R. Edwards (ca. 1874–1951) in Siler City, Marion M. Farmer in Winston-Salem, Calvin A. Flanagan (b. 1890) in Goldsboro, James E. Hemphill (1886–1959) in Charlotte, William T. Jones (b. 1890) in Holly Springs and Durham, Benjamin B. Keith in Wilmington,

John E. W. Mickens in Concord, Shepard Richmond (b. 1882) in Greensboro, Alonzo L. Roberts in Rocky Mount, Richard P. Rogers in Asheville, George A. Troxler in Greensboro, and Charles Tyson in Winston-Salem. African American women began working in the profession about 1910. Ellen F. Dozier of Elizabeth City and possibly Letitia (Martisha?) Stewart of Greensboro were two of the earliest of their race to work in photography studios in the state.[41]

Katie L. Johnson (1874–1964) emerged as Durham's first woman photographer at the beginning of the twentieth century. Johnson, a native of Sampson

County, was active in the profession by 1900 and continued to work in the field until the 1930s. She apprenticed under Oliver W. Cole and Waller Holladay in Durham and later specialized in portraits of children and school groups. During the early years of her business on East Main Street, Miss Johnson billed herself as "the Children's Photographer."[42]

The wife of Fayetteville photographer George E. Paton (1855–1902) was forced to take over the business following the untimely death of her husband. Octavia E. "Nellie" Paton (1866–1941), a native of Canada, had assisted her spouse for several years and operated the business to support her family. The Paton Studio became the leading photographic enterprise in the Fayetteville vicinity for more than forty years. Leadership of the firm passed on to her son, Noel E. Paton (1895–1965), at the conclusion of his service in World War I.[43]

Sisters Dora and Edith Felch arrived in Sanford from the North in 1903 and by 1905 established a photography business above the post office on Main Street. They specialized in children's pictures, as well as real-photo postcards. The Felch Studio was a popular but short-lived enterprise, as matrimony brought an end to the partnership. Both sisters were married by 1908 and removed from North Carolina with their husbands.[44]

Bayard Wootten was undoubtedly the preeminent female photographer in the state during the first half of the twentieth century. She began her career in 1904 at New Bern, where she received instruction from local operator Edward Gerock. Wootten also took lessons and received inspiration from her friend and fellow-photographer Ignatius W. Brock in Asheville. She quickly gained an excellent reputation for her work as a photographer at the encampment of the State Guard at nearby Camp Glenn. Wootten aggressively pursued her profession and in 1914 even took aerial views of New Bern, thus becoming one of the first women in the nation to undertake such an assignment. She subsequently opened a studio on the military base at Camp (later Fort) Bragg near Fayetteville. After 1928 Wootten spent most of her career in Chapel Hill in partnership with her half brother, George C. Moulton. She made her living executing portrait work in the studio, but her real passion was traveling throughout North Carolina and the South taking photographs of people, scenes, and historic homes and buildings. Wootten's style was pictorial photography, which emphasized artistic content and art form rather than realism. Her photographs taken in the Carolinas received national recognition in exhibitions and were used as illustrations in numerous publications during the peak of her career between 1932 and 1941.[45]

Other successful women operators during the early portion of the century included Ada M. Eckenrod (b. 1878) in Canton, Alma B. Eckenrod (1900–1987) in Canton and Mount Airy, Florence Evans (b. 1903) in Hickory, Anne M. Farrell (1895–1977) in Greensboro, Lillian A. Ferguson in Lumberton, Marguerite D. Gaddy (1894–1987) in Raleigh and Charlotte, Isa M. Howard (b. 1879) in Asheville, Celia Moulton Lively (1898–1975) in New Bern, Luesa M. Marker (1883–1967) in Asheville, Georgie (Georgia) C. Oxley (1877–1938) in New Bern, Zenia Parker (1887–1966) in Charlotte, Sarah D. Rader (1872–1948) in Charlotte, Elizabeth O. Ramsey (1900–1988) in Durham, Hallie S. Siddell (1896–1977) in Raleigh, Ada Lindsey Slagle (1875–after 1937) in Asheville, Laura Talley in Durham, Amelia Van Buren (1854–1942) in Tryon, Blanche E. Wilson (b. 1905) in High Point and Burlington, and Clara M. Winter in Asheville.

The census of 1900 recorded 14 female photographers (compared to nearly 200 male practitioners) in the state; ten years later the total had reached 33 women (compared to 275 men). The outbreak of World War I brought more women into the profession; by 1920 their numbers had risen to a total of 49 (compared to 216 men).[46] Indeed, by the 1920s women had gained a foothold in the photographic profession in North Carolina and were beginning to rival their male counterparts. Although the trade remained mostly the province of men, women had closed the gap and demonstrated that they too could execute the tasks associated with the occupation. (For a listing of female photographers or operators of photographic studios in North Carolina, 1842–1941, see Appendix 4.)

Lewis W. Hine (1874–1940) traveled the country for the National Child Labor Committee during the first two decades of the century, documenting deplorable conditions for children in the nation's textile mills, factories, mines, and agricultural industries. Hine was a staunch supporter of stricter child labor laws and was perhaps the nation's most successful social welfare photographer. He worked in North Carolina on several occasions, using his camera to record child labor conditions in dozens of mill communities throughout the state.[47]

By the early 1900s some North Carolina photographers had joined the Photographers' Association of Virginia and the Carolinas, the area's regional professional association. The organization met once a year to elect officers, examine innovations in the field, exhibit and judge the work of members, and present awards for the best photography. Subsequently, the state's photographers formed the North Carolina Photographers' Association. During the depression era this organization

proposed the formation of a state board to regulate the photography profession in the state. Leaders in the movement included Albert O. Clement, Ray W. Goodrich, George M. Hoole, and Ben V. Matthews. As a result of the efforts of these men and others, the General Assembly in 1935 enacted legislation that established the State Board of Photographic Examiners to oversee the photography profession, as well as the photo-finishing business. The board required photographers to be certified and licensed by passing a written examination, demonstrating ability and integrity, and paying a fee. The organization regulated the photography industry in the state until 1949, when the Supreme Court of North Carolina declared the board unconstitutional.[48]

The depression era also brought a talented group of photographers to North Carolina via a New Deal agency known as the Farm Security Administration. Under the direction of Roy Stryker, photographers traveled throughout the country between 1935 and 1943 documenting rural suffering and the nation's poor farmers. The cameramen subsequently recorded valuable urban scenes. Members of the team of photographers that visited North Carolina and left a large body of unique visual records for researchers to study included Frank Delano (1914–1997), Dorothea Lange (1895–1965), Carl Mydans (b. 1907), Arthur Rothstein (1915–1985), Ben Shahn (1898–1969), John Vachon (1914–1975), and Marion Post Wolcott (1910–1990).[49]

A group of dedicated photographers visited North Carolina in the 1930s and early 1940s on behalf of the U.S. Bureau of Public Roads to document construction of the Blue Ridge Parkway in western portions of the state. These men, headquartered in Roanoke, Virginia, made monthly forays into the area to photograph the massive road-building project. They worked in all kinds of weather and under adverse conditions. They included J. B. Bornwell, G. W. Bussey, J. D. Cockey, G. I. Gibbs, A. C. Haygard, E. G. Middleton, M. B. Ring, K. F. Shiply, and W. D. Stanton.[50]

Between 1930 and 1940, the number of professional photographers in the nation and the state declined. There were 39,500 professionals in the United States and 368 in North Carolina in 1930. By 1940 the total in the nation was about 25,000, including 345 in North Carolina. The depressed economy caused much of the reduction. Moreover, many professional photographers entered the photo-finishing business during these years, and that trend may have led to a decrease in the number of photography studios. In 1940 the United States had some 5,700 people occupied in the photo-finishing industry, and the state reported 44 individuals involved in that business.[51]

The onset of World War II interrupted or brought an end to the careers of many North Carolina photographers. With so many men filling the ranks of the military service, women increasingly entered the profession. Shortages of photographic supplies and the recycling of silver for the war effort may have hampered the profession to a degree. On the other hand, the war increased the business of some operators in the state who were called on to take numerous pictures of servicemen in uniform, as well as photographs of civilians for their loved ones in the military service out of state. Photographer H. Lee Waters (1902–1997) of Lexington was one of a few operators who took a movie camera into cities and towns throughout the state and filmed local people on main streets, workers at mills and factories, and children at schools. Between 1936 and 1942 Waters visited dozens of locations and offered local townspeople an opportunity to "see themselves in the movies." He showed the silent color and black-and-white movies at local theaters for a small admission fee. Waters quit the movie business in 1942 because of the increased demand for portraits created by the war.[52]

Approximately 2,500 individuals have been identified as engaging in the field of professional photography during the first one hundred years of the industry in North Carolina. In the early days, many were itinerants from other states. By the twentieth century, resident operators had become more commonplace, particularly in the state's largest cities. Those individuals deserve recognition for the work they left behind. The intention of this directory is to identify those practitioners who labored behind the camera and in studios and darkrooms to produce likenesses and views for customers throughout the state. This work is by its very nature incomplete. It is the hope of the compiler that names of photographers and biographical information omitted from the list will be identified and submitted for subsequent updates to the directory. As more states publish directories of their photographers, additional facts will emerge about the individuals who worked during the first century of the profession in the Tar Heel State.

NOTES

1. *Roanoke Advocate and States Rights Banner* (Halifax), May 2, 11, 1842.
2. *Raleigh Register and North Carolina Gazette*, Dec. 30, 1842, Mar. 10, 1843. Samuel Finley Breese Morse (1791–1872), noted inventor, painter, and photographer, also offered instruction in the art of the daguerreotype.

3. *Fayetteville Observer*, June 14, 1843; *Raleigh Register and North Carolina Gazette*, Nov. 25, 1843.

4. *Hillsborough Recorder*, June 15, 1843; *Newbernian* (New Bern), Nov. 25, 1843.

5. *Fayetteville Observer*, Nov. 25, 1845, Jan. 6, June 9, 16, 1846; *Wilmington Journal*, Feb. 6, Dec. 25, 1846. The earliest known extant outdoor photograph made in North Carolina was taken from an upper-floor window of a building on Market Street in Wilmington, probably in the late 1840s. It shows St. James Episcopal Church and the Burgwin-Wright House. Local historians are attempting to identify who made the daguerreotype. Author Susan Block of Wilmington speculates that well-known photographer John Plumbe Jr. may have taken the Mexican War-era image. The Amon Carter Museum in Fort Worth, Texas, owns the original daguerreotype pictured on page 3.

Wilmington native Henry William Bradley (1813–1891) became one of the best-known early photographers in the nation, although he is not known to have made any photographs inside his native state. Perhaps he met some of the early daguerreotypers who visited Wilmington and through them became acquainted with the new art. Bradley learned the daguerreotype process in New Orleans in the late 1840s and moved to San Francisco in 1850. He gained a fine reputation as a sole practitioner before forming the successful photographic firm of Bradley and Rulofson. (Information on Bradley courtesy Peter Palmquist, Arcata, Calif.)

6. *Raleigh Register and North Carolina Gazette*, Nov. 16, 1842, Apr. 2, 1844, Sept. 29, Nov. 20, 1846.

7. *Fayetteville Observer*, Apr. 11, 1848; *Raleigh Register and North Carolina Gazette*, May 24, 1848.

8. *Hillsborough Recorder*, Dec. 5, 1849, Jan. 22, 1851; *Greensborough Patriot*, Mar. 15, 1851; *North Carolina Whig* (Charlotte), Feb. 10, 1852; *Western Democrat* (Charlotte), Dec. 17, 1852; *Asheville News*, July 28, 1853.

9. *Greensborough Patriot*, Aug. 19, 1848, May 1, July 3, Oct. 16, 1852, Oct. 1, 29, 1853, July 20, 1855, Dec. 26, 1856; *Patriot and Flag* (Greensborough), Mar. 8, 1857.

10. *Newbernian*, Mar. 28, Apr. 11, May 23, 1848, Feb. 26, 1850; *Newbernian and North Carolina Advocate*, Jan. 21, 1851.

11. *Weekly Raleigh Register and North Carolina Gazette*, Feb. 12, 1851; *Greensborough Patriot*, Mar. 15, Apr. 12, 1851; *Carolina Watchman* (Salisbury), Apr. 17, May 22, 1851.

12. *Wilmington Journal*, Jan. 14, July 1, July 22, Dec. 2, 1853, Jan. 27, July 28, Aug. 4, Oct. 20, 1854.

13. *North Carolina Standard* (Raleigh), Aug. 30, 1851; *Semi-Weekly Raleigh Register*, Feb. 18, 1854.

14. *Semi-Weekly Raleigh Register*, Feb. 4, Apr. 25, Dec. 17, 1857, Dec. 25, 1858; *Spirit of the Age* (Raleigh), Aug. 10, 1859. T. J. Havens won awards in the fine-arts category at the North Carolina State Fair of 1858. Along with Joshua P. Andrews, he was recognized for best daguerreotype, ambrotype, and photograph.

15. *Semi-Weekly Raleigh Register*, Nov. 17, 1855; *Dictionary of North Carolina Biography*, s.v. "Copeland, Oliver Perry."

16. *Hillsborough Recorder*, Mar. 12, 1856; *Spirit of the Age* (Raleigh), Aug. 10, 1859; *Weekly Standard* (Raleigh), Mar. 7, 1860.

17. *New Bern Journal*, Mar. 26, 1856; *Union* (New Bern), June 11, Aug. 27, 1856, Jan. 19, 1857; Craven County Estates Records (State Archives, Office of Archives and History [A&H], Raleigh).

18. *Historical and Descriptive Review of the State of North Carolina Including the Manufacturing and Mercantile Industries of the Towns of Durham, Fayetteville, Henderson, Oxford and Raleigh, and Sketches of Their Leading Men and Business Houses, 2nd Volume of N.C.* (Charleston, S.C.: Empire Publishing Company, 1885), 96–97; *Hillsborough Recorder*, Aug. 22, 1855; *Southerner* (Tarborough), Nov. 24, 1855; *Union* (New Bern), Sept. 24, 1856, Sept. 2, Dec. 10, 17, 1857; *Beaufort Journal*, July 15, 1857.

19. *New Bern Weekly Progress*, Jan. 8, 1861; *Daily North-Carolina Standard* (Raleigh), Oct. 5, 1865.

20. *People's Press* (Salem), May 21, 1853; *Fayetteville Observer*, Feb. 5, 1855; *Greensboro Patriot*, May 6, 1859; *High Point Reporter*, Apr. 20, Dec. 13, 1860.

21. *Fayetteville Observer*, May 2, Oct. 3, 1859; *North Carolina Presbyterian* (Fayetteville), Nov. 24, 1860; *Morning Star* (Wilmington), May 24, 1883.

22. *Lincoln Courier* (Lincolnton), May 23, 1890; Lincoln County Estates Records (A&H); Marvin A. Brown, *Our Enduring Past: A Survey of 235 Years of Life and Architecture in Lincoln County, N.C.* (Lincolnton: Lincoln County Historical Properties Commission), 1986. 140–141.

23. *Seventh Census of the United States, 1850, Embracing a Statistical View of the States and Territories* (Washington: Robert Armstrong, Public Printer, 1853), lxx–lxxvii; *Population of the United States in 1860, Compiled from the Original Returns of the Eighth Census* (Washington: Government Printing Office, 1864), 362–363, 657, 661, 670–671. (For the number of photographers in the United States and North Carolina in 1850 and 1860, see Appendix 1.)

24. Photographer Timothy H. O'Sullivan traveled to Fort Fisher after it fell into Union control in January 1865 and made numerous glass-plate negatives of the coastal fortification. Alexander Gardner fashioned prints from those negatives at his gallery in Washington, D.C. The photographs—probably the largest group of surviving visual records of North Carolina during the Civil War—are stored at the Library of Congress. Several Union photographers, including O. J. Smith, Lucien Stayner, Moses S. Chapin, and W. B. Rose, were active at the Union Art Gallery in New Bern during its occupation by Federal forces between 1862 and 1865. Two other known practitioners included Edwin J. Leland and Charles W. Dodge, who operated Dodge's Photo Room. These artists produced numerous wartime images of that Craven County town.

25. *Ninth Census of the United States, Population and Social Statistics, 1870* (Washington: Department of Interior, Census Office, 1872), 680–690, 690–691; *Tenth Census of the United States, 1880, Population and Social Statistics* (Washington: Department of Interior, Census Office, 1883), 750–751, 772, 788, 804. (For the number of photographers in the United States and North Carolina in 1870 and 1880, see Appendix 1.)

26. Stephen E. Massengill, "To Secure a Faithful Likeness," *Carolina Comments* 44 (January 1996): 27. In preparing this listing, the compiler relied upon a number of reference guides published by the firm of Dun and Bradstreet in the late nineteenth century. The guides feature ratings of business firms (including photographers) according to their estimated wealth, credit, and overall financial stability.

27. *New Bern Journal of Commerce*, Feb. 23, 1869; *Weekly Pioneer* (Asheville), Aug. 15, 1872; *Evening Post* (Wilmington), Mar. 5, 19, 1873; *New Bern Times*, Nov. 12, 1873; *Newbernian*, Feb. 22, 1879, Apr. 24, 1880; Stephen E. Massengill, "One Man's View," *State* 61 (May 1994): 21–23. (For a listing of photographic artists and companies known to have produced stereographs in North Carolina, see Appendix 2.)

28. Terrell Armistead Crow and Mary Moulton Barden, eds., *Live Your Own Life: The Family Papers of Mary Bayard Clarke, 1854–1886* (Columbia: University of South Carolina Press, 2003), 238.

29. Ninth Census, 1870: Forsyth County, Pop. Sch.; information provided by Jennifer Bean Bower, Museum of Early Southern Decorative Arts (MESDA), Winston-Salem.

30. *Oxford Torchlight*, June 20, 1882; *Granville Free Lance* (Oxford), July 7, 1882.

31. *Dispatch* (Wilmington), Oct. 29, 1898.

32. Twelfth Census, 1900: Guilford County, Pop. Sch., E.D. 53, 55; Fourteenth Census, 1920: Buncombe County, Pop. Sch., E.D. 139. (For a listing of female photographers or operators of photographic studios in North Carolina, 1842–1941, see Appendix 4.)

33. Ninth Census, 1870: Wake County, Pop. Sch., Raleigh Township, p. 12.

34. Tenth Census, 1880: Buncombe County, Pop. Sch., E.D. 34.

35. Ninth Census, 1870: Craven County, Pop. Sch., New Bern (first ward), p. 16; Tenth Census, 1880: Wake County, Pop. Sch., Raleigh, E.D. 269; *North Carolina Republican* (Raleigh), Mar. 19, 1880.

36. Tenth Census, 1880: Chowan County, Pop. Sch., E.D. 31; *Fisherman and Farmer* (Edenton), Apr. 6, 1888; Auditor's Records, Miscellaneous Tax Group, Box 3, 1877–1887 (A&H); Chowan County Deed Records, Book W, p. 571, Book Y, p. 124 (A&H).

37. *Maloney's Charlotte 1897–'98 City Directory* (Atlanta: Maloney Directory Company, 1897), 355; Twelfth Census, 1900: Mecklenburg County, Pop. Sch., E.D. 86; Twelfth Census, 1900: Guilford County, Pop. Sch., E.D. 56. (For a listing of African American photographers or operators of photographic studios in North Carolina, 1842–1941, see Appendix 5.)

38. *Public Laws of the State of North Carolina, Session of 1856–'57*, c. 34; *Public Laws of the State of North Carolina, Session of 1858–'9*, c. 25; *Public Laws and Resolutions of the State of North Carolina, Session 1872–'73*, c. 144; *Laws and Resolutions of the State of North Carolina, Session 1876–'77*, c. 156; *Laws and Resolutions of the State of North Carolina, Session of 1883*, c. 136; *Laws and Resolutions of the State of North Carolina, Session of 1885*, c. 175; *Laws and Resolutions of the State of North Carolina, Session of 1887*, c. 135; *Public Laws and Resolutions of the State of North Carolina, Session of 1899*, c. 11; *Consolidated Statutes of North Carolina . . . 1917 . . . and . . . 1919, Vol. Two*, c. 131; *North Carolina Code of 1931*, p. 2173; *North Carolina Code of 1935*, pp. 2434–2435; *North Carolina Code of 1939*, pp. 2639–2640.

39. *Eleventh Census of the United States, Miscellaneous Statistics, Part III, 1890* (Washington: Government Printing Office, Department of Interior, Census Office, 1897), 430; *Twelfth Census of the United States, 1900, Population, Census Reports, Volume II, Part II* (Washington: United States Census Office, 1902), 538–539.

40. Stephen Kirk, *First in Flight: The Wright Brothers in North Carolina* (Winston-Salem: John F. Blair Publisher, 1995), 180.

41. *Fourteenth Census of the United States Taken in the Year 1920, Volume V, Population 1920, Occupations* (Washington: Department of Commerce, Bureau of the Census, Government Printing Office, 1923), 14, 33. Thirteenth Census, 1910: Pasquotank County, Pop. Sch., Elizabeth City, E.D. 76; Thirteenth Census, 1910: Guilford County, Pop. Sch., Greensboro, E.D. 104; Hill, *Greensboro Directory*, 1909–1910, 1912–1913, 1913–1914; information supplied by Tim Cole, Greensboro. The census of 1930 lists 39,529 employees in the photography industry in the United States. Only 545 of these individuals were African American. The census did not record African American photographers by state. (For a listing of African American photographers or operators of photographic studios in North Carolina, 1842–1941, see Appendix 5.)

42. Thirteenth Census, 1910: Durham County, Pop. Sch., E.D. 41; *Durham Morning Herald*, Oct. 25, 1964.

43. *News and Observer* (Raleigh), Mar. 27, 1902; Twelfth Census, 1900: Cumberland County, Pop. Sch., E.D. 23.

44. *Sanford Express*, Jan. 12, Mar. 2, 1906, Mar. 29, 1907, June 26, 1908.

45. Jerry W. Cotten, *Light and Air: The Photography of Bayard Wootten* (Chapel Hill and London: University of North Carolina Press, 1998), 10, 12–13, 17–21, 30, 32, 44–49, 52–53.

46. *Twelfth Census of the United States, 1900, Population, Census Reports, Volume II, Part II* (Washington: United States Census Office, 1902), 538–539; *Thirteenth Census of the*

United States Taken in the Year 1910, Volume IV, Population 1910, Occupation Statistics (Washington: Department of Commerce, Bureau of Census, Government Printing Office, 1914), 137; *Fourteenth Census of the United States Taken in the Year 1920, Volume V, Population 1920, Occupations* (Washington: Department of Commerce, Bureau of the Census, Government Printing Office, 1923), 107. Thirty-six photographers from throughout the nation received special permission from the U.S. Army to take photographs at Camp Greene, a World War I military training base in Charlotte. They traveled to Charlotte in 1917 and 1918, usually to photograph soldiers for their hometown newspapers and for the folks back home.

47. *http://www.photocollect.com.* The Library of Congress Prints and Photographs Division maintains a helpful index to Hine's photographs.

48. *Guide to Research Materials in the North Carolina State Archives: State Agency Records* (Raleigh: Department of Cultural Resources, Division of Archives and History, 1995), 766–767. In *State v. Balance*, filed February 4, 1949, the North Carolina Supreme Court ruled that photography was a private business that did not imperil the public safety and welfare and thus did not require a state board of regulation. Correspondence in the State Board of Photographic Examiner's Records contains valuable biographical information about many twentieth-century North Carolina photographers.

49. "Reference Guide to Farm Security Administration/Office of War Information Photographs" (undated in-house finding aid, Library of Congress, Prints and Photographs Division, Washington, D.C.). The FSA/OWI photograph collection is housed at the Library of Congress; Penelope Dixon, *Photographers of the Farm Security Administration: An Annotated Bibliography, 1930–1980* (New York and London: Garland Publishing, Inc., 1983), 9, 17, 53, 73, 85, 119, 151, 161, 167.

50. Blue Ridge Parkway Photograph Collection (A&H).

51. *Fifteenth Census of the United States: 1930. Population.* Vol. IV: *Occupations, by States.* . . . (Washington: U.S. Government Printing Office, 1933), 33, 1205, 1208; *Sixteenth Census of the United States: 1940. Census of Business.* Vol. III: *Service Establishments, Places of Amusement, Hotels, Tourist Courts and Tourist Camps, 1939* (Washington: U.S. Government Printing Office, 1942), 2, 16, 54–55, 167, 381; *Sixteenth Census of the United States: 1940. Population.* Vol. III: *The Labor Force.* . . . *Part 4: Nebraska-Oregon* (Washington: U.S. Government Printing Office, 1943), 539. By the 1930s the larger daily newspapers in the state began hiring photographers to produce pictures to accompany their news stories. Some of the leading newspaper photographers are included in the directory.

52. *Dispatch* (Lexington), Dec. 10, 1997; Alex Albright, "The Early North Carolina Movies," *State* 54 (July 1986): 10–11.

STEPHEN E. MASSENGILL, a native of Durham, received his undergraduate degree in history from St. Andrews College in 1972, then earned an M.A. in history from North Carolina State University in 1976. He has been employed by the North Carolina Office of Archives and History since 1973 and has been head of the Nontextual Materials Unit of the agency's Archives and Records Section since 1990. He has published a number of pictorial articles and books on certain aspects of North Carolina history and especially on the history of photography and photographers in the state. Examples of his published works include *The Photographs of Frank Marchant, Commercial Photographer, Hamlet, North Carolina, 1907–1930s* (1989); *Around Southern Pines, A Sandhills Album: Photographs by E. C. Eddy* (1998); and *Western North Carolina: A Visual Journey through Stereo Views and Photographs* (1999). Massengill is a long-time collector of postcards and stereographs that feature North Carolina-related subjects.

Readers are encouraged to submit additions and corrections to the roster. The compiler can be reached at any of the following addresses:

By mail:
Office of Archives and History
Archives and Records Section
4614 Mail Service Center
Raleigh, NC 27699-4614

By telephone: (919) 807-7311

By e-mail: *steve.massengill@ncmail.net*

APPENDIX 1

Number of Photographers in the United States and North Carolina, 1850–1940

YEAR	U.S.	N.C.	Male	Female
1850	3,031*	18*		
1860	7,667*	61*		
1870	7,558	58		
1880	9,900	73		
1890	20,040	96		
1900	27,029	213	199	14
1910	31,775	308	275	33
1920	34,259	265	216	49
1930	39,529	368	290	78
1940	24,996	345	276	69

*Totals include artists
SOURCE: Census compilations for respective years

APPENDIX 2

Photographic Artists and Companies Known to Have Produced Stereographs in North Carolina

Anthony, E. and H. T.

Baker, Arthur F. (in partnership with D. T. Johnson)

Berry, Kelly & Chadwick (Chicago)

Blakemore, J. H.

Branson, _____ (in partnership with McCrary)

Broadaway, John S.

Campbell, Alfred S. (publisher from Elizabeth, N.J.)

Chadwick, _____ (in partnership with Berry and Kelly)

Clark, David L.

Dodson, James M.

Engle, John F. (in partnership with Nat W. Taylor)

Fellows, _____ (in partnership with H. L. Roberts)

Galloway, Thomas K.

Gerock, Edward

Gibson, John H. (in partnership with Nat W. Taylor)

H. C. White Company (North Bennington, Vt.)

Harris, Thomas C.

Heywood, John D.

Hinson, _____ (in partnership with Luther A. Ramsour)

Hix, William P. (in partnership with Richard Wearn)

Jernigan, James

Johnson, D. T. (in partnership with Arthur F. Baker)

Jones, G. W. (in partnership with Nat W. Taylor and H. G. Trotter)

Kelly, _____ (in partnership with Berry and Chadwick)

Keystone View Company (Meadville, Pa.)

Kilburn Brothers (Littleton, N.H.)

Leonard, Joseph A.

Lindsey, Thomas H.

Lyall, Arthur

McArtan, C.

McCrary, _____ (in partnership with Branson)

Morgan, Rufus

Murphy, P. Henry

Orr, Alexander, Jr. (in partnership with Charles W. Yates)

Patrick, J. C.

Ramsour, Luther A. (in partnership with Hinson)

Riggsbee, William H.

Roberts, H. L. (in partnership with Fellows)

Robertson, William T.

Scadin, R. Henry

Shuford, Thomas R.

Singley, B. L. (Keystone View Company)

Smith, O. J.

Stuart, _____

Taylor, Nat W. (in partnership with John F. Engle, John H. Gibson, G. W. Jones, and H. G. Trotter)

Trotter, H. G. (in partnership with G. W. Jones and Nat W. Taylor)

Underwood & Underwood (New York City)

Van Ness, James H.

Van Orsdell, Cornelius M.

Von Herff, Balduin

Wearn, Richard (in partnership with William P. Hix)

Whitehurst, Jesse H. (stereographic daguerreotypes)

Wood, C. H.

Wormell, E. S.

Yates, Charles W. (in partnership with Alexander Orr Jr.)

APPENDIX 3

Photographic Artists and Companies Known to Have Produced Picture Postcards in North Carolina

A & T College Photo Studio
Baker, Arthur (Baker Art Gallery)
Barber, Armitage F. (Baker Art Gallery)
Barber Printing and Stationery Company / Barber's Book Store
Blough, Newton W. (in partnership with Luther L. Higgason)
Bradshaw, Albert J.
Brock, I. W.
Caine, _____
Clement, Albert O.
Cline, Walter M.
Cobb, John S.
Conger, M. N.
Coward (in partnership with Bayard Wootten)
Cutrell, Romulus
Draper, Thomas R.
Eddy, E. C.
Engle, John F.
Evans, Benjamin V. (in partnership with D. Victor Meekins)

Felch, Dora A.
Felch, Edith E.
Foust, Orren V.
George, John N.
Goodale, I. E.
Gowdy, M. B.
Harris, _____ (in partnership with Miller)
Hemmer, John H.
Hennis, _____
Higgason, Luther L. (in partnership with Newton W. Blough)
Hitchcock, J. J.
Holladay, Waller
Jackson, W. F.
Jackson, William H
Johnson, G. C.
Johnson, Katie L.
Johnson, W. C.
Kluttz, J. H. J. (in partnership with Oates)
Marchant, Frank

Meekins, D. Victor (in partnership with Benjamin V. Evans)
Merrow, Edmond L.
Miller, _____ (in partnership with Harris)
Oates, _____ (in partnership with J. H. J. Kluttz)
Pelton, Herbert W.
Plateau Studio
Ramsey, H. B.
Ribble, _____
Riggan, D. H.
Spencer, John E.
Spilman, J. B.
Staton, R. B.
Turlington, Henry A.
Walton, S. W.
Waters, H. Lee
Webb, James C.
Wootten, Bayard (in partnership with Coward)
Zoeller, William H.

APPENDIX 4

Female Photographers, Operators of Photographic Studios in North Carolina, 1842–1941

Adams, Mary E.
Ahrens, Miss H. M.
Alderman, Bessie S.
Allen, Octavia E. (Octavia E. Paton)
Arnold, Bennie L.
Ashburn, Mrs. Thomas
Badgett, Monnie P.
Baker, Miss Mary M.
Ball, Docia
Barnes, Alexandria
Barringer, Mabel S.
Blackwell, Bonnie J.
Bragg, Sadie E.
Branagan, Florence M.
Brewer, Florence W.
Briley, Alice
Brumfield, Elizabeth S.
Burleson, Mary G.
Burns, Lula
Burns, Pauline D.
Burt, Mrs. Joseph P.

Cain, Emma F.
Chant, Elizabeth A.
Cone, Lela
Cook, Myrtie
Cox, Estelle
Credle, Sophia B.
Curry, Mrs. M. H.
Darnell, Bertie
Davis, Blanche M.
Davisson, Mrs. H. H.
Delory, Ethel L.
Denmark, Leonita
DeRuitter, Annie
Dickinson, Alice M.
Dockery, Stella
Dozier, Ellen F. (also African American)
Eatman, Wilonia
Eckenrod, Ada M.
Eckenrod, Alma B.
Edwards, Mattie S.

Einstein, Bessie L.
Ensley, Beulah E.
Epps, Mrs. Herman L.
Evans, Florence
Farrell, Anne M.
Felch, Dora A.
Felch, Edith E.
Ferguson, Lillian A.
Fields, Marie
Fink, Elva B.
Fowler, Virginia M.
Franklin, Claudia
Gaddy, Marguerite D.
Gilbert, Mrs. Alpha
Gilliam, Mary E.
Godwin, Caroline
Hancock, Lucy W.
Harris, Sarah E.
Harward (or Howard), Jessie
Hayes, Cora
Heffner, Laura R.

Hicks, Mrs. T. C.
Hobbs, Ella J.
Home Portrait Studio (Helen V.
 Howard, operator)
Hooks, Dorothy
Horn, Helen
Howard, Helen V. (Home Portrait
 Studio)
Howard, Isa M.
Inglis, Mrs. E. M. C.
James, Susan E.
Johnson, Katie L.
Jones, Mrs. D. W.
Keen, Lenora E.
Kelly, Annie Ruth Underwood
Koch, Helen
Koonce, Nellie L.
Lange, Dorothea
Lare, Dorothy G.
LeMort, Marguerite
Leonard, Annie B.
Lindsay, Rosa J.
Lively, Celia M.
Lively, Winona B.
Lloyd, Nellie G.
Lohr, Katie A.
Lomax, Ruby T.
McArthur, Margaret D.
McCoy. Eloise Frances
McGarry, May M.
McKay, Mrs. L. L.
McMillan, Lena A.
Mallen, Isadore
Mann, Alma
Marker, Luesa M. (Venus Studio and
 Preston Studio)
Mathewson, Lucy
Matlock, Mrs. O.
Matthews, Vera R.
Meador, Mrs. J. R.
Michael, Grace
Miller, Mrs. _____

Miller, Luvenia C.
Minton, Susie
Moody, Mrs. Pat. V.
Moon, Mary E.
Moore, Patsy
Moose, Ida Lambeth
Morley, Margaret W.
Mosher, Augusta W. (Augusta Wilde)
Muir, Canis (Candis, Candice?)
Overby, Alice
Overby, Maud
Overton, Myrtle P.
Oxley, Georgia
Parker, Miss Zenia
Paton, Octavia E. (Octavia E. Allen)
Pearson, Kathryn
Peters, Madelon M.
Preston Studio (Luesa M. Marker)
Rader, Sarah D.
Ramsaur, Melvina T.
Ramsey, Elizabeth O.
Remington, Ella
Rhodes, Grace P.
Robbins, Mrs. J. B.
Robbins, Sue S.
Robbins, Tetlulah
Robinson, Bethel
Sams, Sarah E.
Sasscer, Ruth G.
Scheneter, Rosalind
Scott, Ethyle
Scott, Julia
Scott, Knox F.
Scott, Miss R. E.
Sessoms, Laura
Sharkey, Josephine
Shelby, Fannie M.
Shields, Rosa E.
Siddell, Hallie S.
Simpkins, Virginia
Slagle, Ada L.
Small, Martha W.

Smith, E.
Smith, Sue
Smyer, Sally J.
St. John, Harriet
Stepp, Gussie
Stepp, Pearl
Stewart, Letitia (Martisha?) (also
 African American)
Stone, Annie K.
Stoner, Dorothy W.
Talley, Laura
Tate, Edith W.
Taylor, Ethel
Teachey, Elma
Topalian, Ethel
Turner, Annie
Turner, Emma D.
Turner, Lula
Turner, Tessie (Union Art Studio)
Tyson, Rubie
Ulmann, Doris
Union Art Studio (Tessie Turner)
Van Buren, Amelia
Vaughan, Sallie
Venus Studio (Luesa M. Marker)
Weill, Blanche B.
Whitener, Kathryn
Whitley, Atossa
Wicks, Metta W.
Wilde, Augusta
Williams, Mrs. Lumis A.
Williams, Rosa E.
Wilson, Blanche E.
Wilson, Frances
Wilson, Juanita E.
Winter, Clara M.
Wolcott, Marion Post
Womble, Lillian R.
Wootten, Bayard
Yancey, Ruby S.

APPENDIX 5

African American Photographers, Operators of Photographic Studios in North Carolina, 1842–1941

Anders, Fred D.
Arnett, Samuel
Artis, J. Thomas
Barnes, George W.
Bennett, Leo W.
Blake, Noah F.
Bush, John
Campbell, Corel B.
Carolina Studio (James E. Hemphill)
Cason, Cleveland
Cute Studio (Marion M. Farmer and
 Robah L. Scales, proprietors)
Davis, Horace (Oak City Photograph
 Gallery)
Dean, Elmer W.
Devereaux, Edward D.
Dillard, Ned
Dozier, Ellen F.
Eason, W. A.
Edwards, Colvin M.
Edwards, Tod R.
Ewing, Lewis
Farmer, Marion M. (in association with
 Robah L. Scales in operation of
 Cute Studio)

Fisher, Edwin M.
Flanagan, Calvin
Hayden, Henry H.
Hemphill, James E. (Carolina Studio)
Hogan, Harris
Hunter, A. S.
James, William
Johnson, Frank
Johnston, Julius
Jones, William T.
Keith, Benjamin B.
Lilly, H. Walter
Little, Isaac
Lucas, Cornelius
Manly, Frank
Mickens, John E. W.
Murphy, E. Phillips
Oak City Photograph Gallery
 (Horace Davis)
Patterson, Hugh B.
Peterson, John A.
Quarles, R. E.
Ray, William M.
Rich, Charles G.
Richmond, Shepard

Roberts, Alonzo L.
Rogers, Richard P.
Royster, Zeb Vance
Rudolph Reuben Studios (Charles R.
 Stanback, proprietor)
Scales, Robah L. (in association with
 Marion M. Farmer in operation
 of Cute Studio)
Scales, Walter S.
Simms, Frank
Stanback, Charles R. (Rudolph Reuben
 Studios)
Stewart, Letitia (Martisha?)
Sturgis, William F.
Troxler, George A.
Tyson, Charles
Tyson, John L.
Tyson, Joseph E.
Williams, J. W.
Winston, John D.
Young, Robert W.

BIOGRAPHICAL DIRECTORY OF PHOTOGRAPHERS
IN NORTH CAROLINA, 1842–1941

Compiled by Stephen E. Massengill

A

A&T COLLEGE PHOTO STUDIO: active ca. 1918–1920s, Greensboro; A. Mosby, photographer.

SOURCE: name on real-photo postcard offered for sale by eBay.

A&W PHOTO GALLERY: active 1880s, Wilson; Sydney R. Alley and Francis M. Winstead, operators.

SOURCE: photograph bearing gallery name.

AARON, N. C.: school photographer, active 1906, Alamance County.

SOURCE: *Gleaner* (Graham), Mar. 15, 1906.

ABANANZA STUDIOS: active early twentieth century, Atlanta, Ga., and Wrightsville Beach.

SOURCE: photograph bearing studio name.

ABBEY, EMERY (b. ca. 1877): native of Miss.; active by 1930, Fayetteville.

SOURCE: Fifteenth Census, 1930: Cumberland County, Pop. Sch., Fayetteville, E.D. 26-11.

ABERNATHY, NIK A. (b. ca. 1860): native of N.C.; active by 1910–1919, Statesville.

SOURCES: Thirteenth Census, 1910: Iredell County, Pop. Sch., Statesville, E.D. 87; State Auditor's Records, Sch. B.

ABERNETHY (ABERNATHY) J. S.: active 1906–1907, Lincolnton; in partnership with a Mr. McNeely in 1906.

SOURCES: *N.C. Year Book*, 1906, 1907.

ACME PHOTO COMPANY: active (obtained license to practice statewide) 1902; in Washington County (1902); in Asheville (1902).

SOURCES: Registry of Licenses to Trade, Washington County, 1883–1902 (A&H); *Asheville Daily Gazette*, June 13, 1902.

ACME STUDIO: active 1918, 1936 on Fayetteville St., Raleigh; operated by Grover C. Haynes Jr. in 1936.

SOURCE: Photographic Examiners Records.

ADAMS, A. J.: active (obtained license to practice) 1917–1918, Durham County.

SOURCE: Record of Special Licenses Issued, Durham County, 1917–1918 (A&H).

ADAMS, HERBERT AIRLEE ("JAKE") (1883–1947): native of Shelbyville, Tenn.; active ca. 1902–1940s in Henderson, Durham, Wilson, Wilmington, 1926–1940s, including Gem Studio, 1938, and Gem Kodak Exchange, 1940, and in Asheville; wife, Mary Ethal Adams, assisted in studio (Adams Studio and Art Shop) in Wilmington in 1930s and 1940s; served as official photographer for the Atlantic Coast Line Railroad, Wilmington.

SOURCES: State Auditor's Records, Sch. B; *Bradstreet's*, 1917, 1921, 1925; Hill, Wilson, *N.C. Directory, 1925*; Hill, *Wilmington Directory, 1926–1940*; Fifteenth Census, 1930: New Hanover County, Pop. Sch., Wilmington, E.D. 65-12; Reaves list of Wilmington photographers.

ADAMS, JAMES LEWIS (b. 1910): active 1920s–1940s with Adams Photo Studio, Leaksville.

SOURCE: Photographic Examiners Records.

ADAMS, MARY ETHAL (b. 1888): native of N.C.; wife of Herbert A. Adams; active 1930s and 1940s, Wilmington.

SOURCES: Photographic Examiners Records; Fifteenth Census, 1930: New Hanover County, Pop. Sch., Wilmington, E.D. 65-12; *Mercantile Agency Reference Book*, 1943.

ADAMS, THOMAS P. (b. ca. 1881): native of Va.; active 1925–late 1940s, Adams Photo Studio, Leaksville (later became Francis Photography).

SOURCES: Fifteenth Census, 1930: Rockingham County, Pop. Sch., Leaksville, E.D. 79-3; Photographic Examiners Records; Aheron, *From Avalon to Eden*, p. 83.

ADDISON, JOHN (b. ca. 1888): native of N.Y.; active by 1910, Wilmington.

SOURCE: Thirteenth Census, 1910: New Hanover County, Pop. Sch., Wilmington, E.D. 91.

ADICKES, THOMAS W.: active early twentieth century; assistant curator, State Museum of Natural History, Raleigh.

SOURCES: Herbert H. Brimley Photograph Collection (A&H); information provided by Sarah Robinson, Jacksonville, Fla.

AERO PIX: active 1940s, W. Hargett St., Raleigh; Wyman Viall, operator.

SOURCE: photograph bearing studio name.

AETNA COPYING COMPANY: active (obtained license to practice portrait enlarging) 1888–1889, New Hanover County.

SOURCE: Registry of Licenses to Trade, New Hanover County, 1869–1894 (A&H).

AHERON, DAN (b. ca. 1890): native of N.C.; active 1910s– 1920s, Spray; cotton mill employee and part-time photographer.

SOURCES: Fourteenth Census, 1920: Rockingham County, Pop. Sch., Spray, E.D. 205; Aheron, *From Avalon to Eden*, 103.

AHRENS, H. M. (Miss): active 1925 on W. 5th St., Charlotte; representative of Moffett Studios, Charlotte.

SOURCE: Miller, *Charlotte Directory*, 1925.

AIRVIEW PHOTO SERVICE: active 1927–1930 on W. Trade St., Charlotte.

SOURCE: Miller, *Charlotte Directory*, 1927–1930.

ALDERMAN, BESSIE SHERRILL (1871–1939): native of N.C.; active ca. 1900, Greensboro; assisted husband, Sidney L. Alderman.

SOURCE: Twelfth Census, 1900: Guilford County, Pop. Sch., Greensboro, E.D. 53.

ALDERMAN, MILES GARLAND (ca. 1897–late 1920s): native of N.C.; active by 1920, Greensboro; associated with father, Sidney L. Alderman; son of Bessie S. Alderman.

SOURCE: Fourteenth Census, 1920: Guilford County, Pop. Sch, Greensboro, E.D. 143.

ALDERMAN, SIDNEY L. (1860–1931): native of N.C.; son of Prof. William and Mariah Alderman; active ca. 1880– 1931, Greensboro, Raleigh, Wilmington, and High Point; succeeded by H. F. Maneely in Raleigh (1883); in partnerships with Charles W. Yates, Wilmington (1896–1897), and with William E. Eutsler, Greensboro (1905–1911); moved studio to High Point in 1921 as Alderman Photograph Company, Inc., to engage in photography work for the furniture industry; Alderman & Son (1928–1929); vice-president, Photographers' Association of Virginia and North Carolina; portrait on file at N.C. Office of Archives and History, Raleigh.

SOURCES: Tenth Census, 1880: Guilford County, Pop. Sch., Greensboro, E.D. 127; Tenth Census, 1880: Wake County, Pop. Sch., Raleigh, E.D. 267; Twelfth Census, 1900: Guilford County, Pop. Sch., Greensboro, E.D. 53; Richards, *Raleigh City Directory, 1883; State Chronicle* (Raleigh), Sept. 11, 1885; Sprange, *Blue Book,* 289; Branson, *NCBD,* 1896, 1897; *N.C. Year*

Photographer Sidney L. Alderman of Greensboro posed for this portrait about 1884. Photograph courtesy A&H.

This portrait of "Drummer Evangelist" W. P. Fife is here reproduced on a cabinet card made by Alderman during the 1880s. Photograph courtesy Earl Butler, Clinton.

Book, 1902–1916; *Mercantile Agency Reference Book*, 1904, 1943; *Mercantile Reference Book*, 1931; *Bradstreet's*, 1908, 1917, 1925; State Auditor's Records, Sch. B; *Turner's Greensboro Directory*, 1890–1891; *Greensboro City Directory, 1892–'93*; Brenizer, *A Directory of the City of Greensboro, 1896–1897*; *Maloney's 1899– 1900 Greensboro Directory*; *Maloney's 1901 Greensboro Directory*; Hill, *Greensboro Directory*, 1903–1904, 1905–1906, 1907–1908, 1909–1910, 1917; Miller, *High Point Directory*, 1908; biographical files, Greensboro Public Library; *News and Observer* (Raleigh), Oct. 7, 1931; *Greensboro Daily News*, Oct. 7, 1931.

ALDERMAN STUDIOS (Photo Company, Inc.): active 1925 and afterward, High Point.

SOURCES: Miller, *High Point Directory*, 1925–1926, 1927, 1929–1930, 1930–1931; *Hill's High Point Directory*, 1933; *Mercantile Reference Book*, 1931.

ALEXANDER, A. W.: itinerant photographer; active June–July 1856, Concord; rented rooms at the Smith House and offered to give instructions.

SOURCE: *Concord Weekly Gazette*, June 21, 28, July 5, 12, 1856.

ALEXANDER, ISAAC B.: native of Camden, S.C; active as itinerant in Columbia and Camden, S.C. (1840s), and in Charlotte (June 1843); rented room at Robertson's Hotel, where he offered daguerreotype likenesses; his specimens were on display at the Charlotte Hotel; also miniaturist and jeweler.

SOURCES: *Mecklenburg Jeffersonian* (Charlotte), June 6, 1843; Rinhart and Rinhart, *The American Daguerreotype*, 380; Teal, *Partners with the Sun*, 15.

ALEXANDER, JAMES: active 1919, Oxford.

SOURCE: State Auditor's Records, Sch. B.

ALEXANDER, JAMES EARNEST (1880–1941): native of N.C.; active 1906–ca. 1940, Alexander's Studio, Salisbury.

SOURCES: Photographic Examiners Records; Thirteenth Census, 1910: Rowan County, Pop. Sch., Salisbury, E.D. 109; State Auditor's Records, Sch. B; *N.C. Year Book*, 1910–1916; Miller, *Salisbury Directory*, 1907–1908, 1913–1917, 1919–1920, 1922–1923, 1924–1929; Baldwin, *Salisbury City Directory*, 1935, 1938–1940; *Bradstreet's*, 1908, 1917, 1921, 1925; *Mercantile Reference Book*, 1931.

ALEXANDER, N. R.: active 1920, Warren County.

SOURCE: State Auditor's Records, Sch. B.

ALEXANDER, OSWALD (b. ca. 1838): active in early 1860s, Mecklenburg County; daguerreotyper prior to enlisting in Company B, Thirteenth Regiment, N.C. State Troops, on July 17, 1861; paroled at Appomattox Courthouse, 1865.

SOURCE: Manarin and Jordan, *N.C. Troops*, 5:299.

ALLEN, C. C.: active (paid tax to operate merchant and daguerreotype business) 1866, Pasquotank County.

SOURCE: Pasquotank County Miscellaneous Tax Records, 1785–1912 (A&H).

ALLEN, JAMES M. ("JERRY") (b. ca. 1852): native of Ala.; active by 1910–1921; in Kannapolis (by 1910); proprietor of Allen's Studio, Bessemer City (1916–1921).

SOURCES: Thirteenth Census, 1910: Cabarrus County, Pop. Sch., Kannapolis, E.D. 38; State Auditor's Records, Sch. B; Fourteenth Census, 1920: Gaston County, Pop. Sch., Bessemer City, E.D. 76.

ALLEN, L. E.: active early 1900s, western N.C.; portrait and view photographer.

SOURCE: Nontextual Materials Unit Photographic Files (A&H).

ALLEN, MARTIN (b. 1849): native of N.C.; active 1900, China Grove.

SOURCE: Twelfth Census, 1900: Rowan County, Pop. Sch., China Grove, E.D. 102.

ALLEN, OCTAVIA E. ("NELLIE") PATON (Mrs. John L. Allen): *See* Paton, Octavia E. ("Nellie").

ALLEN, WILLIAM MAYNARD (b. 1900): African American; active after 1935, Durham; also worked in New Orleans and in Chester, S.C.

SOURCE: Photographic Examiners Records.

ALLEY, SYDNEY R. (b. 1860): native of Va.; active 1872–1917; worked as itinerant for eight years (1880–1890s) in Wilson and on Main St. in Tarboro (1884–1917); in partnership with Francis M. Winstead in Wilson (1880–1886) and in Tarboro (1884–ca. 1886) as proprietors of A & W Photo Gallery; in Greenville (ca. 1895) in partnership with A. Rudolph Hyman; brother of Wesley J. Alley.

SOURCES: Tenth Census, 1880: Wilson County, Pop. Sch., Wilson, E.D. 303; Twelfth Census, 1900: Edgecombe County, Pop. Sch., Tarboro, E.D. 1; *Historical and Descriptive Review of the State of North Carolina, 1885*, 188–189; *Weekly Brief* (Wilson), July 13, 1886; *Wilson Mirror*, Sept. 13, 1887; *Wilson Advance*, Nov. 17, 1887; *Carolina Banner* (Tarboro), July 19, 1889; Sprange, *Blue Book*, 289; *N.C. Year Book*, 1902–1916; *Mercantile Agency Reference Book*, 1904; *Bradstreet's*, 1908, 1917.

ALLEY, WESLEY J. (b. 1875): native of N.C.; active by 1900, Wilson; brother of Sydney R. Alley.

SOURCE: Twelfth Census, 1900: Wilson County, Pop. Sch., Wilson, E.D. 126.

ALLISON, WILLIAM S. (b. 1857): native of N.C.; active by 1900, Charlotte; photograph agent.

SOURCE: Twelfth Census, 1900: Mecklenburg County, Pop. Sch., Charlotte, E.D. 82.

ALLRED, S. R.: active 1916, Reidsville.

SOURCE: State Auditor's Records, Sch. B.

ALPHIN, J. E.: active 1915, Wilson.

SOURCE: *N.C. Year Book*, 1915.

ALSTON, CLIFTON C. (1904–1991): active 1935–1942, Littleton; also worked as printer.

SOURCES: *Mercantile Agency Reference Book*, 1943; *www.familysearch.org*.

ALSTON, WILLIE: active 1920, Warrenton.

SOURCE: State Auditor's Records, Sch. B.

AMBURN, A. M.: active (paid license fee to practice) 1874, Alleghany County.

SOURCE: Registry of Licenses to Trade, Alleghany County, 1874–1906 (A&H).

AMERICAN PHOTOGRAPH PORCELAIN COMPANY: active 1861, New York City; offered photography upon porcelain on such items as urns, vases, cups, and toilet articles.

SOURCE: *Roanoke Cresset* (Plymouth), Feb. 9, 1861.

AMERICAN TRAVELING PHOTOGRAPH COMPANY OF NORTH CAROLINA: active ca. early 1900s; James C. Webb, manager. *See* Webb, James C.

AMERICAN VIEW COMPANY: active late 1890s, S. Tryon St., Charlotte; company launched in Blacksburg, S.C., in 1895 by Daniel A. Gold; William Basom and C. W. Drace, operators; name later changed to Piedmont View Company.

SOURCES: *Directory of the City of Charlotte, 1896–1897*; Moss, *The Old Iron District*, 303; Teal, *Partners with the Sun*, 175.

AMES, EDGAR D.: active late 1930s–1940s, Greensboro; Taylor-Ames Studio, in partnership with Herbert Louis Taylor.

SOURCE: Hill, *Greensboro, N.C. City Directory, 1941*.

AMMON, BOB VAN ATLEE (1920–1986): active 1939 and afterward, Statesville; son of Elbert A. Ammon.

SOURCES: Photographic Examiners Records; Miller, *Statesville Directory, 1932–1933, 1938–1939, 1940–1941*; *Mercantile Agency Reference Book*, 1943; *www.familysearch.org*.

AMMON, ELBERT A. (1885–1975): active 1912–after 1941; worked in Asheville with Herbert W. Pelton (1912–1915) and Luther L. Higgason (1916–1917); Army Signal Corps Photo Division (1917–1919); in Marion (1919–1926); worked with Ben Stimson, Statesville (1926–1930); operated own studio (Ammon's Studio) in Statesville (1930–after 1941); father of Bob Van Atlee Ammon.

SOURCES: Photographic Examiners Records; State Auditor's Records, Sch. B; *www.familysearch.org*.

ANCHOR STORES STUDIO: active 1938–1941, Winston-Salem; Dorothy Grace Lare, operator.

SOURCE: Photographic Examiners Records.

ANDERS, FRED D. (1905–1975): African American; active ca. 1922–1940s, Fayetteville; also employed as a teacher.

SOURCES: Photographic Examiners Records; *Hill's Fayetteville Directory, 1941*; *www.familysearch.org*; *Fayetteville Observer-Times*, Nov. 2, 1975.

ANDERS (ANDERSON), G. L.: active 1915–1919; in Burgaw (1915), in Fayetteville (1919).

SOURCE: State Auditor's Records, Sch. B.

ANDERSON, G. R.: active 1871, Fayetteville, in partnership with Calvin A. Price; chemist and photographer.

SOURCE: *Fayetteville Advertiser and Gazette*, Dec. 25, 1871.

ANDERSON, J. A.: active ca. 1880s–1890s; proprietor of Raleigh Art Gallery, Raleigh; took photographs of the unveiling of the Confederate Monument at State Capitol, Raleigh, 1895.

SOURCE: photographs bearing his name, N.C. Museum of History Photograph Collection (A&H).

ANDERSON, RICHARD: active 1922 with Anderson's Studio, Greensboro.

SOURCES: State Auditor's Records, Sch. B; *Hill Directory Co.'s Greensboro N.C. City Directory, 1922.*

ANDREWS, _____: active (paid photographer's tax) 1873, Northampton County.

SOURCE: Northampton County Tax Records, 1858–1879 (A&H).

ANDREWS, C. L.: active 1919, Durham.

SOURCE: State Auditor's Records, Sch. B.

ANDREWS, EARL: active 1920, Draper.

SOURCE: State Auditor's Records, Sch. B.

ANDREWS, JOSEPH B. (b. 1853): native of N.C.; active 1900–1901, Asheville.

SOURCES: Twelfth Census, 1900: Buncombe County, Pop. Sch., Asheville, E.D. 133; Maloney, *Asheville, N.C. City Directory, 1901.*

ANDREWS, JOSHUA P.: active 1857–1863, Raleigh; came to Raleigh in 1857 from New York and Philadelphia; in partnership in Raleigh with T. J. Havens (1857–1858) and Esley Hunt (1859–1863); portrait painter; Havens and Andrews won award for their photography at the N.C. State Fair in 1858.

SOURCES: *American Advocate* (Kinston), Nov. 3, 1858; Witham, *Catalogue of Civil War Photographers*, 60; *Spirit of the Age* (Raleigh), Aug. 10, 1859; *Weekly Standard* (Raleigh), July 15, 1863.

ANDREWS, LEWIS WASHINGTON (1837–1901): native of Ga.; graduate of Trinity College, 1859; served in regimental band of Company E, Twenty-fifth Regiment, Ga. Infantry; active in Greensboro (1872–1880s), Raleigh (1880s); in partnership with William P. Hughes, (1872–1873), Greensboro; in partnership with Sydney L. Alderman (early 1880s), Raleigh; portrait on file at N.C. Office of Archives and History.

SOURCES: Tenth Census, 1880: Guilford County, Pop. Sch., Greensboro, E.D. 127; *Chataigne's Raleigh Directory*, 1875, 188; *Zell's U.S. Business Directory*, 1875, 1881, 1883, 1884, 1885, 1887, 1889; *Beveridge and Co.'s N.C. Directory*, 1877–'78, 183; Branson, *NCBD*, 1877–1878; *Curtin's United States Business Directory, 1890*, 1400; Col. Leonidas Campbell Jones Diary, Southern Historical Collection, Wilson Library, University of North Carolina at Chapel Hill (UNC-CH); Murray list of Wake County photographers; Guilford County Wills (A&H); *Greensboro Patriot*, Dec. 17, 1901; biographical information provided by descendant, Barney L. Jones Jr., Bridgehampton, N.Y.

ANGELLOZ, R. E.: active 1911–1916, on S. Tryon St., Charlotte.

This portrait of photographer Lewis W. Andrews of Greensboro and Raleigh was taken in the 1870s. Photograph courtesy Barney L. Jones Jr., Bridgehampton, N.Y.

SOURCES: Miller, *Charlotte Directory*, 1911; *N.C. Year Book*, 1912–1916.

ANGLIN, HAL M. (b. 1905): active 1920–after 1935, Anglin Studio, Burlington; son of John M. Anglin and brother of John M. Anglin Jr.

SOURCE: Photographic Examiners Records.

ANGLIN, JOHN M. (b. 1871): native of Va.; began as an itinerant in 1897 in Va. and N.C.; active 1897–1940s; tent at Graham in 1903; first pitched tent in Burlington (1907); in partnership with R. K. Davenport (1908–1911); operated Anglin Studio, Graham (1909–1910) and Burlington (1920–1940s); father of Hal M. Anglin and John M. Anglin Jr.

SOURCES: *N.C. Year Book*, 1907–1916; Photographic Examiners Records; *Bradstreet's*, 1908, 1917; Miller, *Burlington Directory*, 1909–1910, 1924–1925, 1927–1928, 1929–1930; Thirteenth Census, 1910: Alamance County, Pop. Sch., Graham, E.D. 8; State Auditor's Records, Sch. B; *Modern Progress Blue Book—February, 1915* [Alamance County], 11; *Mercantile Reference Book*, 1931; *Hill's Burlington Directory*, 1935; *Mercantile Agency Reference Book*, 1943; Stokes, *Auction and Action*, 36.

ANGLIN, JOHN M., JR. (b. 1913): native of N.C.; active 1930 and afterward with Anglin Studio, Burlington, with father, John M. Anglin, and brother, Hal M. Anglin.

SOURCE: Photographic Examiners Records.

ANTHONY, E. AND H. T.: active 1860s–1870s; headquartered in New York City; publisher of stereographs.

SOURCES: Darrah, *World of Stereographs*, 23–24; stereographs of N.C. bearing company name.

ANTHONY, WILLIAM D. (b. ca. 1840): native of N.C.; member Co. F, Ninth Regiment, N.C. State Troops; active 1880; operated Anthony's Art Gallery in Central Hotel, Concord, 1880.

SOURCES: Eighth Census, 1860: Cabarrus County, Pop. Sch., Concord; Tenth Census, 1880: Cabarrus County, Pop. Sch., Concord (Township #12), E.D. 31; *Concord Sun*, Aug. 14, 1880; Manarin and Jordan, *N.C. Troops*, 2:54.

APPLE, ANNIE LOUIS (1911–1998): received training under Emma Dowdee Turner (Mrs. L. L. Turner), Durham, 1934–1936; active by 1936, Roxboro.

SOURCES: Photographic Examiners Records; *www.familysearch.org.*

ARNETT, SAMUEL (b. ca. 1895): native of Ga.; African American; active by 1930, Moore County.

SOURCE: Fifteenth Census, 1930: Moore County, Pop. Sch., Sand Hill Township 8, E.D. 63-21.

ARNOLD, BENNIE L. (b. ca. 1901): native of N.C.; active by 1930, Andrews; daughter of Charles W. and Ellen V. Arnold; took over father's business after his death.

SOURCE: Fifteenth Census, 1930: Cherokee County, Pop. Sch., Andrews, E.D. 20-9.

ARNOLD, CHARLES W. (ca. 1873–1929): native of N.C.; active by 1910–1929 as proprietor of Arnold Studio, Andrews; husband of Ellen V. Arnold and father of Bennie L. Arnold.

SOURCES: Thirteenth Census, 1910: Cherokee County, Pop. Sch., Andrews, E.D. 45; Photographic Examiners Records; *N.C. Year Book*, 1916; Fourteenth Census, 1920: Cherokee County, Pop. Sch., Andrews, E.D. 51; Vital Records, death certificates, Book 1266, p. 7 (A&H).

ARNOLD, ELLEN V. (b. ca. 1871): native of N.C.; active by 1910, Andrews; wife of Charles W. Arnold and mother of Bennie L. Arnold.

SOURCE: Thirteenth Census, 1910: Cherokee County, Pop. Sch., Andrews, E.D. 45.

ART CRAFT STUDIO: active 1935, Rocky Mount.

SOURCE: Photographic Examiners Records.

ART SHOP: active 1928–ca. 1960, Greensboro; Charles A. and Anne M. Farrell, proprietors; employed Warren E. Fulcher (1930).

SOURCE: *Hill's Greensboro Directory*, 1928–1941.

ART STUDIO: active 1930–1931, Thomasville; Hobart H. Yarborough, proprietor.

SOURCE: Miller, *Thomasville Directory*, 1930–1931.

ARTIS, J. THOMAS: African American; active 1920s; in Wilson (1921), in Wilmington (1920s).

SOURCE: State Auditor's Records, Sch. B.

ASHBURN, THOMAS: active 1922, Greensboro.

SOURCE: State Auditor's Records, Sch. B.

ASHBURN, MRS. THOMAS: active 1922; Greensboro.

SOURCE: State Auditor's Records, Sch. B.

ASHEVILLE ART PARLORS: operated by John F. McFarland in partnership with Thomas H. Lindsey; active ca. 1902–1903, Asheville.

SOURCES: *Asheville, North Carolina City Directory, 1902–'03*; Cotten list of N.C. photographers.

ASHEVILLE-BILTMORE FILM COMPANY: active 1926, Asheville; operated by George Masa.

SOURCE: Miller, *Asheville Directory*, 1926.

ASHEVILLE-BILTMORE PHOTO SERVICE: active 1927, Asheville; operated by George Masa.

SOURCE: Miller, *Asheville Directory*, 1927.

ASHEVILLE PHOTO COMPANY: active 1931–1932, Asheville; operated by George Masa.

SOURCE: Miller, *Asheville Directory*, 1931, 1932.

ASHEVILLE PHOTO SERVICE: active 1915–1950s, Asheville; operated by George Masa (1881–1933) in partnership with F. Blake Creasman (1928–1930); Elliot L. Fisher purchased company (ca. 1934).

SOURCES: Miller, *Asheville Directory*, 1928–1930, 1936–1941; information provided by staff of Pack Memorial Public Library, Asheville.

ASHEVILLE PHOTO STUDIO: active 1899–1901, Asheville; Samuel A. McCanless, operator.

SOURCE: *Asheville, North Carolina City Directory, 1899–1900*.

ASHMANN (ASHBURN), THOMAS: active 1921, Winston-Salem and Wilmington.

SOURCE: State Auditor's Records, Sch. B.

ASKEW, WILBUR F. (1847–1905): active ca. 1895–early 1900s, Windsor; prior to photography business served as captain of several steamships, including the *Kalula*, the *Bertie*, the *Tahoma*, and the *McCall*; also active in minstrel shows.

SOURCES: Twelfth Census, 1900: Bertie County, Pop. Sch., Windsor, E.D. 22; *Windsor Ledger*, Feb. 13, 1895, May 11, 1905; WPA Cemetery Index (A&H).

ATKINS, ENNIS WOODALL (1909–1998): active 1939; photographer for *Gastonia Daily Gazette*.

SOURCES: Photographic Examiners Records; *www.familysearch.org.*

ATWOOD, A. H.: active 1919, Marion.

SOURCE: State Auditor's Records, Sch. B.

ATWOOD, EARL F. (1899–1977): active 1916–1940s; proprietor of Atwood Studio, Laurel Springs; also located in Longwood community, near Hickory.

SOURCES: Photographic Examiners Records; State Auditor's Records, Sch. B; *www.familysearch.org.*

AUBURN ART UNION: active (obtained license to practice) 1887–1888; itinerant firm.

SOURCE: State Auditor's Records, Miscellaneous Tax Group (1868–1932), Box 3, Artists' and Photographers' Privilege Licenses, 1877–1887 (A&H).

AUSTIN, H. L.: active 1898, Southern Pines.

SOURCE: Cotten list of N.C. photographers.

AUSTIN, WILLIAM CHARLES (1884–1954): active 1920s–1954 with Austin Photo Shop, Brevard; purchased business from Frank D. Clement (1937); assisted by wife, Mildred Galbraith Austin (1889–1954); both were killed in an automobile accident.

SOURCES: information provided by Austin Photo Shop, Main St., Brevard; *Mercantile Agency Reference Book*, 1943; Photographic Examiners Records.

AUTREY, GEORGE WILLSON (b. 1882): native of N.C.; studied under Lee Greer, 1908–1918, Wilmington; active 1917–1940s, Wilmington; operated Gem Studio (1917–1923); later in Southport (by 1930–1940s).

SOURCES: Photographic Examiners Records; Fourteenth Census, 1920: New Hanover County, Pop. Sch., Wilmington, E.D. 112; Fifteenth Census, 1930: Brunswick County, Pop. Sch., Southport, E.D. 10-7; Hill, *Wilmington Directory*, 1917–1923.

AUTREY, WILLIAM B.: active 1921–1941 in Sanford (1921) and Durham (1933–1941).

SOURCES: State Auditor's Records, Sch. B; *Sanford Express*, June 17, 1921.

AYASH, ELIAS (1890–1970): active 1936–1941, Durham; died in Mass.

SOURCES: Hill, *Durham, N.C. City Directory, 1936*; *www.familysearch.org.*

AYCOCKE, JOHN C.: active ca. 1854; advertised to sell daguerrean apparatus in a Louisburg newspaper.

SOURCE: *Weekly News* (Louisburg), Feb. 10, 1855.

B

B & H PHOTO COMPANY: active 1937–1940s, E. Trade St., Charlotte; operated by Robert W. Barnett, William S. Barnett, A. Dallas Hartis, and J. Glenn Hartis.

SOURCE: *Hill's Charlotte Directory*, 1938–1941.

BADGER, HOLAND F. (b. 1856): native of N.C.; itinerant, active ca. 1869–1910, in Oxford (1878)—advertisement boasted of ten years' experience in photography—in Henderson (1879), in Washington County (1885), in Hamilton (1886) in association with S. F. Everett of Everettsville; in Williamston (1889–1892), and Plymouth (1898); gallery opposite Skittleharpe and Cooper's store, Bethel (by 1900); in Roanoke Rapids (by 1910).

SOURCES: *Granville Free Lance* (Oxford), Sept. 27, 1878; *Torch-Light* (Oxford), Oct. 22, 1878; *Border Review* (Henderson), Mar. 24, 1879; *Eastern Reflector* (Greenville), Apr. 14, 1886; Registry of Licenses to Trade, Washington County, 1883–1902 (A&H); Cotten list of N.C. photographers.; *Roanoke Beacon* (Plymouth), Nov. 4, 1898; Twelfth Census, 1900: Pitt County, Pop. Sch., Bethel, E.D. 83; Thirteenth Census, 1910: Halifax County, Pop. Sch., Roanoke Rapids Township, E.D. 57.

BADGER, J. S.: active (paid tax to practice) 1873; Northampton County.

SOURCE: Northampton County Tax Records, 1858–1879 (A&H).

BADGETT, MONNIE PEARL (d. 1990s): active early 1940s; in partnership with Haywood Howell, Sanford.

SOURCE: information provided by James Vann Comer, Sanford.

BAILEY, J. W.: active early 1900s–1916, Lincolnton; in association with Thomas N. Hale as Hale and Bailey, ca. early 1900s.

SOURCES: State Auditor's Records, Sch. B; photograph bearing his name.

BAILY, H.: active (paid tax to practice) 1909, Durham.

SOURCE: Registry of Licenses to Trade, Durham County, 1881–1913 (A&H).

BAIRD, J. N.: active 1851; itinerant daguerreotyper; rented rooms above C. C. Green's store, Elizabeth City.

SOURCE: *Old North State* (Elizabeth City), June 7, 1851.

BAKER, _____: itinerant; active 1852, Salisbury, in partnership with a Mr. Gordon; gallery located upstairs in Rowan County Courthouse.

SOURCE: *Carolina Watchman* (Salisbury), Sept. 2, 1852.

BAKER, ALTON PROCTOR (1905–1993): native of N.C.; active 1920s–1959; worked with father, William Henry Baker, in Washington (1920s); operated Baker's Studio, Greenville (1925–1959); assisted by wife, Ethel A. Baker (1930); brother of Walter W. Baker.

SOURCES: Fifteenth Census, 1930: Pitt County, Pop. Sch., Greenville, E.D. 74-28; *Mercantile Reference Book*, 1931; *Mercantile Agency Reference Book*, 1943; *News and Observer* (Raleigh), Apr. 9, 1993.

BAKER, ARTHUR FARRINGTON (1857–1936): native of England; active 1884–ca. 1930; operated gallery in

Arthur F. Baker took this photograph of the building that housed his gallery in Hendersonville and reproduced it on a postcard about 1910. Courtesy Stephen E. Massengill, Cary, hereafter cited as the compiler.

London before coming to U.S.; operated London Art Gallery and Baker's Art Gallery, Hendersonville; in partnership with Benjamin John Barber (1884–1911); in partnership with nephew, Armitage Farrington Barber (early twentieth century); also operated studio in Blackville, S.C. (1880s and 1890s); in Chester, S.C., in partnership with D. T. Johnson (1880s); also produced stereographs in partnership with Johnson (1880s).

SOURCES: *Hendersonville Times,* 1895 (Trade Edition); *News and Observer* (Raleigh), Aug. 24, 1899; Twelfth Census, 1900: Henderson County, Pop. Sch., Hendersonville, E.D. 43; *N.C. Year Book,* 1902–1916; *Mercantile Agency Reference Book,* 1904; *Bradsteet's,* 1908, 1917, 1921, 1925; Miller, *Hendersonville Directory,* 1921–1922, 1924–1927, 1939–1940; *Mercantile Reference Book,* 1931; *Asheville Citizen,* Jan. 13, 1936; *Hendersonville City Directory, 1937–1938;* State Auditor's Records, Sch. B; Teal, *Partners with the Sun,* 186; Jones, *Heritage of Henderson County, North Carolina,* 1:37; Barber and Bailey, *Hendersonville and Henderson County,* 7–13.

BAKER, ARTHUR WYATT (b. 1920): active 1941, Rock Drug Company, Valdese.

SOURCE: Photographic Examiners Records.

BAKER, BILL: active late 1930s–early 1940s; with staff of News Bureau of N.C., State Department of Conservation and Development, 1939–1940.

SOURCE: State Department of Conservation and Development Records (A&H).

BAKER, EDGAR (b. ca. 1891): native of N.C.; active by 1910, Goldsboro.

SOURCE: Thirteenth Census, 1910: Wayne County, Pop. Sch., Goldsboro, E.D. 104.

BAKER, L. W.: active 1905, Woodland (Northampton County).

SOURCE: information provided by Jerry R. Roughton, Kenansville.

BAKER, MARY MADISON (Miss): active 1918–after 1935, Reidsville; purchased Wheeler Studio (1918); sold Wheeler Studio (1923); operated Baker Studio (1933–1940s), Reidsville.

SOURCES: Photographic Examiners Records; State Auditor's Records, Sch. B; Baldwin, *Reidsville City Directory, 1935;* Miller, *Reidsville Directory, 1941–42.*

BAKER, WALTER WILLIAM (1902–1990): native of N.C.; active 1921–after 1957, Kinston; apprenticed under father, William H. Baker, in Washington, N.C.; brother of Alton P. Baker.

SOURCES: State Auditor's Records, Sch. B; Photographic Examiners Records; *Bradstreet's,* 1925; Fifteenth Census, 1930: Lenoir County, Pop. Sch., Kinston, E.D. 54-7; *Mercantile Reference Book,* 1931; *Mercantile Agency Reference Book,* 1943; *Kinston Daily Free Press,* Nov. 23, 1957; *www.familysearch.org.*

BAKER, WILLIAM HENRY (1870–1939): native of N.C.; active 1895–1938; in Edenton (1895–1906); in Washington (1896–1938); operated Baker's Studio; father of Alton P. and Walter W. Baker; former employee Myrtle Pauline Overton purchased the business in 1939.

SOURCES: Photographic Examiners Records; Twelfth Census, 1900: Chowan County, Pop. Sch., Edenton, E.D. 28; State Auditor's Records, Sch. B; *Mercantile Agency Reference Book,* 1904; *Bradstreet's,* 1917, 1921, 1925; *Mercantile Reference Book,* 1931; *N.C. Year Book,* 1910–1916; Miller, *Washington, N.C. City Directory, 1916–'17;* Baldwin's *Washington, N.C., Directory,* 1937.

BALDWIN, LESLIE: active early 1940s–1990s, Whiteville; in partnership with Donald S. Gillespie after World War II; Baldwin was murdered; Columbus County Library has collection of his portraits.

SOURCE: Nontextual Materials Unit Photographic Files (A&H).

BALDWIN'S DEPARTMENT STORE: active 1940–1941, Durham; Rufus L. Graves, operator.

SOURCE: Photographic Examiners Records.

BALL, DOCIA (Mrs. Ewart M. Ball) (1891–1983): active late 1930s, Asheville; along with son, Ewart M. Ball Jr., operated Plateau Studios after death of her husband in 1937.

SOURCES: information provided by staff of Pack Memorial Public Library, Asheville; *www.familysearch.org.*

BALL, EWART MCKINLEY (1894/5–1937): native of N.C.; active 1919–1937; member of Company K, Third Infantry Division, during World War I; became interested in photography while in the army; in Georgetown, S.C. (n.d.); in Marshall (1919–1920); in Asheville (1921–1937); purchased Plateau Studios in Asheville from George Masa in mid-1920s; active in North Carolina Photographers' Association; staff photographer for *Asheville Citizen* and *Asheville Times*; his widow (Docia Ball) and son (E. M. Ball Jr.) attempted to operate studio for short period after his death; Ball's photo collection is housed at the Southern Highlands Center, D. Hiden Ramsey Library, UNC-Asheville.

SOURCES: Photographic Examiners Records; State Auditor's Records, Sch. B; Miller, *Asheville, N.C. City Directory, 1926–1932; Miller's Asheville Directory, 1936–1941; Baldwin, Asheville, N.C. City Directory, 1935; Mercantile Reference Book, 1931; Asheville Citizen,* Aug. 27, 28, 1937; information provided by staff of Pack Memorial Public Library, Asheville; information provided by Peggy Gardner, Asheville.

BALL, EWART MCKINLEY, JR. (1918–1966): active 1930s–1940s, Asheville; photographer for *Asheville Citizen-Times,* 1937 and afterward; son of Ewart M. Ball and Docia Ball; with his mother, operated Plateau Studios after death of his father.

SOURCES: information provided by staff of Pack Memorial Public Library, Asheville; *Asheville Citizen,* June 24, 1966.

BALL, JESSE GRIFFIN (1862–1948): active late nineteenth century, Wake County; also operated a wholesale grocery business.

SOURCES: *News and Observer* (Raleigh), Oct. 12, 1948; Murray list of Wake County photographers.

BALL, WILLIAM R. (b. ca. 1883); native of N.C.; active by 1920, Charlotte.

SOURCE: Fourteenth Census, 1920: Mecklenburg County, Pop. Sch., Charlotte, E.D. 146.

BAMES, B. M.: active 1911–1912, 1921, Durham.

SOURCES: Registry of Licenses to Trade, Durham County, 1911–1912 (A&H); State Auditor's Records, Sch. B.

BANKS, ERNEST LINWOOD (ca. 1875–1947): active 1916, Winton; daughter was wife of Secretary of State Thad Eure.

SOURCES: *News and Observer* (Raleigh), Jan. 25, 1947; *N.C. Year Book,* 1916.

BANKS, WAYNE A. (b. ca. 1895): native of N.C.; active by 1930, Asheville.

SOURCE: Fifteenth Census, 1930: Buncombe County, Pop. Sch., Asheville, E.D. 11-65.

BANTHERS, D. W.: active 1916; Marion.

SOURCE: State Auditor's Records, Sch. B.

BARATLE, ALBERT A.: active ca. 1918, Camp Greene; corporal with Company D, 38th Infantry; received permission to take photographs at the camp.

SOURCES: National Army Camps, Camp Greene, Charlotte, N.C., RG 393, Box 20, National Archives; information provided by Jane Johnson, Charlotte.

BARBER, ARMITAGE FARRINGTON (1889–1980): native of S.C.; active ca. 1900–ca. 1960s with Baker Art Gallery (Barber's Art Gallery after 1939), Hendersonville; briefly active in Wake County (1936); son of Benjamin John Barber and nephew of Arthur F. Baker, who started business in 1884; sons Donald M. Barber and Joseph E. ("Jody") Barber also worked at the studio.

SOURCES: Photographic Examiners Records; Fifteenth Census, 1930: Henderson County, Pop. Sch., Hendersonville, E.D. 45-10; Murray list of Wake County photographers; *Mercantile Agency Reference Book, 1943;* Barber and Bailey, *Hendersonville and Henderson County,* 7–13; Jones, *Heritage of Henderson County North Carolina,* 1:37.

BARBER, BENJAMIN JOHN (1850–1911): native of England; active 1884–1911; in Hendersonville (1884–early 1900s); in Rock Hill, S.C. (early 1900s until his death); opened Baker's London Art Gallery with Arthur F. Baker; father of Armitage F. Barber and grandfather of Donald M. Barber and Joseph E. Barber.

SOURCES: Jones, *Heritage of Henderson County North Carolina,* 1:37; *Western North Carolina Times* (Hendersonville), June 2, 1911; Barber and Bailey, *Hendersonville and Henderson County,* 7–13.

BARBER, DONALD MACARTHUR (b. 1918): active by 1934 with Baker's Art Gallery, Hendersonville; grandson of Benjamin J. Barber, son of Armitage F. Barber, and brother of Joseph E. Barber.

SOURCES: Photographic Examiners Records; Jones, *Heritage of Henderson County North Carolina,* 1:37; Barber and Bailey, *Hendersonville and Henderson County,* 7–13.

BARBER, JOSEPH EDGERTON ("JODY") (1923–2001): active 1940s–1990s with Barber's Art Gallery, Hendersonville; grandson of Benjamin J. Barber, son of Armitage F. Barber, and brother of Donald M. Barber.

SOURCES: Photographic Examiners Records; Jones, *Heritage of Henderson County North Carolina,* I:37; *Times-News* (Hendersonville), Jan. 26, 2001; Barber and Bailey, *Hendersonville and Henderson County,* 7–13.

RIGHT: During the early twentieth century Barber's Printing & Stationery Company was one of the leading Kodak suppliers and photo finishers in Winston-Salem. This postcard features a view of the business. Postcard courtesy Durwood Barbour, Raleigh. **BELOW:** This portrait of Raleigh commercial photographer Albert Barden was taken in 1947—six years before his death. Photograph courtesy A&H.

BARBER PRINTING & STATIONERY CO., WINSTON-SALEM, N. C.

BARBER PHOTO SUPPLY COMPANY (BARBER'S BOOK STORE; BARBER PRINTING & STATIONERY COMPANY): active ca. 1915–after 1941, Winston-Salem; operated by Henry C. Lindley.

SOURCES: State Auditor's Records, Sch. B; *Winston-Salem Directory,* 1920.

BARDEN, ALBERT (1888–1953): native of England; active 1908–1953, Raleigh; in partnership with Manly W. Tyree (1908–1911); in partnership with Joseph C. Ellington (1911–1924); operated own business (1924–1953); also active with father, Charles H. Barden; donated to the N.C. Museum of History a large collection of photographs that were subsequently

transferred to the State Archives. Examples on pages 11 and 12.

SOURCES: Photographic Examiners Records; Murray list of Wake County photographers; Nontextual Materials Unit Photographic Files (A&H); *Mercantile Agency Reference Book,* 1943; *News and Observer* (Raleigh), Nov. 8, 1953.

BARDEN, CHARLES H. (b. ca. 1863): native of England; active 1913–ca. 1940, Raleigh, with son, Albert Barden.

SOURCES: Fifteenth Census, 1930: Wake County, Pop. Sch., Raleigh, E.D. 92-37; Murray list of Wake County photographers.

BARDEN, J. U.: active 1906, Enfield.

SOURCE: *N.C. Year Book,* 1906.

BAREMORE, DAVID: itinerant daguerreotyper; at Orange County Courthouse, Hillsborough (1852); in rooms at corner of Main and Market Streets, Washington, N.C. (1853); in New York City (1854–1857).

SOURCES: *Hillsborough Recorder,* Apr. 27–May 16, 1852; *North State Whig* (Washington), Mar. 29, 1853–Apr. 13, 1853; *Craig's Daguerreian Registry,* 2:32.

BARHAM, JOHN: active 1935, Burlington; operated Central Photo Company.

SOURCE: *Hill's Burlington Directory,* 1935.

BARKER, FRANK A.: active 1910–1911, Gastonia (Loray Mills).

SOURCE: *Gastonia Directory,* 1910–1911.

BARKER, MALVIN: active 1916, Mount Airy.

SOURCE: State Auditor's Records, Sch. B.

BARNES, ALEXANDRIA: of Clarksville, Va.; active 1921–1922, Granville County, presumably under her married name, Alexandria (Alexandrew) James.

SOURCE: State Auditor's Records, Sch. B.

BARNES, GEORGE W. (b. ca. 1872): native of N.C.; African American; active by 1910–1930, Wilson.

SOURCES: Thirteenth Census, 1910: Wilson County, Pop. Sch., Wilson Township, E.D. 115; Hill, *Wilson, N.C. City Directory, 1916–1917*; Fourteenth Census, 1920: Wilson County, Pop. Sch., Wilson, E.D. 114; Fifteenth Census, 1930: Wilson County, Pop. Sch., Wilson, E.D. 98-27; information provided by J. Marshall Daniel, Wilson.

BARNES, JOHN H.: active 1892–1895; in New Hanover County (1892–1893), and in tent at Five Points, Greenville (1895); representative of the United States View Company; took photographs of historic sites and old homesteads for the United States Artist's Association for lithographic purposes.

SOURCES: Registry of Licenses to Trade, New Hanover County, 1881–1894 (1892) (A&H); *King's Weekly* (Greenville), Apr. 19, May 3, 1895.

BARNES, REUBEN: active 1911–1922; itinerant in Durham (1911), Henderson (1916), Oxford (1919– 1921), and Boydton, Va. (1921–1922).

SOURCES: Registry of Licenses to Trade, Durham County, 1881–1913 (1911) (A&H); State Auditor's Records, Sch. B.

BARNETT, E. J.: active 1910, Forest City.

SOURCE: *N.C. Year Book*, 1910.

BARNETT, ROBERT W.: active 1919–1920s with Barnett Photo Company, East Ave., Charlotte; probably father of Robert W. Barnett and William S. Barnett.

SOURCES: State Auditor's Records, Sch. B; Miller, *Charlotte Directory*, 1920–1929.

BARNETT, ROBERT WITHERS (1909–1995): active ca. 1926–1940s, Charlotte; operator of Barnett Photo Company (ca. 1926–1935); in partnership with William S. Barnett, A. Dallas Hartis, and J. Glenn Hartis in B & H Photo Company (1937–1940s); secretary of North Carolina Photographers' Association in 1942; probably son of Robert W. Barnett and brother of William S. Barnett.

SOURCES: Photographic Examiners Records; Miller, *Charlotte Directory*, 1930; *Hill's Charlotte Directory*, 1932–1941; *Mercantile Reference Book*, 1931; *www.familysearch.org*.

BARNETT, WILLIAM STURGES (1918–1986); active 1937–1940s, Charlotte; B & H Photo Company, with brother, Robert W. Barnett, A. Dallas Hartis, and J. Glenn Hartis; probably son of Robert W. Barnett.

SOURCES: Photographic Examiners Records; *Hill's Charlotte Directory*, 1938–1941; *www.familysearch.org*.

BARNHILL, WILLIAM A. (1889–1987): active 1914–1922, Asheville; operated Barnhill Studios; took photographs depicting pioneer life in N.C., 1914–1917; aerial photographer during World War I; returned to Asheville in 1919; moved to Cleveland, Ohio, in 1922; negatives housed at Mars Hill College; collection of his photographs housed at Library of Congress, Washington, D.C.; died in Ohio.

SOURCES: State Auditor's Records, Sch. B; Miller, *Asheville, N.C. City Directory*, 1916–1922; *Bradstreet's*, 1921; information provided by Carol Johnson, Library of Congress, Washington, D.C.; information provided by Linda March, Arden, and staff of Pack Memorial Public Library, Asheville; *www.familysearch.org*.

BARNSDALE, GEORGE: active 1940s, Fayetteville, Charlotte, Winston-Salem; operated Dunbar Studio in all these cities.

SOURCE: Photographic Examiners Records.

BARRINGER, MABEL SLOOP (MRS.) (1902–1976): active 1936–1940s, Salisbury; worked at Alexander's Studio under James E. Alexander.

SOURCES: Photographic Examiners Records; *www.familysearch.org*.

BARRINGER, OSMOND LONG, JR. ("BUGS") (1911–1994): active 1936–1980s, Rocky Mount; newspaper photographer (1936–1945); operated Barringer Studio (after 1945).

SOURCES: Photographic Examiners Records; *www.familysearch.org*.

BARROW, WILLIE: active 1916, Washington.

SOURCE: State Auditor's Records, Sch. B.

BARRY, ALONZA: active (paid tax to practice) 1859, Cumberland County.

SOURCE: Cumberland County Miscellaneous Tax List, 1857–1884 (A&H).

BARRY, E. T.: active 1856–1861; itinerant maker of ambrotypes; occupied rooms in building of W. Dunn next to post office, Kinston (1856); occupied rooms above Martin's Store, Washington (1856); occupied rooms in Union Hotel, Chapel Hill (1857); at Mozart Hall, Front St., Wilmington (1860–1861); in association with Edwin C. Thompson (1861).

SOURCES: *American Advocate* (Kinston), Aug. 21, 1856; *North Carolina Times* (Washington), Oct. 8, 1856; *Chapel Hill Weekly Gazette*, May 16, 1857; *Kelley's Wilmington Directory*, 1860–61; Witham, *Catalogue of Civil War Photographers*, 32.

BART, HARRY: active 1920, Salisbury.

SOURCE: State Auditor's Records, Sch. B.

BARTLETT, C. F.: itinerant statewide; active (paid tax to practice) 1884–1888; in partnership with a Mr. Taylor (1884–1885); at Company Shops (1886–1888).

SOURCES: State Auditor's Records, Ledgers, 1869–1899, Vol. 17, p. 614, Vol. 18, pp. 218, 390 (A&H); State Auditor's Records, Miscellaneous Tax Group (1868–1932), Box 3, Artists' and Photographers' Privilege Licenses, 1877–1887 (A&H).

BASKERVILLE, G. S.: active by 1935, Asheville.

SOURCE: Photographic Examiners Records.

BASOM, WILLIAM.: active late 1890s, Charlotte; along with partner, C. W. Drace, traveled to Charlotte representing American View Company, which had been established in Blacksburg, S.C., in 1896; operated studio in Basom's residence on S. McDowell St.; both departed Charlotte by 1900.

SOURCES: *Weeks' 1899 Charlotte City Directory*; information provided by Shelia Bumgarner, Public Library of Charlotte and Mecklenburg County.

BASS, E.: active 1919, Raleigh.

SOURCE: State Auditor's Records, Sch. B.

BATCHELDOR (BATCHELOR), WILLIAM: active 1859–1867; in Haverhill, Mass. (1859); on Front St., between Market and Princess Sts., Wilmington, during Civil War and 1865–1867.

SOURCES: Rinhart and Rinhart, *The American Daguerreotype*, 382; Witham, *Catalogue of Civil War Photographers*, 32; *Wilmington Directory, 1865–66*; *Branson & Farrar's NCBD, 1866–1867*; *Craig's Daguerreian Registry*, 2:39; Polito, *A Directory of Massachusetts Photographers*, 273, 376, 381, 540.

BATTLEY, WILLIAM T. (b. 1834): native of N.C.; active 1857–1860, Fayetteville; maker of ambrotypes; rented rooms above J. M. Beasley's store (1857) and rooms in building just east of Fayetteville Hotel (1858); took over rooms previously occupied by James A. Palmer; by 1880 he was employed as a carriage-trimmer in Carthage.

SOURCES: *Fayetteville Observer*, Nov. 5–Dec. 21, 1857; May 19, 24, 1858; Eighth Census, 1860: Cumberland County, Pop. Sch., Fayetteville; *www.familysearch.org*.

BATTON, _____: active 1903, Spring Hope; operated Spring Hope Photo Company in partnership with Thomas H. Hester.

SOURCE: *N.C. Year Book*, 1903.

BAUGUS, JOHN: active 1856; itinerant; maker of ambrotypes, Concord; located in hall above Dr. Fink's drugstore.

SOURCE: *Concord Weekly Gazette*, July 26, Aug. 2, 1856.

BAUMGARTEN, HENRY (1839–1918): native of Germany; emigrated with family to Baltimore as young boy; engraver and worker in Baltimore photography gallery before coming to Charlotte after Civil War; served with Sixth Mich. Infantry during war (his obituary declares, however, that he was with the Commissary Department of the CSA); active 1864–1913; in Baltimore (ca. 1864–1866); on W. Trade St., Charlotte (1867–1913); purchased gallery of J. S. Broadaway (July

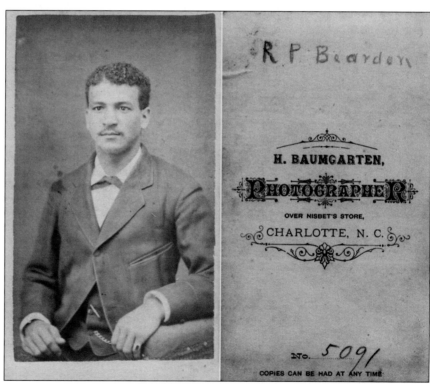

LEFT: Shown here is an advertisement for Henry Baumgarten's photograph gallery on Trade Street in Charlotte. Advertisement courtesy Public Library of Charlotte and Mecklenburg County, Charlotte. **RIGHT:** An African American gentleman named R. P. Beardon struck this pose for Baumgarten about 1870. Photograph courtesy Public Library of Charlotte and Mecklenburg County.

1872) to reduce competition in Charlotte photography trade; in Winnsboro, S.C. (1873–1874); father of Blanche Weill, who worked as a photographer in his studio (late 1890s–early 1900s).

SOURCES: Dumont, *North Carolina As a Place For Investment, Manufactures, 1879*, 50; Witham, *Catalogue of Civil War Photographers*, 32; Ninth Census, 1870: Mecklenburg County, Pop. Sch., Charlotte, Ward 4; Tenth Census, 1880: Mecklenburg County, Pop. Sch., Charlotte, E.D. 107; Twelfth Census, 1900: Mecklenburg County, Pop. Sch., Charlotte, E.D. 47; Branson, *NCBD*, 1869, 1872, 1877–1878, 1896, 1897; *Statesville American*, July 1, 1872; Kelbaugh, *Directory of Maryland Photographers*, 4; Teal, *Partners with the Sun*, 163; *Beasley and Emerson's Charlotte Directory, For 1875–1876*; *Zell's U.S. Business Directory*, 1875; *Chataigne's N.C. Directory and Gazetteer, 1883–'84*; *Henry Baumgarten v. J. S. Broadaway*, 77 N.C. 8 (Case No. 11,904 [June 1877]), N.C. Supreme Court Records; *Charlotte Democrat*, Dec. 19, 1879; Sprange, *Blue Book*, 289; *N.C. Year Book*, 1902–1916; *Mercantile Agency Reference Book*, 1904; *Bradstreet's*, 1908; *Walsh's Directory of the City of Charlotte*, 1908–1910; Miller, *Charlotte Directory*, 1911–1913; Vital Records, death certificates, Book 317, p. 357 (A&H); *Charlotte Observer*, Apr. 8, 1918; information provided by Shelia Bumgarner, Public Library of Charlotte and Mecklenburg County.

BAXTER, JOHN ROBERT (1911–1971): active 1934–1941, Pollock St., New Bern; in partnership with brother, Theodore J. Baxter, after 1944; later entered the jewelry business.

SOURCES: Green, *A New Bern Album*, 16; *Baldwin's New Bern Directory*, 1937, 1941.

BAXTER, THEODORE JOSHUA (1917–1993): active 1936–1944, New Bern; in partnership with brother, John R. Baxter.

SOURCES: Photographic Examiners Records; *www.familysearch.org*.

BAYLESS, THOMAS B. (b. ca. 1840): native of Tenn.; active as itinerant in Asheville, 1870, 1871–1872, 1877–1878; operated gallery opposite Railroad Hotel (1870) and opposite Buck Hotel (1871–1872).

SOURCES: Tenth Census, 1870: Buncombe County, Pop. Sch., Asheville Township #9; *Weekly Pioneer* (Asheville), Nov. 24, 1870, Sept. 28, 1871; *Beveridge and Co.'s N.C. Directory, 1877–'78*, 18.

BAYLEY, D. W.: active (acquired license to practice) 1909–1910, Durham.

SOURCE: Registry of Licenses to Trade, Durham County, 1881–1913 (A&H).

BEACHY, L. J.: active 1922; took photographs near community of Grantville (Madison County).

SOURCE: real-photo postcard by Beachy offered for sale by eBay, Feb. 2004.

BEAMAN, B. G.: active (paid tax to practice) 1886, with B. G. Beaman and Company, Plymouth.

This advertisement for the services of Thomas B. Bayless appeared in the Asheville *Weekly Pioneer* on September 28, 1871. Advertisement courtesy A&H.

SOURCE: State Auditor's Records, Ledgers, 1869–1899, Vol. 18, p. 195 (A&H).

BEASLEY, RICHARD H. (b. 1871): native of Petersburg, Va.; active 1903–1941; in Goldsboro (1903); in Charlotte (1911–1921) in partnership with Zachius E. Scott (1911–1920); operated Green Studio (1921); in New Bern with Edward Gerock (n.d.); in Asheville with Lindsey & Brown (n.d.); in Monroe (1920, 1925–1927); in Hendersonville (1934–1935); operated Beasley Studio, Thomasville (1935, 1940–1941).

SOURCES: Photographic Examiners Records; State Auditor's Records, Sch. B; *Mercantile Agency Reference Book*, 1904; Miller, *Charlotte Directory*, 1916; Fourteenth Census, 1920: Union County, Pop. Sch., Monroe, E.D. 158; *Baldwin and Times' Thomasville North Carolina City Directory, 1935*.

BEASLEY, THOMAS (b. ca. 1875): native of N.C.; active by 1910 with Albert S. Ramsey, Salisbury.

SOURCE: Thirteenth Census, 1910: Rowan County, Pop. Sch., Salisbury, E.D. 109.

BEATTY, JAMES A. (born ca. 1865): native of N.C.; active 1919–1930; in Gastonia (1919); in Kings Mountain (by 1930).

SOURCES: State Auditor's Records, Sch. B; Fifteenth Census, 1930: Cleveland County, Pop. Sch., Kings Mountain, E.D. 23-8.

BEAVER, ROBERT L. (b. ca. 1885): native of N.C.; active 1919–1920, Lincolnton.

SOURCES: State Auditor's Records, Sch. B; Fourteenth Census, 1920: Mecklenburg County, Pop. Sch., Charlotte, E.D. 153 (no occupation listed).

BELCH, WILLIAM BRADLEY (b. 1919): active 1941, Fayetteville.

SOURCE: Photographic Examiners Records.

BELK-LEGGETT STUDIO: active 1940, Durham; managed by Bill Hines after 1946.

SOURCE: Photographic Examiners Records.

BELL, BENJAMIN W. (b. ca. 1826): active 1850, Macon County; daguerreotyper; brother of Jonathan K. Bell.

SOURCE: Ninth Census, 1850: Macon County, Pop. Sch.

BELL, DANIEL GRAHAM, JR. (b. 1913): active 1934– after 1935, Morehead City.

SOURCE: Photographic Examiners Records.

BELL, JONATHAN K. (b. ca. 1828): active 1850, Macon County; daguerreotyper; brother of Benjamin W. Bell.

SOURCE: Ninth Census, 1850: Macon County, Pop. Sch.

BELL, JOSEPH (b. ca. 1852): native of N.C.; active by 1870 as (photographic) artist, Washington.

SOURCE: Ninth Census, 1870: Beaufort County, Pop. Sch., Washington.

BELLAMY, DR. T. M.: active 1867–1868, Warrenton; druggist and photographer; operated Bellamy & Company; owner, Bellamy's Picture Gallery (operated by a Mr. Martin); by Mar. 1868 Bellamy had moved to Norfolk, Va.

SOURCES: *Indicator* (Warrenton), July 10, 1867; Ginsberg, *Photographers in Virginia*, 15.

BELLIS, HARRY REX (b. 1902): active 1935–after 1943, Salisbury; photographer for *Salisbury Post*.

SOURCE: Photographic Examiners Records.

BELTON, EDWARD R. (1897–1988): active 1915–after 1941; in Mount Airy (1915–1925) with Moore's Studio (1915– 1921) and as sole proprietor (1922–1925); in Pinehurst (1925–1928) with John Hemmer; operated Belton's Studio, Asheboro (1928–1935); Arthur A. Sambergh purchased the studio (1935); with E & S Photo Company, Mount Airy (1940–1941).

SOURCES: Photographic Examiners Records; *Mercantile Reference Book*, 1931; *www.familysearch.org*.

BENAMY, SOL P.: active 1935–1940s, Greensboro; proprietor of Franklin Studio.

SOURCES: Photographic Examiners Records; *Hill's Greensboro Directory*, 1935–1941.

BENEDICT, BUC H. (JAMES?) (b. ca. 1890): native of N.Y.; active 1920, Asheville.

SOURCES: Fourteenth Census, 1920: Buncombe County, Pop. Sch., Asheville, E.D. 11; Miller, *Asheville N.C. City Directory, 1920*.

BENNETT, CHARLES (b. 1859): native of N.Y.; active by 1900, Fayetteville.

SOURCE: Twelfth Census, 1900: Cumberland County, Pop. Sch., Fayetteville, E.D. 23.

BENNETT, LEO W.: African American; active 1924–1925, Raleigh (1924), in partnership with Corel B. Campbell; in Durham (1925) as operator of Bennett's Studio.

SOURCES: Hill, *Raleigh Directory*, 1924; Hill, *Durham City Directory, 1925*.

BENNETT, NAHUM (NATHAN) S. (b. ca. 1816): itinerant daguerreotyper; active 1840s–1860s; in Boston (1844); in Wilmington (1848); occupied rooms in Dr. Ware's office on Front St.; advertised sale of miniature daguerreo- types; in Fayetteville (1848); rented room in Lafayette Hotel; in Washington, D.C. (1850–1853); in Alexandria, Va. (1860, 1864).

SOURCES: *Chronicle* (Wilmington), Jan. 5, 1848; *Fayetteville Observer*, Apr. 18, 1848; Eskind, *Index to American Photographic Collections*, 483; *Craig's Daguerreian Registry*, 2:49; Polito, *A Directory of Massachusetts Photographers*, 30; Ginsberg, *Photographers in Virginia*, 1; Laurie A. Baty, "On the Trail of Nahum S. Bennett," in Palmquist, *The Daguerreian Annual, 1990*, 25–28.

BENNETT, W. C.: active 1916–1919, Powellsville (Bertie County).

SOURCE: State Auditor's Records, Sch. B.

BENSON, RAYMOND FREDERICK (1911–1994): active 1936–1937 with Shuford's Studio, Charlotte.

SOURCES: Photographic Examiners Records; *www.familysearch.org*.

BENTLEY, _____: active late nineteenth century, Carthage; in partnership with R. C. McKenzie as Bentley & McKenzie.

SOURCE: photograph bearing name "Bentley" owned by Jerry R. Roughton, Kenansville.

BENTON, ALLEN: active early 1900s, Madison and Mayodan.

SOURCE: Aheron, *From Avalon to Eden*, 8, 40.

BENTON, JAMES H.: active 1875–1876, Polkton; gallery located upstairs in Carter House.

SOURCE: *Ansonian* (Polkton), Apr. 15, 1875, Feb. 2, 1876.

BERNAN, R. C.: active 1916–1922, Greensboro.

SOURCE: State Auditor's Records, Sch. B.

BERRY, KELLY & CHADWICK: active 1907; headquartered in Chicago; publisher of stereographs of N.C.

SOURCE: stereograph of interior of Charlotte textile mill bearing company name.

BEST, WILFRED GEORGE (1897–1961): native of N.Y.; active ca. 1928–after 1947, Marion.

SOURCES: Fifteenth Census, 1930: McDowell County, Pop. Sch., Marion, E.D. 56-7; Photographic Examiners Records; *Mercantile Reference Book*, 1931; *Mercantile Agency Reference Book*, 1943; *www.familysearch.org*.

BETHEA, H. W.: active 1919, Laurinburg.

SOURCE: State Auditor's Records, Sch. B.

BEYMER, N. S.: active 1916, Gastonia.

SOURCE: State Auditor's Records, Sch. B.

BICKNELL, FRANK WADE (1866–1933): native of Iowa; active ca. 1905–1920, Linville area; journalist-photographer who documented northern Burke County area; took photographs for the N.C. Division of Forest Resources; some of his photographs of the Linville area are housed at N.C. Office of Archives and History.

SOURCES: Thirteenth Census, 1910: Burke County, Pop. Sch., Upper Creek Township, E.D. 14; Alexander, *Mountain Fever*, 162; *www.familysearch.org*.

BIEDERMANN, LOUIS, JR.: active ca. 1918, Camp Greene; associated with New York *World*; received permission to take photographs at the camp.

SOURCES: National Army Camps, Camp Greene, Charlotte, N.C., RG 393, Box 20, National Archives; information provided by Jane Johnson, Charlotte.

BIGGS, HERBERT RICHARD (b. ca. 1896): native of N.C.; active 1915–after 1944; with Albert O. Clement, Goldsboro (1915–1916, 1923–1925); in sole proprietorship (ca. 1927–1935); in Anderson, S.C. (1918–1921); with Paton Studio, Fayetteville (1921–1923).

SOURCES: Fifteenth Census, 1930: Wayne County, Pop. Sch., Goldsboro, E.D. 96-16; *Hill's Goldsboro Directory*, 1934; *Baldwin's Goldsboro Directory*, 1938; Photographic Examiners Records.

BIGGS, JAMES W.: active 1915–1916, N. Tryon St., Charlotte.

SOURCES: Miller, *Charlotte Directory*, 1915; *N.C. Year Book*, 1916.

BIVENS, R. T.: active 1902, Greenville.

SOURCE: *N.C. Year Book*, 1902.

BLACK, IRVIN ROSCOE (b. 1918): active 1937–after 1948 with Alderman Photograph Company, High Point.

SOURCE: Photographic Examiners Records.

BLACKBURNE, L. B. (b. ca. 1827): native of Va.; active by 1860, Wilmington.

SOURCE: Eighth Census, 1860: New Hanover County, Pop. Sch., Wilmington.

BLACKMAN, OSCAR L. (b. ca. 1887): native of S.C.; active by 1910–1916, 1920, Lumberton; itinerant (1910); outdoor photographer (1920).

SOURCES: Thirteenth Census, 1910: Robeson County, Pop. Sch., East Lumberton, E.D. 107; State Auditor's Records, Sch. B; Fourteenth Census, 1920: Robeson County, Pop. Sch., Lumberton, E.D. 31.

BLACKWELL, BONNIE J. (MRS.) (1906–1995): active 1940–1941, Blackwell's Studio, Durham.

SOURCES: Hill, *Durham City Directory, 1940*; *www.familysearch.org*.

BLACKWELL, DANIEL C. (b. ca. 1890): native of N.C.; active by 1930, Wilmington.

SOURCE: Fifteenth Census, 1930: New Hanover County, Pop. Sch., Wilmington, E.D. 65-15.

BLACKWELL, OTTIE BLAN (b. 1909): active 1932–1939, Durham; with Camera Craft Studio (1932–1934) and Dunbar & Daniel Studio (1938).

SOURCE: Photographic Examiners Records.

BLADENBORO STUDIO: active 1916, Bladenboro.

SOURCE: *N.C. Year Book*, 1916.

BLAIR, L. N.: active 1921, Lake Junaluska.

SOURCE: State Auditor's Records, Sch. B.

BLAKE, J. F. (T.): active 1916–1919; in Raeford (1916); in Red Springs (1919).

SOURCE: State Auditor's Records, Sch. B.

BLAKE, J. R.: active 1921–1924, Blake's Studio, Durham.

SOURCE: State Auditor's Records, Sch. B.

BLAKE, NOAH F. (b. ca. 1885): native of S.C.; African American; active 1919–1930, Charlotte.

SOURCES: State Auditor's Records, Sch. B; Fourteenth Census, 1920: Mecklenburg County, Pop. Sch., Charlotte, E.D. 140; Fifteenth Census, 1930: Mecklenburg County, Pop. Sch., Charlotte, E.D. 60-8.

BLAKEMORE, J. H. (b. 1832): native of Va.; active ca. 1866–after 1900, Mount Airy; publisher of stereographs; operated Mount Airy Fine Art Gallery above W. M. Banner's Store (1870); taught photography trade to Marcus L. Dean; moved to Roanoke, Va., after 1900. Example on page 74.

SOURCES: information provided by Randle E. Brim, Asheboro; *Mount Airy News*, June 4, 1870; Ninth Census, 1870: Surry County, Pop. Sch., Mount Airy; Twelfth Census, 1900: Surry County, Pop. Sch., Mount Airy, E.D. 113; Branson, *NCBD*, 1890; Sprange, *Blue Book*, 289; Darrah, *World of Stereographs*, 208.

BLAND, CHARLES A. (b. ca. 1880): native of N.C.; active 1910–1920s, Wadesboro; studio located on second floor of building that housed Yadkin River Power Company.

SOURCES: *N.C. Year Book*, 1910–1916; State Auditor's Records, Sch. B; *Bradstreet's*, 1917, 1921; Fourteenth Census, 1920: Anson County, Pop. Sch., Wadesboro, E.D. 15.

BLANTON, JOHN C. (b. ca. 1874): native of N.C.; active by 1910, 1919–1920, 1935, Lincolnton.

SOURCES: State Auditor's Records, Sch. B; Thirteenth Census, 1910: Lincoln County, Pop. Sch., Lincolnton, E.D. 72; Fourteenth Census, 1920: Lincoln County, Pop. Sch., Lincolnton, E.D. 108.

BLANTON, JOHN S. (b. ca. 1890): native of N.C.; active 1916, Lattimore; by 1920 was employed as a salesman.

SOURCES: *N.C. Year Book*, 1916; Fourteenth Census, 1920: Cleveland County, Pop. Sch., Lattimore, E.D. 64.

BLASINGAME, BRYANT: active (paid license tax to practice statewide) 1911–1912, Durham.

SOURCE: Registry of Licenses to Trade, Durham County, 1881–1913 (A&H).

BLATNER, H. A.: active 1919, Raleigh.

SOURCE: State Auditor's Records, Sch. B.

BLATNER, SAM: active 1920, Laurinburg.

SOURCE: State Auditor's Records, Sch. B.

BLEVINS, POINDEXTER ("PINE") (1863–1954): active early 1900s; in partnership with a Mr. Ham (1907–1922), Jefferson; also associated with a Mr. Mock in firm of Blevins and Mock, Grimsley (Ashe County).

SOURCES: information provided by Jennie W. Hightower, Jefferson; State Auditor's Records, Sch. B.

BLOCTON, J.: active 1920, Laurinburg.

SOURCE: State Auditor's Records, Sch. B.

BLOOMER, W. E.: active 1866–1867, Wilson.

SOURCE: *Branson & Farrar's NCBD*, 1866–1867.

BLOUGH, NEWTON W.: active 1910–1911, Asheville; operated Higgason-Blough Studio in partnership with Luther L. Higgason (1910–1911); in partnership with Frank W. Wolfe (1911); by 1914 was working in Detroit, Mich.

SOURCES: Miller, *Asheville, N.C. City Directory*; 1910–1911; Tinder list of Mich. photographers.

BLUNT, A. H.: active ca. 1870–1874; in Winston (ca. 1870); paid license fee to practice, Davidson County (1873–1874).

SOURCES: photograph bearing his name; Registry of Licenses to Trade, Davidson County, 1871–1878 (A&H).

BLYTHE, WILLIAM H. (b. 1872): native of Tex.; itinerant; active by 1900, Louisburg.

SOURCE: Twelfth Census, 1900: Franklin County, Pop. Sch., Louisburg, E.D. 48.

BOLIN, ERNEST E. (b. 1894): active 1940s, Hickory (n.d.), Gastonia (1941).

SOURCE: Photographic Examiners Records.

BOMER, ROBERT B.: (1888–1963): native of Va.; active by 1920, Charlotte.

SOURCES: Fourteenth Census, 1920: Mecklenburg County, Pop. Sch., Charlotte, E.D. 141; *www.familysearch.org*.

BON AIR STUDIO: active 1935, Charlotte; F. B. Cook, operator.

SOURCE: Photographic Examiners Records.

BON-ART STUDIO, INC.: active 1933–1936; in Durham (1933); on S. Tryon St., Charlotte (1933–1936); Myron M. Weiss, vice-president and manager.

SOURCES: Hill, *Durham City Directory*, 1933; *Hill's Charlotte Directory*, 1933–1936.

BON-NA STUDIO: active 1930, Wilmington.

SOURCE: Hill, *Wilmington Directory*, 1930.

BOONE, GEORGE: active 1919, Warrenton.

SOURCE: State Auditor's Records, Sch. B.

BOONE, H. B.: active 1917–1919; purchased license to practice in East Durham (1917–1918); in Durham (1919).

SOURCES: Record of Special Licenses Issued, Durham County, 1917–1918 (A&H); State Auditor's Records, Sch. B.

BOONE, JOHN A. D. (ca. 1843–1909): native of N.C.; worked as gunsmith before entering photography business; active 1887–1909; in tent on Lucknow Square, Dunn (1887–1888, 1890); in Fayetteville (ca. 1896–1909); operated Boone's Picture Gallery, located near Rose & Leaks' store.

SOURCES: *Dunn Signboard*, Dec. 9, 1887; Branson, *NCBD*, 1890, 1896–1897; *Bradstreet's*, 1908; Hill, *Fayetteville, N.C. Directory*, 1909–'10; Vital Records, death certificates, Book D-3, p. 156 (A&H); *Fayetteville Observer*, Nov. 25, 1909.

BOOZER, VIRGIL R. (1890–1970): active 1935–1938, Asheville-Hendersonville area; spent winters in West Palm Beach, Fla.; died in Fla.

SOURCES: Photographic Examiners Records; *www.familysearch.org*.

BORNWELL, J. B.: photographed construction of Blue Ridge Parkway, 1937.

SOURCE: Blue Ridge Parkway Photograph Collection (A&H).

BOWE, ERNEST GRANT (1899–1965): active 1932–1940, Alderman Photograph Company, High Point.

SOURCES: Photographic Examiners Records; *www.familysearch.org*.

BOWEN, ARTHUR FINN (1872–1942): native of Va.; active ca. 1890s–early 1900s, Raleigh; not a commercial photographer; as amateur, documented late-nineteenth- and early-twentieth-century life in Raleigh; employed by N.C. State College.

SOURCES: Murray list of Wake County photographers; *News and Observer* (Raleigh), Nov. 3, 1942, Apr. 3, 1966.

BOWEN, R. J.: active 1913, R. J. Bowen & Company, Winston-Salem.

SOURCE: *N.C. Year Book*, 1913.

BOWER, T. C.: itinerant; active 1855, Lincolnton; rented room next door to Mr. Henderson's store; had previously worked in Lincolnton.

SOURCE: *Hokeville Express* (Hokeville, Lincoln Factory), June 7, 1855.

BOWMAN, HARRY G. (b. 1891): active 1918–after 1946, Greensboro; took aerial photographs during World War I.

SOURCES: Photographic Examiners Records; State Auditor's Records, Sch. B.

BOXIL, HARRY: active 1922, Greensboro; studio at Hotel Guilford.

SOURCE: State Auditor's Records, Sch. B.

BOYCE, I. D.: proprietor of Richmond (Art) Gallery, which was active ca. 1880s–1890s in Richmond, Va.; gallery in Winston (ca. 1890).

SOURCES: photograph of First Presbyterian Church, Winston, bearing gallery name; information from files of Museum of Early Southern Decorative Arts (MESDA), Winston-Salem; Ginsberg, *Photographers in Virginia*, 41.

BOYCE, SAMUEL C. (ca.1862–1910): native of Ky.; active 1890–1910; in Monroe (1890); on S. Tryon St., outside city limits of Charlotte (1899–1900); in partnership with Thomas W. Long (1910).

SOURCES: *Maloney's 1899–1900 Charlotte Directory*; Twelfth Census, 1900: Mecklenburg County, Pop. Sch., Charlotte, E.D. 41; *N.C. Year Book*, 1910, 1911; Vital Records, death certificates, Book D-15, p. 288 (A&H); Union County Estates Records (A&H).

BOYCE, WILLIAM T. (b. ca. 1886): active 1938–1947, Williamston.

SOURCE: Photographic Examiners Records.

BOYD, W. CRAWFORD (1904–1987): native of N.C.; active 1923–after 1947; at Fort Bragg (1923–1924); with Wootten-Moulton Studio, Fort Bragg (1925–after 1947); operated Boyd's Studio, Fayetteville.

SOURCES: Photographic Examiners Records; Fifteenth Census, 1930: Cumberland County, Pop. Sch., Fayetteville, E.D. 26-14; *Mercantile Reference Book*, 1931; *News and Observer* (Raleigh), Nov. 15, 1939; *Mercantile Agency Reference Book*, 1943; American

Legion, City Directory of Fayetteville, 1928; *Hill's Fayetteville Directory*, 1937–1941; *www.familysearch.org*.

BOYKIN, J. R.: itinerant; active 1880–1884, Whiteville and statewide; obtained privilege license to practice, 1880–1882; in Rocky Mount (1884).

SOURCES: Registry of Licenses to Trade, Columbus County, 1876–1892 (A&H); State Auditor's Records, Miscellaneous Tax Group (1868–1932), Box 3, Artists' and Photographers' Privilege Licenses, 1877–1887 (A&H); State Auditor's Records, Ledgers, 1869–1899, Vol. 17, pp.10, 226 (A&H); *Wilson Advance*, May 30, June 6, 1884.

BOYLAN-PEARCE COMPANY, INC.: active 1933–1935, Raleigh; R. L. Grove, operator (1935).

SOURCES: Murray list of Wake County photographers; Photographic Examiners Records.

BOYLES, WILLIAM COBB (b. 1920): active 1941 with Boyles Photo Company, Thomasville.

SOURCE: Photographic Examiners Records.

BRACKETT, ERSKINE W. (b. ca. 1885): native of N.C.; active by 1910–1940s; in Morganton Township, assisted by his wife, Hester (by 1910); in Asheville (1913–1914, 1937–1940s).

SOURCES: Thirteenth Census, 1910: Burke County, Pop. Sch., Morganton Township, E.D. 7; State Auditor's Records, Sch. B; *Miller's Asheville Directory*, 1914, 1937–1941.

BRADLEY, I. A.: active 1921, Weaverville.

SOURCE: State Auditor's Records, Sch. B.

BRADSHAW, ALBERT JOHN (1860–1952): native of Mich.; active 1883–1935; in various locations in Mich. (1883–1911); in Hickory (1913–1935); sold out to Robert S. Cilley in 1935.

Sources: *N.C. Year Book*, 1913–1916; State Auditor's Records, Sch. B; Fourteenth Census, 1920: Catawba County, Pop. Sch., Hickory, E.D. 38; *Bradstreet's*, 1921, 1925; *Mercantile Reference Book*, 1931; Miller, *Hickory, N.C. City Directory*, 1925–1926, 1928–1931; Photographic Examiners Records; Tinder list of Mich. photographers.

BRAGG, SADIE ELIZABETH (1892–1987): active 1910s–after 1942; associated with Waller Holladay in Durham (1910s); with Katie L. Johnson in Durham (1910s–1920s); in Oxford (1920s–1930s) and Laurinburg (1934–1935); self-employed in Durham (early 1940s).

SOURCES: Photographic Examiners Records; *Mercantile Reference Book*, 1931; *www.familysearch.org*.

BRANAGAN, FLORENCE M. (1872–1942): native of England; active 1899–1924, with Branagan Studio, Asheville (Joseph McGarry, proprietor), 1917–1923; wife of John J. Branagan.

SOURCES: Twelfth Census, 1900: Buncombe County, Pop. Sch., Asheville, E.D. 133; *Bradstreet's*, 1908; Maloney, *Asheville, N.C. City Directory*, 1900–1901; Hill, *Asheville, N.C. City Directory*,

1902–1907; Miller, *Asheville, N.C. City Directory*, 1907–1912, 1914–1919, 1921–1924; *Asheville Citizen*, June 8, 1942.

BRANAGAN, JOHN J. (1863–1938): native of N.Y.; active 1913, Asheville; later employed as a tailor; husband of Florence M. Branagan.

SOURCES: State Auditor's Records, Sch. B; information provided by staff of Pack Memorial Public Library, Asheville.

BRANNAN, G. W.: active 1916, Clayton.

SOURCES: *N.C. Year Book*, 1916; State Auditor's Records, Sch. B.

BRANSON, _____: of Knoxville, Tenn.; active early 1870s, western N.C.; in partnership with a Mr. McCrary in publishing stereographs.

SOURCE: information provided by Carol Johnson, Library of Congress, Washington, D.C.

BRANSON, OLIVER M.: (b. ca. 1861): native of Tenn.; active by 1930, Hendersonville.

SOURCE: Fifteenth Census, 1930: Henderson County, Pop. Sch., Hendersonville, E.D. 45-9.

BRASINGTON, CARL LEFRAGE (1903–1980): native of N.C.; active 1928–after 1941; associated with Irving St. John in Gastonia (1928); in High Point with St. John (1928–1929); in Charlotte (1930); in Selma (1929, 1930–1940); in Roanoke Rapids (1938–1941) as Brasington Studio.

SOURCES: Fifteenth Census, 1930: Mecklenburg County, Pop. Sch., Charlotte, E.D. 60-31; Photographic Examiners Records; *www.familysearch.org*.

BREWER, C. O.: active 1919, Greensboro.

SOURCE: State Auditor's Records, Sch. B.

BREWER, FLORENCE W. (Mrs.): active 1908, Reidsville.

SOURCE: *Bradstreet's*, 1908.

BREWER, J. C.: active 1919–1921, Prosperity (Moore County).

SOURCE: State Auditor's Records, Sch. B.

BREWSTER, WILLIAM: active 1922, Pensacola (Yancey County).

SOURCE: State Auditor's Records, Sch. B.

BRIDGES, JOHN D. (b. ca. 1884): native of S.C.; active 1910–1911, Kings Mountain; in partnership (Davis, Bridges, and Broadfoot) with Lewis W. Broadfoot and a Mr. Davis.

SOURCES: Thirteenth Census, 1910: Cleveland County, Pop. Sch., Kings Mountain, E.D. 39; *N.C. Year Book*, 1910, 1911.

BRIGGS, ISAAC: itinerant daguerreotyper; active 1848–1852, Md., Va. (1848–1850); in Salisbury, N.C. (1852); gallery located in upper apartments of female academy

building near Presbyterian church; entered daguerrean trade in 1848 under instruction of Henry Pollock in Baltimore; made daguerreotypes at several Md. locations before moving to Va. in 1850; in Salisbury, Md. (1848).

SOURCES: *Carolina Watchman* (Salisbury), Apr. 22, 1852; *Craig's Daguerreian Registry*, 2:71; Kelbaugh, *Directory of Maryland Photographers*, 9, 61.

BRIGHTLEY, T. OR W.: of Toronto, Canada; active ca. 1918, Camp Greene; received permission to take photographs at the camp.

SOURCES: National Army Camps, Camp Greene, Charlotte, N.C., RG 393, Box 20, National Archives; information provided by Jane Johnson, Charlotte.

BRILEY, ALICE (b. ca. 1908): native of N.C.; active by 1930, Kinston.

SOURCE: Fifteenth Census, 1930: Lenoir County, Pop. Sch., Kinston, E.D. 54-10.

BRILL, H. G.: active (obtained license to practice) 1887–1888, New Hanover County.

SOURCE: Registry of Licenses to Trade, New Hanover County, 1881–1894, Vol. II (A&H).

BRIMLEY, HERBERT HUTCHINSON (1861–1946): native of England; active late nineteenth and early twentieth centuries; curator, State Museum of Natural History, Raleigh; collections of his photographs are on file at N.C. Office of Archives and History and the N.C. Museum of Natural Sciences, Raleigh.

SOURCES: Herbert H. Brimley Photograph Collection (A&H); *News and Observer* (Raleigh), Apr. 5, 1946; Odum, *A North Carolina Naturalist*.

BRINKLEY, JOHN D. (1862–1939): native of Va.; active 1883–1934; in Suffolk, Va. (1883–1884) with Parker & Harrell; studied at studio in Richmond, Va. (ca. 1880s); in Talladega, Ala. (1880s); in Oxford (1885, ca. 1889–1923), in partnership with W. F. Washington (1911–1912); studied at Illinois Art School (1890) to learn art of copying and enlarging photographs and finishing them with airbrush; in Henderson (1927–1934); returned to vicinity of Oxford following his retirement; member, N.C. Photographers' Association.

SOURCES: Photographic Examiners Records; State Auditor's Records, Ledgers, 1869–1899, Vol. 18, p. 104 (A&H); *State Chronicle* (Raleigh), Apr. 19, 1889; *Public Ledger* (Oxford), Jan. 24, Feb. 14, 1890; Branson, *NCBD*, 1890, 1896–1897; Sprange, *Blue Book*, 289; *Mercantile Agency Reference Book*, 1904; *Bradstreet's*, 1908; Thirteenth Census, 1910: Granville County, Pop. Sch., Oxford, E.D. 85; *Mercantile Reference Book*, 1931; *N.C. Year Book*, 1911, 1912; Robb list of Ala. photographers; Vital Records, death certificates, Book 2100, p. 274 (A&H); *Oxford Public Ledger*, Apr. 25, 1939; *News and Observer* (Raleigh), Apr. 25, 1939.

BROADAWAY, JOHN S. (ca. 1838–1891): native of N.C.; active 1859–ca. 1890; in Sumter, S.C. (1859); in Charlotte (1865, 1867–1872, 1877); occupied room above Charlotte Bank (1865); in Brown's Building on Tryon St., opposite Charlotte Hotel (1867–1870), and on Trade St. (1870–1872) in rooms over rear part of store of A. R. Nesbit & Brother; sold out to Henry Baumgarten (July 1872) to reduce competition in Charlotte photography trade; moved to S.C. and worked there as a photographer for several years before attempting unsuccessfully to open gallery in Charlotte (1877); state supreme court ruling against Broadaway upheld lower-court decision in a case brought by Henry Baumgarten alleging that Broadaway had not only sold his business in 1872 but also agreed not to open another gallery there; in Augusta, Ga., and Rutherfordton, N.C. (1873); in Greenville, S.C. (1876, 1878, 1880–1881); in Winston (1883–ca. 1890).

SOURCES: *Western Democrat* (Charlotte), Aug. 1, 1865; *Daily Observer* (Charlotte), Jan. 25, 1869; Teal, *Partners with the Sun*, 152; Branson, *NCBD*, 1867–1868, 1869, 1872, 1884; *Western Vindicator* (Rutherfordton), May 31, 1869; Tenth Census, 1870: Mecklenburg County, Pop. Sch., Charlotte, Fourth Ward; *Western-Carolina Record* (Rutherfordton), July 26, 1873; *Zell's U.S. Business Directory*, 1875; *Henry Baumgarten v. J. S. Broadaway*, 77 N.C. 8 (Case No. 11,904 [June 1877]); *Directory of Greensboro, Salem and Winston*, 1884; *People's Press* (Salem), Feb. 12, 1891; Forsyth County Estates Records (A&H); *Craig's Daguerreian Registry*, 2:72.

BROADBENT, SAMUEL (1810–1880): student of Samuel F. B. Morse; daguerreotyper, miniature painter, and photographer; active 1840–1870s; established Broadbent & Company, the leading galleries in New York and Philadelphia (1851–1870s); during winter months, traveled south; in Charleston and Columbia, S.C. (1845); in Wilmington (1847); in Fayetteville (1848), where he occupied rooms in "New Hotel"; in Raleigh (1848), where he occupied rooms at D. B. Smith's corner; in Baltimore (1849–1850) in partnership with a Mr. Carey.

SOURCES: Rinhart and Rinhart, *The American Daguerreotype*, 383–384; Teal, *Partners with the Sun*, 18; *Commercial* (Wilmington), Nov. 2, 1847; *Fayetteville Observer*, Apr. 11, 1848; *Raleigh Register and North Carolina Gazette*, May 24, 1848; Witham, *Catalogue of Civil War Photographers*, 68; Murray list of Wake County photographers; Brey and Brey, *Philadelphia Photographers*; *Craig's Daguerreian Registry*, 2:72–73; Kelbaugh, *Directory of Maryland Photographers*, 9; Ries and Ruby, *Directory of Pennsylvania Photographers*, 33.

BROADFOOT, LEWIS W. (b. ca. 1876): native of Ga.; active 1910–1911, Kings Mountain, in partnership with John D. Bridges and a Mr. Davis.

SOURCES: Thirteenth Census, 1910: Cleveland County, Pop. Sch., Kings Mountain, E.D. 39; *N.C. Year Book*, 1910, 1911.

BROCK, IGNATIUS WAD(T)SWORTH (1866–1950); native of N.C.; talented painter and award-winning photographer; active ca. 1891–1939; apprenticed under Edward Gerock in New Bern (early 1890s); in partnership of Gerock & Brock; in Asheville (1897–after 1939); operated Brock's Photo Art Studio (1901–1902) in partnership with Henry C. Koonce on S. Main St. (1902–1910); as partner with Koonce, Brock wanted to devote more time to portrait painting; in partnership with John E. Hage (1920); in partnership with Ray Mathewson (1920–1922); in partnership with Charles A. Farrell (1923, 1935); also operated as N. Brock & Company (1910s–1920s) and as Brock's Brownie Studio (1914).

SOURCES: *Reference Book of the Mercantile Association of the Carolinas*, 1891; Twelfth Census, 1900: Buncombe County, Pop. Sch., Asheville, E.D. 139; *N.C. Year Book*, 1910–1916; State Auditor's Records, Sch. B; *Mercantile Agency Reference Book*, 1904; *Bradstreet's*, 1917, 1921, 1925; *Mercantile Reference Book*, 1931; Maloney, *Asheville, N.C. City Directory, 1900–1901*; Hill, *Asheville, N.C. City Directory, 1902–1907*; Miller, *Asheville, N.C. City Directory, 1907–1932, 1936–1939*; Baldwin, *Asheville, N.C. City Directory, 1935*; Photographic Examiners Records;

Talented Asheville photographer Ignatius W. Brock sat for this portrait about 1914. Photograph courtesy A&H.

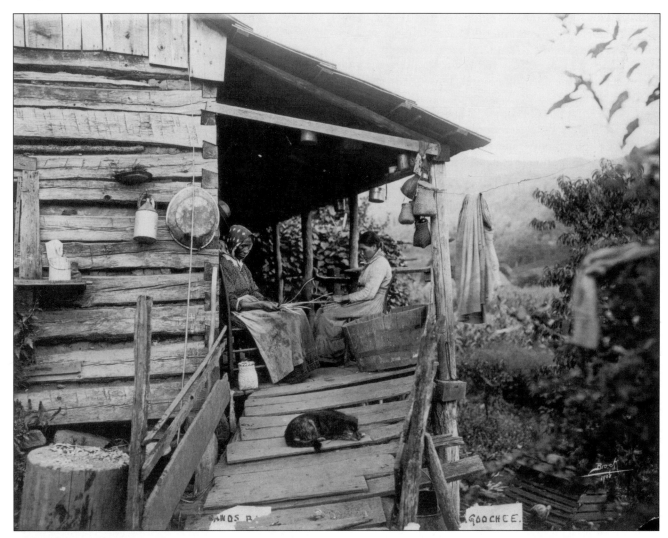

Native American Aunt Lydia Sands (*left*) and an unidentified woman are the subjects of this photograph made by Ignatius Brock in 1908 for the North Carolina Hall of History. Brock made the photo at Sands's cabin near Cherokee, North Carolina, at the request of historian Fred A. Olds. Photograph courtesy A&H.

Appalachian National Park Association Collection (A&H); "N. Brock, and a Dream of Fair Women," *Sky-Land* 1 (Sept. 1914): 671–675; *DNCB*, s.v. "Brock, Ignatius Wadsworth"; *Asheville Daily Gazette*, May 18, 1902; *Asheville Citizen*, Nov. 9, 1950.

BROCK, MILTON D.: active ca. 1910; Kinston.
SOURCE: photograph bearing his name.

BROOKS, _____: itinerant; active 1876 with Brooks & Company, Salisbury; at George Scott's old stand, Salisbury; advertised ten years' experience in New Orleans and other southern cities.
SOURCE: *Carolina Watchman* (Salisbury), Jan. 20, 1876.

BROOKS, JESSE: active 1919; Washington.
SOURCE: State Auditor's Records, Sch. B.

BROTHERS, _____: active (obtained license to practice) 1891, Alleghany County; in partnership with a Mr. Howel.

SOURCE: Registry of Licenses to Trade, Alleghany County, 1874–1906 (A&H).

BROWN, ALPHEUS: active ca. mid-nineteenth century, Browntown (Davidson County).
SOURCE: Joyce, *Clark's Collection of Historical Remembrances*, 190.

BROWN, C. E.: active 1919, Asheboro.
SOURCE: State Auditor's Records, Sch. B.

BROWN, CHARLES BRANTLEY AYCOCK (1904–1984): native of N.C.; active 1930s–1970s; employed by State Department of Conservation and Development; photographed and published numerous coastal views, especially the Outer Banks area; publicity director for outdoor drama *The Lost Colony*, 1948 and afterward; first director of Dare County Tourist Bureau, 1952 and afterward; a collection of his photographs is housed at the Outer Banks History Center (OBHC), Manteo.

SOURCES: State Department of Conservation and Development Records (A&H); Khoury, *Manteo, A Roanoke Island Town*; *News and Observer* (Raleigh), Apr. 15, 1984.

BROWN, CLAUDE O. (b. 1870): native of N.C.; active 1900–1930s; in Clinton as itinerant (by 1900); in Rocky Mount (early 1900s); operated C. O. Brown's Art Studio, Mount Olive (1910s–1930s); in Fremont (1920); Moye Library at Mount Olive College has a small collection of his photographs.

SOURCES: Twelfth Census, 1900: Sampson County, Pop. Sch., Clinton, E.D. 100; *N.C. Year Book*, 1910–1916; State Auditor's Records, Sch. B; *Mercantile Reference Book*, 1931; *Mount Olive Tribune*, July 4, 1995.

BROWN, EDWARD ELMER (ca. 1858–1934): native of Ohio; moved to Asheville in 1886; active ca.1887–1897, Asheville; in partnership with W. F. Willett of New York (1887); in partnership with Thomas H. Lindsey (early 1890s); some of his photographs of western N.C. were exhibited at the World's Fair in Chicago in 1893; following career in photography he worked in the nursery business.

SOURCES: *Country Homes* (Asheville), Aug. 1887 (in Glennie Tomlinson Miller Collection, [A&H]); Branson, *NCBD*, 1890, 1896–1897; *Mercantile Agency Reference Book*, 1890, 1891; Sprange, *Blue Book*, 288; McIlwaine, *Asheville, N.C. City Directory, 1896–1897*; Thirteenth Census, 1910: Buncombe County, Pop. Sch., Asheville, E.D. 9; *Asheville Citizen*, Aug. 8, 1934.

BROWN, FRANK H. (b. 1866): native of Ohio; active 1897–1900, Durham; studio located above Rawls' store, Main St.

SOURCES: *Mangum's Directory of Durham, 1897*, 42.; *News and Observer* (Raleigh), Aug. 24, 1899; Twelfth Census, 1900: Durham County, Pop. Sch., Durham, E.D. 32.

BROWN, FRED (b. ca. 1875): native of Colo.; active by 1930, Warsaw.

SOURCE: Fifteenth Census, 1930: Duplin County, Pop. Sch., Warsaw, E.D. 31-25.

BROWN, G. O.: active early 1900s, Mount Olive.

SOURCE: photograph bearing his name.

BROWN, GEORGE (b. 1864): native of Va.; itinerant; active by 1900, Durham.

SOURCE: Twelfth Census, 1900: Durham County, Pop. Sch., Durham, E.D. 31.

BROWN, GEORGE H.: itinerant; active 1856, Salisbury; rooms at the Rowan House.

SOURCE: *Carolina Watchman* (Salisbury), June 24, 1856.

BROWN, J. E.: active 1921, Denim (Guilford County).

SOURCE: State Auditor's Records, Sch. B.

BROWN, JAMES: of Emporia, Va.; active 1921, Northampton County.

SOURCE: State Auditor's Records, Sch. B.

BROWN, JOE: active (paid license fee to practice) 1911, Durham.

SOURCE: Registry of Licenses to Trade, Durham County, 1881–1913 (A&H).

BROWN, M. (b. ca. 1873): native of Poland; active by 1930, Asheville.

SOURCE: Fifteenth Census, 1930: Buncombe County, Pop. Sch., Asheville, E.D. 11-5.

BROWN, S. S.: active 1906, Matney (Watauga County).

SOURCE: name on return address of postal cover postmarked Sept. 24, 1906.

BROWN, SAM: active 1920, Laurinburg.

SOURCE: State Auditor's Records, Sch. B.

BROWN, THOMAS P. (b. ca. 1885): native of N.C.; active by 1910, Winston.

SOURCE: Thirteenth Census, 1910: Forsyth County, Pop. Sch., Winston, E.D. 70.

BROWN, W. A.: active 1919, Mooresville.

SOURCE: State Auditor's Records, Sch. B.

BROWN, W. C.: active 1921, Magnolia.

SOURCE: State Auditor's Records, Sch. B.

BROWN, WALTER: active 1919, Tyrrell County.

SOURCE: State Auditor's Records, Sch. B.

BROWN, WILLIAM: active 1896–1897, Greensboro; in partnership with Joseph A. Leonard.

SOURCE: Brenizer, *A Directory of the City of Greensboro, 1896–1897*.

BROWN STUDIO: active 1923–1924, Gastonia.

SOURCE: *Gastonia Directory*, 1923–1924.

BROWNING, ALLEN, JR. (b. ca. 1905): native of N.C.; active as newspaper photographer by 1930, Greensboro.

SOURCE: Fifteenth Census, 1930: Guilford County, Pop. Sch., Greensboro, E.D. 41-25.

BRUMFIELD, ELIZABETH ("BETTY") STEELE (1907–1986): active 1934–after 1944, Charlotte; worked for Gaddy Photo Lab; purchased Rembrandt Studio from Sarah D. Rader in 1944.

SOURCES: Photographic Examiners Records; *www.familysearch.org*.

BRUNER, STEPHEN C.: native of N.C.; active ca. 1900 with N.C. Department of Agriculture; took

photographs for State Museum of Natural History, Raleigh; son of Thomas K. Bruner.

SOURCES: Herbert H. Brimley Photograph Collection (A&H); information provided by Sarah Robinson, Jacksonville, Fla.

BRUNER, THOMAS K. (ca. 1855–1908): native of N.C.; secretary, N.C. Department of Agriculture; active late nineteenth, early twentieth centuries; took photographs of N.C. for exhibit at national and international expositions; father of Stephen C. Bruner.

SOURCES: *News and Observer* (Raleigh), Feb. 18, 1908; Herbert H. Brimley Photograph Collection (A&H); information provided by Sarah Robinson, Jacksonville, Fla.

BRUNSON, JOEL EDGAR (b. 1897): native of S.C.; active 1928–1940; in photo department of engraving companies, Charlotte (1928–1933); worked for Whitsett Photo Company (1933–1935); for Barnett Photo Company (1935 and afterward); with Sumter Photo Shop, Sumter, S.C. (1940).

SOURCES: Fifteenth Census, 1930: Mecklenburg County, Pop. Sch., Charlotte, E.D. 60-10; Photographic Examiners Records; Teal, *Partners with the Sun*, 268.

BRUSH, S. B.: itinerant daguerreotyper; active 1854–1855, New Bern.

SOURCE: *Newbern Journal*, Oct. 25, 1854, Jan. 3, 1855.

BRYAN, J. L.: itinerant daguerreotyper; active 1846–1848, with Samuel Dwight Humphrey as Humphrey & Company, Fayetteville; rooms on Hay St., upstairs, a few doors west of the Briggs's Hotel.

SOURCE: *Fayetteville Observer*, June 23, Aug. 18, Dec. 8, 1846, Apr. 27, 1847, June 13, 1848.

BRYANT, SAMUEL M.: active 1916, 1919; at "cotton mill" (1916); in Marion (1919).

SOURCE: State Auditor's Records, Sch. B.

BRYSON, J. NEWTON: itinerant maker of ambrotypes; active 1861–1862, Asheville; gallery located at the Carolina House on Main St.

SOURCE: *Asheville News*, Jan. 2, 1862.

BUCHANAN, PAUL (1910–1987): itinerant; active 1920–ca. 1951, Mitchell and surrounding counties; his photographs were the subject of *The Picture Man* (Chapel Hill: UNC Press, 1993), edited by Ann Hawthorne.

SOURCES: Hawthorne, *The Picture Man*; *News and Observer* (Raleigh), Nov. 10, 1993; *www.familysearch.org*.

BUCK, CHARLES (b. ca. 1887): native of N.Y.; active by 1910, Wilmington.

SOURCE: Thirteenth Census, 1910: New Hanover County, Pop. Sch., Wilmington, E.D. 91.

Thomas K. Bruner is shown seated behind a large box camera on top of Big Bald in Yancey County in the 1890s. Bruner, an employee of the North Carolina Museum of Natural History, took scenic views of the state for display in national and international expositions. Photograph courtesy A&H.

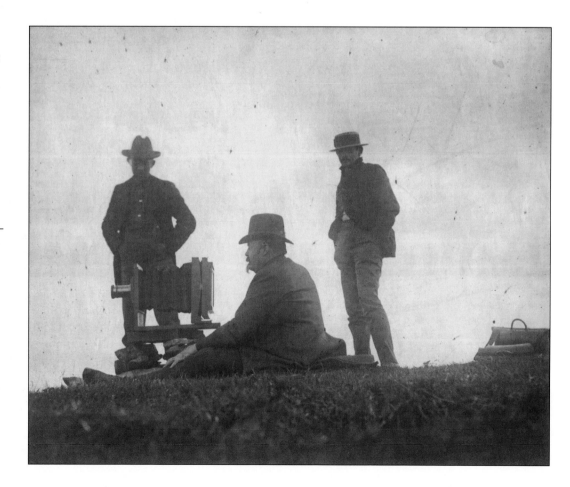

BUCK, JAMES W. (b. ca. 1868): native of Md.; active 1909–after 1930; in Richmond, Va. (1900); in Wilmington (1909–1930); active as outdoor photographer (1910); operated Buck's Studio; bought out firm of Foltz & Kendrick in 1914; opened new studio on Princess St. in 1924 and operated there through 1928.

SOURCES: *Dispatch* (Wilmington), Apr. 9, 1914; *N.C. Year Book*, 1916; *Bradstreet's*, 1917, 1921, 1925; Thirteenth Census, 1910: New Hanover County, Pop. Sch., Wilmington, E.D. 93; Fourteenth Census, 1920: New Hanover County, Pop. Sch., Wilmington, E.D. 101; *News-Dispatch* (Wilmington), Dec. 11, 1924; Hill, *Wilmington Directory*, 1926, 1928; *Mercantile Reference Book*, 1931; Ginsberg, *Photographers in Virginia*, 28; Reaves list of Wilmington photographers.

BUELL, FRANK (b. ca. 1858): native of Ky.; active by 1910, Murphy.

SOURCE: Thirteenth Census, 1910: Cherokee County, Pop. Sch., Murphy, E.D. 39.

BUIS, WILLIAM A. (b. ca. 1834): maker of ambrotypes; active 1856–1857, Salisbury; rented rooms above Fleming's law office; enlisted ln Company K, Fourth Regiment, N.C. State Troops, 1861; worked as blacksmith (1861).

SOURCES: *Carolina Watchman* (Salisbury), Nov. 28, 1856; Eighth Census, 1860: Rowan County, Pop. Sch.; Manarin and Jordan, *N.C. Troops*, 4:105.

BUNN, _____: active 1919, Durham, in partnership with a Mr. Doughtry (Doutry).

SOURCE: State Auditor's Records, Sch. B.

BURCH, _____: active (acquired license to practice) 1877–1878, Person County; in partnership with Thomas Moore.

SOURCE: Registry of Licenses to Trade, Person County, 1877–1901 (A&H).

BURGESS, G. B.: active 1895, Hertford, Morehead City; closed business in 1895 and moved to Murfreesboro to undertake mission work.

SOURCE: *Eastern Courier* (Hertford), May 22, June 6, Aug. 7, 1895.

BURGESS, JAMES L.: active 1916, Broadway (Lee County).

SOURCE: *N.C. Year Book*, 1916.

BURGESS, JOSEPH I.: active 1857, Elizabeth City, in rooms outfitted with a ladies' parlor and a piano for the amusement of female customers.

SOURCE: *Democratic Pioneer* (Elizabeth City), Aug. 11, 1857.

BURGESS, JOSEPH L. ?: active 1867–1910; in Trenton (1867–1868); in Norfolk, Va., and eastern N.C. (1872–1910).

SOURCES: Branson, *NCBD*, 1867–1868; Ginsberg, *Photographers in Virginia*, 16.

BURGESS, WALTER F.: active 1935, Elkin.

SOURCE: Photographic Examiners Records.

BURKE GROCERY COMPANY: active 1902, Morganton.

SOURCE: *N.C. Year Book*, 1902.

BURLESON, MARY G. (Mrs.) (1894–1976): active 1935, Morganton.

SOURCES: Photographic Examiners Records; *www.familysearch.org*.

BURNETT, J. J. (1854–1919): native of N.C.; active 1882–1890s; itinerant (1882); in Wilmington (1883–1890s) in studio located above W. H. Green's drugstore (1892); in Clinton (1892).

SOURCES: State Auditor's Records, Ledgers, 1869–1899, Vol. 17, p. 247 (A&H); Branson, *NCBD*, 1883, 1884, 1885, 1894; *Directory of the City of Wilmington, North Carolina, 1889*; *Caucasian* (Clinton), Apr. 21, 1892; Sprange, *Blue Book*, 289; Reaves list of Wilmington photographers; Vital Records, death certificates, Book 483, p. 52 (A&H); *Morning Star* (Wilmington), Aug. 30, 1919.

BURNETT, W. (b. ca. 1836): native of N.C.; active as a maker of ambrotypes in Wilmington by 1860.

SOURCE: Eighth Census, 1860: New Hanover County, Pop. Sch., Wilmington.

BURNEY, JAMES: itinerant daguerreotyper; active 1847–1848, New Bern; located on the corner of Broad and Hancock Streets, one door west of Washington Hotel.

SOURCE: *Newbernian* (New Bern), Nov. 23, 1847, Jan. 18, 1848.

BURNS, LULA E. (Mrs. Jones Burns) (b. ca. 1897): native of N.C.; active 1922–1926, High Point; operated Burns Studio.

SOURCES: State Auditor's Records, Sch. B; Miller, *High Point Directory*, 1923–1926; Fourteenth Census, 1920: Guilford County, Pop. Sch., High Point, E.D. 155.

BURNS, PAULINE DAVIS (1911–1989): active 1933–1939, Charlotte.

SOURCES: Photographic Examiners Records; *www.familysearch.org*.

BURRIS (BULLIS), T. C.: active 1919–1922, Pomona (Guilford County).

SOURCE: State Auditor's Records, Sch. B.

BURT, JOSEPH P. (b. 1899): active 1910s–1940s; operated Flynt Studios, Greensboro (1926–1930); proprietor, Rembrandt Studio, Greensboro (1928–1929); in Lexington (1931–1940s) as proprietor of Burt's Studio and Burt Photo Finishing Company, Thomasville (1935–1940s); wife worked in studio by 1934.

SOURCES: N.C. Supreme Court Records, 39S-665, *Darr v. Carolina Aluminum Company*, spring 1939 (A&H); Photographic Examiners Records; *Hill's Greensboro Directory, 1928–1929*; *Baldwin and Times' Thomasville, North Carolina City Directory, 1935*; *Miller's Thomasville, North Carolina City Directory, 1941–42*; *Baldwin, Lexington City Directory, 1937*; *Miller's Lexington City Directory, 1941–1942*; *Mercantile Agency Reference Book, 1943*.

BURT, MRS. JOSEPH P. (b. 1902): active by 1934, Lexington; worked with husband in Burt's Studio.

SOURCE: Photographic Examiners Records.

BURTON, W. L.: itinerant; active 1889, Edenton.

SOURCE: *Fisherman and Farmer* (Edenton), Jan. 11–Apr. 12, 1889.

BUSH, JOHN: African American; active 1905–1906, Wilmington.

SOURCE: Hill, *Wilmington Directory, 1905–1906*.

BUSSEY, _____: active 1911, Lexington; in partnership with William H. Dunwick.

SOURCE: *N.C. Year Book*, 1911.

BUSSEY, G. W.: photographed construction of Blue Ridge Parkway, 1936.

SOURCE: Blue Ridge Parkway Photograph Collection (A&H).

BUTTS, R. B.: itinerant; active 1896, Wilmington; operated photographic tent on Front St. between Church and Castle Streets.

SOURCES: *Star* (Wilmington), Mar. 29, 1896; Reaves list of Wilmington photographers.

BYERLY, JOHN DAVIS: of Frederick, Md.; active late 1850s–1897; in Frederick, Md. (ca. 1858–1897) as proprietor of Byerly Picture Gallery; in Richmond, Va. (1866); in Northampton County N.C. (paid tax to practice, 1867); itinerant in partnership at various times with a Mr. Newsome (1867) and Thomas J. Nimmo (n.d.); son of photographer Jacob D. Byerly of Md.

SOURCES: Ginsberg, *Photographers in Virginia*, 28; Kelbaugh, *Directory of Maryland Photographers*, 63–64; Northampton County Tax Records, 1858–1879, Folder 1860–1867 (A&H); cartes-de-visite (ca. late 1860s) bearing Byerly's name; *Craig's Daguerreian Registry*, 2:89.

BYNER, W. S.: active 1921, Charlotte.

SOURCE: State Auditor's Records, Sch. B.

BYRD, BYRON W.: active 1941, on Hargett St., Raleigh.

SOURCE: Hill, *Raleigh Directory*, 1941.

C

CAIN, EMMA FISCHER (1864–1924): active 1880s–1890s, Winston; worked as photographer's assistant in gallery

Photographer Sylvester E. Hough of Winston took this portrait of Emma Fischer Cain about 1896. Cain was one of only a few women who were working in the profession in the state during the late nineteenth century. Photograph courtesy Museum of Early Southern Decorative Arts, Winston-Salem (MESDA).

of Sylvester E. Hough; portraits of Cain are housed at MESDA in Winston-Salem.

SOURCE: information from the files of MESDA.

CAINE, _____: active early 1930s, western N.C.; published real-photo postcard of Soco Falls Indian Reservation.

SOURCE: real-photo postcard bearing name "Caine."

CAIRNS, _____: itinerant daguerreotyper; active 1850, Hillsborough; rented rooms in west end of a house formerly occupied by a Mr. Clancy.

SOURCE: *Hillsborough Recorder*, May 8, 1850.

CALLAWAY, N. C.: of Norfolk, Va.; active 1919, Hertford County.

SOURCE: State Auditor's Records, Sch. B.

CAMEO CRAFT STUDIO: active 1925–1940s, Durham; operated by F. Gilbert Whitley (n.d.) and by Robert E. Lewis (1939–1940).

SOURCES: Hill, *Durham City Directory, 1925–1941*; Photographic Examiners Records.

CAMERA SHOP: active 1919–1940, Wilmington; John Spillman, proprietor.

SOURCE: Hill, *Wilmington Directory*, 1919–1920, 1922, 1924, 1926, 1928, 1938, 1940.

CAMON, O. J. (b. 1879): native of S.C.; itinerant; active by 1900, Monroe.

SOURCE: Twelfth Census, 1900: Union County, Pop. Sch., Monroe, E.D. 140.

CAMP GREENE STUDIO: active late 1910s, Charlotte.

SOURCE: photograph bearing studio name.

CAMPBELL, _____: active 1903, Rutherfordton, in partnership with a Mr. Daves as Campbell & Daves; gallery located above Carpenter's Meat Market.

SOURCE: *Rutherfordton Sun*, Apr. 19, 1903.

CAMPBELL, A. J.: active 1907–1918, Boone.

SOURCES: Lentz, *W. R. Trivett, Appalachian Picture Man*, 28–30; *Watauga Democrat* (Boone), Aug. 15, 1907, Sept. 26, 1918.

CAMPBELL, ALFRED S.: active ca. 1893–1904; head-quartered in Elizabeth, N.J.; publisher of stereographs; published scenes of Dismal Swamp area in northeastern N.C.

SOURCES: Darrah, *World of Stereographs*, 52; stereographs bearing his name.

CAMPBELL, CHARLES O. (b. 1842): native of Md.; active 1885–ca. 1900; in Oxford (1885) as itinerant with firm of Campbell, Foster & Company of Richmond, Va.; in Richmond (1886, 1893); in Louisburg (by 1900).

SOURCES: *Oxford Torchlight*, Apr. 7, 1885; Ginsberg, *Photographers in Virginia*, 28; Twelfth Census, 1900: Franklin County, Pop. Sch., Louisburg, E.D. 48.

CAMPBELL, COREL B. (1896–1960): African American; active 1922–1926, Raleigh; in partnership with Leo W. Bennett (1924); studio located on E. Hargett St.; died in New York; samples of his work on display at Raleigh City Museum, 1994–1995.

SOURCES: Hill, *Raleigh Directory*, 1922–1924, 1926; *News and Observer* (Raleigh), Nov. 9, 1993; information provided by photographer Sherman Jenkins, Raleigh; *www.familysearch.org*.

CAMPBELL, JOHN: active 1916–1919, Robeson County.

Source: State Auditor's Records, Sch. B.

CANNADAY, W. H.: active 1916, Duke (Harnett County).

SOURCE: *N.C. Year Book*, 1916.

CANNADY, L. P.: active (acquired license to practice) 1909–1910, Durham; itinerant statewide.

SOURCE: Record of Special Licenses Issued, Durham County, 1908–1909 (A&H).

CANNON, JOHN: active 1938, Blue Ridge Parkway.

SOURCE: identified as photographer in State Department of Conservation and Development Records (A&H).

CAPEHART, CHARLES SMALLWOOD (1905–1986): active 1940–1941, Roxobel (Bertie County); died in Tex.

SOURCES: Photographic Examiners Records; *www.familysearch.org*.

CAPITOL STUDIO: active 1920–1923, Fayetteville St., Raleigh; operated by Charles G. Powers.

SOURCE: Hill, *Raleigh Directory*, 1920, 1922–1923.

CARAWAN, HENRY ARLINE (b. 1906): active 1931–1940s; with Wootten-Moulton Studio, Chapel Hill (1931–1940); in Vandemere (Pamlico County) by 1946.

SOURCE: Photographic Examiners Records.

CARDEN, J. B. ("PROFESSOR CARDEN"): active 1898, Franklin.

SOURCE: photograph bearing his name.

CARLISLE, MARION: active 1886–1909; statewide itinerant in N.C. in partnership with T. W. Moore (1886–1887); in Rockingham (n.d.); operated M. Carlisle's Gallery, Rockingham (1894); in Marion, S.C. (1890s); in Rock Hill, S.C. (1904–1909); in York, S.C. (1905).

SOURCES: State Auditor's Records, Ledgers, 1869–1899, Vol. 18, p. 248 (A&H); *Rocket* (Rockingham), July 19, 1894; Teal, *Partners with the Sun*, 202.

CAROLINA DEVELOPING & PRINTING HOUSE: active 1918–1924, Charlotte.

SOURCE: Photographic Examiners Records.

CAROLINA KODAK FINISHING COMPANY: active 1916–1922, Charlotte; known as Carolina Studio (1919–1922); also known as Carolina Developing & Printing House (1918–1924).

SOURCE: State Auditor's Records, Sch. B.

CAROLINA PHOTO COMPANY: active 1916–1926, Patton Ave., Asheville (1916–1921); Ernest G. Wilson, operator (1924–1926), Joseph H. Howard and a Mr. Watts, operators (1924–1926); in West Asheville (1926); Joseph H. Howard, operator.

SOURCE: Miller, *Asheville, N.C. City Directory*, 1916–1926.

CAROLINA PHOTO COMPANY: active 1918–1919, Dunn; William Arthur Gasque, manager.

SOURCE: Gardiner, *Dunn, N.C. City Directory*, 1918–1919.

CAROLINA PHOTO COMPANY: active 1930–1931, High Point; J. A. Daniel Jr., manager.

SOURCE: Miller, *High Point Directory*, 1930–1931.

CAROLINA PHOTO STUDIO: active 1927–1928, Gastonia; Irving St. John, manager.

SOURCE: *Gastonia Directory*, 1927–1928.

CAROLINA STUDIO: African American establishment; active 1917–1940s, Charlotte; James E. Hemphill, operator.

SOURCES: Miller, *Charlotte Directory*, 1920–1930; *Hill's Charlotte Directory*, 1932–1941.

CAROLINA STUDIO OF PHOTOGRAPHY: active 1940, Fayetteville St., Raleigh; Henry D. Shacklette, operator.

SOURCE: Hill, *Raleigh Directory*, 1940.

CAROLINA STUDIOS: active ca. 1926–1930s, Four Oaks; Elvin Roddey, operator.

SOURCES: *Four Oaks News*, June 13, 1979; information provided by Durwood Barbour, Raleigh.

CARPENTER, H. P.: itinerant; active (acquired license to practice) 1885–1886, Mitchell County.

SOURCE: Registry of Licenses to Trade, Mitchell County, 1877–1902 (A&H).

CARPENTER, LAWSON L.: active late nineteenth century, Jonesboro.

SOURCE: photograph bearing his name.

CARR, _____: active early twentieth century, at unidentified N.C. location in partnership with a Mr. Johnson.

SOURCE: photograph bearing name "Carr," John L. Patterson Papers (A&H).

CARR, F. A. (possibly Frank A. Carr): active 1915–1916, Lincolnton.

SOURCE. *N.C. Year Book*, 1915, 1916.

CARR, FRANK A. (b. ca. 1865): native of Wis.; active in association with his wife, ca. 1905–1930, Elk Park and Avery County; also a newspaper publisher.

SOURCES: Fifteenth Census, 1930: Avery County, Pop. Sch., Elk Park, E.D. 8; Lentz, *W. R. Trivett, Appalachian Picture Man*, 32.

CARR, W. L.: active 1921–1922, Hendersonville; operated Carr's Studio.

SOURCE: Miller, *Hendersonville, N.C. City Directory, 1921–1922*.

CARRIER, A. D.: itinerant; active (paid tax to practice as artist) 1859, Fayetteville; in Hamilton, N.Y. (1859).

SOURCES: Cumberland County Miscellaneous Tax List, 1857–1884, Taxes Received, p. 27 (A&H); *Craig's Daguerreian Registry*, 2:97.

CARRIER, PAUL E.: active 1931–1934, Charlotte; manager of Coffey's Photo Studio on N. Tryon St.

SOURCE: *Hill's Charlotte Directory*, 1932–1934.

CARROLL, E. E.: active 1921–1922, Mount Airy.

SOURCE: State Auditor's Records, Sch. B.

CARROLL, J. C.: active early 1930s, Gastonia.

SOURCE: *Mercantile Reference Book*, 1931.

CARSON, _____: active 1916, Asheboro; operated Carson's Studio.

SOURCE: State Auditor's Records, Sch. B.

CARSON, G. RAY (b. ca. 1893): native of N.C.; active by 1920, Charlotte.

SOURCE: Fourteenth Census, 1920: Mecklenburg County, Pop. Sch., Charlotte, E.D. 153.

CARTER, W. ESMOND (1913–ca. 1991): active 1930s–1940s, Weldon.

SOURCES: information provided by Whit Joyner, New Hill; information provided by Bill Carter, Lumberton.

CARTER, W. H.: active 1916, Robeson County.

SOURCE: State Auditor's Records, Sch. B.

CARTWRIGHT, CLINTON C. (1879–1925): native of N.C.; active ca. 1910s, Nixonton (Pasquotank County); also worked as a painter.

SOURCES: photograph bearing his name; Vital Records, death certificates, Book 616, p. 45 (A&H).

CASE, ARTHUR H. (b. ca. 1878): native of N.Y.; active by 1910, Asheville.

SOURCE: Thirteenth Census, 1910: Buncombe County, Pop. Sch., Asheville, E.D. 5.

CASON, CLEVELAND (b. ca. 1894): native of N.C.; African American; active 1919, 1921; in Wadesboro (1919); in Winston-Salem (1921); in 1920 he was a truck driver for an automobile company.

SOURCES: State Auditor's Records, Sch. B; Fourteenth Census, 1920: Forsyth County, Pop. Sch., Winston-Salem, E.D. 97.

CASSENS, R. H.: active ca. 1918, Camp Greene; received permission to take photographs at the camp.

SOURCES: National Army Camps, Camp Greene, Charlotte, N.C., RG 393, Box 20, National Archives; information provided by Jane Johnson, Charlotte.

CATLETT, GEORGE SIDNEY: active 1909–1919, Wake Forest; father of Needham Arthur Catlett.

SOURCE: Murray list of Wake County photographers.

CATLETT, NEEDHAM ARTHUR (1898–1990s): active throughout twentieth century, Wake Forest and other places; son of George S. Catlett; also Baptist minister.

SOURCE: Murray list of Wake County photographers.

CAUDLE, ARCHIBALD B. (b. ca. 1846): native of N.C.; active by 1880–1890s, Monroe.

SOURCES: Tenth Census, 1880: Union County, Pop. Sch., Monroe, E.D. 210; Branson, *NCBD*, 1883–1884, 1884, 1885–1886, 1889, 1890, 1892.

CAUDLE, D. L.: active 1926, Asheville.

SOURCE: Miller, *Asheville, N.C. City Directory*, 1926.

CAUDLE, JESSE F.: active 1891, Rockingham; gallery located near the newspaper office.

SOURCES: *Rocket* (Rockingham), Sept. 17, 1891; Richmond County Deed Records (A&H).

CAVALRY, _____: itinerant; active (acquired license to practice) 1892–1893, Columbus County, in partnership with a Mr. Lyon.

SOURCE: Registry of Licenses to Trade, Columbus County, 1876–1892 (A&H).

CAVINESS, W. W.: active 1919–1921, Winston-Salem.

SOURCE: State Auditor's Records, Sch. B.

CENTRAL PHOTO COMPANY: active 1935, Burlington; John Barham, operator.

SOURCE: *Hill's Burlington Directory*, 1935.

CHADWICK, _____: active 1907; associated with firm of Berry, Kelly & Chadwick, headquartered in Chicago; publisher of stereographs of N.C.

SOURCE: stereograph of interior of Charlotte textile mill bearing company name.

CHADWICK, EDWARD H. (1831–1875): native of N.C.; active by 1860, Kinston; sergeant in Company B, Sixty-third Regiment, N.C. State Troops (Fifth Regiment N.C. Cavalry).

SOURCES: Eighth Census, 1860: Lenoir County, Pop. Sch.; Manarin and Jordan, *N.C. Troops*, 2:373, 384–385; WPA Cemetery Index (A&H).

CHAMBERS, DONALD: active 1940s; in Greensboro (1940 and afterward), with Joseph B. McGowan; in Durham (1940 and afterward); entered military service in 1941.

SOURCE: Photographic Examiners Records.

CHAMBERS, DWIGHT THOMAS (b. 1879): active 1934–1940s; in Asheville (1934–1943); in Arden (1934 and 1940–1941); operated Chambers Studio there; in association with Carl E. Clark (1935); father of J. D. Chambers, who assisted in studio in 1935.

SOURCES: Photographic Examiners Records; Baldwin, *Asheville, N.C. City Directory*, 1935; *Miller's Asheville Directory*, 1936, 1938; information provided by staff of Pack Memorial Public Library, Asheville.

CHAMBERS, J. D.: active 1940–1941, Arden; also assisted father, Dwight T. Chambers, at Asheville studio, 1935.

SOURCE: Photographic Examiners Records.

CHAMPION, J. L.: active 1916, Henrietta (Rutherford County).

SOURCE: State Auditor's Records, Sch. B.

CHANT, ELIZABETH A.: active 1930, Wilmington; operated Cottage Lane Studio.

SOURCE: Hill, *Wilmington Directory, 1930.*

CHAPIN, MOSES SANFORD (b. 1810): active 1840s–1870s, in Worcester, Mass.; worked with Union occupying forces at Union Art Gallery, New Bern, 1862.

SOURCES: Mann, *History of the Forty-Fifth Regiment Massachusetts Volunteer Militia*; Polito, *A Directory of Massachusetts Photographers*, 508.

CHAPMAN, GARNET ANDREW (1911–1981): active 1941 and afterward, Burlington.

SOURCES: Photographic Examiners Records; *www.familysearch.org.*

CHAPPELL, ROBERT L. (b. ca. 1871): native of Va.; active 1906–1915, Roxboro.

SOURCES: *N.C. Year Book*, 1906–1915; *Bradstreet's*, 1908; Thirteenth Census, 1910: Person County, Pop. Sch., Roxboro, E.D. 149.

CHERRY, J. FRANK: active 1914–1916, Roanoke Rapids.

SOURCE: *N.C. Year Book*, 1914, 1916.

CHICAGO PORTRAIT COMPANY: active 1898, Wilmington; R. F. Stockton of Salem, N.C., agent.

SOURCES: *Star* (Wilmington), Nov. 9, 1898; Reaves list of Wilmington photographers.

CHICKERING, ELMER E. (1894–1965): native of Wis.; active early twentieth century; operated Elmer Chickering Company; took photographs for State Museum of Natural History, Raleigh; died in Wis.

SOURCES: Herbert H. Brimley Photograph Collection (A&H); information provided by Sarah Robinson, Jacksonville, Fla.; *www.familysearch.org.*

CHIDNOFF, IRVING (1896–1966): active 1937–1941, Durham; operated Chidnoff's Studio of New York City (assisted by James V. Colonna in 1937 and by Herman Fink after 1937); died in Fla.

SOURCES: Photographic Examiners Records; *www.familysearch.org.*

CHILDERS, JAMES ROBERT: active by 1900, Swain County.

SOURCE: photograph bearing his name.

CHIPMAN, J. G.: active (acquired license to practice) 1905–1906, Alleghany County.

SOURCE: Registry of Licenses to Trade, Alleghany County, 1874–1906 (A&H).

CHISHOLM, R. K.: active 1905, Lincolnton.

SOURCE: *N.C. Year Book*, 1905.

CHRIST, JAMES (JANUS?) E. (b. ca. 1883): native of Greece; active by 1930, Winston-Salem.

SOURCE: Fifteenth Census, 1930: Forsyth County, Pop. Sch., Winston-Salem, E.D. 34-30.

CHRISTENBURY, FRANK M. (b. ca. 1886): native of N.C.; active 1921, Concord; worked as a weaver in a cotton mill (1920).

SOURCES: Fourteenth Census, 1920: Cabarrus County, Pop. Sch., Concord, E.D. 53; State Auditor's Records, Sch. B.

CHRISTENBURY, PETER SMITH (b. ca. 1867): native of N.C.; active 1919–1921; in Mooresville (1919); in Concord (1920–1921).

SOURCES: State Auditor's Records, Sch. B; Fourteenth Census, 1920: Iredell County, Pop. Sch., Mooresville, E.D. 85; *Concord City Directory,* 1920–1921.

CHURCHILL, JAMES M. (1914–1998): active prior to World War II, Durham, with Jack Williams.

SOURCE: *News and Observer* (Raleigh), Jan. 28, 1998.

CHURCHWELL, WILLIAM J. (b. ca. 1847): native of N.C.; active by 1870, Wilson.

SOURCE: Ninth Census, 1870: Wilson County, Pop. Sch., Town of Wilson.

CILLEY, ROBERT S. (1909–1984): active 1935–1941, Hickory; purchased studio of Albert J. Bradshaw in 1935; died in Fla.

SOURCES: Photographic Examiners Records; *Hickory, N.C. City Directory, 1935; Miller's Hickory City Directory, 1937–1938; www.familysearch.org.*

CLANCY, _____: itinerant; active by 1850, Hillsborough.

SOURCE: Seventh Census, 1850: Orange County, Pop. Sch.

CLAPP, _____: active early 1900s, Belhaven. Source not recorded.

CLARK, CARL E.: active 1935, Asheville; in association with Dwight T. Chambers as Chambers Studio.

SOURCE: information provided by staff of Pack Memorial Public Library, Asheville.

CLARK, CHARLES H.: active 1909–1922; in Durham (1909–1910); in Oxford (1916–1922); by 1922 home base was Richmond, Va.

SOURCES: Registry of Licenses to Trade, Durham County, 1881–1913 (1909) (A&H); State Auditor's Records, Sch. B.

CLARK, DAVID LOWERY (1824–1915): native of Va.; active ca. 1859–1902, High Point (after locating there in 1856); began career as itinerant portrait painter; studied under Thomas Sully in Philadelphia; began advertising the use of "Woodward's Patent Solar Camera" in High Point, 1859 (the previous year, Baltimore inventor and artist David A. Woodward [1823–1909] had taught Clark how to use the device, which made copies of daguerreotypes and ambrotypes); occupied rooms in Barbee's Hotel, High Point,

Shown here is a portrait of artist/photographer David L. Clark of High Point. Photograph courtesy Mary Lib Clark Joyce, High Point.

in partnership with Calvin A. Price (1860); continued to work as portrait painter and photographer into early twentieth century; operated gallery on northeast corner of Washington St. and N. Main St., High Point, at which his wife, Elizabeth Ann Alston Clark, was proprietress of a millinery shop; portrait on file at N.C. Office of Archives and History.

SOURCES: *People's Press* (Salem), May 21, 1853; *Fayetteville Observer,* Feb. 5, 1855; *Greensboro Patriot,* May 6, 1859; *High Point Reporter,* Apr. 20, June 18–Dec. 13, 1860; Eighth Census, 1860: Guilford County, Pop. Sch., South Division; Ninth Census, 1870: Guilford County, Pop. Sch., High Point Township; Tenth Census, 1880: Guilford County, Pop. Sch., High Point, E.D. 126; Twelfth Census, 1900: Guilford County, Pop. Sch., High Point, E.D. 60; Branson, *NCBD,* 1866–1867, 1869, 1872, 1877–1878, 1884, 1890; Vital Records, death certificates, Book 90, p. 93 (A&H); information provided by Mary Lib Clark Joyce, High Point (including Clark's autobiography titled *The Roving Artist*); *Review* (High Point), Mar. 18, 1915.

CLARK, E. B.: active 1934; took photograph of bridge at Weldon.

SOURCE: information provided by Carol Johnson, Library of Congress, Washington, D.C.

CLARK, E. W.: itinerant daguerreotyper; active 1846–1847; in rooms in Masonic Hall, above Carolina Hotel, Wilmington (1846); in Raleigh (1847) in partnership with a Mr. Hutchins; occupied rooms on third floor of large brick building known as Smith's Corner, above Page's store; also a medical doctor.

SOURCES: *Chronicle* (Wilmington), Feb. 4–Apr. 1, 1846; *Raleigh Register and North Carolina Gazette,* Nov. 24, 1847; *Raleigh Register* (semi-weekly), Nov. 24, 1847; Murray list of Wake County photographers.

CLARK, J. ANDREW: active 1917, West Asheville.

SOURCE: Miller, *Asheville, N.C. City Directory*, 1917.

CLARK, R. F.: active 1935, Durham; affiliated with Ellis Stone (department store).

SOURCE: Photographic Examiners Records.

CLARK, T. W.: active 1850s–1910, in Norfolk, Va. (1850s–1910); as operator for Jesse Whitehurst (1850s); in partnership with Thomas Hankins (n.d.); in business as T. W. Clark & Company (1860s) and as T. W. Clark's National Photographic Gallery (1872–1910); in Oxford (1876) as itinerant from Norfolk; rented space above W. T. Crabtree's store, next door to Oxford Hotel; advertisement claimed that Clark had thirty years' experience in photography.

SOURCES: Witham, *Catalogue of Civil War Photographers*, 82; Ginsberg, *Photographers in Virginia*, 16, 17; *Oxford Torchlight*, Sept. 5, 1876.

CLARKE, _____: active ca. 1915, Lake Ellis, Craven County.

SOURCE: photograph bearing name "Clarke."

CLARKE, WILLIAM D. (1863–1941): native of Scotland; active 1894–1941; in Charleston, S.C. (1894–ca. 1941); also on E. Morehead St., Charlotte (1928–1941).

SOURCES: Teal, *Partners with the Sun*, 180–181; Miller, *Charlotte Directory*, 1929–1930; Fifteenth Census, 1930: Mecklenburg County, Pop. Sch., Charlotte, E.D. 60-23; *Hill's Charlotte Directory*, 1932–1940; Photographic Examiners Records; *Mercantile Reference Book*, 1931.

CLAY, MARSHALL: active 1916, Creedmoor.

SOURCE: State Auditor's Records, Sch. B.

CLEMENT, ALBERT OLIVER (1882–1936): native of N.C.; active 1904–1936; in Goldsboro (1904–1905), in partnership with John E. Hage; sole proprietor of Clement Studio (1905–1936); worked briefly in Wilmington (1917); served as president of N.C. Photographers' Association and as chairman of the State Board of Photographic Examiners; lobbied for legislation that established the board.

SOURCES: Photographic Examiners Records; *N.C. Year Book*, 1910–1936; State Auditor's Records, Sch. B; Gardiner, *Goldsboro, N.C. City Directory, 1916–1917*; Fourteenth Census, 1920: Wayne County, Pop. Sch., Goldsboro, E.D. 114; *Hill's Goldsboro Directory*, 1934; *Baldwin's Goldsboro Directory*, 1938; *Bradstreet's*, 1908, 1917, 1921, 1925; *Mercantile Reference Book*, 1931; *News and Observer* (Raleigh), Apr. 26, 1936.

CLEMENT, FRANK DEFOREST (b. 1869): active ca. 1914–1937, Brevard; sold business to William C. Austin in 1937.

SOURCE: Photographic Examiners Records.

CLIFFORD, J. A.: active 1869, Wilmington.

SOURCE: Branson, *NCBD*, 1869.

CLIFTON, YOUNG BOLLING (b. ca. 1847): native of N.C.; studied under Richard Walzl of Baltimore; active ca. 1874–1880s; in Louisburg (ca. 1874, 1877–1880s); in Rolesville (late 1870s).

SOURCES: *Courier* (Louisburg), Oct. 2, 1874; Branson, *NCBD*, 1877–1878, 1884; Tenth Census, 1880: Franklin County, Pop. Sch., Louisburg, E.D. 96; photograph (ca. late 1870s) bearing Clifton's name and marked "Rolesville."

CLINE, WALTER M. (1914–1984): active 1930s and 1940s; took mostly views of western N.C. and East Tenn.; located in Chattanooga, Tenn.; published numerous

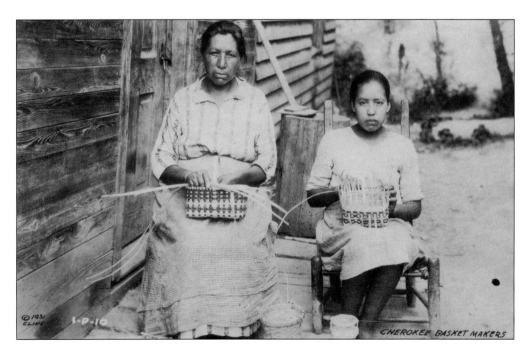

Walter M. Cline took numerous photographs in western North Carolina during the 1930s and 1940s. He published many real-photo postcards, including this one of Cherokee Indian basket makers in 1931. Courtesy of the compiler.

real-photo postcards of his western images; died in Tenn.

SOURCES: real-photo postcards bearing his name; information provided by Carol Johnson, Library of Congress, Washington, D.C.; *www.familysearch.org.*

CLIPPER PHOTO COMPANY: active 1902–1903, Elizabeth City; A. L. Divers, owner and manager.

SOURCES: *Tar Heel* (Elizabeth City), June 13, 1902; *N.C. Year Book,* 1903.

CLODFELTER, WILLIAM FRANK (1911–1984): native of N.C.; active 1935, Asheville, in partnership with Lyle C. Henderson.

SOURCES: Baldwin, *Asheville, N.C. City Directory, 1935;* information provided by staff of Pack Memorial Public Library, Asheville.

COATS, A. S.: active 1919, Marion.

SOURCE: State Auditor's Records, Sch. B.

COBB, COLLIER (1862–1934): college professor and geologist; active late nineteenth, early twentieth centuries; assistant with U.S. Geological Survey, 1886–1892; amateur photographer; took photograph of wreckage of *Priscilla* at Cape Hatteras (Aug. 1889).

SOURCES: *DNCB,* s.v. "Cobb, Collier"; Herbert H. Brimley Photograph Collection (A&H); information provided by Sarah Robinson, Jacksonville, Fla.

COBB, JOHN S.: active 1903–1910; in Durham (1903–1904); in Henderson (1908); in Louisburg (1910).

SOURCES: Hill, *Durham, N.C. Directory, 1903–1904;* postcard bearing his name (advertised for sale by eBay); *N.C. Year Book,* 1910.

COBB, M. M.: active 1916, Kinston.

SOURCE: State Auditor's Records, Sch. B.

COBLE, ALBERT HENRY (1880–1964): native of N.C.; active 1904–after 1948; in Kinston (1904–1916, 1932–after 1948; associated with father as W. M. Coble & Son; in New Bern (1907–1908) but returned to Kinston; worked as itinerant in counties around Kinston; in Raleigh (1916–1932); son of Wesley M. Coble.

SOURCES: Photographic Examiners Records; Hill, *New Bern Directory, 1907–1908;* Thirteenth Census, 1910: Lenoir County, Pop. Sch., Kinston, E.D. 62; Green, *A New Bern Album,* 16; *Kinston Daily Free Press,* Nov. 23, 1957; *www.familysearch.org.*

COBLE, WESLEY MILTON (1856–1942): native of N.C.; active ca. 1890–1925; itinerant (1890); in Trenton (1890s–early 1900s); also listed as jeweler in 1903; in Kinston (by 1906–ca.1930s); in business as Coble Art Studio and later as W. M. Coble & Son, in partnership with son, Albert H. Coble; acquired Raleigh business of Manly W. Tyree in late 1914; in Raleigh (1914–1925); operated Raleigh studio from 1916 to 1932.

SOURCES: Branson, *NCBD,* 1890, 1896, 1897; State Auditor's Records, Ledgers, 1869–1899, Vol. 19, p. 418 (A&H); *Mercantile Agency Reference Book,* 1904; *Kinston Daily Free Press,* Mar. 4, May 2, 1904, Nov. 23, 1957; Thirteenth Census, 1910: Lenoir County, Pop. Sch., Kinston, E.D. 62; *Mercantile Reference Book,* 1931; *Bradstreet's,* 1908, 1917, 1925; *N.C. Year Book,* 1910–1916; Photographic Examiners Records; State Auditor's Records, Sch. B; *News and Observer* (Raleigh), May 10, 1942.

COBURN, A.: active 1841–1849; in partnership with a Mr. Cerveau in Savannah, Ga., 1841; in Harrisburg, Pa. (1847), as A. Coburn & Company; itinerant daguerreotyper; in Camden, S.C. (1848); in Charlotte (1849); occupied rooms in Mecklenburg County Courthouse.

SOURCES: Rinhart and Rinhart, *The American Daguerreotype,* 387; Teal, *Partners with the Sun,* 15; *Charlotte Journal,* Feb. 2, 1849; *Craig's Daguerreian Registry,* 2:118; Ries and Ruby, *Directory of Pennsylvania Photographers,* 52.

COCHRAN, _____: itinerant daguerreotyper; active 1855, Fayetteville; in partnership with Levi Crowl; room located above Doctors Foulkes' and McRae's Drugstore on Hay St., east corner, opposite Fayetteville Hotel.

SOURCE: *Fayetteville Observer,* Jan. 1, 1855.

COCHRANE, J. E.: active 1881, Concord; gallery located above William Propst's store.

SOURCE: *Temperance Herald* (Concord), June 16, 1881.

COCKLEY, J. D.: photographed construction of Blue Ridge Parkway, 1936.

SOURCE: Blue Ridge Parkway Photograph Collection (A&H).

COFFEY, CLOYD FINLEY (1912–1987): active after 1938; in Granite Falls (1938); in Wilmington after World War II.

SOURCES: Photographic Examiners Records; *www.familysearch.org.*

COFFEY'S PHOTO STUDIO: active 1931–1934; in Durham and on N. Tryon St., Charlotte; Paul E. Carrier, manager.

SOURCE: *Hill's Charlotte Directory,* 1932–1934.

COFFIN, Z. S.: active 1855–1857; itinerant daguerreotyper; at Rowan House, Salisbury (1855); occupied rooms above Gilmer and Hendrix's store, Greensboro (1857); listed as a dentist in New Bern, 1860.

SOURCES: *Carolina Watchman* (Salisbury), Nov. 13, 1855; *Patriot and Flag* (Greensboro), Apr. 10–Oct. 9, 1857; Eighth Census, 1860: Craven County, Pop. Sch., New Bern.

COHIN, ISAH (b. ca. 1888): native of Syria; active as itinerant in Fayetteville (by 1910).

SOURCE: Thirteenth Census, 1910: Cumberland County, Pop. Sch., Fayetteville, E.D. 50.

COLBURN, H.: active 1919, Laurinburg.

SOURCE: State Auditor's Records, Sch. B.

COLE, DANIEL: active early twentieth century, Lee County.

SOURCE: information provided by Lee County Genealogical and Historical Society, Sanford.

COLE, OLIVER W. (1859–1919): native of Mo.; active ca. 1880s–after 1905; learned trade at studio of Neal & Henry in Windsor, Mo.; worked in New York and New England for several years; moved to Alexandria, Va., in 1881 and later to Lynchburg, where he managed the Hill City Studio from 1894 to 1898; in Durham (1898–ca. 1904) in partnership with Waller Holladay; purchased studio of J. W. Thomas; the pair also operated studios in Winston-Salem and Roxboro (1900); in latter town, gallery was open every Friday and Saturday and located above R. J. Hall's harness store; specialized as university and college photographers; served as president of Photographers' Association of Virginia and North Carolina; dissolved partnership with Holladay about 1904; died in Roanoke, Va.

SOURCES: Ginsberg, *Photographers in Virginia*, 12; *News and Observer* (Raleigh), Aug. 24, 1899; *Durham Recorder*, Jan. 19, 1899, Apr. 16, 1900; *Courier* (Roxboro), Jan. 10, 1900; Twelfth Census, 1900: Durham County, Pop. Sch., Durham, E.D. 31; *N.C. Year Book*, 1902–1906; *Mercantile Agency Reference Book*, 1904; *www.familysearch.org*.

COLE, VOLLEY W. (b. ca. 1872): native of N.C.; active 1911–1930; in Spartanburg, S.C. (1911–ca. 1915); in Hendersonville (1916); in Darlington, S.C. (by 1918); in Gastonia (1930).

SOURCES: Teal, *Partners with the Sun*, 249; State Auditor's Records, Sch. B; Fifteenth Census, 1930: Gaston County, Pop. Sch., Gastonia, E.D. 56-23.

COLLEGE PHOTO SHOP: active 1930s, Mars Hill; R. C. Stringfield, operator.

SOURCE: Photographic Examiners Records.

COLLIE, C. W.: active 1919, Greensboro.

SOURCE: State Auditor's Records, Sch. B.

COLLINS, _____: active 1887, Lincolnton, in partnership with a Mr. Davis; advertised that they were preparing to open gallery above Dr. Lawson's drugstore.

SOURCE: *Lincoln Courier* (Lincolnton), Sept. 10, 1887.

COLONNA, JAMES V.: active in N.C. with Chidnoff Studio of New York City (1937).

SOURCE: Photographic Examiners Records.

COLTON, W. M.: active 1921, Wilson.

SOURCE: State Auditor's Records, Sch. B.

COLUMBUS PHOTOGRAPH COPYING COMPANY: itinerant; active statewide (paid tax to practice) 1886–1887.

SOURCE: State Auditor's Records, Ledgers, 1869–1899, Vol. 18, p. 195 (A&H).

COMBS, LUTHER RICHARD (1879–1945): native of N.C.; active 1912–after 1935, Elkin.

SOURCES: Photographic Examiners Records; State Auditor's Records, Sch. B; Fourteenth Census, 1920: Surry County, Pop. Sch., Elkin, E.D. 251; Fifteenth Census, 1930: Surry County, Pop. Sch., Elkin, E.D. 86-6; *www.familysearch.org*.

COMBS, S. P.: active early 1900s, State Road (Surry County).

SOURCE: photograph bearing his name.

COMMERCIAL COLORTYPE COMPANY: active ca. 1918, Camp Greene; L. E. Pfaadt of Chicago, photographer; received permission to take photographs at the camp.

SOURCES: National Army Camps, Camp Greene, Charlotte, N.C., RG 393, Box 20, National Archives; information provided by Jane Johnson, Charlotte.

COMMERCIAL PHOTO COMPANY: active 1913–1914, Wilmington; William H. Dyer, proprietor.

SOURCE: Hill, *Wilmington Directory, 1913–1914*.

COMMERCIAL PHOTO COMPANY (COMMERCIAL PHOTOGRAPHERS): active 1928–1930, Charlotte; R. A. Edwards, operator (1928–1929).

SOURCE: Miller, *Charlotte Directory*, 1928–1930.

COMPSON, RAY MICHAEL (b. 1909): active with Belk-Leggett Company after 1940, Durham and Danville, Va.

SOURCE: Photographic Examiners Records.

COMSTOCK, DAVID (b. ca. 1907): native of N.Y.; active by 1930, Asheville.

SOURCE: Fifteenth Census, 1930: Buncombe County, Pop. Sch., Asheville, E.D. 11-6.

CONE, LELA (b. ca. 1907): native of N.C.; active by 1930, Raleigh.

SOURCE: Fifteenth Census, 1930: Wake County, Pop. Sch., Raleigh, E.D. 92-32.

CONGER, M. N.: active ca. 1910, Pinehurst area.

SOURCE: postcard bearing his name.

CONNELLY, _____: active 1902, Morganton, in partnership with a Mr. Huffman.

SOURCE: *N.C. Year Book*, 1902.

CONNERY, THOMAS ANDREW (1905–1970): active ca. 1930–1936, Durham, Raleigh, and Winston-Salem (as itinerant); lived in Durham after World War II.

SOURCES: Photographic Examiners Records; *www.familysearch.org*.

CONNOR, TEXAS: active 1919, Claremont.

SOURCE: State Auditor's Records, Sch. B.

CONOLEY, JOHN J.: active mid-1870s, Wilmington, in partnership with Charles W. Yates (ca. 1875).

SOURCE: Reaves list of Wilmington photographers.

COOK, F. B.: active 1935–1937; operated Bon Air Studio in Charlotte (1935) and Van Dyke Studio in Valdese (1937); convicted at Lenoir for operating without a photographer's license.

SOURCE: Photographic Examiners Records.

COOK, G. B.: active 1892, on Market St., Wilmington.

SOURCES: *Weekly Star* (Wilmington), Apr. 29, Aug. 5, 1892; Reaves list of Wilmington photographers.

COOK (COOKE), J. W.: active ca. 1911–1920; in Union County (1910s); in Charlotte (1920); purchased photographic equipment from the estate of Samuel C. Boyce.

SOURCES: Union County Estates Records (A&H); Miller, *Charlotte Directory*, 1920.

COOK, JOHN J. (1873–1921): native of N.C.; active by 1900–1921; in Concord (1900–1909); in Albemarle (1910s); in Greensboro (1913–1921); in partnership with Audrey W. Jones (1913–1917); operated Cook's Studio; husband of Myrtie Cook.

SOURCES: Twelfth Census, 1900: Cabarrus County, Pop. Sch., Concord, E.D. 24; Fourteenth Census, 1920: Guilford County, Pop. Sch., Greensboro, E.D. 137; *Concord City Directory*, 1908; *N.C. Year Book*, 1910–1916; State Auditor's Records, Sch. B; Hill, *Greensboro, N.C. Directory*, 1913–1920; Vital Records, death certificates, Book 614, p. 242 (A&H); *Greensboro Daily Record*, Apr. 16, 1921.

COOK, MYRTIE N. (b. 1876): native of N.C.; active with Cook's Studio, Greensboro (1921); wife of John J. Cook.

SOURCES: Hill, *Greensboro, N.C. Directory, 1921*; Twelfth Census, 1900: Cabarrus County, Pop. Sch., Concord, E.D. 24; Fourteenth Census, 1920: Guilford County, Pop. Sch., Greensboro, E.D. 137.

COOKE, LEONARD COOPER (1877–1945): native of Mass.; active ca. 1914–1945; operated Cooke's Studio, N. Tryon St. (and later E. Fourth St.), Charlotte.

SOURCES: Photographic Examiners Records; State Auditor's Records, Sch. B; *Bradstreet's*, 1925; Fifteenth Census, 1930: Mecklenburg County, Pop. Sch., Charlotte, E.D. 60-23; *Mercantile Reference Book*, 1931; *Mercantile Agency Reference Book*, 1943; Miller, *Charlotte Directory*, 1915–1930; *Hill's Charlotte Directory*, 1932–1941; information provided by Shelia Bumgarner, Public Library of Charlotte and Mecklenburg County.

COOPER, DWIGHT (b. ca. 1891): native of N.C.; active by 1910, Mooresville.

SOURCE: Thirteenth Census, 1910: Iredell County, Pop. Sch., Mooresville, E.D. 72.

COOPER, WILLIAM S. (1846–1914): native of N.C.; active ca. 1880–1910s; in Leaksville (by 1880); as itinerant (1880s); in Taylorsville (1890), in tent on courthouse yard; in Davidson (1890); in Mooresville (ca. 1890s–1910s).

SOURCES: Tenth Census, 1880: Rockingham County, Pop. Sch., Leaksville, E.D. 227; State Auditor's Records, Ledgers, 1869–1899, Vol. 17, p. 576, Vol. 18, pp. 127, 258, 443, Vol. 19, p. 216, Miscellaneous Tax Group (1868–1932), Box 3, Artists' and Photographers' Privilege Licenses, 1877–1887 (A&H); *Taylorsville Index*, May 22, June 12, 1890; *N.C. Year Book*, 1910–1912; Black and Black, *Cemeteries of Iredell County*, 7:124; Vital Records, death certificates, Book 22, p. 97 (A&H).

COPE, FRED: active 1921, Cramerton (Gaston County).

SOURCE: State Auditor's Records, Sch. B.

COPELAND, JOHN R. (b. ca. 1878): native of N.C.; active by 1910, Apex.

SOURCE: Eleventh Census, 1910: Wake County, Pop. Sch., Village of Apex, E.D. 134.

COPELAND, OLIVER PERRY (1816–after 1876): native of Va.; active 1840s–1876; portrait painter, art teacher, and daguerreotyper; moved to N.C. from Va. after 1840; in Warrenton (1840s); in Jackson (1840s); in Raleigh (1854–1856); in partnership with C. B. Havens (1854); in Salem (1857); in Oxford (1858–1859); operated Copeland's Gallery above store of Grandy & Clay; moved back to Va. in 1861; operated gallery on Main St. in Norfolk (1872–1876).

SOURCES: *Spirit of the Age* (Raleigh), Jan. 18, 1854; *Semi-Weekly Raleigh Register*, Nov. 14, 1855; *People's Press* (Salem), June 5, 1857; *Leisure Hour* (Oxford), Feb. 11, 1858; Granville County Miscellaneous Tax Records, undated, 1754–1886 (A&H); Montgomery, *Sketches of Old Warrenton*, 107; Murray, *Wake, Capital County of North Carolina*, 1:346–347; DNCB, s.v. "Copeland, Oliver Perry"; Rinhart and Rinhart, *The American Daguerreotype*, 387; Ginsberg, *Photographers in Virginia*, 17.

CORBETT, R. L.: active 1928–1929, Hickory; operator of Melbourne Studio.

SOURCE: Miller, *Hickory, N.C. City Directory, 1928–1929*.

CORDER, M. W.: active 1916, Charlotte.

SOURCE: State Auditor's Records, Sch. B.

CORLEY, S. T.: itinerant daguerreotyper; active 1848–1850; in Albany, Ga. (1848); occupied room in Rowan County Courthouse, Salisbury (1850).

SOURCES: Rinhart and Rinhart, *The American Daguerreotype*, 387; *Carolina Watchman* (Salisbury), June 13, 1850; *Craig's Daguerreian Registry*, 2:131.

CORNEIT, J. M.: of Trade, Tenn.; active in Ashe County (1921).

SOURCE: State Auditor's Records, Sch. B.

CORY, F. M.: of New York; itinerant daguerreotyper, active 1848–1850; in Fayetteville (1848–1850) in partnership with a Mr. Newsome (1848) and on his own (1849–1850); occupied rooms at Fayetteville Hotel; in Washington (1850); occupied rooms one door below Joseph Potts's store; in Warrenton (1850); occupied rooms at Goodloe's Hotel.

SOURCES: *Fayetteville Observer*, Oct. 17, 1848, Dec. 24, 1849, Jan. 1, 1850; *Washington Whig*, Apr. 3, 1850; *North State Whig* (Washington), Apr. 3, 1850; *Warrenton News*, Aug. 29, 1850.

CORY, THOMAS D.: itinerant daguerreotyper; active 1849–1852; in Salisbury (1852); occupied rooms at Rowan House; advertised four years' experience in the art; in Yorkville, S.C. (1852).

SOURCES: *Carolina Watchman* (Salisbury), July 1, 1852; Teal, *Partners with the Sun*, 82.

COSMOPOLITAN STUDIO: of St. Paul, Minn.; active 1937 in multiple N.C. locations; operated without a photographer's license.

SOURCE: Photographic Examiners Records.

COTTAGE LANE STUDIO: active 1930, Wilmington; Elizabeth A. Chant, operator.

SOURCE: Hill, *Wilmington Directory, 1930.*

COWARD, _____: active ca. 1910s, unidentified location; published postcard of Greenville in partnership with Wootten (likely Bayard Wootten).

SOURCE: published postcard bearing name "Coward."

COWEN, R. P.: active 1916–1919, Reidsville.

SOURCE: State Auditor's Records, Sch. B.

COWLES, WILLIAM W. (1863–1918): native of N.Y.; active ca. 1918, Charlotte; resided there for only a few months.

SOURCE: *Charlotte Observer*, Apr. 1, 1918.

COWLING, GEORGE W. (ca. 1828–1862): native of Va.; maker of ambrotypes; active by 1860, New Bern; brother of Jesse L. Cowling.

SOURCES: Eighth Census, 1860: Craven County, Pop. Sch., New Bern; Green, *A New Bern Album*, 65; www.familysearch.org.

COWLING, JESSE L. (ca. 1832–1864): native of Va.; daguerreotyper and maker of ambrotypes; active ca. 1856–1862; in Norfolk, Va. (1850s); in New Bern (1856–1862); located on Craven St. above jewelry store of J. Whaley in gallery formerly occupied by George A. Jeffers; in Washington (1857, 1859); occupied rooms above E. Martin's store on Main St.; Cowling, his wife, and a child died in New Bern during the yellow fever epidemic of Sept. and Oct. 1864; brother of George W. Cowling.

SOURCES: *Newbern Journal*, Mar. 26, May 28, 1856; *Union* (New Bern), June 4–Nov. 24, 1856, Jan. 19, 1857; *Washington Dispatch*, Dec. 23, 1857, July 12, 1859; Eighth Census, 1860: Craven County, Pop. Sch., New Bern; Craven County Estates Records (A&H); Witham, *Catalogue of Civil War Photographers*, 65; Green, *A New Bern Album*, 13–14; Benjamin, *The Great Epidemic in New Berne*, 28.

Shown here is a rare view of Jesse L. Cowling's photography studio on Pollock Street in New Bern during the town's occupation by Union forces about 1863. A photographer, perhaps Cowling, poses with a camera in the upstairs window. Photograph courtesy United States Military History Institute, Carlisle Barracks, Pa.

COX, ALPHEUS: active ca 1854, Currituck County; purchased photo supplies from dealer in Philadelphia; subsequently moved to Decatur, Kan., and Cerro Gordo, Ill., where he continued his photography profession.

SOURCE: Cox-Northern Collection, Museum of the Albemarle, Elizabeth City.

COX, BOYD W. (b. ca. 1902): native of N.C.; active 1930–1931, Gastonia.

SOURCES: Fifteenth Census, 1930: Gaston County, Pop. Sch., Gastonia, E.D. 20; Miller, *Gastonia Directory*, 1930–1931.

COX, ESTELLE (b. 1875): native of N.C.; active by 1900–1910s; Asheville; apprentice to Ignatius W. Brock (1900); in partnership with John Frank Manning Sr. (ca. 1914–1917) as Cox and Manning.

SOURCES: Twelfth Census, 1900: Buncombe County, Pop. Sch., Asheville, E.D. 139; photograph bearing her name.

COX, GUY OFFLEY (b. 1922): active 1939–1942 with Carolina Photo Finishers, Wilson; active during World War II in U.S. Navy as a photographer's mate; subsequently in partnership with Charles E. Raines as Raines and Cox (1947–2001).

SOURCES: Photographic Examiners Records; *Wilson Daily Times*, Aug. 21, 1993; *News and Observer* (Raleigh), Mar. 3, 2002; information provided by Guy Cox, Wilson.

COX, W. R.: active as itinerant statewide, 1883–1888; paid tax to practice, 1883–1884; in Carthage (1888).

SOURCES: State Auditor's Records, Ledgers, 1869–1899, Vol. 17, p. 424 (A&H); *Carthage Blade*, June 21, 1888.

CRABTREE, ED: active (acquired license to practice) 1918, West Durham.

SOURCE: Record of Special Licenses Issued, Durham County, 1917–1918 (A&H).

CRAWFORD, JOHN W. (1841–1912): native of N.C.; active 1890–early 1900s; in Asheville (1890s); in Hendersonville (by 1900–1902).

SOURCES: Fulenweider, *Asheville, N.C. City Directory, 1890*; Sprange, *Blue Book*, 288; Twelfth Census, 1900: Henderson County, Pop. Sch., Hendersonville, E.D. 43; *N.C. Year Book*, 1902; Vital Records, death certificates, Book D-38, p. 294 (A&H).

CREASMAN, FRANKLIN BLAKE: active 1928–1930s, Asheville, in partnership with George Masa; operated Asheville Photo Service (1928–1930).

SOURCES: *Miller's Asheville Directory*, 1928–1930; Fifteenth Census, 1930: Buncombe County, Pop. Sch., Asheville, E.D. 11-26; Photographic Examiners Records.

CREDLE, SOPHIA BURRUS (1914–1985): active 1940s, Raleigh (1940); operated Siddell Studio there; in Washington (ca. 1941 and postwar).

SOURCES: Photographic Examiners Records; *Mercantile Agency Reference Book*, 1943; *www.familysearch.org*.

CREEKMORE, RAYMOND OSCAR (1914–1985): native of Ark.; active 1938–1939, Charlotte; operated Shuford's Studio; moved to Calif. after World War II; died there.

SOURCES: Photographic Examiners Records; *www.familysearch.org*.

CREPAULT, J. E.: active 1924, Asheville.

SOURCE: Miller, *Asheville, N.C. City Directory*, 1924.

CRESCENT STUDIO: active 1916, Winston-Salem; Horace D. Moses, proprietor.

SOURCES: State Auditor's Records, Sch. B; information from the files of MESDA.

CREWS, FLEET L. (b. ca. 1878): native of N.C.; active as itinerant in Salem (by 1910).

SOURCE: Thirteenth Census, 1910: Forsyth County, Pop. Sch., Salem, E.D. 67.

CRIDER, E. M.: active 1919, Charlotte.

SOURCE: State Auditor's Records, Sch. B.

CRISP, GEORGE W.: active 1916–1921; in Robbinsville (1916); in Cheoah (Graham County) (1921).

SOURCE: State Auditor's Records, Sch. B.

CRISP, JAMES CLYDE (b. ca. 1910): native of N.C.; active by 1930–1942; in Bryson City by 1930, in Franklin in early 1940s; likely a son of Robert A. Crisp.

SOURCES: Fifteenth Census, 1930: Swain County, Pop. Sch., Bryson City, E.D. 87-1; Photographic Examiners Records; *Mercantile Agency Reference Book*, 1943.

CRISP, ROBERT A. (ca. 1887–1952): native of N.C.; active ca. 1920–1930s; in Judson (Swain County) (1920), in Bryson City (1930, 1935), in Murphy (1935); likely the father of James Clyde Crisp.

SOURCES: State Auditor's Records, Sch. B; Photographic Examiners Records; Fifteenth Census, 1930: Swain County, Pop. Sch., Bryson City, Pop. Sch., E.D. 87-1.

CROCKETT, _____: active 1883–1884, Elizabeth City, in partnership with John W. T. Smith.

SOURCES: Branson, *NCBD*, 1884; *Chataigne's N.C. Directory and Gazetteer, 1883–'84*.

CRONENBERG, HENRY (1856–1914): native of S.C.; active ca. 1870s–1914; in Columbia, Rock Hill, and Newberry, S.C. (1870s–1883); in Wilmington (1883–1914); brought to Wilmington by Elisha H. Freeman (who bought studio of Cornelius M. Van Orsdell); fire damaged his studio in May 1898.

SOURCES: Teal, *Partners with the Sun*, 153; Reaves list of Wilmington photographers; Sprange, *Blue Book*, 289; Branson, *NCBD*, 1883, 1884, 1885, 1896, 1897; Twelfth Census, 1900: New Hanover County, Pop. Sch., Wilmington, E.D. 70;

Wilmington photographer Henry Cronenberg used a straw hat and rowboat as props in this studio likeness of himself about 1890. Photograph courtesy New Hanover County Public Library, Wilmington.

N.C. Year Book, 1902–1914; *Mercantile Agency Reference Book*, 1904; *Bradstreet's*, 1908; *J. L. Hill Printing Co.'s Directory of Wilmington, N.C.*, 1897; Hill, *Wilmington Directory*, 1905–1910, 1913–1914; Vital Records, death certificates, Book 22, p. 489 (A&H); *Dispatch* (Wilmington), May 20, 1898, Mar. 26, 1914; *Star* (Wilmington), Aug. 16, 1895; *Morning Star* (Wilmington), Mar. 27, 1914.

CROOM, MARION S. (b. ca. 1879): native of N.C.; active 1916–1930, Kinston, as operator of Croom's Picture Shop.

SOURCES: State Auditor's Records, Sch. B.; Fifteenth Census, 1930: Lenoir County, Pop. Sch., Kinston, E.D. 54-7.

CROSBY, _____: active 1894, Rockingham; operated Crosby Art Gallery; described as leading photographer in Pee Dee section.

SOURCES: *Rocket* (Rockingham), July 19, 1894; *Daily Rocket* (Rockingham), Sept. 26, 1894.

CROWDER, _____: active 1870s; in association with Bingham B. Horton in firm of Horton and Crowder, Wadesboro.

SOURCE: photograph bearing name "Crowder."

CROWL, LEVI (1820–1890): native of Pa.; itinerant daguerreotyper, active 1850–1861, in West Chester, Pa.

(1850–1854); in Fayetteville (1855), in partnership with a Mr. Cochran; occupied rooms above Drs. Foulkes' and McRae's drugstore on Hay St., directly opposite Fayetteville Hotel; in partnership with Calvin A. Price (ca. late 1850s); in Wilmington (1858–1861); occupied gallery known as Crowl's Ambrotype and Photographic Rooms on Front St., three doors north of Lippitt's drugstore.

SOURCES: *Fayetteville Observer*, Jan. 1, Apr. 2, 1855; *North Carolina Argus* (Fayetteville), Nov. 10, 1855; *Wilmington Journal*, Nov. 12, 1858; *Kelley's Wilmington Directory, 1860–61*; Eighth Census, 1860: New Hanover County, Pop. Sch., Wilmington; Eskind, *Index to American Photographic Collections*, 563, 883; Witham, *Catalogue of Civil War Photographers*, 60; *Craig's Daguerreian Registry*, 2:138; Ries and Ruby, *Directory of Pennsylvania Photographers*, 61.

CRUMBAKER, J. C.: active 1906–1907, Sanford; operated Crumbaker Commercial Photograph Company, with office on Summit Ave.; after operating a year in Sanford, he returned to the North in Sept. 1907.

SOURCE: *Sanford Express*, Apr. 5, July 12, Sept. 6, 27, 1907.

CUDDINGTON, WILLIAM FRANKLIN (1909–1988): active 1933–1939; as itinerant in N.C. (1933); in Smithfield (1934–1939); moved to Roanoke, Va., by 1939; died in Mo.

SOURCES: Photographic Examiners Records; *www.familysearch.org*.

CULBERSON, BROADUS ALLEN (1894–1975): native of S.C.; active ca. 1919–1940s; in Greenville, S.C. (ca. 1919–1925); moved to Asheville in 1927; in Asheville (1932–1940s); operated Culberson Studio. Pictured on page 90.

SOURCES: Photographic Examiners Records; Fifteenth Census, 1930: Buncombe County, Pop. Sch., Asheville, E.D. 11-22; Teal, *Partners with the Sun*, 241; Miller, *Asheville, N.C. City Directory*, 1932, 1936–1941; *Mercantile Agency Reference Book*, 1943; information provided by staff of Pack Memorial Public Library, Asheville.

CULBERSON, W. O.: active (acquired license to practice) 1914, Durham.

SOURCE: Record of Special Licenses Issued, Durham County, 1914–1916 (A&H).

CULBRETH, J. MARSHALL (b. 1852): native of N.C.; active by 1900–1910; in Magnolia (by 1900, by 1910); in Wilmington (1901).

SOURCES: Twelfth Census, 1900: Duplin County, Pop. Sch., Magnolia, E.D. 115; *Star* (Wilmington), Jan. 16, 1901; Thirteenth Census, 1910: Duplin County, Pop. Sch., Magnolia, E.D. 39.

CUNNINGHAM, ROBERT (b. ca. 1837): active 1850s–1860s; in New York (1850s–1860s); in Franklin (1860); resided with Jesse R. Siler.

SOURCES: Eighth Census, 1860: Macon County, Pop. Sch.; Eskind, *Index to American Photographic Collections*, 564.

CURRY, MRS. M. H.: active 1911–1912, Gastonia; operated Curry Studio; purchased studio of John I. Green (1911); in partnership with Rosa J. Lindsay (1911–1912).

SOURCES: Teal, *Partners with the Sun*, p. 197; *N.C. Year Book*, 1912.

CURTIS, E. H.: active late nineteenth century, Raleigh.

SOURCE: photograph bearing his name.

CURTIS, W. A.: active early twentieth century, Franklin; also editor of Franklin *Press*.

SOURCE: photographs bearing his name.

CUSHMAN, JONATHAN C.: active 1912–1922, Charlotte; operated Cushman's Studio (1916–1922) and The Photo Shop (1912–1916) in association with Harvey W. South; sold photo shop to William M. Morse ca. 1920.

SOURCES: Miller, *Charlotte Directory*, 1913–1918, 1920–1922; *N.C. Year Book*, 1914–1916; State Auditor's Records, Sch. B; information provided by Shelia Bumgarner, Public Library of Charlotte and Mecklenburg County.

Pictured here is a view of the photography studio of Jonathan C. Cushman in Charlotte about 1920. Photograph courtesy Public Library of Charlotte and Mecklenburg County.

CUTE STUDIO: active 1912–1917, S. Elm St., Greensboro.

Sources: Hill, *Greensboro, N.C. Directory*, 1912–1917; *N.C. Year Book*, 1914–1916.

CUTE STUDIO: African American establishment; active 1918–1920s, Winston-Salem; Marion M. Farmer and Robah L. Scales, proprietors (1918); operated as Farmer-Cute Studio (1926).

SOURCES: *Winston-Salem Directory*, 1918, 1920–1921, 1926; information from the files of MESDA.

CUTHBERT, EDWARD C.: active 1916–1918, Durham.

SOURCES: Record of Special Licenses Issued, Durham County, 1917–1918 (A&H); State Auditor's Records, Sch. B.

CUTHRELL, D. L.: active 1907, Enfield.

SOURCE: *N.C. Year Book*, 1907.

CUTRELL, ROMULUS (b. 1875): native of N.C.; active late 1890s–1930s; itinerant photographer in eastern N.C. (1890s–1930s); in Elizabeth City (by 1900) as home base; in Winston-Salem (1921); publisher of penny postcards.

SOURCES: Photographic Examiners Records; Twelfth Census, 1900: Pasquotank County, Pop. Sch., Elizabeth City, E.D. 76; *Winston-Salem Directory*, 1921.

D

DAINGERFIELD, ELLIOTT (1859–1932): native of W. Va. but moved to N.C. soon after his birth; a well-known artist; active 1876–1880, Fayetteville, in partnership with James M. Dodson and Montraville P. Stone, photographers; copied old pictures and daguerreotypes or converted them into india ink portraits; moved to New York in 1880 (R. C. McKenzie took over his Fayetteville studio in June 1880), studied art, and became noted artist; lecturer on art and head of Permanent Art School at Blowing Rock.

SOURCES: *North Carolina Gazette* (Fayetteville), Dec. 21, 1876; Branson, *NCBD*, 1877–1878, 1879–1880; Tenth Census, 1880: Cumberland County, Pop. Sch., Fayetteville, E.D. 68; Oates, *The Story of Fayetteville*, 826; Hobbs, *Elliott Daingerfield: Retrospective Exhibition*; *News and Observer* (Raleigh), Jan. 20, 1880, Oct. 26, 1932.

DALE, _____: active 1904, Wilmington; operated Dale's Studio.

SOURCE: *N.C. Year Book*, 1904.

DAME, MELVIN (b. ca. 1882): native of Mass.; active by 1930, Charlotte.

SOURCE: Fifteenth Census, 1930: Mecklenburg County, Pop. Sch., Charlotte, E.D. 60-28.

DAMON, H. C.: active 1916, Winston-Salem.

SOURCE: State Auditor's Records, Sch. B.

DANIEL, H. E.: of Asheville; active 1920, Northampton County.

SOURCE: State Auditor's Records, Sch. B.

DANIEL, J. A., JR.: active 1930–1931 with Carolina Photo Company, High Point.

SOURCE: Miller, *High Point Directory*, 1930–1931.

DANIEL, JAMES WILLIAM ("BILL") (1906–1995): native of Tenn.; active 1931–1976; in partnership with Millard F. Dunbar and Thomas N. Daniel as Dunbar & Daniel Studio (1931–1940) and as William Daniel's Camera Shop, Hargett St., Raleigh. The relationship between James W., Thomas N., and William A. Daniel has not been determined.

SOURCES: Photographic Examiners Records; *Mercantile Agency Reference Book*, 1943; *News and Observer* (Raleigh), Apr. 19, 1995.

DANIEL, M. URSULA: active 1910; photographed ruins both of a colonial church and the so-called "Constitution House" in Halifax.

SOURCE: information provided by Carol Johnson, Library of Congress, Washington, D.C.

DANIEL, THOMAS NANCE (b. 1911): active 1931–1940s; in Raleigh (1931–1936) in partnership with Millard F. Dunbar and James William Daniel as Dunbar & Daniel Studio; on Corcoran St. in Durham (1937, 1940–1941) in partnership with Jack Williams as Daniel-Williams Studio.

SOURCE: Photographic Examiners Records.

DANIEL, WILLIAM A.: active 1930s–1940s; on Fayetteville St., Raleigh (1930s–1940s), with Millard F. Dunbar and James William Daniel; in Wilmington as Daniels' Studio and Camera Shop (1938); with A. Fay Smith in Raleigh (1939–1940) as Daniel & Smith Studio; on Corcoran St. in Durham (1938–1941) in partnership with Millard F. Dunbar (1938–1939) and with A. Fay Smith (1940–1941); with Efird's Department Store, N. Front St., Wilmington (1941).

SOURCES: Photographic Examiners Records; Hill, *Durham, N.C. Directory*, 1938, 1940; Hill, *Wilmington, N.C. City Directory*, 1938, 1941.

DANIELS, _____: active (acquired license to practice) 1899–1900, Alleghany County, in partnership with a Mr. Sells.

SOURCE: Registry of Licenses to Trade, Alleghany County, 1874–1906 (A&H).

DARNELL, BERTIE (ca. 1853–1942): native of Md.; active 1910s; photo developer, Fayetteville St., Raleigh (1915–1916); daughter of Thomas L. Darnell and brother of William Darnell.

SOURCES: Thirteenth Census, 1910: Wake County, Pop. Sch., Raleigh, E.D. 116; Hill, *Raleigh Directory*, 1915–1916; Records of Oakwood Cemetery, Raleigh; Smith, *The Darnall, Darnell Family*, 1:10.

DARNELL, THOMAS LEWIS (1825–1908): native of Md.; with Commissary Department, Confederate States of America, Richmond, Va., during Civil War; active 1871–1907; in Va., W. Va., and Md. (1871, 1880–1901); associated with son William Darnell (1880–1901) before moving to Raleigh; on Fayetteville St. (1904–1907); father of Bertie and William Darnell.

SOURCES: Witham, *Catalogue of Civil War Photographers*, 82; Kelbaugh, *Directory of Maryland Photographers*, 65; *N.C. Year Book*, 1904–1907; Smith, *The Darnall, Darnell Family*, 1:10; *News and Observer* (Raleigh), Mar. 11, 1908; Wake County Wills (A&H); Wake County Estates Records (A&H).

DARNELL, WILLIAM (b. ca. 1855): native of Md.; active 1880s–1910s; in Md. with father, Thomas L. Darnell (1880–1901); in Raleigh (1910s).

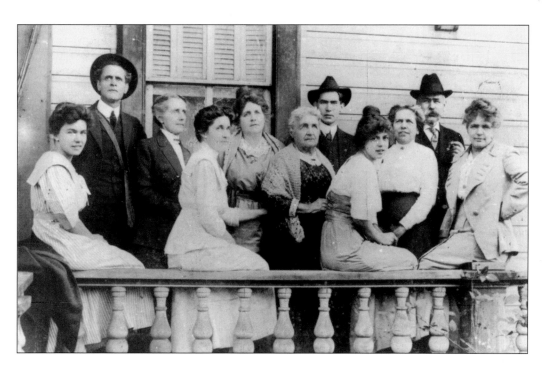

Members of the Darnell family of Raleigh gathered on the front porch of their East Jones Street home for this portrait about 1912. William, at right, was a commercial photographer in Raleigh between 1904 and 1908. His sister Bertie (not pictured because she may have taken the photograph) operated the family studio after William's retirement. Postcard courtesy Durwood Barbour, Raleigh.

SOURCES: Thirteenth Census, 1910: Wake County, Pop. Sch., Raleigh, E.D. 116; Smith, *The Darnall, Darnell Family*, 1:10; Kelbaugh, *Directory of Maryland Photographers*, 65.

DARTT, HARLEY ALAN (1901–1988): active 1928–1940s; in Elizabeth City (1928–1933) with William H. Zoeller; in Oxford (1935–1940s); son-in-law of Zoeller.

SOURCES: Photographic Examiners Records; *Mercantile Agency Reference Book*, 1943; information provided by William H. Dartt, Oxford; *www.familysearch.org*.

DAVENPORT, JOHN (ca. 1880–1940s): active early 1900s in Gaston County, Charlotte, and vicinity; noted amateur photographer.

SOURCE: information provided by Rachael Abernathy, a niece of Davenport.

DAVENPORT, P. E.: active ca. 1910, Plymouth.

SOURCE: photograph bearing his name.

DAVENPORT, R. K.: active 1907–1920s; operated Davenport Studio, Burlington (1907); in partnership with John M. Anglin (1908–1911); in Greensboro (1910s–1920s); proprietor of Eutsler's Studio (early 1910s); operated own studio (1915–1920s).

SOURCES: biographical files at Greensboro Public Library, Greensboro; *Bradstreet's*, 1908, 1917, 1921; *N.C. Year Book*, 1910, 1911, 1915, 1916.

DAVES, _____: active 1903, Rutherfordton, in partnership with a Mr. Campbell as Campbell & Daves; gallery located above Carpenter's Meat Market.

SOURCE: *Rutherfordton Sun*, Apr. 19, 1903.

DAVES (DAVIS), _____: active (paid tax to practice) 1886–1887; itinerant, statewide; in partnership with unidentified brother as Daves & Bro.

SOURCE: State Auditor's Records, Ledgers, 1869–1899, Vol. 18, p. 258 (A&H).

DAVIDSON, P. R.: active 1916, Canton.

SOURCES: State Auditor's Records, Sch. B; *N.C. Year Book*, 1916.

DAVIS, _____: active 1910–1911, Kings Mountain; in partnership with John D. Bridges and Lewis W. Broadfoot as Davis, Bridges, and Broadfoot.

SOURCE: *N.C. Year Book*, 1910, 1911.

DAVIS, _____ (possibly W. A. Davis): active 1887, Lincolnton; in partnership with a Mr. Collins; preparing to open gallery above Dr. Lawing's drugstore.

SOURCE: *Lincoln Courier* (Lincolnton), Sept. 10, 1887.

DAVIS, DR. _____: itinerant daguerreotyper; earliest documented photographer in the state; active 1842, Halifax; occupied room located at William Pride's hotel. Likely one of the three Davis brothers—Ari, Asahel, or Daniel—early daguerreotypers of Boston, Mass.

Daguerreotype Miniatures.

To cherish the mem'ry of friends that are dear,
Their shadows secure ere their forms disappear.

DR. DAVIS, respectfully announces to the citizens of Halifax that he will wait upon them for a few days, and will furnish them with excellent fac simile likenesses, by means of his Daguerreotype; far more accurate than is possible to be obtained by any other means, for $8. His room is at Mr. Wm. Pride's Hotel, where he will be happy to wait upon the ladies and gentlemen, and explain the principles of this curious art to sitters.

May 2. 1842

In May 1842 the *Roanoke Advocate and States Rights Banner* of Halifax published this advertisement by a Dr. Davis, an early maker of daguerreotypes in the United States. The itinerant operator may have been from Boston and perhaps was the first photographer to offer his services in North Carolina. Advertisement courtesy A&H.

SOURCES: *Roanoke Advocate and States' Rights Banner* (Halifax), May 11, 1842; *Craig's Daguerreian Registry*, 2:147–148.

DAVIS, BLANCHE M. (Mrs.) (b. 1892): active ca. 1933–1938, Smithfield; in partnership with Edward L. K. Gruehn (late 1930s); also portrait painter; her studio purchased by Dorothy Hooks in 1939.

SOURCE: Photographic Examiners Records.

DAVIS, C. W.: active 1879–1892; in Charlotte (1879–1880); in Lynchburg, Va. (1882–1883); in Linville, Mitchell (now Avery) County (1884–1885) in partnership with William J. Stimson; in Durham (1892); in Raleigh (1892) in gallery located next to post office; itinerant.

SOURCES: Ginsberg, *Photographers in Virginia*, 12; Registry of Licenses to Trade, Mitchell County, 1877–1902 (1884) (A&H); Registry of Licenses to Trade, Durham County, 1881–1913 (1892) (A&H); *State Chronicle* (Raleigh), Oct. 29, 1892.

DAVIS, H. C.: active ca. 1895, Gregory's (Currituck County?).

SOURCE: Sprange, *Blue Book*, 289.

DAVIS, HORACE (b. ca. 1851): mulatto native of N.C.; active by 1870–1880; in New Bern (by 1870); active in Raleigh (by 1880) as proprietor of Oak City Photograph Gallery, Hargett St., east of Wilmington St.; perhaps the first African American to operate a permanent gallery in the state.

SOURCES: Ninth Census, 1870: Craven County, Pop. Sch., New Bern, First Ward; Tenth Census, 1880: Wake County, Pop. Sch., Raleigh (northwest division); *North Carolina Republican* (Raleigh), Mar. 19, 1880.

OAK CITY PHOTOGRAPH GALLERY

Just Opened,

Hargett Street, East of Wilmington Street. Building erected especially for the business.

New Outfit Entire,

BEST LIGHT IN THE CITY.

Pictures taken in Cloudy as well as fair weather.
Copies of all kinds of Pictures made at short notice.
Photographs and Ferrotypes in all styles

8 Pictures for 50 Cents.

Call and examine work.
 HORACE DAVIS,
feb.21-tf. Artist.

PHOTOGRAPHIC GALLERY, LOOK AT THIS. HO FOR OXFORD. PHOTOGRAPHS FOR ALL.

New Departure for Oxford.

Mrs. H. H. Davisson has opened a First Class Photograpic Gallery in the Grandy building, on Main street, in the wide awake town of Oxford, and hopes to merit, by good work and attention to business, the patronage of the town and surrounding county. She has come to stay, and feels assured by strict attention to business to build up a first class Art Emporium in the South.
One of the first photographers of *Washington City* will be associated with her and the work will be first class in every respect.

LEFT: Horace Davis, probably the first African American photographer to operate a permanent studio in the state, placed this advertisement for his Oak City Photograph Gallery in the Raleigh *North Carolina Republican* in March 1880. Advertisement courtesy A&H. **CENTER:** Oxford may have been the site of the first photograph studio in the state to be operated solely by a woman. The *Oxford Torchlight* printed this announcement for Mrs. H. H. Davisson in its issue of June 20, 1882. Advertisement courtesy A&H. **RIGHT:** Shown here is Elizabeth City's first permanent photographer, William C. Dawson. The image dates from the early 1860s. Photograph courtesy A&H.

DAVIS, J. T.: active 1921, Lumberton.
SOURCE: State Auditor's Records, Sch. B.

DAVIS, L. WILKINS: active 1941 and afterward, Thomasville; operated Southern Studios.
SOURCES: Photographic Examiners Records; *Miller's Thomasville, North Carolina City Directory, 1941–42.*

DAVIS, THOMAS WARREN, JR. (b. 1903): active late 1930s, Mount Airy; school photographer with Pierson Studio (Earl L. Pierson, proprietor) in Pa.
SOURCE: Photographic Examiners Records.

DAVIS, W. A.: active 1881–1928; in Lancaster, S.C. (1881–1924); in Lowesville (Lincoln County), n.d.; in Chesterfield, S.C. (1900); in Fort Mill, S.C. (1903); in Kershaw, S.C. (n.d.); in Monroe, N.C. (1925–1928).
SOURCES: photograph bearing his name and marked "Lowesville, N.C."; Teal, *Partners with the Sun,* 186.

DAVIS, W. CARSON: active 1908–1910, Charlotte; in partnership with William M. Morse (1909–1910).
SOURCE: *Walsh's Directory of the City of Charlotte,* 1908–1909.

DAVISSON, MRS. H. H.: active 1882, Oxford; gallery on Main St., above store of Grandy & Brother; perhaps the first female commercial photographer in the state.
SOURCES: *Oxford Torchlight,* June 20, 1882; *Granville Free Lance* (Oxford), July 7, 1882.

DAWSON, JOSEPH M. (b. ca. 1873): native of Mass.; active by 1910, Hendersonville.
SOURCE: Thirteenth Census, 1910: Henderson County, Pop. Sch., Hendersonville, E.D. 78.

DAWSON, WILLIAM CRAWFORD (1831–1879): native of N.C.; active by 1860–1879, Elizabeth City; first permanent photographer there; private in Company L, Seventeenth Regiment, N.C. State Troops; portrait on file at N.C. Office of Archives and History.
SOURCES: Eighth Census, 1860: Pasquotank County, Pop. Sch., Elizabeth City; Manarin and Jordan, *N.C. Troops,* 5:194; Pasquotank County Miscellaneous Tax Records, 1785–1912, Officials-Valuation, State Taxes, 1866 (A&H); *Zell's U.S. Business Directory,* 1875; Branson, *NCBD,* 1877–1878; *Economist* (Elizabeth City), Apr. 1, 1879; *Biblical Recorder* (Raleigh), Apr. 16, 1879; *Year Book* 1:125.

DAY, EDWARD WARREN: active 1900s, Charlotte.
SOURCE: photograph bearing his name.

DAY, HARVEY M.: active ca. 1895–1909, Charlotte; in business as H. M. Day & Company, 204 N. Tryon St.
SOURCES: Sprange, *Blue Book,* 289; *Walsh's Directory of the City of Charlotte,* 1909.

DEAL, GASTON E. (b. ca. 1876): native of N.C.; active 1919–1920, Taylorsville; listed as a farmer in the 1920 census.
SOURCES: State Auditor's Records, Sch. B; Fourteenth Census, 1920: Alexander County, Pop. Sch., Taylorsville, E.D. 7.

DEAL, HARRY A. (b. ca. 1898): native of N.C.; active 1929–1930, Concord.
SOURCES: *Concord City Directory,* 1929–1930; Fifteenth Census, 1930: Cabarrus County, Pop. Sch., Concord, No. 11 Township, E.D. 21.

DEAN, ELMER W.: African American; active 1916, Asheville; operated Dean's Studio.

SOURCE: Miller, *Asheville, N.C. City Directory, 1916*.

DEAN, MARCUS LEE (b. 1869): native of Va.; active 1890s–1905, Mount Airy; apprenticed under J. H. Blakemore in Mount Airy; returned to Va. after 1905; portrait on file at N.C. Office of Archives and History.

SOURCES: Twelfth Census, 1900: Surry County, Pop. Sch., Mount Airy, E.D. 113; *Mercantile Agency Reference Book*, 1904.

Marcus L. Dean poses for fellow photographer and mentor J. H. Blakemore in Mount Airy. Photograph courtesy A&H.

DEANS, JAMES B. (ca. 1840–1924): active 1860s, Wilson County; private, Company E, Seventh Regiment, N.C. State Troops; advertised in Raleigh newspaper the sale of daguerrean fixtures in 1863.

SOURCES: *Daily State Journal* (Raleigh), Mar. 11, 1863; Manarin and Jordan, *N.C. Troops*, 4:455; Vital Records, death certificates, Book 859, p. 354 (A&H).

DEANS, W. T.: active 1906; proprietor of W. T. Deans and Company; took photographs of Elizabeth City.

SOURCE: information provided by Carol Johnson, Library of Congress, Washington, D.C.

DEATON, THOMAS (b. ca. 1862): native of N.C.; active by 1880, Concord.

SOURCE: Eighth Census, 1880, Cabarrus County, Pop. Sch., Concord, E.D. 31.

DEBERRY, WILL: active 1919, Oxford.

SOURCE: State Auditor's Records, Sch. B.

DEES, JESSE D. (b. ca. 1898): native of Ga.; active 1927–1931, West Asheville; operated Dees Studio.

SOURCE: Miller, *Asheville, N.C. City Directory*, 1927–1930; Fifteenth Census, 1930: Buncombe County, Pop. Sch., Asheville, E.D. 11-65; information provided by staff of Pack Memorial Public Library, Asheville.

DEES, JOHN T.: itinerant; active 1873–1880s; in Lumberton (1873) in gallery in building occupied by Pope & McLeod; in Goldsboro (1883–1886); in tent (1883–1884); specialized in photographs of horses, livestock, and babies.

SOURCES: *Robesonian* (Lumberton), Aug. 20, 1873; *Chataigne's N.C. Directory and Gazetteer, 1883–'84*; *Goldsboro Bulletin*, Nov. 17, 1883, Jan. 5, 1884.

DELANO, JACK (1914–1997): active 1940–1941 with U.S. Farm Security Administration; worked in Camden County, Carrboro, Cedar Grove, Durham, Farrington, Fort Bragg, Graham, Orange County, and Yanceyville.

SOURCES: Cotten, *Light and Air*, 57; Dixon, *Photographers of the Farm Security Administration*, 9; "Reference Guide to FSA/OWI Photographs."

DELLINGER, C. L.: active 1916, Marion.

SOURCE: State Auditor's Records, Sch. B.

DELORY, ETHEL L. (Mrs.): active 1941, Asheville.

SOURCE: *Miller's Asheville Directory*, 1941.

DE LUXE STUDIO: active 1914, Asheville; Joseph McGarry, operator.

SOURCE: Miller, *Asheville, N.C. City Directory, 1914*.

DE LUXE STUDIO: active 1922, Winston-Salem.

SOURCE: *Winston-Salem Directory*, 1922.

DE LUXE STUDIO: active 1930, Hendersonville.

SOURCE: *Mercantile Reference Book*, 1931.

DEMPSEY, C. J.: active (acquired license to practice) 1910–1911, Durham.

SOURCE: Record of Special Licenses Issued, Durham County, 1910–1911 (A&H).

DEMPSTER, THOMAS, JR.: active 1929–1941, High Point; in partnership with Frederick C. West as West-Dempster Company.

SOURCES: Photographic Examiners Records; Miller, *High Point Directory*, 1929–1931; *Hill's High Point Directory*, 1933.

DEMPT, HARRY (b. 1880): native of Pa.; active ca. 1907– late 1940s; operated Dempt Studio, Rocky Mount.

SOURCES: *N.C. Year Book*, 1907–1916; *Bradstreet's*, 1908, 1917, 1921, 1925; Thirteenth Census, 1910: Edgecombe County, Pop. Sch., Rocky Mount, E.D. 26; *Hill's Rocky Mount Directory*, 1912– 1913, 1925, 1930, 1934; Fifteenth Census, 1930: Nash County, Pop. Sch., Rocky Mount, E.D. 64-28; *Mercantile Reference Book*, 1931; *Mercantile Agency Reference Book*, 1943; Photographic Examiners Records; State Auditor's Records, Sch. B.

DENMARK, JAMES WILLIAM (1896–1956): native of N.C.; active 1915–1940s; in Goldsboro (1915); operated Clement Studio, Goldsboro (1921), official photographer for Fort Caswell, Brunswick County, during World War I; in Raleigh (1920s–1940s); with Coble Studio and Fowler's Studio, Raleigh (1920s); operated Denmark Studio, Fayetteville St., Raleigh (1929–1940s), in partnership with sister, Leonita Denmark (1930s–1940s); grandson of Leonidas L. Polk; studio in Hudson-Belk Department Store.

SOURCES: Photographic Examiners Records; State Auditor's Records, Sch. B; Fifteenth Census, 1930: Wake County, Pop. Sch., Raleigh, E.D. 92-55; Murray list of Wake County photographers; *Mercantile Agency Reference Book*, 1943; Wake County Wills (A&H).

DENMARK, LEONITA (1889–1965): active 1930s–1940s with Denmark Studio, Raleigh; assisted brother, James W. Denmark, in studio; color tinted photographs and served as receptionist; granddaughter of Leonidas L. Polk.

SOURCES: Wake County Wills (A&H); *www.familysearch.org*.

DENNY, D. C.: active (acquired license to practice) 1907, Durham.

SOURCE: Registry of Licenses to Trade, Durham County, 1881–1913 (A&H).

DE OVIES, GONVILLE (1886–1983): native of England; active 1915–1940s; in Durham (1915–1917) with Waller Holladay; in Greensboro (1918–1940s); proprietor of Eutsler's Studio, Greensboro (1918–1920); sole proprietor after 1920.

SOURCES: Photographic Examiners Records; Hill, *Greensboro N.C. Directory*, 1918–1923, 1928, 1930–1931, 1934–1941; *Bradstreet's*, 1921, 1925; Fifteenth Census, 1930: Guilford County, Pop. Sch., Greensboro, E.D. 41-25; *Mercantile Reference Book*, 1931; *Mercantile Agency Reference Book*, 1943; *www.familysearch.org*.

DE OVIES, GONVILLE, JR. (b. 1914): native of Ala.; active 1937–1940s, Greensboro; with father (1937–1940); manager of Gaddy Photo Lab, Charlotte (1940–1941); active after World War II; son of Gonville de Ovies.

SOURCES: Fifteenth Census, 1930: Guilford County, Pop. Sch., Greensboro, E.D. 41-25; Photographic Examiners Records.

DERR, RESLER MARVIN (b. 1900): African American; active 1930s–1940, Hickory; worked with Robert S. Cilley (late 1930s); apprenticed under Cilley (1941– 1942).

SOURCE: Photographic Examiners Records.

Raleigh photographer James W. Denmark captured this scene of local importance about 1927. Two aircraft—a Curtis Travel Air and a Waco—are shown at Marshburn-Robbins Airfield off Old Garner Road near Raleigh. At right is local pilot Alton Stewart, who was tragically killed in an airplane crash in December 1929. Photograph courtesy Hardy Mills, Raleigh.

DE RUITTER, ANNIE (b. ca. 1895): native of Holland; active by 1920, Wilmington; sister of Gerard DeRuitter.

SOURCE: Fourteenth Census, 1920. New Hanover County, Pop. Sch., Wilmington, E.D. 100.

DE RUITTER, GERARD (b. 1892): native of Holland; active 1910s–1938, Wilmington; with William H. Dyer (1913–1919; 1921–1932); with Green's Drugstore (1919–1921); self-employed after 1932; operator of Photographic Developing and Printing (1934–1938); brother of Annie DeRuitter.

SOURCES: Photographic Examiners Records; Fifteenth Census, 1930: New Hanover County, Pop. Sch., Wilmington, E.D. 65-26; Hill, *Wilmington N.C. City Directory*, 1934, 1938.

DESHONG, WILLIAM H.: itinerant, active late 1840s–1850s; occupied rooms in Mecklenburg County Courthouse, Charlotte (1849–1850); in Yorkville, S.C., 1851; in Mobile, Ala. (1851); in Memphis, Tenn. (1854–1859); occupied rooms located above store of Gilmer and Hendrix, Greensboro (1858); prior to operating in Greensboro, had worked in Atlanta, Ga. and Jacksonville, Fla.; also worked in Atlanta, 1859.

SOURCES: *Mecklenburg Jeffersonian* (Charlotte), Apr. 11, 1849; *Hornet's Nest* (Charlotte), Sept. 7, 1850; *Greensboro Patriot*, June 18, 1858; Rinhart and Rinhart, *The American Daguerreotype*, 388; *Craig's Daguerreian Registry*, 2:151–152; Robb list of Ala. photographers.

DEVANE, S. H.: active 1919–1920, Jacksonville.

SOURCE: State Auditor's Records, Sch. B.

DEVEREAUX, EDWARD D. ("EDDIE") (b. 1892): African American; active 1911–1940s, Rocky Mount; with Harry Dempt (1911–1923); self employed (1923–1940s).

SOURCES: Photographic Examiners Records; *Hill's Rocky Mount Directory*, 1930, 1934; *Mercantile Reference Book*, 1931.

DEYAM, H. W.: active 1919, Pilot Mountain.

SOURCE: State Auditor's Records, Sch. B.

DICKERSON, ANDREW JACKSON (b. 1922): active early 1940s; in Charlotte (1940); in Wake Forest (1940).

SOURCE: Photographic Examiners Records.

DICKINSON, ALICE MARGARET: active 1908 in un-identified location.

SOURCES: photograph of Montreat and Swannanoa River bearing her name; information provided by Carol Johnson, Library of Congress, Washington, D.C.

DICKSON, EDITH E. *See* Felch, Edith E.

DICKSON, S. WALLACE: active 1908, 1912–1914, Sanford; operated Dickson's Picture Shop; husband of Edith E. Felch; in 1908 returned for a few years to his home in Ill.

SOURCES: *Sanford Express*, Feb. 21, May 9, 24, June 12, 1908; Apr. 19, Nov. 15, 1912, Jan. 13, May 9, 1913, Jan. 16, Nov. 13, 1914, Feb. 5, 1915.

DICKTOR, HARRY (1896–1982): native of Germany; active by 1920, Wilmington (shipyard); died in Calif.

SOURCES: Fourteenth Census, 1920: New Hanover County, Pop. Sch., Wilmington, E.D. 111; *www.familysearch.org*.

DIDLEY, H. L.: active 1902–1903, Asheville.

SOURCE: Cotten list of N.C. photographers.

DIETZ, ALBERT: active 1921, Charlotte.

SOURCE: Miller, *Charlotte Directory*, 1921.

DILLARD, JOE (b. ca. 1893): native of Va.; active 1919, Orion (Ashe County).

SOURCES: State Auditor's Records, Sch. B; Fourteenth Census, 1920: Ashe County, Pop. Sch., Jefferson Township, E.D. 30.

DILLARD, NED: African American; active 1915, Winston-Salem.

SOURCE: *Winston-Salem Directory*, 1915.

DILWORTH, _____: active 1886–1887, Company Shops (Burlington), in partnership with M. Charles Henley.

SOURCE: Cotten list of N.C. photographers.

DIVERS, A. LEE (b. 1874): native of Mo.; active 1902–1907, Elizabeth City; owner and manager of Clipper Photo Company.

SOURCES: *Tar Heel* (Elizabeth City), June 13, 1902; *N.C. Year Book*, 1902–1907; *www.familysearch.org*.

DIXIE PHOTO STUDIOS: active 1940s, Monroe; Walter C. Sprouse, proprietor.

SOURCE: Photographic Examiners Records.

DIXIE STUDIO: active 1907–1908, Salisbury; operated by John C. and J. H. Ramsey.

SOURCE: Miller, *Salisbury Directory*, 1907–1908.

DIXIE STUDIO: active 1918, N. Tryon St., Charlotte; Mrs. Rosalind Scheneter, proprietor.

SOURCE: Miller, *Charlotte Directory*, 1918.

DIXIE STUDIO: active 1918, Lumberton.

SOURCE: State Auditor's Records, Sch. B.

DIXON, FRANCIS E. (b. ca. 1876): native of N.C.; active 1905–1920; in Kinston (1905–1907, 1919–1920); succeeded Erastus A. Parker (1905–1907); in Kenansville (1908); operated Dixon Photo Gallery as itinerant on Mondays in the old Universalist church; also executed work in crayon, pastel, and color.

SOURCES: *Eastern Carolina News* (Kenansville), May 29, 1908; State Auditor's Records, Sch. B; Fourteenth Census, 1920: Lenoir County, Pop. Sch., Kinston, E.D. 58.

DOBBINS, _____: active 1913, Caroleen, in partnership with a Mr. Yelton.

SOURCE: *N.C. Year Book*, 1913.

DOCKERY, STELLA: active 1941, Asheville.

SOURCE: *Miller's Asheville Directory*, 1941.

DODAMEAD, THOMAS EMILE (b. 1893): active 1924–1940s, High Point; apprenticed under David L. Clark; operated Dodamead Studio (Mrs. Mattie Shields Edwards operated the studio in 1925–1926).

SOURCES: Photographic Examiners Records; *Bradstreet's*, 1925; *Mercantile Agency Reference Book*, 1943; Miller, *High Point Directory*, 1925–1926; *Hill's High Point Directory*, 1940; information provided by Mary Lib Clark Joyce, High Point.

DODGE, CHARLES W.: from Mass.; active 1850–1860s, Boston; in New Bern (ca. 1863); operated Dodge's Photo Rooms; may have been Union soldier.

SOURCES: Green, *A New Bern Album*, 14; *Craig's Daguerreian Registry*, 2:160; Polito, *A Directory of Massachusetts Photographers*, 51.

DODSON, JAMES M. (b. 1848): native of N.C.; itinerant; active 1870–after 1908; in Abbeville, S.C. (1870–1871, 1873); in Camden, S.C. (1870–1872); in Hillsborough (1874); operated gallery in Berry's building in partnership with Montraville P. Stone; in Fayetteville (1875–1878); operated gallery on Person St. in partnership with Stone; artist Elliott Daingerfield managed the gallery (1876–1877); in Asheboro (1876) in partnership with Stone; in Kinston (1877–1878, 1879); in Wilson (1878); on W. Center St., Goldsboro (1881–1884); in Lexington (1888–early 1890s); operated gallery nearly opposite the courthouse; in Thomasville (by 1900–after 1908).

SOURCES: Teal, *Partners with the Sun*, 124–125; *Hillsborough Recorder*, June 3, 1874; Col. Leonidas Campbell Jones Diaries, Southern Historical Collection, Wilson Library, UNC-CH; *Chataigne's Raleigh Directory*, 1875, 177; *Wide Awake* (Fayetteville), July 19, 1876; *Randolph Regulator* (Asheboro), Nov. 15, 22, 1876; *North Carolina Gazette* (Fayetteville), Dec. 21, 1876; Branson, *NCBD*, 1877–1878, 1890, 1896, 1897; *Wilson Advance*, Apr. 19, 1878; *Kinston Journal*, Jan. 17, 1879; *Goldsboro Star*, June 24, 1882; *Chataigne's N.C. Directory and Gazetteer*, 1883–'84; *Davidson Dispatch* (Lexington), Apr. 18, 1888; Sprange, *Blue Book*, 289; Twelfth Census, 1900: Davidson County, Pop. Sch., Thomasville Village, E.D. 39; *N.C. Year Book*, 1905–1907; *Bradstreet's*, 1908.

DOEBEREINER, P.: active ca. 1870, Fayetteville(?).

SOURCE: photograph bearing name "Doebereiner."

DONNAHOE, _____: active ca. 1912–1917, Asheville, in partnership with Grant Wight.

SOURCE: information provided by staff of Pack Memorial Public Library, Asheville.

DONNELL, R. L.: active 1858–1859, Greensboro; operated Donnell's Gallery; rooms located on second floor of Garrett's brick building.

SOURCES: *Greensborough Patriot*, Oct. 1, 1858–June 9, 1859; *Times* (Greensboro), Dec. 11, 1858, June 11, 1859.

DONNELL, WILLIAM C. (1831–1917): native of N.C.; maker of ambrotypes; active 1859–1860, Greensboro; operated Donnell's Gallery; rooms located on second floor of Garrett's brick building.

SOURCES: *Greensborough Patriot*, Sept. 16, 1859; Eighth Census, 1860: Guilford County, Pop. Sch., South Division, Greensboro; Vital Records, death certificates, Book 215, p. 7 (A&H).

DONNELL, WILLIAM O., JR. (1873–1951): native of N.C.; active ca. 1899, Chapel Hill; also employed as jeweler and optician; active as merchant in Oak Ridge Township, Guilford County, 1900.

SOURCES: Twelfth Census, 1900: Guilford County, Pop. Sch., Oak Ridge Township, E.D. 67; *www.familysearch.org*.

DORATT, CHARLES: came to Raleigh from New York City in 1840 to teach at Raleigh Institute; art instructor and portrait painter; advertised the sale of a daguerreotype machine (camera) in 1844; active 1845–1848; in Savannah, Ga. (1845), in partnership with a Mr. Cooley; in Charlotte (1846) in partnership with a Mr. Smith; in Raleigh (1846–ca.1848) in partnership with portrait painter L. T. Voigt; offered to take daguerreotypes of members of the N.C. General Assembly.

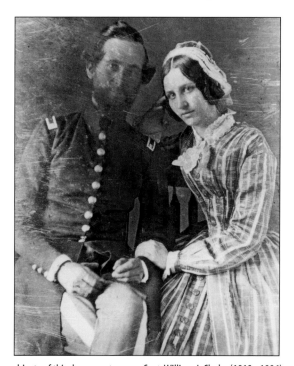

The subjects of this daguerreotype are Capt. William J. Clarke (1819–1886) and his wife Mary Bayard Devereux Clarke (1827–1886). Charles Doratt captured their likenesses in Raleigh in 1848 following Clarke's return from the Mexican War. Photograph courtesy Mary M. Barden, New Bern.

Thomas R. Draper photographed this scene showing the aftermath of a flood at Belhaven in October 1913. Postcard courtesy Durwood Barbour, Raleigh.

SOURCES: *Raleigh Register and North Carolina Gazette*, Nov. 16, 1842, Apr. 2, 1844, Sept. 29, Nov. 20, 1846, Sept. 16, 1848; *Mecklenburg Jeffersonian* (Charlotte), May 8, 1846; *Semi-Weekly Raleigh Register*, Oct. 30, 1846; *Raleigh Register* (semi-weekly), Nov. 24, 1846; Murray, *Wake: Capital County of North Carolina*, Vol. 1; Rinhart and Rinhart, *The American Daguerreotype*, 389; *Craig's Daguerreian Registry*, 2:161.

DORNS, WILLIAM (b. ca. 1875): native of N.C.; active by 1910, Goldsboro.

SOURCE: Thirteenth Census, 1910: Wayne County, Pop. Sch., Goldsboro, E.D. 104.

DORSEY, S. BOWEN (b. 1891): active 1928–1940s; photographer at State Penitentiary, Raleigh (1928–1930s); in Greenville (1940s), with Greenville Police Department.

SOURCE: Photographic Examiners Records.

DOTY, CHARLES C.: active 1854–1860s; itinerant; in Troy, N.Y. (1854–1858); in Kinston (1855) in partnership with George A. Jeffers; in Wilmington, Del. (1857); located in Elmira, N.Y., during Civil War.

SOURCES: *American Advocate* (Kinston), Aug. 30, 1855; Witham, *Catalogue of Civil War Photographers*, 53; *Craig's Daguerreian Registry*, 2:162.

DOTY, LORENZO: active 1855–1860; in New Bern (1855) as itinerant daguerreotyper with gallery located on Craven St.; in Hillsdale, Mich. (1860).

SOURCES: *New Bern Journal*, Oct. 31, 1855; *Craig's Daguerreian Registry*, 2: 162.

DOUGHTRY (DOUTRY), _____: active 1919, Durham, in partnership with a Mr. Bunn.

SOURCE: State Auditor's Records, Sch. B.

DOUGLASS, MRS. LOUIS: active 1935, Roxboro.

SOURCE: Photographic Examiners Records.

DOUMAR, GEORGE: active 1918, Charlotte; operated George Doumar Photo Company.

SOURCES: Miller, *Charlotte Directory*, 1918; information provided by Carol Johnson, Library of Congress, Washington, D.C.

DOWDY, LEMUEL: active 1935, Sanford.

SOURCE: Photographic Examiners Records.

DOWLING, WILLIAM P. (d. ca. 1937): active 1894–ca. 1937; in Charleston, S.C. (1894–ca. 1920); in Hendersonville, N.C. (1921–1922); in Greenville, S.C. (1923–ca. 1937).

SOURCES: Teal, *Partners with the Sun*, 182–185; Miller, *Hendersonville, N.C. City Directory*, 1921–1922.

DOZIER, ELLEN F. (b. ca. 1873): native of Va.; African American; active by 1910, Elizabeth City; listed in census as "artist" in unidentified photography studio; one of the earliest African American women working in the photography field in N.C.

SOURCE: Thirteenth Census, 1910: Pasquotank County, Pop. Sch., Elizabeth City, E.D. 76.

DRACE, C. W.: active late 1890s, Charlotte; along with partner, William Basom, traveled to Charlotte representing American View Company, which had been established in Blacksburg, S.C., 1896; operated studio in Basom's residence on S. McDowell St.; both departed Charlotte by 1900.

SOURCES: *Weeks' 1899 Charlotte City Directory*; information provided by Shelia Bumgarner, Public Library of Charlotte and Mecklenburg County.

DRAPER, THOMAS RICHARD (1868–1940): native of N.C.; active ca. 1890–1939; in Hyde County (1890); in Bath (by 1900, 1930s); in Belhaven (1909–1916); in

Washington (1919–1920s); also engaged in farming and operated a curio shop near St. Thomas Episcopal Church in Bath.

SOURCES: Registry of Licenses to Trade, Hyde County, 1881–1903 (1890) (A&H); Twelfth Census, 1900: Beaufort County, Pop. Sch., Bath, E.D. 2; *N.C. Year Book*, 1916; State Auditor's Records, Sch. B; *Mercantile Reference Book*, 1931; information provided by Louis Martin, Washington, N.C.; Vital Records, death certificates, Book 25, p. 5; *News and Observer* (Raleigh), Mar. 21, 1940; information provided by John H. Oden III, Pinetown.

DREYER, HANS P.: active 1906–1908, Winston; operated Twin City Studio.

SOURCES: Walsh, *City Directory of Winston and Salem*, 1906, 1908; information from files of MESDA.

DROBNEA, ALBERT (b. 1908): active 1939–1940s, Durham; with Chidnoff Studio of New York City.

SOURCE: Photographic Examiners Records.

DRUCKER, _____: active early twentieth century; proprietor of Drucker and Company; took photographs for State Museum of Natural History, Raleigh.

SOURCES: Herbert H. Brimley Photograph Collection (A&H); information provided by Sarah Robinson, Jacksonville, Fla.

DUBOIS, D.: active 1919–1920; in Raleigh (1919); in Concord (1920).

SOURCE: State Auditor's Records, Sch. B.

DUCKWORTH, RAYMOND BOUCHELL (1910–1995): active 1941, Charlotte; with Goldcraft Studio (1941); died in Washington, D.C.

SOURCES: Photographic Examiners Records; *www.familysearch.org*.

DUDLEY, HORACE L.: active 1902–1903, Asheville.

SOURCES: Hill, *Asheville, N.C. City Directory, 1902–1903*; information provided by staff of Pack Memorial Public Library, Asheville.

DUGAN, R.: itinerant daguerreotyper; active 1843, Fayetteville; located at Mrs. E. Smith's residence.

SOURCE: *Fayetteville Observer*, May 31, 1843.

DUGGAN, EDWARD: of Spartanburg, S.C.; itinerant statewide; active (obtained license to practice) 1880–1881.

SOURCE: State Auditor's Records, Miscellaneous Tax Group (1868–1932), Box 3, Artists' and Photographers' Privilege Licenses, 1877–1887 (A&H).

DUKE, J. W.: itinerant maker of ambrotypes and tintypes; active 1857, Hillsborough; gallery at Masonic Hall.

SOURCE: *Hillsborough Recorder*, Aug. 26, 1857.

DUKE PHOTO COMPANY: active 1940–1941, on W. Trade St., Charlotte; V. Dumas Sanchez, proprietor.

SOURCES: *Hill's Charlotte Directory*, 1940–1941; *Mercantile Agency Reference Book*, 1943.

DUNBAR, MILLARD FILMORE (1896–1948): native of Md.; active ca. 1918–1940s; on Front St., Wilmington (1918), in partnership with a Mr. Daniel; in Raleigh (ca. 1925–1940s) in partnership with James William Daniel and Thomas N. Daniel (1931–1940) as Dunbar & Daniel Studio; on Corcoran St., Durham (1938–1939), in partnership with William A. Daniel; in Wilmington (1938) in partnership with William A. Daniel; on N. Tryon St., Charlotte (1940–1942) as Dunbar Studio (operated by George Barnsdale).

SOURCES: Photographic Examiners Records; Fifteenth Census, 1930: Wake County, Pop. Sch., Raleigh, E.D. 92-55; Murray list of Wake County photographers; Reaves list of Wilmington photographers; Hill, *Wilmington Directory, 1938*; Hill, *Durham, N.C. City Directory, 1938–1939*; *Hill's Charlotte Directory, 1940–1941*; *Mercantile Agency Reference Book, 1943*.

DUNFORD, _____: active late 1920s; operated Dunford's Studio in unidentified location; took interior view of county clerk's office in Caswell County Courthouse, Yanceyville.

SOURCES: photograph of Providence Baptist Church (Caswell County) bearing his name, reproduced in *Caswell Messenger* (Yanceyville), Sept. 17, 2003; photo of county clerk's office bearing name "Dunford."

DUNWICK, _____: active 1916–1917, Lenoir; with father, William H. Dunwick, and brother, Fred Dunwick, as Dunwick & Sons.

SOURCE: *N.C. Year Book*, 1916.

DUNWICK, FRED: active ca. 1907–1917; in Salisbury (1907–1908); in Lexington (1912–1915); in Lenoir (1916–1917); son of William H. Dunwick.

SOURCES: Miller, *Salisbury Directory*, 1907–1908; *N.C. Year Book*, 1912–1916.

DUNWICK, WILLIAM H. (1847–1917): active ca. 1907–1917; in Salisbury (1907–1908); operated as W. H. Dunwick & Son (with Fred Dunwick); in Lexington (1908–1916); in partnership with a Mr. Bussey (1911); in Lenoir (1916–1917) as Dunwick & Sons.

SOURCES: Miller, *Salisbury Directory*, 1907–1908; *Bradstreet's*, 1908; *N.C. Year Book*, 1910–1916; Thirteenth Census, 1910: Davidson County, Pop. Sch., Lexington, E.D. 28; State Auditor's Records, Sch. B; Vital Records, death certificates, Book 289, p. 281 (A&H).

DUPUY, EDWARD (1914–1991): active late 1930s, early 1940s, Black Mountain; did photographic work for Black Mountain College.

SOURCES: Harris, *The Arts at Black Mountain College*, 24, 266; *www.familysearch.org*.

DURHAM, JOE S. (b. ca. 1851): native of N.C.; active ca. 1910, Shelby; listed as a house painter in 1910 census.

SOURCES: Thirteenth Census, 1910: Cleveland County, Pop. Sch., Shelby, E.D. 43; *N.C. Year Book*, 1910.

DURHAM ART GALLERY: active ca. 1906, Durham.

SOURCE: photograph bearing gallery name.

DURHAM PHOTO SUPPLY COMPANY: active 1906–1907, Durham.

SOURCE: *N.C. Year Book*, 1906, 1907.

DURHAM STUDIO: active 1930–1932, W. Main St., Durham.

SOURCE: Hill, *Durham, N.C. City Directory, 1930–1932.*

DUSHAN, CHARLES (1869–1964): active 1913–1914, Wilmington, in partnership with Edward H. Hodges; operated The Photo Shop.

SOURCE: Hill, *Wilmington Directory, 1913–1914*; *www.familysearch.org.*

DUTZ, ALBERT: active 1921–1922, Charlotte.

SOURCE: State Auditor's Records, Sch. B.

DYER, WILLIAM H. ("LITTLE BILLIE") (ca. 1867–1932): native of Va.; active 1910–1930; in Louisburg (ca. 1910); in Sanford (1910–1911); purchased gallery of W. F. Washington and operated in partnership with Victor Stevens; in Carthage (1911), likewise in partnership with Stevens; in Wilmington (1913–1930); operated Little Billie Kodak Finishing Company on Princess St. (1917–1930).

SOURCES: Reaves list of Wilmington photographers; *Sanford Express*, July 1, 1910, Feb. 17, Mar. 17, 31, 1911; *N.C. Year Book*, 1911, 1916; State Auditor's Records, Sch. B; Hill, *Wilmington Directory*, 1913–1930; *Star* (Wilmington), Nov. 26, 1932.

E

EAGELL COMPANY: active 1906; photographed Toxaway Inn and nearby mountains.

SOURCE: information provided by Carol Johnson, Library of Congress, Washington, D.C.

EAKES, G. L.: active 1919, Raleigh.

SOURCE: State Auditor's Records, Sch. B.

EAKES, WILLIAM G.: active 1909–1913, W. Main St., Durham; in partnership with William Kennedy (1909–1910).

SOURCES: Hill, *Durham, N.C. Directory, 1911–1912*; Registry of Licenses to Trade, Durham County, 1881–1913 (1909) (A&H).

EARL'S PHOTO SERVICE: active 1934–1940s, Salisbury; William E. Miller, proprietor.

SOURCE: Photographic Examiners Records.

EARP, P. L. (b. 1870): native of N.C.; itinerant; active by 1900, Gastonia.

SOURCE: Twelfth Census, 1900: Gaston County, Pop. Sch., Gastonia Township, E.D. 80.

EASON, W. A.: African American; active (acquired license to practice) 1911–1912, Durham.

SOURCE: Record of Special Licenses Issued, Durham County, 1911–1912 (A&H).

EATMAN, WILONIA (b. ca. 1888): native of N.C.; active by 1910, Wilson.

SOURCE: Thirteenth Census, 1910: Wilson County, Pop. Sch., Wilson, E.D. 116.

EATON, CYRUS BLACK (1884–1967): active 1935–1940s; in Mount Airy (1935–1937); in Winston-Salem (early 1940s); school photographer with Pierson Studio of Pa.

SOURCES: Photographic Examiners Records; *Mercantile Agency Reference Book*, 1943; *www.familysearch.org.*

ECHARD, WILLIAM C. (b. 1847): native of Va.; active 1877–1900; itinerant statewide; obtained license to practice, 1877–1878; in Memphis, Tenn., 1880–1886; in Columbus, Miss., 1880–1886; in Birmingham, Ala., 1887; in Florence, S.C., 1890s–1900.

SOURCES: State Auditor's Records, Miscellaneous Tax Group (1868–1932), Box 3, Artists' and Photographers' Privilege Licenses, 1877–1887 (A&H); Robb list of Ala. photographers.

ECKENROD, ADA MAY (b. 1878): active 1906–late 1940s, Canton (ca. 1919–1940s); mother of William R., Silas F., Walter B., Isaac J., and C. Raymond Eckenrod; affiliated with Eckenrod Studio, Canton.

SOURCES: Photographic Examiners Records; *Mercantile Reference Book*, 1931; *Miller's Canton City Directory, 1937–1938.*

ECKENROD, ALMA BOWMAN (1900–1987): native of Va.; active 1920–1970s; in Canton (1920–1923); in Mount Airy (1924–1940s); operated Eckenrod Studio, Mount Airy, with husband, William R. Eckenrod.

SOURCES: Photographic Examiners Records; *Mount Airy News,* Mar. 28, 1993.

ECKENROD, C. RAYMOND: active 1930s–1940s; worked for Eckenrod's Studio, North Wilkesboro; son of Ada M. Eckenrod; brother of William R., Isaac J., Silas F., and Walter B. Eckenrod.

SOURCES: Photographic Examiners Records; *Miller's North Wilkesboro City Directory, 1939–1940.*

ECKENROD, ISAAC J. (1916–1993): active 1930s, Canton; son of Ada M. Eckenrod; brother of Silas F., C. Raymond, Walter B., and William R. Eckenrod.

SOURCES: Photographic Examiners Records; *www.familysearch.org.*

ECKENROD, SILAS FRANKLIN (1914–1998): active 1928–late 1940s, Canton, with mother, Ada M. Eckenrod (1928–1935); brother of Isaac J., C. Raymond, Walter B., and William R. Eckenrod.

SOURCES: Photographic Examiners Records; *www.familysearch.org.*

ECKENROD, WALTER B. (1906–1989): active 1931–late 1940s, Marion; son of Ada M. Eckenrod; brother of C. Raymond, Isaac J., Silas F., and William R. Eckenrod.

SOURCES: Photographic Examiners Records; *Miller's Marion City Directory, 1940–1941; www.familysearch.org.*

ECKENROD, WILLIAM RUDOLPH (1898–1960): native of Ohio; active early 1920s–1960; in Canton (early 1920s and 1930), with mother, Ada M. Eckenrod; in Mount Airy (1924–1960); operated Eckenrod Studio with wife, Alma B. Eckenrod; brother of C. Raymond, Isaac J., Silas F., and Walter B. Eckenrod.

SOURCES: Photographic Examiners Records; *Mount Airy News,* Mar. 28, 1993; State Auditor's Records, Sch. B; Miller, *Mount Airy, N.C. City Directory, 1928–1929 Mercantile Reference Book,* 1931; *Mercantile Agency Reference Book,* 1943.

ECONOMY, STEPHEN (1877–1965): native of Greece; active 1928–1931, High Point; operated Stephens Studio; died in Colo.

SOURCES: Miller, *High Point Directory,* 1928–1931; Fifteenth Census, 1930: Guilford County, Pop. Sch., High Point, E.D. 41-54; *Mercantile Reference Book,* 1931; *www.familysearch.org.*

EDDY, ELLSWORTH CURTIS (1882–1969): native of N.H.; active 1908–1946; in Pinehurst (1908–1911) with Edmond L. Merrow; in Southern Pines (1913–1946), purchased studio of I. E. Goodale in 1913; subsequently operated it as Eddy's Studio; publisher of numerous postcards of Sandhills area; sold his business to P. Emerson Humphrey, 1946; portraits of Eddy are on file at N.C. Office of Archives and History.

SOURCES: Photographic Examiners Records; *Southern Pines Tourist,* May 23, 1913; Fourteenth Census, 1920: Moore County, Pop. Sch., Southern Pines, E.D. 92; State Auditor's Records, Sch. B; *Bradstreet's,* 1917; handwritten journal by Eddy in possession of his daughter, Ellennore Eddy Smith, Southern Pines; interview with Mrs. Smith, June 17, 1997; Massengill, *Around Southern Pines, A Sandhills Album,* 1998.

ABOVE: Southern Pines photographer E. C. Eddy posed in profile for this portrait about 1910. **LEFT:** E. C. Eddy almost certainly took this photograph of a fire engine loaded with firemen in Southern Pines about 1917. The building on Broad Street, which housed Eddy's studio, is situated behind the vehicle. Both photographs courtesy Ellennore Eddy Smith, Southern Pines.

EDMISTON, RAYMOND E. (b. ca. 1892): native of N.C.; active by 1930, Highland (Catawba County).

SOURCE: Fifteenth Census, 1930: Catawba County, Pop. Sch., Highland, E.D. 18-14.

EDMONDS, J.: active 1894, New Bern; offered new "electrograph" portraits, as well as standard photographic portraits.

SOURCE: *Daily Journal* (New Bern), Feb. 8, 1894.

EDWARDS, _____: active ca. 1880s, Oxford.

SOURCE: cabinet-card photograph bearing name "Edwards."

EDWARDS, COLLIN (b. 1877): native of N.C.; active by 1900, Kinston, with Erastus A. Parker.

SOURCE: Twelfth Census, 1900: Lenoir County, Pop. Sch., Kinston, E.D. 44.

EDWARDS, COLVIN MARSHALL (1903–1989): native of N.C.; African American; worked in Shuford Studio, Gastonia, as boy and young man; active 1930s–1980s, Charlotte; worked for Gaddy Photo Lab and St. John Studio, Belk's Department Store (1930s); began doing his own portrait work in 1941.

SOURCE: Photographic Examiners Records.

EDWARDS, MATTIE SHIELDS (Mrs. William R. Edwards) (1896–1985): native of N.C.; active 1916–1930s; in Durham (1910s) with Waller Holladay; in Norfolk, Va. (late 1910s–early 1920s) with Holladay; in Greensboro (1919–1920) with Gonville de Ovies; in Durham (1921–1923) with Ramsey-Kah Studio; in High Point (1923–1930s) with Dodamead Studio (1925–1926) and Edwards Studio with husband, William R. Edwards.

SOURCES: Photographic Examiners Records; Miller, *High Point Directory*, 1925–1926; Fifteenth Census, 1930: Guilford County, Pop. Sch., High Point, E.D. 41-48; *www.familysearch.org*.

EDWARDS, R. A.: active 1928–1930, Charlotte; associated with Commercial Photo Company commercial photographers.

SOURCE: Miller, *Charlotte Directory*, 1928–1930.

EDWARDS, ROBERT L.: active 1930s, Franklin.

SOURCE: Photographic Examiners Records.

EDWARDS, TOD R. (ca. 1874–1951): native of N.C.; mulatto; active late 1890s–1930s, Siler City; with Henry A. York (1908); with a Mr. Mansfield (1909); as proprietor of Edwards Studio (1910s–1930s); also jeweler and watchmaker.

SOURCES: Photographic Examiners Records; State Auditor's Records, Sch. B; Hadley, Horton and Strowd, *Chatham County, 1771–1971*, 215, 340–341.

EDWARDS, V. S.: active 1919, Statesville.

SOURCE: State Auditor's Records, Sch. B.

EDWARDS, W. E.: active 1886–1887, Reidsville.

SOURCE: Cotten list of N.C. photographers.

EDWARDS, W. THOMAS: active 1934, Greensboro.

SOURCE: *Hill's Greensboro Directory*, 1934.

EDWARDS, WILLIAM D. (b. 1864): native of N.C.; moved to Winston in 1890s, probably from S.C.; active 1890s–1930s; in Florence, S.C. (ca. 1895) in partnership with Andrew J. Farrell; in Winston and later Winston-Salem (1890s–1930s) in partnership with Andrew J. Farrell (1902–1910) and later with Henry A. Lineback (1911–1922).

SOURCES: Twelfth Census, 1900: Forsyth County, Pop. Sch., Winston, E.D. 39; *Walsh's Winston-Salem, North Carolina City Directory*, 1906; *N.C. Year Book*, 1910–1914; *Winston-Salem Directory*, 1923; Fifteenth Census, 1930: Forsyth County, Pop. Sch., Winston-Salem, E.D. 34-57.

EDWARDS, WILLIAM R. (b. ca. 1887): native of Va.; active 1923–1930s, High Point; husband of Mattie Shields Edwards.

SOURCES: Miller, *High Point Directory*, 1927–1931; Fifteenth Census, 1930: Guilford County, Pop. Sch., High Point, E.D. 41-48; *Mercantile Reference Book*, 1931; *Hill's High Point Directory*, 1933.

EDY, W. H.: active 1921, Wilmington.

SOURCE: State Auditor's Records, Sch. B.

EFIRD'S STUDIO: active late 1930s–1940s, third floor of Efird's Department Store, Raleigh, and at Efird's Department Store, Charlotte (1937–1940s); Milo W. Lindow, operator.

SOURCES: information provided by Karl G. Hudson Jr., Raleigh; Photographic Examiners Records.

EINSTEIN, BESSIE L. (b. ca. 1886): native of Va.; active by 1930 as industrial photographer in High Point.

SOURCE: Fifteenth Census, 1930: Guilford County, Pop. Sch., High Point, E.D. 41-51.

ELAM, RICHARD J. (b. ca. 1857): active (obtained license to practice) 1883–1884, Richmond County; son of Samuel Elam.

SOURCE: Registry of Licenses to Trade, Richmond County, 1875–1885 (A&H).

ELAM, SAMUEL (b. ca. 1821): native of N.C.; active by 1870, Charlotte; father of Richard J. Elam.

SOURCE: Ninth Census, 1870: Mecklenburg County, Pop. Sch., Charlotte, First Ward.

ELLEGOOD, THOMAS C. (ca. 1825–1852): native of Va.; itinerant tailor and daguerreotyper; active early 1850s, Winston; drowned during skating accident at Belo's Pond near Salem, Jan. 14, 1852.

SOURCES: *People's Press* (Salem), Jan. 17, 1852; Forsyth County Estates Records (A&H).

ELLER, WILLIAM VANCE (1878–1960): native of N.C.; active early 1900s; Gold Hill (Rowan County).

SOURCE: information provided by Melissa Eller, Salisbury.

ELLINGTON, JOSEPH CLAIRE (1871–1965): native of N.C.; came to Raleigh in 1889 and worked as a clerk for W. H. and R. S. Tucker, merchants; later worked briefly with Dobbin & Ferrall Company; active as photographer, 1903–1927; in 1903 purchased Watson's Art Store from Fred A. Watson and operated it until 1927 as Ellington's Studio, Fayetteville St., Raleigh; subsequently joined Taylor Furnishing Company (later known as Ivey-Taylor Company) prior to retirement.

SOURCES: *N.C. Year Book*, 1912–1916; *Bradstreet's*, 1917, 1921, 1925; State Auditor's Records, Sch. B; Hill, *Raleigh Directory*, 1913–1914, 1919–1920, 1922–1923, 1925; *News and Observer* (Raleigh), Aug. 30, 1951, Nov. 2, 1965.

ELLINGTON, W. F.: active 1921, Fayetteville.

SOURCE: State Auditor's Records, Sch. B.

ELLIOTT, ROBERT NEAL, JR. (1915–2003): native of N.C.; active prior to World War II, Charlotte; served in First Motion Picture Division, U.S. Army Air Force, during war; member of history faculty, N.C. State University, 1956–1981.

SOURCE: *News and Observer* (Raleigh), Dec. 13, 2003.

ELLIS, _____: itinerant maker of ambrotypes; active 1856, Hillsborough; occupied rooms at the Masonic Hall; in partnership with a Mr. Lipscombe.

SOURCE: *Hillsborough Recorder*, Nov. 19, 1856.

ELLIS, EDWARD R.: active late 1890s–1900; in Goldsboro (briefly, late 1890s); in Wilmington (ca. 1900); operated Star Studio, Market St.; briefly assisted Henry Cronenberg.

SOURCES: *Dispatch* (Wilmington), Nov. 17, 1899; *Wilmington, N.C. City Directory*, 1900; Reaves list of Wilmington photographers.

ELLIS, FORREST LEE (1890–1961): native of N.C.; active 1910–1940, Shelby; in partnership with George W. Harris (1910–1911); later operated Ellis Studio.

SOURCES: Photographic Examiners Records; *N.C. Year Book*, 1914–1916; State Auditor's Records, Sch. B; *Bradstreet's*, 1917, 1925; Fourteenth Census, 1920: Cleveland County, Pop. Sch., Shelby, E.D. 62; *Miller's Shelby City Directory, 1937–1940*; *www.familysearch.org*.

ELLIS, FREEMAN G. (b. ca. 1879): native of N.C.; active 1898, Wilmington.

SOURCES: *Star* (Wilmington), Mar. 9, 1898; Reaves list of Wilmington photographers; *www.familysearch.org*.

ELLIS, S. F., JR.: active 1896–1897; operated Ellis Studio, Louisburg.

SOURCE: Branson, *NCBD*, 1896, 1897.

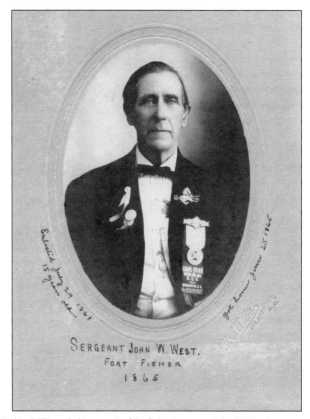

SERGEANT JOHN W. WEST.
FORT FISHER
1865

Urchie C. Ellis took this portrait of Confederate veteran John W. West in Wilmington during the early years of the twentieth century. West served as a sergeant in the First Battalion, Heavy Artillery, and was captured by Union forces at Fort Fisher, N.C., on January 15, 1865. Photograph courtesy A&H.

ELLIS, T. S.: active 1904–1907, Hamlet.

SOURCE: *N.C. Year Book*, 1904–1907.

ELLIS, TOBIAS WALTER (1866–1916): native of N.C.; active 1890s–1910s; in Hiddenite (1890s); in Statesville (1906–1910s) in partnership with Richard H. Maynard (1909–1910); in Mooresville (1912).

SOURCES: Miller, *Statesville, N.C. City Directory, 1909–1910*; *N.C. Year Book*, 1912; *Iredell County Landmarks*, 159; Vital Records, death certificates, Book 193, p. 419 (A&H).

ELLIS, URCHIE CHADWICK (1866–1910): native of N.C.; active ca. 1890–1910, Wilmington; operated Ellis Studio on Market St., later Front St.; in partnership with a Mr. Smith (1890).

SOURCES: *Atlantic Methodist* (Wilmington), Feb. 17, 1892; Branson, *NCBD*, 1896, 1897; *J. L. Hill Printing Co.'s Directory for Wilmington, N.C., 1897*; *N.C. Year Book*, 1902–1907, 1910–1915; *Mercantile Agency Reference Book*, 1904; Hill, *Wilmington Directory*, 1905–1910; Thirteenth Census, 1910: New Hanover County, Pop. Sch., Wilmington, E.D. 92; Cotten list of N.C. photographers; Vital Records, death certificates, Book D-8, p. 466 (A&H).

ELLISON, JOSEPH MARION (1852–1927): native of N.C.; active 1884–1890s, Franklinville; also worked as confectioner.

SOURCES: Branson, *NCBD*, 1884, 1890; Vital Records, death certificates, Book 1164, p. 131 (A&H).

EMMONS, ELBERT A. (b. ca. 1886): native of N.C.; active by 1930, Statesville.

SOURCE: Fifteenth Census, 1930: Iredell County, Pop. Sch., Statesville, E.D. 49-29.

EMSBERGER, _____: itinerant; active (paid tax to practice) 1883–1884, statewide; in partnership with a Mr. Smith.

SOURCE: State Auditor's Records, Ledgers, 1869–1899, Vol. 17, p. 467 (A&H).

ENGLE, JOHN FOREMAN (1824–1908): native of N.J.; active 1857–ca.1907; moved to N.C. from N.J. in 1857; in Salisbury (1859) as itinerant with photo tent; in Statesville (1859) as itinerant with photo tent; returned to N.J. at start of Civil War; photographer with Army of Potomac; also reported to have worked for Confederate government; in Philadelphia, Pa. (1864–1865); in Greensboro (1865); worked in Fla. and Ga. (late 1860s and ca. 1875); in Raleigh (1870); in partnership with a Mr. Furlong in Fla. (ca. 1875); in Ohio (1870s); again

This damaged photograph by John F. Engle shows Concord Female College in Statesville in 1859. It is one of the earliest-known paper prints of an outdoor scene in North Carolina. Possibly a salt print. Photograph courtesy Mitchell Community College, Statesville.

in Raleigh (1877–1882); at Catawba Springs as itinerant (1878); publisher of stereographs, in partnership with Nat W. Taylor; in Greenville (1884–1886) in partnership with William H. Zoeller; in Mexico (ca. 1886–1887); in Weldon (1887); in Elizabeth City (1889) in partnership with Zoeller and in association with M. W. Newberry; in Edenton (1889) in partnership with Zoeller; in Hertford (briefly, 1890) in association with R. Frank Peterson and a Mr. Long; in Elizabeth City (by 1892–ca. 1907); occupied permanent studio with Zoeller in Advance Building on corner of Fearing and Water Streets; worked in association with Viggo Lund, who operated Engle's Art Gallery on Water St. (1892–1893); sole proprietor (ca. 1907); portraits of Engle on file at N.C. Office of Archives and History.

SOURCES: Dumont, *North Carolina as a Place for Investment*, 55–56; *Historical and Descriptive Review*, 216–217; *Carolina Watchman* (Salisbury), July 12, 1859; *Iredell Express* (Statesville), Aug. 19, 26, 1859; Witham, *Catalogue of Civil War Photographers*, 4; biographical sketch provided by the Museum of the Albemarle, Elizabeth City; Tenth Census, 1880: Wake County, Pop. Sch., Raleigh, E.D. 266; Registry of Licenses to Trade, Wake County, 1876–1877 (A&H); Branson, *NCBD*, 1877–1878; *Daily Nut Shell* (New Bern), Aug. 13, 1878; State Auditor's Records, Miscellaneous Tax Group (1868–1932), Box 3, Artists' and Photographers' Privilege Licenses, 1877–1887 (A&H); State Auditor's Records, Ledgers, 1869–1899, Vol. 17, p. 10 (A&H); *Roanoke News* (Weldon), Sept. 15, 1887; *Economist* (Elizabeth City), Feb. 26, 1889; *Fisherman and Farmer* (Edenton), July 26, 1889; Sprange, *Blue Book*, 289; *N.C. Year Book*, 1907; Darrah, *World of Stereographs*, 208; Ries and Ruby, *Directory of Pennsylvania Photographers*, 78; Rinhart and Rinhart, *Victorian Florida*, 36.

ENGLE, W. L.: active 1911–1916, Dobson.

SOURCE: *N.C. Year Book*, 1911–1916.

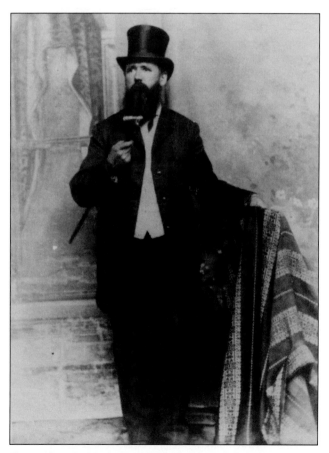

Photographer John F. Engle stepped in front of a camera, donned a top hat, and held a cane to create this dapper pose about 1880. Photograph courtesy Museum of the Albemarle, Elizabeth City.

ENSLEY, ABRAHAM LINCOLN (1865–1948): active ca. 1900, Jackson County; father-in-law of George D. Sherrill.

SOURCES: *Haywood County Heritage*, 1:54; *www.familysearch.org.*

ENSLEY, BEULAH E.: active 1931–late 1940s, Waynesville; operated Sherrill's Studio with husband, Ralph Ensley.

SOURCES: Photographic Examiners Records; *Haywood County Heritage*, 1:54.

ENSLEY, RALPH: active 1931–late 1940s, Waynesville; operated Sherrill's Studio with wife, Beulah E. Ensley; nephew of George D. Sherrill.

SOURCE: *Haywood County Heritage*, 1:54.

EPPS, HERMAN LESLIE (1896–1974): active 1932–1940s, Aberdeen (1930s); operated Sandhills Photo Shop, Southern Pines (ca. 1937–1940s); assisted by his wife; died in Md.

SOURCES: Photographic Examiners Records; *www.familysearch.org.*

EPPS, MRS. HERMAN L.: active 1937–late 1940s, Aberdeen (1930s); assisted husband, Herman L. Epps, in Sandhills Photo Shop, Southern Pines (ca. 1937–1940s).

SOURCE: Photographic Examiners Records.

ERBACH, JOHN: active 1891–1904; employed by U.S. Geological Survey.

SOURCES: Herbert H. Brimley Photograph Collection (A&H); information provided by Sarah Robinson, Jacksonville, Fla.

ESSARY, S. H.: active ca. 1900, western N.C.

SOURCE: information provided by Cynthia Bright.

EUBANKS, CHARLES ROY (1906–1977): active 1932–late 1940s, Beaufort (1932–1940s); with N.C. Emergency Relief Administration (1934–1935); in Morehead City (1940s–).

SOURCES: Photographic Examiners Records; *Mercantile Agency Reference Book*, 1943; Dudley, *Morehead City*, 4; *www.familysearch.org.*

EUGAL, GEORGE: active (obtained license to practice) 1888–1889, Washington County.

SOURCE: Registry of Licenses to Trade, Washington County, 1883–1902 (A&H).

EURE, FRANK L.: active 1930s, Albemarle.

SOURCE: Photographic Examiners Records.

EUREKA PHOTO COMPANY: active 1927–1941, on S. Tryon St., Charlotte; Mrs. Sarah E. Hartis, proprietor (1927–1936); A. Dallas Hartis and J. Glenn Hartis, proprietors (1937–1941).

SOURCES: Miller, *Charlotte Directory*, 1927–1930; *Hill's Charlotte Directory*, 1932–1936, 1938–1941.

EUTSLER, CHARLES W. J. (b. 1867): native of Va.; active 1905–1910, on N. Tryon St., Charlotte, in partnership with Leon E. Seay; brother of William E. Eutsler.

SOURCES: *Walsh's Directory of the City of Charlotte*, 1905–1910; *www.familysearch.org.*

EUTSLER, WILLIAM E. (b. 1860): native of Va.; active 1888–1922; in Roanoke, Va. (1888–1891); at 421 Main St., Danville, Va. (1892), above Rosenstock's; in Greensboro (by 1905–1922); in partnership with Sidney L. Alderman (1905–1911); owner, Eutsler's Studio (1912–1922), Gonville de Ovies, proprietor (1918–1920); brother of Charles W. J. Eutsler.

SOURCES: Ginsberg, *Photographers in Virginia*, 45; *Webster's Weekly* (Reidsville), Jan. 26, 1892; *N.C. Year Book*, 1905–1916; State Auditor's Records, Sch. B; Hill, *Greensboro, N.C. Directory*, 1905–1910, 1912–1920; Miller, *High Point Directory*, 1908; Thirteenth Census, 1910: Guilford County, Pop. Sch., Greensboro, E.D. 109; *www.familysearch.org.*

EVANS, _____: active 1940s, Raleigh; operated Evans Studio on Martin St. Source not recorded.

EVANS, B. F. active 1878, Elizabeth City; chromo photographer; in office on Main St. previously occupied by John Black; offered classes in art of "photo chromo painting."

SOURCE: *Economist* (Elizabeth City), Mar. 5, 1878.

EVANS, BENJAMIN V. (1890–1919): native of N.C.; active 1910s, Manteo, in partnership with D. Victor Meekins; published postcards of Dare County; died of Spanish influenza contracted at Norfolk, Va.

SOURCES: *N.C. Year Book*, 1916; postcards bearing his name; Khoury, *Manteo: A Roanoke Island Town*, 10; Vital Records, death certificates, Book 451, p. 5 (A&H).

EVANS, C. A.: active 1864, Washington, N.C.; operated "picture gallery" on Main St. during Federal occupation of Washington.

SOURCE: information provided by Louis Martin, Washington.

EVANS, FLORENCE (Miss) (b. 1903): active 1925–1940s; Hickory; with Meeker Art Studios (1925–1928); operated Melbourne Studio with R. L. Corbett (1928–1929); sole proprietor (1930–1940s); operated Melbourne Studio with J. H. Gilbert (postwar).

SOURCES: Photographic Examiners Records; Miller, *Hickory, N.C. City Directory*, 1930–1931, 1937–1938; *Hickory, N.C. City Directory*, 1935.

EVANS, RICHARD B. (1875–1962): native of N.C.; active by 1900, Hendersonville.

SOURCE: Twelfth Census, 1900: Henderson County, Pop. Sch., Hendersonville, E.D. 42.

EVANS, ROY T. (d. July 2, 1910): native of N.C.; active by 1900–1908, Greenville; began working from tent at Five

Points on Dickinson Ave.; later established permanent studio there.

SOURCES: *King's Weekly* (Greenville), Jan. 17, 1900; *Eastern Reflector* (Greenville), Mar. 16, June 22, 1900, June 19, 1903, July 8, 1910; *N.C. Year Book*, 1903–1907; *Mercantile Agency Reference Book*, 1904, *Bradstreet's*, 1908; information provided by Roger Kammerer, Greenville.

EVERETT, HENRY: active 1916–1920; in Williamston (1916–1919); in Durham (1920).

SOURCES: State Auditor's Records, Sch. B; Fourteenth Census, 1920: Durham County, Pop. Sch., Durham, E.D. 49.

EVERETT, S. F.: active 1886, Hamilton, in association with Holand F. Badger.

SOURCE: *Eastern Reflector* (Greenville), Apr. 14, 1886.

EWING, LEWIS (1899–1976): native of N.C.; African American; active by 1930 as street photographer in Durham.

SOURCES: Fifteenth Census, 1930: Durham County, Pop. Sch., Durham, E.D. 32-9; *www.familysearch.org*.

EXLINE, EDOUARD EVARTT: active 1935; photographed Great Smoky Mountains.

SOURCE: information provided by Carol Johnson, Library of Congress, Washington, D.C.

EYER, [R. V.?]: active 1896–1911; operated Eyer's Gallery, Marion (1911); may have been the Eyer who worked in Urbana, Ohio, ca. 1896, or R. V. Eyer, who worked in Mich., 1902–1903.

SOURCES: *N.C. Year Book*, 1911; Tinder list of Mich. photographers; Gagel, *Ohio Photographers*, 56.

EZZELL, D. J. (b. ca. 1834): native of N.C.; in Chapel Hill by 1860.

SOURCE: Eighth Census, 1860: Orange County, Pop. Sch., Chapel Hill.

F

FABER, J. J.: active 1889–1896; in Norfolk, Va. (1889); in Hertford, N.C. (1896) in upstairs portion of new brick building on Main St.

SOURCES: Ginsberg, *Photographers in Virginia*, 17; *Eastern Courier* (Hertford), Jan. 9, 1896.

FABER, JOSEPH H.: active 1888–1904; in Norfolk, Va. (1888–1894); in partnership with a Mr. Friese (1889); employed by U.S. Geological Survey (1891–1904).

SOURCES: Ginsberg, *Photographers in Virginia*, 17; *Roanoke Beacon* (Plymouth), June 28, 1889; Herbert H. Brimley Photograph Collection (A&H); information provided by Sarah Robinson, Jacksonville, Fla.

FAIN, SIMPSON: active 1921, Asheville.

SOURCE: State Auditor's Records, Sch. B.

FAIRBANKS, EUGENE B. (b. 1886): active 1934–1940s; photographer with Federal Emergency Relief Administration at unidentified locations (1934 and afterward); operated New York Studio in Statesville (1938–1939); operated New York Studio in Mooresville (1939–1940); photographer in Mooresville after World War II.

SOURCES: Photographic Examiners Records; *Miller's Statesville City Directory, 1938–1939*; *Miller's Mooresville City Directory, 1939–1940*.

FAIRCLOTH, RUDOLPH ("RUDY") (1918–1976): active 1930s–1940s; in Chapel Hill (1930s); in Raleigh (1930s–1940s); learned photography trade from Bayard Wootten in Chapel Hill; died in S.C.

SOURCES: Photographic Examiners Records; Murray list of Wake County photographers; Cotten, *Light and Air*, 3, 42; *www.familysearch.org*.

FANE, JACOB: active 1920, Wilmington.

SOURCE: State Auditor's Records, Sch. B.

FANNEY, _____: of Franklin, Va.; active 1892, Hertford, Edenton.

SOURCE: *Perquimans Record* (Hertford), May 11, June 1, 1892.

FARMER, MARION M. (b. ca. 1880): native of S.C.; African American; active 1912–1930s; in Sumter, S.C. (1912–1916); in Winston-Salem (1918–1930s); associated with Robah L. Scales (1918); associated with Farmer-Cute Studio (1926).

SOURCES: Teal, *Partners with the Sun*, 298; State Auditor's Records, Sch. B; Fourteenth Census, 1920: Forsyth County, Pop. Sch., Winston-Salem, E.D. 89; *Winston-Salem Directory*, 1926; information from the files of MESDA.

FARRAR, WILLIAM EDMUND (b. 1899): active late 1930s–1940s; in Macon, Ga. (late 1930s); in Wilson (1940); in Greensboro (1940) with Charles and Anne Farrell in the Art Shop.

SOURCE: Photographic Examiners Records.

FARRELL, ANDREW JACKSON (1860–1924): native of N.C.; active ca. 1886–1920s; itinerant in N.C. (1886–1887); in Walnut Cove in partnership with N. J. Reid (1890s); in Florence, S.C. (ca. 1895) in partnership with William D. Edwards; in Winston and later Winston-Salem (ca. 1897–1920s) in partnership with a Mr. Naramore (1899) and with William D. Edwards (1902–1910); afterward operated his own studios; vice-president of the Carolina Photographers' Association; father of Charles A. Farrell and father-in-law of Anne M. Farrell; portrait on file at N.C. Office of Archives and History.

SOURCES: State Auditor's Records, Ledgers, 1869–1899, Vol. 18, p. 236 (A&H); Branson, *NCBD*, 1890; Teal, *Partners with the Sun*, 194; Twelfth Census, 1900: Forsyth County, Pop. Sch., Winston, E.D. 39; *Walsh's Winston-Salem, North Carolina City Directory*, 1902–1908; *Winston-Salem Directory*,

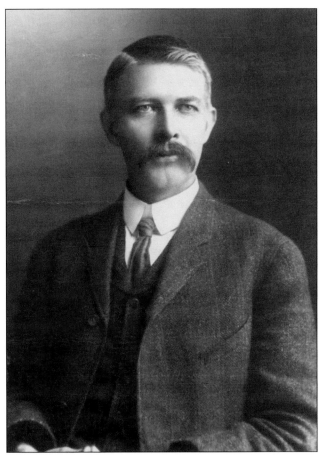

This handsome gentleman is photographer Andrew J. Farrell of Winston-Salem. His son and daughter-in-law, Charles and Anne Farrell, were likewise engaged in the photography profession. Photograph courtesy A&H.

1910–1920; Weaver, *Winston-Salem, North Carolina, City of Industry*, 10; *Mercantile Agency Reference Book*, 1904; *Bradstreet's*, 1908, 1917, 1921; State Auditor's Records, Sch. B; *N.C. Year Book*, 1910–1916; Vital Records, death certificates, Book 891, p. 284 (A&H); information from the files of MESDA; *Winston-Salem Journal*, Oct. 25, 1924.

FARRELL, ANNE MCKAUGHAN (1895–1977): native of N.C.; active 1930s–1960; with the Art Shop, Greensboro; wife of Charles A. Farrell and daughter-in-law of Andrew J. Farrell; photo collection on file at N.C. Office of Archives and History.

SOURCE: Charles A. and Anne M. Farrell Photograph Collection (A&H).

FARRELL, CHARLES ANDERSON (1893–1977): native of N.C.; active 1912–1940s; operated Farrell Studio with father, Andrew Jackson Farrell, in Winston-Salem (1912–1917); active in World War I; worked for Eastman Kodak (1919–1923); in Asheville (1923, 1935) in partnership with Ignatius W. Brock; operated the Art Shop in Greensboro with wife, Anne M. Farrell (1924–1940s); took aerial views in N.C.; photographed first performance of outdoor drama *The Lost Colony*;

active in N.C. Photographers' Association; because of disability, his wife required to run the business by late 1940s; photo collection on file at N.C. Office of Archives and History.

SOURCES: Photographic Examiners Records; Miller, *Asheville, N.C. City Directory, 1923*; *Hill's Greensboro Directory*, 1928–1941; *Mercantile Reference Book*, 1931; Charles A. and Anne M. Farrell Photograph Collection (A&H); *Greensboro Daily News*, Mar. 8, 1977.

FARROW, CHARLIE: active 1919, Mount Holly.

SOURCE: State Auditor's Records, Sch. B.

FASSA, F. J.: active (obtained license to practice) 1910–1911, Durham.

SOURCE: Record of Special Licenses Issued, Durham County, 1910–1911 (A&H).

FAULKNER, LEE (b. ca. 1908): native of N.C.; active by 1930, Lincolnton.

SOURCE: Fifteenth Census, 1930: Lincoln County, Pop. Sch., Lincolnton, E.D. 53-13.

FAUST, CARL: native of Germany; active 1888; formerly a member of Mora's Studio in New York City; briefly operated gallery of Charles W. Yates on Market St., Wilmington; greatly in debt, he secretly departed the city.

SOURCES: *Messenger* (Wilmington), Aug. 16, 24, Oct. 3, 1888; Reaves list of Wilmington photographers.

FELCH, DORA ALICE (b. ca. 1886): native of N.H.; active 1903–1908, Sanford; studio located above post office; in partnership with sister, Edith E. Felch; married a Mr. Welch and moved to Hanover, N.H., in 1908;

Anne M. Farrell and husband Charles A. Farrell, shown here, operated a successful commercial studio in Greensboro. Photographs courtesy A&H.

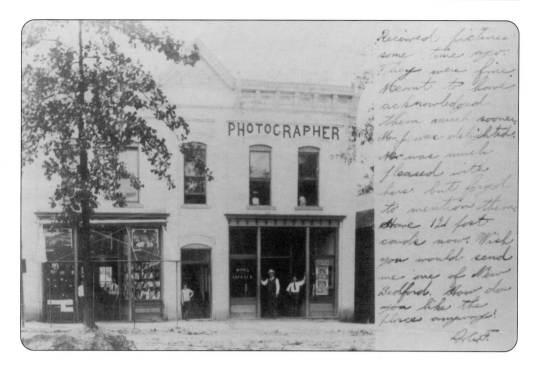

Sisters Dora and Edith Felch operated a studio in Sanford for a few years prior to 1910. This postcard shows the location of their photography business—the second floor of the post office building. Dora Felch penned the message at right, which indicates that she mailed the postcard to an acquaintance out of state. Photograph courtesy A&H.

photo of studio on file at N.C. Office of Archives and History.

SOURCES: *Sanford Express*, Mar. 2, June 12, 1906, Mar. 29, 1907, June 12, 1908; *www.familysearch.org*.

FELCH, EDITH E. (b. ca. 1874): native of N.H.; active 1903–1908, Sanford; studio located above post office; in partnership with sister Dora A. Felch; member of Photographers' Association of Virginia and the Carolinas; married S. W. Dickson in 1908 and moved to Idaho.

SOURCES: *Sanford Express*, Jan. 12, 1906, Mar. 2, 29, 1907, June 26, 1908, Sept. 25, 1908; *www.familysearch.org*.

FELL, MAX K.: active 1938–1941, Asheville; licensed photo finisher; operated Fotocraft.

SOURCE: Photographic Examiners Records.

FELLOWS, _____: active ca. 1890s, Asheville and western N.C.; in partnership with H. L. Roberts as Roberts & Fellows; firm headquartered in Philadelphia; publisher of N.C. stereographs.

SOURCE: stereographs bearing his name.

FERGUSON, E. M.: active 1851–1859; in New Bern (1851–1852) as daguerreotyper in gallery located on east side of Craven St.; also employed as jeweler; in Mattoon, Ill. (1858–1859).

SOURCES: *Semi-Weekly Newbernian* (New Bern), Sept. 14, 1852; *Craig's Daguerrian Registry*, 2:189.

FERGUSON, ERIC JERRY (1900–1960): native of N.C.; active 1922–1950; in West Asheville (1927–1928); operated Ferguson's Studio in Asheville (1922–1950).

SOURCES: Photographic Examiners Records; *Miller's Asheville Directory*, 1927–1928, 1936, 1938–1941; *Asheville Citizen*, Oct. 25, 1960; information provided by staff of Pack Memorial Public Library, Asheville.

FERGUSON, LILLIAN A. (Miss): active 1910–1920s; in Carthage (1910); in Lumberton (1910s–1920s); in partnership with Walter B. Gragg (ca. 1910); in Lumberton as sole proprietor of Ferguson's Studio (1910s–1920s).

SOURCES: *N.C. Year Book*, 1910, 1916; Gardiner, *Lumberton, N.C. City Directory, 1916–1917*; State Auditor's Records, Sch. B.

FERGUSON, M. M.: itinerant maker of ambrotypes; active 1857–1899; in Fayetteville (1857) in studio in rooms formerly occupied by J. D. Nott above Beasley's and Houston's jewelry store; in Marion, S.C. (1866, 1869); in Georgetown, Tex. (1882–1883); in Goliad, Tex. (1892; 1898–1899).

SOURCES: *Fayetteville Observer*, Apr. 27, 1857; Cumberland County Miscellaneous Tax List, 1857–1884, Taxes Received, p. 10 (A&H); Teal, *Partners with the Sun*, 156; Haynes, *Catching Shadows*, 39.

FESPERMAN, LAWRENCE H. (1855–1906): native of N.C.; itinerant during early career; active 1874–1906; in Hickory (1874–1875); in Stanly County (1879–1881); in Wadesboro (1883–1889); in Cheraw, S.C. (1890); in Charlotte (by 1900–1906).

SOURCES: Diary of Lucy Morgan, in possession of Louise Morgan, Brevard; *Piedmont Press* (Hickory), June 20, 1875; Registry of Licenses to Trade, Stanly County, 1874–1904 (1879–1881) (A&H); Teal, *Partners with the Sun*, 186; Twelfth Census, 1900: Mecklenburg County, Pop. Sch., Charlotte, E.D. 49; *Walsh's Directory of the City of Charlotte*, 1903–1906; Mecklenburg County Estates Records (A&H); Cotten list of N.C. photographers.

FIELDER, H. H.: active 1919–1925, Lumberton.

SOURCES: State Auditor's Records, Sch. B; *Bradstreet's*, 1925.

FIELDMAN, SAM: active 1921, Durham.

SOURCE: State Auditor's Records, Sch. B.

FIELDS, MARIE (b. ca. 1904): native of N.C.; active by 1930, High Point.

SOURCE: Fifteenth Census, 1930: Guilford County, Pop. Sch., High Point, E.D. 41-54.

FILE, CHARLES W. (b. ca. 1906): native of N.C.; active 1927–1931, High Point, in partnership with father, Orrie W. File, as File & Son.

SOURCES: Miller, *High Point Directory*, 1927–1931; Fifteenth Census, 1930: Guilford County, Pop. Sch., High Point, E.D. 41-54.

FILE, ORRIE (ORA) W. (b. ca. 1883): native of N.C.; active 1927–1931, High Point, in partnership with son, Charles W. File, as File & Son.

SOURCES: Miller, *High Point Directory*, 1927–1931; Fifteenth Census, 1930: Guilford County, Pop. Sch., High Point, E.D. 41-54.

FINCH, K. S. (b. 1866): native of N.C.; active by 1900, Charlotte.

SOURCE: Twelfth Census, 1900: Mecklenburg County, Pop. Sch., Charlotte, E.D. 45.

FINK, DANIEL M.: itinerant maker of ambrotypes; active 1856–1857, Concord; studied under Gabriel Utley.

SOURCE: *Concord Weekly Gazette*, Dec. 12, 1856, Jan. 10, 1857.

FINK, ELVA B. (b. ca. 1900): native of N.C.; active with Fink's Studio, Albemarle, 1920–1940s; wife of Luther B. Fink.

SOURCES: Fourteenth Census, 1920: Stanly County, Pop. Sch., Albemarle, E.D. 144; Photographic Examiners Records; *Albemarle, N.C. City Directory*, 1937–1940; *Mercantile Reference Book*, 1931; *Mercantile Agency Reference Book*, 1943.

FINK, HERMAN (b. 1901): active after 1937, N.C.; with Chidnoff Studio of New York City.

SOURCE: Photographic Examiners Records.

FINK, LUTHER B. (b. ca. 1890): native of N.C.; active 1916–1924, Albemarle; husband of Elva B. Fink.

SOURCES: State Auditor's Records, Sch. B; *Bradstreet's*, 1917, 1921, 1925; Fourteenth Census, 1920: Stanly County, Pop. Sch., Albemarle, E.D. 144.

FINK, PAUL: active early 1900s, western N.C. Source not recorded.

FISHER, EDWIN D. (b. ca. 1894): native of Conn.; African American; active by 1930, Wilson.

SOURCE: Fifteenth Census, 1930: Wilson County, Pop. Sch., Wilson, E.D. 98-26.

FISHER, ELLIOT LYMAN (1885–1968): active ca. 1934–1958, Asheville; operated Asheville Photo Service after purchasing it from George Masa; specialized in mural photography.

SOURCES: Photographic Examiners Records; *Miller's Asheville Directory*, 1936–1941; information provided by staff of Pack Memorial Public Library, Asheville.

FISHER, JOHN U.: active after 1941; Hendersonville.

SOURCE: *Miller's Hendersonville City Directory, 1941–1942*.

REAL PHOTOGRAPH BY MISS FERGUSON, LUMBERTON, N. C. MAIN STREET—ELIZABETHTOWN, N. C.

Lillian A. Ferguson of Lumberton published this postcard view of Main Street in Elizabethtown (Bladen County) during the 1920s. Postcard courtesy Durwood Barbour, Raleigh.

FITCH, FRED M.: African American; active 1904–1905, Winston, in partnership with John L. Tyson.

SOURCE: *Walsh's Directory of the Cities of Winston and Salem, 1904–1905.*

FIT(Z)PATRICK, GEORGE: active 1921, Wilson.

SOURCE: State Auditor's Records, Sch. B.

FIVE POINTS PHOTO GALLERY: active 1912–1915, Durham.

SOURCE: *N.C. Year Book,* 1912–1915.

FLANAGAN (FLANIGAN), CALVIN A. (b. ca. 1884 or 1890): native of N.C.; African American; active 1911–1939; in Kinston (1911–1912) with J. H. Hargett; in Durham (1914–1916); in Goldsboro (ca. 1919–1939); worked as street photographer (1920).

SOURCES: Photographic Examiners Records, Record of Special Licenses Issued, Durham County, 1914–1916 (A&H); State Auditor's Records, Sch. B; Fourteenth Census, 1920: Wayne County, Pop. Sch., Goldsboro, E.D. 130; *Baldwin's Goldsboro Directory,* 1938.

FLETCHER, W. N.: active 1916, Newland.

SOURCE: *N.C. Year Book,* 1916.

FLORIAN, R. S.: active 1933–1935, Asheboro, as Florian Studio, with branches in Burlington, Fayetteville (with W. L. Gilbert as manager), Greensboro, and Winston-Salem.

SOURCE: Photographic Examiners Records.

FLYNT, HENRY ALLEN, II (1895–1973); active ca. 1920–late 1940s, Greensboro; operated Flynt Studios; Winston-Salem (1921–1922); in High Point (1933).

SOURCES: State Board of Photographic Examiners Records; State Auditor's Records, Sch. B; *Winston-Salem Directory,* 1921–1922; *Hill's Greensboro Directory,* 1921–1923, 1928–1931, 1934–1941; *Hill's High Point Directory,* 1933; *Mercantile Reference Book,* 1931; *www.familysearch.org.*

FOISTER, ROBERT WELCH (b. ca. 1890): native of N.C.; owned and operated Foister's Art Store (later Foister's Photo Company), 1914–1940s, Chapel Hill; identified as photo finisher in 1930; father of Robert W. Foister Jr.

SOURCES: Photographic Examiners Records; *N.C. Year Book,* 1914–1916; State Auditor's Records, Sch. B; Fifteenth Census, 1930: Orange County, Pop. Sch., Chapel Hill, E.D. 68-6.

FOISTER, ROBERT WELCH, JR. (1915–ca. 1943): active with Foister's Photo Company, Chapel Hill, 1932–ca. 1943; son of Robert W. Foister.

SOURCE: Photographic Examiners Records.

FOLSOM, J. H.: active ca. 1873–1884, Danbury and Waterbury, Conn. (ca. 1873); in Asheville (ca. 1883–1884), in partnership with Nat W. Taylor.

An African American photographer in Smithfield is shown here (October 1936) surrounded by curious bystanders. The artist is perhaps Calvin A. Flanagan, an itinerant street photographer working at that time in eastern North Carolina. Photograph courtesy Library of Congress, Washington, D.C.

Attending a photography exhibit at a meeting of the North Carolina Photographers' Association in Raleigh in February 1940 were photographers Henry A. Flynt of Greensboro, secretary of the organization; Broadus A. Culberson of Asheville, president; and Johnie R. Frisby of Elizabeth City, vice president. Photograph courtesy News and Observer Publishing Company, Raleigh.

SOURCES: Davidson, *Asheville, N.C. City Directory, 1883–'84*; Fuller, "Checklist of Connecticut Photographers," 124; photograph bearing Folsom's name.

FOLTZ, ANDREW J. (b. ca. 1866): native of Pa.; apprentice to unidentified photographer (1880); active 1890–1928; in Philadelphia, Pa. (1890–1891); on Market St. (later Front St.), Wilmington (1909–1928); in partnership with brother-in-law, Frederick W. Kendrick (1910–1914, 1919–1928); operated Gem Studio (1909–1910) in partnership with Fred Titmas; studio purchased by James W. Buck in 1914; probably brother of Frederick A. Foltz.

SOURCES: Hill, *City Directory of Wilmington*, 1909–1928; Thirteenth Census, 1910: New Hanover County, Pop. Sch., Wilmington, E.D. 91; *Dispatch* (Wilmington), July 1, 1911; State Auditor's Records, Sch. B; Fourteenth Census, 1920: New Hanover County, Pop. Sch., Wilmington, E.D. 97; *Bradstreet's*, 1925; Reaves list of Wilmington photographers; Ries and Ruby, *Directory of Pennsylvania Photographers*, 88; *www.familysearch.org*.

FOLTZ, FREDERICK A.: active 1919, Wilmington, in partnership with Frederick W. Kendrick; probably brother of Andrew J. Foltz.

SOURCE: Hill, *Wilmington Directory, 1919–'20.*

FORBES, DONALD HOWARD (1911–1992): active after 1940, Danville, Va.; with Belk-Leggett Department Store and Southern Studios; may have later worked at Belk-Leggett in Durham; died in Alaska.

SOURCES: Photographic Examiners Records; *www.familysearch.org.*

FORBIS, H. R.: itinerant; active 1860–1861, Hillsborough; occupied room at Masonic Hall (1860); occupied room one door west of drugstore (1861).

SOURCE: *Hillsborough Recorder*, Mar. 7, 1860, Mar. 6, 1861.

FORD, LESTER S., SR. (b. ca. 1880): native of Va.; active ca. 1910s–1930s; in High Point (1919–1920s); operated Ford Commercial Studio, Lenoir (by 1930–late 1930s); involved in accident ca. 1935, which limited his work.

SOURCES: Photographic Examiners Records; State Auditor's Records, Sch. B; Fourteenth Census, 1920: Guilford County, Pop. Sch., High Point, E.D. 159; Miller, *High Point Directory*, 1921–1927; *Bradstreet's*, 1925; Fifteenth Census, 1930: Caldwell County, Pop. Sch., Lenoir, E.D. 14-15; *Miller's Lenoir City Directory, 1939–1940.*

FORDHAM, CHARLES (1871–1940): native of N.J.; active 1899–1930s, Winston-Salem, with Farrell & Edwards (1899–1909), with Henry A. Lineback (1909–1913), with Barber's Book Store (1913–1917), with Russell & Moses (1917–1927); purchased Russell & Moses Studio in 1927; operated that studio from 1927 to ca. late 1930s.

SOURCES: Photographic Examiners Records; Vital Records, death certificates, Book 2218, p. 208 (A&H); *Winston-Salem Journal*, Oct. 8, 1940.

FOSTER, _____: itinerant; active 1859, Northampton County; in partnership with John R. Rose.

SOURCE: Northampton County Tax Records, 1858–1879, Folder 1858–1859, (A&H).

FOSTER, _____: itinerant; active 1885, Oxford; in association with Charles Campbell as Campbell, Foster & Company, Richmond, Va., 1885.

SOURCE: *Oxford Torchlight*, Apr. 7, 1885.

FOTO ART SHOP: active 1931, Raleigh; Hallie S. Siddell, operator.

SOURCES: Murray list of Wake County photographers; Hill, *Raleigh Directory*, 1931.

FOTOCRAFT: active 1938–1941, Asheville; Max K. Fell and Madelon M. Peters, managers.

SOURCE: Photographic Examiners Records.

FOUST, ORREN V. (b. ca. 1874): native of Ind.; active ca. 1895–ca. 1930s; in Concord (1902–ca. 1906); owner and operator of Foust's Studio, Wilson (ca. 1909–1930s).

SOURCES: *N.C. Year Book*, 1902, 1910–1916; *Concord City Directory*, 1902; *Mercantile Agency Reference Book*, 1904; Thirteenth Census, 1910: Wilson County, Pop. Sch., Wilson, E.D. 116; *Hill's Wilson, N.C. City Directory*, 1917, 1920, 1922– 1923, 1925, 1930; State Auditor's Records, Sch. B; 1943; *Bradstreet's*, 1917, 1925; Fifteenth Census, 1930: Wilson County, Pop. Sch., Wilson, E.D. 98-23; biographical information provided by J. Marshall Daniel, Wilson.

FOWLER, OMAR V. (b. ca. 1879): native of Md.; active 1922–1930s; in Raleigh (1922–1923); in Rocky Mount (1925–1933); in partnership with Grover C. Haynes Jr. (1932–1933); operated Fowler's Studio in association with wife, Virginia M. Fowler (1930s).

SOURCES: *Hill's Rocky Mount Directory*, 1925, 1930; Murray list of Wake County photographers; *www.familysearch.org.*

FOWLER, SAM (b. ca. 1901): native of Ky.; active by 1930, Rocky Mount.

SOURCE: Fifteenth Census, 1930: Nash County, Pop. Sch., Rocky Mount, E.D. 64-30.

FOWLER, VIRGINIA M.: active 1930s, Rocky Mount; operated Fowler's Studio in association with husband, Omar V. Fowler.

SOURCE: *Hill's Rocky Mount Directory*, 1930.

FRALEY, ROBERT E. (b. ca. 1875): native of N.C.; active 1910–1913, Mocksville.

SOURCES: Thirteenth Census, 1910: Davie County, Pop. Sch., Mocksville, E.D. 42; *N.C. Year Book*, 1910, 1911, 1913.

FRANCIS, _____: active after 1925, Leaksville; operated Francis Photography (formerly Adams Photo Studio, operated by James L. Adams).

SOURCE: Photographic Examiners Records.

FRANKLIN, ALTON WALLER (b. 1879): native of Va.; active 1905–1930; operated Franklin's Studio, Hendersonville (1905); in Mount Airy (1908); in Mitchell County (1908–1909) as itinerant, in partnership with a Mr. Hicks; in Charlotte (1908–1920s); operated Iris Studio in Charlotte (1923–1924); by 1926 Franklin's wife, Claudia, was operating her husband's studio; Franklin remained active as a photographer at least to 1930; by 1935 he had remarried and two years later was employed as a traveling salesman.

SOURCES: *N.C. Year Book*, 1905, 1909–1916; Registry of Licenses to Trade, Mitchell County, 1877–1911 (1908–1909) (A&H); State Auditor's Records, Sch. B; *Mercantile Agency Reference Book*, 1904; *Bradstreet's*, 1908, 1917, 1921, 1925; *Walsh's Directory of the City of Charlotte*, 1908–1910; Thirteenth Census, 1910: Mecklenburg County, Pop. Sch., Charlotte, E.D. 102; Miller, *Charlotte Directory*, 1911–1930; Fifteenth Census, 1930: Mecklenburg County, Pop. Sch., Charlotte, E.D. 60-9; *Hill's Charlotte Directory*, 1932–1935, 1937; information provided by Shelia Bumgarner, Public Library of Charlotte and Mecklenburg County

FRANKLIN, CLAUDIA (Mrs. A. W. Franklin) (b. ca. 1885): native of N.C.; active by 1910–1940s, Charlotte; proprietor of Franklin's Studio following the departure of her husband (ca. 1926).

SOURCES: Thirteenth Census, 1910: Mecklenburg County, Pop. Sch., Charlotte, E.D. 102; information provided by Shelia Bumgarner, Public Library of Charlotte and Mecklenburg County.

FRANKLIN, M.: active 1919, Elkin.

SOURCE: State Auditor's Records, Sch. B.

FRANKLIN, THOMAS SKINNER, JR. (b. 1905): active 1930s–1940s, Charlotte; photographer for *Charlotte News* in late 1930s; commercial photographer in association with Roy E. Tredaway (1940–1941) and postwar; operated Thomas Franklin Commercial Photography on W. Fourth St.

SOURCES: Photographic Examiners Records; *Hill's Charlotte Directory*, 1940–1941.

FRANKLIN PHOTO: active 1921–1922, Franklin.

SOURCE: State Auditor's Records, Sch. B.

FRANKLIN STUDIO: active 1935–1940s, Greensboro; Sol P. Benamy, proprietor.

SOURCES: Photographic Examiners Records; *Hill's Greensboro Directory*, 1935–1941.

FRANKS, HARRY E.: active 1911 on N. Tryon St., Charlotte, in partnership with J. Tate Powell.

SOURCE: Miller, *Charlotte Directory*, 1911.

FRAYSER, WALTER G. R.: active 1852–1905; in Petersburg, Va. (1852); in Richmond, Va. (1860–1881); in partnership with C. R. Reese (1868–1881); in Durham (1902–1905) as manager of Globe Photo Company Gallery.

SOURCES: Ginsberg, *Photographers in Virginia*, 20, 33; *N.C. Year Book*, 1902–1905.

FRAZIER, A. M.: active 1916, Hickory.

SOURCE: State Auditor's Records, Sch. B.

FREAR, W. H.: itinerant daguerreotyper; active 1848–1849, Wilmington; occupied room at Dr. Ware's office on Front St.; in Saint Augustine, Fla. (1850); in Montgomery, Ala. (1853–1856).

SOURCES: *Wilmington Journal*, Dec. 4, 1848–Jan. 7, 1849; *Ancient City* (Saint Augustine, Fla.), Jan. 26, 1850; Rinhart and Rinhart, *The American Daguerreotype*, 391; Robb list of Ala. photographers.

FREEBURGER, _____: active 1889, Wilmington, in partnership with a Mr. Willard; advertised that he would occupy Yates' Gallery on or about Apr. 8 and that he was prepared to produce photographs, oil, crayon, and pastel portraits.

SOURCES: *Messenger* (Wilmington), Mar. 31, 1889; Reaves list of Wilmington photographers.

FREEMAN, A. L.: active 1919, Asheville.

SOURCE: State Auditor's Records, Sch. B.

FREEMAN, ELISHA H. (ca. 1861–1923): native of N.C.; active 1883–1886, Wilmington; purchased gallery of Cornelius M. Van Orsdell in 1883 and secured the services of Henry Cronenberg of Columbia, S.C.

SOURCE: Reaves list of Wilmington photographers.

FREEMAN, GEORGE W.: active 1921–1928; in Lowell (1922); in Gastonia (1927–1928), in partnership with G. L. Hodge.

SOURCES: State Auditor's Records, Sch. B; *Gastonia Directory*, 1927–1928.

FREEMAN, J. R.: active (paid tax to practice) 1873–1874, Northampton County, in partnership with a Mr. Green.

SOURCES: State Auditor's Records, Sch. B, Taxes, Box 1, Folder 1873 (A&H); Northampton County Tax Records, 1858–1879, Folder 1871–1879 (A&H).

FREEZE, F. B.: active 1919, Mooresville.

SOURCE: State Auditor's Records, Sch. B.

FRENCH, JOHN A.: active 1919, New Bern.

SOURCE: State Auditor's Records, Sch. B.

FRENCH, WILLIAM C. A. (b. 1829); native of Belgium; active by 1860, Greensboro.

SOURCE: Eighth Census, 1860: Guilford County, Pop. Sch., Greensboro P.O., South Division.

FRIEDMAN, ED: active 1919, Oxford.

SOURCE: State Auditor's Records, Sch. B.

FRIER, TOM: active 1936, Fayetteville; "dime" photographer found to be operating without a license.

SOURCE: Photographic Examiners Records.

FRISBY J. ("JOHNIE") R. (b. 1896): native of N.C.; active 1916–1940s; in Marshall (1916–1919); operated Pelton Studio (1924) and Howard Studio (1927) in Asheville; operated Frisby's Studio in Elizabeth City (1933–1940s). Pictured on page 90.

SOURCES: *N.C. Year Book*, 1916; State Auditor's Records, Sch. B; Photographic Examiners Records; *Miller's Elizabeth City City Directory*, 1936–1939; *Mercantile Agency Reference Book*, 1943.

FRORWISS, M.: active 1916, Robersonville.

SOURCE: State Auditor's Records, Sch. B.

FRY, JESSE A. (b. ca. 1878): native of N.C.; active by 1910–1919; in Greensboro as outdoor photographer (by 1910); in Winston-Salem (1919).

SOURCES: Thirteenth Census, 1910: Guilford County, Pop. Sch., Greensboro, E.D. 104; State Auditor's Records, Sch. B.

FRYE, THOMAS F.: active 1937–1940s, Hay St., Fayetteville.

SOURCE: *Hill's Fayetteville Directory*, 1937–1941.

FULCHER, WARREN E. (b. ca. 1895): native of N.C.; active by 1930 at the Art Shop in Greensboro.

SOURCE: Fifteenth Census, 1930: Guilford County, Pop. Sch., Greensboro, E.D. 41-26.

FULFORD, CARL W., JR. (1920–1979): active 1939–1940, Wilmington; afterward an apprentice photographer.

SOURCES: Photographic Examiners Records; *www.familysearch.org*.

FULLER, _____: active 1928, W. Main St., Durham, under the name Venus-Fuller Studio.

SOURCE: Hill, *Durham, N.C. City Directory, 1928*.

FUNK, D. M. (b. ca. 1831): native of N.C.; active by 1860, Hendersonville.

SOURCE: Eighth Census, 1860: Henderson County, Pop. Sch., Hendersonville.

FUSHNUCAN, M.: active 1920, Salisbury.

SOURCE: State Auditor's Records, Sch. B.

G

GABRIEL, BENJAMIN (1825–1864): native of N.C.; active ca. early 1860s, Beaufort; also a silversmith and watchmaker.

SOURCES: Eighth Census, 1860: Carteret County, Pop. Sch., Beaufort; Carteret County Estates Records (A&H); Carteret County Wills (A&H); information provided by Helen Garner.

GADDY, _____: active ca. 1900; in partnership with Daniel Frank Morgan as Morgan & Gaddy, Troy.

SOURCE: photograph bearing name "Gaddy."

GADDY, MARGUERITE D. (Mrs. H. M. Gaddy) (1894–1987): active 1930s–1940s; in Raleigh (1933–1940) in association with Rufus L. Graves (1933–1935); in Charlotte (1930s and 1940s); also worked out of Charlotte in the following cities in early 1940s: Asheville, Durham, Fayetteville, Salisbury, and Winston-Salem.

SOURCES: *Hill's Charlotte Directory*, 1938–1940; *Mercantile Agency Reference Book*, 1943; Murray list of Wake County photographers; *www.familysearch.org*.

GAESSER, G. F.: itinerant; active (paid tax to practice in N.C.) 1882.

SOURCE: State Auditor's Records, Ledgers, 1869–1899, Vol. 17, p. 238 (A&H).

GALLAGHER, A. J.: formerly of Canada; itinerant; active ca. 1883–1908; in Rutherfordton (1880s); at fairgrounds in Concord (1888); in Salisbury (1888–1889); in other N.C. locations, including Lenoir and Blowing Rock

A. J. Gallagher photographed this interior view of a meeting in an unidentified public building in Salisbury about 1888. Photograph courtesy A&H.

(1888), in partnership with brothers, L. B. and W. C. Gallagher, as Gallagher Brothers; by 1889 he and his brothers contemplated reopening the Reed Gold Mine in Cabarrus County; in partnership with his brothers, particularly W. C., in about half a dozen towns in S.C. between 1888 and 1908.

SOURCES: State Auditor's Records, Ledgers, 1869–1899, Vol. 19, p. 71 (A&H); *Carolina Watchman* (Salisbury), Apr. 19, Aug. 23, Oct. 25, 1888, Feb. 28, 1889, July 25, 1889; *Standard* (Concord), Oct. 5, 1888; Teal, *Partners with the Sun*, 169–170; photograph made in Rutherfordton bearing A. J. Gallagher's name.

GALLAGHER, EDWARD F. (1888–1943): native of Ky.; active 1919–1925; operated Gallagher Commercial Studio on N. Tryon St., Charlotte; by 1925 became president of Colonial Realty Company; studio managed by Verdie L. Perrell, 1925.

SOURCES: State Auditor's Records, Sch. B; Fourteenth Census, 1920: Mecklenburg County, Pop. Sch., Charlotte, E.D. 134; Miller, *Charlotte Directory, 1920–1925.*

GALLAGHER, L. B.: formerly of Canada; itinerant; active ca. 1883–1908; in partnership with brothers, A. J. and W. C. Gallagher, as Gallagher Brothers at fairgrounds in Concord; in Salisbury (1888–1889); in Lenoir and Blowing Rock (1888); by 1889 he and his brothers expressed an interest in reopening Reed Gold Mine in Cabarrus County; employed between 1891 and 1904 by U.S. Geological Survey; probably in partnership with his brothers in several towns in S.C. between 1888 and 1908.

SOURCES: State Auditor's Records, Sch. B; *Carolina Watchman* (Salisbury), Apr. 19, Aug. 23, Oct. 25, 1888; *Standard* (Concord), Oct. 5, 1888; information provided by Sarah Robinson, Jacksonville, Fla.

GALLAGHER, W. C.: formerly of Canada; active ca. 1883–1908; worked primarily in S.C.; may have assisted his brothers in N.C. under the firm name of Gallagher Brothers in 1880s and 1890s.

SOURCE: Teal, *Partners with the Sun*, 169–170.

GALLOWAY, THOMAS K.: itinerant; active 1859–1860s; in Xenia, Ohio (1859–1860); in Asheville (n.d.); inscription "Galloway's Photographic Palace Wagon" found on reverse of carte-de-visite; advertised stereographs.

SOURCES: information provided by Tex Treadwell, Institute of Photographic Research, Bryan, Tex.; *Craig's Daguerreian Registry*, 2:212.

GALLOWMORE, W. R. (b. 1853): native of N.C.; active by 1900, near Lexington.

SOURCE: Twelfth Census, 1900: Davidson County, Pop. Sch., Lexington, E.D. 33.

GANT, M. D.: active 1916, Winston-Salem.

SOURCE: State Auditor's Records, Sch. B.

GARDNER, CHARLY D. (b. ca. 1880): native of N.C.; active by 1910, Rutherford County.

SOURCE: Thirteenth Census, 1910: Rutherford County, Pop. Sch., High Shoals Township, E.D. 138.

GARDNER, JESSE: active 1920, Wilmington.

SOURCE: State Auditor's Records, Sch. B.

GARDNER, JOHN W.: of Wilson; active 1919–1921; in Rowan County (1919); in Winston-Salem (1921).

SOURCE: State Auditor's Records, Sch. B.

GARDNER, LEROY (1866–1917): native of N.C.; active by 1910, Salisbury.

SOURCE: Thirteenth Census, 1910: Rowan County, Pop. Sch., Salisbury, E.D. 109; *www.familysearch.org.*

GARREN, O. B.: active 1916, Saluda.

SOURCE: *N.C. Year Book*, 1916.

GARRETT, F. J.: active 1919, Rockingham.

SOURCE: State Auditor's Records, Sch. B.

GARRETT, J. G.: itinerant; active 1876–1878; in Smithfield (1876), during court week; occupied room above post office, Rockingham (1876); in Rocky Mount (1877–1878), in partnership with a Mr. Pool.

SOURCES: *Johnston Courier* (Smithfield), Mar. 2, 1876; *Spirit of the South* (Rockingham), July 1, 1876; *Beveridge and Co.'s N.C. Directory, 1877–'78*, 363.

GARRICK, MAURICE: active 1919, Raleigh.

SOURCE: State Auditor's Records, Sch. B.

GASQUE, WILLIAM ARTHUR (b. ca. 1878): native of S.C.; active by 1910, 1916–1919; in Dunn (1910, 1916–1919) as manager of Carolina Photo Company (1918–1919); in Clinton (1919).

SOURCES: Thirteenth Census, 1910: Harnett County, Pop. Sch., Dunn, E.D. 65; State Auditor's Records, Sch. B; Gardiner, *Dunn, N.C. City Directory, 1918–1919.*

GASTER, JOSEPH (b. ca. 1870s): active 1908–1920s, Sanford; also farmer and stonemason.

SOURCE: *Sanford Express*, Aug. 21, 1908.

GATTIS, JAMES R.: active 1867, Hillsborough; accepted produce of all kinds in payment for photographs.

SOURCE: *Hillsborough Recorder*, Sept. 4, Dec. 11, 1867.

GAY, C. H.: active (obtained license to practice) 1886–1887, Person County.

SOURCE: Registry of Licenses to Trade, Person County, 1877–1901 (A&H).

GAY, W. R.: active 1914, Washington.

SOURCE: *N.C. Year Book*, 1914.

This view of the intersection of Pollock and Middle Streets in New Bern includes the photography establishment of Edward Gerock. The photograph was taken after a snowfall in Craven County about 1900. Photograph courtesy John R. Taylor Collection, Craven County Public Library, New Bern.

GAYLE, SIDNEY A.: active 1935, High Point.

SOURCE: Photographic Examiners Records.

GEE, CHARLES JAMES (1879–1956): native of Ark.; active 1915–1940s; near Burlington (ca. 1931–1940s); near Elmira Mills (1924–1925).

SOURCES: Photographic Examiners Records; *www.familysearch.org.*

GEM KODAK EXCHANGE: active 1940, Wilmington; Herbert A. Adams, proprietor.

SOURCE: Hill, *Wilmington Directory, 1940.*

GEM STUDIO: active 1907–1938, Wilmington; Fred Titmas, proprietor (1907–1908); Titmas in partnership with Andrew J. Foltz (1909–1910); Foltz in partnership with Frederick W. Kendrick (1911–1912); George Thaddeus Grotgen Jr., proprietor (1913–1914); studio purchased by James W. Buck in 1914; George W. Autry, proprietor (1917–1923); Lee Greer, proprietor (1924–1928); Herbert A. Adams, proprietor (1938).

SOURCES: Reaves list of Wilmington photographers; Hill, *Wilmington Directory,* 1907–1914, 1917–1919, 1922–1928, 1938; *N.C. Year Book,* 1910–1916.

GEM STUDIO: active 1925–1928, W. Martin St., Raleigh; Walter Taylor, operator (1925–1929); C. E. Smith and Walter Taylor, operators (1928).

SOURCE: Hill, *Raleigh Directory,* 1925–1928.

GENERAL PHOTO COMPANY: active 1919, Winston-Salem.

SOURCE: State Auditor's Records, Sch. B.

GENTHE, ARNOLD: active 1932; photographed house in Biltmore Forest, Asheville.

SOURCE: information provided by Carol Johnson, Library of Congress, Washington, D.C.

GEORGE, JOHN N.: active 1910s; published postcard view of Pensacola, ca. 1913.

SOURCE: postcard bearing his name.

GEROCK, EDWARD (1845–1906): native of N.C.; active from 1876 to early 1900s; in Raleigh (1876); in New Bern (1877–early 1900s); in partnership with Ignatius W. Brock (1891); Bayard Wootten apprenticed in his studio in 1905.

SOURCES: Registry of Licenses to Trade, Wake County, 1876–1877 (A&H); Tenth Census, 1880: Craven County, Pop. Sch., New Bern, Second Ward, E.D. 41; Twelfth Census, 1900: Craven County, Pop. Sch., New Bern, E.D. 50; *Beveridge and Co.'s N.C. Directory, 1877–'78,* 266; Branson, *NCBD,* 1877–1878, 1884, 1896, 1897; *Mercantile Agency Reference Book,* 1891, 1904; *Charles Emerson & Company's Newbern Directory, 1880–'81;* Hatchett & Watson, *Business Directory of the City of New Berne,* 1893; Sprange, *Blue Book,* 289; Hill, *New Bern Directory,* 1904–1905; WPA Cemetery Index (A&H); Craven County Estates Records (A&H).

GIBBS, G. I.: photographed construction of Blue Ridge Parkway, 1937–1940.

SOURCE: Blue Ridge Parkway Photograph Collection (A&H).

GIBSON, _____: itinerant; active 1882–1883; in partnership with his father, L. B. Gibson.

SOURCE: State Auditor's Records, Ledgers, 1869–1899, Vol 17, p. 238 (A&H).

GIBSON, FRANK: active 1919, Lumberton.

SOURCE: State Auditor's Records, Sch. B.

GIBSON, JESSE J. (b. ca. 1888): native of N.C.; active 1919–1930s; in Charlotte (1919); in Winston-Salem (1930); in Lincolnton (ca. 1935).

SOURCES: State Auditor's Records, Sch. B; Fifteenth Census, 1930: Forsyth County, Pop. Sch., Winston-Salem, E.D. 34–65; Photographic Examiners Records.

GIBSON, JOHN H.: of Jonesboro, Tenn.; active 1885–1890s, Asheville, in partnership with Nat W. Taylor; Gibson and Taylor produced stereographs of western N.C.

SOURCES: *Asheville Citizen*, July 6, 1885; State Auditor's Records, Ledgers, 1869–1899, Vol. 18, p. 135 (A&H); stereographs bearing his and Taylor's names.

GIBSON, L. B.: itinerant statewide; active (paid tax to practice) 1882–1883; in partnership with unidentified son.

SOURCE: State Auditor's Records, Ledgers, 1869–1899, Vol. 17, p. 238 (A&H).

GIBSON, SAM: active 1919, Winston-Salem.

SOURCE: State Auditor's Records, Sch. B.

GIBSON, W. L. P.: active 1916, Statesville.

SOURCE: State Auditor's Records, Sch. B.

GIDDINGS, A. J. P. (b. ca. 1838): native of N.C.; itinerant; active (paid tax to practice) 1872–1873; in Onslow County (1872); in Hyde County (1873); by 1880 was working as a merchant in Pender County.

SOURCES: Treasurer's and Comptroller's Records, County Settlements with the State, Boxes 52, 68 (A&H); *www.familysearch.org*.

GIER, W. M.: active (obtained license to practice) 1874–1875, Alleghany County.

SOURCE: Registry of Licenses to Trade, Alleghany County, 1874–1906 (A&H).

GILBERT, ALPHA (Mrs.): active 1938, on S. Tryon St., Charlotte.

SOURCE: *Hill's Charlotte Directory*, 1938.

GILBERT, JONATHAN TAYLOR (1884–1970): native of N.C.; active 1905–1940s; in Asheville (1905–1906) with George W. Harris; in Caroleen (ca. 1909); operated Gilbert Studio in Gastonia (by 1910–1915); in Spartanburg, S.C. (ca. 1916–1922); in Cliffside (1919–1920), in partnership with William E. Hames; in Forest City (1923–1940s).

SOURCES: Photographic Examiners Records; Thirteenth Census, 1910: Gaston County, Pop. Sch., Gastonia, E.D. 61; *N.C. Year Book*, 1910, 1913–1915; *Gastonia Directory*, 1913–1914; *Forest City Courier*, Jan. 29, Feb. 12, 1920; *Mercantile Reference Book*, 1931; *Mercantile Agency Reference Book*, 1943; information provided by Don Bailey, Etowah, N.C.; *www.familysearch.org*.

GILBERT, W. L.: active ca. 1933–1935, Fayetteville; manager, Florian Studio.

SOURCE: Photographic Examiners Records.

GILCHRIST, CHARLES A.: from Philadelphia, Pa.; active 1901; took photographs at Biltmore, near Asheville.

SOURCE: information provided by Carol Johnson, Library of Congress, Washington, D.C.

GILES, MILTON A. (b. 1872): native of N.C.; itinerant; active by 1900, Marshville.

SOURCE: Twelfth Census, 1900: Union County, Pop. Sch., Marshville Township, E.D. 138.

GILL, J. W.: active ca. 1907, Wilson.

SOURCE: photograph bearing his name.

GILLEIGER, ED F.: active 1916, Scroll (Macon County).

SOURCE: State Auditor's Records, Sch. B.

GILLESPIE, DONALD S. (1914–1999): active 1933–1940s, Elizabethtown; died in Ore.

SOURCES: Photographic Examiners Records; *www.familysearch.org*.

GILLIAM, MARY E. ANDERSON ("MAMIE") (Mrs. Thomas I. Gilliam) (1866–1941): native of N.C.; learned photography trade from a graduate of the Illinois College of Photography, who gave instruction under her own skylight; also studied under F. W. Tyler of Morganton; active ca. 1899–1930s, Morganton; also an artist; crayon and pastel work were specialties.

SOURCES: Photographic Examiners Records; Twelfth Census, 1900: Burke County, Pop. Sch., Morganton, E.D. 15; *Morganton Herald*, July 19, 1900; *N.C. Year Book*, 1906–1916; *Mercantile Agency Reference Book*, 1904; *Bradstreet's*, 1908, 1917; Fifteenth Census, 1930: Burke County, Pop. Sch., Morganton, E.D. 12-15; State Auditor's Records, Sch. B; Phifer, *Burke County*, 301; Vital Records, death certificates, Book 2299, p. 221 (A&H).

GILMORE, JOHN THOMAS (b. 1892): active in N.C., 1937, with Underwood & Underwood of Washington, D.C.

SOURCE: Photographic Examiners Records.

GINSBURG, HENRY: active ca. 1918, Camp Greene; associated with Newark Photo Company, Newark, N.J.; received permission to take photographs at the camp.

SOURCES: National Army Camps, Camp Greene, Charlotte, N.C., RG 393, Box 20, National Archives; information provided by Jane Johnson, Charlotte.

GLADDEN, JOHN G.: itinerant maker of ambrotypes; active 1859–1860; occupied gallery above Trotter's jewelry store, Charlotte (1859); in Columbia, S.C. (1859–1860).

SOURCES: *Western Democrat* (Charlotte), May 3, 1859; *Craig's Daguerreian Registry*, 2:220.

GLASS, J. W. (b. ca. 1830): native of Va.; itinerant; active 1850, Washington; occupied rooms in house next to Potts' store on Main St.

SOURCES: *North State Whig* (Washington), May 1, Nov. 13, 1850; Seventh Census, 1850: Beaufort County, Pop. Sch., Washington.

GLAZE, J. WILL (ca. 1863–1929): native of Ohio; active 1883–1922; in Marysville, Ohio (1883–1884); in Beaufort (1910–1916); in Morehead City (1920–1922); in partnership with a Mr. Phelps (1921–1922).

SOURCES: Gagel, *Ohio Photographers*, 60; *N.C. Year Book*, 1910–1916; State Auditor's Records, Sch. B; Fourteenth Census, 1920: Carteret County, Pop. Sch., Morehead City, E.D. 3; Vital Records, death certificates, Book 1346, p. 416 (A&H).

GLAZENER, J. RILEY (b. ca. 1839): native of N.C.; active by 1880–1916; in Pickens, S.C. (1880); in Laurens, S.C. (1885); in Easley, S.C. (1886, 1898, 1900); in Mars Hill, N.C. (1916) in partnership with a Mr. Gregory as Gregory and Glazener.

SOURCES: Teal, *Partners with the Sun*, 201; *N.C. Year Book*, 1916; *www.familysearch.org*.

GLENN, G. EVAN (b. ca. 1902): native of N.C.; active 1928–1930, Gastonia; 1930 census lists him as owner of a job-printing firm.

SOURCES: Photographic Examiners Records; Fifteenth Census, 1930: Gaston County, Pop. Sch., Gastonia, E.D. 22.

GLENN, JUNE, JR.: active 1930s–1940s, Black Mountain; with J. C. Wolcott until 1940; as sole proprietor after 1941.

SOURCE: Photographic Examiners Records.

GLOBE PHOTO COMPANY (GALLERY): active 1901–1905; E. Main St., Durham; operated by Walter G. R. Frayser.

SOURCES: *N.C. Year Book*, 1902–1905; Adams, *Directory of Greater Durham, 1902*.

GODDARD, W. M.: active ca. 1912; credited with real-photo postcard of public school at Southern Pines.

SOURCE: postcard bearing his name.

GODWIN, CARLINE (b. ca. 1888): native of N.C.; active by 1930, Asheville.

SOURCE: Fifteenth Census, 1930: Buncombe County, Pop. Sch., Asheville, E.D. 11-10.

GOLDBERG, A.: active 1919, Charlotte.

SOURCE: State Auditor's Records, Sch. B.

GOLDCRAFT PORTRAITS, INC. (STUDIOS): of Washington, D.C.; active early 1940s in Charlotte, Durham (Kenneth D. Petrey, operator), Raleigh, Winston-Salem.

SOURCE: Photographic Examiners Records.

GOLDENBURG, LOUIS: active 1919–1921; in Elizabeth City (1919); in Rowan County (1921).

SOURCE: State Auditor's Records, Sch. B.

GOLDIE, H.: active ca. 1918, Camp Greene; associated with Newark Photo Company, Newark, N.J.; received permission to take photographs at the camp.

SOURCES: National Army Camps, Camp Greene, Charlotte, N.C., RG 393, Box 20, National Archives; information provided by Jane Johnson, Charlotte.

GOLDSTON STUDIO: active early 1900s, Goldston (Chatham County).

SOURCE: photograph bearing studio name.

GOODALE, I. E.: active ca. 1912–1913, Southern Pines; sold studio to Ellsworth C. Eddy in 1913.

SOURCES: Handwritten journal of E. C. Eddy in possession of Ellennore Eddy Smith, Southern Pines; postcards in Sandhills area bearing his name.

I. E. Goodale published many postcard views of the Sandhills area, including this one of the Jefferson Inn in Southern Pines about 1906. Courtesy of the compiler.

GOODE, W. C.: active 1884–1889; in Newton (1884) in gallery located in old bowling alley on Haynes' lot; in Lincolnton (1889) in gallery located on North Corner Square, in Colonel Hoke's old office; left Lincolnton about Nov. 25, 1889.

SOURCES: *Newton Enterprise*, Jan. 26, 1884; *Lincoln Courier* (Lincolnton), Mar. 22, Nov. 8, 1889.

GOODMAN, H. A.: itinerant statewide; active (paid tax to practice) 1883–1884.

SOURCE: State Auditor's Records, Ledgers, 1869–1899, Vol. 17, p. 440 (A&H).

GOODMAN, J. H.: active 1916, Salisbury.

SOURCE: State Auditor's Records, Sch. B.

GOODRAIN, S. C.: active 1916, Durham.

SOURCE: State Auditor's Records, Sch. B.

GOODRICH, RAY WILKES (1900–1975): native of Va.; active ca. 1920–1960s; head of department of industrial photography at E. I. DuPont de Nemours and Company (n.d.); in Durham (1920) with Waller Holladay (briefly); in Henderson (1920–1940s) as Goodrich Studio; in Winston-Salem (1940–1960s); purchased studio of Ben V. Matthews in 1940; helped to create and served as member of the State Board of Photographic Examiners (in operation from 1935 to 1949); president, American Society of Photographers.

SOURCES: Photographic Examiners Records; State Auditor's Records, Sch. B; Fifteenth Census, 1930: Vance County, Pop. Sch., Henderson, E.D. 91-3; *Mercantile Reference Book*, 1931; *Mercantile Agency Reference Book*, 1943; *Miller's Henderson City Directory*, 1938–1941; Vital Records, death certificates, Forsyth County (A&H); *Journal* (Winston-Salem), July 23, 1975; *Henderson Daily Dispatch*, July 23, 1975.

GOODWIN, CHARLES: active 1918, Asheville.

SOURCE: Miller, *Asheville, N.C. City Directory, 1918*.

GOODWIN, E. D.: active 1919, Raleigh.

SOURCE: State Auditor's Records, Sch. B.

GOODWIN, JOHN H.: active 1917–1919; in Durham (1917) in partnership with Gurney I. Hightower; in Raleigh (1919).

SOURCES: *Bradstreet's*, 1917; State Auditor's Records, Sch. B.

GORDON, _____: itinerant; active 1852, Salisbury, in partnership with a Mr. Baker; gallery located upstairs in Rowan County Courthouse.

SOURCE: *Carolina Watchman* (Salisbury), Sept. 2, 1852.

GORDON, FRANK (b. 1873): native of Ind.; active by 1900, Asheville.

SOURCE: Twelfth Census, 1900: Buncombe County, Pop. Sch., Asheville, E.D. 133.

GORDON, JACK (b. 1906): with Chidnoff Studio of New York City; active after 1937, Durham.

SOURCE: Photographic Examiners Records.

GORRELL, HENRY CLAY (ca. 1838–1862): native of N.C.; active 1858, Greensboro; gallery located in rooms formerly occupied by Alexander Starrett on second floor of Garrett's brick building on W. Market St.; also in partnership with a Mr. Scott; enlisted Apr. 20, 1861, as a private in Company C, Twenty-seventh Regiment, N.C. State Troops; killed in action near Richmond, June 21, 1862.

SOURCES: *Patriot and Flag* (Greensborough), Mar. 5, Apr. 30, 1858, *Greensborough Patriot*, Sept. 25, 1858; Manarin and Jordan, *N.C. Troops*, 3:421, 8:24.

GOTTSCHO-SCHLEISNER, INC.: active 1940; photographed a residence in Southern Pines.

SOURCE: information provided by Carol Johnson, Library of Congress, Washington, D.C.

GOWDY, M. B.: active 1907–1908; near Beaufort (1907); in Edenton (1908); operated Gowdy Studio.

SOURCES: postcard bearing his name; *Bradstreet's*, 1908; Herbert H. Brimley Photograph Collection (N.C. Dept. of Agriculture, N.C. Museum of Natural Sciences).

GOWER, HARRY W.: active 1907; photographed Masonic temple at Halifax.

SOURCE: information provided by Carol Johnson, Library of Congress, Washington, D.C.

GRAGG, WALTER BINGHAM (1883–1964): native of N.C.; active 1899–1940s; began business at Bee Tree, Buncombe County (1899); in Black Mountain periodically between 1904 and 1940s (erected new studio there in 1927); in Asheville (1908); in Lumberton (1910) in partnership with Miss Lillian A. Ferguson; in Darlington, S.C. (1924–1925); in Deland, Fla. (n.d.).

SOURCES: *Bradstreet's*, 1908; photograph bearing names of Gragg and Ferguson; *N.C. Year Book*, 1913–1916; State Auditor's Records, Sch. B; Teal, *Partners with the Sun*, 262; *Asheville Citizen*, June 9, 1964; information provided by staff of Pack Memorial Public Library, Asheville.

GRAHAM, H. J.: active 1912, Asheville.

SOURCE: Miller, *Asheville, N.C. City Directory, 1912*.

GRANT, _____: active ca. 1905–1906, Edenton.

SOURCE: photograph bearing name "Grant," N.C. Museum of History Photograph Collection (A&H).

GRANT, HARVEY SIMEON (1906–1980): active 1937–1940s; in Swannanoa (1937–1941); in Asheville after 1941; died in Ga.

SOURCES: Photographic Examiners Records; *www.familysearch.org*.

Walter B. Gragg erected this studio at Black Mountain in 1927. He equipped it to handle high-class portrait work, as well as commercial and amateur finishing jobs. Postcard courtesy Durwood Barbour, Raleigh.

GRANT, JOHN LEWIS (1864–1942): active early 1900s; in New Bern (1905–1906) in partnership with Bayard Wootten; in Grantsboro (1908); also employed as lumber trucker and worked at odd jobs.

SOURCES: *Pamlico County 100 Years, 1872–1972*, 111; Willis, *Pamlico County, North Carolina Cemeteries*, 79; Twelfth Census, 1900: Pamlico County, Pop. Sch., Grantsboro, E.D. 85; Thirteenth Census, 1910: Pamlico County, Pop. Sch., Grantsboro, E.D. 65; information provided by Jerry Cotten, North Carolina Collection, Wilson Library, University of North Carolina at Chapel Hill (UNC-CH).

GRANT, RUSSELL JACKSON (1899–1972): active 1933–1940s, Roanoke Rapids; operated Grant's Studio.

SOURCES: Photographic Examiners Records; *Miller's Roanoke Rapids City Directory, 1938–1939*; *www.familysearch.org*.

GRASCH, OSCAR (b. 1868): native of Germany; active by 1900, Rockingham; boarded with photographer John E. Spencer.

SOURCE: Twelfth Census, 1900: Richmond County, Pop. Sch., Rockingham, E.D. 88.

GRAVES, RUFUS L. (1896–1978): active 1933–1940s; in Raleigh (1933–1935) with Marguerite D. Gaddy; in Durham (1940–1941) with Baldwin's Department Store.

SOURCES: Photographic Examiners Records; *www.familysearch.org*.

GREEN, _____: itinerant; active (paid tax to practice) 1873–1874, Northampton County; in partnership with J. R. Freeman.

SOURCES: State Auditor's Records, Sch. B, Taxes, Box 1, Folder 1873 (A&H); Northampton County Tax Records, 1858–1879, Folder 1871–1879 (A&H).

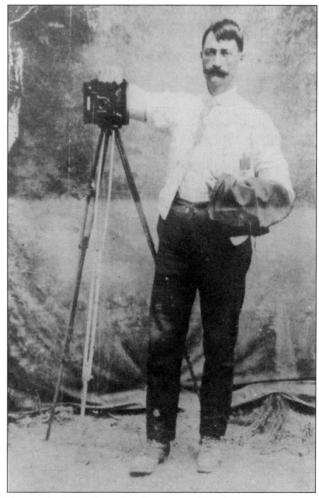

Photographer John L. Grant of Pamlico County is shown here with his camera atop a tripod about 1908. Photograph courtesy A&H.

GREEN, _____: active ca. 1920s, Durham, in partnership with a Mr. Poteat.

SOURCE: envelope (containing negatives) bearing name "Green."

GREEN, CHARLES F.: active ca. 1910s–1920s, Wilmington; proprietor of Green's Drugstore, which included a camera department and photo-finishing service.

SOURCE: New Hanover County Wills (A&H).

GREEN, FRED E.: active 1919, Shelby.

SOURCE: State Auditor's Records, Sch. B.

GREEN, JOHN I. (1872–1970): native of N.C.; active 1899–1940; in Gaffney, S.C. (1899–1902); in Gastonia, N.C. (1903–1911) in partnership with William E. Hames (1906–1908); Mrs. M. H. Curry purchased Green's Gastonia studio in 1911; in Anderson, S.C. (1915–1940), periodically in partnership with W. E. Hames; died in S.C.

SOURCES: Teal, *Partners with the Sun*, 196–197; *N.C. Year Book*, 1904–1907, 1910–1911; *Bradstreet's*, 1908; Thirteenth Census, 1910: Gaston County, Pop. Sch., Gastonia, E.D. 59; *Gastonia Directory*, 1910–1911; www.familysearch.org.

GREEN STUDIO: active 1921, Charlotte; R. H. Beasley, operator.

SOURCE: State Auditor's Records, Sch. B.

GREENE, WALTER LEITH (1898–1962): native of N.C.; apprenticed under Lloyd E. Webb; active ca. 1915–1940s, Morganton; operated Greene's Studio in association with William A. Harbison Jr. (1937–1940).

SOURCES: Photographic Examiners Records; Fifteenth Census, 1930: Burke County, Pop. Sch., Morganton, E.D. 12-15; *Miller's Morganton City Directory*, 1939–1942; *Mercantile Agency Reference Book*, 1943; www.familysearch.org.

GREENVILLE STUDIO: active 1916–1917, Greenville: John W. Shaw, proprietor.

SOURCE: Miller, *Greenville, N.C. City Directory, 1916–1917*.

GREENWOOD, N. M.: active 1880s–1907, Elkin; made tintypes as early as the 1880s.

SOURCE: *N.C. Year Book*, 1902–1907.

GREER, LEE (1870–1943): native of N.C.; active mid-1890s–early 1940s; apprenticed under Urchie C. Ellis (1894); in Greenville, S.C. (1897–1898); in Chapel Hill (by 1900); operated Greer Studio and Gem Studio (1924–1928) in Wilmington (early 1900s–1940); in Charleston, S.C. for six months (1907); also operated studio in Atlanta (n.d.).

SOURCES: Photographic Examiners Records; *Star* (Wilmington), Apr. 30, 1907, June 24, 1943; *Dispatch* (Wilmington), Oct. 30, 1907; Teal, *Partners with the Sun*, 199; Twelfth Census, 1900: Orange County, Pop. Sch., Chapel Hill, E.D. 67; Fourteenth Census, 1920: New Hanover County, Pop. Sch.,

Wilmington, E.D. 97; *N.C. Year Book*, 1903–1916; Hill, *City Directory of Wilmington*, 1905–1906, 1909–1912, 1917–1928, 1930–1934, 1940; State Auditor's Records, Sch. B; *Mercantile Reference Book*, 1931; *Mercantile Agency Reference Book*, 1943; *News and Observer* (Raleigh), June 23, 1943.

GREER, THOMAS: active 1916–1920, Kinston.

SOURCE: State Auditor's Records, Sch. B.

GREGORY, _____: active 1916, Mars Hill, perhaps in partnership with J. Riley Glazener.

SOURCE: *N.C. Year Book*, 1916.

GRENELL, C. E.: active 1933–1940s, Lake Junaluska; operated Grenell Studio.

SOURCE: Photographic Examiners Records.

GRIFFIN, _____: itinerant daguerreotyper in partnership with Dr. George H. Weeks; active 1851; in Farmville, Va. (Jan. 1851); in Raleigh (Feb.–May 1851), where they operated a "locomotive daguerrean gallery" at rear of Pomeroy & O'Neal's bookstore and later moved to courthouse square; in Greensboro (Mar.–May 1851), where they operated a "sky-light gallery" at Col. William Gott's Hotel; in Salisbury (ca. May–July 1851), where they produced "ivory daguerreotypes."

SOURCES: *Raleigh Register* (weekly), Feb. 12, May 10, 1851; *Raleigh Register* (semi-weekly), May 7, 10, 1851; *Greensborough Patriot*, Mar. 10, 1851; *Carolina Watchman* (Salisbury), Apr. 17, May 22, 1851.

GRIFFITH, THOMAS LEE (b. 1892): active by 1941 at Camp Davis Marine Barracks, New River.

SOURCE: Photographic Examiners Records.

GRIMES, GEORGE WASHINGTON (1837–1906): native of Va.; active 1870s–early 1900s; in Henderson and Murfreesboro (1870s) in partnership with A. F. Harrell; in Murfreesboro (1880s–early 1900s) as sole proprietor; also dealer in furniture, sewing machines, carpeting, and groceries in Murfreesboro; portrait on file at N.C. Office of Archives and History.

SOURCES: photograph bearing names of Grimes and Harrell; *Murfreesboro Index*, Apr. 29, 1887, Sept. 20, 1889; Ginsberg, *Photographers in Virginia*, 24; Sprange, *Blue Book*, 289; Cotten list of N.C. photographers; Stephenson, *Murfreesboro, North Carolina*, 38.

GRIMES, N. M.: active 1935, Asheville.

SOURCE: Photographic Examiners Records.

GRINDSTAFF, W. A.: active 1916, Robbinsville.

SOURCE: State Auditor's Records, Sch. B.

GROSE, _____: active 1935, Harmony, in partnership with C. A. Grose as Grose & Brother.

SOURCE: Photographic Examiners Records.

Shown here is a formal portrait of George W. Grimes, who was engaged in several professions, including photography, in Murfreesboro. Photograph courtesy A&H.

GROSE, C. A.: active 1935, Harmony, in partnership with unidentified brother as Grose & Brother.

SOURCE: Photographic Examiners Records.

GROTGEN, GEORGE THADDEUS, JR. (ca. 1890–1938): native of N.C.; active 1913–1914, Wilmington; operated the Gem Studio.

SOURCES: Hill, *City Directory of Wilmington, 1913–1914*; Reaves list of Wilmington photographers.

GROVE, R. L.: active 1935, Raleigh, with Boylan-Pearce Company.

SOURCE: Photographic Examiners Records.

GROVE, V. O.: active 1919, Fayetteville.

SOURCE: State Auditor's Records, Sch. B.

GRUBB, S. FARRIS: active 1908–1911, High Point.

SOURCE: Miller, *High Point Directory*, 1908, 1910–1911.

GRUBB, WALTER C. (b. 1867): native of N.C.; active by 1900–1916, Yadkin College.

SOURCES: Twelfth Census, 1900: Davidson County, Pop. Sch., Yadkin College, E.D. 36; *N.C. Year Book*, 1902, 1905–1907, 1910, 1911, 1913, 1914, 1916.

GRUBB, WILSON C. (b. 1852): native of N.C.; active by 1900–1908; in Davidson County (by 1900); in High Point (1908).

SOURCES: Twelfth Census, 1900: Davidson County, Pop. Sch., High Point, E.D. 28; Miller, *High Point Directory*, 1908.

GRUEHN, EDWARD L. K. (1909–1981): active 1938–1940s; with Denmark Studio, Raleigh (1938); sole proprietor of Denmark Studio (1939); in partnership with artists Blanche M. Davis and later Dorothy Hooks, Smithfield (1939); in Wilmington (after 1940 and postwar) in partnership with Fred Wolfe as Wolfe-Gruehn Studio (with slogan "In the Modern Manner"); died in Fla.

SOURCES: Photographic Examiners Records; Hill, *Wilmington City Directory, 1940*; *Star* (Wilmington), Dec. 1, 1940; Reaves list of Wilmington photographers; *www.familysearch.org*.

GULICK, JOHN W. (b. ca. 1827): native of N.J.; itinerant daguerreotyper; active 1851–1866; in Wilmington (1851–1852); occupied gallery in Mozart Hall, northwest of Hart & Polley's store on Front St.; second location above Hart & Polley's store on Front St.; took pictures of deceased or sick persons at their dwellings; offered instructions in the art; in Cincinnati, Ohio (1865–1866); employed as a butcher in Cincinnati, Ohio, in 1880.

SOURCES: *Wilmington Journal*, Mar. 14, 1851, Jan. 16, Apr. 9, 1852; Gagel, *Ohio Photographers*, 62; *www.familysearch.org*.

GURLEY, ROBERT W.: active 1902–1909, Asheville.

SOURCES: Hill, *City Directory of Asheville*, 1902–1903, 1906–1907; Miller, *City Directory of Asheville*, 1909; *Bradstreet's*, 1908.

GUTKES, J.: active (obtained license to practice) 1917–1918, Durham.

SOURCE: Record of Special Licenses Issued, Durham County, 1917–1918 (A&H).

GWYN, LILL: active 1916, West Jefferson.

SOURCE: State Auditor's Records, Sch. B.

H

H. C. WHITE COMPANY: active early twentieth century; headquartered in North Bennington, Vt.; publisher of stereoscopic views.

SOURCES: Darrah, *World of Stereographs*, 52; stereographs bearing company name.

H & N STUDIO: active 1918, E. Trade St., Charlotte.

SOURCE: Miller, *Charlotte Directory*, 1918.

H & P STUDIO: active ca. 1920s, Charlotte; Charles Franklin Harrison and M. Luther Philemon, operators.

SOURCE: information provided by Shelia Bumgarner, Public Library of Charlotte and Mecklenburg County.

HAAS, ROBERT (b. 1898): Viennese photographer; served as resident photographer at Black Mountain College (1940).

SOURCE: Harris, *The Arts at Black Mountain College*, 28, 267.

HACKNEY AND MOALE COMPANY: active 1909; photographed Connemara (home of Carl Sandburg), Flat Rock.

SOURCE: information provided by Carol Johnson, Library of Congress, Washington, D.C.

HAGE, JOHN E.: active 1904–1920; in Goldsboro (1904–1905) in partnership with Albert O. Clement; in Asheville (1910–1920) in partnership with Henry C. Koonce (1910–1914) and with Ignatius W. Brock (1920).

SOURCES: Miller, *Asheville, N.C. City Directory*, 1910, 1920; *N.C. Year Book*, 1911–1914; information provided by staff of Pack Memorial Public Library, Asheville.

HAIGHT, B. F.: active 1857–1876; in Petersburg, Va. (1857), in partnership with a Mr. Wevere; on Main St. near Church St., Durham (1875–1876).

SOURCES: *Weldon Patriot*, May 7, 1857; *Chataigne's Raleigh Directory*, 1875, 167.

HALE, THOMAS N. (b. 1868): native of Tenn.; active 1900–1914; in Lincolnton by 1900 and periodically through 1914; in association with J. W. Bailey as Hale and Bailey (early 1900s); in Monroe (1908–1913).

SOURCES: Twelfth Census, 1900: Lincoln County, Pop. Sch., Lincolnton, E.D. 111; *Bradstreet's*, 1908; Thirteenth Census, 1910: Union County, Pop. Sch., Monroe, E.D. 129; photograph bearing names of Hale and Bailey; *N.C. Year Book*, 1910, 1911, 1913, 1914.

HALES, JOHN ERNEST (b. 1902): active 1929–1940s; in Charlotte (1929–1940s); with Long's Studio, Asheville (briefly, 1934).

SOURCE: Photographic Examiners Records.

HALL, _____: active 1917–1924, Raleigh, in partnership with John P. Hayes.

SOURCE: *Bradstreet's*, 1917, 1921, 1925.

HALL, A. B.: active 1888–1889, Murphy.

SOURCE: *Murphy Advance*, June 7, 1889.

HALL, A. P.: active 1905, Statesville.

SOURCE: information provided by Jerry R. Roughton, Kenansville.

HALL, F. S.: active 1919, Davidson.

SOURCE: State Auditor's Records, Sch. B.

HALL, JUNIUS (b. 1880): native of N.C.; active by 1900, Durham.

SOURCE: Twelfth Census, 1900: Durham County, Pop. Sch., Durham, E.D. 32.

HALL, WALTER: active 1916, Hayesville; also a teacher.

SOURCE: State Auditor's Records, Sch. B.

HALLIS, W. J.: active 1919, Wilmington.

SOURCE: State Auditor's Records, Sch. B.

HALPERT, CARL: active ca. 1918, Camp Greene; associated with Newark Photo Company, Newark, N.J.; received permission to take photographs at the camp.

SOURCES: National Army Camps, Camp Greene, Charlotte, N.C., RG 393, Box 20, National Archives; information provided by Jane Johnson, Charlotte.

HALPIN, H. N.: active 1921, West Durham.

SOURCE: State Auditor's Records, Sch. B.

HAM, _____: active 1907–1922, Crumpler (Ashe County) and Jefferson, in partnership with Poindexter Blevins.

SOURCE: State Auditor's Records, Sch. B.

HAMBRICK, JOHN T.: active late 1860s, Thomasville; also worked as jeweler.

SOURCES: Branson, *NCBD*, 1867–1868, 1869.

HAMES, WILLIAM EDGAR (b. ca. 1880): native of N.C.; active early 1900s–1930s; in Caroleen (1903) as photographer and dealer in watches; gallery located next door to Caroleen Store; in Gastonia (1906–1908) in partnership with John I. Green; periodically in Cliffside (1910–1920) as proprietor of Hames' Studio (in partnership in Jonathan T. Gilbert, 1919–1920); in Monroe as itinerant (by 1910); in Monroe (1914–1916); in Lincolnton (1916); in Anderson, S.C. (1920–1930) in partnership with John I. Green.

SOURCES: *Rutherfordton Sun*, Apr. 19, 1903; *N.C. Year Book*, 1906, 1907, 1914–1916; *Bradstreet's*, 1908; Thirteenth Census, 1910: Rutherford County, Pop. Sch., High Shoals Township, E.D. 136; Thirteenth Census, 1910: Union County, Pop. Sch., Monroe, E.D. 130; *Forest City Courier*, Jan. 29, Feb. 12, 1920; State Auditor's Records, Sch. B; Teal, *Partners with the Sun*, 218; information provided by Don Bailey, Etowah, N.C.

HAMILTON, JAMES W. (b. ca. 1874): native of N.C.; active by 1900, Concord.

SOURCE: Twelfth Census, 1900: Cabarrus County, Pop. Sch., Concord, Township #12, E.D. 23.

HAMLET, EDWARD LEE: active 1919, Micro.

SOURCE: State Auditor's Records, Sch. B.

HAMMOND, S. H. (b. ca. 1829): native of N.Y.; itinerant daguerreotyper; active 1853, New Bern; skylight gallery located on Craven St.; previously operated gallery in New York City.

SOURCES: *Newbernian and North Carolina Advocate*, Jan. 11, 1853; *Weekly News* (New Bern), Feb. 5, 1853; *www.familysearch.org*.

HAMPTON, C. M.: active 1923–1930, Gastonia; operated Hampton's Studio.

SOURCES: *Gastonia Directory*, 1923–1924; *Mercantile Reference Book*, 1931; photograph bearing his name.

HANCOCK, LUCY W. (b. ca. 1890): native of N.C.; active by 1910, Durham.

SOURCE: Thirteenth Census, 1910: Durham County, Pop. Sch., Durham, E.D. 40.

HANES, GIDEON ISAAC (1898–1986): active ca. 1930–late 1940s, Winston-Salem.

SOURCES: Photographic Examiners Records; *www.familysearch.org*.

HANES, LEWIS FRANCIS ("FRANK") (b. ca. 1869): native of N.C.; active 1902–1917, on S. Elm St., Greensboro.

SOURCES: *N.C. Year Book*, 1902–1907, 1910–1916; *Mercantile Agency Reference Book*, 1904; *Bradstreet's*, 1908, 1917; State Auditor's Records, Sch. B; Hill, *Greensboro, N.C. Directory*, 1903–1910, 1912–1913, 1915–1917; Thirteenth Census, 1910: Guilford County, Pop. Sch., Greensboro, E.D. 110; biographical sketch in files of Greensboro Public Library; *www.familysearch.org*.

HANKINS, THOMAS: active 1860 as daguerreotyper in Norfolk, Va., in partnership with T. W. Clark (n.d.); operated one of the largest galleries in the state.

SOURCES: *Albemarle Southern* (Murfreesboro), Apr. 5, 1860; Ginsberg, *Photographers in Virginia*, 17.

HANSLEY, THOMAS S. (b. ca. 1837): native of N.C.; active 1867–1869, Wilmington (1867–1868), in gallery located at corner of Market and Second Streets; gallery purchased by Charles W. Yates of Greensboro in Apr. 1868; in Smithville (1867–1869); employed as a showman in Mich. in 1880.

SOURCES: Branson, *NCBD*, 1867–1868, 1869; Reaves list of Wilmington photographers; *www.familysearch.org*.

HARBISON, WILLIAM ALEXANDER, JR. (b. 1909): active 1937–1940s; operated Greene Studio, Morganton, in association with Walter Greene (1937–1940); later (1940–1942) operated The Photo Shop.

SOURCES: Photographic Examiners Records; *Miller's Morganton City Directory*, 1941–1942.

HARDEN, CHARLES THOMAS (1845–1896): active 1866–1890s; in Beaufort (1866–1867); in Windsor (1875–1890s); also jeweler, watchmaker, machinist, cotton manufacturer, silversmith, dry goods salesman, and real estate dealer; built the steamer *Bertie* in 1872; served several terms as mayor of Windsor.

SOURCES: *Branson & Farrar's NCBD*, 1866–1867; Ninth Census, 1870: Bertie County, Pop. Sch., Windsor; *Zell's U.S. Business Directory*, 1875; *Mercantile Agency Reference Book*, 1875, 1878; *Windsor Public Ledger*, Oct. 19, 1887; *Reference Book of the Mercantile Association of the Carolinas*, 1889–1892; *Windsor Ledger*, Nov. 5, 1896; Bertie County Estates Records (A&H).

HARDIN, CHARLES M. (ca. 1868–1940): native of Tenn.; active ca. 1886–1940; at unidentified locations (ca. 1886–1900); in Kings Mountain (1894); in Hickory (1900–1940); first studio on Thornton Ave., later located on Union Square; father of Kathryn H. Whitener.

SOURCES: *N.C. Year Book*, 1902–1916; Thirteenth Census, 1910: Catawba County, Pop. Sch., Hickory, E.D. 25; State Auditor's Records, Sch. B; *Bradstreet's*, 1917, 1921, 1925; Miller, *Hickory, N.C. City Directory*, 1925–1926, 1928–1931, 1937–1938; Fifteenth Census, 1930: Catawba County, Pop. Sch., Hickory, E.D. 18-11; *Mercantile Reference Book*, 1931; *Hickory, N.C. City Directory*, 1935; Photographic Examiners Records; *News and Observer* (Raleigh), July 23, 1940.

HARDIN, F. B.: active 1919, Huntersville.

SOURCE: State Auditor's Records, Sch. B.

HARDY, EARL F. (b. ca. 1889): native of Ill.; active 1919–1924; operated Hardy Studio, Lenoir.

SOURCES: State Auditor's Records, Sch. B; Fourteenth Census, 1920: Caldwell County, Pop. Sch., Lenoir, E.D. 67; *Bradstreet's*, 1921, 1925.

HARDY, IRA MAY (1874–1948): native of N.C.; active ca. 1908, Washington.

SOURCES: photograph bearing his name; *www.familysearch.org*.

HARDY, J. H.: active 1919, Woodland (Northampton County).

SOURCE: State Auditor's Records, Sch. B.

HARDY, W. C.: active 1919, Woodland.

SOURCE: State Auditor's Records, Sch. B.

HARE, JAMES H.: active ca. 1918, Camp Greene; associated with *Leslie's Weekly*; received permission to take photographs at the camp.

SOURCES: National Army Camps, Camp Greene, Charlotte, N.C., RG 393, Box 20, National Archives; information provided by Jane Johnson, Charlotte.

HARGETT, J. H.: active 1910–1911, Kinston; operated Hargett's Studio.

SOURCE: *N.C. Year Book*, 1910, 1911.

HARMAN, W.: active 1919–1920, New Bern.

SOURCE: State Auditor's Records, Sch. B.

HAROLD, L. C.: active 1916, Franklinton.

SOURCE: State Auditor's Records, Sch. B.

HARPER, IRA. GRISSOM (1887–1972): native of N.C.; active ca. 1913–late 1940s, Deep Run (Lenoir County).

SOURCES: Photographic Examiners Records; *www.familysearch.org*.

HARRELL, A. F.: active ca. early 1870s, Gatesville, Henderson, and Murfreesboro, in partnership with George W. Grimes.

SOURCE: photographs bearing names of Harrell and Grimes.

HARRELL, ALFRED FRANKLIN (1894–1942): native of N.C. or Va.; active 1916–1940s; in Goldsboro (ca. 1916–1917); operated Harrell's Ideal Studio, Main St., Rocky Mount (1910s–1940s); member, State Board of Photographic Examiners; father of Alfred Franklin Harrell Jr. and brother of Benjamin Franklin Harrell.

SOURCES: Photographic Examiners Records; Gardiner, *Goldsboro, N.C. City Directory, 1916–1917*; State Auditor's Records, Sch. B; Fourteenth Census, 1920: Edgecombe County, Pop. Sch., Rocky Mount, E.D. 19; *Mercantile Reference Book*, 1931; *Mercantile Agency Reference Book*, 1943; *News and Observer* (Raleigh), Aug. 26, 1942.

HARRELL, ALFRED FRANKLIN, JR. (1921–1983): active late 1930s–1940s; operated in Wilson a branch of his father's business, Harrell's Ideal Studio of Rocky Mount; served in U.S. Army, early 1940s; son of Alfred Franklin Harrell and nephew of Benjamin Franklin Harrell.

SOURCES: Photographic Examiners Records; information provided by Guy Cox, Wilson; *www.familysearch.org*.

HARRELL, BENJAMIN FRANKLIN (1888–1959): active 1909–1940s, Greensboro; operated Harrell's Cute Studio and Harrell's Studio; brother of Alfred Franklin Harrell and uncle of Alfred F. Harrell Jr.

SOURCES: Photographic Examiners Records; State Auditor's Records, Sch. B; *Mercantile Reference Book*, 1931; *Mercantile Agency Reference Book*, 1943; Hill, *Greensboro, N.C. City Directory*, 1918–1923, 1928–1941; *www.familysearch.org*.

HARRELL, FRED F.: active 1925–1934, Rocky Mount; associated with Harrell Studio.

SOURCE: *Hill's Rocky Mount Directory*, 1925, 1930, 1934.

HARRELL, WALTER LAFAYETTE (1882–1969): native of N.C.; active 1912–1940s; in Charleston, S.C. (1912–1926); in Winston-Salem (ca.1926–1940s).

SOURCES: Photographic Examiners Records; *Bradstreet's*, 1925; Fifteenth Census, 1930: Forsyth County, Pop. Sch., Winston-Salem, E.D. 34-24; *Mercantile Agency Reference Book*, 1943; Teal, *Partners with the Sun*, 225; *www.familysearch.org*.

HARRINGTON, M. B.: active ca. early 1900s, Scotland Neck.

SOURCE: photograph bearing his name.

HARRINGTON, P. G.: active 1916–1919; in Lillington (1916); in Angier (1919).

SOURCE: State Auditor's Records, Sch. B.

HARRIS, _____: active ca. 1910, North Wilkesboro, in partnership with a Mr. Miller as Miller, Harris & Company, publisher of postcards.

SOURCE: postcard bearing company name.

HARRIS, FLOYD G. (b. ca. 1877): native of N.C.; active by 1910, Henderson.

SOURCE: Thirteenth Census, 1910: Vance County, Pop. Sch., Henderson, E.D. 82.

HARRIS, GEORGE W.: active 1905–1911; in Asheville (1905–1907); in association with Jonathan T. Gilbert (1905–1906); in Shelby (1910–1911) in partnership with Forrest L. Ellis.

SOURCES: Photographic Examiners Records; Hill, *Asheville, N.C. City Directory, 1906–1907*.

HARRIS, ISAAC JOSEPH (b. ca. 1832): native of N.C.; active 1850s–early 1860s, Warrenton; enlisted in Company G, Forty-third Regiment, N.C. State Troops, Feb. 1862; did not resume photography trade after the war; moved to Rocky Mount and engaged in several businesses, including operating a hotel.

SOURCES: Manarin and Jordan, *N.C. Troops*, 10:353; information provided by John Durham, historian, Guilford Courthouse National Military Park, Greensboro.

HARRIS, JOHN G.: active 1915, W. Fifth St., Charlotte.

SOURCE: Miller, *Charlotte Directory*, 1915.

HARRIS, L. G.: active 1935, Elk Park (Avery County).

SOURCE: Photographic Examiners Records.

HARRIS, P. H.: active 1917–1918, Asheville.

SOURCE: Miller, *Asheville, N.C. City Directory*, 1917–1918.

HARRIS, THOMAS CLARKE (b. 1849); native of N.C.; active 1870–1890s; in Sassafras Fork (Granville County) (1874); in Oxford (1875); publisher of stereographs; located in Raleigh (late 1870s–1897), where he also worked as wood engraver and mapmaker; moved to Baltimore ca. 1897; brother of Eugene L. Harris, artist and registrar of University of North Carolina.

SOURCES: *Torch-Light* (Oxford), Feb. 24, 1874, May 11, 25, 1875; *Fire Fly* (Sassafras Fork), May 5, 1874; Sprange, *Blue Book*, 289; biographical files of map collection provided by George Stevenson (A&H); undated article by Thomas C. Harris, probably from the *Public Ledger* (Oxford); Darrah, *World of Stereographs*, 208.

HARRIS, W. G.: active 1912–1913, Shelby.

SOURCE: *N.C. Year Book*, 1912, 1913.

HARRISON, BENJAMIN FRANKLIN (b. 1824): daguerreotyper; probably native of Va.; active 1852–1854; in Wilmington (1852–1853) as operator of gallery of Jesse H. Whitehurst; gallery in Mozart Hall above Hart & Polley's store on Front St.; in autumn of 1852 he took rooms in Wilmington formerly occupied by J. W. Gulick; in New Bern (1853–1854) at gallery located above Whaley's Jewelry Store; operated B. F. Harrison & Company; brother of William T. Harrison and cousin of Jesse H. Whitehurst.

SOURCES: *Wilmington Daily Journal*, Nov. 30, 1852; *Wilmington Journal*, Jan. 14, 1853; *Weekly News* (New Bern), Nov. 5, 1853;

biographical information provided by Mark White, Hightstown, N.J.; Palmquist, *The Daguerreian Annual, 1990,* 199.

HARRISON, CHARLES FRANKLIN (1883–1932): native of N.C.; active 1905–1932; in Charlotte (1905–1918) in partnership with M. Luther Philemon (1918); involved in operation of Ideal Studio and H & P Studio (ca. 1920s); in Kannapolis (1910s–1932) with Ideal Studio (1921) and Harrison's Studio; father of Charles Franklin Harrison Jr.

SOURCES: *Walsh's Directory of the City of Charlotte,* 1905–1906; Thirteenth Census, 1910: Mecklenburg County, Pop. Sch., Charlotte, E.D. 102; Miller, *Charlotte Directory,* 1913, 1918; *N.C. Year Book,* 1914–1916; *Mercantile Reference Book,* 1931; Vital Records, death certificates, Book 1584, p. 82 (A&H); information provided by Shelia Bumgarner, Public Library of Charlotte and Mecklenburg County.

HARRISON, CHARLES FRANKLIN, JR. (1905–1966): active 1924–1940s, Kannapolis; associated with Harrison's Studio; son of Charles Franklin Harrison.

SOURCES: Photographic Examiners Records; *Mercantile Agency Reference Book,* 1943; *www.familysearch.org.*

HARRISON, WILLIAM T. (b. 1820): probably native of Va.; daguerreotyper; active 1853–1854, with Whitehurst's Gallery, Wilmington; brother of Benjamin F. Harrison and cousin of Jesse H. Whitehurst.

SOURCES: biographical information provided by Mark White, Hightstown, N.J.; Palmquist, *The Daguerreian Annual, 1990,* 199.

HARROLD, VERLIN J.: active ca. 1918, Camp Greene; took photographs for *Caduceus* magazine, which was published at base hospital; received permission to take photographs at the camp.

SOURCES: National Army Camps, Camp Greene, Charlotte, N.C., RG 393, Box 20, National Archives; information provided by Jane Johnson, Charlotte.

HART, CHARLES W. ("CHARLIE") (1860–1913): native of N.C.; active by 1900–1910, Littleton; operated C. W. Hart's Gallery; assisted by James Parker of Suffolk, Va. (1902–1903).

SOURCES: Twelfth Census, 1900: Warren County, Pop. Sch., Littleton, E.D. 97; Thirteenth Census, 1910: Warren County, Pop. Sch., Littleton, E.D. 50; Dozier, *Town Leaders, Littleton, North Carolina,* 93; information provided by Rebecca Leach Dozier, Augusta, Ga.

HART, CLAUDE: native of N.C.; active ca. 1900–1930s; in Red Springs (ca. 1900); in Hartsville, S.C. (1920s–1930s).

SOURCES: photographs bearing his name; Teal, *Partners with the Sun,* 266.

HARTIS, ANDREW DALLAS (1915–1972): active 1932–1940s, Charlotte; operated Eureka Photo Company and B & H Photo Company (1938–1941) in association with John Glenn Hartis; probably son of John M. and Sarah E. Hartis; died in Calif.

SOURCES: Photographic Examiners Records; *Hill's Charlotte Directory,* 1938–1941; *www.familysearch.org.*

HARTIS, JOHN GLENN (1917–1985): active 1938–1940s, Charlotte; operated B & H. Photo Company in association with A. Dallas Hartis; probably son of John M. and Sarah E. Hartis; died in Calif.

SOURCES: *Hill's Charlotte Directory,* 1938–1941; *www.familysearch.org.*

HARTIS, JOHN M. (b. ca. 1873): native of N.C.; active 1907–1930 on Trade St., Charlotte; operated J. M. Hartis Studio (1918); husband of Sarah E. Hartis and probably father of A. Dallas Hartis and John Glenn Hartis; died in Calif.

SOURCES: *Walsh's Directory of the City of Charlotte,* 1907; Miller, *Charlotte Directory,* 1918; Fifteenth Census, 1930: Mecklenburg County, Pop. Sch., Charlotte, E.D. 60-19; *www.familysearch.org.*

HARTIS, SARAH E. (Mrs.) (b. 1890): native of N.C.; active ca. 1917–late 1930s, Charlotte; associated with Eureka Photo Company (1927–1936); wife of John M. Hartis and probably mother of A. Dallas Hartis and John Glenn Hartis.

SOURCES: Photographic Examiners Records; Miller, *Charlotte Directory,* 1927–1930; Fifteenth Census, 1930: Mecklenburg County, Pop. Sch., Charlotte, E.D. 60-19; *Hill's Charlotte Directory,* 1932–1936.

HARTSOG, R. V.: active 1919, Ashe County.

SOURCE: State Auditor's Records, Sch. B.

HARVEL, PAUL WILSON, JR. (1919–1962): active late 1930s–1940s, North Wilkesboro; in partnership with Edgar R. Rollins as Rembrandt Studio (late 1930s–1941); sole proprietor, Harvel's Studio (after 1941).

SOURCES: Miller, *City Directory of North Wilkesboro,* 1939–1940; Photographic Examiners Records; *Mercantile Agency Reference Book,* 1943; *www.familysearch.org.*

HARWARD (HOWARD?), JESSIE (b. ca. 1877): native of N.C.; active by 1910, Raleigh.

SOURCE: Thirteenth Census, 1910: Wake County, Pop. Sch., Raleigh, E.D. 113.

HASSELL, C. R.: active 1890, Beaufort.

SOURCE: *Mercantile Agency Reference Book,* 1890.

HATCHELL, WILLIAM A.: active 1907–1908, in Wilmington, N.C., and in Hartsville and Bishopville, S.C. (1908).

SOURCES: Hill, *Wilmington Directory, 1907–1908;* Teal, *Partners with the Sun,* 246.

HATLEY, _____: active early twentieth century; n.p.; n.d.

SOURCE: postcard bearing name "Hatley."

HAVENS, C. B.: itinerant daguerreotyper; active early 1850s; in Benjamin B. Smith's building, Fayetteville St., Raleigh (1851); in brick building previously erected by

W. J. and A. S. Lougee; in partnership with Oliver P. Copeland, a portrait and miniature painter (1854).

SOURCES: *North Carolina Standard*, Aug. 30, 1851; *Semi-Weekly Raleigh Register*, Feb. 18, 1854; Murray list of Wake County photographers.

HAVENS, T. J.: itinerant; active 1852–1859; in Raleigh (1852–1853) in gallery located above post office on Fayetteville St.; operated (permanent) Havens' Gallery on Fayetteville St. (1857–1859); offered daguerreotypes, ambrotypes, cameotypes, and melainotypes; in partnership with M. M. Mallon (1857); in partnership with Joshua P. Andrews, a portrait painter (1858–1859); in Beaufort (1857) as itinerant; occupied rooms at Odd Fellows Hall; in partnership with M. M. Mallon; in Tarboro (1857) as itinerant; occupied rooms at Odd Fellows Hall; in partnership with M. M. Mallon; sold established gallery on Fayetteville St. in Raleigh to Esley Hunt in 1859; won several awards in fine arts category at N.C. State Fair in 1858.

SOURCES: *Raleigh Register* (semi-weekly), Feb. 4, 1852; Rinhart and Rinhart, *The American Daguerreotype*, 394; *Semi-Weekly Raleigh Register*, Feb. 4, Apr. 25, Dec. 16, 1857, Oct. 28, Dec. 25, 1858; *Raleigh Register* (semi-weekly), Sept. 19, 1857; *Beaufort Journal*, July 1, 1857; *Southerner* (Tarborough), Mar. 14, Apr. 4, 18, 1857; *American Advocate* (Kinston), Nov. 3, 1858; *Spirit of the Age* (Raleigh), Aug. 10, 1859.

HAWKINS, J. W. (b. ca. 1855): native of N.C.; active by 1880, Wilmington.

SOURCE: Tenth Census, 1880: New Hanover County, Pop. Sch., Wilmington, E.D. 145.

HAWKS, FRED: active 1919–1920, Draper.

SOURCE: State Auditor's Records, Sch. B.

HAYDEN, HENRY H. (1872–1934): African American; active 1897–1902, Charlotte; studio on S. Brevard St.; may have been Charlotte's first African American photographer; by 1902 was employed as a hack driver and later owned his own café.

SOURCES: *Maloney's Charlotte 1897–'98 Directory*; *Weeks' 1899 Charlotte City Directory*; *Maloney's 1899–1900 Charlotte Directory*; Twelfth Census, 1900: Mecklenburg County, Pop. Sch., Charlotte, E.D. 86; information provided by Shelia Bumgarner, Public Library of Charlotte and Mecklenburg County.

HAYES, C. W.: active 1919, St. Johns (Hertford County).

SOURCE: State Auditor's Records, Sch. B.

HAYES, CORA (b. ca. 1874): native of S.C.; active by 1910, Raleigh; wife of John P. Hayes and mother of Ransom Hayes.

SOURCE: Thirteenth Census, 1910: Wake County, Pop. Sch., Raleigh, E.D. 122.

HAYES, ELI P. (b. 1856): native of N.C.; active 1880–1890s, Randleman; by 1900 was employed as a merchant.

SOURCE: Twelfth Census, 1900: Randolph County, Pop. Sch., Randleman, E.D. 95.

HAYES, JOHN PICKARD (ca. 1868–1924): native of N.C.; active ca. 1901–1920s; operated Hayes' Studio, Raleigh, in partnership with a Mr. Hall (1917–1924); husband of Cora Hayes and father of Ransom Hayes.

SOURCES: *Maloney's 1901 Raleigh Directory*, 5:393; *N.C. Year Book*, 1902–1907, 1909–1916; *Mercantile Agency Reference Book*, 1904; *Bradstreet's*, 1908, 1917, 1921, 1925; State Auditor's Records, Sch. B; Vital Records, death certificates, Book 886, p. 394 (A&H).

HAYES, RANSOM (b. ca. 1890): native of N.C.; active by 1910, Raleigh; son of John P. and Cora Hayes.

SOURCE: Thirteenth Census, 1910: Wake County, Pop. Sch., Raleigh, E.D. 122.

HAYES, W. J.: active 1881, Hillsborough; gallery located above the millinery store of Mrs. Mattie Taylor.

SOURCE: *Durham Recorder*, Mar. 31, 1881.

HAYGARD, A. C.: photographed construction of Blue Ridge Parkway, 1936–1941.

SOURCE: Blue Ridge Parkway Photograph Collection (A&H).

HAYNES, ALPHONZA H. (ca. 1850–1907): native of S.C.; active by 1870–1907, Raleigh.

SOURCES: Ninth Census, 1870: Wake County, Pop. Sch., Raleigh Township; Tenth Census, 1880: Wake County, Pop. Sch., Raleigh E.D. 266; *Directory of the City of Raleigh, North Carolina, 1887*, 194; *Directory of the City of Raleigh, 1888*, 144; Cotten list of N.C. photographers; Wake County Estates Records (A&H).

HAYNES, GROVER CLEVELAND, JR. (1912–1993): active 1930s–1973; in Rocky Mount (1932–1933) in partnership with Omar V. Fowler; in Durham (1934) with Mrs. Emma D. Turner at Efird's Photo Shop; served apprenticeship with F. Gilbert Whitley in Durham (1934–1935); in Raleigh (1935–1973) in association with Acme Studio (1936) and later operated Haynes' Studio on Fayetteville St.

SOURCES: Photographic Examiners Records; Murray list of Wake County photographers; *Mercantile Agency Reference Book*, 1943.

HAYS, JOSEPH G. (b. ca. 1898): native of N.C.; active by 1930, Charlotte.

SOURCE: Fifteenth Census, 1930: Mecklenburg County, Pop. Sch., Charlotte, E.D. 60-6.

HEALEY, S. A.: active 1935, Murphy.

SOURCE: Photographic Examiners Records.

HEFFNER, LAURA ROSALIND (b. 1891): active 1908–1940s; at Belk's Department Store in Florence, S.C. (1930s–1940s); licensed to practice in N.C.

SOURCE: Photographic Examiners Records.

HEGE, FRANK E. (d. 1909): active ca. 1880s, Salem; portrait housed at MESDA.

SOURCES: information provided by Jennifer Bean Bower, MESDA; Forsyth County Estates Records (A&H).

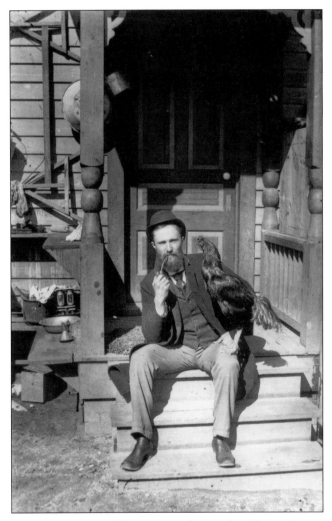

Salem photographer Frank E. Hege poses on the steps of a residence with a rooster on his knee. Photograph (ca. 1880s) courtesy MESDA.

HEGE, THOMAS CHRISTIAN (1871–1923): active 1890s–early 1900s, Winston and Salem; operated Tom's Photograph Gallery, Main St., Winston; great uncle of Frank B. Jones Jr.

SOURCES: *Republican* (Winston), Apr. 30, 1896; Brownlee, *Winston-Salem: A Pictorial History*, 7; *Twin-City Sentinel*, (Winston-Salem), Sept. 25, 1923; information provided by Molly Rawls, Forsyth County Public Library; information from the files of MESDA.

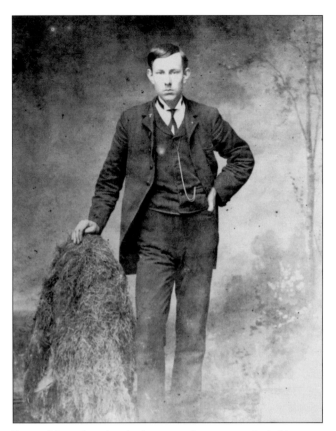

Thomas C. Hege, shown here leaning on a studio prop, was active in Salem and Winston during the 1890s. He was one of Winston's first Seventh-Day Adventists and would sometimes engage in "sidewalk evangelism." Photograph courtesy Forsyth County Public Library, Winston-Salem.

HELLAMS, J. E.: active 1880s–1900; in Waynesville (1880s–1890s); in Brevard (1893); in Gaffney, S.C. (1897); in Greenville, S.C. (1899–1900).

SOURCES: *Transylvania Hustler* (Brevard), Nov. 2, 1893; Teal, *Partners with the Sun*, 196.

HEMINGWAY, LEROY G.: active 1915–1920, Winston-Salem (1915); proprietor of Hemingway Photo Company; operated Hemingway Studio, Nash St., Wilson (1919–1920).

SOURCES: State Auditor's Records, Sch. B; *Winston-Salem Directory*, 1915; *Hill's, Wilson, N.C. City Directory*, 1920; information from the files of MESDA.

HEMMER, JOHN H. (1892–1981): native of Brooklyn, N.Y.; active ca. 1911–1960s; attended United States School of Military Cinematography, Columbia University (1918); during World War I served with U.S. Signal Corps as cameraman specializing in aerial photography; after war worked with Edwin Lebick Studios in New York City; employed as photographer for *New York Daily News* (1936); in Pinehurst periodically during tourist season (1924–1944); became permanent resident of N.C. (1944); split time as photographer between Pinehurst, Inc., and State Department of

RIGHT: Award-winning photographer John H. Hemmer of Pinehurst was employed by the North Carolina Department of Conservation and Development (C&D) during the 1940s and 1950s to take pictures to help promote travel and tourism in the state. A Raleigh *News and Observer* staff photographer took this picture of Hemmer in the C&D office in Raleigh in July 1949. Photograph courtesy News and Observer Publishing Company.
BELOW: The subjects of this Hemmer photograph are Charles Anderson of Lynchburg, Va., and Anderson's bird dog, "Peerless Blockem," at the National Quail Championship of the Amateur Field Trial Clubs of America at Pinehurst in the late 1930s. Courtesy of the compiler.

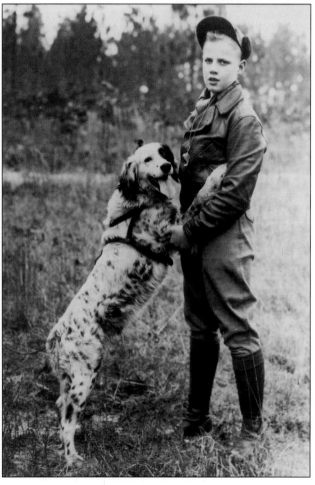

Conservation and Development (1944–1950s); operated Hemmer's Photo Shop, Pinehurst (1944–1960s); winner of photography awards; specialized in photographs of golf- and horse-related activities; founder of N.C. Press Photographers' Association; photograph collection of 71,000 negatives housed in Tufts Archives wing of Given Memorial Library, Pinehurst.

SOURCES: Page, *Tales of Pinehurst*, 1:51; *Sandhill Citizen* (Southern Pines), Oct. 7, 1981; information provided by Khristine E. Januzik, Pinehurst; *www.familysearch.org*.

HEMPHILL, JAMES E. (1886–1959): native of S.C.; African American; active 1917–1950s, Charlotte; operated Carolina Studio on E. Trade St.

SOURCES: Photographic Examiners Records; Miller, *Charlotte Directory*, 1917–1930; Fifteenth Census, 1930: Mecklenburg County, Pop. Sch., Charlotte, E.D. 60-1; *Hill's Charlotte Directory*, 1932–1942; Vital Records, death certificates, Book 22, p. 216 (A&H); information provided by Shelia Bumgarner, Public Library of Charlotte and Mecklenburg County; *Charlotte Observer*, Aug. 22, 1959.

HENDERSON, LYLE CHARLES (b. 1908): active 1935–1940s, Asheville, in partnership with William F. Clodfelter (1935); associated with Preston Studio (1935–1940s); began profession with Luesa M. Marker.

SOURCES: Photographic Examiners Records; Baldwin, *Asheville, N.C. City Directory, 1935*.

HENDRICK, _____: active ca. 1935, Mebane.
SOURCE: photograph bearing name "Hendrick."

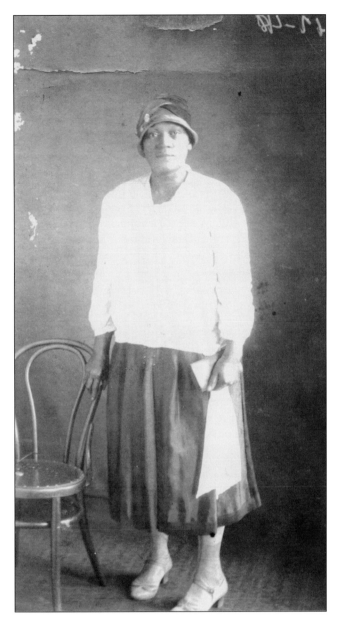

James E. Hemphill photographed this unidentified African American woman at his Carolina Studio in Charlotte in the 1920s. Postcard courtesy Durwood Barbour, Raleigh.

HENDRIX, J. R.: active 1919, Boone.

SOURCE: State Auditor's Records, Sch. B; *Watauga Democrat* (Boone), Apr. 24, 1919; Lentz, *W. R. Trivett, Appalachian Picture Man*, 30–31.

HENLEY (HENLY), M. CHARLES (b. ca. 1849); native of N.C.; active 1876–1880s; itinerant (resident of Guilford County) (1878–1879); in Winston (1876, 1879–1880); in Greensboro (1880); itinerant (resident of Graham) (1880–1881) in partnership with George Teague; at "Carolina Factory" (1882); at Company Shops (1886–1887) in partnership with a Mr. Dilworth.

SOURCES: *Mount Airy Watchman*, Sept. 16, 1876; State Auditor's Records, Miscellaneous Tax Group (1868–1932), Box 3, Artists' and Photographers' Privilege Licenses, 1877–1887 (A&H); *Charles Emerson & Company's Winston, Salem and Greensboro, North Carolina Directory, 1879–'80*; Tenth Census, 1880: Guilford County, Pop. Sch., Greensboro, E.D. 127; Cotten list of N.C. photographers.

HENNIS, _____: active ca. 1908–1910s, Mount Airy; publisher of postcard views.

SOURCE: postcards bearing name "Hennis."

HERMAN, BENJAMIN F. (b. ca. 1879): native of S.C.; active 1916–1921, Hudson (Caldwell County); managed a farm in 1920.

SOURCES: State Auditor's Records, Sch. B; *Bradstreet's*, 1917; Fourteenth Census, 1920: Caldwell County, Pop. Sch., Hudson, E.D. 62.

HERMAN, CLYDE (1895–1977): native of N.C.; active by 1930, Hickory.

SOURCES: Fifteenth Census, 1930: Catawba County, Pop. Sch., Hickory, E.D. 18-4; *www.familysearch.org*.

HERN, JOSEPH: active 1930s, Valdese.

SOURCE: Photographic Examiners Records.

HERNDON, EDWARD W. (1839–1886): native of Va.; active by 1859–1860s, Asheville; purchased gallery of Oscar M. Lewis in 1859; maker of ambrotypes; also dealer in watches and jewelry; enlisted in Company F, Fourteenth Regiment, N.C. State Troops, May 3, 1861; served as assistant quartermaster on staff of Brig. Gen. Robert B. Vance; married Hannah Vance, sister of Zebulon B. Vance; after war opened dry goods, grocery, and hardware business and reopened his photography gallery; served as clerk of superior court of Buncombe County, 1877–1885 (A&H).

SOURCES: *Asheville News*, Apr. 7, Sept. 22, Nov. 24, 1859; Nov. 16, 1865; Eighth Census, 1860: Buncombe County, Pop. Sch., Asheville; Manarin and Jordan, *N.C. Troops*, 5:445; Buncombe County Estates Records (A&H); Buncombe County Wills (A&H).

HERRING, L. J.: active 1916, Wilson.

SOURCE: State Auditor's Records, Sch. B.

HERRITAGE, C. C.: active 1908, Trenton; proprietor of C. C. Herritage & Company, publisher of postcard views.

SOURCE: *Bradstreet's*, 1908.

HESTER, THOMAS HENRY (1874–1949): native of N.C.; active 1903–1919; in Spring Hope (1903–1912); operated Spring Hope Photo Company (1903) in partnership with a Mr. Batton; associated with Hester's Art Gallery; Rocky Mount (1912–1913); in Wendell (1916); in Raleigh (1919); landscape artist.

SOURCES: *N.C. Year Book*, 1903, 1905, 1906, 1910–1912, 1916; Thirteenth Census, 1910: Nash County, Pop. Sch., Spring Hope, E.D. 64; *Hill's Rocky Mount Directory*, 1912–1913; State Auditor's Records, Sch. B; Belvin and Riggs, *The Heritage of Wake County, North Carolina*, 1983, 254.

HEYWOOD, JOHN D.: active 1850s–ca. 1870; in Boston and Cambridge (1856–1866); operated J. D. Heywood's Photographic Rooms, publisher of stereographs, on Craven St. in New Bern (1867–1869).

SOURCES: Rinhart and Rinhart, *The American Daguerreotype*, 395. Branson, *NCBD*, 1869; *New Bern Republican*, May 7, 1867; *Craig's Daguerreian Registry*, 2:268–269; Polito, *A Directory of Massachusetts Photographers*, 77, 195; Darrah, *World of Stereographs*, 208.

HICKMAN, D. T.: active ca. 1918, Camp Greene; associated with Miller Studio, Augusta, Ga.; received permission to take photographs at the camp.

SOURCES: National Army Camps, Camp Greene, Charlotte, N.C., RG 393, Box 20, National Archives; information provided by Jane Johnson, Charlotte.

HICKS, _____: active (obtained license to practice) 1908–1909, Mitchell County, in partnership with A. Waller Franklin.

SOURCE: Registry of Licenses to Trade, Mitchell County, 1877–1909 (A&H).

HICKS, CECIL ELMER (1881–1967): active 1930s, High Point; operated Hicks' Studio; died in Calif.

SOURCES: Photographic Examiners Records; *www.familysearch.org.*

HICKS, JOHN: of Norfolk, Va.; active 1919, Hertford County.

SOURCE: State Auditor's Records, Sch. B.

HICKS, MRS. T. C.: active 1930s, Elk Park (Avery County).

SOURCE: Photographic Examiners Records.

HIGGASON, LUTHER L. (1885–1934): native of Va. or W. Va.; active ca. 1901–1932; in Asheville (1907–1932); in partnership with a Mr. Lomax (perhaps John Avery Lomax) (ca. 1908–1909); in partnership with Newton W. Blough (1910–1911); in partnership with Herbert W. Pelton (1914–1916); sole proprietor (1916–1932); president, Photographers' Association of the Middle Atlantic States; member, Southeastern Photographers' Association; took views of the flood of 1916 in western N.C.

SOURCES: Miller, *Asheville, N.C. City Directory*, 1907–1932; photographs bearing names of Lomax and Higgason, in possession of compiler; *N.C. Year Book*, 1915; Fifteenth Census, 1930: Buncombe County, Pop. Sch., Asheville, E.D. 11-10; State Auditor's Records, Sch. B; *Bradstreet's*, 1917, 1921, 1925; *Mercantile Reference Book*, 1931; *Asheville Citizen*, Apr. 2, 1934.

HIGH POINT STUDIO: active 1913–1924, High Point; James Edward Jones, proprietor.

SOURCES: Miller, *High Point Directory*, 1913, 1919–1924; *N.C. Year Book*, 1914–1916.

HIGHTOWER, GURNEY I. (b. ca. 1894): native of N.C.; active ca. 1916–1923, Durham (1916–1919); in partnership with John J. Hitchcock (1910s); in partnership with

Asheville photographer Luther L. Higgason recorded this scene of the area surrounding the city's railroad depot following the devastating flood of July 1916. Photograph courtesy A&H.

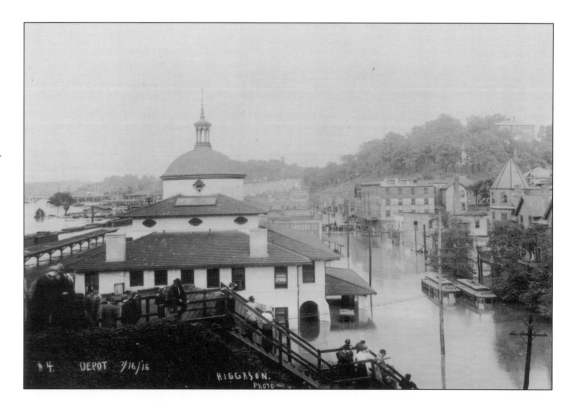

About 1910, Higgason teamed with associate Newton W. Blough to produce this postcard, which features the portrait of an unidentified woman. Courtesy of the compiler.

John H. Goodwin (1917); operated Hightower Studio in Tarboro (1919–1923); in partnership with brother-in-law, Haywood Howell (1919–1922).

SOURCES: State Auditor's Records, Sch. B; Record of Special Licenses Issued, Durham County, 1917–1918 (A&H); *Bradstreet's*, 1917; Fourteenth Census, 1920: Edgecombe County, Pop. Sch., Rocky Mount, E.D. 18.

HILL, _____: active 1916, Saluda, in partnership with R. B. Staton.

SOURCE: *N.C. Year Book*, 1916.

HILL, CHARLES E.: active 1910–1911, Gastonia.

SOURCE: *Gastonia Directory*, 1910–1911.

HILL, EUGENE VALENTINE (1898–1983): active 1921–1940s; in Hickory (1921–1923) with Albert J. Bradshaw; in Thomasville (1939) with James M. Richardson; in High Point (1933–1940s).

SOURCES: Photographic Examiners Records; *Hill's High Point Directory*, 1933; *www.familysearch.org*.

HILL, JOE: active 1916, Winston-Salem.

SOURCE: State Auditor's Records, Sch. B.

HILL, R. G.: active 1916, Greensboro.

SOURCE: State Auditor's Records, Sch. B.

HILL, W. B.: active 1916, Snow Hill.

SOURCE: State Auditor's Records, Sch. B.

HILLERS, JOHN K. ("JACK") (1843–1925): nationally known photographer; active nineteenth and early twentieth centuries; employed by U.S. Geological Survey in Washington, D.C.; worked for N.C. Department of Agriculture and N.C. Geological Survey.

SOURCE: Herbert H. Brimley Photograph Collection (A&H); information provided by Sarah Robinson, Jacksonville, Fla.; Fowler, *The Western Photographs of John K. Hillers*, 11.

HINE, LEWIS W. (1874–1940): nationally renowned photographer who took photographs of textile mills in N.C. for the National Child Labor Committee; in Cherryville, Gastonia, Hickory, High Shoals, Laurinburg, Lincolnton, Newton, Salisbury, and Whitnel (all 1908); in Charlotte (1909); in Bessemer City, Clayton, Concord, Greensboro, High Point, Kannapolis, Lexington, and Winston-Salem (all 1912); in Randleman (1913); in Fayetteville, Henderson, Lumberton, Roanoke Rapids, Sanford, Scotland Neck, and Weldon (all 1914); in Evergreen (1915).

SOURCES: Nontextual Materials Unit Photographic Files (A&H); biography of Lewis Hine from *www.photocollect.com*; information from Library of Congress, Prints and Photographs Division, Washington, D.C.

HINES, C. A.: active 1914, Asheville.

SOURCE: Miller, *Asheville, N.C. City Directory, 1914*.

HINES, WILLIAM: active 1919, Elm City.

SOURCE: State Auditor's Records, Sch. B.

HINSON, _____: active ca. 1875, Gaston County, in partnership with Luther A. Ramsour; published stereographs of All Healing Springs.

SOURCE: stereographs bearing Hinson's name.

HINSON, WALTER L. (b. ca. 1906): native of N.C.; active by 1930, Charlotte.

SOURCE: Fifteenth Census, 1930: Mecklenburg County, Pop. Sch., Charlotte, E.D. 60-2.

HINSON, WILLIS (b. ca. 1879): native of Tenn.; active by 1910, Greensboro.

SOURCE: Thirteenth Census, 1910: Guilford County, Pop. Sch., Greensboro, E.D. 108.

While headquartered in Durham, John J. Hitchcock published this postcard view of damage to the central part of the city resulting from a destructive fire that occurred in March 1914. Courtesy of the compiler.

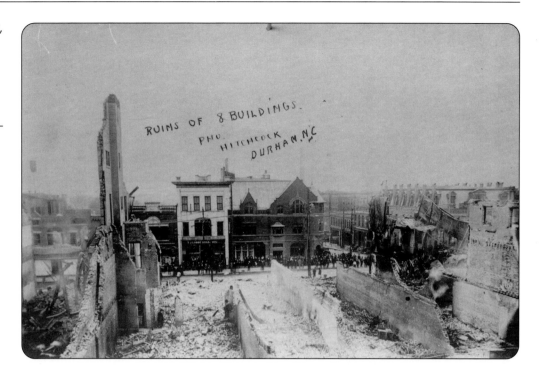

HITCHCOCK, JOHN J. (b. ca. 1877): native of Va.; active ca. 1904–1930s; in Richmond, Va. (early 1900s); in Durham (1909–1915), in partnership with Gurney I. Hightower (early 1910s); in Lexington (1916–1926); in Winston-Salem (early 1930s) in association with James O. Spear Jr.; probably brother of Leonard A. Hitchcock.

SOURCES: Registry of Licenses to Trade, Durham County, 1881–1913 (A&H); *N.C. Year Book*, 1910–1916; Thirteenth Census, 1910: Durham County, Pop. Sch., Durham, E.D. 34; Gardiner, *City Directory of Lexington*, 1916–1917; Miller, *City Directory of Lexington*, 1925–1926; State Auditor's Records, Sch. B; *Bradstreet's*, 1917, 1921, 1925; *Mercantile Agency Reference Book*, 1943; information from the files of MESDA.

HITCHCOCK, LEONARD ALEXANDER (b. 1884): native of Va.; active 1904–1940; in Richmond, Va. (1904–1905), with John J. Hitchcock; in Albemarle (ca. 1921–1940); probably brother of John J. Hitchcock.

SOURCES: Photographic Examiners Records; State Auditor's Records, Sch. B; Fifteenth Census, 1930: Stanly County, Pop. Sch., Albemarle, E.D. 84-15; Baldwin, *Albemarle, N.C. City Directory*, 1937, 1939–1940.

HIX, C. G.: itinerant maker of ambrotypes; active 1859, Salisbury.

SOURCE: *Salisbury Banner*, July 26, 1859.

HIX, WILLIAM PRESTON: active 1860–ca. 1874, Columbia, S.C.; published stereographs of N.C. mountains in association with Richard Wearn.

SOURCES: stereographs bearing Hix's name; *Craig's Daguerreian Registry*, 2:273.

HOBBS, ELLA J. (b. ca. 1871): native of N.C.; active as retoucher, Garland, by 1930.

SOURCE: Fifteenth Census, 1930: Sampson County, Pop. Sch., Garland, E.D. 82-29.

HOBBS, ROBERT LEE (b. 1887): active 1902–ca. 1940; in Clinton (ca. 1908–ca. 1940).

SOURCES: Photographic Examiners Records; *N.C. Year Book*, 1910–1916; State Auditor's Records, Sch. B.

HOBGOOD, _____: active late 1890s, Durham, in partnership with J. W. Thomas.

SOURCE: photographs bearing names of Hobgood and Thomas.

HODGE, G. L.: active 1927–1928, Gastonia, in partnership with George W. Freeman.

SOURCE: *Gastonia Directory*, 1927–1928.

HODGES, EDWARD H.: native of N.C.; active 1909–1920s; operated The Photo Shop, Wilmington, in partnership with Charles Dushan (1913–1914); operated Hodges' Studio (1917–1920); former assistant of Paul M. Taylor; took over studio on Princess St. previously occupied by Charles E. Vale.

SOURCES: *Dispatch* (Wilmington), July 13, 1909; Reaves list of Wilmington photographers; Hill, *Wilmington Directory*, 1913–1914, 1917–1920.

HODGES, H. H.: active 1921, Edenton.

SOURCE: State Auditor's Records, Sch. B.

HODGES, J. B.: active 1910–1914, Roanoke Rapids.

SOURCE: *N.C. Year Book*, 1910–1914.

HOGAN, HARRIS (b. 1857): native of N.C.; African American; active by 1900, Greensboro.

SOURCE: Twelfth Census, 1900: Guilford County, Pop. Sch., Greensboro, E. D. 56.

HOLBROOKS, N.: active 1919, Merry Oaks (Chatham County).

SOURCE: State Auditor's Records, Sch. B.

HOLDEN, NEEDHAM CLAUDIUS (1900–1975): native of N.C.; active 1921–1940s; operated Holden Studio, Nash St., Wilson; in Charlotte (n.d.) as a "penny-per-pound" photographer (a marketing scheme whereby photographers charged for photographing young children on the basis of the weight of each child).

SOURCES: Photographic Examiners Records; *Hill's, Wilson, N.C. City Directory*, 1922–1923, 1925, 1930, 1941; Fifteenth Census, 1930: Wilson County, Pop. Sch., Wilson, E.D. 98-23; *Mercantile Reference Book*, 1931; *Mercantile Agency Reference Book*, 1943; information provided by Guy Cox, Wilson; *www.familysearch.org*.

HOLDER, JOHN: active 1916, Winston-Salem.

SOURCE: State Auditor's Records, Sch. B.

HOLDER, W. S.: active 1916, King (Stokes County).

SOURCE: *N.C. Year Book*, 1916.

HOLLADAY, WALLER (b. ca.1875); native of Va.; active 1890s–1920s; studied under T. G. Murry in Salem, Va. (1896); in Lynchburg, Va. (1897–1898) as printer for A. H. Piecker's Gallery and Hill City Studio (operated by Oliver W. Cole); in Des Moines, Iowa (1898) with gallery of F. W. Webster; in Durham (1898–ca. 1920); in partnership with Oliver W. Cole (1898–ca. 1906); purchased studio of J. W. Thomas, Main St.; specialized in university and college groups; although headquartered in Durham, also worked in Chapel Hill, Winston-Salem, and Roxboro (1900); at latter location gallery was open every Friday and Saturday above R. J. Hall's harness store; sole proprietorship of Holladay Studio, Durham (ca. 1906–ca. 1920); by 1920s was working in Newport News and Richmond, Va.

SOURCES: Twelfth Census, 1900: Durham County, Pop. Sch., Durham; Thirteenth Census, 1910: Durham County, Pop. Sch., Durham, E.D. 36; *N.C. Year Book*, 1906, 1907, 1910–1916; *Bradstreet's*, 1908, 1917, 1921; State Auditor's Records, Sch. B; *Durham Recorder*, Jan. 19, 1899, Apr. 16, 1900; *News and Observer* (Raleigh), Aug. 24, 1899; *Courier* (Roxboro), Jan. 10, 1900. `

HOLLAND, HERBERT S.: active 1916–1917, Asheville; proprietor of Holland's Studio.

SOURCES: State Auditor's Records, Sch. B; Miller, *Asheville, N.C. City Directory, 1917*.

HOLLAND, JOEL COOK: active 1940 and after, Murfreesboro; proprietor of Holland Art Studio.

SOURCE: Photographic Examiners Records.

HOLLIS, JOHN R. (b. 1876): native of N.C.; active by 1900, Beaufort.

SOURCE: Twelfth Census, 1900: Carteret County, Pop. Sch., Beaufort, E.D. 25.

HOLLYWOOD STUDIO: active mid-1930s–1940s, Forest City, Shelby, Kings Mountain; Mr. and Mrs. Lumis A. Williams, operators (mid-1930s); James E. White, manager (1937–1940).

SOURCES: Photographic Examiners Records; *Miller's Shelby City Directory*, 1937–1940.

HOLLYWOOD STUDIO: active mid-1930s; Goldsboro; Marion J. Talley, operator.

SOURCE: Photographic Examiners Records.

HOLLYWOOD STUDIO: active 1941, E. Trade St., Charlotte.

SOURCE: *Hill's Charlotte Directory*, 1941.

HOLMES, A. G.: active (obtained license to practice) 1881–1882, Columbus County.

SOURCE: Registry of Licenses to Trade, Columbus County, 1876–1892 (A&H).

HOLT, JAMES: active 1916, Raeford.

SOURCE: State Auditor's Records, Sch. B.

HOME PORTRAIT STUDIO: active 1938–1939, Asheville; Mrs. Helen V. Howard, operator.

SOURCE: *Miller's Asheville Directory*, 1938–1939.

HOME VIEW COMPANY: active 1895–1897, Peeler (Rowan County), Richard M. Peeler, proprietor.

SOURCE: *Carolina Watchman* (Salisbury), Jan. 28, 1897.

HONIGMAN, MAURICE (1897–1974): active ca. 1930–1940s, Gastonia; proprietor of Honigman's Studio and Gift Shoppe.

SOURCES: Photographic Examiners Records; *Hill's Gastonia Directory*, 1934, 1936; *Mercantile Agency Reference Book*, 1943; *www.familysearch.org*.

HONRINE, JACK (1901–1988): active ca. 1928–1937, New Bern; sold out on July 1, 1937.

SOURCES: Photographic Examiners Records; tombstone inscription, Cedar Grove Cemetery, New Bern.

HOOK, CHARLES ROBERT, SR. (b. 1884): active ca. 1932–1935, High Point; employed by southern office of West-Dempster Company of Grand Rapids, Mich.

SOURCE: Photographic Examiners Records.

HOOKS, DOROTHY ("DOT") HOOD (1913–2003): native of N.C.; active 1939–1978, Smithfield; operated Hooks Studio; purchased studio of Blanche M. Davis (Edward L. K. Gruehn, photographer) in 1939; also active as artist and art teacher; served as president of Professional Photographers of N.C. (1962).

SOURCES: Photographic Examiners Records; *Greensboro Daily News*, July 18, 1948; *News and Observer* (Raleigh), Oct. 24, 2003; information provided by Guy Cox, Wilson.

HOOLE, GEORGE MARSHALL (b. 1889): native of Ill.; active 1925–1940s, Charlotte; proprietor of Hoole Studio; helped establish State Board of Photographic Examiners.

SOURCES: Photographic Examiners Records; Miller, *Charlotte Directory*, 1927–1930; Fifteenth Census, 1930: Mecklenburg County, Pop. Sch., Charlotte, E.D. 60-22; *Hill's Charlotte Directory*, 1932–1934, 1938–1941; *Mercantile Reference Book*, 1931.

HOOPER, A. S.: active 1921–1930s; in Murphy (1921); in Andrews (1930s).

SOURCES: Photographic Examiners Records; State Auditor's Records, Sch. B.

HOPE, H. A.: active 1921, McAdenville (Gaston County).

SOURCE: State Auditor's Records, Sch. B.

HOPE, J. E.: active 1916, McAdenville.

SOURCE: *N.C. Year Book*, 1916.

HORD, TIMON NICHOLAS (b. 1908): active 1938–1940s; in Kings Mountain (1938–ca. 1941); operated Hord's Studio, Shelby (1942 and afterward).

SOURCES: Photographic Examiners Records; *Mercantile Agency Reference Book*, 1943.

HORN, HELEN (b. ca. 1891): native of W. Va.; active by 1910, Burlington.

SOURCE: Thirteenth Census, 1910: Alamance County, Pop. Sch., Burlington, E.D. 17.

HORN-SHAFER COMPANY: of Baltimore, Md.; active ca. 1918, Camp Greene; received permission to take photographs at the camp.

SOURCES: National Army Camps, Camp Greene, Charlotte, N.C., RG 393, Box 20, National Archives; information provided by Jane Johnson, Charlotte.

HORNADAY, GEORGE JAMES (1913–1979): active 1939–1940s, Charlotte.

SOURCES: Photographic Examiners Records; *www.familysearch.org.*

HORNADY, THOMAS J. (b. 1855): native of N.C.; active early 1900s; in Hope Mills (by 1900); in Sanford (early 1900s).

SOURCES: Twelfth Census, 1900: Cumberland County, Pop. Sch., Hope Mills, E.D. 31; information provided by Lee County Genealogical and Historical Society, Sanford.

HORNE, _____: active 1876–1877, Wadesboro; erected house on "old Tavern lot for the purpose of taking pictures."

SOURCE: *Pee Dee Herald* (Wadesboro), Dec. 6, 1876.

Shown here is a portrait of Archibald Horton as a young man. Horton was a leading commercial photographer in Raleigh during the first half of the twentieth century. Photograph courtesy Rebecca Cone, Concord.

HORNEGAY, J. F.: active 1916, Pine Level (Johnston County).

SOURCE: *N.C. Year Book*, 1916.

HORSE, J.: active 1916, Minneapolis (Avery County).

SOURCE: *N.C. Year Book*, 1916.

HORTON, ARCHIBALD ("ARCHIE") (1878–1947): native of N.C.; active 1905–1930s; Raleigh; with Tyree Studio (1905–1916); sole proprietor (1916–1936) of Horton's Studio, located in Masonic Temple, Fayetteville St.

SOURCES: Photographic Examiners Records: *N.C. Year Book*, 1916; *Bradstreet's*, 1917, 1921, 1925; Fifteenth Census, 1930: Wake County, Pop. Sch., Raleigh, E.D. 92-52; *Mercantile Reference Book*, 1931; State Auditor's Records, Sch. B; *News and Observer* (Raleigh), Oct. 3, 1947; information provided by Rebecca Telfair Horton Cone, Concord.

HORTON, BINGHAM BLOOMFIELD (1817–1883): native of S.C.; active ca. 1848–1870s; in Wadesboro (1848–1870s); in Richmond County (1857–1858); operated Horton's Photographic Gallery (1859–1860); offered ambrotypes and melainotypes; in association with a Mr. Crowder as Horton and Crowder (1870s); also worked as a dentist and merchant.

SOURCES: Richmond County Tax Records, 1783–1898, n.d., Broken Series, Tax, 1850–1859 (A&H); *North Carolina Argus* (Wadesborough), Aug. 25, 1859, Sept. 27, 1860; Anson County Estates Records (A&H); Anson County Wills (A&H); information provided by Bill Kendall, Morganton.

HORYDCZAK, THEODOR (1889–1971): active ca. 1920–1950; photographed statues and sculpture in High Point.

SOURCES: information provided by Carol Johnson, Library of Congress, Washington, D.C.; *www.familysearch.org.*

HOUFF, _____: active ca. 1894, Henderson, in partnership with an unidentified brother as Houff Brothers. *See* Houff, Albert Hunter.

HOUFF, ALBERT HUNTER (1864–1927): native of Va.; active ca. 1887–1927, in Henderson (ca. 1894–1927).

SOURCES: *N.C. Year Book*, 1902–1907, 1910–1916; Twelfth Census, 1900: Vance County, Pop. Sch., Henderson, E.D. 85; *Mercantile Agency Reference Book*, 1904; *Bradstreet's*, 1908, 1917, 1921, 1925: State Auditor's Records, Sch. B; Vital Records, death certificates, Book 1149, p. 71 (A&H); *News and Observer* (Raleigh), Oct. 16, 1927.

HOUGH, EUGENIO KINKAID (1834–1902): native of Conn.; active 1850s–ca.1887; created primitive pastels in Vt. (ca. 1850); in Petersburg, Va. (1858); in Louisburg (1859) as itinerant maker of ambrotypes in partnership with a Mr. Levois; occupied gallery in rooms formerly occupied by a Mr. Walker; in Hillsborough (1859) as itinerant in gallery at Masonic Hall; offered ambrotypes and melainotypes; in Winston (1885–ca. 1887) as operator of Twin-City Gallery, Main St.; sold business to his brother, Sylvester E. Hough, ca. 1887.

SOURCES: Rinhart and Rinhart, *The American Daguerreotype*, 395; *Hillsborough Recorder*, Apr. 27, 1859; Orange County Miscellaneous Records, Tax Records, 1800–1881 (A&H); *American Eagle* (Louisburg), Feb. 26, 1859; advertisement from unidentified local newspaper dated Apr. 22, 1886, information from the files of MESDA; *Craig's Daguerreian Registry*, 2:282; *www.familysearch.org.*

HOUGH, SYLVESTER E. (b. 1849): native of N.Y.; active ca. 1870s–early 1900s; in West Indies for three years; in New York City for twelve years; in Winston (ca. 1887–early 1900s); operated Twin-City Gallery on Main St.; Emma Fischer Cain assisted him in his gallery in the 1880s; brother of Eugenio Kinkaid Hough.

SOURCES: *Kernersville News*, Nov. 2, 1887; Robbins, *Descriptive Sketch of Winston-Salem*, 54; *Turner's Winston and Salem Directory*, 1889–1890, 1891–1892, 1894–1895; *Union Republican* (Winston), Jan. 15, 1891; Sprange, *Blue Book*, 289; Twelfth Census, 1900: Forsyth County, Pop. Sch., Winston, E.D. 37; information provided by Jennifer Bean Bower, MESDA.

HOUSH COMPANY: active 1911; photographed Broad River at Chimney Rock.

SOURCE: information provided by Carol Johnson, Library of Congress, Washington, D.C.

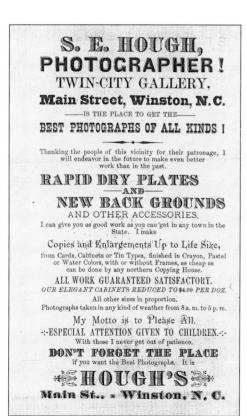

LEFT: This advertisement for Sylvester E. Hough's Twin-City Gallery appeared in a Winston, North Carolina, city directory in 1889. Advertisement courtesy Forsyth County Public Library. **ABOVE:** Hough's studio stood on Main Street, pictured here about 1895. Photograph courtesy MESDA.

HOUSTON, JOHN T. (b. ca. 1906): native of S.C.; active by 1930, Charlotte.

SOURCE: Fifteenth Census, 1930: Mecklenburg County, Pop. Sch., Charlotte, E.D. 60-9.

HOWARD, FRANK F. (b. ca. 1864): native of Ind.; active 1922–1923, Asheville; operated Howard Studio; husband of Isa M. Howard.

SOURCES: Miller, *Asheville, N.C. City Directory*, 1922–1923; Fifteenth Census, 1930: Buncombe County, Pop. Sch., Asheville, E.D. 11-5.

HOWARD, HELEN V.: active 1938–1939, Asheville; operated Home Portrait Studio.

SOURCE: *Miller's Asheville Directory*, 1938–1939.

HOWARD, ISA M. (Mrs. Frank F. Howard) (b. 1879): native of Ind.; active 1922–1940s, Asheville; associated with husband in operation of Howard Studio, Patton Ave. (operated by Johnie R. Frisby, 1927).

SOURCES: Photographic Examiners Records; Miller, *Asheville, N.C. City Directory*, 1926–1932, 1936–1941; Fifteenth Census, 1930: Buncombe County, Pop. Sch., Asheville, E.D. 11-5; Baldwin, *Asheville, N.C. City Directory, 1935*; State Auditor's Records, Sch. B; *Mercantile Reference Book*, 1931; *Mercantile Agency Reference Book*, 1943.

HOWARD, JESSIE. *See* Harward, Jessie.

HOWARD, JOSEPH H.: active 1924–1926, Asheville; operated Carolina Photo Company on Patton Ave. in partnership with a Mr. Watts (1924–1925); in West Asheville (1926) as sole proprietor of Carolina Photo Company.

SOURCE: Miller, *Asheville, N.C. City Directory*, 1924–1926.

HOWEL, _____ : active (obtained license to practice) 1891, Alleghany County, in partnership with a Mr. Brothers.

SOURCE: Registry of Licenses to Trade, Alleghany County, 1874–1906 (A&H).

HOWELL, HAYWOOD (1898–1992): native of N.C.; active 1919–1940s; in Tarboro (1919–1922) in partnership with brother-in-law, Gurney I. Hightower (resided with Hightower in 1920); in Durham (1922–1925) with Johnson Studio, with Katie L. Johnson; at Fort Bragg (1926–1937) with Wootten-Moulton Studio (1926–1931); in Fayetteville (1928) as sole proprietor of Photo Hut (1932–1937); in Sanford (1940s) in partnership with Monnie Pearl Badgett.

SOURCES: Photographic Examiners Records; Fourteenth Census, 1920: Edgecombe County, Pop. Sch., Rocky Mount, E.D. 18; *American Legion North Carolina Fayetteville City Directory, 1928*; information provided by James Vann Comer, Sanford; *www.familysearch.org*.

HOWENSTEIN, JOHN C. (b. 1872): native of Ohio; active 1891–1905; in Fort Wayne, Ind. (1891–1894); in Morganton (by 1900–1905); in Marion (1902–1905).

SOURCES: Twelfth Census, 1900: Burke County, Pop. Sch., Morganton, E.D. 15; *N.C. Year Book*, 1902–1905; Phifer, *Burke County*, 301; Marusek list of Ind. photographers.

HOWERTON, LEICEL PARKER (b. ca. 1896): native of N.C.; active 1922–1930s, Greensboro, as Howerton Studios; court action brought against him in 1937 for practicing without a license.

SOURCES: Photographic Examiners Records; *Hill's Greensboro Directory*, 1928–1931, 1934–1940; Fifteenth Census, 1930: Guilford County, Pop. Sch., Greensboro, E.D. 41-27; *Mercantile Reference Book*, 1931.

HUBBARD, HERBERT E.: active ca. 1918, Camp Greene; musician third class, Hqt. Company, 1st Regiment Conn. Infantry; received permission to take photographs at the camp.

SOURCES: National Army Camps, Camp Greene, Charlotte, N.C., RG 393, Box 20, National Archives; information provided by Jane Johnson, Charlotte.

HUFF, ELIAS KERNER (1856–1920): native of N.C.; active 1880s–1910s, Winston and later Winston-Salem; also worked as decorator and painter.

SOURCES: Branson, *NCBD*, 1890; *Winston-Salem Directory*, 1915; Vital Records, death certificates, Book 519, p. 82 (A&H); Forsyth County Estates Records (A&H); information provided by Jerry Cotten, North Carolina Collection, Wilson Library, UNC-CH.

HUFFMAN, _____: active 1902, Morganton, in partnership with a Mr. Connelly.

SOURCE: *N.C. Year Book*, 1902.

HUFFMAN, W. C.: active 1913–1914, Salisbury.

SOURCE: Miller, *Salisbury Directory*, 1913–1914.

HUGGINS, T.: itinerant daguerreotyper; active 1848, Wilmington; room above store of Perrin & Hartsfield on Market St.

SOURCE: *Wilmington Journal*, June 23, 1848.

HUGHES, _____: active 1921, Wilmington; operated Hughes' Studio.

SOURCE: State Auditor's Records, Sch. B.

HUGHES, W. F.: active 1879–1880, Person County.

SOURCE: Registry of Licenses to Trade, Person County, 1877–1901 (A&H).

HUGHES, WILLIAM MILTON (b. 1906): active 1930–1940s; in Loris, S.C. (1930–1935); in Lumberton (1935–1940s) with James C. Webb (1935–1938); as sole proprietor of Hughes' Studio (1938–1940s).

SOURCE: Photographic Examiners Records.

HUGHES & ANDREWS,
Photographers,
GREENSBORO', N. C.

☞ Furnish the latest and finest styles of Rembrandt Pictures, or any others connected with the art of Photography.

Branson's North Carolina Business Directory, 1872 includes this brief notice for partners William P. Hughes and Lewis W. Andrews in Greensboro. Notice courtesy State Library of North Carolina, Raleigh.

HUGHES, WILLIAM PARSLEY (b. ca. 1835): native of N.C.; itinerant; active 1853–1880s; in Yorkville, S.C. (1853), with Dr. J. W. F. Wilde and daughter Augusta; in Charlotte (1854, 1857) in room above Brown, Brawley & Company's store (1854) and rooms in Carson's brick building above Boone & Company's shoe store (1857); in Salisbury (1855, 1856) in room at Rowan House; in Asheville (1855, 1868, 1869) in rooms at courthouse (1855) and in room in Nat Atkinson's law office in rear of *Asheville News* offices (1868–1869); in Tuscaloosa, Ala. (1857–1859); in Camden, S.C. (1858, 1866, 1868); in Lancaster, S.C. (1858); in Greensboro (ca. 1864–1880); in partnership with Lewis W. Andrews (1872–1873) in gallery at Guilford County Courthouse; in Wilmington in partnership with Charles W. Yates as Hughes & Yates (n.d.).

SOURCES: Teal, *Partners with the Sun*, 42; *Western Democrat* (Charlotte), Nov. 17, 1854, Oct. 20, 1857; *Carolina Watchman* (Salisbury), Feb. 22, 1855, Mar. 25, 1856; *Asheville News*, Aug. 23, 1855; *Daily Southern News* (Greensboro), Aug. 12, 1864; *Asheville Pioneer*, May 14, 1868, Aug. 26, 1869; *Asheville*

News and Mountain Farmer, Aug. 20, Sept. 10, 1869; Branson, *NCBD*, 1867–1868, 1869, 1872, 1877–1878; Ninth Census, 1870: Guilford County, Pop. Sch., Greensboro, Morehead Township; *Record* (Asheville), Mar. 8, 1873; *Chataigne's Raleigh Directory*, 1875, 188; *Zell's U.S. Business Directory*, 1875; Robb list of Ala. photographers; photograph bearing Hughes's name, owned by Bill Bennett, Rocky Mount.

HUGO, _____ (two brothers): active 1921, Cherokee County; operating as Hugo Brothers of Memphis, Tenn.

SOURCE: State Auditor's Records, Sch. B.

HULET, LEROY E.: crayon portrait artist and photographer; active 1898, Court St., Rutherfordton.

SOURCE: *Western Vindicator* (Rutherfordton), Apr. 14, 1898.

HUMPHREY, PRYOR EMERSON (1906–1979): native of Ga.; active 1926–ca. 1970s; at Fort Bragg (1926–1929) with Wootten-Moulton Studio; in Pinehurst (1929–1944) with John H. Hemmer, primarily during winter months (worked in western N.C. and at White Sulphur Springs, W. Va., during summers); photographer for Pinehurst, Inc. (1940–1945); in Southern Pines (1946–1970s); purchased studio of Ellsworth C. Eddy in 1946 and became official photographer for town of Southern Pines.

SOURCES: Photographic Examiners Records; interview with Ellennore Eddy Smith, Southern Pines; *Pilot* (Southern Pines), Aug. 1, 1979.

HUMPHREY, SAMUEL DWIGHT (1823–1883): active late 1840s–1860s; in Ohio (late 1840s); in New York City (1849–1859); leading daguerreotyper of the era;

An unidentified man (lying on floor), a camera, and photographer P. Emerson Humphrey of Southern Pines are the points of interest in this candid photograph. Photograph courtesy Tufts Archives, Given Memorial Library, Pinehurst.

publisher of *Daguerreian Journal*, (1850s–1865) and *American Handbook of the Daguerreotype* (1858); in Fayetteville (1845–1846) as itinerant; occupied rooms above post office and later on Brick Row at the foot of Haymount, a few doors above Briggs's Hotel; operated as Humphrey & Company in partnership with J. L. Bryan; in Wilmington (1846) as itinerant on Front St., upstairs, adjoining Dr. Ware's office across from the office of the *Chronicle*; operated as Humphrey & Company in partnership with Bryan.

SOURCES: *Fayetteville Observer*, Nov. 25, 1845, Jan. 6, June 9, 16, 1846; *Chronicle* (Wilmington), Jan. 30, Feb. 4, 1846; *Journal* (Wilmington), Feb. 6, Dec. 25, 1846; Rinhart and Rinhart, *The American Daguerreotype*, 418; *Craig's Daguerreian Registry*, 2:290–291; Newhall, *The Daguerreotype In America*, 147.

HUNT, _____: active ca. 1913, western N.C.; in partnership with Arthur Keith as Hunt-Keith Studio.

SOURCE: photograph bearing name "Hunt."

HUNT, A. THEO: active 1877–1881; operated Hunt's Southern Temple of Photographic Art, Fayetteville St., Raleigh, in studio of John W. Watson while Watson was working in other southern states.

SOURCES: Branson, *NCBD*, 1877–1878; photographs bearing Hunt's name; business receipt in Joseph A. Engelhard Papers (A&H); Cotten list of N.C. photographers.

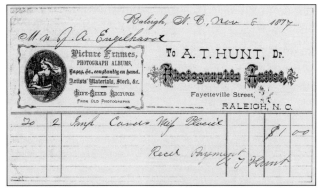

Shown here is a billhead of "Photographic Artist" A. Theo Hunt of Raleigh. The invoice indicates that Mrs. J. A. Engelhard purchased two picture cases on November 8, 1877. Photograph courtesy A&H.

HUNT, ESLEY (b. ca. 1824): native of Tenn.; active 1856–1869; maker of ambrotypes on Franklin St., Chapel Hill (1856–1859); in Guilford County (1860) as itinerant; operated E. Hunt's Photographic Gallery, Raleigh (1859–1864); purchased gallery of T. J. Havens on Fayetteville St.; in partnership with portrait painter Joshua P. Andrews; John W. Watson took over studio, fall 1865; on Person St., Fayetteville (ca. 1865–1868); Calvin A. Price took over studio in 1869; in Wytheville, Va. (n.d.).

SOURCES: *Hillsborough Recorder*, Mar. 12, 1856; Orange County Miscellaneous Records, Tax Records, 1800–1881 (A&H); *Spirit of the Age* (Raleigh), Aug. 10, 1859; Wake County Deed

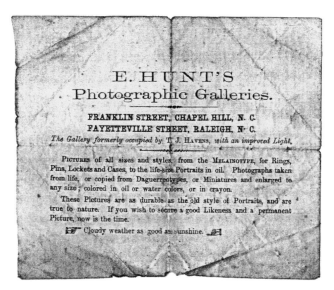

An early business notice for photographer Esley Hunt indicates that he operated galleries in Chapel Hill and Raleigh about 1859. Notice courtesy Leigh H. Gunn, Timberlake.

Records (A&H); *Weekly Standard* (Raleigh), Mar. 7, 1860; Eighth Census, 1860: Wake County, Pop. Sch., Raleigh; printed announcement in Holeman Family Papers, in possession of Leigh Holeman Gunn, Timberlake; Witham, *Catalogue of Civil War Photographers*, 60; *North Carolina Presbyterian* (Fayetteville), Feb. 17, 1869; Ginsberg, *Photographers in Virginia*, 53.

HUNTER, A. S.: African American; active (obtained license to practice) 1917–1918, Durham.

SOURCE: Record of Special Licenses Issued, Durham County, 1917–1918 (A&H).

HUNTINGTON, JAMES: active 1938–1940s, Greenville.

SOURCE: Photographic Examiners Records.

HUTCHINS, _____: itinerant daguerreotyper; active 1847, Raleigh, in partnership with E. W. Clark; rooms on third floor of large brick building known as Smith's Corner above Mr. Page's store.

SOURCE: *Raleigh Register and North Carolina Gazette*, Nov. 24, 1847.

HUTCHINS, _____: active early 1900s, Pinebluff (Moore County).

SOURCE: photograph bearing name "Hutchins."

HUTCHINS, LEO EUGENE (b. ca.1916): active 1930s–1954, Main St., Kernersville. Source not recorded.

HYATT, C. L.: active 1902–1907, Lumberton; operated gallery above Dr. J. D. McMillan's drugstore; also active as oil painter.

SOURCES: *Argus* (Lumberton), Aug. 28, Dec. 25, 1902; *N.C. Year Book*, 1904–1907.

HYMAN, A. RUDOLPH (1864–1941): native of N.C.; active 1894–ca.1910; in Greenville in partnership with Sydney R. Alley (ca.1895); sole proprietor on Dickinson Ave. at Five Points (1896); served as deputy sheriff of Pitt County under five sheriffs after 1910.

SOURCES: Sprange, *Blue Book*, 289; photograph bearing names of Hyman and Alley; *Eastern Reflector* (Greenville), Jan. 10, 1894; *King's Weekly* (Greenville), Apr. 10, Oct. 11, 1896; Twelfth Census, 1900: Pitt County, Pop. Sch., Greenville, E.D. 94; *N.C. Year Book*, 1902; *Mercantile Agency Reference Book*, 1904; *Daily Reflector* (Greenville), Feb. 3, 1941.

I

IDEAL PHOTO COMPANY: active ca. 1910–1923, Winston and later Winston-Salem; operated by Cleve Simpson and E. Remington (1910).

SOURCES: *N.C. Year Book*, 1916; *Winston-Salem Directory*, 1910–1923; State Auditor's Records, Sch. B; Weaver, *Winston-Salem, North Carolina, City of Industry*, 37.

IDEAL STUDIO: active 1918, Charlotte; Charles F. Harrison and M. Luther Philemon, operators.

SOURCE: Miller, *Charlotte Directory*, 1918.

IDEAL STUDIO: active 1921, Kannapolis; Charles F. Harrison, operator.

SOURCE: State Auditor's Records, Sch. B.

INDUSTRIAL PHOTO SERVICE, INC.: active 1927–1933, High Point; Roy A. Spearman, proprietor.

SOURCES: Miller, *High Point Directory*, 1927–1931; *Hill's High Point Directory*, 1933.

INGLIS, E. M. C. (Mrs.): active 1916–1917; assisted husband, W. J. Inglis, with Inglis Studio, Washington.

SOURCE: Miller, *Washington, North Carolina, City Directory*, 1916–1917.

INGLIS, W. J.; active 1916–1927; operated Inglis Studio, Washington (1916–1917), assisted by wife, Mrs. E. M. C. Inglis; on Haywood Rd. in West Asheville (1925–1927); took panoramic view of members of N.C. Firemen's Association, 1925.

SOURCES: *N.C. Year Book*, 1916; Miller, *Asheville, N.C. City Directory*, 1926–1927.

INGRAM, ROBERT C.: active 1935–1940s, Asheville; operated Long's Studio (1935–1941) and Skyland Studio (1939–1940).

SOURCES: Photographic Examiners Records; Baldwin, *City Directory of Asheville*, 1935; *Miller's Asheville Directory*, 1936–1941.

INTERNATIONAL NEWS PHOTOS, INC.: active 1934; photographed Labor Day parade in Gastonia.

SOURCE: information provided by Carol Johnson, Library of Congress, Washington, D.C.

IRIS STUDIO: active 1923–1924, S. Tryon St., Charlotte; A. Waller Franklin, operator.

SOURCE: Miller, *Charlotte Directory*, 1923–1924.

ISAAC, _____: active 1919–1920, New Bern, with father as S. Isaac & Son.

SOURCE: State Auditor's Records, Sch. B.

ISAAC, S.: active 1919–1920, New Bern, with son as S. Isaac & Son.

SOURCE: State Auditor's Records, Sch. B.

ISAASM (ISAASHAM), ABRAHAM: active (obtained license to practice) 1908–1909, Durham.

SOURCES: Registry of Licenses to Trade, Durham County, 1881–1913 (A&H); Record of Special Licenses Issued, Durham County, 1908–1909 (A&H).

ISIDOR, BUBA M. (b. ca. 1880): native of S.C.; active by 1910, Leaksville.

SOURCE: Thirteenth Census, 1910: Rockingham County, Pop. Sch., Leaksville Township, E.D. 154.

ISLEY, BENJAMIN R. (1848–1915): native of N.C.; active 1910–1915, Carthage.

SOURCES: *N.C. Year Book*, 1910–1915; Vital Records, death certificates, Book 91, p. 140 (A&H).

IVES, L. D.: active late 1860s–1870, Tarboro and Goldsboro.

SOURCE: photographs bearing his name, in possession of Stephen M. Rowe, Raleigh.

IVEY'S, INC. (department store): active 1937–1940s, Haywood St., Asheville.

SOURCE: *Miller's Asheville Directory*, 1937–1941.

J

JACKSON, _____: active early 1900s, Spray.

SOURCE: Aheron, *From Avalon to Eden*, 8.

JACKSON, A. R.: active 1919, Greensboro.

SOURCE: State Auditor's Records, Sch. B.

JACKSON, J. E.: active 1885, Clinton.

SOURCE: information provided by Jerry R. Roughton, Kenansville.

JACKSON, JACOB (ca. 1839–1862): native of N.C.; active early 1860s, Orange County; enlisted as private in Company G, Twenty-seventh Regiment, N.C. State Troops, June 26, 1861; killed at Sharpsburg, Md., Sept. 17, 1862.

SOURCE: Manarin and Jordan, *N.C. Troops*, 3:67.

JACKSON, R. E.: from Wake Forest; active 1921–1922, Granville County.

SOURCE: State Auditor's Records, Sch. B.

JACKSON, ROBERT L.: active 1919–1921, Gastonia.
SOURCE: State Auditor's Records, Sch. B.

JACKSON, W.: active 1921, Kinston.
SOURCE: State Auditor's Records, Sch. B.

JACKSON, W. F.: active 1910s; in Winston-Salem (1919); in Reidsville (1910s).
SOURCES: postcard bearing his name; State Auditor's Records, Sch. B.

JACKSON, WILLIAM HENRY (1843–1942): native of N.Y.; nationally known for his landscape work from photographic expeditions to western U.S. in 1870s; active in N.C. early 1900s while affiliated with Detroit Photographic Company; photographed Biltmore, near Asheville; photographed scenic views in western N.C., May, June 1902; along with R. Henry Scadin, photographed waterfalls there, June 1902.
SOURCES: R. Henry Scadin Collection, University of North Carolina at Asheville; information provided by staff of Pack

Memorial Public Library, Asheville; information provided by Peggy Gardner, Asheville.

JACOBS, G. K.: active 1915, Mollie (Columbus County).
SOURCE: State Auditor's Records, Sch. B.

JACOCKS, FRANCIS GILLAM, JR. (1910–1991): active 1940–1941, Asheville.
SOURCES: Photographic Examiners Records; *www.familysearch.org.*

JAMES, ALEXANDREW. *See* Barnes, Alexandria.

JAMES, SUSAN ELIZABETH (1848–1933): native of N.C.; active by 1870; photographic assistant in gallery of Henry A. Lineback, Salem; married Lineback in 1876; portraits of her are housed at MESDA in Winston-Salem.
SOURCES: Ninth Census, 1870: Forsyth County, Pop. Sch., Salem (Winston Township); information provided by Jennifer Bean Bower, MESDA.

LEFT: While associated with the Detroit Photographic Company, nationally known photographer William Henry Jackson obtained this dazzling view of Whitewater Falls at Sapphire during a brief trip to western North Carolina in June 1902. Photograph courtesy A&H.
ABOVE: Henry A. Lineback probably took this formal likeness of Susan Elizabeth James about the time of their marriage on August 8, 1876. Prior to the wedding James assisted Lineback in his thriving gallery at Salem. Photograph courtesy MESDA.

JAMES, WILLIAM ("WILL") (ca. 1860–ca. 1930): active 1880s–1890s, Lincoln County; also employed as a furniture maker.

SOURCE: information provided by Jason Harpe, Lincoln County Museum, Lincolnton.

JAMES, WILLIAM (b. ca. 1895): native of N.C.; African American; active by 1930, Raleigh.

SOURCE: Fifteenth Census, 1930: Wake County, Pop. Sch., Raleigh, E.D. 92-47.

JAMESTOWN OFFICIAL PHOTO CORPORATION: of Norfolk, Va.; active 1906; photographed N.C. portions of Great Dismal Swamp.

SOURCE: information provided by Carol Johnson, Library of Congress, Washington, D.C.

JANS (JAMES?), FRED (b. 1879): native of N.C.; active by 1900, High Point, with James Edward Jones.

SOURCE: Twelfth Census, 1900: Guilford County, Pop. Sch., High Point, E.D. 60.

JAY, A. C.: active 1921, Charlotte; operated Piedmont Studio on W. Trade St. in partnership with T. B. Robertson.

SOURCE: Miller, *Charlotte Directory*, 1921.

JEAN'S PHOTO SHOP: active 1940, Broadway St., Asheville; Jean Lail, operator.

SOURCE: *Miller's Asheville Directory*, 1940.

JEFFERS, GEORGE ABBEN: native of N.Y.; itinerant, active 1847–1857; in Albany and Troy County, N.Y. (1852); in Norfolk, Va. (ca. 1853); in New Bern (1854–1855) as itinerant daguerreotyper; operated gallery above Whaley's store on Craven St.; in Kinston (1855) in partnership with a Mr. Doty in rooms located above E. Williams's store; in Charleston and Georgetown, S.C. (1856–1857) as Jeffers & Company; in Chester, S.C. (1856); in Charlotte (1856) in rooms above Brown, Stitt & Company's store, opposite Kerr's hospital.

SOURCES: Rinhart and Rinhart, *The American Daguerreotype*, 397; *New Bern Journal*, Dec. 20, 1854; *American Advocate* (Kinston), Aug. 30, 1855; Teal, *Partners with the Sun*, 61; *Western Democrat* (Charlotte), Sept. 23, 1856; *Craig's Daguerreian Registry*, 2:303–304; Green, *A New Bern Album*, 13.

JENKINS, A. C.: active 1907–1910, Graham.

SOURCE: *N.C. Year Book*, 1907, 1910.

JENKINS, J. H.: active 1916, Winton.

SOURCE: *N.C. Year Book*, 1916.

JENKINS, KYER (KYLER): active early 1900s, western N.C.

SOURCE: photograph bearing his name.

JENKINS, W. C.: active (obtained license to practice) 1910–1911, Durham.

SOURCE: Record of Special Licenses Issued, Durham County, 1910–1911 (A&H).

JENNINGS, CHARLES (b. 1871): native of N.C.; active by 1900, Wilkesboro.

SOURCE: Twelfth Census, 1900: Wilkes County, Pop. Sch., Wilkesboro, E.D. 162.

JERNIGAN, JAMES: "stereotype" artist; active (obtained license to practice) 1870–1871, Moore County.

SOURCE: Treasurer's and Comptroller's Records, County Settlements with the State, Box 64, File 1840–1870 (A&H).

JEROME, CONDOR P. (b. ca. 1858): native of N.C.; active 1928–1931, Goldsboro.

SOURCES: Fifteenth Census, 1930: Wayne County, Pop. Sch., Goldsboro, E.D. 96-18; *Mercantile Reference Book*, 1931; *Hill's Goldsboro, North Carolina City Directory*, 1928.

JOGLO PHOTO SERVICE: active 1932–1940s, Greensboro (1932–1934) and High Point (1934–1940s); Joseph G. Link, operator.

SOURCE: Photographic Examiners Records.

JOHN, JESSE: active 1921, Winston-Salem.

SOURCE: State Auditor's Records, Sch. B.

JOHNSON, _____: active early twentieth century in unidentified N.C. location; in partnership with a Mr. Carr.

SOURCE: photograph bearing name "Johnson," John L. Patterson Papers (A&H).

JOHNSON, A. J.: active 1930s, North Wilkesboro.

SOURCE: Photographic Examiners Records.

JOHNSON, D. T.: active 1880s, Hendersonville; operated London Art Gallery, publisher of stereographs, in partnership with Arthur F. Baker; with Baker in Chester, S.C. (1886).

SOURCES: stereographs bearing Johnson's name; Teal, *Partners with the Sun*, 186.

JOHNSON, E.: active 1919, Laurinburg.

SOURCE: State Auditor's Records, Sch. B.

JOHNSON, FRANK (b. 1866): native of Canada; African American; active by 1900, Raleigh; inmate in state prison.

SOURCE: Twelfth Census, 1900: Wake County, Pop. Sch., Raleigh, E.D. 138.

JOHNSON, GROVER CLEVELAND (b. ca. 1885): native of N.C.; active by 1910, Goldsboro; also publisher of picture postcards.

SOURCES: Thirteenth Census, 1910: Wayne County, Pop. Sch., Goldsboro, E.D. 105; postcard bearing his name.

JOHNSON, H. A.: active 1940–1941, Gastonia.

SOURCE: Photographic Examiners Records.

JOHNSON, HUBERT HARRISON (b. 1905): active 1928–1930s, Gastonia; with G. E. Glenn (1928–1930); as sole proprietor (1933–1940s).

SOURCES: Photographic Examiners Records; *Hill's Gastonia Directory*, 1934, 1936.

JOHNSON, JOHN LEWIS (1871–1968): native of N.C.; active 1890s–1920s, Johnston County; also worked as farmer, merchant, watchmaker, and real estate developer.

SOURCE: biographical sketch in Nontextual Materials Unit Photographic Files (A&H).

JOHNSON, JONATHAN: active (obtained license to practice) 1915–1916, Durham.

SOURCE: Record of Special Licenses Issued, Durham County, 1914–1916 (A&H).

JOHNSON, KATIE L. (1874–1964): native of N.C.; active ca. 1900–late 1930s; operated Johnson Studio, E. Main St., Durham, in partnership with Mrs. Ruth G. Sasscer

On this postcard, which advertised her business in the 1910s, Katie L. Johnson of Durham, who billed herself "The Children's Photographer," is shown seated in a chair. A collage of her pictures of children surrounds her and beckons potential customers with the words "are your children here? If not[,] why not? Bring this [the postcard] in or send in photographs to recopy or enlarge." Courtesy of the compiler.

(1936–1938); specialized in children's photographs; married Thomas E. Rigsbee in 1924.

SOURCES: Twelfth Census, 1900: Durham County, Pop. Sch., Durham, E.D. 32; Thirteenth Census, 1910: Durham County, Pop. Sch., Durham, E.D. 41; Fourteenth Census, 1920: Durham County, Pop. Sch., Durham, E.D. 58; *N.C. Year Book*, 1906–1916; *Bradstreet's*, 1908, 1917, 1921, 1925; State Auditor's Records, Sch. B; Hill, *Durham, N.C. Directory*, 1905–1938; Records of Maplewood Cemetery, Durham; *Durham Morning Herald*, Oct. 25, 1964.

JOHNSON, R. CAVE: itinerant daguerreotyper; active 1851, Mount Airy, N.C., and Hillsville, Va.

SOURCE: *Craig's Daguerreian Registry*, 2:310.

JOHNSON, RALPH W. (1885–1969): active 1906–1919; in Snow Camp (1906); in Siler City (1919).

SOURCES: photograph bearing his name; State Auditor's Records, Sch. B.

JOHNSON, S. G.: active 1919, Fayetteville.

SOURCE: State Auditor's Records, Sch. B.

JOHNSON, THOMAS B.: active 1896–1900, on Fayetteville St., Raleigh; in partnership with a Mr. Smith (1896); in partnership with Albert P. Michelow (1899–1900).

SOURCES: Separk, *Directory of the City of Raleigh, N.C., 1896–'97*, 354; Murray list of Wake County photographers; Cotten list of N.C. photographers.

JOHNSON, W. C.: active ca. 1914, Tabor (now Tabor City).

SOURCE: real-photo postcard bearing his name.

JOHNSON, W. E.: active 1916, Durham.

SOURCE: State Auditor's Records, Sch. B.

JOHNSON, W. T.: active (obtained license to practice) 1889–1890, New Hanover County.

SOURCE: Registry of Licenses to Trade, New Hanover County, Vol. II, 1881–1894 (A&H).

JOHNSTON, _____: active 1915, Marion, in partnership with A. E. Puckridge.

SOURCE: *N.C. Year Book*, 1915.

JOHNSTON, FRANCES BENJAMIN (1864–1952): native of W. Va.; active 1880s–1940s in Washington, New York, New Orleans; documentary photographer in N.C. (1935–1940s) who took photographs for book *The Early Architecture of North Carolina* (1941); photograph collection of her works housed at Library of Congress, Washington, D.C.; the collection includes architectural photographs of N.C. and other southern states.

SOURCES: *Durham Sun*, Aug. 28, 1974; *Early Architecture of North Carolina*, 8–19; information provided by Carol Johnson, Library of Congress, Washington, D.C.

JOHNSTON, JULIUS (b. ca. 1860): African American; active by 1880, Asheville; assistant in gallery of Nat W. Taylor.

SOURCE: Tenth Census, 1880: Buncombe County, Pop. Sch., Asheville, E.D. 34.

JOHNSTON, SAMUEL WILLIAM, JR. (b. 1913): active 1937–1950s, Raleigh (1937); photographer for Raleigh *Times*; operated Johnston's Studio in Wake Forest (1938–1950s); in High Point (1939).

SOURCES: Photographic Examiners Records; Murray list of Wake County photographers.

JONES, _____: active (paid tax to practice) 1885–1886, Randolph County, in partnership with B. J. Wicker.

SOURCE: Treasurer's and Comptroller's Records, County Settlements with the State, Box 74, Randolph County (A&H).

JONES, _____: active late nineteenth century, Pittsboro.

SOURCE: photograph bearing name "Jones."

JONES, ABRAHAM: active 1921, Oxford.

SOURCE: State Auditor's Records, Sch. B.

JONES, AUDREY W.: active 1912–1917, Greensboro as A. W. Jones Photographers, Allen Benton, agent; in partnership with John J. Cook as Cook's Studio (1913–1917).

SOURCES: Aheron, *From Avalon to Eden*, 46; Hill, *Greensboro, N.C. Directory*, 1912–1914, 1917; State Auditor's Records, Sch. B.

JONES, CAREY: active 1921, Garysburg (Northampton County).

SOURCE: State Auditor's Records, Sch. B.

JONES, D. K.: itinerant; active (paid license tax) 1887–1888 statewide.

SOURCE: State Auditor's Records, Ledgers, 1869–1899, Vol. 18, p. 430 (A&H).

JONES, MRS. D. W.: active ca. 1867, Smithfield; mentioned in letter from Mary Custis Lee to Mary Bayard Clarke, Feb. 22, [1867].

SOURCE: Crow and Barden, *Live Your Own Life*, 238.

JONES, E.: active 1885–1891; in Oxford (1885–1886); in Roxboro (1891) in partnership with George A. Newell.

SOURCES: *Reference Book of the Mercantile Association of the Carolinas*, 1891; Cotten list of N.C. photographers.

JONES, E. E.: active 1919–1920; in Oxford (1919); in Raleigh (1920).

SOURCE: State Auditor's Records, Sch. B.

JONES, F.: active 1916, Red Springs.

SOURCE: *N.C. Year Book*, 1916.

JONES, FRANK B., JR. (ca. 1915–1975): active 1930s–1970s, Winston-Salem; staff photographer for *Winston-Salem Journal*; unofficial photographer for Old Salem, Inc.; grand nephew of Thomas C. Hege; collection housed at Forsyth County Public Library, Winston-Salem.

SOURCE: information provided by Molly Rawls, Forsyth County Public Library.

Frank B. Jones Jr., who for a time served as staff photographer for the *Winston-Salem Journal*, posed here with his camera in 1937. Photograph courtesy Forsyth County Public Library.

JONES, G. W.: active early 1880s; in Clay County (1881–1882); in Jackson County (1881); in Franklin (1881); in partnership with H. G. Trotter (1881); in partnership with Nat W. Taylor (1881); publisher of stereographs.

SOURCES: Registry of Licenses to Trade, Clay County, 1876–1904 (A&H); Registry of Licenses to Trade, Jackson County, 1874–1903 (A&H); name on stereographs with Taylor and Trotter.

JONES, H. H.: active 1916, Winton.

SOURCE: *N.C. Year Book*, 1916.

JONES, HEALY EUGENE (b. 1911): active 1940 and afterward, Concord; operated Model Studio with James M. Torrence.

SOURCES: Photographic Examiners Records; *Baldwin's Concord Directory*, 1940.

JONES, J. R.: itinerant; active (paid tax to practice) 1887–1888, statewide.

SOURCE: State Auditor's Records, Ledgers, 1869–1899, Vol. 18, p. 430 (A&H).

JONES, JAMES B. (b. ca. 1896): native of N.C.; active 1916–1930, Bakersville.

SOURCES: State Auditor's Records, Sch. B.; Fifteenth Census, 1930: Mitchell County, Pop. Sch., Bakersville, E.D. 61-1.

JONES, JAMES EDWARD (1865–1942): native of N.C.; active 1895–1930s; in High Point (by 1900–1930s); operated Jones Studio; manager, High Point Studio; in Grassy Creek (1921).

SOURCES: Sprange, *Blue Book,* 289; Twelfth Census, 1900: Guilford County, Pop. Sch., High Point, E.D. 60; *Mercantile Agency Reference Book,* 1904; *Bradstreet's,* 1908, 1917, 1921, 1925; *Mercantile Reference Book,* 1931; *N.C. Year Book,* 1910–1916; Miller, *High Point Directory,* 1910–1911, 1913, 1919–1931; *Hill's High Point Directory,* 1933, 1940; State Auditor's Records, Sch. B; *Greensboro Daily News,* Nov. 11, 1942.

JONES, JAMES W. (b. ca. 1848): native of N.C.; active by 1870, Goldsboro.

SOURCE: Ninth Census, 1870: Wayne County, Pop. Sch., Goldsboro.

JONES, JOHN T. (b. ca. 1887): native of N.C.; active by 1910, Barker's Township, Jackson County.

SOURCE: Thirteenth Census, 1910: Jackson County, Pop. Sch., Barker's Township, E.D. 82.

JONES, O. J.: active ca. 1908, Oregon Inlet area.

SOURCE: photograph bearing his name.

JONES, W. J.: active 1916, Fayetteville.

SOURCE: State Auditor's Records, Sch. B.

JONES, WILLIAM THOMAS ("WILLIE") (b. 1890): African American; active 1918–ca. 1950s; in Holly Springs (Wake County) (1918–1928); in Raleigh (1928); in Chapel Hill (1928–1929); in Durham (1930–ca. 1950s); moved to Durham in 1930 and established a studio in building that housed Amey Funeral Home; occupied studio on Mangum St. after 1933; portrait on file at Durham County Public Library, Durham.

SOURCES: Photographic Examiners Records; Hill, *Durham, N.C. Directory,* 1933–1941.

JOYNER, JAMES: itinerant daguerreotyper; traveled in North and South; active 1843–1844; in Hillsborough (1843) in gallery in house formerly occupied by

Miss Walker, above Judge Nash's on Margaret St.; in New Bern (1843–1844) in gallery on third floor of northeastern corner of Devereaux Building.

SOURCES: *Hillsborough Recorder,* June 15, 1843; *New Bernian,* Nov. 25, Dec. 2, 1843; Green, *A New Bern Album,* 13.

JUSTIG (JUSTIS), G. W.: active 1890, Dillsboro.

SOURCE: Cotten list of N.C. photographers.

K

KAH, JONATHAN S.: active early 1920s, Durham; operated Ramsey-Kah Studio on W. Main St. in partnership with Daniel H. Ramsey.

SOURCE: Hill, *Durham, N.C. Directory, 1923.*

KEEN, C. H.: active 1913–1914, Wilmington; operator of C. H. Keen & Company.

SOURCE: Hill, *Wilmington Directory, 1913–1914.*

KEEN, JAMES DANIEL (b. 1911): native of N.C.; active with Keen's Studio, Greensboro (1929–1930s); son of John Daniel Keen and Mrs. Lenora E. Keen; brother of Johnie L. Keen.

SOURCE: Photographic Examiners Records.

Durham photographer William T. "Willie" Jones took this interesting self-portrait about 1940. Photograph courtesy Durham County Public Library and Harriet Jones, Durham.

KEEN, JOHN DANIEL (1872–1938): native of Va.; active 1899–1936; in Dunn (1899–1903); in Siler City (1900) as itinerant; in Albemarle (1903–1904); associated with Shartle's Studio in Lynchburg, Va. (1904–1909); in Fayetteville (1909–1917); Keen's Studio, Person St.; operated Keen's Studio in Greensboro (1917–1935); husband of Mrs. Lenora E. Keen; father of James Daniel Keen and Johnie L. Keen.

SOURCES: Photographic Examiners Records; Twelfth Census, 1900: Chatham County, Pop. Sch., Siler City, E.D. 11; Fourteenth Census, 1920: Guilford County, Pop. Sch., Greensboro, E.D. 147; *N.C. Year Book*, 1910–1916; Hill, *Fayetteville, N.C. Directory, 1909–1910*; Gardiner, *Fayetteville, N.C. City Directory, 1915–1916*; Hill, *Greensboro, N.C. Directory*, 1917–1938; State Auditor's Records, Sch. B; Vital Records, death certificates, Book 2054, p. 294 (A&H); *Greensboro Daily News*, Sept. 11, 1938.

KEEN, JOHNIE LEON (b. 1912): native of N.C.; active with Keen's Studio, Greensboro (1930–1940s); son of John D. Keen and Mrs. Lenora E. Keen; brother of James D. Keen.

SOURCE: Photographic Examiners Records.

KEEN, L. W. (b. 1824): native of Tenn.; itinerant daguerreotyper; active 1840s–1854; in Sullivan County, Tenn. (1850); in Blountville, Tenn. (1854); in Asheville (1854) in gallery in Temperance Hall.

SOURCES: Rinhart and Rinhart, *The American Daguerreotype* 398; *Asheville News*, June 22, 29, 1854; *Craig's Daguerreian Registry*, 2:321.

KEEN, LENORA E. (b. ca. 1887): native of N.C.; active with Keen's Studio, Greensboro (1920–1922); wife of John D. Keen; mother of James D. Keen and Johnie L. Keen.

SOURCES: Fourteenth Census, 1920: Guilford County, Pop. Sch., Greensboro, E.D. 147; State Auditor's Records, Sch. B.

KEFAUVER, LESTER R. (b. ca. 1899): native of N.C.; active 1934 with Warner Studio, Main St., Durham.

SOURCES: Hill, *Durham, N.C. Directory, 1934*; www.familysearch.org.

KEITH, ARTHUR: active early 1900s, western N.C.; in partnership with a Mr. Hunt as Hunt-Keith Studio (ca. 1913).

SOURCE: photographs bearing Keith's name.

KEITH, BENJAMIN B.: African American; active 1918, 1930–1938, on Dawson St., Wilmington.

SOURCES: Reaves list of Wilmington photographers; Hill, *Wilmington Directory*, 1930–1938.

KELLER, _____: itinerant; active (paid tax to practice) 1886–1887, Durham, in partnership with a Mr. Tally.

SOURCE: State Auditor's Records, Ledgers, 1869–1899, Vol. 18, p. 258 (A&H).

KELLY, _____: active 1907 in association with firm of Berry, Kelly & Chadwick, headquartered in Chicago, publisher of stereographs of N.C.

SOURCE: stereograph of interior of Charlotte textile mill bearing company name.

KELLY, ANNIE RUTH UNDERWOOD (b. 1904): active 1920s–1930s, Waynesville; started in business with George D. Sherrill; later opened studio with husband Samuel H. Kelly. Source not recorded.

KELLY, JOHN, JR. (1909–1984): native of N.C.; itinerant before World War II; operated at Carolina Beach during war; moved to Wilmington after war and located on S. Third St.

SOURCE: Photographic Examiners Records.

KELLY, SAMUEL HARVEY (1892–1967): active 1920s–1930s in Waynesville, Lake Junaluska, and Aiken, S.C.; husband of Annie Ruth Underwood Kelly.

SOURCES: *Mercantile Agency Reference Book*, 1943; www.familysearch.org.

KELLY, W. H.: active 1920, Clinton.

SOURCE: State Auditor's Records, Sch. B.

KENDRICK, FREDERICK W. (b. ca. 1875): native of England; active by 1910–1914, 1919–1928, Wilmington; operated Gem Studio in partnership with brother-in-law, Andrew J. Foltz; returned to his home in Philadelphia in 1914 (James W. Buck purchased the studio in that year); returned to Wilmington and operated the studio in partnership with Andrew J. Foltz and Frederick A. Foltz (1919–1928).

SOURCES: Thirteenth Census, 1910: New Hanover County, Pop. Sch., Wilmington, E.D. 91; Hill, *Wilmington Directory*, 1911–1928; *Bradstreet's*, 1925; Reaves list of Wilmington photographers.

KENDRICK, WILLIE F. (1908–1983): active 1926–1940s; operated Palm Photo Service, Mebane (1926–late 1930s); in Chapel Hill (1941 and afterward) in association with Robert W. Foister.

SOURCES: Photographic Examiners Records; www.familysearch.org.

KENNEDY, M. E.: itinerant daguerreotyper; active 1853–1854, Goldsboro; gallery in Odd Fellows Hall.

SOURCE: *New Era* (Goldsboro), Oct. 27, 1853.

KENNEDY, O. C.: active 1919, Raleigh.

SOURCE: Photographic Examiners Records.

KENNEDY, PHILIP B.: itinerant; active 1859–1869; in Brooklyn, N.Y. (1859–1860); army photographer at Deep Bottom during Civil War; in Asheville (1866–1867); in Greensboro (1866–1867); operated gallery in Hendersonville (1866) in storehouse below post office

stairs; operated gallery in Masonic Hall, Hillsborough (1867); operated gallery on corner of Main and Fisher Streets, Salisbury (1869).

SOURCES: Witham, *Catalogue of Civil War Photographers*, 4; Branson, *NCBD* 1866–1867, 1869; *Hendersonville Pioneer*, Sept. 12, 1866; *Hillsborough Recorder*, June 19, 1867; *Tri-Weekly Examiner* (Salisbury), Sept. 10, 1869; *Craig's Daguerreian Registry*, 2:324.

KENNEDY, WILLIAM (b. ca. 1886): native of N.C.; active (obtained license to practice) 1909–1910, Durham; operated as Kennedy & Company and in partnership with William G. Eakes.

SOURCES: Registry of Licenses to Trade, Durham County, 1881–1913 (A&H); Thirteenth Census, 1910: Durham County, Pop. Sch., Durham, E.D. 41.

KEPHART, HORACE SOWERS (1862–1931): native of Pa.; active 1904–1931, Bryson City; also a writer; author of *Our Southern Highlanders* (1913); photograph collection housed at Western Carolina University, Cullowhee.

SOURCE: information provided by staff of Pack Memorial Public Library, Asheville.

KETNER, E. S.: active ca. 1895, Kernersville.

SOURCE: Sprange, *Blue Book*, 289.

KETZ, A.: active (obtained license to practice) Oct. 21, 1911 (for one-day snake show), Durham.

SOURCE: Registry of Licenses to Trade, Durham County, 1881–1913 (A&H).

KEY, JAYSON DAVID (1869–1953): native of N.C.; active by 1900, Pilot Mountain.

SOURCES: Twelfth Census, 1900: Surry County, Pop. Sch., Pilot Mountain, E.D. 114; *www.familysearch.org.*

KEYES, KENNETH S., II (b. 1921): active 1938–1939 with Parnell Photo Service, Durham.

SOURCE: Photographic Examiners Records.

KEYSTONE VIEW COMPANY: active early twentieth century; headquartered in Meadville, Pa.; publisher of stereographs of N.C., early twentieth century.

SOURCES: Darrah, *World of Stereographs*, 48–51; stereographs bearing company name.

KILLBURN BROTHERS: active late nineteenth and early twentieth centuries; headquartered in Littleton, N.H.; publisher of stereographs of N.C. in late nineteenth and early twentieth centuries.

SOURCES: Darrah, *World of Stereographs*, 45–46; stereographs bearing company name.

KILLIAN, JOE ROBERT (b. 1914): active 1938–1940 with St. John Studio, Belk's Department Store, Charlotte.

SOURCE: Photographic Examiners Records.

KING, GEORGE F.: active 1883–1884, Fayetteville St., Raleigh.

SOURCES: Richards, *Raleigh City Directory, 1883*, 164; Branson, *NCBD*, 1884.

KING, HENRY H. (b. 1848): native of N.C.; active early 1890s, Wilmington.

SOURCES: *Mercantile Agency Reference Book*, 1892; Twelfth Census, 1900: New Hanover County, Pop. Sch., Wilmington, E.D. 71.

KING, JARVIS ARTHUR (1883–1953): active 1929–1939, Charlotte.

SOURCES: Photographic Examiners Records; Miller, *Charlotte Directory*, 1929–1930; Hill, *Mercantile Reference Book*, 1931; *Charlotte, N.C. City Directory*, 1932–1939; *www.familysearch.org.*

KING, WILLIAM LESTER (1879–1940): active 1926–1940s, Durham; with Ramsey Studio (1926–1932); sole proprietor of King's Studio, Main St. (1932–1940s).

SOURCES: Photographic Examiners Records; Hill, *Durham, N.C. Directory*, 1935–1941; Vital Records, death certificates, Book 2218, p. 76 (A&H).

KINNER, EDWARD: active 1920, Laurinburg.

SOURCE: State Auditor's Records, Sch. B.

KINNER, JOHN G. (b. ca. 1879): native of Ky.; active by 1930, Charlotte.

SOURCE: Fifteenth Census, 1930: Mecklenburg County, Pop. Sch., Charlotte, E.D. 60-18.

KIRKLAND, WILLIAM REID (b. 1878): native of Pa.; active 1911–1940s; in Aiken, S.C. (1911–1929); with Smoky Mountain Photo Company, Waynesville (1930–1940s).

SOURCE: Photographic Examiners Records.

KISER, W. E.: active 1911–1916; in Forest City (1911–1914); in Caroleen (1915–1916).

SOURCE: *N.C. Year Book*, 1911–1916.

KITRELL, JAMES P. (b. ca. 1860): native of N.C.; active by 1910, Farmville.

SOURCE: Thirteenth Census, 1910: Pitt County, Pop. Sch., Farmville, E.D. 97.

KLUTTZ, JACOB HENRY JEREMIAH (1861–1930): native of N.C.; active by 1885–1920s; as itinerant in N.C. (1885); in Concord (by 1900); in Salisbury (1906–1916); in partnership with a Mr. Oates (1906); in Charlotte (1919) with J. H. Kluttz Studio.

SOURCES: State Auditor's Records, Ledgers, 1869–1899, Vol. 18, p. 115 (A&H); Twelfth Census, 1900: Cabarrus County, Pop. Sch., Concord (Township #10), E.D. 24; Miller, *Salisbury Directory*, 1907–1908, 1913–1916; *N.C. Year Book*, 1916; State Auditor's Records, Sch. B; postcard bearing his name (1906); Kluttz, *The Descendants of Johann Jacob Klotz*, 193, 196.

KNEPPER, PAUL AUSHERMAN (1910–1998): native of N.Y.; active by 1930–1940s; in Asheville by 1930; in Lexington (1933–1940s) in association with J. P. Burt.

SOURCES: Fifteenth Census, 1930: Buncombe County, Pop. Sch., Asheville, E.D. 11-6; Photographic Examiners Records; *www.familysearch.org.*

KNIGHT, HENRY (b. ca. 1893): native of N.C.; active 1920, Mayodan; also a cotton mill worker that year.

SOURCES: Fourteenth Census, 1920: Rockingham County, Pop. Sch., Mayodan, E.D. 209; State Auditor's Records, Sch. B.

KNOX, A. A.: itinerant from Richmond, Va.; active 1873–1877; in Richmond (1873–1874); in Elizabeth City (1877) in gallery located next door to Dr. Butt's drugstore; in partnership with Julian Vannerson.

SOURCES: Ginsberg, *Photographers in Virginia,* 35; *Economist* (Elizabeth City), Aug. 29, 1877.

KNOX, MAX: active (obtained license to practice) 1914–1915, Durham.

SOURCE: Record of Special Licenses Issued, Durham County, 1914–1916 (A&H).

KOCH, HELEN (b. ca. 1905): native of N.C.; active by 1930, Elizabeth City.

SOURCE: Fifteenth Census, 1930: Pasquotank County, Pop. Sch., Elizabeth City, E.D. 70-5.

KODAK STUDIO: active 1919, Asheboro.

SOURCE: State Auditor's Records, Sch. B.

KOHURING, WILLIAM F. (b. ca. 1904): native of N.Y.; active by 1930, Southern Pines.

SOURCE: Fifteenth Census, 1930: Moore County, Pop. Sch., Southern Pines, E.D. 63-14.

KOONCE, HENRY CLAY (b. 1877): native of N.C.; active by 1900–1910s; in Asheville in association with brother-in-law, Ignatius W. Brock (by 1900–1908, 1914–1915); in partnership with John E. Hage (1910–1914); sole proprietor (1913) of gallery located in Morsell Building; managed Brock's Brownie Studio (1914–1915); wife, Nellie, likewise worked as photographer in 1914–1915; son-in-law of Thomas H. Lindsey; resided in Atlanta, Ga., by 1927.

SOURCES: Twelfth Census, 1900: Buncombe County, Pop. Sch., Asheville, E.D. 139; *Asheville Daily Gazette,* June 13, 1902; Hill, *Asheville, N.C. Directory,* 1902–1907; Miller, *Asheville, N.C. Directory* 1910, 1913; *N.C. Year Book,* 1911, 1912; State Auditor's Records, Sch. B; information provided by staff of Pack Memorial Public Library, Asheville.

KOONCE, NELLIE LINDSAY: active 1914–1915, Asheville; wife of Henry Clay Koonce; daughter of Thomas H. Lindsey; resided in Atlanta, Ga., by 1927.

SOURCE: information provided by staff of Pack Memorial Public Library, Asheville.

KORNEGAY, GEORGE (b. 1849): native of N.C.; itinerant; active by 1870, Kinston; by 1880, employed as a merchant in Kinston.

SOURCES: Ninth Census, 1870: Lenoir County, Pop. Sch., Town of Kinston; *www.familysearch.org.*

KRAFT, FRED: active (obtained license to practice) 1909–1911, Durham.

SOURCE: Record of Special Licenses Issued, Durham County, 1908–1909, 1910–1911 (A&H).

KRAMER, H.: active 1919, Raleigh.

SOURCE: State Auditor's Records, Sch. B.

KRUPP, B. F.: active 1891, Wilmington; took charge of photograph gallery of Peterson Brothers on Market St.

SOURCE: *Morning Star* (Wilmington), Sept. 24, 1891.

KRYZANER, MORRIS: a former soldier of Charlotte; active 1918, Camp Greene; became a representative of Photographic Division of U.S. Army Signal Corps at the camp; received permission to take photographs there.

SOURCES: National Army Camps, Camp Greene, Charlotte, N.C., RG 393, Box 20, National Archives; information provided by Jane Johnson, Charlotte.

L

LACKEY, JAMES D. (b. ca. 1876): native of N.C.; active 1910–1930; in Laurinburg (1910–1920); in Saint Pauls (by 1930).

SOURCES: *N.C. Year Book,* 1910–1916; State Auditor's Records, Sch. B; Fourteenth Census, 1920: Scotland County, Pop. Sch., Laurinburg, E.D. 138; Fifteenth Census, 1930: Robeson County, Pop. Sch., St. Pauls, E.D. 75-47.

LAIL, JEAN: active 1940, Asheville; operated Jean's Photo Shop on Broadway St.

SOURCE: *Miller's Asheville Directory,* 1940.

LAKE, B. J. ("BAN"): itinerant; active 1889–1890, Bryson City; occupied tent gallery near railroad; specialized in views of western N.C.

SOURCES: *Swain County Herald* (Bryson City), June 13, 27, July 18, Nov. 28, 1889; Branson, *NCBD,* 1890.

LAMB, CHARLES W.: active 1939, Asheville; operated Lamb's Studio.

SOURCE: Miller, *Miller's Asheville Directory,* 1939.

LANCASTER, J. M. (b. ca. 1815): native of N.C.; employed as shoemaker in Charlotte, 1850; itinerant maker of ambrotypes; active 1857, 1866; in Charlotte (1857); occupied gallery in Springs' new brick building; in Winston (1866); operated ambrotype gallery in Miller's Hall.

> AMBROTYPE
> LIKENESSES.
>
> The public is respectfully informed that J. M. LANCASTER'S
> **Ambrotype Gallery,**
> opposite J. T. & S. M. Blair's Grocery Store, in Springs' new brick building, is now open, where a fine colored Ambrotype can be procured at from 75 cents to $9.
> Ladies and gentlemen are requested to call and examine his Specimens, and have a Likeness taken of themselves or children. Call early, as such an opportunity is seldom offered.
> J. M. LANCASTER.
> Charlotte, May 12, 1857. 3m

J. M. Lancaster, an itinerant maker of ambrotypes, placed this advertisement in the Charlotte *Western Democrat* in May, 1857. Advertisement courtesy A&H.

SOURCES: Seventh Census, 1850: Mecklenburg County, Pop. Sch., Charlotte; Western *Democrat* (Charlotte), May 12–Aug. 11, 1857; *Western Sentinel* (Winston), June 1, 1866.

LANDERS, ROBERT (b. 1872): native of N.C.; active by 1900, Hot Springs (Madison County).

SOURCE: Twelfth Census, 1900: Madison County, Pop. Sch., Hot Springs, E.D. 82.

LANE, E. F.: active 1914–1920; in Durham (1914–1915); in Raleigh (1920).

SOURCES: Record of Special Licenses Issued, Durham County, 1914–1916 (A&H); State Auditor's Records, Sch. B.

LANE, J. H.: active 1916–1921, Wilmington.

SOURCE: State Auditor's Records, Sch. B.

LANE, PHILLIP(S): active 1919–1921, Garysburg (Northampton County).

SOURCE: State Auditor's Records, Sch. B.

LANEY, F. B.: active early 1900s, western N.C. Source not recorded.

LANGDON, JAMES WILLIAM ("BILLY") (b. ca. 1865): active 1890–1930, Four Oaks.

SOURCES: Thirteenth Census, 1910: Johnston County, Pop. Sch., Four Oaks, E.D. 49; *N.C. Year Book*, 1910, 1915, 1916; State Auditor's Records, Sch. B; *Four Oaks News*, Feb. 19, 1985; *www.familysearch.org*.

LANGE, DOROTHEA (1895–1965): nationally known photographer, active 1939 in N.C. with U.S. Farm Security Administration; in Chapel Hill and Caswell, Chatham, Durham, Granville, Orange, Person, Randolph, and Wake Counties.

SOURCES: Wilson and Ferris, *Encyclopedia of Southern Culture*, 98; Cotten, *Light and Air*, 56–58; Dixon, *Photographers of the*

Farm Security Administration, 53; "Reference Guide to FSA/OWI Photographs."

LANGLEY, JAMES P.: active 1916–1917, S. Elm St., Greensboro.

SOURCES: Hill, *Greensboro, N.C. Directory, 1915–1916*; *N.C. Year Book*, 1916; *Bradstreet's*, 1917.

LANIER, WILLIAM: maker of ambrotypes; active late 1850s; Granville County.

SOURCE: Granville County Miscellaneous Tax Records, undated, 1754–1886, Folder 1850–1858 (A&H).

LANOUETTE, DANIEL W.: active ca. 1918, Camp Greene; major, 1st Regiment Conn. Infantry; received permission to take photographs at the camp.

SOURCES: National Army Camps, Camp Greene, Charlotte, N.C., RG 393, Box 20, National Archives; information provided by Jane Johnson, Charlotte.

LARDNER, J. F.: active 1883, Wilmington; operated Yates' Gallery on Market St.

SOURCE: Reaves list of Wilmington photographers.

LARE, DOROTHY GRACE (Miss) (1900–1979): active 1938–1941, with Anchor Stores, Winston-Salem; died in Ore.

SOURCES: Photographic Examiners Records; *www.familysearch.org*.

LASSITER, _____: active 1916, Marion.

SOURCE: *N.C. Year Book*, 1916.

LATTA, IRA (b. 1880): native of N.C.; itinerant; active by 1900, Durham.

SOURCE: Twelfth Census, 1900: Durham County, Pop. Sch., Durham, E.D. 32.

LAUDY, L. C.: itinerant maker of ambrotypes; active 1857–1859; in New York City (1857–1858); in Wadesboro (1858–1859); occupied gallery above Falkner's Store and in the Masonic Hall.

SOURCES: *North Carolina Argus* (Wadesboro), Sept. 23, 1858, Jan. 6, Feb. 17, 1859; *Craig's Daguerreian Registry*, 2:341.

LAWRENCE, _____: active late nineteenth century, Franklinton, Va., and Edenton, N.C.

SOURCE: photograph bearing name "Lawrence," in possession of Jerry R. Roughton, Kenansville.

LAWRENCE, FRANK E. (b. ca. 1886): native of N.C.; active by 1910, Hickory.

SOURCE: Thirteenth Census, 1910: Catawba County, Pop. Sch., Hickory, E.D. 24.

LAWRENCE, N. L.: active late 1930s, Winston-Salem; brought to trial by State Board of Photographic Examiners for practicing without a license and won case.

SOURCE: Photographic Examiners Records.

LAWS, CLIFTON (1886–1965): active 1920s–1930s, Elk Park and Avery County; proprietor of Tip Top Studio.

SOURCES: Lentz, *W. R. Trivett, Appalachian Picture Man*, 32–33; *www.familysearch.org.*

LAZELLE, HENRY H. (b. ca. 1830): native of N.Y.; active 1860s; photographer with Union army during Civil War; operated Excellsior Gallery, Petersburg, Va. (ca. late 1860s); in partnership with a Mr. McMullen (1866); in Washington (1869) in gallery located first door west of Cape Fear Bank; by 1880, employed as a confectioner in Washington, D.C.

SOURCES: Witham, *Catalogue of Civil War Photographers*, 4; Ginsberg, *Photographers in Virginia*, 20; *Eastern Intelligencer* (Washington), June 1, 1869; information provided by Stephen M. Rowe, Raleigh; *www.familysearch.org.*

LEACH, T. M.: active 1921, Fayetteville.

SOURCE: State Auditor's Records, Sch. B.

LEARY, S. LINTON: active 1902–1905, Winston; operated Leary Photographic Gallery, opposite Jones Hotel.

SOURCES: *Walsh's Directory of the Cities of Winston and Salem*, 1902–1905; *Mercantile Agency Reference Book*, 1904; information from the files of MESDA.

LEATH, ERNEST C. (b. ca. 1845): native of Va.; itinerant, active 1871–1880; operated Tarboro Photograph and Pearltype Gallery, Tarboro (1871–1872) "at the old stand lately occupied by William F. Staples"; in Petersburg, Va. (1875–1880)

SOURCES: *Enquirer* (Tarboro), Dec. 9, 1871; Ginsberg, *Photographers in Virginia*, 20; tintype bearing his name; *www.familysearch.org.*

LEDFORD, E.: active 1921, Canton.

SOURCE: State Auditor's Records, Sch. B.

LEE, J. H.: active 1916, Winton.

SOURCE: *N.C. Year Book*, 1916.

LEE, J. W.: active 1919, Raeford.

SOURCE: State Auditor's Records, Sch. B.

LEE, JOHN F. (ca. 1850–1888): mulatto; native of Va.; active by 1880–1887, Edenton; deceased by Apr. 1888, when P. Henry Murphy purchased Lee's gallery.

SOURCES: Tenth Census, 1880: Chowan County, Pop. Sch., Town of Edenton, E.D. 31; State Auditor's Records, Ledgers, 1869–1899, Vol. 18, p. 104 (A&H); *Fisherman & Farmer* (Edenton), Apr. 6, 1888.

LEGWIN, JO HARDY (ca. 1879–1926): native of N.C.; active 1901, Wilmington; purchased novelty photograph business from George W. Shear on Princess St.

SOURCES: *Messenger* (Wilmington), Sept. 12, 1901; Reaves list of Wilmington photographers.

LEINBACH, HENRY A. *See* Lineback, Henry A.

LEINBACH, TRAUGOTT (1798–1863): native of N.C.; early important amateur daguerreotyper; active 1843–1850s, Salem; also well-known silversmith; uncle of Henry A. Lineback (Leinbach); portraits housed at MESDA in Winston-Salem.

SOURCES: Seventh Census, 1850: Forsyth County, Pop. Sch., Salem; *Humphrey's Daguerreian Journal*, 2:268 (1851); Peacock, *Silversmiths of North Carolina*, 89, 93; information provided by Jennifer Bean Bower, MESDA; Forsyth County Estates Records (A&H).

LELAND, EDWIN J. (b. ca. 1839): native of Mass.; active late 1850s–1870s; associated with J. A. Whipple in Boston, (1850s) and Worcester, Mass. (1860s–1870s); in New Bern (1862); occupied rooms in brick block on Broad St.; took photographs of Union occupying forces in New Bern; employed as electrician in Worcester, Mass., in 1880.

SOURCES: *Newbern Daily Progress*, Aug. 11, 1862; Eskind, *Index to American Photograph Collections*, 766; Polito, *A Directory of Massachusetts Photographers*, 505–508, 513; *www.familysearch.org.*

LEMORT, MARGUERITE (1901–1992): active 1923–1940s, with Baker's Art Gallery, Hendersonville.

SOURCES: Photographic Examiners Records; *www.familysearch.org.*

LEONARD, ANNIE BLANCH (b. 1879): native of N.C.; active by 1900; Greensboro; daughter of Joseph A. Leonard and sister of John C. and Joseph D. Leonard.

SOURCES: Twelfth Census, 1900: Guilford County, Pop. Sch., Greensboro, E.D. 55; Thirteenth Census, 1910: Guilford County, Pop. Sch., Greensboro, E.D. 106; *www.familysearch.org.*

LEONARD (LONARD), FRANK (b. 1871): native of N.C.; active by 1900, Mayodan (Rockingham County).

SOURCE: Twelfth Census, 1900: Rockingham County, Pop. Sch., Mayodan, E.D. 74.

LEONARD, JOHN C. (b. ca. 1888): native of N.C.; active by 1910, Greensboro; son of Joseph A. Leonard and brother of Annie B. and Joseph D. Leonard.

SOURCE: Thirteenth Census, 1910: Guilford County, Pop. Sch., Greensboro, E.D. 106.

LEONARD, JOSEPH ADDISON (1853–1912): native of N.C.; employed as a mechanic in 1880; active 1896–1912, Greensboro; in partnership with William Brown (1896–1897); producer of stereographs; father of Annie B., John C., and Joseph D. Leonard.

SOURCES: Brenizer, *A Directory of the City of Greensboro For 1896–97*; *Maloney's 1899–1900 Greensboro Directory*; Hill, *Greensboro Directory 1903–1906, 1909–1910*; Twelfth Census, 1900: Guilford County, Pop. Sch., Greensboro, E.D. 55; *N.C. Year Book*, 1902–1907, 1910–1912; *Mercantile Agency Reference Book*, 1904; Thirteenth Census, 1910: Guilford County, Pop. Sch., Greensboro, E.D. 106; Vital Records, death

certificates, Book D46, p. 247 (A&H); biographical files at Greensboro Public Library; *www.familysearch.org*.

LEONARD, JOSEPH D. (b. ca. 1892): native of N.C.; active by 1910, Greensboro; son of Joseph A. Leonard and brother of Annie B. and John C. Leonard.

SOURCE: Thirteenth Census, 1910: Guilford County, Pop. Sch., Greensboro, E.D. 106.

LESLIE, WILLIAM AUGUSTUS (1869–1922): active 1902, Morganton.

SOURCES: *N.C. Year Book*, 1902; *Cemeteries of Burke County*, 3:48.

LESTER, SAM: active early 1900s, Manteo.

SOURCE: photograph bearing his name.

LEVOIS, _____: itinerant maker of ambrotypes; active 1859, Louisburg, in partnership with Eugenio K. Hough in rooms formerly occupied by a Mr. Walker.

SOURCE: *American Eagle* (Louisburg), Feb. 26, 1859.

LEWIS, GEORGE: active 1921, Ahoskie.

SOURCE: State Auditor's Records, Sch. B.

LEWIS, GEORGE V.: from Ind.; itinerant; active 1899–1909; in Wilson (1899) in gallery on Nash St., opposite First National Bank; in Washington County (1900–1901); in Sumter, S.C. (1909).

SOURCES: *Wilson Advance*, May 26, 1899; *Wilson Times*, Aug. 18, 1899; Registry of Licenses to Trade, Washington County, 1883–1902 (A&H); Teal, *Partners with the Sun*, 250.

LEWIS, H. L.: active 1919, Charlotte.

SOURCE: State Auditor's Records, Sch. B.

LEWIS, HENRY THEO (b. 1904): active 1938–1940s; in Asheboro (1938–1941); operated Lewis Studio in Raleigh (1940) and in Sanford (n.d.); operated Stone Studio in High Point (1945 and afterward); served as district chairman, N.C. Photographers' Association.

SOURCES: Photographic Examiners Records; Miller, *Asheboro, N.C. Directory*, 1939–1942; Hill, *Raleigh Directory*, 1940.

LEWIS, J. HOWELL: active 1899–1903, Asheville, in partnership with Adelbert E. Riley (1902–1903) on Patton Ave.

SOURCES: *Asheville Daily Gazette*, Apr. 12, 1902; Hill, *Asheville, N.C. Directory, 1902–1903*; information provided by staff of Pack Memorial Public Library, Asheville.

LEWIS, JAMES C. (b. 1862): native of Va.; active by 1900, Asheville; resided near Ignatius W. Brock.

SOURCE: Twelfth Census, 1900: Buncombe County, Pop. Sch., Asheville, E.D. 139.

LEWIS, JOHN P. (b. 1866): native of N.C.; active 1893–1920s; in North Wilkesboro as itinerant maker of tintypes (1893); in Pilot Mountain (1894–1920s); awarded premium at 1897 N.C. State Fair for best photography display; also worked as merchant (1910).

SOURCES: *North Wilkesboro News*, Sept. 21, 1893; *News and Observer* (Raleigh), Aug. 24, 1899; Twelfth Census, 1900: Surry County, Pop. Sch., Pilot Mountain, E.D. 114; *N.C. Year Book*, 1902–1907, 1913, 1915, 1916; *Bradstreet's*, 1908; Thirteenth Census, 1910: Surry County, Pop. Sch., Pilot Mountain, E.D. 138; State Auditor's Records, Sch. B.

LEWIS, OSCAR MARVEL (1833–1903): native of N.C.; itinerant daguerreotyper and maker of ambrotypes; active 1856–1859; in Asheville (1856); occupied rooms in Chunn House, opposite courthouse; also occupied rooms on Main St. (1856–1858); advertised sale of a lithographed copy of an ambrotype of Mitchell's Falls on Black Mountain (1858); sold gallery to Edward W. Herndon in 1859.

SOURCES: *Asheville News*, Mar. 20, Nov. 20, 1856, Jan. 21, July 15, Aug. 5, 1858, Jan. 6, 1859; *Asheville Spectator*, Sept. 3, 1858; *www.familysearch.org*.

LEWIS, R. F.: active 1908, Canton.

SOURCE: *Bradstreet's*, 1908.

LEWIS, ROBERT EARLIE (b. 1912): active 1939–1940s; operated Camera Craft Studio, Durham (1939–1940); operated Daniel & Smith Studio, Raleigh (1940–1942).

SOURCE: Photographic Examiners Records.

LEWIS, SAM: active 1920, Laurinburg.

SOURCE: State Auditor's Records, Sch. B.

LIBBY, WALDO EDWIN (1906–1972): active 1937–1940s, Asheville; member of U.S. Army Air Corps during World War II.

SOURCES: Photographic Examiners Records; *www.familysearch.org*.

LIGHTSEY, GEORGE: active 1919, Raleigh.

SOURCE: State Auditor's Records, Sch. B.

LILES, _____: active 1912, Tarboro, in partnership with William Ruffin as the Liles-Ruffin Company.

SOURCE: information provided by Jerry R. Roughton, Kenansville.

LILES, HAMPTON F. (1865–1911): native of N.C.; active ca. 1895–1897, Monroe; died in Chattanooga, Tenn.

SOURCES: Sprange, *Blue Book*, 289; Branson *NCBD*, 1896–1897; Union County Estates Records (A&H); WPA Cemetery Index (A&H).

LILES, JOSEPH MELVIN: active 1920–1935; operated Liles Studio, Hay St., Fayetteville (1920–1924); operated Liles Studio, Raleigh (1928); in Zebulon (1935).

SOURCES: *Bradstreet's*, 1921, 1925; Hill, *Fayetteville, N.C. City Directory, 1924*; Murray list of Wake County photographers; Photographic Examiners Records.

LILLY, H. WALTER: African American; active 1917, Charlotte.

SOURCE: Miller, *Charlotte Directory*, 1917.

LINCOLNTON DAGUERREOTYPE ESTABLISHMENT: operated by unidentified itinerant; active 1845, Lincolnton; located at hotel of A. A. McLane.

SOURCE: *Lincoln Courier* (Lincolnton), July 30, 1845.

LINDLEY, HENRY C. (1894–1979): active ca. 1915–1940s, Winston-Salem, as manager of Barber Photo Supply Company, also known as Barber Printing & Stationery Company (1916) and as Barber Photo Company (1921, 1935).

SOURCE: Photographic Examiners Records; *www.familysearch.org*.

LINDLEY, R. H.: active 1919–1920, Hillsborough.

SOURCE: State Auditor's Records, Sch. B.

LINDOW, MILO WILLIAM (1910–1998): active 1937–1940s, Charlotte; studio located in Efird's Department Store; also associated with Wheelan's Studio; died in Wis.

SOURCES: Photographic Examiners Records; *www.familysearch.org*.

LINDSAY, R. C.: active 1916, Madison.

SOURCE: State Auditor's Records, Sch. B.

LINDSAY, ROSA J.: active 1903–1910s; in Yorkville, S.C. (1903–1911); in Gastonia, N.C. (1911–1912), in partnership with Mrs. M. H. Curry.

SOURCES: Teal, *Partners with the Sun*, 320; *N.C. Year Book*, 1912.

LINDSAY, WILLIAM THOMAS (1860–1932): native of Tex.; active 1918–early 1920s, late 1920s–1932, Charlotte; in

partnership with William M. Morse on S. Tryon St. (1918); operated Lindsay's Picture Factory at Latta Arcade on S. Tryon St. (1920); soon afterward moved to Birmingham, Ala., where he worked as a salesman; returned to Charlotte and operated Lindsay Studio (1929–1932); died of tuberculosis at Mecklenburg Sanitarium.

SOURCES: Miller, *Charlotte Directory* 1918, 1929–1930; *Hill's Charlotte Directory*, 1932; State Auditor's Records, Sch. B; *Charlotte News*, Feb. 22, 1932; information provided by Shelia Bumgarner, Public Library of Charlotte and Mecklenburg County.

LINDSEY, THOMAS H. (1849–1927): native of Va.; member of Company B, Twenty-third Va. Battalion; active 1870s–1910s; in Knoxville, Tenn. (1870s–1880s); publisher of stereographs; relocated to Asheville from Tenn. about 1887; in Asheville (1887–1910s); in partnership with Edward E. Brown (1890–1891) on S. Court Pl.; produced views of western N.C.; in sole proprietorship on Main St. (1890s–ca. 1916) as Lindsey's Art Gallery and Lindsey's Photographic Parlors (1890s), as Lindsey's Art Parlors (1900–1901), as Asheville Art Parlors in partnership with John F. McFarland (1902–1903); as Lindsey & Company (1904–1907); father of Ada L. Slagle and father-in-law of John Hamilton Slagle; photo of studio on file at N.C. Office of Archives and History.

SOURCES: information provided by Tom Wise, Talbott, Tenn.; *Asheville City Directory*, 1887, 227; *Country Home* (Asheville), 1887; Fulenweider, *Asheville City Directory, 1890*; McIlwaine, *Asheville City Directory, 1896–1897*; Maloney, *Asheville City Directory* 1900–1901; Hill, *Asheville City Directory*, 1902–1907; Miller, *Asheville City Directory*, 1907–1910; *Lindsey & Brown's Descriptive Catalogue of Photographic Views*, ca. 1890 (Rare Book, Manuscript, and Special Collections Library, Duke University, Durham); Branson, *NCBD*, 1890, 1896, 1897; Sprange, *Blue*

This exterior view of Thomas H. Lindsey's "photographic parlors" on South Court Street in Asheville was printed on the reverse side of many of his photographs during the early 1890s. Courtesy of the compiler.

LINDSEY'S ⋆ PHOTOGRAPHIC ⋆ PARLORS,
SOUTH COURT PLACE, ASHEVILLE, N. C.

VISITORS
ALWAYS
WELCOME

Where they may spend leisure hours pleasantly wandering through scenes of beauty, rambling over mountains grand or in gorges deep; by murmuring streamlets or torrents wild.

More than one thousand views on exhibition, portraying the grandeur and beauty of this "Land of the Sky."

A descriptive catalogue of these beautiful views free on application.

LINDSEY'S GUIDE BOOK
TO
ASHEVILLE AND WESTERN
NORTH CAROLINA.

JUST OUT.

Contains 25 fine illustrations from Photographs; a large Map of Western N. Carolina, showing the different places of interest, their distance from Asheville, and how to reach them; an article descriptive of Western North Carolina and its resources. Numerous tables of Altitudes, Temperature, Rain Fall, Moisture, Distances, Railroad Fare, etc. Neat pocket size, handsomely bound in leatherette. Price 25 cents. Address T. H. LINDSEY, or call at Lindsey's Studio.

FINE ⋆ PORTRAITS ⋆ A ⋆ SPECIALTY.

RIGHT: This town view by Lindsey and Brown shows a "prairie schooner" on Court Square in front of E. L. Jacobs's drugstore in Asheville about 1890. Photograph courtesy Pack Memorial Public Library, Asheville. **BELOW:** Lindsey, along with partner Edward E. Brown, published many scenic views, including this one of Peter's Rock, overlooking the French Broad River near Hot Springs in northern Madison County, about 1890. Photograph courtesy Rare Book, Manuscript, and Special Collections Library, Duke University, Durham.

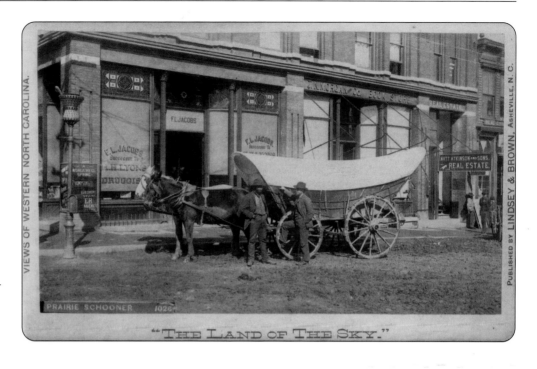

Book, 288; *N.C. Year Book*, 1910–1916; Twelfth Census, 1900: Buncombe County, Pop. Sch., Asheville, E.D. 135; *Asheville Daily Gazette*, Apr. 12, 1902; *Asheville Citizen*, July 21, 1927; Vital Records, death certificates, Book 1126, p. 172 (A&H); Darrah, *World of Stereographs*, 208.

LINDSEY, THOMAS W. (b. ca. 1831): native of Va.; active by 1860–1870; in Greensboro (by 1860); in Lincolnton (by 1870).

SOURCES: Eighth Census, 1860: Guilford County, Pop. Sch., Greensboro Postoffice, South Division; Ninth Census, 1870: Lincoln County, Pop. Sch., Lincolnton.

LINEBACK (LEINBACH) HENRY ALEXANDER (1839–1932): native of N.C.; first received training as cabinetmaker but turned to photography after an illness kept him out of Confederate service; active ca. 1860s–ca. 1922; in Salem (1860s–1880s); in Winston (1889) and Winston-Salem (1913 and afterward); in partnership with William D. Edwards (1911–1922); photographed Siamese twins Chang and Eng Bunker after their death in 1870 for scientific and medical research; nephew of Traugott Leinbach; married Susan Elizabeth James (who had worked in his studio for six years) in 1876; portraits of and by Lineback housed at MESDA in Winston-Salem. Example on page 121.

SOURCES: Branson, *NCBD*, 1869, 1872, 1877–1878, 1884; Ninth Census, 1870: Forsyth County, Pop. Sch., Salem (Winston Township); Tenth Census, 1880: Forsyth County, Pop. Sch., Salem, E.D. 86; Twelfth Census, 1900: Forsyth County, Pop. Sch., Salem, Winston Township, E.D. 35; Robbins, *Descriptive Sketch of Winston-Salem*, 54; Zell's U.S. Business Directory, 1875; *Charles Emerson & Company's Winston, Salem and Greensboro, North Carolina Directory, 1879–'80*; *Directory of Greensboro, Salem and Winston, 1884*; *Turner's Winston and Salem Directory, 1889–1890, 1891–1892, 1894–1895*; *Walsh's*

A youthful-looking Henry A. Lineback of Salem had this tintype portrait made at Charles L. Marston's gallery in Philadelphia in 1866. Photograph courtesy MESDA.

Winston-Salem, North Carolina City Directory, 1902–1908; *Winston-Salem Directory*, 1910–1922; *Union Republican* (Winston), Jan. 15, 1891; *Twin-City Sentinel* (Winston-Salem), Oct. 24, 1925, Nov. 12, 1960; *Mercantile Agency Reference Book*, 1904; *Bradstreet's*, 1917, 1921; *N.C. Year Book*, 1910–1916; State Auditor's Records, Sch. B; information provided by Jennifer Bean Bower, MESDA; *Winston-Salem Journal*, Dec. 31, 1932.

LINEBERGER, B. F.: active 1916, LaGrange.

SOURCE: State Auditor's Records, Sch. B.

LINEBERGER, B. T.: active (obtained license to practice) 1900–1901, Washington County.

SOURCE: Registry of Licenses to Trade, Washington County, 1883–1902 (A&H).

LINEBERRY, PAUL FISHER (b. 1918): active 1939–1940, with Denmark Studio, Raleigh.

SOURCE: Photographic Examiners Records.

LINK, JOSEPH GURLEY (1892–1975): active 1918–1940s; in Lexington (1918); worked as photo finisher for Joglo Photo Service in Greensboro (1932–1934) and High Point (1934–1940s).

SOURCES: Photographic Examiners Records; *www.familysearch.org*.

LINK, R. F.: active 1919–1920; in Newton (1919); in Iron Station (1919–1920).

SOURCE: State Auditor's Records, Sch. B.

LIPSCOMBE, _____: itinerant maker of ambrotypes; active 1856, Hillsborough, in partnership with a Mr. Ellis; occupied rooms at Masonic Hall.

SOURCE: *Hillsborough Recorder*, Nov. 19, 1856.

LITHOGRAPHING & DECORATING COMPANY: active 1940–1941, Asheville.

SOURCE: *Miller's Asheville Directory*, 1940, 1941.

LITTLE, _____: active ca. 1920s; operated Little Studio in New Bern.

SOURCE: photograph bearing name "Little."

LITTLE, ISAAC (b. ca. 1895): native of N.C.; African American; active by 1920, Washington.

SOURCE: Fourteenth Census, 1920: Beaufort County, Pop. Sch., Washington, E.D. 16.

LITTLE, ROBERT DALE (b. 1919): active 1940s at Duke Hospital, Durham.

SOURCE: Photographic Examiners Records.

LITTLE BILLIE'S STUDIO (also Little Billie's Kodak and Amateur Finishing): active 1917–1934, Wilmington; William H. Dyer, operator.

SOURCE: Hill, *Wilmington Directory*, 1917–1934.

LITTLE FOLKS' STUDIO: active 1930s–1940s, Charlotte, Earl L. Moore, proprietor.

SOURCES: Photographic Examiners Records; Hill, *Charlotte, N.C. City Directory*, 1933–1941.

LIVELY, CELIA MOULTON (1898–1975): active 1923–1930s with Wootten-Moulton Studio, New Bern; sister of George C. Moulton.

SOURCES: Photographic Examiners Records; tombstone inscription, Cedar Grove Cemetery, New Bern; Cotten, *Light and Air*, 34–36.

LIVELY, JOSEPH S. (b. ca. 1881): native of Ala.; active 1927–1930 on Patton Ave., Asheville; associated with his father, William S. Lively, in operation of Southern School of Photography during first quarter of century; husband of Winona B. Lively; father of William A. Lively.

SOURCES: *Miller's Asheville Directory*, 1928–1930; Fifteenth Census, 1930: Buncombe County, Pop. Sch., Asheville, E.D. 11-7; *Mercantile Reference Book*, 1931; *Asheville Citizen*, Feb. 2, 1927.

LIVELY, WILLIAM A. (b. ca. 1904): native of Tenn.; active by 1930, Asheville; associated with Wootten-Moulton Studio, Chapel Hill (1930s); son of Joseph S. and Winona B. Lively.

SOURCES: Fifteenth Census, 1930: Buncombe County, Pop. Sch., Asheville, E.D. 11-7; Cotten, *Light and Air*, 34–35.

LIVELY, WINONA B. (b. ca. 1886): native of Ind.; active by 1930, Asheville; wife of Joseph S. Lively; mother of William A. Lively.

SOURCE: Fifteenth Census, 1930: Buncombe County, Pop. Sch., Asheville, E.D. 11-7.

LLOYD, ALFRED (b. 1863): active in Albemarle (1941 and afterward); out of state for fifty years before moving in with daughter in Albemarle.

SOURCE: Photographic Examiners Records.

LLOYD, NELLIE GRAY (1896–1987): native of N.C.; active by 1920, Durham.

SOURCES: Fourteenth Census, 1920: Durham County, Pop. Sch., Durham, E.D. 49; *www.familysearch.org*.

LOGAN, CURTIS G. (b. ca. 1873): native of N.C.; active early 1900s, Waynesville, as dealer in Kodaks and supplies; offered developing and finishing for amateurs; took views of Waynesville and surrounding area; later operated undertaking business and worked as an electrician; helped install first electric lights in Waynesville.

SOURCES: *Daily Waynesville Courier*, Aug. 8, 1906; *Waynesville Courier*, Jan. 3, 1908; Thirteenth Census, 1910: Haywood County, Pop. Sch., Waynesville, E.D. 68.

LOGAN, G.: active 1869–1872, Shelby.

SOURCE: Cotten list of N.C. photographers.

LOHR, KATIE A. (b. ca. 1891): native of N.C.; active by 1910, Hickory.

SOURCE: Thirteenth Census, 1910: Catawba County, Pop. Sch., Hickory, E.D. 24.

LOMAX, ALAN (1915–1980): active 1934–ca. 1950; photographed sound-recording expeditions in the South carried out by John Avery Lomax and Ruby Terrill Lomax (who likewise made photographs) for the Archive of American Folk Song; photographed performers at Asheville Mountain Music Festival; photograph collection housed at Library of Congress, Washington, D.C.; died in Ala.

SOURCES: information provided by Carol Johnson, Library of Congress, Washington, D.C.; *www.familysearch.org*.

LOMAX, JOHN AVERY (1867–1948): active ca. 1908–1909, Asheville, in partnership with Luther L. Higgason.

SOURCE: photograph bearing names of Lomax and Higgason, in possession of compiler.

LONDON PHOTO COMPANY: active 1904, Elizabeth City.

SOURCE: *N.C. Year Book*, 1904.

LONG, _____: active 1890, Hertford, in association with R. Frank Peterson and John F. Engle.

SOURCE: *Perquimans Record* (Hertford), Dec. 10, 1890.

LONG, E. K.: active (obtained license to practice) 1914–1915, Durham.

SOURCE: Record of Special Licenses Issued, Durham County, 1914–1916 (A&H).

LONG, ERNEST: active 1912–1914, Edenton.

SOURCE: *N.C. Year Book*, 1912–1914.

LONG, JAMES G. (b. 1854): native of N.C.; active by 1900, Forest City.

SOURCE: Twelfth Census, 1900: Rutherford County, Pop. Sch., Forest City, Cool Spring Township, E.D. 134.

LONG, T. G.: active 1908, Washington.

SOURCE: *Bradstreet's*, 1908.

LONG, THOMAS W. (b. ca. 1873); native of N.C.; active by 1910–1920s, Monroe, in partnership with Samuel C. Boyce (1910); as sole proprietor (1911–1920s).

SOURCES: Thirteenth Census, 1910: Union County, Pop. Sch., Monroe, E.D. 130; *N.C. Year Book*, 1912–1916; State Auditor's Records, Sch. B; *Miller's Monroe, N.C. City Directory, 1922–1923*.

LONG'S STUDIO: active 1934–1941, Asheville; Robert C. Ingram, operator (briefly operated, 1934, by John E. Hales).

SOURCES: Photographic Examiners Records; Baldwin, *Asheville City Directory, 1935*; *Miller's Asheville Directory, 1936*.

LOTHERY, THOMAS EARLY, JR. (1907–1954): active 1935–1941 with Whitsett Photo Company, Charlotte.

SOURCES: Photographic Examiners Records; *www.familysearch.org*.

LOUDY, HUGH TAYLOR (1882–1965): active 1930s in N.C., with home base in Winston-Salem; by 1938 had moved to Tenn.; died in Tenn.

SOURCES: Photographic Examiners Records; *www.familysearch.org*.

LOUNSBURY, CHARLES S.: itinerant daguerreotyper; active in 1853 in Washington and Salisbury; occupied rooms at Colonel Robard's hotel in latter town.

SOURCES: *North State Whig* (Washington), Feb. 23, 1853; *Carolina Watchman* (Salisbury), Aug. 18, 1853.

LOVELESS, _____: itinerant; active 1883–1884 statewide in partnership with a Mr. McConchie.

SOURCE: State Auditor's Records, Ledgers, 1869–1899, Vol. 17, p. 478 (A&H).

LOVIT (LOVETT), J. D.: active 1919–1920, Kinston.

SOURCE: State Auditor's Records, Sch. B.

LOWDER, _____: active 1908, Albemarle, in partnership with Martin A. Whitlock as Whitlock & Lowder.

SOURCE: information provided by Jerry R. Roughton, Kenansville.

LOWE, A. M.: active 1872, High Point.

SOURCE: Branson, *NCBD*, 1872.

LOWRY, JOHN KERR (1912–1985): active 1939–1940s; with William Daniel's Camera Shop, Raleigh (1939–1940); with Carolina Photo Finishers, Wilson (1941 and afterward).

SOURCES: Photographic Examiners Records; *www.familysearch.org*.

LUCAS, CORNELIUS (b. ca. 1893): native of N.C.; African American; active by 1910, Washington.

SOURCE: Thirteenth Census, 1910: Beaufort County, Pop. Sch., Washington, E.D. 16.

LUCAS, JACK: with Fox Studio of St. Paul, Minn.; active 1936, Charlotte; accused of practicing without a license and lost court case.

SOURCE: Photographic Examiners Records.

LUEDERS, LOUIS H.: active late 1930s–1940s, Greensboro; found to be practicing without a license.

SOURCES: Photographic Examiners Records; *Mercantile Agency Reference Book*, 1943.

LUMPKIN, J. G.: active 1906, Enfield.

SOURCE: *N.C. Year Book*, 1906.

LUND, VIGGO: native of Denmark; active ca.1892–1897 on Nash St., Wilson (1897), in partnership with John F. Engle; in charge of Engle's Art Gallery on Water St., Elizabeth City (1892–1893).

SOURCES: *Perquimans Record* (Hertford), Nov. 23, 1892; *North Carolinian* (Elizabeth City), Apr. 19, 1893; *Times* (Wilson), Aug. 23, 1897; *Advance* (Wilson), Nov. 11, 1897.

LUPTON, _____: active 1890, Columbia; also employed as saloon keeper.

SOURCE: Branson, *NCBD*, 1890.

LYALL, ARTHUR (b. ca. 1884): native of N.C.; active from late nineteenth century to 1920s, Garretson (Ashe County) (n.d.); in West Jefferson (by 1920); producer of stereograph of Ashe County Courthouse at Jefferson.

SOURCES: Fourteenth Census, 1920: Ashe County, Pop. Sch., West Jefferson, E.D. 28; information provided by Tex Treadwell, Institute for Photographic Research, Bryan, Tex.

LYNCH, H. H.: active 1873, Rutherfordton; gallery located at N. Scoggins' (store?).

SOURCE: *West-Carolina Record* (Rutherfordton), Apr. 26, 1873.

LYNCH, JOHN J.: active 1902–1903, Raleigh.

SOURCE: *N.C. Year Book*, 1902, 1903.

LYNCH, NORTH MCFARLAND (1914–1994): active 1935–1940s; in Mebane (1935–1937); operated Lynch Photo Service, Graham (1938–1940s).

SOURCES: Photographic Examiners Records; *www.familysearch.org*.

LYNN (LINN), C. M.: active 1919–1921, Kannapolis.

SOURCE: State Auditor's Records, Sch. B.

LYON, _____: active (obtained license to practice) 1892–1893, Columbus County, in partnership with a Mr. Cavalry.

SOURCE: Registry of Licenses to Trade, Columbus County, 1876–1892 (A&H).

LYON, LENTO HENRY (b. 1887): active ca. 1926–1940s; operated Lyon Photo Service, Statesville.

SOURCES: Photographic Examiners Records; *Mercantile Reference Book*, 1931.

M

M & W EXCHANGE: active 1925 at Latta Arcade, Charlotte; Mrs. Pat V. Moody, manager.

SOURCE: Miller, *Charlotte Directory*, 1925.

MABE, CHARLES: active 1916, Walnut Cove.

SOURCE: State Auditor's Records, Sch. B.

MCADAMS, _____: itinerant in N.C.; active (paid license tax to practice) 1883–1884; in partnership with a Mr. Moore.

SOURCE: State Auditor's Records, Ledgers, 1869–1899, Vol. 17, p. 424 (A&H).

MCARTAN, ALEXANDER BELL (1898–1962): native of N.C.; active 1919–1940s, Linden (Cumberland County).

SOURCES: Photographic Examiners Records; *www.familysearch.org*.

MCARTAN, C.: active 1872–1874 on Hay St., Fayetteville; purchased gallery of Calvin A. Price in 1872; publisher of stereographs; left Fayetteville in Feb. 1874.

SOURCES: *Eagle* (Fayetteville), Mar. 14, 1872; *North Carolina Presbyterian* (Fayetteville), Mar. 27, 1872, Jan. 14, 1874; *Robesonian* (Lumberton), June 20, Nov. 20, 1872, Feb. 5, 1873; George Eastman House Photographers Database.

MCARTHUR, JOHN CRAYTON (1856–1923): native of N.C.; active 1877–1920s; in Shelby (1877–1908); in Forest City (1919–1920s); also employed as a tinner (1908); brother of William E. McArthur and uncle of Margaret D. McArthur.

SOURCES: Tenth Census, 1880. Cleveland County, Pop. Sch., Shelby, E.D. 70; *N.C. Year Book*, 1904, 1905; *Bradstreet's*, 1908;

William E. McArthur of Shelby made this studio photograph of his younger brother John C. McArthur and sister-in-law Edith ("Edie") Saluda Watson McArthur in 1893. The younger McArthur also worked as a photographer. Photograph courtesy Miles Philbeck, Chapel Hill.

State Auditor's Records, Sch. B; Rutherford County Estates Records (A&H); Vital Records, death certificates, Book 754, p. 1; information provided by Miles Philbeck, Chapel Hill.

McARTHUR, MARGARET D. (b. ca. 1897): native of N.C.; active by 1920, Rutherfordton; daughter of William E. McArthur and niece of John C. McArthur.

SOURCE: Fourteenth Census, 1920: Rutherford County, Pop. Sch., Rutherfordton, E.D. 171.

McARTHUR, WILLIAM E. ("WILL") (1859–1956): native of N.C.; active 1877–1950s; entered photography trade with his brother, John C. McArthur; occupied studio located at intersecton of S. Washington and Warren Sts., Shelby (1877–1914); in Rutherfordton (1916–1950s); studio fire destroyed many of his early photographs; father of Margaret D. McArthur.

SOURCES: Tenth Census, 1880: Cleveland County, Pop. Sch.,

Shelby, E.D. 70; Twelfth Census, 1900: Cleveland County, Pop. Sch., Shelby, E.D. 56; *N.C. Year Book*, 1902–1906, 1910, 1914, 1916; *Bradstreet's*, 1908; State Auditor's Records, Sch. B; Fourteenth Census, 1920: Rutherford County, Pop. Sch., Rutherfordton, E.D. 171; Fifteenth Census, 1930: Rutherford County, Pop. Sch., Rutherfordton, E.D. 81–24; Sprange, *Blue Book*, 289; Cotten list of N.C. photographers; *Shelby Star*, Oct. 11, 1984; Rutherford County Estates Records (A&H).

McCADDEN, H. C.: itinerant; active 1872, Durham; gallery specialized in photographs of children.

SOURCE: *Durham Tobacco Plant*, Feb. 14, 1872.

McCAIG, W. L.: active 1916, Canton.

SOURCE: State Auditor's Records, Sch. B.

McCANLESS, D. A. W.: native of N.C.; itinerant; active early 1880s, Gaffney, S.C. (made photographs at Limestone College).

SOURCE: Teal, *Partners with the Sun*, 196.

McCANLESS, JAMES MELMONT (1857–1923): native of N.C.; active 1890–1920; on Patton Ave. in Asheville in partnership with brother, Samuel A. McCanless (1890); as sole proprietorship (1892 and afterward) on W. Court Square, Asheville; at Camp Wadsworth near Spartanburg, S.C. (1917) as McCanless Brothers with brother Samuel A.; brother of Lonzo McCanless.

SOURCES: *Western Carolina Advocate* (Asheville), Jan. 5, 1893; Sprange, *Blue Book*, 288; McIlwaine, *Asheville City Directory, 1896–1897*; Maloney, *Asheville City Directory*, 1900–1901; Hill, *Asheville City Directory*, 1904–1907; Miller, *Asheville City Directory*, 1907–1920; Twelfth Census, 1900: Buncombe County, Pop. Sch., Asheville, E.D. 140; *Bradstreet's*, 1908, 1917; *N.C. Year Book*, 1910–1916; State Auditor's Records, Sch. B; Ward, *The Heritage of Old Buncombe County, North Carolina*, 2:245.

McCANLESS, ALONZO (LONZO) (b. 1861); native of N.C.; active by 1900, Asheville; brother of James M. and Samuel A. McCanless.

SOURCE: Twelfth Census, 1900: Buncombe County, Pop. Sch., Asheville, E.D. 140.

McCANLESS, SAMUEL ALONZO (1859–1922): native of N.C.; active 1890–1922; on Patton Ave. in Asheville (1890–1901) in partnership with brother, James M. McCanless (1890); operated Asheville Photo Studio (1899–1901); in Marion (1910–1913); in Old Fort (by 1910, 1916–1922); at Camp Wadsworth near Spartanburg, S.C. (1917) as McCanless Brothers, with brother, James M.; brother of Lonzo McCanless.

SOURCES: Fulenweider, *Asheville City Directory, 1890*; McIlwaine, *Asheville City Directory, 1896–1897*; *Asheville, North Carolina City Directory, 1899–1900*; Maloney, *Asheville, City Directory*, 1900–1901; *N.C. Year Book*, 1910–1913, 1916; Fifteenth Census, 1930: McDowell County, Pop. Sch., Old Fort, E.D. 105; State Auditor's Records, Sch. B; Ward, *The Heritage of Old Buncombe County, North Carolina*, 2:245; Vital Records,

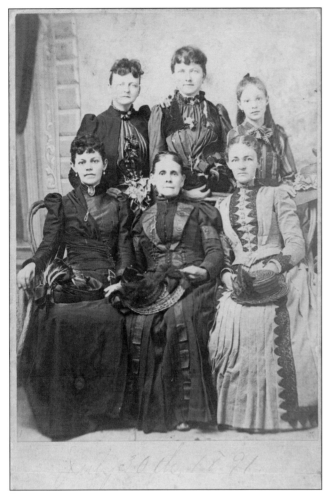

The McCanless brothers' (James M. and Samuel A.) studio of Asheville was responsible for this portrait of six unidentified fashionably attired female members of the same family, made on July 30, 1891. Photograph courtesy A&H.

death certificates, Book 821, p. 132 (A&H); Aldridge et al., *McDowell County, North Carolina Cemetery Records*, 3:77.

McCANLESS, W. OSCAR (b. ca. 1843): native of Va.; itinerant; active 1876, Danbury; gallery located in rooms above post office; worked as a farmer by 1880.
SOURCES: *Danbury Reporter*, June 8, 1876; *www.familysearch.org*.

McCLELLAND, G. L. D.: active (obtained license to practice) 1878–1879, Clay County.
SOURCE: Registry of Licenses to Trade, Clay County, 1876–1904 (A&H)

McCLURKEN, JAMES L.: active 1908–1910, Patton Ave., Asheville.
SOURCES: *Bradstreet's*, 1908; Miller, *Asheville City Directory*, 1908–1910.

McCONCHIE, _____: itinerant in N.C.; active (paid tax to practice) 1883–1884; in partnership with a Mr. Loveless.

SOURCE: State Auditor's Records, Ledgers, 1869–1899, Vol. 17, p. 478.

McCOY, ELOISE FRANCES (Miss) (b. 1915): active 1940s with Efird's Department Store, Charlotte.
SOURCE: Photographic Examiners Records.

McCRACKEN, HARRY M. (b. ca. 1888): native of N.C.; active by 1910–1916, Burnsville.
SOURCES: Thirteenth Census, 1910: Yancey County, Pop. Sch., Burnsville, E.D. 152; *N.C. Year Book*, 1916.

McCRACKEN, JOHN W. (b. ca. 1875): native of Tenn.; active by 1910–1910s; in Elk Park (by 1910, 1916); in Cranberry (1910s).
SOURCES: Thirteenth Census, 1910: Mitchell County, Pop. Sch., Elk Park, E.D. 141; State Auditor's Records, Sch. B; *N.C. Year Book*, 1916.

McCRARY, _____: of Knoxville, Tenn.; active early 1870s, western N.C.; in partnership with a Mr. Branson as publishers of stereographs.
SOURCE: information provided by Carol Johnson, Library of Congress, Washington, D.C.

McCRARY, WALTER FRANKLIN (1912–1972): active 1939–1940, Lenoir, in association with Fred Scott of Scott's Studio.
SOURCES: Photographic Examiners Records; *www.familysearch.org*.

McCURRY, ELLA (Mrs. Max M. McCurry) (b. ca. 1870): native of N.C.; active 1908–1924, Forest City; also employed as milliner.
SOURCES: *N.C. Year Book*, 1910–1916; State Auditor's Records, Sch. B; *Bradstreet's*, 1908, 1917, 1921, 1925; Fourteenth Census, 1920: Rutherford County, Pop. Sch., Forest City, E.D. 158.

MACDONALD, H. J.: active 1941, Fayetteville; operator of Mac's Camera Shop, Donaldson St.
SOURCE: *Hill's Fayetteville Directory*, 1941.

McFARLAND, JOHN F. (b. ca. 1881): native of Ky.; active 1900–1911, Asheville; operated Asheville Art Parlors in partnership with Thomas H. Lindsey (1902–1903) on S. Main St. and later Pack Square.
SOURCES: Maloney, *Asheville City Directory*, 1900–1901; *Asheville, North Carolina City Directory*, 1904–1907; Miller, *Asheville City Directory*, 1907–1911; *Asheville Daily Gazette*, Apr. 12, 1902; Thirteenth Census, 1910: Buncombe County, Pop. Sch., Asheville, E.D. 14.

MACFEE, EDWARD D. (1865–1939): native of N.Y.; "Flash Light Artist"; active 1899–1900, Raleigh; took photographs of great snowstorm of Feb. 1899 in that city; in Oxford (ca. 1899); in Petersburg, Va. (n.d.); died in N.Y.
SOURCES: photographs bearing his name, N.C. Museum of History (copy negatives of some photographs housed

Edward D. MacFee, an itinerant "Flash Light Artist," photographed this scene along Fayetteville Street in Raleigh following a record-setting snowfall in February 1899. Photograph courtesy A&H.

in State Archives); Ginsberg, *Photographers in Virginia*, 20; information provided by A. S. Woodlief, Franklinton; *www.familysearch.org*.

MCGARRY, JOSEPH: active 1913–1923, Asheville; proprietor of DeLuxe Studio (1914); proprietor of McGarry Studio (1914–1916); proprietor of Branagan Studio (1917–1923); husband of May M. McGarry.

SOURCES: Miller, *Asheville City Directory*, 1913–1915; information provided by staff of Pack Memorial Public Library, Asheville.

MCGARRY, MAY M.: active 1913–1924, Asheville; wife of Joseph McGarry.

SOURCES: State Auditor's Records, Sch. B; *Bradstreet's*, 1925.

MCGEE, C. J.: active (obtained license to practice) 1911– 1913, 1915–1916, Durham.

SOURCES: Record of Special Licenses Issued, Durham County, 1910–1911, 1914–1916 (A&H); Registry of Licenses to Trade, Durham County, 1881–1913 (A&H).

MCGEHEE, VIRGIL: active 1908, Candor.

SOURCE: information provided by Jerry R. Roughton, Kenansville.

MCGILVARY, THOMAS T. (1855–1918): native of N.C.; active 1898–1899, Fayetteville; proprietor of Winburn's Gallery, located above A. E. Rankin & Company's store on Person St.; previously employed in car shops of Cape Fear & Yadkin Valley Railroad; at the time of his death was employed as a pattern maker in a machine shop.

SOURCES: *News and Observer* (Raleigh), Aug. 24, 1899; Vital Records, death certificates, Book 315, p. 480 (A&H).

MCGOWAN, CARL DANIEL (b. 1894): native of Fla.; active 1924–1930s, Rocky Mount; proprietor of McGowan's Studio; employed as photographer by N.C. Emergency Relief Administration (mid-1930s); the N.C. Office of Archives and History holds copy negatives of a portion of his ERA photographs.

SOURCES: Photographic Examiners Records; Fifteenth Census, 1930: Nash County, Pop. Sch., Rocky Mount, E.D. 64-29; Hill, *Rocky Mount City Directory, 1930*; *Mercantile Reference Book*, 1931.

MCGOWAN, JOSEPH BERNARD (b. 1896): active 1932–1940s in Greensboro (1932–1940) in partnerships with Dwight T. Chambers (1932–1939) and Donald Chambers (1940); in Durham (1940–1941) with Donald Chambers.

SOURCE: Photographic Examiners Records.

MACHLUS, MAX (1893–1980): active 1921, Rowan County; died in N.Y.

SOURCES: State Auditor's Records, Sch. B; *www.familysearch.org*.

MCINNIS, W. T. (b. ca. 1897): native of N.C.; active by 1930, Greensboro.

SOURCE: Fifteenth Census, 1930: Guilford County, Pop. Sch., Greensboro, E.D. 41-12.

MCINTOSH, ARCHIBALD (1837–1912): native of N.C.; active ca. 1874–1907; in Hickory (ca. 1874–1907); in

Newton (1884); one of the best-known late-nineteenth-century photographers in western N.C.

SOURCES: Tenth Census, 1880: Catawba County, Pop. Sch., Hickory, E.D. 41; Twelfth Census, 1900: Catawba County, Pop. Sch., E.D. 41; *Chataigne's N.C. Directory and Gazetteer, 1883–'84*; *State Chronicle* (Raleigh), Aug. 25, 1887; Sprange, *Blue Book*, 289; *News and Observer* (Raleigh), Aug. 24, 1899; *N.C. Year Book*, 1902–1907; *Mercantile Agency Reference Book*, 1904; *Catawba County Cemeteries*, VI:26.

MCINTOSH, REUBEN MUSSEY (1823–1902): native of Vt.; itinerant daguerreotyper; active 1851–1880; in Salisbury (1851); occupied rooms at the Rowan House; specialized in miniatures; employed as photographer in Vt. (1880); died in Vt.

SOURCES: *Carolina Watchman* (Salisbury), Sept. 25, 1851; Eskind, *Index to American Photographic Collections*, 805; *www.familysearch.org*.

MCINTURFF, S. W.: active (obtained license to practice) 1880–1881, Mitchell County.

SOURCE: Registry of Licenses to Trade, Mitchell County, 1877–1902 (A&H).

MCINTYRE, LAWRENCE E. (1902–1965): active 1936, Hargett St., Raleigh.

SOURCES: Murray list of Wake County photographers; *www.familysearch.org*.

MCIVER, WILLIAM D. (b. ca. 1866): native of N.C.; active 1919–1920, New Bern; listed as an attorney in 1920 census.

SOURCES: Hill, *New Bern Directory*, 1918–1920; Fourteenth Census, 1920: Craven County, Pop. Sch. New Bern, E.D. 22.

MCKAY, L. C.: active 1920–1921, Wilmington.

SOURCE: State Auditor's Records, Sch. B.

MCKAY, MRS. L. L.: active 1894, Marion; sold photos of ruins resulting from a fire in that town.

SOURCE: *Marion Record*, Jan. 3, 1894.

MCKEE, A. C.: active 1939 with Franklin Studios, Charlotte; charged with operating without a photographer's license.

SOURCE: Photographic Examiners Records.

MCKEE, G. W.: active 1919, near Shelby.

SOURCE: State Auditor's Records, Sch. B.

MCKENZIE, R. C. (b. ca. 1853): native of N.C.; in Fayetteville (1880–1881) in gallery located on upper floor of McDaniel Building, Person Street, in space formerly occupied by Elliott Daingerfield; R. Frank Peterson took over his studio in Feb. 1881; in Carthage in partnership with a Mr. Bentley (n.d.).

SOURCES: Tenth Census, 1880: Cumberland County, Pop. Sch., Fayetteville, 4th Ward; *Cape Fear Banner* (Fayetteville), June 22, 1880; *Fayetteville Examiner*, Feb. 10, 1881.

MCKIMSEY, FRED: active 1921–1922, Franklin.

SOURCE: State Auditor's Records, Sch. B.

MCKINNON, P. G.: active 1916, Robeson County.

SOURCE: State Auditor's Records, Sch. B.

MCKINZEY, W. W.: active 1920, Salisbury.

SOURCE: State Auditor's Records, Sch. B.

MCLANE, DAVE: active 1938, at Tweetsie Railroad, Watauga County.

SOURCE: identified as photographer in State Conservation and Development Records (A&H).

MCLAUGHLIN & COMPANY: active 1901; photographed Fayetteville St., Raleigh.

SOURCE: information provided by Carol Johnson, Library of Congress, Washington, D.C.

MCLELLAN'S DEPARTMENT STORE: active 1934–1935, Charlotte, Ethel Topalian, operator.

SOURCE: Photographic Examiners Records.

MCMILLAN, CHARLES VANCE (1897–1962): active ca. 1930–1940s, Southern Pines; operated McMillan Photo Shop; husband of Lena Allen McMillan.

SOURCES: Photographic Examiners Records; *www.familysearch.org*.

MCMILLAN, LENA ALLEN (1904–1986): active ca. 1930–1940s with McMillan Photo Shop, Southern Pines; wife of Charles V. McMillan; died in Fla.

SOURCES: Photographic Examiners Records; *www.familysearch.org*.

MCNEELY, _____: active 1906, Lincolnton, in partnership with J. S. Abernethy.

SOURCE: *N.C. Year Book*, 1906.

MACNEILL, BEN DIXON (1889–1960): native of N.C.; active 1930s–1940s along Outer Banks; newspaper reporter in Wilmington and Raleigh, 1910s–1930s; publicity director for outdoor drama *The Lost Colony*, 1937–1940s; also well-known writer; some of his photographs are housed at the OBHC, Manteo.

SOURCES: *DNCB*, s.v. "MacNeill, Ben Dixon"; Khoury, *Manteo: A Roanoke Island Town*, 10; *News and Observer* (Raleigh), May 28, 1960.

MCNEILL, JAMES: active 1916, Robeson County.

SOURCE: State Auditor's Records, Sch. B.

MACO, I.: active 1916, Durham.

SOURCE: State Auditor's Records, Sch. B.

MAC'S CAMERA SHOP: active 1941, Donaldson St., Fayetteville; H. J. MacDonald, operator.

SOURCE: *Hill's Fayetteville Directory*, 1941.

MAHAFFEY, WILLIE (b. ca. 1882): native of N.C.; active by 1910, Waynesville.

SOURCE: Thirteenth Census, 1910: Haywood County, Pop. Sch., Waynesville, E.D. 67.

MALLARD, T. L.: active 1921, Kinston.

SOURCE: State Auditor's Records, Sch. B.

MALLEN, ISADORE: active 1919, Elizabeth City.

SOURCE: State Auditor's Records, Sch. B.

MALLETT, S.: active 1905, Tarboro.

SOURCE: information provided by Jerry R. Roughton, Kenansville.

MALLON, M. M. (b. ca. 1830): native of N.Y.; active 1853–1860s; in Chester, S.C. (1853); in Columbia, S.C. (1854); associated with Whitehurst's Gallery, Wilmington (1854); in Raleigh (1857) in partnership with T. J. Havens; in Tarboro (1857–1860) periodically as itinerant maker of ambrotypes; occupied rooms in the Odd Fellows Hall in partnership with Havens (1857); in Beaufort (1857), likewise in partnership with Havens and occupied rooms at the Odd Fellows Hall; active in Conn., N.J., and Savannah, Ga., during Civil War years.

SOURCES: *Wilmington Journal*, July 28, 1854; *Semi-Weekly Raleigh Register*, Feb. 4, 1857; *Southerner* (Tarborough), May 23, 1857, Jan. 9, 23, Mar. 16, June 19, 26, Dec. 18, 1858, Jan. 15, Feb. 19, Oct. 8, 1859, Mar. 3, 1860; Eighth Census, 1860: Edgecombe County, Pop. Sch., Tarboro; Teal, *Partners with the Sun*, 68; Witham, *Catalogue of Civil War Photographers*, 10, 15, 50; *Craig's Daguerreian Registry*, 3:375.

MANEELY, H. F. (b. ca. 1853): native of Ohio; active 1880–1884; in Norfolk, Va. (1880–1884); on Fayetteville St., Raleigh (1883); successor to Sidney L. Alderman; sold studio to George W. Swift (Dec. 1883); at corner of Church and Main Sts., Norfolk, Va. (1883–1884).

SOURCES: Richards, *Raleigh City Directory, 1883*, 164; Ginsberg, *Photographers in Virginia*, 18; *Historical and Descriptive Review*, 95; www.familysearch.org.

MANGOLD, JONAS G. (b. 1827): native of Pa.; active 1860s–1880s; in DuQuoin, Ill. (1860, 1868); in Rock Island City, Davenport, and Moline, Ill. (n.d.); in Palatka, Fla. (1870s), where fire destroyed his studio; in Eufaula, Ala. (1880–1881); in Asheville (1887) as itinerant maker of tintypes; operated in a tent on Patton Ave.

SOURCES: *Country Homes* (Asheville), Aug. 1887, p. 16; Robb list of Ala. photographers; Czach, *A Directory of Early Illinois Photographers*, n.p.; Rinhart and Rinhart, *Victorian Florida*, 210.

MANGUM, HUGH LEONARD (1877–1922): native of N.C.; active 1890s–1922; studio located at his home in Durham County; traveled primarily in Southeast as itinerant; briefly operated Mangum Cottage Gallery on Main St. in Durham (ca. 1918); Hugh Mangum Museum of Photography, located in packhouse of McCown-Mangum House at West Point on the Eno, Durham, established as a tribute to his photography career.

SOURCES: *The Hugh Mangum Museum of Photography: The Packhouse at West Point on the Eno* (undated brochure from McCown-Mangum House, Durham County); photograph bearing Mangum's name, Durham County Public Library, Durham.

MANLY, FRANK (b. ca. 1851): African American; active by 1870, Raleigh; employed in unidentified studio as photo worker.

SOURCE: Ninth Census, 1870: Wake County, Pop. Sch., Raleigh.

MANN, ALMA (Mrs.): active 1937, Wilmington; convicted of practicing without a photographer's license.

SOURCE: Photographic Examiners Records.

MANNING, BENJAMIN FRANKLIN (b. ca. 1882): native of N.C.; active 1908–1910; in Ayden (1908, 1910); in Winterville (by 1910); often worked in tent studio; later became merchant.

SOURCES: *Daily Reflector* (Greenville), June 12, 1908; Thirteenth Census, 1910: Pitt County, Pop. Sch., Ayden, E.D. 94.

MANNING, JOHN FRANK, SR. (1885–1965): active 1907–1940s; in Raleigh (1907–1909); in High Point (1910–1913); in Asheville (1914–1917) in partnership with Estelle Cox as Cox and Manning; in Spartanburg, S.C. (1918–1935); in Greensboro (1935–1940s) as Manning Studio.

SOURCES: Photographic Examiners Records; Miller, *Asheville City Directory*, 1916–1918; State Auditor's Records, Sch. B; *Hill's Greensboro Directory*, 1935–1941; www.familysearch.org.

MANSFIELD, _____: active 1909; in Siler City, in association with Tod R. Edwards.

SOURCE: Photographic Examiners Records.

MANSFIELD, WILLIAM FULLER, JR. (b. 1920): active 1938–1940s, Durham, with Dunbar & Daniel Studio (1938–1939) and Daniel & Smith Studio (1940–1941); in Raleigh (1941 and afterward) with Daniel & Smith Studio; returned to Durham after World War II.

SOURCE: Photographic Examiners Records.

MARCHANT, FREDERICK ("FRANK") (1872–1942): native of Pa.; active ca. 1907–1930s, Hamlet; producer of high-quality real-photo postcards; unofficial photographer for Seaboard Air Line Railway Company.

SOURCES: *N.C. Year Book*, 1916; State Auditor's Records, Sch. B; Photographic Examiners Records; Massengill, *The Photographs of Frank Marchant*; *Charlotte Observer*, Feb. 11, 1942; *Hamlet News-Messenger*, Feb. 12, 1942.

MARKER, LUESA (LOUISE) MARIE (Mrs.) (b. 1883): active 1924–1940s; in Asheville with Venus Studio (1931) and

These two views are typical of the high-quality work produced by documentary photographer Frank Marchant of Hamlet during the first quarter of the twentieth century. Shown here are a crowd gathering on Main Street to view the arrival of a circus about 1919 and a large whiskey still captured by law enforcement officers in 1909. Photographs courtesy A&H.

Preston Studio (1936–1940s) and in association with Lyle C. Henderson; in Columbia, S.C. (1930), with Venus Studio.

SOURCES: Photographic Examiners Records; Miller, *Asheville City Directory*, 1931, 1936–1941; Teal, *Partners with the Sun*, 322.

MARSHBURN, _____: active ca. 1920s, Bladen County; photographed White Lake.

SOURCE: photograph bearing name "Marshburn."

MARTIN, _____: active 1867–1868, Warrenton; operator of Bellamy's Picture Gallery, located at Bellamy & Company's Drugstore; by Mar. 1868 business had closed and moved to Norfolk, Va.

SOURCE: *Indicator* (Warrenton), Feb. 18, Apr. 10, 1867.

MARTIN, BISHOP: active 1867–1868, Lincolnton.

SOURCE: Cotten list of N.C. photographers.

MARTIN, CAROL WALTON (1911–1993): native of Va.; active 1938–1992, Greensboro; photographer for *Greensboro Daily News*, 1938–1947; operated Martin's Studio as commercial photographer in partnership with Malcolm L. Miller (1946–1992); his large collection of

negatives is housed at the Greensboro Historical Museum.

SOURCES: Photographic Examiners Records; Catlett, *Martin's and Miller's Greensboro*, 6–16.

MARTIN, E. C.: active 1919, Asheville.

SOURCE: State Auditor's Records, Sch. B.

MARTIN, J. SAUL: active 1869, New Bern.

SOURCE: Branson, *NCBD*, 1869.

MARTIN, S. B.: itinerant daguerreotyper; active 1853, Salisbury; occupied rooms directly opposite Dr. James's hotel (January) and at Rowan House (April–May).

SOURCE: *Carolina Watchman* (Salisbury), Jan. 13, Apr. 21, 1853.

MARUYAMA, G.: active 1920–1921, Asheville.

SOURCE: Miller, *Asheville City Directory*, 1920–1921.

MASA, GEORGE (MASAHARA IIZUKA) (1881–1933): native of Japan; active 1920–1933, Asheville; formed partnership with Herbert W. Pelton as Photo-Craft Shop (1920); operated Plateau Studios, 1920s (business managed by Edward Peppers for one year); sold the business to Ewart M. Ball in mid-1920s; also operated Asheville-Biltmore Film Company, Asheville Photo Company, and Asheville Photo Service; instrumental in formation of Great Smoky Mountains National Park; portrait on file at Pack Memorial Public Library, Asheville.

SOURCES: *DNCB*, s.v. "Masa, George"; Alexander, *Mountain Fever*, 162; William A. Hart Jr., "George Masa: The Best Mountaineer," in Brunk, *May We All Remember Well*, 249–275; Gil Leebrick, "George Masa," in *Coming to Light* (special publication by Asheville Art Museum) 2–8; Miller, *Asheville City Directory*, 1921–1926, 1928–1932; Casada, "George Masa," in *Smoky Mountain Living* 1 (fall 2001): 67–70; *Asheville Citizen*, June 22, 1933; Buncombe County Estates Records (A&H); information provided by staff of Pack Memorial Public Library, Asheville; information provided by Peggy Gardner, Asheville.

MASON, L. W.: active 1916, Wilmington.

SOURCE: State Auditor's Records, Sch. B.

MASON, R. I.: active ca. 1910s, western N.C. Source not recorded.

MASSALON, J.: active 1850s; in Greensboro, Ala. (1850); in Charlotte (1854) as itinerant portrait painter and daguerreotyper in rooms formerly occupied by J. W. F. Wilde; in Montgomery, Ala. (1859).

SOURCES: *Western Democrat* (Charlotte), Aug. 4, 1854; Robb list of Ala. photographers.

MASSEY, S. A.: active 1914–1920; in Spartanburg, S.C. (1914–1915); in Hendersonville (1916–1920).

SOURCES: Teal, *Partners with the Sun*, 249; State Auditor's Records, Sch. B.

MATHEWSON, LUCY: active 1924–1927 on Coleman Ave., Asheville, with husband, Ray Mathewson.

SOURCE: Miller, *Asheville City Directory*, 1924–1927.

MATHEWSON, RAY: active 1917–1927; in Greensboro (1917); on Patton Ave., Asheville, in partnership with Ignatius W. Brock (1920–1922); on Coleman Ave., Asheville, with wife, Lucy Mathewson (1924–1927).

SOURCES: Hill, *Greensboro, N.C. Directory*, 1917; Miller, *Asheville City Directory*, 1921–1922, 1924–1927; *Bradstreet's*, 1921.

MATHIS, ROY: active 1916, Greensboro.

SOURCE: State Auditor's Records, Sch. B.

MATLOCK, MRS. O.: active late 1930s, Albemarle, in association with John M. Ross.

SOURCE: Photographic Examiners Records.

MATTHEWS, AUGUSTUS, JR. (b. ca. 1900): native of Va.; active 1929–1932, Asheville.

SOURCE: Miller, *Asheville City Directory*, 1929, 1932; Fifteenth Census, 1930: Buncombe County, Pop. Sch., Asheville, E.D. 11–12.

MATTHEWS, BEN VESTAL (1887–1939): native of N.C.; active 1907–1939; in Durham (1907–1909) with Waller Holladay; in Goldsboro (1912–1913) with Albert O. Clement; in Concord (1914–1916, 1919–1921) as Matthews Studio; in Kannapolis (1916); served in x-ray service at Camp Jackson, S.C., during World War I; in Winston-Salem (1921–1939) as Matthews Studio; received award of merit from National Photographers' Association in 1939; Ray W. Goodrich purchased studio in 1940.

SOURCES: Photographic Examiners Records; *N.C. Year Book*, 1914–1916; State Auditor's Records, Sch. B; *Concord City Directory*, 1916–1917, 1920–1921; *Winston-Salem Directory*, 1921–1923; *Bradstreet's*, 1917, 1921; *Mercantile Reference Book*, 1931; Horton, *A Bicentennial History of Concord*, 354; Vital Records, death certificates, Book 2150, p. 304 (A&H); *Winston-Salem Journal*, Dec. 2, 1939.

MATTHEWS, VERA ROGERS (Mrs. William D. Matthews) (1899–1991): active 1923–1940s, Kannapolis; with Ideal Studio (1923–1933); later sole proprietor (1933–1940s) of Matthews Studio.

Sources: Photographic Examiners Records; *www.familysearch.org*.

MATTHEWS, W. J.: native of N.C.; active by 1910, Wilson.

SOURCE: Thirteenth Census, 1910: Wilson County, Pop. Sch., Wilson, E.D. 116.

MATTOCKS, BENJAMIN S.: active ca. 1882–1890s; in Georgetown, S.C. (1882) in tent; in Raleigh (ca. early 1890s); in Troy, Ala. (n.d.); in Houston, Tex. (1897–1898).

SOURCES: Teal, *Partners with the Sun*, 197; Haynes, *Catching Shadows*, 70; photograph bearing his name; Robb list of Ala. photographers.

MAXWELL, A. W.: active 1916, Whiteville.

SOURCE: *N.C. Year Book*, 1916.

MAYELD (MAYFIELD), J. H.: active 1912, Concord.

SOURCE: *N.C. Year Book*, 1912.

MAYNARD, RICHARD H. (1855–1924): native of N.C.; active 1880s–1920s; in Hickory (ca. 1880s–early 1900s); in Statesville (1909–1910) in partnership with T. W. Ellis; in North Wilkesboro (1916–1920s).

SOURCES: Twelfth Census, 1900: Catawba County, Pop. Sch., Hickory, E.D. 41; Miller, *Statesville City Directory*, 1909–1910; photograph bearing Maynard's name; State Auditor's Records, Sch. B; Vital Records, death certificates, Book 893, p. 204 (A&H).

MEADOR, MRS. J. R.: active 1916, Reidsville.

SOURCE: *N.C. Year Book*, 1916.

MEARS, KENNETH MARION, JR. (b. 1914): active 1937–1940s; with Wootten-Moulton Studio, Chapel Hill (1937–1938); in Raleigh (1938–1940) as photographer for Raleigh *News and Observer*.

SOURCE: Photographic Examiners Records.

MEDERNACH, EUGENE N. (ca. 1836–1891): native of France; active as fresco painter before 1865; active as photographer, 1865–1891; in Danville, Va. (1865–1882); in Statesville (1882–1884) in gallery located above drugstore of Stimson & Anderson; in Salisbury (1885–1887, 1891) intermittently as tintype artist in tent and in rooms on Main St., corner of Fisher St.

SOURCES: *Chataigne's N.C. Directory and Gazetteer*, 1883–'84; Branson, *NCBD*, 1884; *Carolina Watchman* (Salisbury), Oct. 13, 1887, Dec. 3, 1891; *Landmark* (Statesville), Dec. 3, 1891; Brawley, *The Rowan Story*, 242; Cotten list of N.C. photographers.

MEEKER, DANIEL L.: active 1925–1929 with Meeker Art Studios, Hickory.

SOURCE: Miller, *Hickory City Directory*, 1925–1926, 1928–1929.

MEEKINS, DANIEL VICTOR (1897–1964): active 1910s–1920s, Manteo, in partnership with Benjamin V. Evans (1910s); founded Dare County *Times* in 1935; served as chairman of Dare County Board of Commissioners (late 1940s); his photo collection is housed at the OBHC, Manteo.

SOURCES: postcards bearing his name, held by the OBHC; information provided by Sarah Downing, OBHC; Khoury, *Manteo: A Roanoke Island Town*, 10.

MEGGS, R. C.: active 1916, N. Tryon St., Charlotte.

SOURCES: State Auditor's Records, Sch. B; Miller, Charlotte City Directory, 1916.

MEIELER, WILLIAM: active ca. 1918, Camp Greene; associated with Miller Studio, Cleveland, Ohio; received permission to take photographs at the camp.

SOURCES: National Army Camps, Camp Greene, Charlotte, N.C., RG 393, Box 20, National Archives; information provided by Jane Johnson, Charlotte.

MEINSTAFF, I.: active 1919, Raleigh.

SOURCE: State Auditor's Records, Sch. B.

MELBOURNE STUDIO: active 1928–1938, Hickory; R. L. Corbett, operator (1928–1929); Miss Florence Evans, operator (1930–1940s).

SOURCES: Photographic Examiners Records; Miller, *Hickory City Directory*, 1930–1931, 1937–1938; *Hickory City Directory*, 1935.

MELCHOR, J. T.: active 1919, Reidsville.

SOURCE: State Auditor's Records, Sch. B.

MERIWETHER, _____: active 1880s; in Asheville (mid-1880s) in partnership with a Mr. Roberts; in Huntsville, Ala. (1888) as sole proprietor and in partnership with a Mr. Hatcher and a Mr. Williams.

SOURCES: photograph bearing name "Meriwether"; Robb list of Ala. photographers.

MERRELL, B. A.: active 1906; photographed Oleeta Falls and Little Hungry River, near Dana (Henderson County).

SOURCE: information provided by Carol Johnson, Library of Congress, Washington, D.C.

MERRITT, FRANK M.: active 1919, Halifax.

SOURCE: State Auditor's Records, Sch. B.

MERROW, EDMOND LINCOLN (1860–1922): native of Maine; active late nineteenth century–ca. 1922; operated Merrow Studio in Pinehurst (1900–ca.1922); photographed socialites who vacationed there; located in Pinehurst during winter and worked in Bethlehem, N.H., during summer; reputed to be one of the best photographers in New England; produced postcard views of Sandhills; hired E. C. Eddy as his assistant (1908); prominent businessman; operated resort hotel.

SOURCES: *Pinehurst Outlook*, Vol. 4 (Nov. 9, 1900): 9; Vol. 5 (Nov. 15, 1901): 2; Vol. 18 (1914–1915): 10; *Bradstreet's*, 1908, 1917, 1921; *N.C. Year Book*, 1910, 1913–1916; State Auditor's Records, Sch. B; Fourteenth Census, 1920: Moore County, Pop. Sch., Mineral Springs Township, E.D. 94; biographical files at Tufts Archives, Given Memorial Public Library, Pinehurst; information provided by Khristine E. Januzik, Pinehurst; *www.familysearch.org*.

METZ, W.: active 1916, Asheville.

SOURCE: State Auditor's Records, Sch. B.

MICHAEL, GRACE (Mrs.): active 1925 with Muriello Studio, S. Tryon St., Charlotte; created artistic portraiture.

SOURCE: Miller, *Charlotte City Directory, 1925*.

MICHAEL, JOHN H. (b. ca. 1877): native of N.C.; active by 1910–1922; in Salisbury (by 1910); in Greensboro (1919–1922).

SOURCES: Thirteenth Census, 1910: Rowan County, Pop. Sch., Salisbury, E.D. 107; State Auditor's Records, Sch. B.

MICHAEL, THOMAS B.: active 1914–1922; in Charlotte (1914–1922); in Greensboro (1916).

SOURCES: Miller, *Charlotte City Directory, 1914*; *N.C. Year Book*, 1915, 1916; State Auditor's Records, Sch. B.

MICHAEL, WILLIAM H.: active 1928–1932, Asheville; operated Michael's Studio.

Sources: Miller, *Asheville City Directory*, 1928–1930; *Mercantile Reference Book*, 1931; information provided by staff of Pack Memorial Public Library, Asheville.

MICHELOW, ALBERT P. (b. 1866): native of Sweden; active 1899–1900; in Salem, Va. (before 1900); on Fayetteville St., Raleigh (1899–1900) in partnership with Thomas B. Johnson.

SOURCES: Ginsberg, *Photographers in Virginia*, 47; photographs bearing Michelow's name; Twelfth Census, 1900: Wake County, Pop. Sch., Raleigh, E.D. 143.

MICHIE, JOHN CHAPMAN (1862–1939): native of Va.; an engineer by profession; active 1904; photographed Bennett farmhouse, near Durham.

SOURCES: information provided by Carol Johnson, Library of Congress, Washington, D.C.; Vital Records, death certificates, Book 2136, p. 433 (A&H).

MICKENS, JOHN E. W.: African American; active 1920–1938, Concord.

SOURCES: *Concord City Directory*, 1920–1925, 1929–1930; *Baldwin's Concord Directory*, 1938.

MIDDLETON, E. G.: photographed construction of Blue Ridge Parkway, 1938–1941.

SOURCE: Blue Ridge Parkway Photograph Collection (A&H).

MILLARD, _____: active 1859, Wilmington; made ambrotypes of two houses on Fourth St., near Chestnut St.; possibly L. B. Millard, who was active in Pekin, Ill., 1860.

SOURCES: *Wilmington Daily Journal*, May 18, 1859; *Craig's Daguerreian Registry*, 3:393.

MILLARD, FLOYD B. (b. ca. 1908): native of N.C.; active by 1930, Greensboro.

SOURCE: Fifteenth Census, 1930: Guilford County, Pop. Sch., Greensboro, E.D. 41-32.

MILLER, _____: active ca. 1910, North Wilkesboro, in partnership with a Mr. Harris as Miller, Harris & Company; publisher of postcard views.

SOURCE: postcard bearing name "Miller."

MILLER, MRS. _____: active ca. 1918, Camp Greene; associated with Miller Studio, Augusta, Ga.; received permission to take photographs at the camp.

SOURCES: National Army Camps, Camp Greene, Charlotte, N.C., RG 393, Box 20, National Archives; information provided by Jane Johnson, Charlotte.

MILLER, ALEXANDER A. (1857–1936): native of N.C.; active 1880s–ca. 1930; on W. Center St., Goldsboro (1880s–ca. 1930), in Smithfield (briefly, 1885); in Wilmington (late 1880s); retired about 1930 to manage his large real estate holdings; probably brother of J. F. Miller.

SOURCES: *Clayton Bud*, June 17, 1885; Cotten list of N.C. photographers; Branson, *NCBD*, 1892, 1896, 1897; Sprange, *Blue Book*, 289; Wayne County Schedule B, Tax List, 1898–1899 (A&H); *Mercantile Agency Reference Book*, 1904; *Bradstreet's*,

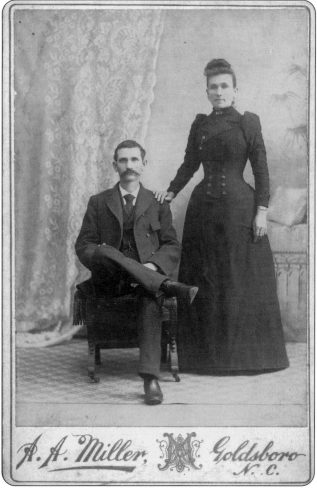

Alexander A. Miller of Goldsboro made this photograph of an unidentified husband and wife in front of a studio backdrop about 1890. Courtesy of the compiler.

1908, 1917; *N.C. Year Book*, 1910–1916; Gardiner, *Goldsboro City Directory, 1916–1917*; State Auditor's Records, Sch. B; Fourteenth Census, 1920: Wayne County, Pop. Sch., Goldsboro, E.D. 113; *News and Observer* (Raleigh), Aug. 13, 1936.

MILLER, CHARLIE M. (b. ca. 1882): native of N.C.; active 1925–1930, as proprietor of Miller's Studio, Lexington.

SOURCES: Miller, *Lexington City Directory*, 1925–1926; Fifteenth Census, 1930: Davidson County, Pop. Sch., Lexington, E.D. 22; *Mercantile Reference Book*, 1931.

MILLER, DALE T.: active 1930s, Rich Square (Northampton County).

SOURCE: Photographic Examiners Records.

MILLER, GEORGE CLEVELAND (1886–1969): active 1920s–1940s; with Ray's Studio, Asheville (ca. 1923); with McCanless Studio, Asheville (ca. 1924); with William A. Roberts in Greensboro (1925–1926); with the Art Shop in Greensboro (1926–1940).

SOURCES: Photographic Examiners Records; *www.familysearch.org*.

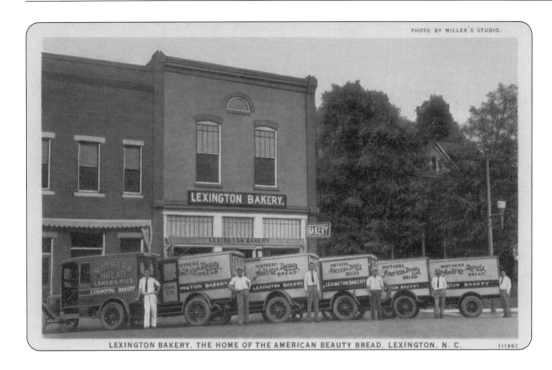

PHOTO BY MILLER'S STUDIO.

LEXINGTON BAKERY.

LEXINGTON BAKERY, THE HOME OF THE AMERICAN BEAUTY BREAD, LEXINGTON, N. C. 111962

LEFT: Drivers pose with a fleet of delivery trucks parked in front of the Lexington Bakery during the late 1920s. Town photographer Charlie M. Miller produced this postcard to publicize one of Lexington's leading businesses. Postcard courtesy Durwood Barbour, Raleigh. **BELOW:** An unidentified man holding a trumpet is the subject of this full-length portrait by a photographer named Mills in Rockingham in 1893. Courtesy of the compiler.

MILLER, H. C.: active 1919–1923, Albemarle, in partnership with James M. Richardson (1923) as Miller-Richardson Studio.

SOURCE: State Auditor's Records, Sch. B.

MILLER, J. F.: active 1880s–1910s; in Wilmington (1880s); in Kinston (1889–1890s); purchased photo gallery of William Shelburn in 1889; in Smithfield (1899) as itinerant in tent located just north of courthouse; in Clayton (ca. 1910); probably brother of Alexander A. Miller.

SOURCES: *Star* (Wilmington), Nov. 2, 1889; Cotten list of N.C. photographers; Sprange, *Blue Book*, 289; *Smithfield Herald*, Sept. 15, 1899; information provided by Durwood Barbour, Raleigh.

MILLER, JOSEPH CLAUD (1879–1948): active 1910, Ernul (Craven County); portrait on file at N.C. Office of Archives and History.

SOURCE: information provided by Victor T. Jones Jr., New Bern-Craven County Public Library, New Bern.

MILLER, LUVENIA C. (1909–1987): active 1940 and afterward with the Art Shop, Greensboro; in Leaksville by 1947.

SOURCES: Photographic Examiners Records; *www.familysearch.org.*

MILLER, WILLIAM EARL (b. 1910): active 1934–1940s with Earl's Photo Service, Salisbury.

SOURCE: Photographic Examiners Records.

MILLS, _____: active 1893, Rockingham.

SOURCE: Cabinet-card photograph bearing name "Mills."

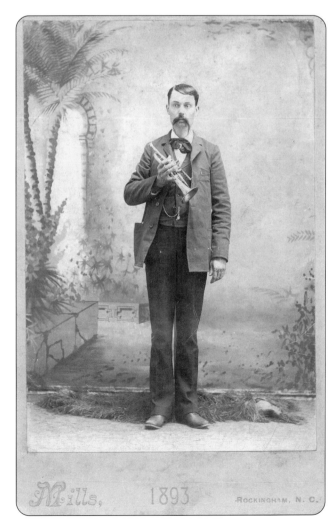

Mills, 1893 ROCKINGHAM, N. C.

MILLS, A.: active ca. 1890s, Denver, N.C.

SOURCES: photograph bearing his name, Lincoln County Museum, Lincolnton; information provided by Jason Harpe, Lincolnton.

MILLS, A. J.: active 1919, Landis (Rowan County).

SOURCE: State Auditor's Records, Sch. B.

MILLSAPS, WILL: active 1916, Graham County.

SOURCE: State Auditor's Records, Sch. B.

MINNIS, GEORGE WASHINGTON (b. ca. 1823): native of Pa.; active 1847–1869; employed with M. A. Root of Philadelphia in Petersburg and Richmond, Va. (1847–1849); in Richmond, Va., in partnership with John W. Watson as Minnis & Watson (1849–1855); operated "daguerrean saloon" (1852–1853); operated studio in Richmond during Civil War; itinerant operator in Elizabeth City (1850) and Henderson (late 1860s).

SOURCES: *Old North State* (Elizabeth City), Aug. 10, 1850; *Thomson's Mercantile and Professional Directory, 1851–1852*; Ginsberg, *Photographers in Virginia*, 36; Eighth Census, 1860: Henrico County, Va., Pop. Sch., City of Richmond, 2nd Ward, Witham, *Catalogue of Civil War Photographers*, 82; *Weekly Index* (Henderson), May 21, 1869; *Craig's Daguerreian Registry*, 3:396.

MINTON, SUSIE: active 1916, Woodland (Northampton County).

SOURCE: *N.C. Year Book*, 1916.

MITCHELL, J. E.: active 1911, Shelby.

SOURCE: *N.C. Year Book*, 1911.

MITCHELL, JAMES H. (ca. 1839–1861): native of N.C.; active 1860–1861 in Granville and Wake Counties; in partnership with Abner D. Peace; learned trade from William Shelburn in Oxford; served as a second lieutenant in Company E, Twenty-third Regiment, N.C. State Troops; died of disease at Culpeper Court House, Va., on or about Nov. 8, 1861.

SOURCES: Granville County Estates Records (A&H); Manarin and Jordan, *N.C. Troops*, 7:185; information provided by Laura Peace, Henderson.

MITCHELL, JOHN WOODFIN (b. ca. 1880): native of N.C.; active 1910–1930s; in Shelby (1910); at Camp Sevier near Greenville, S.C. (ca. 1918–1920); in Greenville (ca. 1918–1924); served as vice-president of Southeastern Photographers' Association (1921); in Raleigh (1930s).

SOURCES: Thirteenth Census, 1910: Cleveland County, Pop. Sch., Shelby, E.D. 43; Photographic Examiners Records; Teal, *Partners with the Sun*, 241.

MITCHELL, N. M.: active 1919, Weldon.

SOURCE: State Auditor's Records, Sch. B.

MIZZELL, POSEY (b. ca. 1882): native of N.C.; active 1910–1911, Edenton.

SOURCES: Thirteenth Census, 1910: Chowan County, Pop. Sch., Edenton, E.D. 22; *N.C. Year Book*, 1910, 1911.

MOALE, _____: active 1909, in association with a Mr. Hackney as Hackney and Moale Company; took photograph of Connemara (home of Carl Sandburg), Flat Rock.

SOURCE: information provided by Carol Johnson, Library of Congress, Washington, D.C.

MOCK, _____: active early 1900s, Grimsley (Ashe County), in association with Poindexter Blevins in firm of Blevins and Mock.

SOURCE: information provided by Jennie W. Hightower, Jefferson.

MODEL STUDIO: active 1940, Concord; Healy E. Jones and James M. Torrence, operators.

SOURCES: *Baldwin's Concord Directory*, 1940; *Mercantile Agency Reference Book*, 1943.

MODERATE PRICE STUDIO: active 1919, Charlotte.

SOURCE: State Auditor's Records, Sch. B.

MOFFETT (MOFFITT), HENRY C.: active 1916, Whiteville.

SOURCE: *N.C. Year Book*, 1916.

MOFFETT STUDIOS: active 1925, W. 5th St., Charlotte; Miss H. M. Ahrens, representative.

SOURCE: Miller, *Charlotte City Directory, 1925*.

MONEYHAN (MONAGHAN), H. J.: active 1921, Winston-Salem.

SOURCE: State Auditor's Records, Sch. B.

MONROE STUDIO: active 1922–1923, Monroe; Fred Scott, operator.

SOURCE: Miller, *Monroe City Directory, 1922–1923*.

MONTGOMERY, B. B. (b. ca. 1882): native of Mo.; active by 1910, Charlotte.

SOURCE: Thirteenth Census, 1910: Mecklenburg County, Pop. Sch., Charlotte, E.D. 103.

MOODY, PAT V. (Mrs.): active 1925; manager, M & W Exchange, Latta Arcade, Charlotte.

SOURCE: Miller, *Charlotte City Directory, 1925*.

MOON, MARY E. (Mrs. William J. Moon) (b. ca. 1884): native of N.Y.; active 1916–1931, Charlotte; operated Moon's Studio in association with husband, William J. Moon; took photographs at Camp Greene, 1917–1918.

SOURCES: National Army Camps, Camp Greene, N.C., RG 393, Box 20, National Archives; Fourteenth Census, 1920: Mecklenburg County, Pop. Sch., Charlotte, E.D. 149; Miller, *Charlotte City Directory*, 1917–1918, 1920–1929; State Auditor's Records, Sch. B; information provided by Shelia Bumgarner, Public Library of Charlotte and Mecklenburg County.

MOON, WILLIAM JOHN (1871–1931): native of N.Y.; active 1916–1931, Parkwood Ave., Charlotte; operated as The Moons (Commercial and Home Photographers) and as W. J. Moon Company, Commercial Photographers; took photographs at Camp Greene, 1917–1918; received permission to photograph only groups and individuals at the camp; in association with wife, Mary E. Moon; specialized in large groups and panoramic photographs; business slogan was "We Cover Dixie Like the Sunshine."

SOURCES: National Army Camps, Camp Greene, N.C., RG 393, Box 20, National Archives; Fourteenth Census, 1920: Mecklenburg County, Pop. Sch., Charlotte, E.D. 149; Miller, *Charlotte City Directory*, 1917–1918, 1920–1930; State Auditor's Records, Sch. B; *Mercantile Reference Book*, 1931; *Mercantile Agency Reference Book*, 1943; panoramic views bearing company name; information provided by Shelia Bumgarner, Public Library of Charlotte and Mecklenburg County.

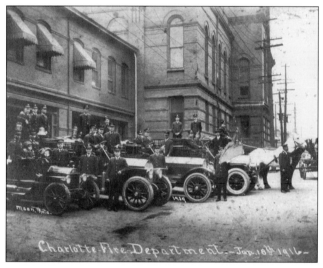

"We Cover Dixie Like the Sunshine" was the catchy slogan for the Moon's Studio in Charlotte. Shown here is a photograph of the Charlotte Fire Department made by the studio in 1916. Firemen pose with their gasoline-powered trucks and one horse-drawn wagon. Photograph courtesy Public Library of Charlotte and Mecklenburg County.

MOORE, _____: itinerant in N.C.; active (paid tax to practice) 1883–1884; in partnership with a Mr. McAdams.

SOURCE: State Auditor's Records, Ledgers, 1869–1899, Vol. 17, p. 424 (A&H).

MOORE, _____: active 1916; operated Moore Studio, Durham.

SOURCE: *N.C. Year Book*, 1916.

MOORE, C. H. L.: active (obtained license to practice) 1910–1911, Durham.

SOURCE: Record of Special Licenses Issued, Durham County, 1910–1911 (A&H).

MOORE, DAVID H.: active 1907–1908, E. Main St., Durham.

SOURCE: Hill, *Durham, N.C. Directory, 1907–1908*.

MOORE, EARL L.: active 1930–1940s, Charlotte; operated Little Folks' Studio (1930–1935) and Moore's Baby Studio (1936–1942) on S. Tryon St.; with Dunbar Studio in Fayetteville after World War II.

SOURCES: Photographic Examiners Records; Hill, *Charlotte, N.C. City Directory*, 1933–1941; *Mercantile Agency Reference Book*, 1943.

MOORE, H. B.: active (obtained license to practice) 1876, Jackson County.

SOURCE: Registry of Licenses to Trade, Jackson County, 1874–1903 (A&H).

MOORE, HENRY FORMYDUVAL (b. 1911): active 1935–1940s, Goldsboro; associated with Albert O. Clement.

SOURCE: Photographic Examiners Records.

MOORE, J. V. A.: active 1916, Hayesville.

SOURCE: State Auditor's Records, Sch. B.

MOORE, J. WALLER (b. 1863): native of Pa.; active by 1900, Asheville.

SOURCE: Twelfth Census, 1900: Buncombe County, Pop. Sch., Asheville, E.D. 136.

MOORE, JEREMIAH B.: active 1840–1850s; in Boston, Mass. (1849–1853); in Kinston (1857) as itinerant in rooms located in *American Advocate* Building; offered camerotypes and ambrotypes (which Moore described as "flesh tint" pictures) to the public.

SOURCES: *Craig's Daguerreian Registry*, 3:400; *American Advocate* (Kinston), Sept. 17, 24, 1857; Polito, *A Directory of Massachusetts Photographers*, 100.

MOORE, L. W.: of Washington, D.C.; active ca. 1918, Camp Greene; received permission to take photographs at the camp.

SOURCES: National Army Camps, Camp Greene, Charlotte, N.C., RG 393, Box 20, National Archives; information provided by Jane Johnson, Charlotte.

MOORE, LOUIS TOOMER (1885–1961): active 1920s–1930s, Wilmington; historian and amateur photographer who documented life in New Hanover County; his large collection of panoramic photographs is housed at New Hanover County Public Library, Wilmington.

SOURCE: Block, *Wilmington through the Lens of Louis T. Moore*.

MOORE, MARVIN: active 1921, Hayesville.

SOURCE: State Auditor's Records, Sch. B.

MOORE, OSCAR REYTON (b. 1873): active ca. 1910–1940s; in Mount Airy (ca. 1910–1940s); operated Moore's Studio, Fayetteville St., Raleigh (1925–1930).

SOURCES: Photographic Examiners Records; Carter and Snyder, *General Directory of Mount Airy, N.C., 1913–1914*; State Auditor's Records, Sch. B; *Bradstreet's*, 1921; postcard bearing his name; Murray list of Wake County photographers.

MOORE, PATSIE: active 1925–1935, Winston-Salem; associated with husband, William M. Moore, in Moore's Photo Studio.

SOURCES: Photographic Examiners Records; *Winston-Salem Directory*, 1923.

MOORE, PAUL M.: of Warsaw; active 1919–1920, Wayne County.

SOURCE: State Auditor's Records, Sch. B.

MOORE, R.: itinerant; active 1859, Winston; gallery located at Miller's brick building.

SOURCE: *Western Sentinel* (Winston), June 24, 1859.

MOORE, RAY: active 1916, Wilmington.

SOURCE: State Auditor's Records, Sch. B.

MOORE, T. W.: active 1884–1887; itinerant (1884, 1886–1887); in partnership with Marion Carlisle (1886–1887); in Mebane (1886–1887).

SOURCES: State Auditor's Records, Ledgers, 1869–1899, Vol. 17, p. 576, and Vol. 18, p. 248 (A&H); Cotten list of N.C. photographers.

MOORE, THEODORE CARLTON (1901–1981): active 1923–1930s with Wootten-Moulton Studio, Chapel Hill.

SOURCES: Photographic Examiners Records; *www.familysearch.org*.

MOORE, THOMAS: active (paid tax to practice) 1876–1878, Person County; in partnership with a Mr. Burch (1877–1878).

SOURCES: State Auditor's Records, Person County, Sch. B, Taxes, Vol. 1869–1883, p. 71 (A&H); Registry of Licenses to Trade, Person County, 1877–1901 (A&H).

MOORE, THOMAS D. (1866–1934): native of S.C.; active 1908–1930s, Franklin County and Kittrell.

SOURCES: Twelfth Census, 1900: Franklin County, Pop. Sch., Hayesville Township, E.D. 47; *News and Observer* (Raleigh), May 16, 1934; information provided by grandson, Rencher Moore.

MOORE, W. L.: itinerant; active 1896 (briefly) in Carthage; in partnership with Cyrus P. Wharton of Raleigh; room located in Shaw Hotel.

SOURCE: *Carthage Blade*, Sept. 8, 1896.

MOORE, WILLIAM MAURICE (b. 1899): active ca. 1921–1940s, Winston-Salem; operated Moore's Photo Studio with wife, Patsie Moore.

SOURCES: Photographic Examiners Records; State Auditor's Records, Sch. B; *Winston-Salem Directory*, 1923; *Mercantile Reference Book*, 1931; *Mercantile Agency Reference Book*, 1943.

MOOSE, IDA LAMBETH (b. 1884): native of N.C.; active 1931–1935 with Moose Studio, S. Elm St., Greensboro, associated with husband, William J. Moose (1931–1932); out of business by 1936; stepmother of Roy J. Moose and Walter R. Moose.

SOURCES: Fifteenth Census, 1930: Guilford County, Pop. Sch., Greensboro, E.D. 41-32; Photographic Examiners Records.

MOOSE, ROY JOHNSON (b. 1888): native of N.C.; active 1907–late 1930s; in Greensboro (1907–1915, 1923) in partnership with father, William J. Moose, as Moose & Son (1910s) and proprietor of Photo Shop (1923); in Sanford (1915–1930s) on Steele St., above Kent's Market; stepson of Ida L. Moose and brother of Walter R. Moose.

SOURCES: Photographic Examiners Records; *Sanford Express*, Jan. 28, 1925; Thirteenth Census, 1910: Guilford County, Pop. Sch., Greensboro, E.D. 111; Fifteenth Census, 1930: Lee County, Pop. Sch., Sanford, E.D. 53-2; biographical information on file at Greensboro Public Library; information provided by Roy E. Wilder Jr., Spring Hope.

MOOSE, THADDEUS BROWER (1860–1926): native of N.C.; active by 1900–late 1910s; in Maiden (by 1900); in Newton (1903–late 1910s).

SOURCES: Twelfth Census, 1900: Catawba County, Pop. Sch., Maiden, E.D. 46; *N.C. Year Book*, 1903, 1904, 1906, 1910–1915; State Auditor's Records, Sch. B; Vital Records, death certificates, Book 1032, p. 111 (A&H).

MOOSE, WALTER R. (b. ca. 1892): active 1916–1920, Greensboro; son of William J. Moose, stepson of Ida L. Moose, brother of Roy J. Moose.

SOURCES: State Auditor's Records, Sch. B; Hill, *Greensboro, N.C. Directory*, 1917, 1923; Fourteenth Census, 1920: Guilford County, Pop. Sch., Greensboro, E.D. 145.

MOOSE, WILLIAM J. (1859–1932): native of N.C.; active 1879–1932; in Stanly County (1879–1880); itinerant operator of W. J. Moose's Art Car; in Concord (ca. 1895); in Greensboro (ca. 1897–1932) in partnership with J. Lee Stone (1905–1907, 1915–1916); in partnership with son, Roy J. Moose, as Moose & Son (1912–1917); operated Moose Studio (1919–1932) on S. Elm St.; associated with wife, Ida L. Moose (1931–1932); father of Walter R. Moose.

SOURCES: Registry of Licenses to Trade, Stanly County, 1874–1904 (A&H); Sprange, *Blue Book*, 289; Hill, *Greensboro, N.C. Directory*, 1905–1921, 1929–1931; *N.C. Year Book*, 1906, 1907, 1910–1916; *Bradstreet's*, 1908, 1917; Fourteenth Census, 1920: Guilford County, Pop. Sch., Greensboro, E.D. 145; Teal, *Partners with the Sun*, 269; Vital Records, death certificates, Book 1586, p. 152 (A&H); *Greensboro Daily News*, Sept. 1, 2, 1932; biographical information from files of Greensboro Public Library.

MORGAN, ALFRED (1855–1924): native of Va.; active 1890s–early 1900s, Murphy; publisher of postcard views; also active as printer and newspaper publisher; brother of Rufus Morgan.

SOURCES: Freel, *Our Heritage*, 321–322; White, *The Heritage of Cherokee County*, 342–343.

MORGAN, ARTHUR (1896–1977): native of N.C.; active 1920s, Rockingham, in partnership with father, Daniel Frank Morgan, and brothers, Elwood and Oliver Morgan.

SOURCES: Fourteenth Census, 1920: Richmond County, Pop. Sch., Rockingham, E.D. 126; photograph bearing Arthur Morgan's name, N.C. Museum of History Photograph Collection (A&H); *www.familysearch.org.*

MORGAN, CHARLES A.: active ca. 1895–1927; in Elizabeth City (ca. 1895) in partnership with William H. Zoeller as Zoeller, Morgan & Company and later as sole proprietor (1902–1906); studio located at corner of Martin and Matthews Streets; in Washington County (1899–1900); in High Point (1919, 1925–1927).

SOURCES: Registry of Licenses to Trade, Washington County, 1883–1902 (A&H); *Tar Heel* (Elizabeth City), June 6, Aug. 2, 1902; *N.C. Year Book*, 1902–1906; State Auditor's Records, Sch. B; Miller, *High Point Directory*, 1925–1927.

MORGAN, CHARLES R. (b. ca. 1885): native of N.C.; active as itinerant in South Mills (by 1910).

SOURCE: Thirteenth Census, 1910: Camden County, Pop. Sch., South Mills, E.D. 20.

MORGAN, DANIEL FRANK (1871–1938): native of N.C.; active by 1896–1930s; in Carthage (1896) as itinerant; in Troy (ca. 1900–1915); in partnerships with a Mr. Gaddy (ca. 1900) and a Mr. Wright (1910s); in Rockingham (1915–1930s) in association with sons, Oliver and Arthur, as D. F. Morgan & Sons (1920s) and with son, Elwood Morgan (1930s); his daughter, Helen Morgan, assisted in studio (1930).

SOURCES: *Carthage Blade*, Feb. 11, 1896; *N.C. Year Book*, 1910–1916; photograph bearing names of Morgan and Gaddy; photograph bearing names of Morgan and Wright; photograph bearing Morgan's name, N.C. Museum of History Photograph Collection (A&H); *Bradstreet's*, 1917, 1921, 1925; *Mercantile Reference Book*, 1931; State Auditor's Records, Sch. B; Fourteenth Census, 1920: Richmond County, Pop. Sch., Rockingham, E.D. 126; Fifteenth Census, 1930: Richmond County, Pop. Sch., Rockingham, E.D. 77-13; Photographic Examiners Records; Vital Records, death certificates, Book 2056, p. 51 (A&H).

MORGAN, ELWOOD (b. ca. 1908): native of N.C.; active by 1930, Rockingham; in association with father, Daniel Frank Morgan; brother of Arthur and Oliver Morgan.

SOURCE: Fifteenth Census, 1930: Richmond County, Pop. Sch., Rockingham, E.D. 77-13.

MORGAN, OLIVER (b. ca. 1894): native of N.C.; active 1920s, Rockingham, in partnership with father, Daniel Frank Morgan, and brothers, Arthur and Elwood Morgan.

SOURCE: Fourteenth Census, 1920: Richmond County, Pop. Sch., Rockingham, E.D. 126; photograph bearing Oliver Morgan's name, N.C. Museum of History Photograph Collection (A&H).

MORGAN, RUFUS (1846–1880): native of Va.; served in Va. unit late in Civil War; itinerant; active 1869–1878; one of the state's foremost stereographic artists; took series of stereographs in western N.C. (including Asheville), Wilmington, Raleigh, Charlotte, etc.; in New Bern (1869–1870); in Goldsboro (early 1870s, 1877–1878) in tent on E. Center St., opposite the Bank of New Hanover; in Morganton (1872–1873); in Asheville (1872); in Raleigh (periodically 1872–1876); in Wilmington (1873); in Charlotte (1873–1874); took views in S.C., Ga., and Fla. (winter 1874); in Hickory (1874); in Oxford (1874); at Trinity College (1875); in Durham (1876); in Salisbury (1876); quit photography trade in late 1870s to pursue beekeeping industry; journeyed to near San Diego, Calif., in early 1879 to operate an apiary; died tragically from accidentally eating poisonous mushrooms; brother of Alfred Morgan; son-in-law of Mary Bayard Devereux Clarke and Judge William J. Clarke; a large collection of his stereographs

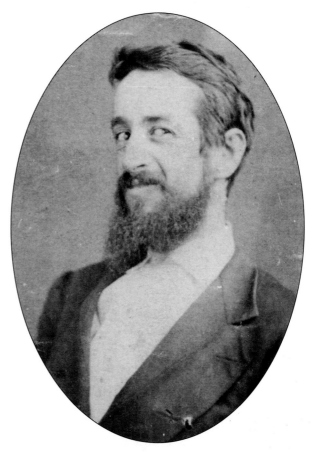

While taking this self-portrait about 1874, Rufus Morgan cuts his eyes toward the camera, creating a comical expression on his face. Photograph courtesy Mary M. Barden, New Bern.

LEFT, TOP: Morgan's camera captured this tourist party at Paint Rock on the French Broad River in Madison County about 1873. The man in the foreground is Gen. Braxton Bragg (1817–1876), who served in the Mexican War and was commanding general of the Army of the Tennessee for the Confederate States of America. **BOTTOM:** Morgan is the tall, slender man on the right in this view of the North Carolina State Capitol from the south about 1875. It is one of the rare occasions that the well-known creator of stereographs positioned himself in front of his camera. Both images courtesy of the compiler.

is housed at the North Carolina Collection, Wilson Library, UNC-CH; portraits of Morgan on file at N.C. Office of Archives and History.

SOURCES: *Newbern Journal of Commerce*, Feb. 23, 1869; Branson, *NCBD*, 1869; Ninth Census, 1870: Craven County, Pop. Sch., New Bern, 1st Ward; photograph made in Goldsboro bearing Morgan's name; *Weekly Pioneer* (Asheville), Aug. 15, 1872; *Evening Post* (Wilmington), Mar. 5, 19, 1873; *New Bern Times*, Nov. 12, 1873; *Daily News* (Raleigh), Feb. 25, 1875; *Chataigne's Raleigh Directory*, 1875, 146; *Durham Tobacco Plant*, Sept. 27, Oct. 3, 18, 1876; *Newbernian* (New Bern), Feb. 22, 1879, Apr. 24, May 1, 1880; *Farmer and Mechanic* (Raleigh), Apr. 29, 1880; information provided by Mary M. Barden, New Bern; Massengill, "One Man's View," 21–23; Massengill, *Western North Carolina*, 9–26; Massengill and Topkins, "Letters Written from San Diego County, 1879–1880, by Rufus Morgan," 142–177; Darrah, *World of Stereographs*, 80–81; Rinhart and Rinhart, *Victorian Florida*, 63.

MORGAN, T. H.: itinerant maker of ambrotypes and tintypes; active 1860, Leaksville; occupied rooms adjoining *Leaksville Herald* office.

SOURCE: *Leaksville Herald*, Oct. 20, 1860.

MORGAN, W. F. (J.): active 1916–1920, Franklin.

SOURCE: State Auditor's Records, Sch. B.

MORGAN, WOODSON G. (b. ca. 1849): native of Ky.; active by 1880–1892; worked as photographer in Ill. (1880); came to Salisbury from Paris, Ky.; in Salisbury (1890–1892); gallery located in Heilig Building.

SOURCES: *Carolina Watchman* (Salisbury), Jan. 2, Feb. 27, 1890, Oct. 8, 1891; *Mercantile Agency Reference Book*, 1891; *www.familysearch.org*.

MORLEY, MARGARET WARNER (1858–1923): active early 1900s, Tryon area; teacher, writer, photographer; published *The Carolina Mountains* in 1913; a collection of her photographs is housed at the N.C. Museum of History, and copy negatives are housed at the N.C. Office of Archives and History.

SOURCES: *Dictionary of American Biography*, 13:193; *Who Was Who in America*, 1:867; McHenry, *Liberty's Women*, 292; Alexander, *Mountain Fever*, 162; *New York Times*, Dec. 15, 1923.

MORRILL, J. O.: active early 1900s, western N.C.

SOURCE: Western Carolina University, Cullowhee.

Charlotte's William M. Morse photographed this unidentified woman sitting at a table in the reading room of a library about 1900. Photograph courtesy Public Library of Charlotte and Mecklenburg County.

Award-winning photographer and shrewd business-man Hugh Morton smiles for the camera in this formal portrait taken in the 1980s. Photograph courtesy A&H.

MORRIS, A. A.: active 1873, Lincolnton.

SOURCE: *Lincoln Progress* (Lincolnton), Sept. 6, 1873.

MORRIS, HERMAN K.: active 1931–1932, Asheville; operated Morris's Studio.

SOURCES: Miller, *Asheville City Directory*, 1931–1932; Photographic Examiners Records.

MORRISON, THOMAS LEE (b. 1918): active 1939–after World War II, Elkin.

SOURCE: Photographic Examiners Records.

MORSE, WILLIAM MEANS (1867–1932): native of N.C.; active 1897–1932, Charlotte; operated Morse's Studio; in partnership with W. Carson Davis (1909–1910); in partnership with William T. Lindsay (1918); purchased The Photo Shop from Jonathan C. Cushman (ca. 1920); died suddenly from a hemorrhage while riding in an automobile with photographer Luther Philemon.

SOURCES: *Maloney's Charlotte 1897–'98 Directory*; *Weeks' 1899 Charlotte City Directory*; *Maloney's 1899–1900 Charlotte Directory*; *Walsh's Directory of the City of Charlotte, 1902–1910*; Miller, *Charlotte Directory*, 1911–1930; *Hill's Charlotte Directory*, 1932; Twelfth Census, 1900: Mecklenburg County, Pop. Sch., Charlotte, E.D. 49; Fourteenth Census, 1920: Mecklenburg County, Pop. Sch., Charlotte, E.D. 145; *N.C. Year Book*, 1902–1907, 1910–1916; State Auditor's Records, Sch. B; *Bradstreet's*, 1917; *Charlotte Observer*, May 25, 26, 1932; information provided by Shelia Bumgarner, Public Library of Charlotte and Mecklenburg County.

MORTON, HUGH MACRAE (b. 1921): native of N.C.; active late 1930s–present; engaged in various assignments for magazines and newspapers as a UNC student in Chapel Hill; newspaper photographer for sports department of *Charlotte News*; assigned to photo lab of U.S. Army anti-aircraft school at Camp Davis, N.C.; combat newsreel cameraman in Army Signal Corps during World War II; after war, at urging of Bill Sharpe, then head of state's travel and tourism division, resumed career in photography; president and promoter of Wilmington Azalea Festival; chairman of USS *North Carolina* Battleship Commission; owner and operator of Grandfather Mountain; active on behalf of environmental and conservation causes; award-winning photographer whose images document people and events, sports, and scenic views.

SOURCES: Sharpe, "Photos By Morton," 4–5, 16–18; Corey, "Hugh Morton's Favorite Ten," 10–13; Morton, *Hugh Morton's North Carolina*, vii–xvi.

MORTON, W. B. (ca. 1834–1862): native of N.C.; active early 1860s, Stanly County; enlisted as private in Company D, Twenty-eighth Regiment, N.C. State Troops, July 29, 1861; died of disease, Jan. 30, 1862.

SOURCE: Manarin and Jordan, *N.C. Troops*, 8:160.

MOSBY, A.: active ca. 1918–1920s in association with A&T College photo studios program.

SOURCE: real-photo postcard bearing his name (advertised for sale by eBay).

MOSES, HORACE D. (b. ca. 1883): native of England; active early 1900s–1921; in London, England (prior to working in Winston-Salem); may have worked in S.C. ca. 1915; in Winston-Salem (1916–1921); proprietor of Crescent Studio (1916); in partnership with William G. Russell (1918–1920); studio located above Elmont Theatre on N. Liberty St.

SOURCES: State Auditor's Records, Sch. B; *Winston-Salem Directory*, 1918, 1920; Fourteenth Census, 1920: Forsyth County, Pop. Sch., Winston-Salem, E.D. 83; Weaver, *Winston-Salem, North Carolina, City of Industry*, 13; information from the files of MESDA.

MOSHER, AUGUSTA WILDE (Mrs. C. S. Mosher): probably native of Md.; daughter of J. W. F. Wilde; in association with father as itinerant daguerreotyper in N.C., late 1840s and early 1850s; later sole proprietor in Ala.; in Yorkville, S.C. (1853–1854); in Savannah, Ga. (1854–1855); in Selma, Ala. (1860–1861, 1866); in Talladega, Ala. (1870).

SOURCES: *Hillsborough Recorder*, Dec. 5, 1849, Jan. 22, 1851; *Greensborough Patriot*, Mar. 15, 1851; *North Carolina Whig* (Charlotte), Feb. 18, 1852; *Western Democrat* (Charlotte), Jan. 28, 1853; *Asheville News*, July 28, 1853; Seventh Census, 1850: Pop. Sch., City of Baltimore, Md., Third Ward; Robb list of Ala. photographers; Teal, *Partners with the Sun*, 82, 304.

MOSS, JOHN (b. ca. 1879): native of S.C.; active by 1910, McAdenville.

SOURCE: Thirteenth Census, 1910: Gaston County, Pop. Sch., McAdenville, E.D. 63.

MOULTON, GEORGE CLARKE (1886–1955): native of N.C.; active ca. 1910–1940s; operated Wootten-Moulton Studio, New Bern (1910–1940s) in partnership (beginning ca. 1912) with half sister, Bayard Wootten; at Fort Bragg (1921–1928); operated (with Bayard Wootten) Wootten-Moulton Studio, Chapel Hill (1928–1940s); brother of Celia Moulton Lively.

SOURCES: Photographic Examiners Records; *Illustrated City of New Bern*, 7; *N.C. Year Book*, 1916; *Bradstreet's*, 1921, 1925; *Mercantile Reference Book*, 1931; *Mercantile Agency Reference Book*, 1943; tombstone inscription, Cedar Grove Cemetery, New Bern; Cotten, *Light and Air*, 18–19, 33–34, 41–42.

MOULTON, H. V.: active 1916, Duke (later Erwin).

SOURCE: State Auditor's Records, Sch. B.

MOXLEY, MORRIS: active (obtained license to practice) 1905–1906, Alleghany County.

SOURCE: Registry of Licenses to Trade, Alleghany County, 1874–1906 (A&H).

MUDGETT, J. B.: active late nineteenth century, Wilson and New Bern; operated J. B. Mudgett's Picture Gallery.

SOURCES: photograph bearing his name, provided by Durwood Barbour, Raleigh; advertising back mark on two photographs.

MUIR, _____: active 1937 with U.S. Forest Service; took photographs of CCC dam construction in Nantahala National Forest.

SOURCE: information provided by Carol Johnson, Library of Congress, Washington, D.C.

MUIR, CANIS (CANDIS, CANDICE?) (b. ca. 1889): native of N.C.; active by 1910 in studio of Urchie C. Ellis, Wilmington.

SOURCE: Thirteenth Census, 1910: New Hanover County, Pop. Sch., Wilmington, E.D. 89.

MULLEN, I.: active 1921, Gastonia.

SOURCE: Photographic Examiners Records.

MURIELLO STUDIO: active 1925, S. Tryon St., Charlotte; Mrs. Grace Michael, artistic portraitist.

SOURCE: Miller, *Charlotte Directory*, 1925.

MURPHY, E. PHILLIPS: African American; active 1929–1930, Asheville.

SOURCE: Miller, *Asheville City Directory*, 1929–1930; information provided by staff of Pack Memorial Public Library, Asheville.

MURPHY, P. HENRY (b. ca. 1840): native of Ireland; active by 1880–1888; on Fayetteville St. at corner of Exchange Pl., Raleigh (1880–1884); on Main St., between Depot and Mangum Sts., Durham (1884); on Road St., Elizabeth City (1886–1888); in Edenton (1888); purchased gallery of the late John F. Lee; operated Murphy's Gallery, opposite the post office.

SOURCES: Tenth Census, 1880: Wake County, Pop. Sch., Raleigh (Southwest Division), E.D. 268; *Charles Emerson & Company's Raleigh Directory, 1880–'81*, 175; *Chataigne's N.C. Directory and Gazetteer, 1883–'84*; Paul, *History of the Town of Durham*, 240; *North Carolinian* (Elizabeth City), July 14, 1886; *Fisherman & Farmer* (Edenton), Apr. 6, 13, 27, 1888.

MURRAY, W. A.: active 1890s; in Rocky Mount (1894); in Wilson (1890s).

SOURCE: photographs bearing his name.

MYDANS, CARL M. (b. 1907): native of Mass.; active 1936 with U.S. Resettlement Administration; in Pender and Wake Counties.

SOURCES: Copy negative (A&H); *Encyclopedia of World Biography*, 2d. ed., II: 283–284; Broecher, *International Center of Photography Encyclopedia of Photography*, 351; Dixon, *Photographers of the Farm Security Administration*, 85; "Reference Guide to FSA/OWI Photographs."

MYERS, G. H.: active 1916, Winston-Salem.

SOURCE: State Auditor's Records, Sch. B.

MYERS, J. Q.: active 1914, on S. Main St., Asheville.

SOURCE: Miller, *Asheville City Directory*, 1914.

NALY, J. C.: active 1930–1931, Lenoir.

SOURCE: Miller, *Lenoir City Directory, 1930–1931.*

NARAMORE, _____: active 1899, Winston, in partnership with Andrew Jackson Farrell. *See also* Farrell, Andrew Jackson. Source not recorded.

NARAMORE, WILLIAM W. (b. ca. 1822): native of Conn.; itinerant daguerreotyper; active 1849–1870s; in Conn. (1849); in Wilmington (1850–1851), where he occupied room in Exchange Building, corner of Market and Front Streets; in Bridgeport, Conn. (1857, 1862–1864, 1865–1867, 1868–1870); employed as a customs inspector in New York City (1880).

SOURCES: *Wilmington Journal,* Dec. 20, 1850, Feb. 28, 1851; Rinhart and Rinhart, *The American Daguerreotype,* 403; Witham, *Catalogue of Civil War Photographers,* 10; *Craig's Daguerreian Registry,* 3:413; Fuller, "Checklist of Connecticut Photographers," 121; *www.familysearch.org.*

NATIONAL PHOTO COMPANY: active 1909–1932; took photographs of Mount Mitchell area.

SOURCE: information provided by Carol Johnson, Library of Congress, Washington, D.C.

NEAL, WILLIAM ROBERT (b. 1869): active 1901–1930s; with Pegg Brothers in Kernersville (1901–1902); in Stokes County (1903–1905); in Randleman (1905–1935); also worked as jeweler and watch repairman.

SOURCES: Photographic Examiners Records; Thirteenth Census, 1910: Randolph County, Pop. Sch., Randleman, E.D. 96; State Auditor's Records, Sch. B; *N.C. Year Book,* 1916; *Mercantile Reference Book,* 1931.

NELSON, JOHN EMERY (b. 1906): active 1937 and afterward, Lenoir; associated with Scott's Studio.

SOURCE: Photographic Examiners Records.

NELSON, WILLIAM THOMPSON (1859–1917): native of N.C.; active 1916, Taylorsville.

SOURCES: State Auditor's Records, Sch. B; *N.C. Year Book,* 1916; Vital Records, death certificates, Book 263, p. 5 (A&H).

NEPHEW, JOHN (b. ca. 1857): native of N.Y.; active by 1880–1884; in Washington, D.C. (1880); in Oxford (1883–1884).

SOURCES: *Chataigne's N.C. Directory and Gazetteer, 1883–'84;* Branson, *NCBD,* 1884; *www.familysearch.org.*

NEVENS, GEORGE: active early twentieth century, Wilmington.

SOURCE: Block, *Along the Cape Fear,* 8, 39.

NEW, GEORGE BENJAMIN (ca. 1862–1898): active 1890s, Wilmington (1891, 1897); in partnership with a Mr. Turney (1891); sole proprietor of gallery on corner of Fourth and Market Streets (1897); died at Norfolk, Va.

SOURCES: *J. L. Hill Printing Co.'s Directory of Wilmington, N.C., 1897; Star* (Wilmington), July 28, 1898; Cotten list of N.C. photographers; Reaves list of Wilmington photographers.

NEWARK PHOTO COMPANY: active ca. 1918; took panoramic photograph of Forty-first Infantry Division at Camp Greene during World War I.

SOURCE: information provided by Carol Johnson, Library of Congress, Washington, D.C.

NEWBERRY, M. W.: active 1889–ca. 1895; in Plymouth (1889–1890s); in Edenton (1889); in Elizabeth City (1889) in association with John F. Engle.

SOURCES: *Roanoke Beacon* (Plymouth), Aug. 16, 1889, Sept. 20, Oct. 18, 1889; Sprange, *Blue Book,* 289.

NEWCOMBE, _____: itinerant; active (obtained license to practice) 1870s–1874, Hyde County, in partnership with a Mr. Swindell; also in Greenville (ca. 1870s), likewise in partnership with Swindell as proprietors of Swindell & Newcombe Art Gallery.

SOURCES: Treasurer's and Comptroller's Records, County Settlements with the State, Box 52, Hyde County (A&H); information provided by Roger Kammerer, Greenville.

NEWELL, ASHBY: active 1910–1922; in Sumter, S.C. (1910–1925), as itinerant from his home in Sumter County; in Durham (1917–1919); in Greensboro (1921); in High Point (1922).

SOURCES: Record of Special Licenses Issued, Durham County, 1917–1918 (A&H); State Auditor's Records, Sch. B; Teal, *Partners with the Sun,* 251.

NEWELL, GEORGE ANGEL (b. ca. 1828): native of Mass.; itinerant with tent studio; active by 1874–1890s; in Magnolia (1874); also active as watchmaker, jeweler, and sewing-machine repairman; in Mount Olive (ca. 1875); at Catherine Lake (1880); in Kinston (1880); operated jewelry and photography business in Roxboro (1888–1890s) in partnership with Mr. E. Jones (1891); in Henderson (ca. 1895); father of George M. Newell and William H. B. Newell; portrait on file at N.C. Office of Archives and History.

SOURCES: *Duplin Record* (Magnolia), Oct. 30, 1874; photograph made in Mount Olive bearing Newell's name; Tenth Census, 1880: Lenoir County, Pop. Sch., Kinston, E.D. 86; State Auditor's Records, Miscellaneous Tax Group (1868–1932), Box 3, Artists' and Photographers' Privilege Licenses, 1877–1887 (A&H); *Reference Book of the Mercantile Association of the Carolinas,* 1891; Sprange, *Blue Book,* 289; information provided by Jean Newell, Roxboro.

NEWELL, GEORGE MORGAN (1863–after 1930): native of N.C.; active by 1880–1890s; in Kinston (by 1880); in Oxford briefly in association with H. W. Pender as Pender, Newell & Company (late 1880s); in Henderson

(1886–1891) in partnership with Pender (late 1880s); served as lieutenant colonel, Quartermaster Corps, U.S. Army, on active service during World War I; attained rank of colonel, Quartermaster Corps; served as officer in Finance Department, regular army, Washington, D.C., 1920s, attaining rank of colonel (retired 1930); died in Falls Church, Va.; son of George A. Newell and brother of William H. B. Newell.

SOURCES: Tenth Census, 1880: Lenoir County, Pop. Sch., Kinston, E.D. 86; *Torchlight* (Oxford), Apr. 13, Aug. 24, 1886; Branson, *NCBD*, 1890; *Courier* (Roxboro), undated obituary; Cotten list of N.C. photographers; information provided by Jean Newell, Roxboro.

NEWELL, J. B.: maker of tintypes; active 1916, Franklinton.

SOURCE: State Auditor's Records, Sch. B.

NEWELL, WILLIAM HENRY BADGER (1856–1913): native of N.C.; active (by 1880–1890s); in Lillington (by 1880); in Roxboro (1880s–1890s); son of George A. Newell and brother of George M. Newell.

SOURCES: Tenth Census, 1880: Harnett County, Pop. Sch., Lillington, E.D. 84; information provided by Jean Newell, Roxboro.

NEWMAN, THOMAS C.: active 1911–1914, Concord.

SOURCES: *N.C. Year Book*, 1911–1913; *Concord City Directory*, 1913–1914.

NEWSOM, _____: itinerant daguerreotyper; active 1848, Fayetteville, in partnership with F. M. Cory; occupied rooms at Fayetteville Hotel.

SOURCE: *Fayetteville Observer*, Oct. 17, 1848.

NEWSOM, _____: itinerant; active (paid tax to practice) 1867–1868; in partnership with a Mr. Byerly (perhaps John Davis Byerly).

SOURCE: Northampton County Tax Records, 1858–1879, Folder (1860–1867) (A&H).

NEWSOM, U. STANLEY: active 1927–1933, High Point; operated Newsom Photo Company (1927); manager, West-Dempster Company (1929–1933).

SOURCES: Miller, *High Point Directory*, 1927–1930; Hill, *High Point City Directory*, 1930–1931, 1933.

NEWTON, L. H.: itinerant; active 1857, Hillsborough; gallery located in William F. Strayhorn's office, opposite James C. Turrentine's residence.

SOURCE: *Hillsborough Recorder*, Oct. 21, 1857.

NEW YORK PHOTOGRAPH GALLERY: active 1880, Raleigh; George W. Stewart, operator.

SOURCE: *Charles Emerson & Company's Raleigh City Directory, 1880–'81*, 175.

NEW YORK STUDIO: active 1938–1940, Statesville (1938–1939) and Mooresville (1939–1940); Eugene B. Fairbanks, proprietor.

SOURCES: Miller, *Statesville City Directory*, 1938–1939; Miller, *Mooresville City Directory*, 1939–1940.

NICHOLS, E. C.: active 1891, Marion.

SOURCE: Cotten list of N.C. photographers.

NICHOLSON, E. C.: active 1916, Oxford.

SOURCE: State Auditor's Records, Sch. B.

NIMMO, THOMAS J. (b. 1835): native of Va.; active 1854–1891; one-time operator for Jesse H. Whitehurst; in Baltimore (1854–1856) as Thomas J. Nimmo and Company; in Washington, D.C. (1858, 1860); itinerant in N.C. (perhaps in Tarboro) in late 1860s; in partnership with a Mr. Byerly (probably John Davis Byerly of Frederick, Md.); in Frostburg and Allegany County, Md. (1870s); in Gallitzen, Pa. (1890–1891).

SOURCES: photograph bearing names of Nimmo and Byerly; *Craig's Daguerreian Registry*, 2:89; 3:419; Rinhart and Rinhart, *The American Daguerreotype*, 403; Kelbaugh, *Directory of Maryland Photographers*, 37, 72; Ries and Ruby, *Directory of Pennsylvania Photographers*, 202; Robb list of Ala. photographers.

NIXON, ALFRED (b. ca. 1884): native of N.C.; active by 1910, Belhaven.

SOURCE: Thirteenth Census, 1910: Beaufort County, Pop. Sch., Belhaven, E.D. 8.

NOLAND, HARRY C.: active 1937–1938, operated Noland Studio in Grove Arcade, Asheville.

SOURCE: *Miller's Asheville Directory*, 1937–1938.

NORDEN, ERIC (1867–1946): native of Sweden; active early twentieth century, Wilmington; civil engineer and amateur photographer; president of YMCA Camera Club, 1902.

SOURCE: Reaves list of Wilmington photographers.

NORRIS, W. R.: active 1919, Mooresville.

SOURCE: State Auditor's Records, Sch. B.

NOTT, J. D.: itinerant daguerreotyper; active 1856–1857, Fayetteville; successor to J. S. Wear; occupied rooms above jewelry store of Beasley & Houston; M. M. Ferguson took over Nott's rooms in Apr. 1857.

SOURCES: *North Carolina Argus* (Fayetteville), Oct. 20, 1856; *Fayetteville Observer*, Apr. 27, 1857.

NOVELTY PHOTO COMPANY: active 1902, Wilmington.

SOURCE: *N.C. Year Book*, 1902.

NUNN, ARCHIE R. (1873–1922): native of N.C.; active by 1900–1907, Rocky Mount; occupation at time of death was sign painter.

SOURCES: Twelfth Census, 1900: Edgecombe County, Pop. Sch., Rocky Mount, E.D. 13; *N.C. Year Book,* 1902–1907; Vital Records, death certificates, Book 680, p. 123 (A&H).

NUSBAUM, CHARLES: active 1920, Salisbury.

SOURCE: State Auditor's Records, Sch. B.

O

O. HENRY DRUG COMPANY: active 1922, Greensboro.

SOURCE: State Auditor's Records, Sch. B.

OAK CITY PHOTOGRAPH GALLERY: active 1880, Raleigh; Horace Davis, proprietor.

SOURCE: *North Carolina Republican* (Raleigh), Mar. 19, 1880.

OAKLEY, DANIEL W. (b. ca. 1873): native of N.C.; active 1914–1920, Roxboro.

SOURCES: State Auditor's Records, Sch. B; *N.C. Year Book,* 1914–1916; Fourteenth Census, 1920: Person County, Pop. Sch., Roxboro, E.D. 195.

OAKLEY, W. L.: active 1919, Durham.

SOURCE: State Auditor's Records, Sch. B.

OATES, _____: active 1906, Salisbury, in partnership with Jacob H. J. Kluttz.

SOURCE: postcard bearing name "Oates."

OKSMAN, H.: active 1921, Lumberton.

SOURCE: State Auditor's Records, Sch. B.

OLDHAM, P. E.: active (obtained license to practice) 1909–1910, Durham.

SOURCE: Registry of Licenses to Trade, Durham County, 1881–1913 (A&H).

OLIVE, ALPHA A. (b. 1877): native of N.C.; active by 1900, Randleman.

SOURCE: Twelfth Census, 1900: Randolph County, Pop. Sch., Randleman, E.D. 95.

OLIVE, DUTCH: active (obtained license to practice) 1917–1918, Durham.

SOURCE: Record of Special Licenses Issued, Durham County, 1917–1918 (A&H).

OLIVER, HENRY G.: active 1921, Charlotte; operated People's Photo Studio, S. Tryon St.

SOURCES: Miller, *Charlotte Directory,* 1921; information provided by Shelia Bumgarner, Public Library of Charlotte and Mecklenburg County.

O'NEAL, J. C.: African American; active (obtained license to practice) 1915–1916, Durham.

SOURCE: Record of Special Licenses Issued, Durham County, 1914–1916 (A&H).

ORPHIN, PHILANDER CHASE (1845–1938): native of Canada; active 1902–1925; on Patton Ave., Asheville (1902–1911); in Norfolk, Va. (n.d.) in association with son, William N. Orphin; in Brevard (1917) and Concord (1922–1925), likewise in association with his son.

SOURCES: Hill, *Asheville, N.C. City Directory,* 1902–1907; Miller, *Asheville, N.C. City Directory,* 1907–1911; *Bradstreet's,* 1908; Thirteenth Census, 1910: Buncombe County, Pop. Sch., Asheville, E.D. 15; information provided by staff of Pack Memorial Public Library, Asheville; *Asheville Citizen,* June 7, 1938.

ORPHIN, WILLIAM N. (b. ca. 1889); native of N.C.; active 1910s–1925; in Norfolk, Va. (n.d.), Brevard (1917), and Concord (1922–1925) in association with his father, Philander C. Orphin.

SOURCES: Thirteenth Census, 1910: Buncombe County, Pop. Sch., Asheville, E.D. 15; *Bradstreet's,* 1917; *Concord City Directory,* 1922–1923, 1924–1925; information provided by staff of Pack Memorial Public Library, Asheville.

ORR, A. F.: of Oldtown, Maine; active ca. 1918, Camp Greene; received permission to take photographs at the camp.

SOURCES: National Army Camps, Camp Greene, Charlotte, N.C., RG 393, Box 20, National Archives; information provided by Jane Johnson, Charlotte.

ORR, ALEXANDER, JR. (b. ca. 1836): native of N.Y.; active 1879–1883, Wilmington, in partnership with Charles W. Yates; the two men published stereographs of Wilmington and vicinity; by 1883 Orr had returned to New York.

SOURCES: Tenth Census, 1880: New Hanover County, Pop. Sch., Wilmington, E.D. 143; Reaves list of Wilmington photographers.

ORTNER, LEON: active 1913–1914, Wilmington.

SOURCE: Hill, *Wilmington Directory, 1913–1914.*

OSBORN, JOB (b. ca. 1825): native of N.C.; active (paid tax to operate as daguerreotyper for 1858–1859 period), Oxford; produced ambrotypes and melainotypes by skylight; employed at grain and feed store at Raleigh in 1880.

SOURCES: *Leisure Hour* (Oxford), Apr. 14, 1859; Granville County Taxables, 1858 (A&H); *www.familysearch.org.*

OSBORNE, ENNIS: active 1919, Ashland (Ashe County).

SOURCE: State Auditor's Records, Sch. B.

O'SULLIVAN, TIMOTHY H. (ca. 1840–1882): native of Ireland; assisted Mathew Brady in New York; Alexander Gardner took over Brady's gallery in Washington, D.C., and secured O'Sullivan to assist him in the early 1860s; O'Sullivan made numerous negatives of Fort Fisher, below Wilmington, after Union forces captured the fortification in January 1865; one of his original prints

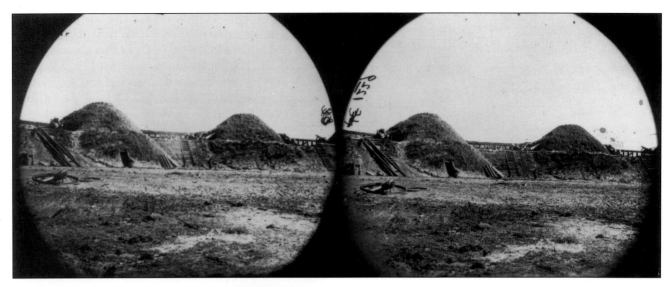

After Federal forces captured Fort Fisher, near the mouth of the Cape Fear River below Wilmington, in January 1865, Timothy H. O'Sullivan entered the bastion and made a set of negatives to record the effects of the Union naval bombardment on the sand fortification. Shown here are a stereograph of the first, second, and third gun emplacements on the fort's land face and a photograph of the powerful Armstrong Gun protecting the sea face. Photographs courtesy A&H.

of Fort Fisher is in the collection of the N.C. Office of Archives and History.

SOURCES: Taft, *Photography and the American Scene*, 230, 235–236, 493–494; Teal, *Partners with the Sun*, 106–107.

OVERBY, A. T.: active in Stokes County as itinerant and tintype artist (ca. 1900).

SOURCE: information provided by Chad Tucker, King, N.C.

OVERBY, ALICE (b. ca. 1887): native of Pa.; active by 1910, High Point; sister of Maud Overby.

SOURCE: Thirteenth Census, 1910: Guilford County, Pop. Sch., High Point, E.D. 119.

OVERBY, MAUD (b. ca. 1889): native of Pa.; active by 1910, High Point; sister of Alice Overby.

SOURCE: Thirteenth Census, 1910: Guilford County, Pop. Sch., High Point, E.D. 119.

OVERMAN, THOMAS F. (b. 1860): native of N.C.; active 1896–1897, Siler City; worked as grocer by 1900.

SOURCES: Branson, *NCBD*, 1896, 1897; Twelfth Census, 1900: Chatham County, Pop. Sch., Siler City, E.D. 11.

OVERTON, MYRTLE PAULINE (1904–ca. 1944): active 1924–ca. 1944, Washington, N.C., with William Henry Baker; purchased Baker Studio in 1939.

SOURCES: Photographic Examiners Records; *Mercantile Agency Reference Book*, 1943.

OWEN, JOHN D.: active 1899–1915, Spartanburg, S.C. (1899, 1908–1913); in Clyde (1900); in Waynesville (1914–1915).

SOURCES: Teal, *Partners with the Sun*, 210; photograph bearing Owen's name, in possession of compiler; *N.C. Year Book*, 1914, 1915.

OXLEY, GEORGIA ("GEORGIE") C. (1877–1938): native of N.C.; active ca. 1908–1930s; operated Oxley Studio, Middle St., New Bern.

SOURCES: *Daily Journal* (New Bern), Jan. 8, 1914; Hill, *New Bern Directory*, 1914–1915, 1918–1919, 1920–1921, 1926; *N.C. Year Book*, 1915, 1916; *Bradstreet's*, 1917, 1921, 1925; *Mercantile Reference Book*, 1931; State Auditor's Records, Sch. B; Vital Records, death certificates, Book 2013, p. 17 (A&H); tombstone inscription, Cedar Grove Cemetery, New Bern; Green, *A New Bern Album*, 16.

P

PACKER, JOSEPH H. (b. ca. 1884): native of Canada; active 1921–1940, High Point; operated Packer Photo Company.

SOURCES: Miller, *High Point Directory*, 1921–1931; Fifteenth Census, 1930: Guilford County, Pop. Sch., High Point, E.D. 49; *Hill's High Point Directory*, 1933, 1940.

PAINE, H.: active (obtained license to practice) 1889–1890, Clay County.

SOURCE: Registry of Licenses to Trade, Clay County, 1876–1904 (A&H).

PALM PHOTO SERVICE: active 1940–1941, Mebane; Willie F. Kendrick, proprietor.

SOURCE: photographs bearing company name.

PALMER, JAMES A. (b. ca. 1828): native of N.Y.; itinerant; active 1858–1870s; in Fayetteville (1858); William T. Battley took over his rooms, just east of the Fayetteville Hotel (May 1858); subsequently worked in Elkhart, Ind. (1860); in Buchanan, Ind. (1865); later in Mich., N.Y., Mass., Washington, D.C., S.C., and La.

SOURCES: *Fayetteville Observer*, May 24, 1858; Eskind, *Index to American Photographic Collections*, 858; Marusek list of Ind. photographers.

PALMER, JOHN C. (ca. 1800–1893): native of N.J.; active 1845–1850s, on Fayetteville St., Raleigh; jeweler and silversmith who added a daguerreotype gallery to his business; in partnership in jewelry business with Walter J. Ramsey (1847–1855).

SOURCES: *North Carolina Standard* (Raleigh), Nov. 18, 1846; *Raleigh Register* (semi-weekly), Dec. 1, 1847; *Weekly North Carolina Standard* (Raleigh), Nov. 27, 1850; DNCB, s.v. "Palmer, John C."; Peacock, *Silversmiths of North Carolina*, 116–119.

PALMER, WILLIAM (b. ca. 1840): native of N.C.; active by 1860, Wilmington.

SOURCE: Eighth Census, 1860: New Hanover County, Pop. Sch., Wilmington.

PARHAM, B. I.: active 1919–1920, Franklinville (Randolph County).

SOURCE: State Auditor's Records, Sch. B.

PARKER, ERASTUS A. (1857–1935): native of N.C.; active ca. 1887–1934; in Kinston (ca. 1887–ca. 1910s) in gallery located above Alex LaRoque's store on corner of Queen and North Streets; succeeded by Francis E. Dixon (1905–1907); advertised as artistic photographer while in Kinston; in Smithfield (1894) as itinerant in tent; took photograph of monument at Bentonville Battleground (Mar. 1895); in Dunn periodically (1895–ca. 1900); in Four Oaks briefly (1895); in Clayton (1895); in Greenville (ca.1919–1934).

SOURCES: *Smithfield Herald*, May 24, 1894; *Times* (Dunn), Jan. 23, 1895; *County Union* (Dunn), Apr. 10, 1895; *Kinston Free Press*, Aug. 18, 1897; *Great Sunny South* (Snow Hill), Aug. 15, 1898; photographs made in Dunn bearing Parker's name; Twelfth Census, 1900: Lenoir County, Pop. Sch., Kinston, E.D. 44; *Mercantile Agency Reference Book*, 1904; *Bradstreet's*, 1908, 1921; *Mercantile Reference Book*, 1931; State Auditor's Records, Sch. B; Photographic Examiners Records; *Kinston Daily Free Press*, Jan. 8, 1935.

PARKER, J. H.: active 1921–1922, High Point.

SOURCE: State Auditor's Records, Sch. B.

PARKER, J. W. (1873–1948): active 1911–1916, Greenville.

SOURCES: *N.C. Year Book*, 1911–1916; St. Amand, *Pitt County Gravestone Records*, Vol. 3, p. 98.

PARKER, JAMES: from Suffolk, Va.; active 1902–1903, Littleton; associated with C. W. Hart's Gallery.

SOURCE: Dozier, *Town Leaders, Littleton, North Carolina*, 93.

PARKER, ZENIA (Miss) (1887–1966): active 1916–1940s; in Charlotte (1916–1936); with Leonard C. Cooke (1916–1925); with Marguerite D. Gaddy (1936); with Efird's Department Store, Raleigh (1936–1942); moved to Savannah, Ga., 1942; died there.

SOURCES: Photographic Examiners Records; *www.familysearch.org*.

PARKS, GEORGE: active 1916, Pilot Mountain.

SOURCE: *N.C. Year Book*, 1916.

PARNELL, ALVIN TALMADGE (1899–1986): native of N.C.; active ca. 1916–1960s, Durham; with Waller Holladay (ca. late 1910s); located permanently in Durham, 1927; sole proprietor of Parnell Studio, Corcoran St. (1932–1960s); wife, Prudence Parnell, assisted with operation of studio.

SOURCES: *Hill's Durham Directory*, 1933–1941; *Mercantile Agency Reference Book*, 1943; *Durham Morning Herald*, Mar. 19, 1986; *www.familysearch.org*.

PARRIS, R. J.: active 1920, Almond (Swain County).

SOURCE: State Auditor's Records, Sch. B.

PARRISH, DAVID (ca. 1811–before 1880): native of Va.; active 1840s–1861, Warrenton; added skylight to gallery in 1853; constructed Warren County Jail in late 1860s; employed as master mechanic by 1870; father of Edward P. Parrish and Walter E. Parrish.

SOURCES: *Warrenton News*, Mar. 24, 1853, Sept. 21, 1860; *Semi-Weekly News* (Warrenton), Feb. 5, 1856; Eighth Census, 1860: Warren County, Pop. Sch., Warrenton; Montgomery, *Sketches of Old Warrenton, North Carolina*, 107–108.

PARRISH, EDWARD P. (b. ca. 1840): native of N.C.; active 1860–1861, Warrenton; enlisted as private in Company F, Twelfth Regiment, N.C. State Troops, Apr. 18, 1861; survived the war; son of David Parrish and brother of Walter E. Parrish.

SOURCES: Eighth Census, 1860: Warren County, Pop. Sch., Warrenton; Manarin and Jordan, *N.C. Troops*, 5:192.

PARRISH, WALTER E. (ca. 1854–1886): native of N.C.; active 1885–1886, Reidsville; son of David Parrish and brother of Edward P. Parrish.

SOURCES: Eighth Census, 1860: Warren County, Pop. Sch., Warrenton; Cotten list of N.C. photographers.

PARSON, LOUIS P.: active 1928, Fayetteville.

SOURCE: *American Legion North Carolina Fayetteville City Directory, 1928.*

PARSONS, CHARLES J. S.: active 1930s, Sapphire (Transylvania County).

SOURCE: Photographic Examiners Records.

PARTIN, JOHN WILEY, JR. (1920–1998): active 1937–1940s with Goodrich Studio, Henderson; in military service during World War II; died in Va.

SOURCES: Photographic Examiners Records; *www.familysearch.org.*

PATON, GEORGE EDWARD (1855–1902): itinerant early in career; active ca. 1897–1901; in Carthage (1897) as artistic photographer, courthouse square; in Asheboro (1897); in Jonesboro (1897); moved tent to Fayetteville in 1897; purchased Winburn's Gallery in A. E. Rankin Building and permanently located in Fayetteville (ca. 1898–1901); father of Noel E. Paton; wife, Octavia E. ("Nellie") Paton (Mrs. John L. Allen after 1907), took over operation of business after her first husband's death.

SOURCES: *Carthage Blade,* Apr. 6, May 11, 1897; *Sanford Express,* Sept. 3, 17, 1897; Twelfth Census, 1900: Cumberland County, Pop. Sch., Cross Creek Township, Fayetteville, E.D. 23; *News and Observer* (Raleigh), Mar. 27, 1902; cemetery records provided by Roy Parker Jr., Fayetteville.

PATON, NOEL E. (1895–1965): native of N.C.; active (ca. 1920–1950) with Paton Studio, Hay St., Fayetteville; son of George E. Paton and Octavia E. ("Nellie") Paton Allen; served as a sergeant in Company A, 344th Tank Battalion, during World War I; wounded and highly decorated war hero; operated studio with mother after

The
Paton Studio

1897 · · · 1939

Two hundred and twenty Business, Professional and Social Leaders of Fayetteville, Cumberland County and vicinity were photographed by us especially for this Sesqui-Centennial Edition of The Fayetteville Observer.

Two Hundred and Twenty Cumberland County Scotchmen Can't Be Wrong:-

"While You're About It, Get A Good Picture."

NOEL PATON
"The Man Who Made The Pictures"
(A Self-Portrait)

Somebody, Somewhere Wants Your Picture THIS Christmas.

This advertisement for the Paton Studio in Fayetteville includes a self-portrait of owner Noel E. Paton pressing the shutter release of a large-format camera in 1939. Photograph courtesy A&H.

World War I; served as president of N.C. Photographers' Association; portrait on file at N.C. Office of Archives and History.

SOURCES: Twelfth Census, 1900: Cumberland County, Pop. Sch., Cross Creek Township, Fayetteville, E.D. 23; Hill, *Fayetteville, N.C. City Directory, 1924; American Legion North Carolina Fayetteville City Directory, 1928; Hill's Fayetteville Directory, 1937–1941; Mercantile Reference Book, 1931; Mercantile Agency Reference Book, 1943; Fayetteville Observer,* May 26, 1924, Jan. 1934 (Inland Port Edition), Nov. 15, 1939, May 3, 1965; cemetery records provided by Roy Parker, Fayetteville.

PATON, OCTAVIA E. ("NELLIE") (1866–1941): native of Canada; active 1901–ca. 1940, Fayetteville; took over operation of Paton Studio after death of husband, George E. Paton, in 1902; sole proprietor until 1920; married John L. Allen in 1907; in business with son, Noel E. Paton (1920–ca. 1940).

SOURCES: Twelfth Census, 1900: Cumberland County, Pop. Sch., Cross Creek Township, Fayetteville, E.D. 23; *Mercantile Agency Reference Book, 1904; Bradstreet's,* 1908, 1917, 1921, 1925; Cumberland County Marriage Register, 1901–1926 (A&H); Hill, *Fayetteville, N.C. Directory, 1909–1910;* Thirteenth Census, 1910: Cumberland County, Pop. Sch., Fayetteville, E.D. 50; Gardiner, *Fayetteville, N.C. City Directory, 1915–1916; N.C. Year Book,* 1910–1916; State Auditor's Records, Sch. B; *Fayetteville Observer,* May 26, 1924, Nov. 28, 1941; Photographic Examiners Records; Cumberland County Wills (A&H), Book L, p. 107; cemetery records provided by Roy Parker Jr., Fayetteville.

PATRICH, J. H.: active (obtained license to practice) 1899–1900, Washington County.

SOURCE: Registry of Licenses to Trade, Washington County, 1883–1902 (A&H).

PATRICK, BEN MOORE (1912–1995): not a commercial photographer; active by early 1940s; photographer/writer for *Durham Herald-Sun,* 1940s; documented creation of Camp Butner, 1942 and afterward, and compiled book about it titled *The Grandurson Story;* later a photographer for the State Department of Conservation and Development.

SOURCES: *Durham Morning Herald,* Apr. 3, 1968; *Herald-Sun* (Durham), Mar. 16, 1995; Smith and Patrick, *Voices from the Field,* 10–11; information provided by John Ansley, Durham County Public Library; *www.familysearch.org.*

PATRICK, J. C.: active 1897–ca. 1910; in Wilmington (1897); in Sanford (1902); in Chester, S.C. (1906–ca. 1910); published picture postcards and produced stereographs.

SOURCES: *N.C. Year Book,* 1902; Teal, *Partners with the Sun,* 226; stereograph bearing his name, in possession of compiler.

PATTERSON, ALEXANDER (ca.1833–after 1908): native of N.C.; active 1860–1861, Fayetteville; apprenticed under William T. Battley; enlisted in Company K, Eighteenth Regiment, N.C. State Troops, Apr. 26, 1861; captured at Spotsylvania Court House, Va., 1864; survived war.

SOURCES: Eighth Census, 1860: Cumberland County, Pop. Sch., Fayetteville; Manarin and Jordan, *N.C. Troops*, 6:420–421; Civil War Pension Applications (A&H).

PATTERSON, BENJAMIN F.: itinerant maker of ambrotypes; active 1861, Washington; gallery above C. G. Buckman's store on Main St.

SOURCE: *Washington Dispatch*, Sept. 17, 1861.

PATTERSON, HUGH B.: African American; active 1925, Charlotte.

Source: Miller, *Charlotte Directory*, 1925.

PATTERSON, J. W.: daguerreotyper; active 1847, Wilmington; occupied room above Dr. A. C. Evans's drugstore in Exchange Building; advertised years of experience in Philadelphia and Baltimore.

Source: *Chronicle* (Wilmington), Feb. 5, 1847.

PATTERSON, THOMAS WILLIAM (b. 1873): native of Ireland; active 1905–1915, Clinton; also operated a leather and harness shop, sold furniture, and served as Clinton's chief of police.

SOURCES: *N.C. Year Book*, 1913–1915; Bizzell, *Heritage of Sampson County*, 554.

PEACE, ABNER DAVID (1838–1915): native of N.C.; active 1860–1861, Granville and Wake Counties; studied under William Shelburn at Oxford, 1860; in partnership with James H. Mitchell; attained rank of captain, Company E, Twenty-third Regiment, N.C. State Troops.

SOURCES: Private correspondence of members of Peace family, in possession of Laura Peace, Henderson; information provided by Laura Peace; Manarin and Jordan, *N.C. Troops*, 7:185.

PEACH, DAVID FRANKLIN (1882–1962): native of N.C.; active 1914–1940s; with Hightower Studio, Durham (1914); with Carolina Developing & Printing House, Charlotte (1918–1924); in Mount Pleasant (1916); operated Peach's Studio, Monroe (ca. 1916–1930s).

SOURCES: Photographic Examiners Records; *N.C. Year Book*, 1916; Fifteenth Census, 1930: Union County, Pop. Sch., Monroe, E.D. 90–19; *www.familysearch.org*.

PEARSON, A. F.: active 1916, Belmont.

SOURCE: State Auditor's Records, Sch. B.

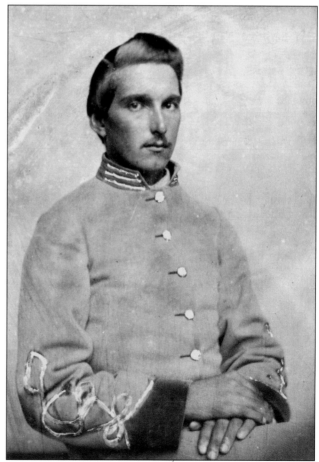

RIGHT, TOP: Thomas W. Patterson is believed to have photographed the last public hanging in Sampson County in 1905. Dr. Frank H. Holmes (1870–1955) is here shown examining the hooded felon, Ashton Moore, who was executed at Clinton for raping a twelve-year-old girl. Photograph courtesy Earl Butler, Clinton. **BOTTOM:** Shown here is a Civil War–era portrait of Abner D. Peace of Granville County. Peace worked briefly as a photographer before enlisting for Confederate military service. Photograph courtesy Laura Peace, Henderson.

PEARSON, HARVEY L.: active 1939, Hillsboro Rd., Durham.

SOURCE: Hill, *Durham, N.C. Directory, 1939.*

PEARSON, KATHRYN (Mrs.): active 1939 and afterward, Monroe; reported to be operating without a photographer's license.

SOURCE: Photographic Examiners Records.

PEARSON, THOMAS GILBERT (1873–1943): native of Ill.; ornithologist and wildlife conservationist; helped form Audubon Society of N.C. and served as its secretary; along with Herbert H. Brimley, took photographs of birds in N.C.

SOURCES: *DNCB,* s.v. "Pearson, Thomas Gilbert"; Herbert H. Brimley Photograph Collection (A&H); information provided by Sarah Robinson, Jacksonville, Fla.

PEASELEY, RICHARD H.: active 1923–1924, E. 7th St., Charlotte.

SOURCE: Miller, *Charlotte Directory,* 1923–1924.

PEELER, DOUGLAS VICTOR J. (1879–1932): native of N.C.; active by 1910 in Salisbury as "picture enlarger."

SOURCES: Thirteenth Census, 1910: Rowan County, Pop. Sch., Salisbury, E.D. 109; *www.familysearch.org.*

PEELER, RICHARD M. (b. 1870); native of N.C.; active 1895–1897, Peeler (Rowan County); operator of Home View Company; winner of photography awards at N.C. State Fair, 1895, 1896.

SOURCES: *Carolina Watchman* (Salisbury), Jan. 28, 1897; *www.familysearch.org.*

PEGG, _____ (unidentified brother of Avery A. Pegg): active 1903, Kernersville; operating as Pegg Brothers.

SOURCE: *Mercantile Agency Reference Book,* 1904.

PEGG, AVERY ATHER (1868–1940): active 1903, Kernersville; operating as Pegg Brothers.

SOURCE: *Mercantile Agency Reference Book,* 1904.

PEGRAM, WILLIAM B. H. (d. 1934): active (obtained license to practice), 1885–1886, Alleghany County; in Weaver's Ford (Ashe County), ca. 1880s; in Elkin, 1892–1893; moved to Calif. by 1923 and died there.

SOURCE: Registry of Licenses to Trade, Alleghany County, 1874–1906 (A&H); photograph bearing his name; photographic artist's license, Elkin, N.C., Dec. 22, 1892 (offered for sale by eBay, Sept. 2002).

PELTON, HERBERT W. (1879–1961): native of Ohio or Ill.; active 1910–1930s; beginning in 1908, produced panoramic views with "Cirkut" camera; also produced postcard views; in Asheville (1910–1928); operated Pelton Studio in partnership with Luther L. Higgason (1914–1916); J. R. Frisby operated studios in 1924; formed partnership with George Masa to operate Photo-Craft Shop (1920); moved to Washington, D.C., in 1930 and operated The Vogue Studio; the Library of Congress houses a collection of his panoramic views.

SOURCES: Miller, *Asheville, N.C. City Directory,* 1910–1928; *N.C. Year Book,* 1915, 1916; State Auditor's Records, Sch. B; Alexander, *Mountain Fever,* 162; Mitzi Tessier, "Asheville and Herbert W. Pelton," in *Coming to Light* (special publication by Asheville Art Museum), 9–15; Benjamin Porter, "Re-Photographing Herbert Pelton's Panoramas," in *Coming*

Asheville's Herbert W. Pelton hauled his camera to the summit of Mount Mitchell to record the arrival on horseback of a group of "Good Roads Enthusiasts" from Asheville during the 1920s. Photograph courtesy A&H.

to Light (special publication by Asheville Art Museum), 16–23; information provided by Benjamin Porter, Asheville; information provided by staff of Pack Memorial Public Library, Asheville; Appalachian National Park Association Collection (A&H).

PENDER, H. W.: active 1880s–1890s; in Baltimore, Md. (ca. 1880s); in Oxford (1886–1888), briefly in association with George M. Newell as Pender, Newell & Company and with W. J. Powell as H. W. Pender & Company (1886–1888); gallery located above post office; in Louisburg (1888); in Henderson (late 1880s) in partnership with George M. Newell; on Fayetteville St., Raleigh (ca. 1890s).

SOURCES: *Torchlight* (Oxford), Apr. 13, Aug. 24, 1886, May 30, 1888; photographs bearing Pender's name.

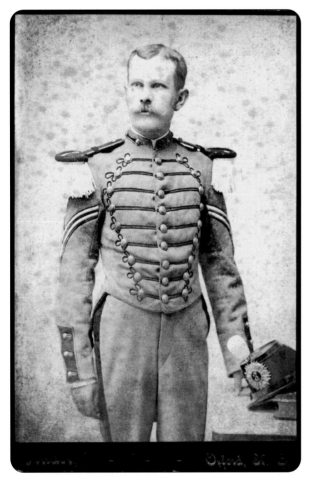

This cabinet-card photograph of an unidentified member of the militia unit known as the "Granville Grays" was taken by H. W. Pender in Oxford about 1888. Courtesy of the compiler.

PEOPLES PHOTO SERVICE: active 1919, Greensboro.

SOURCE: State Auditor's Records, Sch. B.

PEOPLES PHOTO STUDIO: active 1921–1922, S. Tryon St., Charlotte; Henry G. Oliver, manager.

SOURCE: Miller, *Charlotte Directory*, 1921.

PEOPLES STUDIO: active 1924, W. Main St., Durham.

SOURCE: Hill, *Durham, N.C. Directory*, 1924.

PEPPERS, EDWARD: active mid-1920s, Asheville; managed Plateau Studios, Asheville (mid-1920s).

SOURCE: information provided by Peggy Gardner, Asheville.

PERRELL, VERDIE LEE (1902–after 1943): native of N.C.; active 1922–1942, Charlotte; affiliated with Gallagher Commercial Studio, 1922–1925 (manager, 1925); in partnership with W. Marvin Dunaway as Dunaway and Perrell Detective Agency and Commercial Photography (1926); sole proprietor of studio (1927–1930); with Charlotte Engraving Company (1930–1937); with Whitsett Photo Company (1938–1942); employed as defense worker during World War II.

SOURCES: Miller, *Charlotte Directory*, 1926–1930; *Hill's Charlotte Directory*, 1932–1936; *Mercantile Reference Book*, 1931; information provided by Shelia Bumgarner, Public Library of Charlotte and Mecklenburg County.

PERRY, A. W.: active 1919–1922, with Perry's Studio, Wilmington.

SOURCES: State Auditor's Records, Sch. B; Reaves list of Wilmington photographers; *Dispatch* (Wilmington), Sept. 15, 1922.

PERRY, E. B.: active early twentieth century, Littleton and Panacea Springs.

SOURCE: information provided by Phil Perkinson, Norlina.

PERRY, W. H.: active 1916, Wilmington.

SOURCE: State Auditor's Records, Sch. B.

PESCUD, E. F. (b. ca. 1857): native of Md.; active early 1900s, Raleigh; took photographs of State Capitol; employed as store clerk at Raleigh in 1880.

SOURCES: information provided by Carol Johnson, Library of Congress, Washington, D.C.; *www.familysearch.org*.

PETERS, MADELON MARGARET (Miss) (b. 1911): active 1930s–1940s, Asheville (1934–1940s); worked in three unidentified department stores (1934–1938); manager of St. John Studio, Belk's Department Store, Haywood St. (1937); operated Fotocraft (1938–1941) with Max K. Fell.

SOURCES: Photographic Examiners Records; *Miller's Asheville Directory*, 1937.

PETERSON, JOHN A. (b. ca. 1895): native of N.C.; African American; itinerant; active 1919–1930; in Raleigh (1919); in Delway (1920); in Wilmington (1920); in New Bern (1921, 1930).

SOURCES: State Auditor's Records, Sch. B; Fifteenth Census, 1930: Craven County, Pop. Sch., New Bern, E.D. 25-19.

PETERSON, LUTHER THADEUS (1862–1891): native of N.C.; active 1886–1891; itinerant in N.C. (1886); in

Gibson Station (1887); in Concord (briefly, 1889); in Rockingham (1890–1891); itinerant in partnership with brother, R. Frank Peterson (1889–1890); in Wadesboro (1890); in Wilmington (1891) in partnership with brother as Peterson Brothers; left Wilmington because of illness, 1891; B. F. Krupp took over studio.

SOURCES: State Auditor's Records, Ledgers, 1869–1899, Vol. 18, p. 182 (A&H); *Marlboro Democrat* (Bennettsville, S.C.), July 20, 1887; *Standard* (Concord), Oct. 18, 1889; *Star* (Wilmington), May 15, 1891; *Morning Star* (Wilmington), Sept. 24, 1891; *Rocket* (Rockingham), Feb. 19, Oct. 15, 1891; Robeson County Estates Records (A&H); Townsend, *Vanishing Ancestors*, 3:151; information provided by Harvey Teal, Columbia, S.C.

PETERSON, R. FRANK (b. ca. 1852): native of N.C.; active late 1870s–1895; itinerant (late 1870s–1881); in Fayetteville (1881–1886) in gallery located in upper story of McDaniel Building, Person St.; took over studio of R. C. McKenzie (1881); later operator of Peterson's Art Parlors, Hay St.; became part owner of Fayetteville *Daily Evening News* with Stephen G. Worth (Nov. 1885); in Jonesboro (1887–1888); in Kernersville (1887–1888), where his portable gallery was said to be one of the most extensive traveling photographic outfits in the South; in Fayetteville (1889) as itinerant in tent; in partnership with brother, Luther T. Peterson, as itinerant (1889–1890); in Rockingham (ca. 1890); in Hertford (1890) in association with a Mr. Long; in Dunn (1891); in Wilmington (1891) in partnership with brother in gallery located on Market St.; left Wilmington by Sept. 1891; B. F. Krupp took over studio; in Farmington (Davie County) (ca. 1895).

Shown here is an engraving of R. Frank Peterson, Fayetteville photographer and itinerant artist. The drawing was adapted from a photograph made in the 1880s. Illustration courtesy A&H.

SOURCES: *Fayetteville Examiner*, Feb. 10, 1881; *Sun* (Fayetteville), Sept. 26, Oct. 3, 1883; *Chataigne's N.C. Directory and Gazetteer, 1883–'84*; Branson, *NCBD*, 1884; *Historical and Descriptive Review*, 182; *Observer and Gazette* (Fayetteville), Nov. 19, 1885; *Evening News* (Fayetteville), July 30, 1886; *News & Farm* (Kernersville), Oct. 2, 1887, Jan. 20, 1888; *Central Express* (Sanford), Oct. 5, 1889; State Auditor's Records, Ledgers, 1869–1899, Vol. 19, p. 227 (A&H); *Perquimans Record* (Hertford), Dec. 10, 1890; *Central Times* (Dunn), May 7, 1891; *Star* (Wilmington), May 15, 1891; Reaves list of Wilmington photographers; *Mercantile Agency Reference Book*, 1892; Sprange, *Blue Book*, 289; www.familysearch.org.

PETERSON, S. S. (Dr.): active 1907, Morganton.

SOURCE: *N.C. Year Book*, 1907.

PETREY, KENNETH D. (1910–1974): active 1930s–1940s; in unspecified locations in N.C. prior to 1941; operated Goldcraft Studios, Durham (1941 and afterward); in Fayetteville (1944); in Raleigh (1945).

SOURCES: Photographic Examiners Records; www.familysearch.org.

PETRIE, L. C.: active 1912–1926; operated L. C. Petrie Company, High Point.

SOURCES: *N.C. Year Book*, 1912–1916; *Bradstreet's*, 1917; Miller, *High Point Directory*, 1925–1926.

PETTIJOHN, THOMAS J.: active 1916, Windsor.

SOURCE: State Auditor's Records, Sch. B.

PFAADT, L. E.: active ca. 1918, Camp Greene; associated with Commercial Colortype Company, Chicago; received permission to take photographs at the camp.

SOURCES: National Army Camps, Camp Greene, Charlotte, N.C., RG 393, Box 20, National Archives; information provided by Jane Johnson, Charlotte.

PHELLENACE, M. L.: active 1921, Concord.

SOURCE: State Auditor's Records, Sch. B.

PHELPS, _____: active 1921–1922, Morehead City, in partnership with a Mr. Glaze.

SOURCE: State Auditor's Records, Sch. B.

PHILEMON, MARTIN LUTHER (b. ca. 1890): native of N.C.; active by 1910–1936, Charlotte; associated with J. Tate Powell (1910); in partnership with Charles F. Harrison as Ideal Studio (1918) and as H & P Studio (1920s); in partnership with Dorothy W. Stoner (1935–1936).

SOURCES: Thirteenth Census, 1910: Mecklenburg County, Pop. Sch., Charlotte, E.D. 106; Miller, *Charlotte Directory*, 1918; *Hill's Charlotte Directory*, 1932–1933, 1935–1936; information provided by Shelia Bumgarner, Public Library of Charlotte and Mecklenburg County.

PHILLIPS, EMERSON E. (b. 1859): native of N.C. or Tenn.; active by 1910, Greensboro.

SOURCES: Thirteenth Census, 1910: Guilford County, Pop. Sch., Morehead Township, E.D. 193; *www.familysearch.org*.

PHILLIPS, H. R. (Dr.): active late 1860s, Edenton (ca. 1866–1867), in partnership with C. P. Wilhelm; in Washington as sole proprietorship (1867–1868); also employed as dentist.

SOURCES: Branson, *NCBD*, 1867–1868; photograph made in Edenton bearing names of Phillips and Wilhelm.

PHILLIPS, JOHN D. (b. ca. 1873): native of N.C.; active ca. 1900–1930, Carteret County; operated a grocery store in Morehead City (1920).

SOURCE: Fourteenth Census, 1920: Carteret County, Pop. Sch., Morehead City, E.D. 3.

PHILLIPS, LEWIS DAVIS (1875–1947): native of Ohio; active ca. 1922–1947; in Charlotte (ca. 1922–1941); in Winston-Salem (1941–1947); served as president of N.C. Photographers' Association.

SOURCES: Photographic Examiners Records; Miller, *Charlotte Directory*, 1925–1930; *Hill's Charlotte Directory*, 1932–1939; *Mercantile Agency Reference Book*, 1943; *Journal and Sentinel* (Winston-Salem), Mar. 29, 1947.

PHILLIPS, S. R.: maker of ambrotypes; active 1864, Greensboro; occupied room located at Hughes' Gallery.

SOURCE: *Daily Southern Citizen* (Greensboro), Aug. 12, 1864.

PHOTO-CRAFT SHOP: active 1920, Asheville; Herbert W. Pelton and George Masa, proprietors.

SOURCE: information provided by Peggy Gardner, Asheville.

PHOTO HUT: active 1932–1937, Fayetteville; Haywood Howell, proprietor.

SOURCE: Photographic Examiners Records.

PHOTO NOVELTY COMPANY: active 1904–1905, Middle St., New Bern.

SOURCE: Hill, *New Bern Directory, 1904–1905*.

PHOTO SHOP: active 1912–1916, W. Fifth St., Charlotte; Harvey W. South and Jonathan C. Cushman, operators.

SOURCES: Miller, *Charlotte Directory*, 1912; *N.C. Year Book*, 1913–1916.

PHOTO SHOP: active 1913–1919, Wilmington; Charles Dushan and Edward H. Hodges, operators (1913–1914).

SOURCES: Hill, *Wilmington Directory*, 1913–1914; *N.C. Year Book*, 1916; State Auditor's Records, Sch. B.

PHOTO SHOP: active 1923, Greensboro; Roy J. Moose, proprietor.

SOURCE: *Hill Directory Co.'s Greensboro, N.C. City Directory, 1923*.

PHOTO SHOP: active 1941–1942, Morganton; William A. Harbison Jr., proprietor.

SOURCE: *Miller's Morganton City Directory, 1941–1942*.

PHOTO SHOT COMPANY: active 1933–1935 in Silver's Store, Durham; Edward J. Rice, operator.

SOURCE: Hill, *Durham, N.C. City Directory, 1933–1935*.

PHOTOMATON STUDIO: active 1928, S. Tryon St., Charlotte; F. Pasco Powell, operator.

SOURCE: Miller, *Charlotte Directory*, 1928.

PICKARD, JASPER S. (b. ca. 1875): native of Tex.; active 1904–1908 with Pickard's Penny Photo Gallery, Winston.

SOURCES: *Walsh's Directory of the Cities of Winston and Salem*, 1904–1905; *Bradstreet's*, 1908; *www.familysearch.org*.

PICKETT, HENRY FLOYD (1902–1983): native of N.C.; active 1935–1967; in Durham as amateur (1920s–1930s); medical photographer for Duke Hospital.

SOURCE: information provided by Scott Pickett.

PIEDMONT STUDIO: active 1921, W. Trade St., Charlotte; T. B. Robertson and A. C. Jay, operators.

SOURCE: Miller, *Charlotte Directory*, 1921.

PIERSON, EARL L. (PIERSON STUDIO): from Philadelphia; active late 1930s, Mount Airy; hired photographers in N.C.

SOURCE: Photographic Examiners Records.

PIGGOTT, WILLIAM E. (b. ca. 1899): native of N.C.; active by 1930 as a traveling photographer in Jonesboro.

SOURCE: Fifteenth Census, 1930: Lee County, Pop. Sch., Jonesboro, E.D. 53-9.

PILLARS, _____: itinerant; active ca. 1888, Goldsboro, in partnership with a Mr. Robinson.

SOURCE: photograph bearing name "Pillars."

PITTMAN, STEPHEN P. (b. ca. 1872): native of N.C.; active by 1910, High Point.

SOURCE: Thirteenth Census, 1910: Guilford County, Pop. Sch., High Point, E.D. 116.

PLATEAU STUDIOS: active 1920–1940s, Biltmore Ave., Asheville; George Masa, operator (1920–1925); Edward Peppers, manager (mid-1920s); Ewart M. Ball, operator (1926–1937); Docia (Mrs. E. M.) Ball and Ewart M. Ball Jr., operators (late 1930s).

SOURCES: Miller, *Asheville, N.C. City Directory*, 1921–1927, 1931; *Miller's Asheville Directory*, 1928–1930, 1936–1941; Baldwin, *Asheville, N.C. City Directory, 1935*; information provided by staff of Pack Memorial Public Library, Asheville; information provided by Peggy Gardner, Asheville.

PLAYER, A. J.: active 1920, Rockingham.

SOURCE: State Auditor's Records, Sch. B.

PLUMBE, JOHN, JR. (1809–1857): native of Wales; civil engineer; active 1840–1848; one of the earliest

daguerreotypers and a pioneer in operation of branch studios (of "Plumbe National Daguerrian Gallery") in many cities throughout U.S. and in Paris and Liverpool; in Wilmington (1847–1848); located above Hart & Polley's store on Front St.

SOURCES: *Commercial* (Wilmington), Jan. 1, 1848; *Chronicle* (Wilmington), Jan. 5, 1848; *Craig's Daguerreian Registry,* 3:453–454; *www.getty.edu/art/collections/bio* (Web site of J. Paul Getty Museum, Los Angeles); information provided by Susan Block, Wilmington.

PLYLER, HOLLAND HOPE (1904–1972): active 1932–1940s; in Salisbury (1932–1935); operated Rembrandt Studio, Asheville (after World War II).

SOURCES: Photographic Examiners Records; *www.familysearch.org.*

POE, C. H.: Durham-based itinerant; active 1910s, Chatham County, Fairmont, and other places.

SOURCES: photographs bearing his name; Cotten list of N.C. photographers.

POOL, _____: active 1877–1878, Rocky Mount, in partnership with J. G. Garrett.

SOURCE: *Beveridge and Co.'s N.C. Directory, 1877–'78,* 363.

POPE, ALBERT B. (b. 1870): native of Ill.; active by 1899, Asheville.

SOURCE: Twelfth Census, 1900: Buncombe County, Pop. Sch., Asheville, E.D. 137.

POPE, C. E.: active 1900s–1910s; in Dunn (early 1900s); in Henderson (1907–1910s).

SOURCES: *N.C. Year Book,* 1907; photograph bearing his name.

POPE, J. M.: active 1892, Red Springs; later that year was engaged in grocery business.

SOURCE: *Red Springs Comet,* Mar. 9, 1892.

PORTER, C. L.: active 1934–1940s, Wadesboro.

SOURCE: Photographic Examiners Records.

PORTIS, J. W.: active early 1900s, Buies Creek; dealer in watches, clocks, jewelry, silverware, musical instruments, electrical, photographic and optical goods; on faculty at Buies Creek Academy.

SOURCES: *Little River Record* (Buies Creek), Feb., July 1903; information provided by James Vann Comer, Sanford.

PORTIS, SILAR: active mid-nineteenth century, Browntown (Davidson County).

SOURCE: Joyce, *Clark's Collection of Historical Remembrances,* 189–190.

POSEY, B. F.: active (obtained license to practice) 1910–1911, Durham.

SOURCE: Record of Special Licenses Issued, Durham County, 1910–1911 (A&H).

POTEAT, _____: active ca. 1920s, Durham, in partnership with a Mr. Green.

SOURCE: name printed on envelope containing negatives.

POTEAT, F. BEALOR: active 1908–1913, Bakersville.

SOURCES: Registry of Licenses to Trade, Mitchell County, 1877–1902 (A&H); *N.C. Year Book,* 1910–1913.

POTEET, _____: active 1921; operated Poteet Studio, Fayetteville.

SOURCE: State Auditor's Records, Sch. B.

POTEET, J. A.: active 1921, Cherryville.

SOURCE: State Auditor's Records, Sch. B.

POTTER, J. G.: active 1857–1858, Danville, Va.; ambrotype gallery advertised in Milton (Caswell County).

SOURCE: *Milton Chronicle,* Feb. 12, 1857.

POUNDERS, R. F.: active 1913, Asheville.

SOURCE: State Auditor's Records, Sch. B.

POWELL, A. F.: active 1930s, Rocky Mount, in association with his wife.

SOURCE: Photographic Examiners Records.

POWELL, F. PASCO: active 1928, Charlotte; proprietor of Photomaton Studio.

SOURCE: Miller, *Charlotte Directory,* 1928.

POWELL, J. TATE: active by 1905–1919; in Charlotte in partnership with Zachius E. Scott (by 1905–1906); with M. L. Philemon (1910); in partnership with Harry E. Franks (1911); sole proprietor of Powell's Studio (1907–1919).

SOURCES: *Walsh's Directory of the City of Charlotte,* 1904–1910; Miller, *Charlotte Directory,* 1911, 1918, 1920; *N.C. Year Book,* 1907, 1909–1916; State Auditor's Records, Sch. B.

POWELL, W. J.: active 1886, Oxford, in association with H. W. Pender as H. W. Pender & Company; gallery located above post office.

SOURCE: *Torchlight* (Oxford), Aug. 24, 1886.

POWERS, CHARLES G.: active 1920–1923 with Capitol Studio, Fayetteville St., Raleigh.

SOURCE: Hill, *Raleigh Directory,* 1920–1923.

POYTHRESS, CHARLES DAVID (1849–1892): native of Va.; active 1870s–1880s; in Manson (Warren County) (1870s); in Henderson (1880s), assisted by his teenage sons James Sneed and John Alexander and later employed as a merchant and salesman; died in Atlanta, Ga., where he was a salesman for the Singer Sewing Machine Company; copies of portraits of Poythress on file at N.C. Office of Archives and History.

Photographer Charles D. Poythress (*far left*) posed for this interesting family portrait about 1889. Others shown in the photograph are (*left to right*) sons Charles D. (1849–1892), Charles V. (1876–1906), James S. (1871–1918), and John A. (1874–1934) Poythress's wife Indiana Peru Twisdale Poythress (1852–1924); another son, Benjamin E. Poythress (1887–1971); and (*seated on floor*) daughter Effie Poythress (1881–1946). Photograph courtesy Barbara Poythress Wolfe, Newport Beach, Calif.

SOURCES: *Gold Leaf* (Henderson), Aug. 4, 1892; tombstone inscription, Elmwood Cemetery, Henderson; information provided by Barbara Poythress Wolfe, Newport Beach, Calif.

PRATHER, W. F. (b. ca. 1851): active by 1880, Reidsville.

SOURCE: Tenth Census, 1880: Rockingham County, Pop. Sch., Reidsville (North Williamsburg Township), E.D. 233.

PRESAPS, PHILLIP: active 1910–1916; in Durham (1910–1911); in Charlotte (1916).

SOURCES: Record of Special Licenses Issued, Durham County, 1910–1911 (A&H); State Auditor's Records, Sch. B.

PRESTON STUDIO: active 1936–1940s on Patton Ave., Asheville; Luesa M. Marker, operator, in association with Lyle C. Henderson.

SOURCE: *Miller's Asheville Directory*, 1936–1941.

PRICE, C. S.: active 1919, Shelby.

SOURCE: State Auditor's Records, Sch. B.

PRICE, C. Z.: active 1921, Murphy.

SOURCE: State Auditor's Records, Sch. B.

PRICE, CALVIN A. (ca. 1821–1872): native of N.C.; worked as farmer prior to pursuing photographic trade; active late 1850s–1872; itinerant, with Levi Crowl (late 1850s); in High Point (1860) with David L. Clark; occupied rooms at Barbee's Hotel; in Goldsboro (early 1860s, 1865–1868) in gallery located on W. Center St. (early 1860s) and in rear of Dr. Craton's office (1865–1868); on Hay Street, Fayetteville (1869–1872), in rooms formerly arranged by Esley Hunt; received premium award for his photographs at 1871 N.C. State Fair; C. McArtan purchased the gallery in 1872.

SOURCES: Cumberland County Marriage Bonds (A&H); Seventh Census, 1850: Cumberland County, Pop. Sch., Eastern Division; Ninth Census, 1870: Cumberland County, Pop. Sch., Cross Creek Township, Fayetteville; Eskind, *Index to American Photographic Collections*, 883; Witham, *Catalogue of Civil War*

Photographers, 60; Cumberland County Estates Records (A&H); Wayne County Wills (A&H); *Daily News* (Goldsboro), Dec. 2, 1865; *Branson & Farrar's NCBD*, 1866–1867; *North Carolina Presbyterian* (Fayetteville), Feb. 10, 1869, Jan. 31, 1872; *Eagle* (Fayetteville), Nov. 18, 1869, Dec. 21, 1871, Jan. 25, Feb. 1, 1872; *Fayetteville Advertiser and Gazette*, Dec. 25, 1871.

PRICE, CECIL W.: active 1916–1940s, Kinston; out of business in 1930s; resumed business by 1945 as Price Photo Supply Company.

SOURCE: Photographic Examiners Records.

PRICE, N. E.: active 1916, Spray (Rockingham County).

SOURCE: *N.C. Year Book*, 1916.

PRICE, THOMAS W. (b. ca. 1878): native of N.C.; active 1898–1920s; in Newberry, S.C. (1898); in Spray, N.C. (1916–1920s); operated Price Photo Studio and Price Art Gallery in Spray; known as "Picture Price."

SOURCES: Thirteenth Census, 1910: Rockingham County, Pop. Sch., Leaksville Township, E.D. 154; Fourteenth Census, 1920: Rockingham County, Pop. Sch., Leaksville Township, E.D. 205; Aheron, *From Avalon to Eden*, 8; Butler, *Our Proud Heritage*, 30; Teal, *Partners with the Sun*, 204; State Auditor's Records, Sch. B.

PRINCE, DAVID B. (b. ca. 1866): native of Pa.; active by 1910, Greensboro.

SOURCE: Thirteenth Census, 1910: Guilford County, Pop. Sch., Greensboro, E.D. 106.

PRINCE, O. D.: active 1886–1888 on W. Market St., Greensboro, near courthouse; in partnership with Robert Graham White (1888).

SOURCES: Cotten list of N.C. photographers; *Greensboro North State*, Sept. 1, 1887; *North Carolina Prohibitionist* (Greensboro), Oct. 19, 1888.

PRITCHARD, JOHN THOMAS EVANDER (1898–1983): active 1935–1940; operated Pritchard Studio on Route 2, Randleman, near Asheboro.

SOURCES: Photographic Examiners Records; *Miller's Asheboro City Directory*, 1937–1938; *www.familysearch.org*.

PUCKRIDGE, A. E.: active 1915–1919, Marion; in partnership with a Mr. Johnston (1915).

SOURCES: *N.C. Year Book*, 1915; State Auditor's Records, Sch. B.

PUTNAM, RICHARD POE (1910–1996): active 1932–1940s; with Scott Studios, Asheville (1932–1934); owner, Howard Studio (1945 and afterward).

SOURCES: Photographic Examiners Records; *www.familysearch.org*.

<hr>

Q

QUAKENBUSH, L. B. (b. ca. 1898): native of N.C.; active by 1930 at Flynt Studios, Greensboro.

SOURCE: Fifteenth Census, 1930: Guilford County, Pop. Sch., Greensboro, E.D. 41-27.

QUARLES, R. E.: probably African American; active early 1920s–ca. 1955; in Tuskegee, Ala. (ca. 1921); in Winston-Salem and Greensboro (1923) in partnership with Charles G. Rich; in Florence, S.C. (1926–ca. 1955); Fred Scott managed Quarles's studio in 1926.

SOURCES: *Hill Directory Co.'s Greensboro, N.C. City Directory, 1923*; *Winston-Salem Directory*, 1923; Teal, *Partners with the Sun*, 263; Robb list of Ala. photographers.

<hr>

R

RADER, OTTIS JOHNSON (1868–1935): native of N.C.; active ca. 1897–1935; in Chester, S.C. (ca. 1897–1898); in Charlotte (1902–1935); in association with wife, Sarah Rader, operated Rader Studio (1902–1913) and Rembrandt Studio (1913–1935). Rembrandt studio was first Charlotte business to have electric lights (1913).

SOURCES: Teal, *Partners with the Sun*, 186; *Fort Mill* (S.C.) *Times*, May 9, 1900; *Walsh's Directory of the City of Charlotte*, 1902–1910; Miller, *Charlotte Directory*, 1911–1930; *Hill's Charlotte Directory*, 1932–1941; *N.C. Year Book*, 1902–1907, 1910–1916; State Auditor's Records, Sch. B; *Mercantile Reference Book*, 1931; Fourteenth Census, 1920: Mecklenburg County, Pop. Sch., Charlotte, E.D. 150; Vital Records, death certificates, Book 1771, p. 391 (A&H); *Charlotte Observer*, Feb. 17, 1935; information provided by Shelia Bumgarner, Public Library of Charlotte and Mecklenburg County.

RADER, SARAH ("SALLIE") DEAL (Mrs. O. J. Rader) (1872–1948): native of N.C.; active ca. 1897–1944; in Chester, S.C. (ca. 1897–1898); in Charlotte (ca. 1902–1944); with husband, operated Rader Studio (1902–1913) and Rembrandt Studio (1913–1935); sold studio to Betty S. Brumfield, 1944; Sarah Rader may have been Charlotte's first female commercial photographer.

SOURCES: *Bradstreet's*, 1917, 1921, 1925; Fourteenth Census, 1920: Mecklenburg County, Pop. Sch., Charlotte, E.D. 150; Photographic Examiners Records; *Charlotte Observer*, Aug. 7, 1948; information provided by Shelia Bumgarner, Public Library of Charlotte and Mecklenburg County.

RALEIGH ART GALLERY: active ca. 1880s–1890s, Fayetteville St., Raleigh; J. A. Anderson, proprietor.

SOURCE: Murray list of Wake County photographers.

RAMSAUR, MELVINA THOMPSON (ca. 1818–1890): native of N.Y.; early female amateur maker of ambrotypes, active late 1850s, Lincoln County; portrait on file at N.C. Office of Archives and History (A&H).

SOURCES: Brown, *Our Enduring Past*, 140–141; Seventh Census, 1850: Lincoln County, Pop. Sch.; Ninth Census, 1870: Lincoln County, Pop. Sch., Liberty Township; Lincoln County Wills (A&H); *Lincoln Courier* (Lincolnton), May 23, 1890; information in Nontextual Materials Unit Photographic Files (A&H).

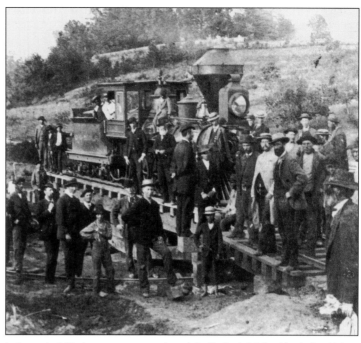

LEFT: Amateur maker of ambrotypes Melvina Thompson Ramsaur of Lincoln County had this daguerreotype portrait made by Charles J. Quinby either in New York City or Charleston in the 1850s. Photograph courtesy Greg Mast, Person County. **RIGHT:** Associates Luther A. Ramsour and a Mr. Hinson published this photograph in the form of a stereograph to document the occasion of the first railroad steam engine on the turntable of the Chester and Lenoir Railroad at Lenoir in Caldwell County in 1884. Photograph courtesy Aubrey Haddock, New Bern.

RAMSEY, ALBERT S. (b. ca. 1880): native of Va. or N.C.; active by 1910–1929 with Ramsey Studio, Salisbury.

SOURCES: Thirteenth Census, 1910: Rowan County, Pop. Sch., Salisbury, E.D. 109; Miller, *Salisbury Directory*, 1915–1929; State Auditor's Records, Sch. B; *Bradstreet's*, 1917, 1921; Fourteenth Census, 1920: Rowan County, Pop. Sch., Salisbury, E.D. 126.

RAMSEY, DANIEL H.: active 1922–1930s with Ramsey Studio, W. Main St., Durham; in association with daughter, Elizabeth O. Ramsey (1922–1933); in partnership with Jonathan S. Kah (1923).

SOURCES: Hill, *Durham, N.C. Directory, 1923*; *Bradstreet's*, 1925; *Mercantile Reference Book*, 1931.

RAMSEY, ELIZABETH O. (1900–1988): active 1922–1950s, Durham; in association with father, Daniel H. Ramsey (1922–1933); with King's Studio (1933–1940); with Baldwin's Studio (1940–1941 and postwar); with Anchor Stores, Winston-Salem (1941 and afterward).

SOURCES: Photographic Examiners Records; *www.familysearch.org.*

RAMSEY, H. B.: active 1916, Asheville; took views of Asheville flood of 1916.

SOURCES: State Auditor's Records, Sch. B; photographs bearing his name.

RAMSEY, J. H.: active 1907–1908 with Dixie Studio, Salisbury.

SOURCE: Miller, *Salisbury Directory*, 1907–1908.

RAMSEY, JOHN C. (1875–1947): active 1907–1908 with Dixie Studio, Salisbury.

SOURCES: Miller, *Salisbury Directory*, 1907–1908; Rowan County Cemetery Records (A&H).

RAMSOUR, LUTHER ADOLPHUS (1849–1917): native of N.C.; active 1870s–1910s; in Morganton (1870s–early 1900s); in partnership with a Mr. Hinson (ca. 1875) as publishers of stereographs; in Hickory (by 1910).

SOURCES: stereographs bearing his name; *N.C. Year Book*, 1904, 1905; Thirteenth Census, 1910: Catawba County, Pop. Sch., Hickory, E.D. 25; Vital Records, death certificates, Book 283, p. 180 (A&H).

RANDALL, GEORGE ANDERSON (b. 1892): active 1930s–1940s, Asheville; with Chambers Studio (1936–1937); sole proprietor of Randall Studio (1943 and afterward); in Arden (1940s).

SOURCES: Photographic Examiners Records; photograph made in Arden bearing his name.

RANDOLPH, J. F.: itinerant; active 1857, Kinston; occupied rooms on first floor of Dunn's new building (the *American Advocate* Building); offered flesh-tint raised ambrotypes.

SOURCE: *American Advocate* (Kinston), Apr. 16, 30, 1857.

RANKIN, ALEXANDER (b. ca. 1843): native of Tenn.; active by 1870, Lincolnton.

SOURCE: Ninth Census, 1870: Lincoln County, Pop. Sch., Lincolnton (Lincoln Township).

RAU, WILLIAM H. (d. 1925): active between 1874 and early 1900s; in Philadelphia (1874–early 1900s) as William H. Rau & Company; employed by N.C. Geological Survey.

SOURCES: Herbert H. Brimley Photograph Collection (A&H); Brey and Brey, *Philadelphia Photographers*; Ries and Ruby, *Directory of Pennsylvania Photographers*, 222; information provided by Sarah Robinson, Jacksonville, Fla.

RAULF(S), GEORGE W. (1888–1972): native of Va.; active by 1910–1911, Elizabeth City.

SOURCES: Thirteenth Census, 1910: Pasquotank County, Pop. Sch., Elizabeth City, E.D. 75; *N.C. Year Book*, 1910, 1911; *www.familysearch.org*.

RAY, C. H.: active 1921, Raleigh.

SOURCE: State Auditor's Records, Sch. B.

RAY, CHARLES (b. ca. 1888): native of Mass.; active by 1930 as itinerant, Wilmington.

SOURCE: Fifteenth Census, 1930: New Hanover County, Pop. Sch., Wilmington, E.D. 65-12.

RAY, CLARENCE F. (b. 1868): native of Tenn.; active 1899–1925, Asheville; operated Ray's Studio, Pack Square (later operated by Pearl and Gussie Stepp, 1927–1931).

SOURCES: Twelfth Census, 1900: Buncombe County, Pop. Sch., Asheville, E.D. 133; Maloney, *Asheville, N.C. City Directory*, 1900–1901; Hill, *Asheville, N.C. City Directory*, 1902–1905; Miller, *Asheville, N.C. City Directory* 1910–1931; *N.C. Year Book*, 1910–1916; State Auditor's Records, Sch. B; *Bradstreet's*, 1917, 1921, 1925.

RAY, J. M.: active 1919, Siler City.

SOURCE: State Auditor's Records, Sch. B.

RAY, S. C.: active early 1900s; in Scotland Neck (1903).

SOURCES: *Mercantile Agency Reference Book*, 1904; photograph bearing his name.

RAY, WILLIAM M. (b. ca. 1890): native of N.C.; African American; active 1916–1930, Charlotte.

SOURCES: State Auditor's Records, Sch. B; Miller, *Charlotte Directory*, 1925; Fifteenth Census, 1930: Mecklenburg County, Pop. Sch., Charlotte, E.D. 60-38.

READ, W. E.: active 1920, Rockingham.

SOURCE: State Auditor's Records, Sch. B.

READMAN, JOHN B. (1851–1903): native of N.Y.; active 1899–1903, Charlotte.

SOURCES: *Weeks' 1899 Charlotte City Directory*; *Maloney's 1899–1900 Charlotte Directory*; *Walsh's Directory of the City of Charlotte*, 1901–1903; Twelfth Census, 1900: Mecklenburg County, Pop. Sch., Charlotte, E.D. 45; *N.C. Year Book*, 1902, 1903; Mecklenburg County Estates Records (A&H); information provided by Shelia Bumgarner, Public Library of Charlotte and Mecklenburg County.

REDMON, JOSEPH H. (1895–1972): active 1919–1940s, Winston-Salem; with Barber Photo Supply Company (1919–1929); with Ideal Photo Company (1929–1935); with W. T. Eagle, jeweler (late 1930s); sole proprietor (1940s).

SOURCES: Photographic Examiners Records; *Mercantile Agency Reference Book*, 1943; *www.familysearch.org*.

REDMOND, E. D.: active 1920, Wilmington.

SOURCE: State Auditor's Records, Sch. B.

REED, H.: active (obtained license to practice) 1888–1889, New Hanover County.

SOURCE: Registry of Licenses to Trade, New Hanover County, 1881–1894, Vol. II (A&H).

REED, JAMES (b. ca. 1889): native of Fla.; active by 1910 as photographer's assistant, Concord.

SOURCE: Thirteenth Census, 1910: Cabarrus County, Pop. Sch., Concord, E.D. 48.

REES, CHARLES RICHARD: active 1871–early 1900s; in Petersburg, Va. (1871–1878); in partnership with George W. Minnis (1871); in Petersburg and Richmond (1880s); took photographs for State Museum of Natural History, Raleigh.

SOURCES: Ginsberg, *Photographers in Virginia*, 22; Herbert H. Brimley Photograph Collection (A&H); information provided by Sarah Robinson, Jacksonville, Fla.

REID, C. A.: active 1919–1920, Goldsboro.

SOURCE: State Auditor's Records, Sch. B.

REID, N. J. (1848–1919): active 1886–1916; itinerant in N.C. (1886–1887) in partnership with Andrew J. Farrell; in Dobson (1890s–1916); in Elkin (1890s).

SOURCES: State Auditor's Records, Ledgers, 1869–1899, Vol. 18, p. 236 (A&H); broadside advertisement, Oct. 18, 1890, North Carolina Collection, Wilson Library, UNC-CH; *N.C. Year Book*, 1911–1914, 1916; Kallam, *Kallam Cemetery Book 2, Surry County, North Carolina*, 42.

REINEHEART, BEN: active (obtained license to practice) 1911–1912, Durham.

SOURCE: Registry of Licenses to Trade, Durham County, 1881–1913 (A&H).

REMBRANDT STUDIO: active 1913–1935, Charlotte; Ottis J. Rader and Sarah D. Rader, operators.

SOURCES: *N.C. Year Book*, 1914–1916; Miller, *Charlotte Directory*, 1914–1930; *Hill's Charlotte Directory*, 1932–1935.

REMBRANDT STUDIO: active 1928–1929, Greensboro; J. P. Burt, proprietor.

SOURCE: *Hill's Greensboro Directory*, 1928–1929.

REMBRANDT STUDIO: active 1929, Reidsville; L. L. Turner, proprietor.

SOURCE: Miller, *Reidsville, N.C. City Directory*, 1929.

REMBRANDT STUDIO: active 1937–1941, North Wilkesboro; Edgar R. Rollins and Paul W. Harvel Jr., operators.
SOURCE: Photographic Examiners Records.

REMINGTON, ELLA (b. ca. 1868): native of N.C.; active 1910 with Ideal Photo Company, Winston, in association with Cleve Simpson.
SOURCES: Thirteenth Census, 1910: Forsyth County, Pop. Sch., Winston, E.D. 72; *Winston-Salem Directory*, 1910.

REW, T. C.: active ca. 1910, Concord.
SOURCE: photograph bearing his name.

REYNOLDS, C. M.: active 1919–1921, Winston-Salem.
SOURCE: State Auditor's Records, Sch. B.

REYNOLDS, P. G.: active 1919, Badin (Stanly County).
SOURCE: State Auditor's Records, Sch. B.

REYNOLDS, R. W.: active 1916, Queen (Montgomery County).
SOURCE: State Auditor's Records, Sch. B.

RHODES, GRACE PARHAM (1913–1986): native of Va.; active 1930–1970s in Durham; with Katie Johnson (1930); with Parnell Studio (1941 and afterward); after World War II in partnership with Mrs. Herman E. Duke as Duke-Rhodes Studio.
SOURCES: Photographic Examiners Records; *Durham Morning Herald*, Nov. 28, 1986; information provided by Dennis Daniels, N.C. Museum of History.

RHODES, HELEN RUTH (b. 1910): active 1937–1941, Winston-Salem, with Ben V. Matthews.
SOURCE: Photographic Examiners Records.

RHODES, J. M.: active 1902–1910s with Rhodes Studio, Rocky Mount.
SOURCE: *N.C. Year Book*, 1902–1906.

RHYNE, ERNEST (b. ca. 1892): native of N.C.; active as itinerant in Wadesboro (by 1910).
SOURCES: Thirteenth Census, 1910: Anson County, Pop. Sch., Wadesboro, E.D. 15.

RIBBLE, _____: active 1907, New London; took photograph of Whitney Dam under construction, Stanly County.
SOURCE: postcard bearing name "Ribble" in possession of Durwood Barbour, Raleigh.

RICE, EDWARD JOSEPH (b. 1909): active 1933–1935 with Silver's Store and Photo Shot Company, both in Durham.
SOURCE: Photographic Examiners Records.

RICE, WILLIAM M. (1849–1921): native of N.C.; active by 1889–1916, Beaufort; also employed as watchmaker.
SOURCES: Cotten list of N.C. photographers; Sprange, *Blue Book*, 289; Branson, *NCBD*, 1896, 1897; Twelfth Census, 1900: Carteret County, Pop. Sch., Beaufort, E.D. 25; *N.C. Year Book*, 1916; Vital Records, death certificates, Book 632, p. 243 (A&H).

RICH, CHARLES G.: probably African American; active 1923, Winston-Salem and Greensboro, in partnership with Robert E. Quarles.
SOURCES: *Winston-Salem Directory*, 1923; *Hill Directory Co.'s Greensboro, N.C. City Directory, 1923*.

RICH, ISAAC OAKES (1839–1920): native of N.C.; active by 1900–1910s, Blowing Rock.
SOURCES: Twelfth Census, 1900: Watauga County, Pop. Sch., Blowing Rock, E.D. 123; Vital Records, death certificates, Book 533, p. 65 (A&H).

RICH, J. J.: active (obtained license to practice) 1873–1874, Davidson County.
SOURCE: Registry of Licenses to Trade, Davidson County, 1871–1878 (A&H).

RICHARD, J. RAY: active late 1930s; operated Richard Photo Company, Burlington; reported to be operating without a photographer's license.
SOURCE: Photographic Examiners Records.

RICHARDS, PAUL: active ca. 1918, Camp Greene; operated Richards Film Service of Montgomery, Ala.; took photographs for *Montgomery Advertiser*; received permission to take photographs at the camp.
SOURCES: National Army Camps, Camp Greene, Charlotte, N.C., RG 393, Box 20, National Archives; information provided by Jane Johnson, Charlotte.

RICHARDSON, _____ (possibly James M.): active 1921 with Richardson Studio, Greensboro.
SOURCE: State Auditor's Records, Sch. B.

RICHARDSON, CARL WESLEY (b. ca. 1885): native of W. Va.; active mid-1920s–1939, Durham; with Parnell Studio (ca. mid-1920s); operated Richardson Photo Service.
SOURCES: photograph bearing Richardson's name in association with Parnell Studio (A&H); *Hill's Durham Directory*, 1929–1939; Fifteenth Census, 1930: Durham County, Pop. Sch., Durham, E.D. 32-4; *Mercantile Reference Book*, 1931.

RICHARDSON, JAMES MICHAEL (b. 1896): active 1923–1940s; in Albemarle (1923) in partnership with H. C. Miller as Miller-Richardson Studio; in Thomasville as sole proprietor of Richardson's Studio (1925–1940s); also in High Point (1933–1940s).
SOURCE: Photographic Examiners Records.

RICHARDSON, T. E.: active 1919, Saxapahaw (Alamance County).

SOURCE: State Auditor's Records, Sch. B.

RICHARDSON, TEALIE: active 1919, Arcola (Warren County).

SOURCE: State Auditor's Records, Sch. B.

RICHMOND, SHEPARD (b. 1882): African American; active 1927–1942; operated Richmond's Studio, Greensboro.

SOURCES: Photographic Examiners Records; *Hill's Greensboro Directory*, 1929–1941.

RICHMOND (ART) GALLERY: active ca. 1880s–1890s, Richmond, Va.; I. D. Boyce, proprietor; gallery in Winston (ca. 1890).

SOURCES: photograph of First Presbyterian Church, Winston, bearing gallery name; information from files of MESDA; Ginsberg, *Photographers in Virginia*, 41.

RICKERT(S), S. J.: itinerant; active 1865, operated S. J. Rickert's Picture Gallery, Statesville.

SOURCE: *American* (Statesville), Nov. 14, 1865.

RICKS, THOMAS J. (1875–1935): native of N.C.; active 1919–1921; in Louisburg (1919); in Wood (Franklin County) (1921); small collection of his photographs on file at N.C. Office of Archives and History.

SOURCES: State Auditor's Records, Sch. B; Vital Records, death certificates, Book 1841, p. 51 (A&H).

RIDDLE, S. C.: active 1896–1930s, Burnsville.

SOURCES: Branson, *NCBD*, 1896, 1897; *N.C. Year Book*, 1904–1907; Photographic Examiners Records.

RIDGE, COLN. (COLIN?): active 1916, Asheboro.

SOURCE: *N.C. Year Book*, 1916.

RIGGAN, ALTON WILLIAM (b. 1911): active 1940–1947 with Daniel & Smith Studio, Raleigh; left the state by 1948.

SOURCE: Photographic Examiners Records.

RIGGAN, D. H.: active early 1900s, Warrenton; publisher of postcard views.

SOURCE: postcard bearing Riggan's name in possession of Phil Perkinson, Norlina.

RIGGSBEE, WILLIAM HENRY (1853–1932): native of N.C.; active early 1880s–ca. 1910; itinerant during early portion of career; in Chester, S.C. (1881), where he exhibited his photographs in competition at Chester Fair; in Burlington (ca. 1880s); in Raleigh (ca. 1890–1892); Cyrus P. Wharton purchased the gallery in the latter year; Riggsbee again in Raleigh (ca. 1904–1910); operated Riggsbee's Gallery, Fayetteville St., Raleigh; proprietor of Watson's Photograph Gallery (1904–1906), owned by Fred A. Watson; in Wake Forest (early

W. H. RIGGSBEE, Photographer.

Shown here is a sample of the portraiture of William H. Riggsbee made about 1890. Riggsbee was an itinerant and sometime resident photographer in Burlington, Raleigh, Wake Forest, and Chapel Hill. Courtesy of the compiler.

1890s); in Chapel Hill as itinerant (1890s–1900); in Graham (1900) in tent opposite Simmons's drugstore.

SOURCES: *Daily State Chronicle* (Raleigh), Mar. 20, 1890, Apr. 2, 1892; *Chatham Record* (Pittsboro), Nov. 26, 1891; Twelfth Census, 1900: Orange County, Pop. Sch., Chapel Hill, E.D. 67; *Graham Tribune*, Aug. 31, 1900; *N.C. Year Book*, 1905; Hill, *Raleigh Directory*, 1907–1908; Thirteenth Census, 1910: Wake County, Pop. Sch., Raleigh, E.D. 119; *News and Observer* (Raleigh), Jan. 8, 1932; Teal, *Partners with the Sun*, 186.

RILEY, ADELBERT E. (b. ca. 1867): native of Wis.; active 1902–1903 on Patton Ave., Asheville, in partnership with J. Howell Lewis.

SOURCES: Hill, *Asheville, N.C. City Directory, 1902–'03*; *www.familysearch.org*.

RING, M. B.: photographed construction of Blue Ridge Parkway in late 1930s.

SOURCE: Blue Ridge Parkway Photograph Collection (A&H).

RINGGOLD, JOHN: active 1919–1920, Greenville.

SOURCE: State Auditor's Records, Sch. B.

RIVENBARK, EUGENE D. (b. ca. 1883): native of N.C.; active 1920, Wilmington; employed as railroad car repairer (1920).

SOURCES: Fourteenth Census, 1920: New Hanover County, Pop. Sch., Wilmington, E.D. 111; State Auditor's Records, Sch. B.

RIVENBARK, WALTER MURPHY (1873–1950); native of N.C.; active by 1900–1910s; in Burgaw (by 1900–1910s); in Mount Olive (1905–1906).

SOURCES: Twelfth Census, 1900: Pender County, Pop. Sch., Burgaw, E.D. 121; *N.C. Year Book*, 1905, 1906; photographs bearing his name; *www.familysearch.org*.

ROBBINS, JESSE BATTLE (1862–1937): native of N.C.; active 1913–1919; in Mooresville, assisted by wife.

SOURCES: *N.C. Year Book*, 1913–1916; State Auditor's Records, Sch. B; Vital Records, death certificates, Book 1943, p. 230 (A&H).

ROBBINS, MRS. JESSE B.: active prior to 1933, Mooresville; assisted husband; went into grocery business, 1933.

SOURCE: Photographic Examiners Records.

ROBBINS, JOHN T. (b. ca. 1889): native of N.C.; active by 1910, Rocky Mount.

SOURCE: Thirteenth Census, 1910: Edgecombe County, Pop. Sch., Rocky Mount, E.D. 26.

ROBBINS, SUE S. (1866–1944): native of N.C.; active by 1900, Lexington; sister of Tetlulah Robbins.

SOURCES: Twelfth Census, 1900: Davidson County, Pop. Sch., Lexington, E.D. 34; Swicegood and Hinson, *Cemetery Records of Davidson County, NC*, 5:70.

ROBBINS, TETLULAH (b. 1872): native of N.C.; active by 1900, Lexington; sister of Sue S. Robbins.

SOURCE: Twelfth Census, 1900: Davidson County, Pop. Sch., Lexington, E.D. 34.

ROBERSON, KYLE O. (b. ca. 1889): native of N.C.; active by 1910, Leaksville.

SOURCE: Thirteenth Census, 1910: Rockingham County, Pop. Sch., Leaksville, E.D. 153.

ROBERSON (ROBERTSON), W. P.: active 1904–1906, Haw River.

SOURCE: *N.C. Year Book*, 1904–1906.

ROBERTS, _____ (perhaps William O. Roberts): active mid-1880s, Asheville, in partnership with a Mr. Meriwether.

SOURCE: photograph bearing name "Roberts."

ROBERTS, ALONZO L.: African American; active 1921–1925, Rocky Mount.

SOURCES: State Auditor's Records, Sch. B; *Hill's Rocky Mount Directory*, 1925.

ROBERTS, BISHOP H. (b. ca. 1862): native of N.C.; active 1916–1919, Cherryville.

SOURCES: *N.C. Year Book*, 1916; State Auditor's Records, Sch. B; Fourteenth Census, 1920: Gaston County, Pop. Sch., Cherryville, E.D. 74.

ROBERTS, DONALD B. (b. ca. 1898): native of Mo.; active by 1920, Wilmington; associated with John Spillman.

SOURCE: Fourteenth Census, 1920: New Hanover County, Pop. Sch., Wilmington, E.D. 100.

ROBERTS, H. L.: active 1890s, Asheville and western N.C.; operated H. L. Roberts & Company of Philadelphia; also in partnership with a Mr. Fellows of Philadelphia as Roberts & Fellows; publisher of stereographs.

SOURCE: stereograph bearing his name.

ROBERTS, LEVI (b. ca. 1864): native of Ind.; active by 1910, Mount Airy.

SOURCE: Thirteenth Census, 1910: Surry County, Pop. Sch., Mount Airy Township, E.D. 136.

ROBERTS, WILLAM ALF (1872–1943): native of N.Y.; active ca. 1903–1940s; in St. Louis, Mo. (ca. 1903–1915); in Greensboro (1916–1940s); operated W. A. Roberts Film Company, Greensboro (ca. 1917–1940s).

SOURCES: Photographic Examiners Records; State Auditor's Records, Sch. B; *Hill's Greensboro Directory*, 1920–1923, 1928–1929, 1938–1941; Fourteenth Census, 1920: Guilford County, Pop. Sch., Greensboro, E.D. 143; N.C. Supreme Court Records, Case No. 37F-683; 38S-674; Vital Records, death certificates, Book 2441, p. 297 (A&H); *Greensboro Daily News*, Aug. 4, 1943.

ROBERTS, WILLIAM O. (b. 1862): native of N.C.; active 1899–1900 in Jackson County (1899–1900) and Marshall (1900).

SOURCES: Registry of Licenses to Trade, Jackson County, 1874–1903 (A&H); Twelfth Census, 1900: Madison County, Pop. Sch., Marshall, E.D. 72.

ROBERTS, ZACK L. (1894–1974): active 1938–1940s, Concord; staff photographer for Concord *Tribune* (1938–1945); commercial photographer after World War II.

SOURCES: Photographic Examiners Records; *www.familysearch.org*.

ROBERTSON, T. B.: active 1921 on W. Trade St., Charlotte, in partnership with A. C. Jay as Piedmont Studio.

SOURCE: Miller, *Charlotte Directory*, 1921.

ROBERTSON, WILLIAM THOMAS (1845–1895): native of Ohio but grew up in Tenn.; private, Tenn. Light Artillery, 1862–1865; active 1860s–1885, Asheville (1872–1885); occupied gallery above Ray & Millard's store (1872); produced stereographs of western N.C.; business known as Photographic Gallery and Stereoscopic View Emporium; purchased photographic

LEFT: Stereographic artist William T. Robertson climbed to the top of the Buncombe County Courthouse tower to execute this bird's-eye view of Asheville about 1880. He aimed his camera in a southwesterly direction to photograph, from left to right, Van Gilder & Brown's hardware store, the former Bank Hotel, probably Ballard & Van Gilder's stove and tinware business, and the *Citizen* Building. **RIGHT:** Robertson made this photograph of an unidentified militia unit standing in formation in front of the Swannanoa Hotel on South Main Street in Asheville during the summer of 1881. Both images courtesy of the compiler.

negatives from Rufus Morgan in 1876 when Morgan gave up his western N.C. business; also active in Spartanburg, S.C.; by 1883 in association with N. S. Jennison; returned to Tenn. in 1885 and served as editor of the *Holston Review* in Rogersville.

SOURCES: *Weekly Pioneer* (Asheville), June 6, 1872, Aug. 22, 1874; *West-Carolina Record* (Rutherfordton), May 17, 1873; *North Carolina Citizen* (Asheville), Aug. 3, 1874; Buncombe County Deeds, Book 38, pp. 72–73 (A&H); *Zell's U.S. Business Directory*, 1875; *Beveridge and Co.'s N.C. Directory, 1877–'78*, 18; *Chataigne's N.C. Directory and Gazetteer, 1883–'84*; Branson, *NCBD*, 1884; Tenth Census, 1880; Buncombe County, Pop. Sch., Asheville, E.D. 34; *Independent Herald* (Hendersonville), July 22, 1881; *Asheville Daily Advocate*, July 7, 1885; Teal, *Partners with the Sun*, 207; *Herald* (Rogersville, Tenn.), Feb. 27, 1895; Ward, *The Heritage of Old Buncombe County, North Carolina*, 1:318; information provided by Tim Cole, Greensboro; information provided by Peggy Cook, Rogersville, Tenn.; Darrah, *World of Stereographs*, 208.

ROBINSON, _____: itinerant; active ca. 1888, Goldsboro, in partnership with a Mr. Pillars.

SOURCE: photograph bearing name "Robinson."

ROBINSON, BETHEL (1909–1978): native of Va.; active by 1930, Sylva; wife of Eston Robinson; died at Canton.

SOURCES: Fifteenth Census, 1930: Jackson County, Pop. Sch., Sylva, E.D. 50-17; *www.familysearch.org*.

ROBINSON, CHARLES J.: active 1919, Asheville.

SOURCE: State Auditor's Records, Sch. B.

ROBINSON, CLIFFORD W. (b. ca. 1905): native of Ga.; active 1929–1940s; with Long's Studio, Asheville (mid-1930s); with Manning Studio, Greensboro (1939).

SOURCES: *Miller's Asheville Directory*, 1929–1930, 1937–1938, 1940; Fifteenth Census, 1930: Buncombe County, Pop. Sch., Asheville, E.D. 11-29; *Mercantile Reference Book*, 1931; Photographic Examiners Records.

ROBINSON, ESTON (1905–1966): native of N.C.; active by 1930, Sylva; husband of Bethel Robinson.

SOURCES: Fifteenth Census, 1930: Jackson County, Pop. Sch., Sylva, E.D. 50-17; *www.familysearch.org*.

ROBINSON, JESSE S. (b. ca. 1862): native of N.C.; active 1921–1930; in Charlotte (1921–1922); in Mooresville (by 1930).

SOURCES: State Auditor's Records, Sch. B; Fifteenth Census, 1930: Iredell County, Pop. Sch., Mooresville, E.D. 49-6.

ROBINSON, JOHN GRAHAM (1878–1923): active 1913–1923, Asheville; operated Robinson Kodak Store, one of the largest supply houses for commercial photographers in N.C.

SOURCES: Miller, *Asheville, N.C. City Directory, 1916*; State Auditor's Records, Sch. B; Photographic Examiners Records; information provided by staff of Pack Memorial Public Library, Asheville.

ROBINSON, T. D.: active 1919, Winston-Salem.

SOURCE: State Auditor's Records, Sch. B.

ROCHELLE, CHARLES W. (1854–1913): native of N.C.; active by 1880–1913; on Main St., Durham (by 1880–late 1890s); in Rock Hill, S.C. (1898–1900); in Reidsville (1902–1904); operated Rochelle's Studio, High Point (1904–1913); studio operated by son, Eugene S. Rochelle, after death of father.

SOURCES: Tenth Census, 1880: Orange County, Pop. Sch., North Durham Township; *Durham Tobacco Plant*, Apr. 20, 1880; *Chataigne's N.C. Directory and Gazetteer, 1883–'84*; Branson, *Directory of the Business and Citizens of Durham City for 1887*, 182; Branson, *NCBD*, 1896, 1897; *N.C. Year Book*, 1902–1904, 1910–1916; *Bradstreet's*, 1908; Miller, *High Point Directory* 1908, 1913; *Review* (High Point), Jan. 9, 1913; Thirteenth Census, 1910: Guilford County, Pop. Sch., High Point, E.D. 116; Vital Records, death certificates, Book D-54, p. 289 (A&H); Paul,

History of the Town of Durham, 240; Sprange, *Blue Book*, 289; Teal, *Partners with the Sun*, 207.

ROCHELLE, EUGENE S. (b. ca. 1882): native of N.C.; active by 1910–1926; in Asheboro (by 1910); with Rochelle's Studio, High Point (ca. 1913–1926); son of Charles W. Rochelle.

SOURCES: Thirteenth Census, 1910: Randolph County, Pop. Sch., Asheboro, E.D. 76; *Bradstreet's*, 1917, 1921, 1925; Miller, *High Point Directory*, 1919–1926; State Auditor's Records, Sch. B; Fourteenth Census, 1920: Guilford County, Pop. Sch., High Point, E.D. 157.

ROCKWELL, J. R.: active 1854–1870, in Petersburg, Va. (1854–1865); associated with D. T. Cowell (1865); in Hillsborough (1870) in partnership with Julian Vannerson of Richmond, Va.; occupied rooms in Masonic Hall; operated permanent gallery in Petersburg, Va.

SOURCES: Ginsberg, *Photographers in Virginia*, 23; *Hillsborough Recorder*, Nov. 6, 1870; *Craig's Daguerreian Registry*, 3:581.

RODDY, ELVIN (1890–1963): native of S.C.; active 1926–1940s; with Carolina Studios, Four Oaks (Johnston County) (1926–1930s); in Fayetteville (1930s); in Charlotte (1940–1941) as school photographer.

Photographer John G. Robinson of Asheville published this real-photo postcard of a gristmill on Reams Creek, near Weaverville, about 1920. Postcard courtesy Durwood Barbour, Raleigh.

SOURCES: *Four Oaks News*, June 13, 1979; *Hill's Charlotte Directory*, 1940–1941; information provided by Durwood Barbour, Raleigh; *www.familysearch.org*.

ROGERS, H. TAYLOR (1862–1949): active ca. 1895–1928, Asheville; also operated bookstore; sold bookstore in 1928 and moved to Philadelphia.

SOURCES: photograph bearing his name; information provided by staff of Pack Memorial Public Library, Asheville; *Asheville Citizen*, Dec. 14, 1949.

ROGERS, J. J.: active 1890, Durham; took photographs of execution of James P. Davis, alias William S. Shakleford, at Pittsboro.

SOURCE: *Chatham Record* (Pittsboro), Apr. 3, 1890.

ROGERS, RICHARD PEARSON (b. ca. 1896): native of N.C.; African American; active 1922–1930, Asheville; operated Rogers' Photo Company; also the proprietor of a watch shop and a jeweler (1930).

SOURCES: Miller, *Asheville, N.C. City Directory, 1922*; *Miller's Asheville Directory*, 1928; Fifteenth Census, 1930: Buncombe County, Pop. Sch., Asheville, E.D. 1; *Mercantile Reference Book*, 1931; information provided by staff of Pack Memorial Public Library, Asheville.

ROGERS, S. C.: active 1919–1920, W. Trade St., Charlotte, in association with Z. V. Rogers as Rogers' Studio.

SOURCES: State Auditor's Records, Sch. B; Miller, *Charlotte Directory*, 1920.

ROGERS, SAM S. (b. ca. 1869): native of N.C.; active 1919–1920 with Rogers' Studio, Charlotte.

SOURCES: Fourteenth Census, 1920: Mecklenburg County, Pop. Sch., Charlotte, E.D. 143. (Note: This man may be the one listed as S. C. Rogers above.)

ROGERS, WILLIAM H. (b. ca. 1870): native of N.C.; active by 1910, Mount Airy.

SOURCE: Thirteenth Census, 1910: Surry County, Pop. Sch., Mount Airy, E.D. 137.

ROGERS, Z. V.: active 1919–1920, W. Trade St., Charlotte, in association with S. C. Rogers as Rogers' Studio.

SOURCES: State Auditor's Records, Sch. B; Miller, *Charlotte Directory*, 1920.

ROLLINS, EDGAR RUSSELL (1895–1975): active ca. 1937–1941 with Rembrandt Studio, North Wilkesboro, in partnership with Paul W. Harvel Jr.

SOURCES: Photographic Examiners Records; *www.familysearch.org*.

ROSE, JOHN R. (b. ca. 1820): native of England; active 1858–1860; in Murfreesboro, 1858, 1860; paid tax to practice in Northampton County in partnership with a Mr. Foster (1859).

SOURCES: Northampton County Tax Records, 1858–1879, Folder 1858–1859 (A&H); Eighth Census, 1860: Hertford County, Pop. Sch., Town of Murfreesboro; information provided by Jerry R. Roughton, Kenansville.

ROSE, WILLIAM B. (ca. 1838–1923): active 1860s; may have worked in Paris, Ky., during Civil War; in Waukegan, Ill., as operator of Rose's Photographic Gallery (1864–1865, 1869); may have been associated with O. J. Smith in New Bern; took photograph of CSS *Albemarle* after it was raised from Roanoke River near Plymouth in early 1865; member of Eighth Conn. Regiment during the war.

SOURCES: Witham, *Catalogue of Civil War Photographers*, 27; photograph of *Albemarle*, Smithsonian Institution, U.S. Naval Imaging Command, Washington, D.C., item No. NH58773; McCaslin, *Portraits of Conflict*, 23; Czach, *A Directory of Early Illinois Photographers*, n.p.

ROSEBOROUGH, EDWARD P. (b. ca. 1859): native of S.C.; active by 1880, Charlotte; stepson of James H. Van Ness.

SOURCE: Tenth Census, 1880: Mecklenburg County, Pop. Sch., Charlotte, Ward 4, E.D. 108.

ROSENTHAL, H.: active (obtained license to practice) 1911, Durham; held one-day snake show, Oct. 21, 1911.

SOURCE: Registry of Licenses to Trade, Durham County, 1881–1913 (A&H).

ROSS, CHARLES A.: active 1891–1904; employed by N.C. Geological Survey.

SOURCES: Herbert H. Brimley Photograph Collection (A&H); information provided by Sarah Robinson, Jacksonville, Fla.

ROSS, CHARLES W. (b. ca. 1893): native of Pa.; active 1930–1931, Belmont Ave., Charlotte.

SOURCES: Fifteenth Census, 1930: Mecklenburg County, Pop. Sch., Charlotte, E.D. 60-18; Miller, *Charlotte Directory*, 1930.

ROSS, JOHN MONTGOMERY (b. 1912): active 1934–1940s; Albemarle; associated with E. W. Seagle (1934–1936); associated with Mrs. O. Matlock (1937–1938); sole proprietor of Ross Studio (1938 and afterward).

SOURCE: Photographic Examiners Records.

ROTHSTEIN, ARTHUR (1915–1985): active 1935–1940 in N.C. with U.S. Resettlement Administration and U.S. Farm Security Administration; worked in Creedmoor, Durham, Fuquay Springs, and Smithfield, as well as Johnston, Pender, and Wayne Counties.

SOURCES: Cotten, *Light and Air*, 57; Dixon, *Photographers of the Farm Security Administration*, 119; "Reference Guide to FSA/OWI Photographs."

ROYAL, DEROY WALDEN (1885–1972): active 1910–1939; in Fayetteville with John Daniel Keen (1910–1911); as itinerant (1910–1914); as sole proprietor of Royal Studio, Hay St. (1914–1939).

SOURCES: Photographic Examiners Records; *Hill's Fayetteville Directory*, 1937–1939; *www.familysearch.org*.

ROYSTER, ZEB VANCE (b. ca. 1894): native of N.C.; African American; active 1916–1922; in Oxford (1916); in Littleton (1919–1921); employed as jeweler there, 1920; in Henderson (1922).

SOURCES: State Auditor's Records, Sch. B; Fourteenth Census, 1920: Warren County, Pop. Sch., Littleton, E.D. 92.

RUDOLPH REUBEN STUDIOS: African American establishment; active 1940 and afterward, Fayetteville Rd., Durham; Charles R. Stanback, operator.

SOURCE: Hill, *Durham, N.C. Directory, 1940.*

RUFFIN, WILLIAM: active 1912–1921; in Tarboro in partnership with a Mr. Liles (1912); in Gates County, working out of Tarboro (1921).

SOURCES: information provided by Jerry R. Roughton, Kenansville; State Auditor's Records, Sch. B.

RUNDLE, FREDERICK J. (b. ca. 1869): native of Mich.; active 1920s and 1930s; in Hendersonville (1926–1927); in Lenoir (1930–1931).

SOURCES: Miller, *Hendersonville, N.C. City Directory, 1926–1927;* Fifteenth Census, 1930: Caldwell County, Pop. Sch., Lenoir, E.D. 14-8; Miller, *Lenoir, N.C. City Directory, 1930–1931;* Photographic Examiners Records.

RUSSELL, B. McD.: active 1894, Dock St., Wilmington; also employed as printer and binder.

SOURCE: Reaves list of Wilmington photographers.

RUSSELL, J. S.: itinerant; active 1874, Rutherfordton; gallery located at Burnett's Hotel.

SOURCE: *Rutherford Star and West-Carolina Record* (Rutherfordton), June 13, 1874.

RUSSELL, JOHN HOWARD (1910–1977): active ca. 1937–1940, Dunn; charged with practicing without a photographer's license.

SOURCES: Photographic Examiners Records; *www.familysearch.org.*

RUSSELL, M. A.: active 1930s, Highlands.

SOURCE: Photographic Examiners Records.

RUSSELL, ROBERT HENRY GIBBS (1877–1941): native of England; active 1939–1940, Winston-Salem.

SOURCES: Photographic Examiners Records; Vital Records, death certificates, Book 2259, p. 26 (A&H).

RUSSELL, WELLINGTON S. (ca. 1836–1871): active by 1860, Hyde County; private, Company B, Seventeenth Regiment, N.C. State Troops; listed as medical student in 1861.

SOURCES: Eighth Census, 1860: Hyde County, Pop. Sch., Middleton Post Office; Hyde County Estates Records (A&H); Manarin and Jordan, *N.C. Troops,* 6:131.

RUSSELL, WILLIAM G. (b. ca. 1880): native of N.J.; active ca. 1902–1920s; operated studios in Philadelphia and Atlantic City (early 1900s); may have worked in Del., ca. 1909; in Winston-Salem (1916–1920s); gallery located on N. Liberty St. above Elmont Theatre; in partnership with W. W. Stroud (1916); in partnership with Horace D. Moses (1918–1920); sole proprietor of Russell's Studio (1921–1923).

SOURCES: *Winston-Salem Directory,* 1918, 1920–1923; State Auditor's Records, Sch. B; Fourteenth Census, 1920: Forsyth County, Pop. Sch., Winston-Salem, E.D. 101; Weaver, *Winston-Salem, North Carolina, City of Industry,* 13; information from the files of MESDA.

RYAN, CHARLES F.: active 1904–1905, Patton Ave., Asheville.

SOURCE: Hill, *Asheville, N.C. City Directory, 1904–'05.*

RYNE, W. S.: active 1919, Gastonia.

SOURCE: State Auditor's Records, Sch. B.

S

SACKETT, _____: of Sackett & Wilhelms Corp. of Brooklyn, N.Y.; active ca. 1918, Camp Greene; received permission to take photographs at the camp.

SOURCES: National Army Camps, Camp Greene, Charlotte, N.C., RG 393, Box 20, National Archives; information provided by Jane Johnson, Charlotte.

SAFFRIT, JAMES: active 1916, China Grove (Rowan County).

SOURCE: *N.C. Year Book,* 1916.

SAMBERGH, ARTHUR ARNOLD (1900–1985): active 1930s; itinerant in N.C. (1930–1933); in Asheboro (1933–1935) with R. S. Florian (branches in Burlington, Greensboro, Winston-Salem); purchased business of Edward R. Belton in 1935.

SOURCES: Photographic Examiners Records; *www.familysearch.org.*

SAMPSON, R. A.: itinerant daguerreotyper; active 1853–1856; in Elizabeth City (1853); occupied rooms at home of Thomas D. Knox on Main St.; in Tarboro (1854); occupied rooms in building opposite Hussey's shoe store; in Kinston (1856); occupied rooms above L. Nethercut's store; offered daguerreotypes for one dollar each (including case); also sold miniatures inserted into lockets and pins.

SOURCES: *Old North State* (Elizabeth City), Apr. 16, 1853; *Southerner* (Tarborough), Jan. 7, 1854; *American Advocate* (Kinston), Feb. 28, 1856.

SAMS, SARAH E. (b. ca. 1899): native of Ga.; active by 1930, Salisbury.

SOURCE: Fifteenth Census, 1930: Rowan County, Pop. Sch., Salisbury, E.D. 80-34.

SANCHEZ, VENANCIO DUMAS (b. 1907): active ca. 1933–1940s, Charlotte; operated Duke Photo Company (1940–1941).

SOURCES: Photographic Examiners Records; *Hill's Charlotte Directory,* 1940–1941.

SANDERLIN, CALEB SANDERSON (1824–1886): native of N.C.; daguerreotyper; active 1847–1849, Elizabeth City; advertised sale of half-size German camera in 1849.

SOURCES: *Old North State* (Elizabeth City), June 16, 1849; *www.familysearch.org.*

SANDERLIN, SAM: active 1916, Greensboro.

SOURCE: State Auditor's Records, Sch. B.

SANDERSON, LOUIS HILL: active early twentieth century, Duplin County; photographer and surveyor.

SOURCE: information provided by Jean Sanderson, Duplin County.

SANDFORD, JAMES M.: active 1869, Laurel Hill.

SOURCE: Branson, *NCBD,* 1869.

SANDFORD, JONATHAN: active 1867–1869; in Springfield (Scotland County) (1867–1868); in Laurel Hill (1869).

SOURCE: Branson, *NCBD,* 1867–1868, 1869.

SANDHILLS PHOTO SHOP: active 1937–1940s, Southern Pines; Mr. and Mrs. Herman L. Epps, proprietors.

SOURCE: Photographic Examiners Records.

SANFORD, JAMES H. (1850–1917): native of N.C.; active ca. 1895–1915, Laurinburg.

SOURCES: Sprange, *Blue Book,* 289; *N.C. Year Book,* 1910–1915; Vital Records, death certificates, Book 220, p. 249 (A&H).

SANFORD ART STUDIO: active 1919, Sanford.

SOURCE: State Auditor's Records, Sch. B.

SASSCER, CHARLES JOSEPH (b. 1897): native of Md.; active 1919–1938; in Richmond and Norfolk, Va. (1919–1926); in Durham with Johnson Studio (1926–1935); sole proprietor (late 1930s); husband of Ruth G. Sasscer.

SOURCES: Fifteenth Census, 1930: Durham County, Pop. Sch., Durham, E.D. 32-13; Photographic Examiners Records; *Mercantile Reference Book,* 1931.

SASSCER, RUTH G. (Mrs. Charles J. Sasscer) (b. ca. 1894): native of Va.; active 1936–1938, Durham; in partnership with Katie L. Johnson as Johnson-Sasscer Studio, W. Main St.

SOURCES: Fifteenth Census, 1930: Durham County, Pop. Sch., Durham, E.D. 32-13; *Hill's Durham Directory,* 1936–1938.

SATTERTHWAITE, FENNER BRYAN (1854–1914): native of N.C.; active 1880–1895, Washington; in partnership with J. P. Phillips, jeweler (1880), in gallery above J. C. Buchanan's store on Main St.; sole proprietor (1883–1895).

SOURCES: *North State Press* (Washington), Mar. 2, July 6, 1880, July 20, 1881; Tenth Census, 1880: Beaufort County, Pop. Sch., Washington, E.D. 8; *Chataigne's N.C. Directory and Gazetteer, 1883–'84;* Cotten list of N.C. photographers; *Washington Gazette,* Sept. 26, 1889; Sprange, *Blue Book,* 289; *Washington Progress,* Aug. 27, 1914.

SAVAGE, ADRIAN: native of N.C.; active early 1900s, Greenville; also worked as horse and mule dealer.

SOURCE: information provided by Roger Kammerer, Greenville.

SAWIN, L. F.: active ca. 1918, Camp Greene; captain, Eighth Mass. Infantry; received permission to take photographs at the camp.

SOURCES: National Army Camps, Camp Greene, Charlotte, N.C., RG 393, Box 20, National Archives; information provided by Jane Johnson, Charlotte.

SAWTELL, E. E.: active 1916–1920, Southern Pines.

SOURCE: State Auditor's Records, Sch. B.

SCADIN, R. HENRY (1861–1923): native of Mich.; active ca. 1890s–1923; in Fla. (1890s); photographed St. John's River area as amateur (1893); in Ann Arbor and Dexter, Mich. (mid-1890s); spent portions of years in Sapphire, N.C., in mid-1890s before moving there in late 1890s; documented construction of three lakes—Fairfield, Sapphire, and Toxaway; took many scenic views near Brevard, Dana, Hendersonville, Highlands, and Sapphire in early twentieth century; employed by N.C. Geological Survey (1890s); operated as Scadin & Company, publisher of stereographs; took photographs of western N.C. scenes and waterfalls (Horsepasture and Whitewater) with nationally renowned photographer William Henry Jackson, June 3–6, 1902; also engaged in horticulture in western N.C.; his farm and orchard were harmed by great flood of July 1916; subsequently moved to Vt. but soon returned to N.C. and worked briefly as a photo developer at Baker's Art Gallery in Hendersonville (1919); returned in 1920 to Vt., where he lived for the remainder of his life; photograph collection housed in Southern Highlands Research Collection, D. Hiden Ramsey Library, UNC-Asheville.

SOURCES: *N.C. Year Book,* 1916; State Auditor's Records, Sch. B; postcards bearing his name; R. Henry Scadin Collection, UNC-Asheville; *http://toto.lib.unca.edu/exhibits/blowers/scadin_exhibit.html* (Web site for exhibit on Scadin, Ramsey Library, UNC-Asheville); Alexander, *Mountain Fever,* 162; Tinder list of Mich. photographers; Darrah, *World of Stereographs,* 208; Appalachian National Park Association Collection (A&H); information provided by staff of Pack Memorial Public Library, Asheville; information provided by Sarah Robinson, Jacksonville, Fla.; Rinhart and Rinhart, *Victorian Florida,* 212.

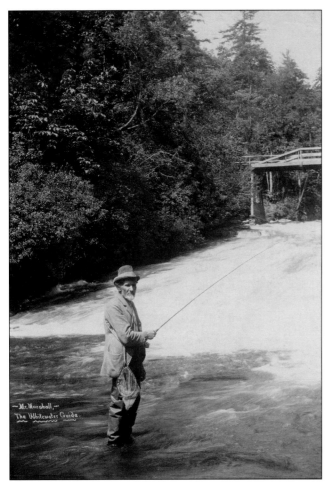

R. Henry Scadin titled this photograph "Mr. Marshall, the Whitewater Guide." Marshall is shown fishing in the Whitewater River in the "Sapphire Country" of western North Carolina in the early 1900s. Photograph courtesy A&H.

SCALES, ROBAH L.: African American, active 1918, Winston; associated with Marion M. Farmer as proprietors of Cute Studio.

SOURCES: *Winston-Salem Directory*, 1918; information from the files of MESDA.

SCALES, WALTER S. (L.) (b. ca. 1877): native of N.C.; African American; active 1919–1930; in Laurinburg (1919); in Monroe (1919–1920); in Charlotte (by 1930).

SOURCES: State Auditor's Records, Sch. B; Fifteenth Census, 1930: Mecklenburg County, Pop. Sch., Charlotte, E.D. 60-9.

SCHENETER, MRS. ROSALIND: active 1918 as proprietor of Dixie Studio, N. Trade St., Charlotte.

SOURCE: Miller, *Charlotte Directory*, 1918.

SCHLEISNER, _____: active 1940 in association with a Mr. Gottscho as Gottscho-Schleisner, Inc.; photographed a residence in Southern Pines.

SOURCE: information provided by Carol Johnson, Library of Congress, Washington, D.C.

SCHLIKER, H. B.: active 1930s, Waynesville.

SOURCE: Photographic Examiners Records.

SCHRECK, VICTOR G.: from Savannah, Ga.; briefly active 1889, Asheville.

SOURCE: information provided by Carol Johnson, Library of Congress, Washington, D.C.

SCHUMACHER, JERRY: active 1937–1950s, Wilmington (1937); convicted of practicing without a photographer's license; in Morehead City (1950s–1960s).

SOURCE: Photographic Examiners Records.

SCHUTT, A. G.: active 1929–1930; operated Schutt Studio, Burlington.

SOURCE: *Miller's Burlington City Directory, 1929–1930*.

SCHWARTZ, SAUL: active 1926; operated Triangle Studio, E. Trade St., Charlotte.

SOURCE: Miller, *Charlotte Directory*, 1926.

SCHWEIKECT, FRITZ (b. ca. 1898): native of N.C.; active by 1920, Goldsboro; boarded with photographer Albert O. Clement.

SOURCE: Fourteenth Census, 1920: Wayne County, Pop. Sch., Goldsboro, E.D. 114.

SCOTT, _____: active 1858, Greensboro, in partnership with Henry C. Gorrell.

SOURCE: *Greensborough Patriot*, Sept. 25, 1858.

SCOTT, ETHYLE (Mrs. Fred Scott): active 1930s–1940s; operated Scott's Studio, Lenoir (1935–1940s); in Newton (1940–1941); in Rock Hill, S.C. (after World War II).

SOURCE: Photographic Examiners Records.

SCOTT, FRED (b. 1885): active 1925–1940s; operated Monroe Studio, Monroe (1922–1923); in Newton (1925–1934); Sally J. Smyer purchased studio in 1934 and sold it in 1936; in Florence, S.C. (1926) as manager of Robert E. Quarles's studio; in Salisbury (1935); operated Scott's Studio, Lenoir (1937–1940), in association with Walter F. McCrary; in Rock Hill, S.C. (after World War II); husband of Ethyle Scott.

SOURCES: Miller, *Monroe, N.C. City Directory, 1922–1923*; Photographic Examiners Records; Teal, *Partners with the Sun*, 263; *Mercantile Reference Book*, 1931; Baldwin, *Salisbury City Directory, 1935*; *Miller's Lenoir City Directory, 1937–1940*.

SCOTT, J. S.: active 1916, Durham.

SOURCE: State Auditor's Records, Sch. B.

SCOTT, JAMES KINGHAM (1901–1969): active 1934–1937, W. Hargett St., Raleigh.

SOURCES: Photographic Examiners Records; Hill, *Raleigh Directory*, 1935, 1936; Murray list of Wake County photographers; *www.familysearch.org*.

SCOTT, JAMES LEON: active ca. 1935–1938, Woodfin (Buncombe County) (ca. 1935–1937); operated Scott's Photo Service, Asheville (1938).

SOURCES: Photographic Examiners Records; *Miller's Asheville Directory*, 1937; information provided by staff of Pack Memorial Public Library, Asheville.

SCOTT, JULIA (Mrs.): active 1919, Jacksonville.

SOURCE: State Auditor's Records, Sch. B.

SCOTT, KNOX (Miss) (b. ca. 1895): native of N.C.; active by 1930, Durham.

SOURCE: Fifteenth Census, 1930: Durham County, Pop. Sch., Durham, E.D. 32-4.

SCOTT, MAURICE H. (1911–1967): active 1934–1940s; in Charlotte with Marguerite D. Gaddy (1934–1935); with St. John Studio at Belk's Department Store (1939); operated St. John Studio at Belk's in Greensboro (1939–1942); operated Adams' Studio, Wilmington (after World War II).

SOURCES: Photographic Examiners Records; *www.familysearch.org.*

SCOTT, R. E. (Miss): active 1898, S. 7th St., Wilmington.

SOURCES: *Dispatch* (Wilmington), Oct. 29, 1898; Reaves list of Wilmington photographers.

SCOTT, TENNY R.: active 1911–1912, Durham.

SOURCES: Record of Special Licenses Issued, Durham County, 1910–1911 (A&H); Hill, *Durham, N.C. Directory, 1911.*

SCOTT, ZACHIUS ("ZACKIE") E. (1866–1943): native of Va. or N.C.; active 1890s–1930s; in Concord (ca. 1895–1902); in Monroe (ca. 1903–1905); in Charlotte (1905–1930s) in partnership with J. Tate Powell (1905–1906) and with Leon E. Seay (1907); sole proprietor of Scott's Studio (1908–1920s); in Fort Mill, S.C. (1906).

SOURCES: Sprange, *Blue Book*, 289; photograph made in Concord bearing Scott's name; Twelfth Census, 1900: Cabarrus County, Pop. Sch., Township 12, E.D. 23; *Concord City Directory*, 1902; *N.C. Year Book*, 1905–1907, 1910–1916; *Walsh's Directory of the City of Charlotte*, 1904–1909; Miller, *Charlotte Directory*, 1911–1930; Fifteenth Census, 1930: Mecklenburg County, Pop. Sch., Charlotte, E.D. 60-17; *Hill's Charlotte Directory* 1932–1941; Teal, *Partners with the Sun*, 236; *Bradstreet's*, 1908, 1917, 1921; State Auditor's Records, Sch. B; Vital Records, death certificates, Book 2426, p. 191 (A&H); *Charlotte Observer*, May 6, 1943.

SEAGLE, BENJAMIN F., JR. (b. ca. 1910): native of N.C.; active by 1930, Hickory.

SOURCE: Fifteenth Census, 1930: Catawba County, Pop. Sch., Hickory, E.D. 18-13.

SEAGLE, E. W.: active 1934–1936, Albemarle, in association with John M. Ross.

SOURCE: Photographic Examiners Records.

SEAY, JESSE G.: active early 1900s, Leaksville; took photographs of a fire at Avalon Mills, 1911.

SOURCE: Aheron, *From Avalon to Eden*, 8.

SEAY, LEON ERNEST (1862–1930): native of Va.; active ca. 1890s–1920s; in Danville, Va. (ca. early 1890s); in Salisbury (1893, 1903); in Charlotte (1905–1920s) in partnership with Charles W. J. Eutsler (1905–1910) and with Zachius E. Scott (1907).

SOURCES: *Carolina Watchman* (Salisbury), May 25, 1893; *Mercantile Agency Reference Book*, 1904; *Bradstreet's*, 1908, 1917, 1921; *Walsh's Directory of the City of Charlotte*, 1905–1910; Miller, *Charlotte Directory*, 1911–1929; *N.C. Year Book*, 1907, 1910–1916; State Auditor's Records, Sch. B; Fourteenth Census, 1920: Mecklenburg County, Pop. Sch., Charlotte, E.D. 150; Vital Records, death certificates, Book 1410, p. 113 (A&H); *Charlotte Observer*, Aug. 13, 1930.

SEBREN, GEORGE ALVA (1913–1975): active 1938–1939, Morganton; purchased and operated Webb Photo Company, studio formerly operated by Lloyd E. Webb; died in Fla.

SOURCES: Photographic Examiners Records; *www.familysearch.org.*

SEEKER, DAVID Y.: active 1920, Salisbury.

SOURCE: State Auditor's Records, Sch. B.

SEIDELL, H. A.: active late nineteenth and early twentieth centuries, Vaughan (Warren County); photographer for Seaboard Air Line Railroad; advertised posing room, flashlights, and outdoor work as specialties; took photograph of Ingleside plantation house in Lincoln County in late 1890s.

SOURCES: *Star* (Wilmington), June 3, 1898; Cotten list of N.C. photographers; Reaves list of Wilmington photographers; photographs bearing his name.

SEITZ, GEORGE A.: active 1918, Charlotte; photographed Camp Greene, Nov. 1918.

SOURCE: Miller, *Charlotte Directory*, 1918.

SELDOMRIDGE, LEWIS CLINTON (b. 1892): active 1935–1940s; in Asheville (1935–1940) with Howard Studio (1935–1939) and as operator of Seldomridge Studios (1940); in Hendersonville (1939–1940) as operator of Seldomridge Studios; in Lakeland, Fla. (1930s–1940s).

SOURCES: Photographic Examiners Records; *Miller's Asheville Directory*, 1940.

SELLERS, CHARLES VICTOR (1870–1941): native of N.C.; active by 1900–1930; in Burlington as C. V. Sellers Art Studio (1909); also garage and wallpaper dealer, hosiery mill operator (co-founded Sellers Hosiery Mills, 1907), and financier.

SOURCES: Twelfth Census, 1900: Alamance County, Pop. Sch., Burlington, E.D. 13; *N.C. Year Book*, 1902–1907, 1909–1916; *Mercantile Agency Reference Book*, 1904; *Bradstreet's*, 1908, 1917,

1921, 1925; Miller, *Burlington, N.C. City Directory, 1909–1910*; *Miller's Burlington City Directory*, 1920–1921, 1927–1930; State Auditor's Records, Sch. B; *Greensboro Daily News*, Sept. 21, 1941; Alamance County Wills (A&H).

SELLS, _____: active (obtained license to practice) 1899–1900, Alleghany County, in partnership with a Mr. Daniels.

SOURCE: Registry of Licenses to Trade, Alleghany County, 1874–1906 (A&H).

SEPARK, J. H. (b. ca. 1831): native of Va.; active by 1860, Warrenton.

SOURCE: Eighth Census, 1860: Warren County, Pop. Sch., Warrenton.

SESSIOM (SESSOMS), ISAAC: active (obtained license to practice) 1916, Durham.

SOURCE: Record of Special Licenses Issued, Durham County, 1914–1916 (A&H).

SESSOMS, BERNICE (b. ca. 1889): native of N.C.; active by 1930, Durham; husband of Laura Sessoms.

SOURCE: Fifteenth Census, 1930: Durham County, Pop. Sch., Durham, E.D. 32-7.

SESSOMS, C. S.: active 1916, Edenton.

SOURCE: State Auditor's Records, Sch. B.

SESSOMS, LAURA (b. ca. 1888): native of N.C.; active by 1930, Durham; wife of Bernice Sessoms.

SOURCE: Fifteenth Census, 1930: Durham County, Pop. Sch., Durham, E.D. 32-7.

SETSZER, P. C. (b. ca. 1849): native of Va.; active by 1880; in Petersburg, Va. (1880s); in Wilson (1880s) in partnership with a Mr. Whittington.

SOURCES: Ginsberg, *Photographers in Virginia*, 23; Cotten list of N.C. photographers; *www.familysearch.org*.

SEXTON, C. F.: active 1921, Grassy Creek, in partnership with J. O. Sexton.

SOURCE: State Auditor's Records, Sch. B.

SEXTON, J. O.: active 1921, Grassy Creek, in partnership with C. F. Sexton.

SOURCE: State Auditor's Records, Sch. B.

SEXTON, JOHN J. (1862–1912): native of N.C.; active 1904–1912; in Elizabeth City (1904–1907); in New Bern (by 1912).

SOURCES: *N.C. Year Book*, 1904–1907; Vital Records, death certificates, Book D-39, p. 34 (A&H).

SHACKLETTE, HENRY DANIEL (1908–2001): native of Mo.; active 1927–1950s; in Raleigh (1927–1941); with Siddell Studio (1927–1930); worked as retoucher at unidentified Durham studio (1930); with Dunbar-Smith Studio (1930–1937); with Carolina Studio of Photography,

Raleigh (1940–1941); in Durham (1939–1950s); with Daniel & Smith Studio (1939–1940); in military service (1942–1947); in Durham (ca. 1950) with F. Gilbert Whitley at Carolina Camera Craft Studio; operated Evans' Studio in Durham (1952); also active in Burlington (ca. 1952).

SOURCES: Photographic Examiners Records; Fifteenth Census, 1930: Durham County, Pop. Sch., Durham, E.D. 32-4; Hill, *Raleigh Directory*, 1940; *Herald-Sun* (Durham), Sept. 20, 2001.

SHAFER, _____: associated with Horn-Shafer Company, Baltimore; active ca. 1918, Camp Greene; received permission to take photographs at the camp.

SOURCES: National Army Camps, Camp Greene, Charlotte, N.C., RG 393, Box 20, National Archives; information provided by Jane Johnson, Charlotte.

SHAFFER, L. G.: active 1919, Rocky Mount.

SOURCE: State Auditor's Records, Sch. B.

SHAHN, BEN (1898–1969): native of Lithuania; active 1936–1937 with U.S. Resettlement Administration; worked in Asheville and Pender County; died in N.J.

SOURCES: "Reference Guide to FSA/OWI Photographs"; *www.familysearch.org*.

SHARKEY, JOSEPHINE (1883–1970): active 1933–1935, Chapel Hill; died in N.Y.

SOURCES: Photographic Examiners Records; *www.familysearch.org*.

SHARTLE, HARRY ELLSWORTH (1862–1943): native of Ind.; active 1895–1910; in Asheville (1895–1897); operated Shartle's Studio on S. Main St.; in Lynchburg, Va. (1902–1910).

SOURCES: Sprange, *Blue Book*, 288; McIlwaine, *Asheville, N.C. City Directory, 1896–'97*; Ginsberg, *Photographers in Virginia*, 14; *www.familysearch.org*.

SHAW, _____: active 1910, Concord, in partnership with J. Lee Stone.

SOURCE: *N.C. Year Book*, 1910.

SHAW, JOHN W.: active 1916–1917, Greenville; operated Greenville Studio.

SOURCE: Miller, *Greenville, N.C. City Directory, 1916–'17*.

SHAW, R. R.: active 1883–1884, Bayboro.

SOURCES: *Chataigne's N.C. Directory and Gazetteer, 1883–'84*; Branson, *NCBD*, 1884.

SHEAR, GEORGE WILLARD: active 1874–1901; in Mich. (1874–1879); in Lima, Ohio (1879–1888); in Wilmington (1901); operated novelty photo business on Princess St.; sold out to Jo Hardy LeGwin, 1901, and moved to Wis. to engage in lumber business with his brother.

SOURCES: Gagel, *Ohio Photographers*, 94; *Messenger* (Wilmington), Sept. 12, 1901; Reaves list of Wilmington photographers; Tinder list of Mich. photographers.

SHEELER, W. R.: of Greenville, S.C.; active ca. 1918, Camp Greene; received permission to take photographs at the camp.

SOURCES: National Army Camps, Camp Greene, Charlotte, N.C., RG 393, Box 20, National Archives; information provided by Jane Johnson, Charlotte.

SHELBURN, EDGAR L. (1863–1889): native of N.C.; active 1880s; in Durham (1880s); in Greenville (where a storm blew down his photography tent) (1882); in Kinston (late 1880s); son of William Shelburn and nephew of Robert B. Shelburn.

SOURCES: Ninth Census, 1870: Wake County, Pop. Sch., Raleigh; Tenth Census, 1880: Wake County, Pop. Sch., Cary Township; *Eastern Reflector* (Greenville), Mar. 1, 1882; *State Chronicle* (Raleigh), Apr. 5, 1889.

SHELBURN, ROBERT B. (b. ca. 1838): native of Va.; active late 1850s–early 1860s; in Oxford (late 1850s); in Warrenton (by 1860); returned to Va. during Civil War and served in Company C, Thirty-second Va. Infantry; brother of William Shelburn and uncle of Edgar L. Shelburn; employed as a sewing machine agent in Petersburg, Va. (1880).

SOURCES: Granville County Miscellaneous Tax Records, undated, 1754–1886, Folder 1850–1858 (A&H); Eighth Census, 1860: Warren County, Pop. Sch., Warrenton; Hewitt, *Roster of Confederate Soldiers*, 16:38; *www.familysearch.org.*

SHELBURN, WILLIAM (1834–1911): native of Yorktown, Va.; active ca. 1856–1907; in Oxford (by 1856–ca. 1861) as operator of Shelburn's Gallery, located above Beasley's and Hester's Drugstore; operated school of photography (1860); returned to Va. during Civil War and served as captain in Twenty-fifth Va. Cavalry and with general and staff Quartermaster Department; on Fayetteville St., Raleigh (by 1870–1878); in Goldsboro (1877–1878, 1884–1886) in gallery located one door north of the *Express* office in rooms formerly occupied by Hugh W. Watson; in Asbury (Wake County) (1880); in Greenville (early 1880s); in Kinston (1881, 1883–1884, 1889); J. F. Miller purchased studio in 1889; operated Shelburn's Gallery on Main St., Durham (ca. 1883–1907); operated Shelburn's Art Gallery in Burlington (ca. 1880s); brother of Robert B. Shelburn and father of Edgar L. Shelburn.

SOURCES: Granville County Taxables, 1856, 1858 (A&H); *Leisure Hour* (Oxford), Oct. 18, 1860; Eighth Census, 1860: Granville County, Pop. Sch., Oxford; Ninth Census, 1870: Wake County, Pop. Sch., Raleigh; Tenth Census, 1880: Wake County, Pop. Sch., Cary Township; Thirteenth Census, 1910: Durham County, Pop. Sch., Durham, E.D. 37; *Sentinel* (Raleigh), May 3, 1871; *Friend of Temperance* (Raleigh), Aug. 2, 1871; *Daily Evening Crescent* (Raleigh), Aug. 25, 1874;

Chataigne's Raleigh Directory, 1875, 146; *Zell's U.S. Business Directory*, 1875; *Goldsboro Messenger*, Nov. 12, 1877, Jan. 14, 1878; *Journal* (Kinston), Sept. 29, 1881; *Chataigne's N.C. Directory and Gazetteer*, 1883–'84; Branson, *NCBD*, 1884, 1896, 1897; *Durham Recorder*, June 3, 1885, Apr. 16, 1900; *Daily Reporter* (Durham), June 5, 1885, May 7, 1886, May 14, 1887; *State Chronicle* (Raleigh), Nov. 18, 1886; Branson, *Directory of the Business and Citizens of Durham, 1887*, 182, 226; Ramsey, *Durham Almanac, 1894*, 49; Sprange, *Blue Book*, 289; *Mangum's Directory of Durham and Suburbs, 1897*, 42; *N.C. Year Book*, 1902–1907; *News and Observer* (Raleigh), Aug. 24, 1899, Mar. 4, 1911; *Daily Reflector* (Greenville), Mar. 3, 1911; *Mercantile Agency Reference Book*, 1904; Vital Records, death certificates, Book D-19, p. 277 (A&H); Hewitt, *Roster of Confederate Soldiers*, 14:38; photograph made in Burlington bearing William Shelburn's name; information provided by Vinia Conte, Raleigh; information provided by Roger Kammerer, Greenville.

SHELBY, ANNIE (OR FANNIE M.) (b. ca. 1884 or 1887): native of N.C.; active by 1920–1930, Gastonia; associated with husband, Robert F. Shelby.

SOURCES: Fourteenth Census, 1920: Gaston County, Pop. Sch., Gastonia, E.D. 90; Fifteenth Census, 1930: Gaston County, Pop. Sch., Gastonia, E.D. 36-22.

SHELBY, ROBERT FITZHUGH (1876–1950): native of N.C.; active 1891–1940s; in Monroe (1891–1893) with S. B. Stephenson; in Kings Mountain (1894) with Charles M. Hardin; in Gastonia (ca.1913–1940s) as Shelby Studio, in partnership with a Mr. Thaxton (1915–1916); by 1920, associated with his wife, Annie (or Fannie M.) Shelby.

SOURCES: Photographic Examiners Records; *N.C. Year Book*, 1915, 1916; State Auditor's Records, Sch. B; *Bradstreet's*, 1917, 1921, 1925; Fourteenth Census, 1920: Gaston County, Pop. Sch., Gastonia, E.D. 90; Fifteenth Census, 1930: Gaston County, Pop. Sch., Gastonia, E.D. 36-22; *Mercantile Reference Book*, 1931; *Mercantile Agency Reference Book*, 1943; *Gastonia Directory*, 1918–1919, 1921–1924, 1927–1928; Miller, *Gastonia Directory*, 1930–1931; *Hill's Gastonia Directory*, 1934, 1936; Vital Records, death certificates, Book 13A, p. 220 (A&H).

SHELTON, J. GREEN: active 1918, Winston; proprietor of Southern Photo Studio.

SOURCES: *Winston-Salem Directory*, 1918; information from the files of MESDA.

SHENANDOAH PHOTOGRAPH COMPANY: of Mt. Clifton, Rinkerton, Va.; active 1889; took outdoor photograph of N.C. ministers and lay readers at Holly Grove Church, Ilex (Davidson County), Nov. 8, 1889.

SOURCE: Photograph offered for sale at Oakwood Antique Mall, Raleigh, Nov. 2003.

SHEPHERD, E. H.: active 1875–1883; obtained license to practice in Richmond County (1875–1876); operated gallery on Tarboro St., Wilson (1883).

SOURCES: Registry of Licenses to Trade, Richmond County, 1875–1885 (A&H); *Wilson Advance*, Apr. 6, 1883.

LEFT: In the 1880s, William Shelburn took this portrait of William T. Blackwell (1839–1903), the father of the tobacco industry in Durham. **RIGHT:** Many of Shelburn's card photographs included fancy artwork printed on their reverse for advertising purposes. Here a woman is shown standing on the globe pouring oval photographs out of a cornucopia. Both images courtesy of the compiler.

SHERMAN, FRANKLIN, JR.: active 1904; employed by N.C. Department of Agriculture; took photographs of J. Van Lindley's orchard, Southern Pines.

SOURCE: Herbert H. Brimley Photograph Collection (A&H); information provided by Sarah Robinson, Jacksonville, Fla.

SHERRILL, GEORGE DEXTER (1879–1931): native of N.C.; active late 1890s–1931; on Depot St., Waynesville (1902–1931), as Sherrill's Studio; in Asheville (1920–1925); following his death in 1931, Sherrill's nephew and wife, Ralph and Beulah E. Ensley, operated the studio in Waynesville into the 1940s; son-in-law of Abraham Lincoln Ensley.

SOURCES: *Haywood County Heritage*, 1:54; *Jackson County Heritage*, 1:419; *Bradstreet's*, 1908, 1921; State Auditor's Records, Sch. B; *N.C. Year Book*, 1910–1916; Miller, *Asheville, N.C. City Directory*, 1920–1925; *Asheville Citizen*, Dec. 23, 1931; *Mercantile Agency Reference Book*, 1943.

SHIELDS, JAMES P.: itinerant maker of ambrotypes; active 1858, Hillsborough; occupied rooms in Masonic Hall.

SOURCES: *Hillsborough Recorder*, Oct. 6, Nov. 17, 1858; Orange County Miscellaneous Records, Tax Records, 1800–1881 (A&H).

SHIELDS, ROSA E.: active 1940–1941, Asheville; operated Shields Studio, Patton Ave. *See also* Williams, Rosa E.

SOURCE: *Miller's Asheville Directory*, 1940–1941.

SHIPPLY, K. F.: photographed construction of Blue Ridge Parkway in late 1930s.

SOURCE: Blue Ridge Parkway Photograph Collection (A&H).

SHISHMANIAN, GEORGE N.: native of Asia Minor; active 1873–1876; in Craven County (1873–1874) as G. N. Shishmanian & Company; on Market St., Wilmington (1875–1876); in Kinston (n.d.).

SOURCES: State Auditor's Records, Sch. B; *Chataigne's Raleigh Directory*, 1875, 229; information from photograph in Delia Hyatt Papers (A&H).

SHOEMAKER, THOMAS F. (b. 1872): native of N.C.; active by 1900–ca. 1933; in Olin Township, Iredell County (by 1900); in Lancaster, S.C. (1924–ca 1933); took over W. A. Davis Studio in Moore Building.

SOURCES: Twelfth Census, 1900: Iredell County, Pop. Sch., Olin Township, E.D. 97; Teal, *Partners with the Sun*, 199.

SHORE, GEORGE (b. ca. 1862): native of N.C.; active by 1880, Salem.

SOURCE: Tenth Census, 1880: Forsyth County, Pop. Sch., Salem, E.D. 86.

SHORTER, B. F.: active 1920, Spray.

SOURCE: State Auditor's Records, Sch. B.

SHUFORD, THOMAS ROBERT (1875–1949): native of N.C.; active 1900–1940s; in Charlotte (ca. 1900, ca. 1920–1940s), operated Shuford's Studio, S. Tryon St.; in Gastonia (1903–1910s, 1921–1922, 1930); in Monroe (1922–1923); in Lincolnton (1930); published stereographs of flood damage at Cliffside and Pacolet Mills, June 1903.

SOURCES: *N.C. Year Book*, 1904, 1905; *Mercantile Agency Reference Book*, 1904; Fourteenth Census, 1920: Gaston County, Pop. Sch., Gastonia, E.D. 90; *Mercantile Reference Book*, 1931; *Gastonia Directory*, 1918–1922; Miller, *Charlotte Directory*, 1922–1930; *Hill's Charlotte Directory*, 1932–1941; Miller, *Monroe, N.C. City Directory*, 1922–1923; State Auditor's Records, Sch. B; Photographic Examiners Records; Vital Records, death certificates, Book 13A, p. 266 (A&H); *Charlotte Observer*, July 1, 1949.

SIDDELL, HALLIE SIMPKINS (1896–1977): native of N.C.; active ca. 1917–1950s, Raleigh; associated with Foto Art Shop (1931), Fayetteville St.; wife of Henry A. Siddell; operated one of the largest photography businesses in the state by mid-1930s.

SOURCES: Photographic Examiners Records; Hill, *Raleigh Directory*, 1917–1940; State Auditor's Records, Sch. B; Fourteenth Census, 1920: Wake County, Pop. Sch., Raleigh, E.D. 136; *Bradstreet's*, 1921, 1925; *Mercantile Reference Book*, 1931; *Mercantile Agency Reference Book*, 1943; www.familysearch.org.

SIDDELL, HENRY A. (b. ca. 1882): native of Ind.; active ca. 1916–1940s, Raleigh (ca. 1916–1940s); operated Siddell Studio, Fayetteville St.; operated studio in St. Petersburg, Fla., in late 1930s; husband of Hallie S. Siddell.

SOURCES: Photographic Examiners Records; *N.C. Year Book*, 1916; State Auditor's Records, Sch. B; Hill, *Raleigh Directory*, 1916–1940; Fourteenth Census, 1920: Wake County, Pop. Sch., Raleigh, E.D. 136; *Bradstreet's*, 1921, 1925; *Mercantile Reference Book*, 1931; *Mercantile Agency Reference Book*, 1943.

SIDES, LESTER (b. ca. 1901): native of N.C.; active by 1920, Greensboro; also worked as insurance agent.

SOURCE: Fourteenth Census, 1920: Guilford County, Pop. Sch., Greensboro, E.D. 144.

SIGMAN, CASWELL (b. 1861): native of N.C.; active by 1900, Lenoir.

SOURCE: Twelfth Census, 1900: Caldwell County, Pop. Sch., Lenoir, E.D. 26.

SILBERSTEIN, S. (?): active ca. 1918, Camp Greene; associated with Savannah Photo Company, Savannah, Ga.; received permission to take photographs at the camp.

SOURCES: National Army Camps, Camp Greene, Charlotte, N.C., RG 393, Box 20, National Archives; information provided by Jane Johnson, Charlotte.

SILVER'S STORE: active 1933–1935, Durham; Edward J. Rice, proprietor.

SOURCE: Hill, *Durham, N.C. City Directory, 1933–1935*.

SIMMONS, GEORGE J.: active 1916–1919; in Colerain (1916); in Ahoskie (1919).

SOURCE: State Auditor's Records, Sch. B.

SIMMONS, R. P.: maker of ambrotypes; active 1860; Ansonville; gallery located at Temperance Hall.

SOURCE: *North Carolina Argus* (Wadesborough), Sept. 20, 1860.

SIMMS, FRANK: African American; active 1924, Wilmington.

SOURCE: Reaves list of Wilmington photographers.

SIMPKINS, VIRGINIA (b. ca. 1880): native of N.C.; active by 1910, Winston.

SOURCE: Thirteenth Census, 1910: Forsyth County, Pop. Sch., Winston, E.D. 72.

SIMPSON, CLEVELAND ("CLEVE") (b. ca. 1886): native of N.C.; active 1910–1940s, Winston and later Winston-Salem; operated Ideal Photo Company (1910–1920s); associated with E. Remington (1910); also worked in printing business in 1930s.

SOURCES: *Winston-Salem Directory*, 1910–1923; State Auditor's Records, Sch. B; Fourteenth Census, 1920: Forsyth County, Pop. Sch., Waughtown, E.D. 70; Weaver, *Winston-Salem, North Carolina, City of Industry*, 37; *Bradstreet's*, 1925; *Mercantile Reference Book*, 1931; *Mercantile Agency Reference Book*, 1943; Photographic Examiners Records.

SIMPSON, HOWARD CALDWELL (1914–1976): active 1930s–1940s; in Concord (mid-1930s) with John A. Simpson; operated St. John Studio, Belk's Department Store, Charlotte (1937–1940s); probably son of John A. Simpson.

SOURCES: Photographic Examiners Records; www.familysearch.org.

SIMPSON, JESSE W.: active 1904–1905, New Bern.

SOURCE: Hill, *New Bern Directory, 1904–1905*.

SIMPSON, JOHN ALEXANDER (1885–1946): active ca. 1925–1940s, Concord; probably father of Howard C. Simpson.

SOURCES: Photographic Examiners Records; *Concord City Directory*, 1929–1930; *Mercantile Reference Book*, 1931; *Baldwin's Concord Directory*, 1938, 1940.

SIMS, SAM: active 1919, Wilson.

SOURCE: State Auditor's Records, Sch. B.

SINCLAIR, P.: itinerant; active 1884–1886, Rockingham (1884–1885); pitched his tent on west side of old Southern Hotel; took photographs of tornado damage in Richmond County (1884); in Wilson (1885–1886).

SOURCES: *Richmond Rocket* (Rockingham), Apr. 3, 1884, Jan. 22, 1885; *State Chronicle* (Raleigh), Apr. 26, 1884; Cotten list of N.C. photographers.

SINGLEY, B. L.: active 1904, western N.C.; associated with Keystone View Company in production of stereographs.

SOURCE: information provided by Carol Johnson, Library of Congress, Washington, D.C.

SIZER, EDGAR (EDWARD) W. (b. ca. 1882): native of N.C.; active 1922–1939, Charlotte; operated Sizer's Studio.

SOURCES: Miller, *Charlotte Directory*, 1922–1930; Fifteenth Census, 1930: Mecklenburg County, Pop. Sch., Charlotte, E.D. 60-13; *Hill's Charlotte Directory*, 1932–1939.

SKIPPER, J. W. (1838–1903): native of S.C.; active 1889–1902, Lumberton.

SOURCES: Cotten list of N.C. photographers; Sprange, *Blue Book*, 289; Twelfth Census, 1900: Robeson County, Pop. Sch., Lumberton, E.D. 108; *Robesonian* (Lumberton), Jan. 9, 1903.

SKYLAND STUDIO: active 1939–1940, Haywood St., Asheville; Robert C. Ingram, operator.

SOURCE: *Miller's Asheville Directory*, 1939–1940.

SLADE, JOHN A.: active 1916, Pelham (Caswell County).

SOURCE: State Auditor's Records, Sch. B.

SLAGLE, ADA LINDSEY (1875–after 1938): active 1902–1938 with Slagle's Studio, Asheville; operated studio for a few years following death of husband, John Hamilton Slagle; daughter of Thomas H. Lindsey.

SOURCES: Photographic Examiners Records; *Miller's Asheville Directory*, 1937–1939.

SLAGLE, JOHN HAMILTON (1870–1936): native of N.C.; active 1890s–1935, Asheville; apprenticed under Lindsey & Brown (1890–1891); with that firm until 1898; in Fla. (1905–1910); in Asheville (ca. 1912–1935); operated Slagle's Studio in association with wife, Ada L. Slagle; in Black Mountain (1914); son-in-law of Thomas H. Lindsey.

SOURCES: Photographic Examiners Records; *N.C. Year Book*, 1914; *Miller's Asheville Directory*, 1930–1932, 1936; *Asheville Citizen*, Mar. 1, 1936.

SLAUGHTER, ABRAHAM R. (1848–1894): active late 1860s–1870s; in Williamsboro (late 1860s–1870s); in Louisburg (1873) in gallery located at Dent's Hotel; in Walnut Grove (Orange County) (1874).

SOURCES: *Franklin Courier* (Louisburg), Aug. 15, 1873; *Oxford Torchlight*, July 14, 17, 1874; Granville County Estates Records (A&H); WPA Cemetery Index (A&H).

SLEDGE, W. H.: active 1887, Leaksville.

SOURCE: *Dan Valley Echo* (Leaksville), Oct. 13, 1887.

SLUSHER, A. M.: active 1910, Raleigh.

SOURCE: *N.C. Year Book*, 1910.

SMALL, EDWARD FEATHERSTON (1844–1924): native of N.C.; member, Second Regiment, N.C. Artillery; Second Company G, Thirty-Sixth Regiment N.C. Troops; and Company D, Thirteenth Battalion, N.C. Light Artillery, during Civil War; active ca. 1868–1883; itinerant during early portion of career (late 1860s) in High Point, Greensboro, Durham, and Winston; in Goldsboro (1870, 1873–1875); in Clinton (1870); at Company Shops (1875); in Mebanesville (1875); in Durham (1876–early 1880s); published series of city views of Winston and Salem (1882) and Greensboro (1882–1883); in Reidsville (briefly, 1883), taking only views; in Durham (1883), taking only views; in Lexington (by 1880) in association with George Teague; also in partnership with Teague in Winston (1881–1882); their studio destroyed by fire, Jan. 1882; by 1883 Small had taken a position as a traveling cigarette salesman with W. Duke, Sons & Company, Durham; a resident of

Seated here is Edward F. Small, itinerant operator and Durham photographer, who later became a successful cigarette salesman with the firm of W. Duke, Sons & Company. Photograph courtesy A&H.

Atlanta, Ga., when he died while attending reunion of United Confederate Veterans in Memphis, Tenn.

SOURCES: Edward Featherston Small Papers, Rare Book, Manuscript, and Special Collections Library, Duke University, Durham; Gertrude Weil Papers (A&H); Ninth Census, 1870: Sampson County, Pop. Sch., Clinton Township; Tenth Census, 1880: Davidson County, Pop. Sch., Lexington Township, E.D. 34; Twelfth Census, 1900: Fulton County, Ga., Pop. Sch., Atlanta, E.D. 65; *Carolina Messenger* (Goldsboro), Jan. 3, 6, Nov. 30, 1873; State Auditor's Records, Sch. B, Taxes; *Zell's U.S. Business Directory*, 1875; *Alamance Gleaner* (Graham), Oct. 5, 1875; *Durham Tobacco Plant*, Jan. 19, Apr. 12, 1876; *Durham Herald*, June 14, 1876; *Webster's Dollar Weekly* (Reidsville), Jan. 30, 1883; *Durham Recorder*, June 13, 1883; information (newspaper clipping from Forsyth County Public Library, Winston-Salem) provided by Jennifer Bean Bower, MESDA; Davidson County Estates Records (A&H); Davidson County Tax Records (A&H); Johnston County Marriage Records (A&H); Confederate Soldiers Home Record, Register of Inmates, Vol II, p. 339 (microfilm copy, Georgia State Archives, Atlanta); *Atlanta City Directory*, 1891–1893, 1923–1924; Garrett, *Atlanta and Environs*, 193–194; *News and Observer* (Raleigh), June 7, 1924; Manarin and Jordan, *N.C. Troops*, 1:278–279; *DNCB*, s.v. "Small, Edward Featherston."

SMALL, JACK BENJAMIN (b. 1899): active 1927–1935, Washington, D.C., with Harris & Ewing and Underwood & Underwood (1935 and afterward); worked for those studios in N.C.; in federal penitentiary in Atlanta, Ga., 1938–1939.

SOURCE: Photographic Examiners Records.

SMALL, JAMES A.: itinerant; active (obtained license to practice) 1887–1888, Haw River.

SOURCES: State Auditor's Records, Miscellaneous Tax Group (1868–1932), Box 3, Artists' and Photographers' Privilege Licenses, 1877–1887 (A&H); State Auditor's Records, Ledgers, 1869–1899, Vol. 18, p. 390 (A&H).

SMALL, MARTHA WARE (Mrs.) (1915–1978): active 1936–1939 with St. John Studio at Belk's Department Store, Charlotte; died in S.C.

SOURCES: Photographic Examiners Records; *www.familysearch.org*.

SMILEY, T. C.: itinerant daguerreotyper; active 1848–1851; in Salisbury (1848); occupied room at Mansion Hotel; in Charlotte (1849); in Lincolnton (1849); occupied room at Mrs. Motz's hotel; in Asheville (1851); displayed his daguerreotypes at Eagle Hotel, Asheville.

SOURCES: *Carolina Watchman* (Salisbury), Apr. 20, 1848; *Charlotte Journal*, May 18, 1849; *Carolina Republican* (Lincolnton), Aug. 24, 1849; *Craig's Daguerreian Registry*, 3:526; *Photographic Art Journal* [ser. I] 2:270.

SMILEY, THOMAS H. (L.?): daguerreotyper; active early 1840s, Philadelphia, Pa.; pupil of Samuel F. B. Morse in Philadelphia; in Raleigh (1842–1843); located at corner of Fayetteville and Morgan Streets, west side (at Dr. Haywood's house).

SOURCES: Rinhart and Rinhart, *The American Daguerreotype*, 409; *Raleigh Register and North Carolina Gazette*, Dec. 30, 1842, Jan. 10–Mar. 10, 1843; *Craig's Daguerreian Registry*, 3:526; Ries and Ruby, *Directory of Pennsylvania Photographers*, 254; Murray list of Wake County photographers.

SMITH, _____: active 1846, Charlotte; itinerant daguerreotyper in partnership with Charles Doratt.

SOURCE: *Mecklenburg Jeffersonian* (Charlotte), May 8, 1846.

SMITH, _____: itinerant; active (paid tax to practice) 1883–1884; in partnership with a Mr. Emsberger.

SOURCE: State Auditor's Records, Ledgers, 1869–1899, Vol. 17, p. 467 (A&H).

SMITH, _____: active 1890, Wilmington, in partnership with Urchie C. Ellis.

SOURCE: Cotten list of N.C. photographers.

SMITH, _____: active 1896 on Fayetteville St., Raleigh, in partnership with Thomas B. Johnson.

SOURCE: photograph bearing name "Smith," N.C. Museum of History Photograph Collection (A&H).

SMITH, A. M.: active 1936, Charlotte, as representative of Fox Studio of St. Paul, Minn.; charged with practicing without photographer's license and lost case in court.

SOURCE: Photographic Examiners Records.

SMITH, ALEXANDER CHARLES: itinerant daguerreotyper; active ca. 1846–1860s; received training in N.Y.; at Shocco Springs (Warren County) (1850); in Fayetteville (1851); occupied room at Fayetteville Hotel; in Harrisburg, Pa. (1852–1862); in Philadelphia (1859–1869); became an attorney in 1862 and was elected to Pa. State House in 1869.

SOURCES: Mary Eliza Battle Papers (A&H); *Fayetteville Observer*, Sept. 2, 16, Nov. 14, 1851; Ries and Ruby, *Directory of Pennsylvania Photographers*, 255.

SMITH, ALEXANDER FAY (b. 1907): active 1935–1940s; with Daniel & Smith Studio, Raleigh (1935–1940s); with Daniel & Smith Studio, Corcoran St., Durham (1940–1941).

SOURCES: Photographic Examiners Records; *Hill's Durham Directory*, 1940–1941; *Mercantile Agency Reference Book*, 1943.

SMITH, ARTHUR J.: active 1938–1940, Salisbury.

SOURCE: Baldwin, *Salisbury City Directory*, 1938–1940.

SMITH, BENJAMIN T. (b. ca. 1872): native of W. Va.; active by 1910, Wadesboro.

SOURCE: Thirteenth Census, 1910: Anson County, Pop. Sch., Wadesboro, E.D. 15.

SMITH, C. E.: active 1928, Raleigh; operated Gem Studio in partnership with Walter Taylor.

SOURCE: Hill, *Raleigh Directory*, 1928.

SMITH, E. (Mrs.): active ca. 1895, Elizabeth City.
SOURCE: Sprange, *Blue Book*, 289.

SMITH, E. A.: active 1890, Monroe.
SOURCE: Branson, *NCBD*, 1890.

SMITH, EDGAR: active 1930s; in Durham (1930); on Fayetteville St., Raleigh (1931–1935).
SOURCES: *Mercantile Reference Book*, 1931; Hill, *Raleigh Directory*, 1931, 1935.

SMITH, FRANK T. (b. ca. 1858): active ca. 1914, Franklin.
SOURCE: postcard bearing his name.

SMITH, GEORGE (b. 1861): native of N.Y.; active by 1900, Asheville.
SOURCE: Twelfth Census, 1900: Buncombe County, Pop. Sch., Asheville, E.D. 136.

SMITH, H. G.: active 1916, Manteo.
SOURCE: *N.C. Year Book*, 1916.

SMITH, HAVILAND (b. 1905): from Bridgeport, Conn.; active 1937–1940s, Charlotte.
SOURCES: Photographic Examiners Records; *Hill's Charlotte Directory*, 1938–1941.

SMITH, HENRY HARRISON (1860–1939): native of N.C.; active ca. 1890s–1920s; itinerant operator in both Carolinas; in Laurinburg (ca. 1895); resided in S.C. ca. 1900–1920.
SOURCES: Photographic Examiners Records; Sprange, *Blue Book*, 289; information provided by Mrs. Ruth Daniel, Smithfield.

SMITH, J. C.: active 1919, Mount Gilead.
SOURCE: State Auditor's Records, Sch. B.

SMITH, J. E.: active ca. 1900, Greensboro.
SOURCE: photograph bearing his name.

SMITH, J. H.: active 1866–1867, Charlotte.
SOURCE: Branson, *NCBD*, 1866–1867.

SMITH, JOHN W. T.: active 1883–1890; on Road St., Elizabeth City, in partnership with a Mr. Crockett (1883–1884); in partnership with a Mr. Watson—probably Hugh W. Watson (1885–1886).
SOURCES: *Chataigne's N.C. Directory and Gazetteer, 1883–'84*; Branson, *NCBD*, 1890; *Falcon* (Elizabeth City), July 7, 1884; Cotten list of N.C. photographers.

SMITH, O. J.: active late 1850s and early 1860s; in Mobile, Ala. (1859); in New Bern (early 1860s); operated Union Photo Rooms in partnership with Lucien M. Stayner and possibly at some point in association with William B. Rose; in Leipsic [Leipsig?], Ohio (n.d.).
SOURCES: Witham, *Catalogue of Civil War Photographers*, 60, 75; *Branson & Farrar's NCBD*, 1866–1867; Green, *A New Bern Album*, 14; Robb list of Ala. photographers; Gagel, *Ohio Photographers*, 97.

SMITH, PAUL L. (b. 1890): active 1907–1940s (out of business 1916–1930), High Point (1934–1940s); operated Smith Studio, S. Main St.
SOURCES: Photographic Examiners Records; *Hill's High Point Directory*, 1940; *Mercantile Agency Reference Book*, 1943.

SMITH, ROBERT: active 1916, Whiteville.
SOURCE: State Auditor's Records, Sch. B.

SMITH, SIDNEY N. (b. ca. 1855): native of N.C.; active 1907–1910, N. Greene St., Greensboro.
SOURCES: Hill, *Greensboro, N.C. Directory, 1907–'08*; Thirteenth Census, 1910: Guilford County, Pop. Sch., Greensboro, E.D. 110.

SMITH, SUE (Miss) (b. ca. 1888): native of N.C.; active ca. 1923–1930s, Dunn; operated Miss Smith's Studio.
SOURCES: Photographic Examiners Records; *Miller's Dunn City Directory, 1926–'27*; Fifteenth Census, 1930: Harnett County, Pop. Sch., Dunn, E.D. 43-2; *Mercantile Reference Book*, 1931.

SMITH, T. O.: active 1849–1852; in Philadelphia (1848–1849) as principal operator of Root's Gallery; in Baltimore (1849) in gallery of Solomon N. Carvalho; in Fayetteville (1852) as itinerant daguerreotyper; occupied room in Benbow's building, near Bank of Cape Fear.
SOURCES: *Fayetteville Observer*, Apr. 20, July 18, Nov. 23, 1852; *Craig's Daguerreian Registry*, 3:531; Kelbaugh, *Directory of Maryland Photographers*, 49–50; Ries and Ruby, *Directory of Pennsylvania Photographers*, 257.

SMITH, VALERIA BARBER (b. 1911): active 1929–1940s; with Alexander's Studio, Salisbury (1929–1934, 1936–1946); with Harris & Ewing, Washington, D.C. (1934–1936).
SOURCE: Photographic Examiners Records.

SMITH, W. E.: active 1885, Asheville; engaged in picture enlarging.
SOURCE: *Asheville Citizen*, July 27, 1885.

SMITH, WILEY F. (b. ca. 1861): native of N.C.; active as itinerant in High Point (by 1910).
SOURCE: Thirteenth Census, 1910: Guilford County, Pop. Sch., High Point Township, E.D. 115.

SMITHEY, SHERMAN BRYAN, JR. (1917–1971): native of N.C.; active late 1930s, early 1940s, with Wootten-Moulton Studio, Chapel Hill; may have operated firm's studio at Fort Bragg during World War II.
SOURCE: information provided by Bryan T. Smithey, Warrenton.

SMOKY MOUNTAIN PHOTO COMPANY: active 1930–1940s, Waynesville; William R. Kirkland, proprietor.
SOURCE: Photographic Examiners Records.

SMYER, SALLY JANE (Miss) (1896–1985): purchased Scott's Studio, Newton, Oct. 1934, and sold it in Apr. 1936.

SOURCES: Photographic Examiners Records; *www.familysearch.org.*

SNOW, _____: active 1904, Zorah (Craven County).

SOURCE: *New Bern Weekly Journal,* Sept. 16, 1904.

SNOW, W. H.: active 1916–1919; in Mount Airy (1916); at Round Peak (Surry County) (1919).

SOURCE: State Auditor's Records, Sch. B.

SNYDER, GEORGE H.: active late 1880–1890s, Franklin, in partnership with H. G. Trotter; also sold musical instruments in late 1880s.

SOURCE: *Mercantile Agency Reference Book,* 1890.

SOLESBEE, WALTER (1902–1974): active 1935–1940s, Laurinburg.

SOURCES: Photographic Examiners Records; *Mercantile Agency Reference Book,* 1943; *www.familysearch.org.*

SOLOMAN, BENNIE T.: active early 1900s, Person County.

SOURCE: Person County Museum, Roxboro.

SOMER, W. T.: active 1919–1920, Reidsville.

SOURCE: State Auditor's Records, Sch. B.

SOPER, W. A. (b. 1861): native of Pa.; active early 1900s, Clyde.

SOURCES: photograph bearing his name, in possession of Jerry R. Roughton, Kenansville; *www.familysearch.org.*

SORRELL, W. B.: active 1910–1915, Chapel Hill and Wilkes County; also worked as jeweler and optician.

SOURCES: *N.C. Year Book,* 1910–1916; photograph of store and post office at Milberry Gap, Wilkes County, in possession of Jerry R. Roughton, Kenansville.

SOUTH, HARVEY W.: active 1912–1916, Charlotte; operated The Photo Shop in association with Jonathan C. Cushman; William M. Morse purchased shop (ca. 1920).

SOURCES: *N.C. Year Book,* 1914–1916; information provided by Shelia Bumgarner, Public Library of Charlotte and Mecklenburg County.

SOUTHERN PHOTO STUDIO: active 1918–1920, Winston-Salem; J. Green Shelton, proprietor (1918); Joseph E. Tyson, likewise proprietor in 1918.

SOURCES: *Winston-Salem Directory* 1918, 1920; State Auditor's Records, Sch. B; information from the files of MESDA.

SOUTHERN STUDIOS: of Danville, Va.; active 1941 and afterward; Thomasville; L. Wilkins Davis, proprietor; Donald H. Forbes worked for studio (early 1940s).

SOURCES: *Miller's Thomasville, North Carolina City Directory, 1941–42;* Photographic Examiners Records.

SOYAK, J.: active 1921, Asheville.

SOURCE: Photographic Examiners Records.

SPAINHOUR, JOSEPH F., JR. (1898–1982): active (licensed but did not practice) 1935–1938, Morganton; died in Tenn.

SOURCES: Photographic Examiners Records; *www.familysearch.org.*

SPARKS, W. C.: active ca. 1918, Camp Greene; photographer for Atlanta *Georgian* and Sunday *American;* received permission to take photographs at the camp.

SOURCES: National Army Camps, Camp Greene, Charlotte, N.C., RG 393, Box 20, National Archives; information provided by Jane Johnson, Charlotte.

SPARROW, EDWARD DURWOOD (1899–1964): native of N.C.; active in Kinston (1919) and Lumberton (1938); perhaps was same Mr. Sparrow(e) who took photographs of state prison for State Highway Department, ca. 1920s–1930s.

SOURCES: State Auditor's Records, Sch. B; Baldwin, *Lumberton City Directory, 1938;* photographs of state prison (ca. 1920s) bearing his name, in possession of A. S. Woodlief, Franklinton; *www.familysearch.org.*

SPAULDING, JOHN H. (b. 1874): native of Va.; active by 1900, Warsaw.

SOURCE: Twelfth Census, 1900: Duplin County, Pop. Sch., Warsaw, E.D. 119.

SPEAR, JAMES OTIS, JR. (1914–1977): active 1931–1940s; in Winston-Salem (1931–1933) in association with John J. Hitchcock; in Danville, Va. (1939 and afterward) in association with J. Raymond Hitchcock; failed photographer's exam in 1941 and 1943 and therefore was operating without a license; died in Va.

SOURCES: Photographic Examiners Records; *www.familysearch.org.*

SPEARMAN, ROY A. (1893–1966): active 1927–1933 with Industrial Photo Service, Inc., High Point; died in Ga.

SOURCES: Photographic Examiners Records; Miller, *High Point Directory,* 1927–1931; *Hill's High Point Directory,* 1933; *www.familysearch.org.*

SPEARS BROTHERS: active 1912, Weldon.

SOURCE: information provided by a resident of Weldon.

SPENCER, J. W.: active 1888–1902; paid license tax to practice in Alleghany County (1888); paid license tax to practice in Sparta (1901–1902).

SOURCE: Registry of Licenses to Trade, Alleghany County, 1874–1906 (A&H).

SPENCER, JOHN E. (b. 1865): native of Md.; active by 1898–1950s; in Rockingham (by 1898–ca. 1912); in Bennettsville, S.C. (ca. 1913–1950s); published postcard views and processed Kodak film.

SOURCES: Twelfth Census, 1900: Richmond County, Pop. Sch., Rockingham, E.D. 88; *Mercantile Agency Reference Book*, 1904; *N.C. Year Book*, 1914; Teal, *Partners with the Sun*, 220.

SPILLMAN, JOHN, SR. (1871–1951): native of N.C.; active ca. 1895–1940s; in Wilmington (1901–1940s); outdoor photographer (1910); operated Camera Shop by 1918; father of John Spillman Jr.

SOURCES: Photographic Examiners Records; Thirteenth Census, 1910: New Hanover County, Pop. Sch., Wilmington, E.D. 93; State Auditor's Records, Sch. B; Fourteenth Census, 1920: New Hanover County, Pop. Sch., Wilmington, E.D. 100; *Mercantile Agency Reference Book*, 1943; Vital Records, death certificates, Book 18, p. 502 (A&H); *Wilmington Morning Star*, Feb. 1, 1951.

SPILLMAN, JOHN, JR. (1903–1995): native of N.C.; active 1919–1940s with Camera Shop, Wilmington; son of John Spillman Sr.

SOURCES: Photographic Examiners Records; *Hill's Wilmington Directory*, 1926–1940; Fifteenth Census, 1930: New Hanover County, Pop. Sch., Wilmington, E.D. 65-15; *www.familysearch.org*.

RIGHT: In 1911 J. B. Spilman photographed this steam engine passenger train "Climbing the Blue Ridge" near Bluemont in Buncombe County. Postcard courtesy Durwood Barbour, Raleigh.

SPILMAN, J. B.: active 1911, western N.C.; published real-photo postcards of mountain scenes near Bluemont and Swannanoa Tunnel; also took photographs of waterfalls.

SOURCES: postcard bearing his name; information provided by Carol Johnson, Library of Congress, Washington, D.C.

SPIVEY, MARTIN LUTHER (b. 1860s): active early twentieth century, Lee County.

SOURCE: information provided by Lee County Genealogical and Historical Society, Sanford.

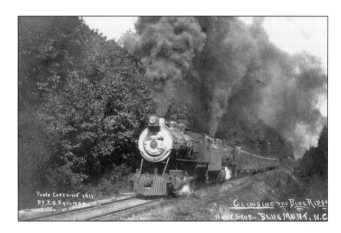

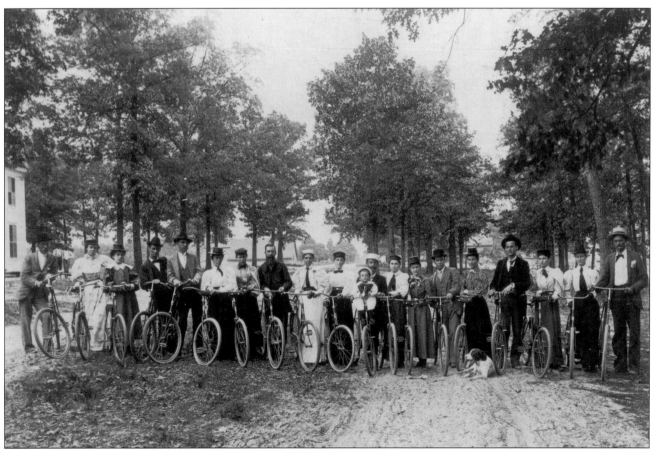

These "bicyclists of Laurinburg" and a canine friend posed in a road for the camera of Rockingham operator John E. Spencer in 1898. Photograph courtesy A&H.

SPOLTON, ARTHUR: active ca. 1918, Camp Greene; associated with Miller Studio, Cleveland, Ohio; received permission to take photographs at the camp.

SOURCES: National Army Camps, Camp Greene, Charlotte, N.C., RG 393, Box 20, National Archives; information provided by Jane Johnson, Charlotte.

SPRAGUE, THOMAS H.: active ca. 1918, Camp Greene; minister with Baptist War Service, Charlotte; received permission to take photographs at the camp.

SOURCES: National Army Camps, Camp Greene, Charlotte, N.C., RG 393, Box 20, National Archives; information provided by Jane Johnson, Charlotte.

SPRING HOPE PHOTO COMPANY: active 1903, Spring Hope; Thomas H. Hester and a Mr. Batton, proprietors.

SOURCE: *N.C. Year Book*, 1903.

SPROUSE, WALTER CLAYTON (1903–1972): active 1925–1940s, Monroe; with W. A. Davis (1925–1928); sole proprietor (1928–1940s); with Dixie Photo Studios (1940s).

SOURCES: Photographic Examiners Records; *www.familysearch.org*.

ST. JOHN, HARRIETT (b. ca. 1891): native of Ga.; active by 1930–1941; in High Point (1930); with St. John Studio, E. Trade St., Charlotte (1938–1941); wife of Irving St. John.

SOURCES: Fifteenth Census, 1930: Guilford County, Pop. Sch., Greensboro, E.D. 41-54; *Hill's Charlotte Directory*, 1938–1941.

ST. JOHN, IRVING (b. 1890): native of Ill.; active 1915–1940s; operated studios outside N.C. until late 1920s; in Birmingham, Ala. (1923–1926); manager, Carolina Photo Studio, Gastonia (1927–1928); in High Point (1930); owned St. John Studio at Belk's stores in Columbia and Florence, S.C. (1930s); at Belk's in Charlotte (1936–1940s) (Howard C. Simpson, operator); at Belk's in Asheville (1937) (Madelon M. Peters, manager); manager of St. John Studio, Belk's Department Store, Greensboro (branch of St. John Studio of Charlotte), with Maurice H. Scott as operator (early 1940s); husband of Harriet St. John.

SOURCES: Photographic Examiners Records; *Gastonia Directory*, 1927–1928; Fifteenth Census, 1930: Guilford County, Pop. Sch., Greensboro, E.D. 41-54; *Miller's Asheville Directory*, 1937; *Hill's Charlotte Directory*, 1938–1941; *Mercantile Agency Reference Book*, 1943; Robb list of Ala. photographers.

STANBACK, CHARLES R.: African American; active 1940 and afterward as operator of Rudolph Reuben Studios, Fayetteville St., Durham.

SOURCE: *Hill's Durham Directory*, 1941.

STANFIELD, C.: active 1919, Roxboro.

SOURCE: State Auditor's Records, Sch. B.

STANTON, W. D.: photographed construction of Blue Ridge Parkway, 1936–1941.

SOURCE: Blue Ridge Parkway Photograph Collection (A&H).

STAPLES, WILLIAM F. (b. ca. 1848): native of N.C.; itinerant; active 1868–1892; in Oxford (1868–1869); in Tarboro (by 1870–1871) in Fayetteville (1871, 1873) in gallery on Person St.; in Lumberton (1872); in Wilson (1875) in gallery located one door east of hardware store; in Mobile, Ala. (ca. 1874); in Meridian, Miss. (mid-1870s); in Atlanta, Ga. (1876); in Selma, Ala. (ca. 1878); in Dallas, Tex. (1880–1882); in Terre Haute, Ind. (1883–1884); in Indianapolis, Ind. (1886–1890); again in Dallas, Tex. (1889–1892); in Nashville, Tenn. (1890).

SOURCES: *Semi-Weekly Index* (Henderson), Feb. 9, 1869; Ninth Census, 1870: Edgecombe County, Pop. Sch., Tarboro; *Tarboro Southerner*, Apr. 6, 1871; *Eagle* (Fayetteville), Oct. 19, 1871; *Robesonian* (Lumberton), June 20, Nov. 20, 1872; *North Carolina Presbyterian* (Fayetteville), July 23, 1873; *Little Jewel* (Wilson), May 27, 1875; Haynes, *Catching Shadows*, 106; Robb list of Ala. photographers; Marusek list of Ind. photographers.

STAR STUDIO: active ca. 1900, Market St., Wilmington; Edward R. Ellis, operator.

SOURCES: *Wilmington, N.C. City Directory, 1900*; photograph bearing studio name.

STARRETT, ALEXANDER (b. ca. 1807): native of N.C.; daguerreotyper; active 1848–1857, Greensboro; operated Starrett's Daguerrean Gallery in rooms located at Gott's hotel (1848); later (1852–1856) situated opposite Bland House; occupied rooms above Garrett's store (1857); began offering ambrotypes in 1856 and melainotypes in 1857; also worked as a saddler in 1850; by 1880, resided in Mo. and worked as a farmer.

SOURCES: Rinhart and Rinhart, *The American Daguerreotype*, 410; *Greensborough Patriot*, Aug. 19, 1848, May 1, July 3, Oct. 16, 1852, Jan. 1, Oct. 1, 29, 1853, July 20, 1855–Dec. 26, 1856; *Greensborough Patriot and Flag*, May 8, 1857; Seventh Census, 1850: Guilford County, Pop. Sch., Northern Division; *www.familysearch.org*.

STATON, R. B.: active 1910s, Saluda, in partnership with a Mr. Hill (1916).

SOURCES: *N.C. Year Book*, 1916; postcard view (of railroad tracks near Saluda) bearing his name.

STAYNER, LUCIEN M. (b. ca. 1835): native of N.H.; active 1860s in New Bern in partnership with O. J. Smith (early 1860s) as Union Photo Rooms; may have worked in Newport, R.I., during Civil War; in Leominster, Mass. (1868); 1870 census lists a man by his name as a farmer in Craven County; by 1880, resided in R.I., where he manufactured flypaper.

SOURCES: Witham, *Catalogue of Civil War Photographers*, 75; Polito, *A Directory of Massachusetts Photographers*, 306; Ninth Census, 1870: Craven County, Pop. Sch., Township # 7; portrait photograph, New Bern, ca. 1865, bearing his name; *www.familysearch.org*.

STEELE, ROCKWELL L. (1864–1890): active 1885–1890, Statesville.

SOURCES: Cotten list of N.C. photographers; *Landmark* (Statesville), May 22, 1890; Iredell County Estates Records (A&H); WPA Cemetery Index (A&H).

STEELE, WALTER RAYMOND (1915–1983): active 1940s, Morganton; with Walter Greene (1941 and afterward); active postwar.

SOURCES: Photographic Examiners Records; *Mercantile Agency Reference Book*, 1943; *www.familysearch.org.*

STEELMAN, JAMES D. (b. ca. 1878): native of N.C.; active by 1930, Winston-Salem.

SOURCE: Fifteenth Census, 1930: Forsyth County, Pop. Sch., Winston-Salem, E.D. 34-33.

STEPHENS STUDIO: active 1928–1931, High Point; Stephen Economy, operator.

SOURCE: Miller, *High Point Directory*, 1928–1931.

STEPHENSON, S. B.: active 1891–1893, Monroe, in association with Robert F. Shelby.

SOURCE: Photographic Examiners Records.

STEPHENSON, VICTOR S. (1890–1950): native of N.C.; active 1920–1950, Asheville; first official staff photographer for *Asheville Citizen* (early 1920s).

SOURCES: Photographic Examiners Records; Miller, *Asheville, N.C. City Directory*, 1920–1932, 1940–1941; *Mercantile Reference Book*, 1931; *Mercantile Agency Reference Book*, 1943; information provided by staff of Pack Memorial Public Library, Asheville; *Asheville Citizen*, Feb. 1, 1950.

STEPP, GUSSIE (b. ca. 1882): native of Pa.; active 1927–1931, Asheville; operated Ray's Studio, Pack Square, in association with sister, Pearl Stepp.

SOURCES: *Miller's Asheville Directory*, 1927–1931; Fifteenth Census, 1930: Buncombe County, Pop. Sch., Asheville, E.D. 11-25.

STEPP, PEARL (b. ca. 1878): native of Pa.; active 1927–1931, Asheville; operated Ray's Studio; Pack Square, in association with sister, Gussie Stepp.

SOURCES: *Miller's Asheville Directory*, 1927–1931; Fifteenth Census, 1930: Buncombe County, Pop. Sch., Asheville, E.D. 11-25.

STERTZBACH, WILLIAM(?) (b. 1877): native of Ohio; active ca. late 1890s–1920s; on Tryon St., Charlotte (1890s); probably the William Stertzbach who operated studio in Portsmouth, Va., 1906–1928.

SOURCE: information provided by Shelia Bumgarner, Public Library of Charlotte and Mecklenburg County.

STEVENS, JOSEPH HOWARD (1912–1997): native of N.C.; active 1938–1980s, Elizabeth City; operated Stevens' Photo Service (postwar years); negatives housed at the genealogy library in Elizabeth City (1997); died in Washington, D.C.

SOURCES: Photographic Examiners Records; information provided by Brenda O'Neal, Museum of the Albemarle, Elizabeth City; *www.familysearch.org.*

STEVENS, VICTOR: active 1911–1921, Sanford and Carthage (1911), in partnership with William H. Dyer; in Wilmington (1921), also in partnership with Dyer.

SOURCES: *Sanford Express*, Feb. 17, Mar. 17, 1911; State Auditor's Records, Sch. B.

STEWART, GEORGE W. (b. ca. 1849): native of Miss.; active 1880–early 1900s; in Raleigh (1880) as operator of New York Photograph Gallery; in Montpelier, Ind. (1895); in Chicago (1895–1896); in Hartford City, Ind. (1899–1904).

SOURCES: Tenth Census, 1880: Wake County, Pop. Sch., Raleigh (Southwest Division), E.D. 268; *Charles Emerson & Company's Raleigh Directory, 1880–'81*, 175; Murray list of Wake County photographers; Marusek list of Ind. photographers.

STEWART, LETITIA (MARTISHA?) (b. ca. 1885): native of N.C.; African American; shown in 1910 census as "photographer" in Greensboro; possibly also worked as a cook.

SOURCES: Thirteenth Census, 1910: Guilford County, Pop. Sch., Greensboro, E.D. 104; Hill, *Greensboro Directory*, 1909–1910, 1912–1913, 1913–1914; information provided by Tim Cole, Greensboro.

STEWART, THEODORE WALTER (1875–1939): active ca. 1900–1939 in Hendersonville (1935–1939); operated studios in Fla. during winters.

SOURCES: Photographic Examiners Records; *Hendersonville City Directory, 1937–'38*; *Miller's Hendersonville City Directory, 1939–'40*; Vital Records, death certificates, Book 2184, p. 12 (A&H).

STEWART, VERNON A.: active 1938–1939, Broadway St., Asheville.

SOURCE: *Miller's Asheville Directory*, 1938–1939.

STILES, WILLIAM J. B. (b. ca. 1862): native of N.C.; resided in S.C. as early as 1903; active 1913–1921; in Spartanburg, S.C. (1913); in Newton, N.C. (1919–1921).

SOURCES: Teal, *Partners with the Sun*, 249; State Auditor's Records, Sch. B; Fourteenth Census, 1920: Catawba County, Pop. Sch., Newton, E.D. 47.

STILL, WILBERT W.: active 1909, S. Main St., Asheville.

SOURCES: Miller, *Asheville, N.C. City Directory, 1909*; information provided by staff of Pack Memorial Public Library, Asheville.

STIMSON, BENJAMIN ALSTON (1893–1969): native of N.C.; active ca. 1905–1960s, Statesville; learned profession from his father and studied at Eastman School of

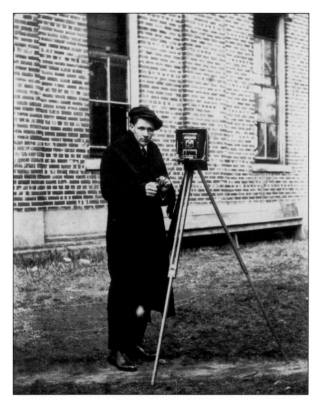

Benjamin A. Stimson of Statesville poses here with his tripod-mounted camera on a chilly day in the 1930s. Photograph courtesy A&H.

Photography; associated with Stimson Studio (1905–1960s); head of studio from late 1920s to 1960s; operated studio in Lenoir (1939–1940); member of National Board of Photographers; son of William J. Stimson; portrait on file at N.C. Office of Archives and History.

SOURCES: Photographic Examiners Records; Twelfth Census, 1900: Iredell County, Pop. Sch., Statesville, E.D. 102; Miller, *Statesville, N.C., City Directory*, 1925–1933, 1938–1941; *Miller's Lenoir City Directory, 1939–'40*; *Mercantile Agency Reference Book*, 1943; Evans, *Iredell County Landmarks*, 149; Miller, *Heritage of Iredell County*, 505–506; *www.familysearch.org*.

STIMSON, WILLIAM JASPER (1860–1929): native of N.C.; active 1880s–1920s; received instruction at Van Ness Studio in Charlotte; in Mitchell County (1884–1885) in partnership with C. W. Davis; in Lenoir (1888–1889); in Statesville (1889–1920s); opened Stimson Studio in gallery formerly occupied by Rockwell L. Steele; father of Benjamin A. Stimson.

SOURCES: Registry of Licenses to Trade, Mitchell County, 1877–1902 (A&H); *Lenoir Topic*, Nov. 16, 1887, Jan. 16, 1889; *Landmark* (Statesville), Oct. 2, 1890, Oct. 28, 1929; Sprange, *Blue Book*, 289; Twelfth Census, 1900: Iredell County, Pop. Sch., Statesville, E.D. 102; *Bradstreet's*, 1908, 1925; *N.C. Year Book*, 1910–1916; Miller, *Statesville, N.C. City Directory*, 1909–1910, 1916–1917, 1922–1923, 1928–1929; State Auditor's Records, Sch. B; Evans, *Iredell County Landmarks*, 149; Miller, *Heritage of Iredell County*, 505–506; Vital Records, death certificates, Book 1357, p. 108 (A&H).

STIREWALT, JOHN (b. 1821): native of N.C., active by 1900, Davidson.

SOURCE: Twelfth Census, 1900: Mecklenburg County, Pop. Sch., Davidson, E.D. 61.

STITZ, GEORGE: of Washington, D.C.; active ca. 1918, Camp Greene; photographer for Syracuse *Herald*; received permission to take photographs at the camp.

SOURCES: National Army Camps, Camp Greene, Charlotte, N.C., RG 393, Box 20, National Archives; information provided by Jane Johnson, Charlotte.

STIWINTER, G. W.: active 1916, Scroll (Macon County).

SOURCE: State Auditor's Records, Sch. B.

STOCKTON, R. F.: of Salem, N.C.; active 1898, Wilmington, representing Chicago Portrait Company.

SOURCES: *Star* (Wilmington), Nov. 9, 1898; Reaves list of Wilmington photographers.

STONE, ANNIE K. (Mrs.): active 1940 with Stone Photo Company, High Point; wife of J. Lee Stone Jr.

SOURCE: *Hill's High Point Directory*, 1940.

STONE, J. LEE (1877–1938): native of N.C.; active 1905–1930s; in Greensboro (1905–1906, 1915–1916) with William J. Moose; in Concord (1908–1910) in partnership with Paul A. Walker (1908) and with a Mr. Shaw (1910); in Mount Airy (1922–1923); in Salisbury (1923–1930s); with Stone Photo Company, High Point (1930s); also operated movie theaters in Hickory, Newton, and Salisbury, and in Ga.; husband of Ruby Stone Yancey.

SOURCES: Hill, *Greensboro, N.C. Directory, 1905–'06*; *Bradstreet's*, 1908; *Concord City Directory*, 1908; *N.C. Year Book*, 1910; Miller, *Salisbury Directory*, 1926–1929; Baldwin, *Salisbury City Directory, 1938*; *Hill's High Point Directory*, 1933; Vital Records, death certificates, Book 2028, p. 18 (A&H); *Greensboro Daily News*, May 29, 1938.

STONE, J. LEE, JR. ("CHARLES") (b. ca. 1912): native of N.C.; active 1930–1940; in Statesville (1930–1931); operated Stone Photo Company, Salisbury (1939–1940); operated Stone Photo Company, High Point (1930s); son of J. Lee Stone and Ruby Stone Yancey; husband of Annie K. Stone.

SOURCES: Fifteenth Census, 1930: Iredell County, Pop. Sch., Statesville, E.D. 49-28; Miller, *Statesville, N.C. City Directory, 1930–'31*; Baldwin, *Salisbury City Directory, 1939–1940*.

STONE, MONTRAVILLE P. (ca. 1847–after 1907); native of N.C.; active 1874–1907; in Hillsborough (1874) in partnership with James M. Dodson in gallery in Berry's building; in Fayetteville (1875–1878) in partnership with Dodson in gallery on Person St.; in Asheboro (1876) in partnership with Dodson; in Cameron (1878) in partnership with B. J. Wicker in gallery located on Carthage St. above Jim McAuley's store; in Carthage (1878) in

tent; in Lexington (1877–1880s); in Monroe (1880); in Greensboro (1887); in Reidsville (1889–1907)—last three locations as sole proprietor.

SOURCES: *Hillsborough Recorder*, June 3, 1874; *Randolph Regulator* (Asheboro), Nov. 15, 22, 1876; *North Carolina Gazette* (Fayetteville), Dec. 21, 1876; *Carthaginian* (Carthage), Mar. 7, June 10, 1878; *Greensboro City Directory for 1887*; Branson, *NCBD*, 1877–78, 1884, 1890, 1896, 1897; Sprange, *Blue Book*, 289; Twelfth Census, 1900: Rockingham County, Pop. Sch., Reidsville, E.D. 81; *N.C. Year Book*, 1902–1907; *Mercantile Agency Reference Book*, 1904; Hill, *Greensboro, N.C. Directory*, 1905–'06; www.familysearch.org.

STONE, ROBERT C. (b. ca. 1850): native of N.C.; active by 1880, Louisburg.

SOURCE: Tenth Census, 1880: Franklin County, Pop. Sch., Louisburg, E.D. 96.

STONER, DOROTHY W.: active 1935–1936, W. Trade St., Charlotte, in partnership with M. Luther Philemon; wife of Robert M. Stoner.

SOURCE: *Hill's Charlotte Directory*, 1935–1936.

STONER, ROBERT M.: active 1925, S. Tryon St., Charlotte; husband of Dorothy W. Stoner.

SOURCES: Miller, *Charlotte Directory*, 1925; George Eastman House Photographers Database.

STOVALL, WILLIE: active 1921, Asheville.

SOURCE: State Auditor's Records, Sch. B.

STRADER, GALVESTON B.: active 1909–1913, Greensboro.

SOURCES: Hill, *Greensboro, N.C. Directory*, 1909–'10; *N.C. Year Book*, 1910–1913.

STRAWBRIDGE, JAMES E. (1894–1964): active 1911–1950s, Durham; leader in school photography.

SOURCES: *Mercantile Agency Reference Book*, 1943; information provided by Kenneth Strawbridge, Durham; www.familysearch.org.

STRINGFELLOW, HENRY B., JR. (b. 1807): native of Ga.; early itinerant daguerreotyper; active 1843–1844; offered colored miniature daguerreotypes; in Fayetteville (1843) in rooms at the Planter's Hotel; in Raleigh (1843–1844) in office above Benjamin B. Smith's store; brother, Dr. L. S. Stringfellow, worked as a dentist out of same office.

SOURCES: *Fayetteville Observer*, June 14, 1843; *Raleigh Register and North Carolina Gazette*, Nov. 25, Dec. 5, 1843; www.familysearch.org.

STRINGFIELD, R. C. active 1930s with College Photo Shop, Mars Hill.

SOURCE: Photographic Examiners Records.

STROUD, W. W.: active 1916–1919, Winston-Salem; in partnership with William G. Russell (1916); with Barber Printing and Stationery Company (1918).

SOURCES: State Auditor's Records, Sch. B; *Winston-Salem Directory*, 1918; information from the files of MESDA.

STUART, _____: active ca. 1880s, Snow Camp.

SOURCE: stereograph bearing his name, in possession of compiler.

STURGIS, WILLIAM FRANK (b. ca. 1840): mulatto; native of N.Y.; active 1870s–1880s; in S.C. (early 1870s); in Durham (1877–1878) as itinerant; in Windsor (1879) as itinerant; in Edenton (1879–1881); moved to Baltimore about Mar. 1881.

SOURCES: State Auditor's Records, Miscellaneous Tax Group (1868–1932), Box 3, Artists' and Photographers' Privilege Licenses, 1877–1887 (A&H); Tenth Census, 1880: Chowan County, Pop. Sch., Edenton, E.D. 31; Chowan County Deed Records, Book W, p. 571, Book Y, p. 124 (A&H).

SUGG, J. C.: itinerant; active 1857, Salisbury; occupied rooms at Boyden's brick building, opposite Robard's hotel.

SOURCE: *Carolina Watchman* (Salisbury), July 21, 1857.

SUMMERS, LOUIS: itinerant; active one day (Oct. 21, 1911), Durham; obtained photographer's license in connection with snake show.

SOURCE: Registry of Licenses to Trade, Durham County, 1881–1913 (A&H).

SUMNER, HENRY: active 1921–1922, Charlotte.

SOURCE: State Auditor's Records, Sch. B.

SUSSDORFF, CHRISTAIN FREDERICK (ca. 1807–1886): native of Germany; active 1844–1850s; daguerreotyper by 1844, Salem; operated magic lantern and stereopticon lantern in early 1850s; took show on road to Raleigh and other locations.

SOURCES: *Raleigh Register* (semi-weekly), Apr. 26, 30, 1851; *People's Press* (Salem), July 22, 1886; Forsyth County Wills (A&H); information provided by Jennifer Bean Bower, MESDA.

SWIFT, GEORGE W.: native of N.Y.; active ca. 1870s–1880s; in Jacksonville, Fla. (1880); in Denver, Colo. (date unknown); in Raleigh (1883–1887) as Swift's Art Studio, Fayetteville St.; purchased studio of H. F. Maneely, Dec. 1883; in Mobile, Ala. (1888–1889).

SOURCES: *Historical and Descriptive Review*, 95–96; Branson, *NCBD*, 1884; *Raleigh City Directory*, 1886, 21, 125; Murray list of Wake County photographers; Robb list of Ala. photographers; Rinhart and Rinhart, *Victorian Florida*, 213.

SWINDELL, _____: active 1870s; obtained license to practice (1873–1874) in Hyde County in partnership with a Mr. Newcombe; also in Greenville (ca. 1870s), likewise in partnership with Newcombe as proprietors of Swindell & Newcombe Art Gallery.

SOURCES: Treasurer's and Comptroller's Records, County Settlements with the State, Box 52, Hyde County (A&H); information provided by Roger Kammerer, Greenville.

SYKES, S. Y. (b. 1867): native of Va.; active by 1900, Salisbury.

SOURCE: Twelfth Census, 1900: Rowan County, Pop. Sch., Salisbury, E.D. 116.

T

TALLEY, J. S.: active 1919, Troutman (Iredell County).

SOURCE: State Auditor's Records, Sch. B.

TALLEY, LAURA (Miss): active 1916–1930, Durham; operated Talley Studio.

SOURCES: State Auditor's Records, Sch. B; Record of Special Licenses Issued, Durham County, 1914–1916, 1917–1918 (A&H); *Mercantile Reference Book*, 1931.

TALLEY, MARION J.: active 1930s with Hollywood Studio, Goldsboro; charged with operating without a photographer's license.

SOURCE: Photographic Examiners Records.

TALLY, _____: itinerant; active (paid tax to practice) 1886–1887, Durham, in partnership with a Mr. Keller.

SOURCE: State Auditor's Records, Ledgers, 1869–1899, Vol. 18, p. 258 (A&H).

TANNER, HENRY S., JR.: itinerant daguerreotyper; active 1852–1876; in Hillsborough (1852); occupied rooms at Orange County Courthouse; operated Tanner's Daguerrean Gallery in New York City (1853); in Erie, Pa. (1854–1855); in Lynchburg, Va., during Civil War and through 1867 in partnership with John I. Van Ness; sole proprietor in Lynchburg (1873–1876).

SOURCES: *Hillsborough Recorder*, Dec. 15, 1852; Rinhart and Rinhart, *The American Daguerreotype*, 411; Witham, *Catalogue of Civil War Photographers*, 83; *Craig's Daguerreian Registry*, 3:555; Ginsberg, *Photographers in Virginia*, 14; Ries and Ruby, *Directory of Pennsylvania Photographers*, 273.

TAR HEEL CAMERA SHOP: active 1934–1938, Goldsboro; Herbert A. Biggs, proprietor.

SOURCES: *Hill's Goldsboro Directory*, 1934; *Baldwin's Goldsboro Directory*, 1938.

TARBELL, JOHN H. (1849–after 1907): native of Mass.; active ca. 1896–1901, S. Main St., Asheville; left Asheville after 1901; living in New England by 1907; photographed southern African Americans and Biltmore, near Asheville; a collection of his photographs is housed at the Library of Congress, Washington, D.C.

SOURCES: Cotten list of N.C. photographers; Twelfth Census, 1900: Buncombe County, Pop. Sch., Asheville, E.D. 133; Maloney, *Asheville, N.C. City Directory, 1900–'01*; information provided by Carol Johnson, Library of Congress, Washington, D.C.

TARBORO PHOTOGRAPH AND PEARLTYPE GALLERY: active 1871–1872, Tarboro; Ernest C. Leath, operator.

SOURCE: *Enquirer* (Tarboro), Dec. 9, 1871.

TATE, EDITH WINIFRED (1902–1996): native of Va.; active 1932–after 1941, Montreat; attended Clarence White School of Photography in New York City; created portraits and landscapes in pictorialist style.

SOURCE: information provided by Peggy Gardner, Asheville.

TATEM, GEORGE WASHINGTON: active 1849, Elizabeth City; occupied room located above J. Grandy's store on Road St.

SOURCE: *Old North State* (Elizabeth City), June 16, 1849.

TAYLOR, A. D.: active 1872, 1875, Morgan St., Raleigh.

SOURCES: Branson, *NCBD*, 1872; *Zell's U.S. Business Directory*, 1875.

TAYLOR, ETHEL (b. ca. 1885): native of N.C.; active 1919–1930; in Scotland Neck (1919); in Ahoskie (by 1930).

SOURCES: State Auditor's Records, Sch. B; Fifteenth Census, 1930: Hertford County, Pop. Sch., Ahoskie, E.D. 46-1.

TAYLOR, HERBERT LOUIS (1902–1970): native of Washington, D.C., area; active late 1930s–1940s, Greensboro; operated Taylor-Ames Studio in partnership with Edgar D. Ames; died in Fla.

SOURCES: Photographic Examiners Records; *Hill's Greensboro Directory*, 1941; *www.familysearch.org*.

TAYLOR, JAMES PENDER (1859–1927): native of N.C.; active ca. 1895–1916; in Faulkland (ca. 1895); itinerant at Five Points, Greenville, across from Dr. Moye's office (1899); in Farmville (by 1900–1916).

SOURCES: Sprange, *Blue Book*, 289; Twelfth Census, 1900: Pitt County, Pop. Sch., Farmville, E.D. 91; *Eastern Reflector* (Greenville), May 16, 1899; *N.C. Year Book*, 1916; Vital Records, death certificates, Book 1099, p. 118 (A&H).

TAYLOR, JOHN B.: itinerant; active 1890s–1940s; in Maxton (1893); in Carthage (1893) in photographic tent located on courthouse square; in Hamlet (1922–1924, 1936); in Valdese (ca. 1925–1940s); father of Mrs. Lumis A. Williams.

SOURCES: *Carthage Blade*, Oct. 3, 24, 1893; Photographic Examiners Records.

TAYLOR, NATHANIEL W. ("NAT") (1852–1904): native of Tenn.; father, Nathaniel G. Taylor, represented Tenn. in Congress; Nat Taylor's brothers—Robert L. Taylor and Alfred A. Taylor—served as governors of Tenn.; studied art and photography in New York; active late 1870s–early 1900s; noted stereographic artist; at Catawba Springs (1878), in partnership with John F. Engle; in Asheville (by 1880–early 1900s) in studio opposite Eagle Hotel; operated one of the best-equipped photographic

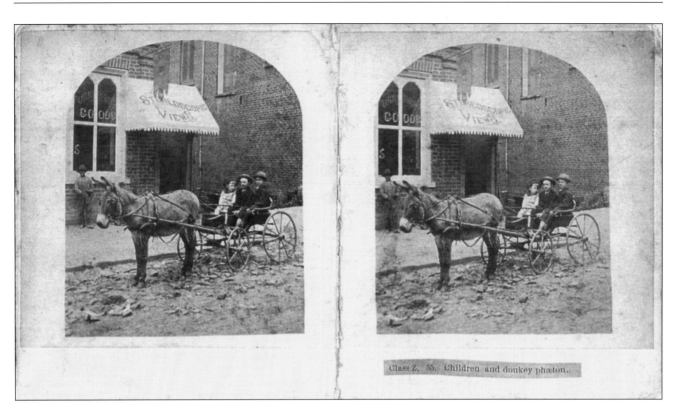

Class Z, 55. Children and donkey phaeton.

ABOVE: This stereograph (early 1880s) of the front of Nat W. Taylor's studio in Asheville features three children seated in a donkey-powered phaeton. **BELOW:** The three-story brick building in Asheville pictured here served as Buncombe County's sixth courthouse between 1876 and 1903. Taylor made this ground-level photograph in the 1880s. Both photographs courtesy Pack Memorial Public Library, Asheville.

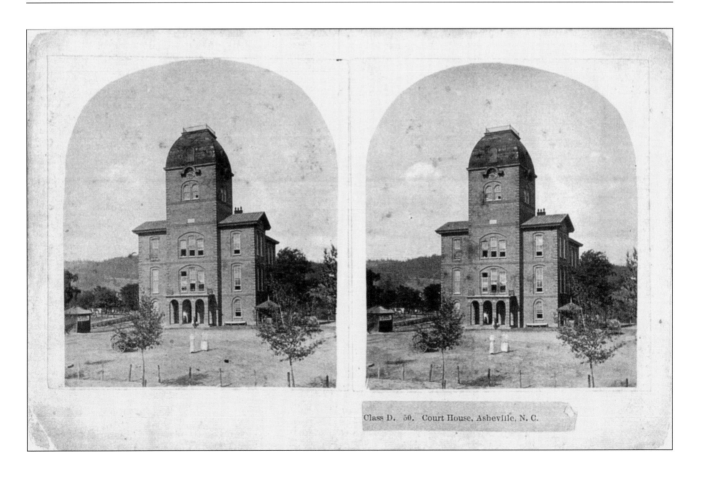

Class D. 50. Court House, Asheville, N. C.

galleries in the state; in partnership with G. W. Jones (1881); in partnership with J. H. Folsom (1883–1884); in partnership with C. W. Bartlett (1884); in partnership with John H. Gibson (1885); in Salisbury (1886) in gallery located in Crawford Building; in Wilmington (1888–1889) as operator of Yates' Gallery; in Spartanburg, S.C. (ca. 1890s); in Elk Park (ca. 1895); retired because of poor health in early 1900s.

SOURCES: *Daily Nut Shell* (New Bern), Aug. 13, 1878; Tenth Census, 1880: Buncombe County, Pop. Sch., Asheville, E.D. 34; name on numerous stereographs with various partners; *Chataigne's N.C. Directory and Gazetteer, 1883–'84*; Branson, *NCBD*, 1884; Davidson, *Asheville, N.C. City Directory, 1883–'84*; State Auditor's Records, Ledgers, 1869–1899, Vol. 17, p. 614; Vol. 18, p. 135 (A&H); *Carolina Watchman* (Salisbury), Dec. 17, 1885, Jan. 7, Mar. 11, 1886; *Star* (Wilmington), Dec. 25, 1888; *Messenger* (Wilmington), Feb. 8, 1889; Teal, *Partners with the Sun*, 208; Sprange, *Blue Book*, 289; *News and Observer* (Raleigh), Aug. 24, 1899; Taylor, Taylor, and Taylor, *Life and Career of Senator Robert Love Taylor*, 11–12, 27–29; Field, *Cemeteries of Carter County, Tennessee*, 309; Massengill, *Western North Carolina*, 37–54; Reaves list of Wilmington photographers; Darrah, *World of Stereographs*, 208.

TAYLOR, PAUL M. (b. 1871): native of N.C.; active ca. 1899–1909, Wilmington; operated gallery located at corner of Front and Princess Streets; slogan was "City By The Sea, Tarheel State"; active in Photographers' Association of Virginia and North Carolina; by 1909 had located at Norfolk, Va.

SOURCES: Twelfth Census, 1900: New Hanover County, Pop. Sch., Wilmington, E.D. 70; *N.C. Year Book*, 1902, 1903; *Dispatch* (Wilmington), Sept. 19, 1899, Aug. 18, 1902, July 13, 1909; *Messenger* (Wilmington), July 2, Nov. 1, 1901; Reaves list of Wilmington photographers.

TAYLOR, REUBEN H.: active 1919–1920, Raleigh.

SOURCE: State Auditor's Records, Sch. B.

TAYLOR, WALTER: active 1922–1928; in Henderson (1922); operated Gem Studio on Fayetteville St., Raleigh (1925–1928), in partnership with C. E. Smith (1928).

SOURCES: State Auditor's Records, Sch. B; Hill, *Raleigh Directory*, 1925–1928; Murray list of Wake County photographers.

TEACHEY, ELMA (Miss) (1903–1990): active 1929–1940s with Adams' Studio, Wilmington.

SOURCES: Photographic Examiners Records; *www.familysearch.org*.

TEAGUE, GEORGE (b. ca. 1854): native of N.C.; active early 1880s as itinerant; in Lexington (1880) and Winston (early 1880s) in association with Edward F. Small (building that housed their studio in Winston was destroyed by fire in Jan. 1882); in Graham (1880–1881) in partnership with M. Charles Henley.

SOURCES: Tenth Census, 1880: Davidson County, Pop. Sch., Lexington Township, E.D. 34; State Auditor's Records, Miscellaneous Tax Group (1868–1932), Box 3, Artists' and Photographers' Privilege Licenses, 1877–1887 (A&H); newspaper clipping dated Jan. 1882 from Forsyth County Public Library, Winston-Salem; information provided by Jennifer Bean Bower, MESDA.

TEAGUE, HEWLETTE (HUELETTE) MORAN (1870–1949): native of N.C.; active ca. 1895–1940, Lenoir; also a city commissioner in Lenoir.

SOURCES: Photographic Examiners Records; *Lenoir Topic*, Jan. 29, 1908; *Bradstreet's*, 1908, 1917, 1921, 1925; *Mercantile*

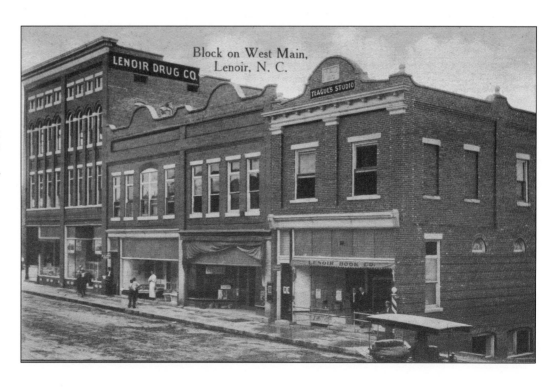

This town scene of Lenoir (ca. 1912) includes the building (at right) that housed the photography studio of Hewlette M. Teague. Teague's business was located on the second floor, above the Lenoir Book Company. Postcard courtesy Durwood Barbour, Raleigh.

Reference Book, 1931; *Mercantile Agency Reference Book*, 1943; *N.C. Year Book*, 1910–1916; State Auditor's Records, Sch. B; Fourteenth Census, 1920: Caldwell County, Pop. Sch., Lenoir, E.D. 68; Miller, *Lenoir, N.C. City Directory*, 1930–'31, 1937–1940; *Caldwell County, North Carolina Cemeteries*, 1:115; Vital Records, death certificates, Book 24B, p. 700 (A&H); *Lenoir News-Topic*, Nov. 22, 1949.

TEHLMAN (TILLMAN), I.: active 1919, Raleigh.

SOURCE: State Auditor's Records, Sch. B.

TESH, C. W.: active 1916–1921, Winston-Salem.

SOURCE: State Auditor's Records, Sch. B.

TESH, CHARLES L. (b. 1882); native of N.C.; active 1903–1907, Reidsville, in partnership with brother, James F. Tesh, as Tesh Brothers; son of James M. Tesh.

SOURCES: Twelfth Census, 1900: Rockingham County, Pop. Sch., Reidsville, E.D. 81; *N.C. Year Book*, 1903–1907.

TESH, JAMES F. (b. 1875): native of N.C.; active 1903–1907, Reidsville, in partnership with brother, Charles L. Tesh, as Tesh Brothers; son of James M. Tesh.

SOURCES: Twelfth Census, 1900: Rockingham County, Pop. Sch., Reidsville, E.D. 81; *N.C. Year Book*, 1903–1907.

TESH, JAMES M. (1845–1936): native of N.C.; served as a corporal in Company D, Fifty-Third Regiment, N.C. State Troops; active ca. 1866–1873; in Davidson County (ca. 1866); in Stokes County (by 1870); in Danbury (1870–1872); also listed as watchmaker; gallery and shop located in post office above medical office of Dr. McCanless; in Madison (1873) in gallery located above *Enterprise* office; also worked as watchmaker and jeweler; by 1875 had moved to Reidsville and worked primarily as a watchmaker and jeweler; by 1900 worked as a jeweler and optician; father of Charles L. Tesh and James F. Tesh.

SOURCES: Manarin and Jordan, *N.C. Troops*, 13:108; Treasurer's and Comptroller's Records, County Settlements with the State, Davidson County, Box 37, ca. 1866 (A&H); Ninth Census, 1870: Stokes County, Pop. Sch., Meadows Township; Twelfth Census, 1900: Rockingham County, Pop. Sch., Reidsville, E.D. 81; *Old Constitution* (Danbury), June 3, 1870; *Danbury Reporter*, Mar. 21, 1872; *Madison Enterprise*, June 4, 1873; Rockingham County Wills, Book H, p. 195 (A&H).

THAXTON, _____: active 1915–1940s, Gastonia, (1915–1916), in partnership with Robert F. Shelby; in Rock Hill, S.C. (early 1920s–1940s); Lillian F. Thaxton managed the studio in 1930s.

SOURCES: *N.C. Year Book*, 1915; Teal, *Partners with the Sun*, 248.

THOMAS, _____: active late nineteenth century, Burlington, in partnership with a Mr. Zachary.

SOURCE: photograph bearing name "Thomas."

THOMAS, J. W.: active 1897–1898, E. Main St., Durham, in partnership with a Mr. Hobgood (late 1890s);

Oliver W. Cole and Waller Holladay purchased the studio in Sept. 1898.

SOURCES: *Mangum's Directory of Durham and Suburbs, 1897*, 42, and ad between pp. 112 and 113; photograph bearing names of Thomas and Hobgood; *Durham Recorder*, Jan. 19, 1899.

THOMAS, JOHN HENRY: active 1919, Snow Hill.

SOURCE: State Auditor's Records, Sch. B.

THOMAS, L. F.: active (obtained license to practice) 1911–1912, Durham.

SOURCE: Registry of Licenses to Trade, Durham County, 1881–1913 (A&H).

THOMAS, W. H.; active (obtained license to practice) 1883–1884, Person County.

SOURCE: Registry of Licenses to Trade, Person County, 1877–1901 (A&H).

THOMAS, WILLIAM E. (b. 1875): native of N.Y.; active by 1900, Manteo.

SOURCE: Twelfth Census, 1900: Dare County, Pop. Sch., Nags Head Township, E.D. 40.

THOMASON, E. H.: active 1935, N. Tryon St., Charlotte.

SOURCE: *Hill's Charlotte Directory*, 1935.

THOMPSON, _____: active 1940; with staff of News Bureau of N.C., State Department of Conservation and Development, 1940.

SOURCE: State Department of Conservation and Development Records (A&H).

THOMPSON, A. M.: formerly of Morrison Studio, Chicago; active 1902–1903 as Thompson & Company on Patton Ave., Asheville, in studio previously operated by Ignatius W. Brock.

SOURCES: Hill, *Asheville, N.C. City Directory, 1902–'03*; *Asheville Daily Gazette*, May 18, June 3, 1902.

THOMPSON, EDWIN C.: active 1848–1861; in New York City (1848–1852); in Washington, D.C. (1852); in Saratoga Springs, N.Y. (1853); in Buffalo, N.Y. (1856); associated with Fredericks Gallery, New York City (n.d.); in Wilmington (1861), in association with E. T. Barry; gallery located in Mozart Hall on Front St.

SOURCES: *Wilmington Daily Journal*, Apr. 1, 1861; *Craig's Daguerreian Registry*, 3:561.

THOMPSON, EUG. A.: active 1940, Greensboro.

SOURCE: *Hill's Greensboro Directory*, 1940.

THOMPSON, JONATHAN: active (obtained license to practice) 1911–1912, Durham.

SOURCE: Registry of Licenses to Trade, Durham County, 1881–1913 (A&H).

THORP, AMOS M.: itinerant; active 1879–1882; in Alleghany County (1879–1880); in Mitchell County (1881–1882).

SOURCES: Registry of Licenses to Trade, Alleghany County, 1874–1906 (A&H); Registry of Licenses to Trade, Mitchell County, 1877–1902 (A&H).

THROCKMORTON, LAWRENCE BECKHAM (1898–1983): active 1919–1940s, Danville, Va. (1919–1922); in Reidsville (ca. 1923–1940s) as Throckmorton Studio.

SOURCES: Photographic Examiners Records; *Bradstreet's*, 1925; *Mercantile Reference Book*, 1931; Miller, *Reidsville, N.C. City Directory*, 1929, 1941–1942; *Hill's Reidsville Directory*, 1932; Baldwin, *Reidsville City Directory, 1935*; *Mercantile Agency Reference Book*, 1943; *www.familysearch.org*.

THURSTON, L. W.: active (obtained license to practice) 1909–1910, Durham.

SOURCE: Registry of Licenses to Trade, Durham County, 1881–1913 (A&H).

TICEHELDT, ALDEN W. (b. ca. 1868): native of N.Y.; active by 1910, Edenton.

SOURCE: Thirteenth Census, 1910: Chowan County, Pop. Sch., Edenton, E.D. 22.

TICHNOR, SAMUEL: of Roxbury, Mass.; active ca. 1918, Camp Greene; received permission to take photographs at the camp.

SOURCES: National Army Camps, Camp Greene, Charlotte, N.C., RG 393, Box 20, National Archives; information provided by Jane Johnson, Charlotte.

TILLEY, J. W.: active (obtained license to practice) 1906–1907, Durham.

SOURCE: Registry of Licenses to Trade, Durham County, 1881–1913 (A&H).

TILLMAN, J. A.: active 1906, Shelby.

SOURCE: *N.C. Year Book*, 1906.

TIMBY, WILLIAM FILMORE (b. ca. 1866): native of Pa.; active ca. 1900–1930; industrial landscape photographer in early twentieth century; in Fayetteville (ca. 1900, 1930); in Weldon (by 1910).

SOURCES: Thirteenth Census, 1910: Halifax County, Pop. Sch., Weldon, E.D. 58; Fifteenth Census, 1930: Cumberland County, Pop. Sch., Fayetteville, E.D. 26-12; photographs bearing his name.

TINKLE, FRANK B. (b. ca. 1871): native of Ind.; active in Charlotte by 1930.

SOURCE: Fifteenth Census, 1930: Mecklenburg County, Pop. Sch., Charlotte, E.D. 60-5.

TIP TOP STUDIO: active 1920s–1930s, Elk Park and Avery County; Clifton Laws, proprietor.

SOURCE: Lentz, *W. R. Trivett, Appalachian Picture Man*, 32–33.

TITMAS, FRED: active 1907–1910; operated Gem Studio, Wilmington, in partnership with Andrew J. Foltz (1909–1910).

SOURCES: Hill, *Wilmington Directory*, 1907–1910; *Bradstreet's*, 1908.

TITTLE, F. W.: active 1930s, Rainbow Springs (Macon County).

SOURCE: Photographic Examiners Records.

TODD, M. N.: active early 1940s, Benson.

SOURCE: Photographic Examiners Records.

TODD, W. T. (b. ca. 1905): native of S.C.; active by 1930, Statesville.

SOURCE: Fifteenth Census, 1930: Iredell County, Pop. Sch., Statesville, E.D. 49-25.

TOM'S PHOTOGRAPH GALLERY: active 1890s–early 1900s, Winston and Salem; Thomas C. Hege, operator.

SOURCES: information provided by Molly Rawls, Forsyth County Public Library; information from the files of MESDA.

TOMLINSON, HERBERT W.: active ca. 1918, Camp Greene; associated with Miller Studio, Cleveland, Ohio; received permission to take photographs at the camp.

SOURCES: National Army Camps, Camp Greene, Charlotte, N.C., RG 393, Box 20, National Archives; information provided by Jane Johnson, Charlotte.

TOPALIAN, ETHEL (b. 1909): active 1934–1935 with McLellan's Department Store, Charlotte.

SOURCE: Photographic Examiners Records.

TORRENCE, JAMES MONROE (b. 1913): active 1936–1940s; with Alexander's Studios, Salisbury (1936); with Ideal Studio, Kannapolis (1937); photographer for Concord *Times* (1937–1939); operated Model Studio, Concord (early 1940s), in partnership with Healy E. Jones; returned to Salisbury by 1944.

SOURCES: Photographic Examiners Records; *Baldwin's Concord Directory*, 1940.

TOWER, _____: active 1916, Albemarle, in partnership with Martin A. Whitlock.

SOURCE: State Auditor's Records, Sch. B.

TRAFTON, H. L.: active 1911, Haywood St., Asheville.

SOURCE: Miller, *Asheville, N.C. City Directory, 1911*.

TREADWELL, C. A.: active 1920, Wilmington.

SOURCE: State Auditor's Records, Sch. B.

TREDAWAY, ROY E.: active 1940–1941 with Thomas Franklin Commercial Photography, Charlotte.

SOURCE: *Hill's Charlotte Directory*, 1940–1941.

TRIANGLE STUDIO: active 1926, E. Trade St., Charlotte; Saul Schwartz, operator.

SOURCE: Miller, *Charlotte Directory*, 1926.

TRICE, M. F.: active ca. 1938; engineer with Industrial Hygiene Division, N.C. State Board of Public Health; photographer at R. T. Vanderbilt industrial plant, Robbins, N.C.

SOURCE: information provided by Carol Johnson, Library of Congress, Washington, D.C.

TRIVETT, WILLIE ROBY (1884–1966): native of N.C.; active ca. 1907–1950s, Avery and Watauga Counties.

SOURCE: Lentz, *W. R. Trivett, Appalachian Picture Man*, 3–38.

TROTTER, H. G. (ca. 1846–1908): native of N.C.; in Walhalla and Anderson, S.C. (1870); active as a merchant and photographer in Franklin, N.C. (ca. 1880s–1890s); producer of stereographs; in partnership with G. W. Jones (1881); in partnership with George H. Snyder (1890).

SOURCES: Teal, *Partners with the Sun*, 127; *Mercantile Agency Reference Book*, 1890; numerous stereographs bearing his name; Macon County Estates Records (A&H); *www.familysearch.org*.

TROUTMAN, RECTOR HOMER (1887–1946): native of N.C.; active by 1910–1912, Statesville.

SOURCES: Thirteenth Census, 1910: Iredell County, Pop. Sch., Statesville, E.D. 87; *N.C. Year Book*, 1911, 1912; *www.familysearch.org*.

TROXLER, GEORGE A. (b. ca. 1884): native of N.C.; African American; active 1919–1930s, Greensboro.

SOURCES: State Auditor's Records, Sch. B; *Hill's Greensboro Directory*, 1929–1930, 1935–1937; Fifteenth Census, 1930: Guilford County, Pop. Sch., Greensboro, E.D. 41-13.

TRUEBLOOD, JOHN BENJAMIN (1913–1996): active 1933–1940s; operated Trueblood Photo Company, Weldon (1933–1935); operated Trueblood Studios as a "coupon photographer" (by offering coupons for discounts for photographic services); on S. Goldsboro St., Wilson (ca. 1939–1940s); moved to Calif. ca. 1960; died there.

SOURCES: Photographic Examiners Records; information provided by J. Marshall Daniel and Guy Cox, both of Wilson; *www.familysearch.org*.

TRY-ME STUDIO: active 1930s, Middle St., New Bern; Troy Tyndall, operator.

SOURCE: *Baldwin's New Bern Directory*, 1937.

TUCKER, L.: active 1920, Concord.

SOURCE: State Auditor's Records, Sch. B.

TULL, JOHN (1849–1915): native of N.C.; active 1902, Morganton; later worked as druggist in Waynesville.

SOURCES: *N.C. Year Book*, 1902; Vital Records, death certificates, Book 84, p. 329 (A&H).

TUMBLE, M. C.: active 1921, Lumberton.

SOURCE: State Auditor's Records, Sch. B.

TUNNELL, W. M.: active 1930s, Boone.

SOURCE: Photographic Examiners Records.

TURLINGTON, HENRY ALLAN (b. ca. 1909): native of S.C.; active by 1930–1940s, Fayetteville; operated Turlington Photo Shop.

SOURCES: Fifteenth Census, 1930: Cumberland County, Pop. Sch., Fayetteville, E.D. 26-12; postcard bearing his name.

TURNER, _____: active ca. 1900, Elizabeth City.

SOURCE: photograph bearing name "Turner."

TURNER, ANNIE: active 1916, Clinton.

SOURCE: *N.C. Year Book*, 1916.

TURNER, EMMA DOWDEE (Mrs. L. L. Turner) (1883–1963): native of N.C.; active 1901–1939; in Durham (1901–1910); with Cole & Holladay (1901–1905); with Waller Holladay (1908–1910); in Fort Bragg (1924–1926) with Wootten-Moulton Studio; at Iron Station (Lincoln County) (by 1930); in Charlotte and Durham (1931–1933) with Coffey's Photo Studio; with Efird's Photo Shop, Durham (1934–1935) in association with Grover C. Haynes Jr. (1934); with Turner Studio, W. Main St., Durham (1939); died in S.C.

SOURCES: Photographic Examiners Records; Fifteenth Census, 1930: Lincoln County, Pop. Sch., Iron Station, E.D. 55-7; Hill, *Durham, N.C. Directory*, 1939; *www.familysearch.org*.

TURNER, L. L.: active 1929; with Rembrandt Studio, Reidsville; husband of Emma D. Turner.

SOURCE: Miller, *Reidsville, N.C. City Directory*, 1929.

TURNER, LULA: active 1916, Clinton.

SOURCE: State Auditor's Records, Sch. B

TURNER, ORREN W.: active 1908–1909; in Tarboro (1908) in partnership with Sydney R. Alley; on W. Nash St., Wilson (1908–1909).

SOURCES: *Bradstreet's*, 1908; Hill, *Wilson, N.C. City Directory*, 1908–'09.

TURNER, TESSIE (Miss): active 1911–1915 with Union Art Studio, Pack Square, Asheville.

SOURCE: Miller, *Asheville, N.C. City Directory*, 1911–1915.

TURNER STUDIOS: active (n.d.), North Wilkesboro.

SOURCE: information provided by Jennifer Bean Bower, MESDA.

TURNEY, _____: active 1891, Wilmington, in partnership with George A. New.

SOURCE: Cotten list of N.C. photographers.

TUSSEY, WILLIAM F. (b. ca. 1853): native of N.C.; active by 1910, Lexington.

SOURCE: Thirteenth Census, 1910: Davidson County, Pop. Sch., Lexington, E.D. 28.

TWIDDY, WILLIAM M.: active early 1900s, Elizabeth City; also worked as sign painter.

SOURCE: *Greensboro Daily News,* June 7, 1925.

TWIN-CITY (ART) GALLERY: active 1885–early 1900s, Winston; Eugenio K. Hough, operator (1885–ca. 1887); Sylvester E. Hough, operator (ca. 1887–early 1900s).

SOURCES: *Turner's Winston and Salem Directory,* 1889–1890, 1891–1892, 1894–1895; information from the files of MESDA.

TWIN-CITY STUDIO: active 1906–1916, Winston and Winston-Salem; Hans P. Dreyer, operator (1906–1908).

SOURCES: *Walsh's Winston-Salem, North Carolina City Directory,* 1906, 1908; *N.C. Year Book,* 1910–1912, 1914–1916.

TYLER, _____: active ca. 1935–1940 with Tyler's Studio, Kernersville.

SOURCE: Carolina Power and Light Company Photograph Collection (A&H).

TYLER, F. W.: active 1890s, Ledger (Mitchell County) (n.d.); in Morganton (ca. 1895–1899); returned to New York about 1900.

SOURCES: Sprange, *Blue Book,* 289; Phifer, Burke County, 301.

TYLER, GEORGE HUGH (1886–ca. 1963): native of N.C.; Native American (and possibly of mixed race); active ca. 1910–1940s; early itinerant; in Kittrell (1916, 1922); in Oxford (1916–1919); operated Tyler's Studio, Henderson (ca. 1918–1940s); portrait on file at N.C. Office of Archives and History.

SOURCES: Photographic Examiners Records; *N.C. Year Book,* 1916; State Auditor's Records, Sch. B; *Miller's Henderson City Directory,* 1938–1941; Fifteenth Census, 1930: Vance County, Pop. Sch., Kittrell, E.D. 91-7; information provided by Goldie Johns, Englewood, N.J.; information provided by Barnetta M. White, Durham.

TYNDALL, TROY (1886–1974): active 1904–1940s; in Kinston (1904–1920s) with Erastus A. Parker and his successor, Francis E. Dixon (1904–1907); operated Try-Me Studio in Kinston (after World War I); operated Try-Me Studio on Middle St. in New Bern (1933–late 1930s); died in Ga.

SOURCES: Photographic Examiners Records; *Baldwin's New Bern Directory,* 1937; Green, *A New Bern Album,* 16; *www.familysearch.org.*

TYREE, MANLY W. (1877–1916): native of Ky.; active 1904–1916; in Durham (1904) in association with Waller Holladay; in Raleigh (1905–1916) in partnership with Cyrus P. Wharton (ca. 1905–ca. 1912) as Wharton & Tyree and as sole proprietor of Tyree Studio (ca. 1912–1916); served as president of Photographers' Association of Virginia and the Carolinas; also president of Photographers' Association of America (1913); an inventory of his studio can be found in the Wake County Estates Records.

SOURCES: *N.C. Year Book,* 1906, 1907, 1913–1916; Hill, *Raleigh Directory,* 1907–1908, 1913–1914; Vital Records, death certificates, Book 148, p. 458 (A&H); Wake County Estates Records (A&H); Murray list of Wake County photographers; *News and Observer* (Raleigh), Jan. 2, 1916.

TYSON, C. R. (b. ca. 1874): native of N.C.; active 1896–1897, Wilson; successor to Francis M. Winstead.

SOURCES: Branson, *NCBD,* 1896–1897; photographs bearing Tyson's name; *www.familysearch.org.*

TYSON, CHARLES (b. ca. 1890): native of N.C.; African American; active 1920–1921, Winston-Salem; operated Tyson's Photo Studio (1920–1921); his wife, Frances Tyson, assisted him, 1920.

SOURCES: Fourteenth Census, 1920: Forsyth County, Pop. Sch., Winston-Salem, E.D. 92; *Winston-Salem Directory,* 1920–1921.

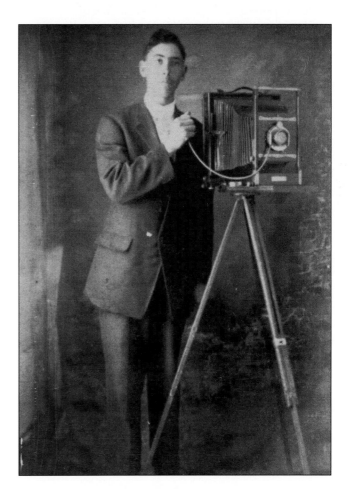

Posing here about 1920 is Vance County photographer George H. Tyler (1886–ca. 1963), a Native American (and possibly of mixed race). Photograph courtesy Goldie Johns, Englewood, N.J., and Barnetta M. White, Durham.

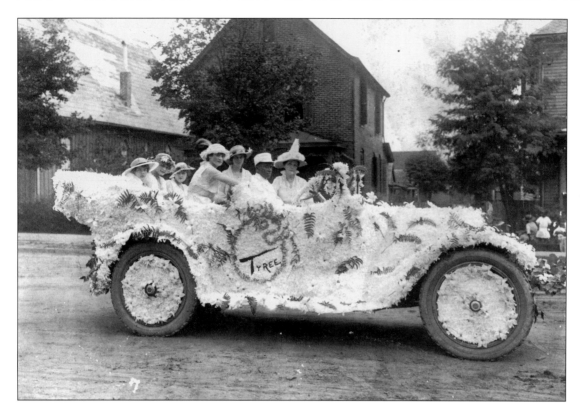

Manly W. Tyree secured a mobile advertisement for his studio in the form of this decorated automobile, which was driven in a parade in Raleigh about 1915. Photograph courtesy Rebecca Cone, Concord.

TYSON, JOHN L.: African American; active 1904–1906; in partnership with Fred M. Fitch in Winston (1904–1905); in Durham (1905–1906).

SOURCES: *Walsh's Directory of the Cities of Winston and Salem*, 1904, 1905; Registry of Licenses to Trade, Durham County, 1881–1913 (A&H); information from the files of MESDA.

TYSON, JOSEPH E. (b. ca. 1892): native of N.C.; African American; active by 1910–1919; in Winston (by 1910, 1918) as proprietor of Southern Photo Studio; in Statesville (1919).

SOURCES: Thirteenth Census, 1910: Forsyth County, Pop. Sch., Winston, E.D. 73; State Auditor's Records, Sch. B; information from the files of MESDA.

TYSON, RUBIE: active 1919, Winston-Salem.

SOURCE: State Auditor's Records, Sch. B.

U

ULMANN, DORIS (1882–1934): native of N.Y.; attended Clarence White School of Photography, New York City; one of founding members of Pictorial Photographers of America; active 1920s and 1930s; photographed craftsmen in Appalachian Mountain section of N.C.

SOURCES: Wilson and Ferris, *Encyclopedia of Southern Culture*, 97–98; Cotten, *Light and Air*, 66–82; *Movers & Makers*, 14–18.

UNDERWOOD, W. J.: active 1902, Elm City.

SOURCE: *Elm City Elevator*, Jan. 17, 1902.

Doris Ulmann, a highly respected photographer of Appalachia, is shown here in her studio with a large camera about 1930. Photograph courtesy A&H.

UNDERWOOD AND UNDERWOOD: active late nineteenth and early twentieth centuries; headquartered in New York City; publisher of stereographs in N.C. in late nineteenth and early twentieth centuries.

SOURCES: Darrah, *World of Stereographs*, 46–48; numerous stereographs bearing company name.

UNION ART STUDIO: active 1911–1915, Pack Square, Asheville; Miss Tessie Turner, operator.

SOURCES: Miller, *Asheville, N.C. City Directory*, 1911–1915; State Auditor's Records, Sch. B.

UNION PHOTO ROOMS: active early 1860s, New Bern; O. J. Smith and Lucien M. Stayner, operators.

SOURCES: Witham, *Catalogue of Civil War Photographers*, 75; Green, *A New Bern Album*, 14; photographs bearing studio name.

UNITED PHOTO COMPANY: active 1915, Durham.

SOURCE: *N.C. Year Book*, 1915.

UNIVERSITY STUDIO: active 1940–1942, Raleigh.

SOURCE: Photographic Examiners Records.

UNTHANK, T. C.: itinerant statewide; active (paid tax to practice) 1885–1886.

SOURCE: State Auditor's Records, Ledgers, 1869–1899, Vol. 18, p. 115 (A&H).

UPTON, THAD: active 1916, Bakersville.

SOURCE: State Auditor's Records, Sch. B.

UPTON, WILLIAM WASTLE (b. 1916): active 1940–1941 with Dunbar Studio, Charlotte.

SOURCE: Photographic Examiners Records.

UTLEY, GABRIEL (b. ca. 1819): native of N.C.; active late 1850s; resident of Chapel Hill; studied under a distinguished artist in Philadelphia; itinerant maker of ambrotypes; active in Salisbury and Concord (1856); taught the art to Daniel M. Fink; by 1860 worked as a merchant in Chapel Hill.

SOURCES: *Carolina Watchman* (Salisbury), July 22, 1856; *Concord Weekly Gazette*, Nov. 15, 1856; Eighth Census, 1860: Orange County, Pop. Sch., Chapel Hill Township; Ninth Census, 1870: Orange County, Pop. Sch., Chapel Hill.

V

VACHON, JOHN (1914–1975): active 1937–1943 with U.S. Office of War Information and U.S. Farm Security Administration; worked in Enfield, Goldsboro, Greensboro, Halifax, McLeansville, Rocky Mount, and Washington, as well as Beaufort and Guilford Counties.

SOURCES: Dixon, *Photographers of the Farm Security Administration*, 151; "Reference Guide to FSA/OWI Photographs."

VALE, CHARLES E. (1876–1918): native of England; active 1896–1909; in Fla. (1896–1897); in Providence, R.I. (1898–early 1900s); in Pinehurst during tourist season (1898–early 1900s); specialized in portrait work, as well as outdoor work used to advertise Pinehurst as resort; in Rock Hill, S.C. (1902) in partnership with a Mr. Hemphill; in Wilmington (1905–1909); left Wilmington by 1909, and Edward H. Hodges took over the studio that year; Vale died in Columbus County.

SOURCES: Twelfth Census, 1900: Moore County, Pop. Sch., Mineral Springs Township (Pinehurst), E.D. 79; Teal, *Partners with the Sun*, 248; *N.C. Year Book*, 1905–1907; Hill, *Wilmington Directory*, 1905–1910; *Bradstreet's*, 1908; Vital Records, death certificates, Book 341, p. 383 (A&H); information provided by Khristine E. Januzik, Pinehurst.

VAN ALSTYNE, EDWARD S.: active 1919–1920, Salisbury; also representative of piano company.

SOURCE: Miller, *Salisbury Directory*, 1919–1920.

VAN BUREN, AMELIA (1854–1942): native of Mich.; active 1890s–ca. 1920s, Tryon; a well-known photographer by the turn of the twentieth century; works exhibited in Paris by Frances Benjamin Johnston; a resident of Tryon by 1920.

SOURCE: information provided by Michael McCue, Asheville.

VAN DYKE STUDIO: active 1937, Valdese; F. B. Cook, operator.

SOURCE: Photographic Examiners Records.

VAN NESS, JAMES H. (1841–1925): native of Md.; active 1860s–1906; in Winnsboro, S.C. (1867), in partnership with unidentified brother; in Chester, S.C. (1871); on Tryon St. near Trade St., Charlotte (early 1870s–1906), opposite Charlotte Hotel; operated James H. Van Ness & Company (1896–1906) with son, William I. Van Ness; also father of James H. Van Ness Jr. and stepfather of Edward P. Roseborough.

SOURCES: Tenth Census, 1880: Mecklenburg County, Pop. Sch., Charlotte, Ward 4, E.D. 108; Twelfth Census, 1900: Mecklenburg County, Pop. Sch., Charlotte, E.D. 50; Teal, *Partners with the Sun*, 63; Branson, *NCBD*, 1872, 1877–'78, 1896, 1897; *Chataigne's Raleigh Directory*, 1875, 160; *Directory of the City of Charlotte, N.C. for 1896 and 1897*; *Weeks' 1899 Charlotte City Directory*; *Maloney's 1899–1900 Charlotte Directory*; *Walsh's Directory of the City of Charlotte*, 1902–1903, 1904–1905; *Zell's U.S. Business Directory*, 1881, 1883, 1884, 1885, 1887, 1889; *Chataigne's N.C. Directory and Gazetteer*, 1883–'84; *Curtin's United States Business Directory*, 1890, 1400; Sprange, *Blue Book*, 289; *N.C. Year Book*, 1902–1906; *Mercantile Agency Reference Book*, 1904; Vital Records, death certificates, Book 982, p. 88 (A&H).

VAN NESS, JAMES. H., JR. (1878–1928): native of N.C.; active by 1900, Charlotte, in association with his father, James H. Van Ness; following the death of his brother, William I. Van Ness, James operated W. I. Van Ness & Company, a photo supply business.

In his Charlotte studio in 1882, James H. Van Ness photographed J. Wadsworth and R. M. Miller, owners of the Rudisill Gold Mine in Mecklenburg County. Studio props and the men's clothing give the illusion that they are outdoors, working near the mine. Photograph courtesy Public Library of Charlotte and Mecklenburg County.

SOURCES: Tenth Census, 1880: Mecklenburg County, Pop. Sch., Charlotte, Ward 4, E.D. 108; Twelfth Census, 1900: Mecklenburg County, Pop. Sch., Charlotte, E.D. 50; *N.C. Year Book*, 1904–1906; State Auditor's Records, Sch. B; Mecklenburg County Estates Records (A&H).

VAN NESS, WILLIAM ISAAC (1868–1904): native of S.C.; active 1890s–1903, Charlotte; in association with his father, James H. Van Ness (1890s–1903); as sole proprietor of W. I. Van Ness & Company, N. Tryon St. (early 1900s), a business that sold photo supplies and art goods; after he died of lung disease in 1904, his family continued to operate the photograph business under his name; brother of James H. Van Ness Jr.

SOURCES: Tenth Census, 1880: Mecklenburg County, Pop. Sch., Charlotte, Ward 4, E.D. 108; Twelfth Census, 1900: Mecklenburg County, Pop. Sch., Charlotte, E.D. 50; *Walsh's Directory of the City of Charlotte*, 1905, 1910; *N.C. Year Book*, 1910; Miller, *Charlotte Directory*, 1911–1914; *Bradstreet's*, 1908, 1917, 1921, 1925; *Mercantile Reference Book*, 1931; State

Auditor's Records, Sch. B; George Eastman House Photographers Database; *Charlotte Observer*, Nov. 1, 1904; Mecklenburg County Wills (A&H).

VAN ORSDELL, CORNELIUS MURRETT (1832–1883): native of Va.; active by 1859–1883; in Fayetteville (1859– ca. 1862) in sky-light photographic gallery opposite C. T. Haigh & Son's store; later in more spacious quarters on Hay St., opposite the marble yard; in Wilmington (ca. 1863–1883) in studio located on Market St.; lightning struck building that housed his studio, and heavy rain damaged many of his negatives and stock (May 1870); fire in his studio destroyed a solar camera and other instruments and stock (Dec. 1876); in Camden and Orangeburg, S.C. (1879–early 1880s); owned studios in those towns operated by his son Cornelius ("Clinton") M. Van Orsdell Jr.; publisher of stereographs; Elisha H. Freeman purchased his gallery in 1883; elected grand high priest of the Grand Chapter of the N.C. Masonic Order; inventory of his studio in New Hanover County Estates Records, N.C. Office of Archives and History; also portraits of Van Orsdell on file at N.C. Office of Archives and History.

Wilmington photographer Cornelius M. Van Orsdell was an active and high-ranking member of the Freemasons. Here he is shown dressed in Masonic attire during the 1870s. Photograph courtesy St. John's Lodge, Wilmington.

SOURCES: Cumberland County Miscellaneous Tax List, 1857–1884, Taxes Received, pp. 27, 43 (A&H); *Fayetteville Observer*, May 2, Oct. 3, 27, 1859; *North Carolina Presbyterian* (Fayetteville), Nov. 24, 1860; Eighth Census, 1860: Cumberland County, Pop. Sch., Fayetteville; Ninth Census, 1870: New Hanover County, Pop. Sch., Wilmington; Tenth Census, 1880: New Hanover County, Pop. Sch., Wilmington, E.D. 144; Witham, *Catalogue of Civil War Photographers*, 60; Minute Book of Meetings, St. John's Lodge, Wilmington, 1863, 1875–1877; *Wilmington Directory, 1865–1866; Smaw's Wilmington Directory, 1866–1867;* Branson, *NCBD*, 1869, 1877–1878; *Haddock's Wilmington Directory, 1870–'71; Chataigne's Raleigh Directory,* 1875, 229; *Sheriff's Wilmington Directory, 1877–8; Chataigne's N.C. Directory and Gazetteer, 1883–'84; Proceedings of the Fiftieth Annual Convocation of the M. E. Grand Royal Arch Chapter of North Carolina,* 197; *Star* (Wilmington), May 6, 1870, Dec. 5, 1876, May 24, 1883, Dec. 3, 1984; *Morning Star* (Wilmington), May 24, 25, 1883; *Daily Review* (Wilmington), May 24, 1883; tombstone inscription, Oakdale Cemetery, Wilmington; New Hanover County Estates Records (A&H); Darrah, *World of Stereographs*, 208; information provided by Amarette P. Pierce, Wilmington.

VAN ORSDELL, CORNELIUS ("CLINTON") MURRETT, JR. (b. 1856); native of Va.; learned photography from his father, Cornelius M. Van Orsdell; active 1870s–1910s; in Camden, S.C. (1879–1880); in Orangeburg, S.C. (1881–1916); in Wilmington (1883–1885); helped operate his father's studio after the latter's death.

SOURCES: Eighth Census, 1860: Cumberland County, Pop. Sch., Fayetteville; Ninth Census, 1870: New Hanover County, Pop. Sch., Wilmington; Teal, *Partners with the Sun,* 156; information provided by Amarette P. Pierce, Wilmington.

VANCE, CHARLES: active 1916, Marion.

SOURCE: State Auditor's Records, Sch. B.

VANCE, MONTEATH: active 1919–1930, Asheville; also worked as grocer in 1930.

SOURCES: State Auditor's Records, Sch. B; *Mercantile Reference Book,* 1931; information provided by staff of Pack Memorial Public Library, Asheville.

VANHOY, LEVI L. (b. 1855): native of Va.; active (obtained license to practice) 1877–1878, Alleghany County.

SOURCES: Registry of Licenses to Trade, Alleghany County, 1874–1906 (A&H); *www.familysearch.org.*

VANNERSON, JULIAN (1826–after 1877): active late 1840s–1877; in Washington, D.C. (1850s), with Jesse H. Whitehurst and opened own gallery in 1856; worked in Richmond, Va., during Civil War; in Hillsborough (1870) in partnership with J. R. Rockwell of Petersburg, Va.; in Elizabeth City (1877) in partnership with A. A. Knox in gallery located next door to Dr. Butt's drugstore; brother of Lucian Vannerson.

SOURCES: *Hillsborough Recorder,* Nov. 6, 1870; *Economist* (Elizabeth City), Aug. 29, 1877; Eskind, *Index to American Photographic Collections,* 1009; *Craig's Daguerreian Registry,* 3:581; Witham, *Catalogue of Civil War Photographers,* 83; *www.familysearch.org.*

VANNERSON, LUCIAN (1828–1903): itinerant daguerreotyper; active late 1840s–1850s; in Tarboro (1851); occupied room above Dr. Lawrence's drugstore; operator for Jesse H. Whitehurst at galleries in Lynchburg, Peterburg, and Richmond, Va.; also worked for George W. Minnis of Petersburg and Richmond; brother of Julian Vannerson.

SOURCES: *Tarborough Press,* Oct. 25, 1851; *Craig's Daguerreian Registry,* 3:581–582.

VANNOY, WILEY C. (1881–1972): native of N.C.; active by 1900–1916; in Boone (by 1900); in Blowing Rock (1916).

SOURCES: Twelfth Census, 1900: Watauga County, Pop. Sch., Boone Township, E.D. 126; *N.C. Year Book,* 1916; State Auditor's Records, Sch. B; *www.familysearch.org.*

VAUGHAN, E. C.: active (obtained license to practice) 1888–1889, Alleghany County.

SOURCE: Registry of Licenses to Trade, Alleghany County, 1874–1906 (A&H).

VAUGHN, J. A.: active 1913, Statesville.

SOURCE: *N.C. Year Book,* 1913.

VAUGHN, SALLIE C. (b. 1877): native of Ga.; active by 1900, Burlington; may have worked with Charles V. Sellers.

SOURCE: Twelfth Census, 1900: Alamance County, Pop. Sch., Burlington, E.D. 13.

VENUS-FULLER STUDIO: active 1928, W. Main St., Durham; operated by a Mr. Fuller.

SOURCE: Hill, *Durham, N.C. Directory, 1928.*

VENUS STUDIO: active 1931, Asheville; Mrs. Luesa M. Marker, operator.

SOURCE: Miller, *Asheville, N.C. City Directory,* 1931.

VEST, JOHN S.: active 1908–1916; in Haw River (1908 and afterward); in Jackson (1916).

SOURCE: State Auditor's Records, Sch. B.

VIALL, WYMAN: active ca. 1940s, W. Hargett St., Raleigh; operator of Aero Pix.

SOURCE: Photograph bearing studio name.

VON HERFF, BALDUIN (BALDWIN): native of Germany; active early 1880s, Raleigh; chemist, Agricultural Department Experiment Station; photographed N.C. State Exposition of 1884, Raleigh (resulting book of photographs housed at N.C. Office of Archives and History); producer of stereographs of state; moved to Sandhills region of N.C. (mid-1880s) and experimented with production of fruit; accepted position with Agricultural College of Miss. in 1888; later held chemistry-related jobs in Washington, D.C. (1890s) and in New York City (after 1900).

ABOVE: This grand edifice, photographed by Balduin Von Herff in the mid 1880s, is the Mountain Park Hotel at Hot Springs in Madison County. Courtesy of the compiler. **BELOW:** United States Senator Zebulon B. Vance (1830–1894) poses with his dog for Von Herff at a log cabin at Vance's estate, known as Gombroon, about twenty-two miles northeast of Asheville. The former governor, congressman, and senator had a Victorian mansion constructed on the property in the 1880s. Photograph courtesy Pack Memorial Public Library, Asheville.

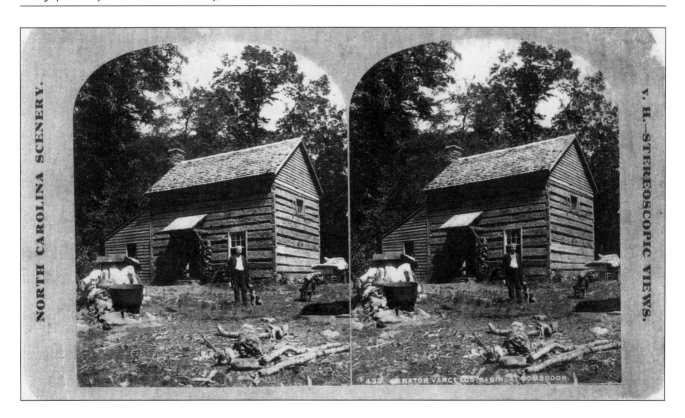

SOURCES: *Executive and Legislative Documents*, Document No. 18, p. 36; *State Chronicle* (Raleigh), Mar. 2, 1888; *Daily State Chronicle* (Raleigh), May 21, 1892; correspondence to Brimley from Von Herff, Mar. 3, 1904, Herbert H. Brimley Photograph Collection (A&H); Darrah, *World of Stereographs*, 208; Murray list of Wake County photographers; Lindau, *The 1st Hundred Years of Southern Pines*, 11; *Illustrations of the North Carolina State Exposition, Raleigh, October, 1884*.

VRIES, JOHN HENDRICK (1868–1935): native of Holland; active ca. 1926–1935, Roanoke Rapids; resided in Patterson (Halifax County), 1930.

SOURCES: Photographic Examiners Records; Fifteenth Census, 1930: Halifax County, Pop. Sch., Patterson, E.D. 42-27; Vital Records, death certificates, Book 1841, p. 97 (A&H).

W

WADDELL, C. H.: active 1919, Morven (Anson County).

SOURCE: State Auditor's Records, Sch. B.

WADDOCK, _____: of Ala.; active 1892 in *Recorder* building, Fayetteville St., Raleigh.

SOURCE: *State Chronicle* (Raleigh), June 18, 1892.

WADE, DAN: native of N.C.; active 1930s–1940s, Morehead City.

SOURCE: Dudley, *Morehead City*, 5.

WAGNER, MARION F. (b. ca. 1892): native of N.C.; active by 1910, Asheville.

SOURCE: Thirteenth Census, 1910: Buncombe County, Pop. Sch., Asheville, E.D. 15.

WAINGOLD, S.: active (obtained license to practice) 1914–1915, Durham.

SOURCE: Record of Special Licenses Issued, Durham County, 1914–1916 (A&H).

WAITE, E. J.: active 1912, Lumberton.

SOURCE: information provided by Jerry R. Roughton, Kenansville.

WAKEFIELD, F. L.: active 1930s, Bessemer City.

SOURCE: Photographic Examiners Records.

WAKEFIELD PHOTO STUDIOS: active ca. 1910s, Wrightsville Beach.

SOURCE: real-photo postcard bearing studio name.

WOLCOTT, MARION POST (1910–1990): native of N.J.; active 1938–1940 with U.S. Farm Security Administration; worked in Bynum, Chapel Hill, Durham, Laurinburg, Maxton, Mebane, Pittsboro, Prospect Hill, Roxboro, Siler City, Wadesboro, Wendell, Yanceyville, and Zebulon, as well as Buncombe, Caswell, Chatham, Durham, Granville, Orange, Person, Robeson, and Wake Counties; died in Calif.

SOURCES: Dixon, *Photographers of the Farm Security Administration*, 161; "Reference Guide to FSA/OWI Photographs"; Wilson and Ferris, *Encyclopedia of Southern Culture*, 98; Cotten, *Light and Air*, 56–58; photographs bearing her name.

WALDEN, J. W.: active 1857–1860s; in Northampton County as itinerant (1857); operated studio in Petersburg, Va. (1859–1860s), as J. W. Walden & Company.

SOURCES: Northampton County Tax Records, 1844–1857, Folder 1854–1857 (A&H); photograph made in Petersburg, Va., bearing his name; *Craig's Daguerreian Registry*, 3:587.

WALKER, _____: active ca. 1859, Louisburg.

SOURCE: *American Eagle* (Louisburg), Feb. 26, 1859.

WALKER, H. C.: native of England; active as school photographer, 1920s, Harnett County.

SOURCE: information provided by J. Mack Wicker.

WALKER, PAUL A.: active 1908 with Stone Photo Company, Concord, in partnership with J. Lee Stone.

SOURCE: *Concord City Directory*, 1908.

WALKER, THOMAS M.: active 1891, Wilmington.

SOURCE: *Mercantile Agency Reference Book*, 1892.

WALKER, W. M.: active 1920, Reidsville.

SOURCE: State Auditor's Records, Sch. B.

WALL, ALBERT HOUCK (1897–1944): native of N.C.; active 1908–late 1930s; in Haw River (1908 and afterward) with John S. Vest; in Winston (1913); in Lenoir (1928–late 1930s); operated Wall Brothers Studio in association with brother, David N. Wall; died at Veterans Hospital, Roanoke, Va.

SOURCES: Fifteenth Census, 1930: Caldwell County, Pop. Sch., Lenoir, E.D. 14-15; Photographic Examiners Records; *Miller's Lenoir City Directory*, 1930–1931, 1939–1940.

WALL, DAVID NELSON ("NED") (b. 1900): native of N.C.; active 1929–1940s, Lenoir; operated Wall Brothers Studio in association with brother, Albert H. Wall.

SOURCES: Fifteenth Census, 1930: Caldwell County, Pop. Sch., Lenoir, E.D. 14-15; Photographic Examiners Records; *Miller's Lenoir City Directory*, 1930–1931, 1939–1940.

WALL, HOWARD BORDEN: active 1929–1940s with Wall's Studio, Avondale (Rutherford County).

SOURCE: Photographic Examiners Records.

WALLACE, ALPHONSO DEKALB (1848–1928): native of N.C.; active by 1880–1882, Rutherfordton; proprietor of Wallace's Fine Art Gallery.

SOURCES: Tenth Census, 1880: Rutherford County, Pop. Sch., Rutherfordton Township, E.D. 156; *Mountain Banner* (Rutherfordton), Mar. 17, Aug. 18, 1882; *Forest City Courier*, Apr. 19, 1928; *Rutherford County News* (Rutherfordton), Apr. 19, 1928.

WALLENSTEIN, ISAAC ("IKE") (b. 1861): active late 1880s–1930s; in business out of state until ca. 1928; in Charlotte (1928–1930s); in Greensboro (briefly).

SOURCES: Photographic Examiners Records; *Hill's Charlotte Directory*, 1935.

WALLER, ASHLEY PILAND (1912–1984): active 1936–1970s; in Raleigh (1936–1970s); with Haynes' Studio (1936); with Dunbar & Daniel (1936–1939); with Daniel & Smith (1939–1940); with University Studio (1940–1942); in Durham (early 1940s) with Daniel & Smith; in partnership with A. Fay Smith as Waller & Smith, E. Hargett St., Raleigh (1946 and afterward).

SOURCES: Photographic Examiners Records; *www.familysearch.org*.

WALLIS, J. D.: native of Canada; active 1860s–1870s; in New Bern (1864–1865) as melainotype artist in studio on Craven St., six doors south of Bank of North Carolina; in New York (1867).

SOURCES: *Old North State* (Beaufort), Dec. 15, 1864, Jan. 7, 1865; Eskind, *Index to American Photographic Collections*, 1019.

WALLNER, KENNETH J.: active twentieth century, Rockingham.

SOURCE: photograph bearing his name on file at N.C. Office of Archives and History.

WALRATH, _____: active early 1900s, Fayetteville, as Walrath's Photographic Studio.

SOURCE: photograph bearing name "Walrath."

WALTER, THOMAS (b. 1834): native of Pa.; active ca. 1863–1910; in Norfolk, Va. (periodically, ca. 1863–1910); in New Bern (1888) in gallery above Duffy's drugstore on northwest corner of Middle and Pollock Streets; advertised twenty-five years' experience in Norfolk, Va.; operated Walters' Art Gallery in Washington, N.C. (ca. 1895–1900).

SOURCES: *Daily Journal* (New Bern), Jan. 25, 1888; Sprange, *Blue Book*, 289; Twelfth Census, 1900: Beaufort County, Pop. Sch., Washington, E.D. 11; Ginsberg, *Photographers in Virginia*, 19.

WALTERS, S. I.: active 1919, Raleigh.

SOURCE: State Auditor's Records, Sch. B.

WALTON, S. W.: active ca. 1912–1916; in Asheville (ca. 1912); in Granite Quarry (1916).

SOURCES: name on real-photo postcard of Biltmore Forest School at Sunburst, N.C.; *N.C. Year Book*, 1916.

WANKE, J. E.: active 1911, Shelby.

SOURCE: *N.C. Year Book*, 1911.

WANNAMAKER, _____: active 1916 with Wannamaker's Studio, Spray.

SOURCES: State Auditor's Records, Sch. B; Aheron, *From Avalon to Eden*, 8.

WARD, ROBERT BRUCE (b. 1916): active 1941, Wilmington; with Adams' Studio; with Gem Studio; with Ward's Studio (ca. 1941 and afterward).

SOURCE: Photographic Examiners Records.

WARD, W.: active early 1900s, Wheeler (Ashe County).

SOURCE: photograph bearing his name, in possession of Jerry R. Roughton, Kenansville.

WARLICK, ELI ALEXANDER (1828–1872): daguerreotyper; active by 1850, Catawba County; also a teacher at Catawba College and later a merchant in Newton.

SOURCES: Seventh Census, 1850: Catawba County, Pop. Sch.; Dunn, *Daniel Warlick of Lincoln County*, 94.

WARNER STUDIO: active 1934, W. Main St., Durham; Lester R. Kefauver, manager.

SOURCE: Hill, *Durham, N.C. Directory, 1934*.

WARREN, FLOYD LEE (1903–1995): native of N.C.; active 1925–1939, Hickory; operated Warren's Studio.

SOURCES: Photographic Examiners Records; *Miller's Hickory Directory*, 1928–1930, 1937–1938; Fifteenth Census, 1930: Catawba County, Pop. Sch., Hickory, E.D. 18-12; *Hickory, N.C. City Directory*, 1935; Dunn, *Mercantile Reference Book*, 1931; *www.familysearch.org*.

WARREN, SAMUEL: active 1857–1859; in Davie County (1857); in Cheraw and Darlington, S.C. (1859).

SOURCES: Davie County Tax Records, 1857 (A&H); *Craig's Daguerreian Registry*, 3:593.

WASHINGTON, W. FRANK (1872–1921): native of N.C.; active by 1900–1920; in Enfield (by 1900); in Sanford (1908–1910) in studio above post office; in Oxford (1910–1913) in partnership with John D. Brinkley (1911–1912); near Archer's Lodge, Johnston County (ca. 1915); in Louisburg (1916); in Newton (ca. 1920).

SOURCES: Twelfth Census, 1900: Halifax County, Pop. Sch., Enfield, E.D. 29; *Sanford Express*, June 19, Oct. 16, 1908, July 1, 1910; Thirteenth Census, 1910: Lee County, Pop. Sch., Sanford, E.D. 46; *N.C. Year Book*, 1910–1913; State Auditor's Records, Sch. B; Vital Records, death certificates, Book 601, p. 333 (A&H); information provided by John C. Sykes III, Baton Rouge, La.

WATERFIELD, WILLIAM (ca. 1838): native of N.C.; active by 1870, Beaufort.

SOURCE: Ninth Census, 1870: Carteret County, Pop. Sch., Beaufort Township.

WATERMAN, FRANCIS E. (b. ca. 1904): native of Calif.; active by 1930, Charlotte.

SOURCE: Fifteenth Census, 1930: Mecklenburg County, Pop. Sch., Charlotte, E.D. 60-10.

WATERS, HERBERT LEE (1902–1997): native of N.C.; active 1925–1990s; in Lexington with John J. Hitchcock (1925–1926); sole proprietor (1926–1990s), S. Main St., assisted by wife, Mabel Elizabeth Gerald Waters; publisher of numerous area postcards; made *Movies of Local People* in towns in N.C., S.C., Va., and Tenn. (1936–1942); some of his films are on file at N.C. Office of Archives and History.

SOURCES: Photographic Examiners Records; *Mercantile Reference Book*, 1931; Baldwin, *Lexington City Directory, 1937*; *Miller's Lexington City Directory, 1941–'42*; *Dispatch* (Lexington), Dec. 10, 1997; name on postcards; Whiteside, *The Cameraman Has Visited Our Town* (documentary videotape).

WATKINS, AL: active 1922, Henderson.

SOURCE: State Auditor's Records, Sch. B.

WATSON, A. L.: active 1919–1920, Mayodan.

SOURCE: State Auditor's Records, Sch. B.

WATSON, C. C.: active 1916, Morven (Anson County).

SOURCE: *N.C. Year Book*, 1916.

WATSON, C. E.: active ca. 1900, Elm City.

SOURCE: photograph bearing his name.

WATSON, ED: active ca. 1918, Camp Greene; associated with *Army and Navy News*; received permission to take photographs at the camp.

SOURCES: National Army Camps, Camp Greene, Charlotte, N.C., RG 393, Box 20, National Archives; information provided by Jane Johnson, Charlotte.

WATSON, FREDERICK A. (1847–1924): native of N.C.; active ca. 1882–1920s on Fayetteville St., Raleigh; operated as Watson & Company, Watson's Art Store, Watson's Picture & Art Store, and Watson's Photograph Gallery (of which William H. Riggsbee was proprietor, 1904–1906); specialized in picture frames and art and photo supplies.

SOURCES: *Historical and Descriptive Review*, 87; Branson, *NCBD*, 1890; *News and Observer* (Raleigh), Aug. 24, 1899, June 22, 1904; *Maloney's 1901 Raleigh Directory*, 5:393; Hill, *Raleigh Directory*, 1919–1920; *N.C. Year Book*, 1902–1904; *Mercantile Agency Reference Book*, 1904; *Bradstreet's*, 1914; Murray list of Wake County photographers; Vital Records, death certificates, Book 868, p. 207 (A&H).

WATSON, G. J.: active 1921, Morven (Anson County).

SOURCE: State Auditor's Records, Sch. B.

WATSON, HUGH WILFRED (b. ca. 1856): native of N.C.; active 1876–1886, Center St., Goldsboro (1876–1877), next to *Express* office; probably out of state in Ala. and vicinity (ca. 1878–1882) with father, John W. Watson; in Elizabeth City (1885–1886) in partnership with John W. T. Smith.

SOURCES: *Beveridge and Co.'s N.C. Directory, 1877–'78*, 164; *Carolina Messenger* (Goldsboro), Jan. 8, June 22, 1877; Cotten

list of N.C. photographers; information provided by Jan Hensley, Greensboro.

WATSON, J. R.: active 1919, Dobson.

SOURCE: State Auditor's Records, Sch. B.

WATSON, JOHN W. (1828–1889): native of Va.; active 1849–1889; learned photography trade in Petersburg, Va.; in Richmond, Va., in partnership with George W. Minnis as Minnis and Watson (1849–1855); operated "daguerrean saloon" (1852–1853); itinerant for following two years; in Hillsborough (1855) in rooms at Masonic Hall; in Tarboro (1855) in studio located above Thomas M. Cooke's jewelry store; in Athens, Ga. (1856); in New Bern (1856) in rooms above Whaley's jewelry store on Craven St.; in Beaufort (1857) in rooms at J. C. Manson's store on Front St.; in New Bern (1857–1862); operated permanent gallery above store of J. Whaley on Craven St.; in Washington briefly (1857); saw service with Confederate army during early years of the Civil War; following the occupation of New Bern, he moved inland and lived at Salisbury for a few years; in Raleigh (1865–1889); opened permanent gallery formerly occupied by Esley Hunt on Fayetteville St.; Watson's Gallery of Photographic Art became one of the finest galleries in the state; in Waco, Tex. (1867); in Goldsboro (1868, 1875–1877) in gallery on Center St. next to *Express* office; son, Hugh W. Watson, operated this gallery during 1876–1877; in Bryan, Tex. (1870); in Brazos County, Tex. (1871); in Hearne, Tex. (1872); in Beaufort (1876) for brief stay at female seminary; in Durham (1877); operated galleries in other southern states (ca. 1878–1882), principally at Eufaula, Ala. (1880–1881), and in Ga.; in Raleigh (1883–1889); considered to be "the father of photography in North Carolina"; shrewd businessman who owned large farm with flour, grist-, and sawmills in Chatham County.

SOURCES: Ginsberg, *Photographers in Virginia*, 36, 44; *Hillsborough Recorder*, Aug. 22, 1855; *Southerner* (Tarborough), Nov. 24, 1855; Rinhart and Rinhart, *The American Daguerreotype*, 413; *Union* (New Bern), Sept. 24, 1856, Sept. 2, Dec. 10, 17, 1857; *Beaufort Journal*, July 15, 1857; *Washington Dispatch*, Dec. 23, 1857; *New Era and Commercial Advertiser* (New Bern), Aug.–Dec. 1858; Eighth Census, 1860: Henrico County, Pop. Sch., City of Richmond, Second Ward; Ninth Census, 1870: Wake County, Pop. Sch., Raleigh Township; Tenth Census, 1880: Barbour County, Ala., Pop. Sch., City of Eufaula, E.D. 7; *New Bern Weekly Progress*, Jan. 8, 1861, July–Aug. 1862; *Carolina Watchman* (Salisbury), Mar. 7, 1864; Wake County Deeds, Book 24, p. 310 (A&H); *Daily North Carolina Standard* (Raleigh), Oct. 5, 9, 1865; *Goldsboro Daily Rough Notes*, Apr. 28, 1868; *Eagle* (Fayetteville), Nov. 18, 1869; *Branson & Farrar's NCBD*, 1866–1867, 132; *Branson's NCBD*, 1867–1868, 1869, 1872, 1877–78, 1884; *Carolina Messenger* (Goldsboro), Sept. 9, 1875; *Chataigne's Raleigh Directory*, 1875, 21; *Beaufort Eagle*, July 29, 1876; *Durham Tobacco Plant*, Oct. 9, 1877; *Durham Recorder*, May 30, 1883; *Zell's U.S. Business Directory*, 1875; *Farmer and Mechanic* (Raleigh), Apr. 25, Aug. 8, 1883; Robb list of Ala. photographers; Richards, *Raleigh City Directory*, 1883, 164; *Raleigh City Directory*, 1886, 125; *Directory*

Shown here is the only known likeness of Raleigh photographer John W. Watson. The engraving was based on a portrait made in the 1870s. Engraving courtesy North Carolina Collection, Wilson Library, UNC-CH.

Josiah Turner Jr. (1821–1901) of Raleigh, Confederate congressman, editor, and dedicated foe of Reconstruction, is the subject of this Watson portrait taken in November 1869. Courtesy of the compiler.

[132]

WATSON'S

PHOTOGRAPHIC GALLERY,

RALEIGH, N. C.

———

Photographs, Ivorytypes,

PORCELAIN PICTURES,

Ambrotypes, Ferreotypes,

GEMS, &c., &c.

ALL EXECUTED IN THE

Very best style of the Art.

———

Life-Sized Portraits

Made from old Daguerreotypes, or other pictures, and

COLORED IN OIL,

BY AN

EXPERIENCED ARTIST.

———

CALL AND EXAMINE SPECIMENS:

J. W. WATSON,

Fayetteville Street, Raleigh, N. C.

ADVERTISEMENTS. LVII

Photograph Gallery,

RALEIGH, N. C.

When you visit Raleigh, don't fail to call at Watson's Gallery, and examine a splendid collection of

PAINTINGS, LIFE SIZE,

PHOTOGRAPHS COLORED IN OIL, IVORYTYPES,

PORCELAIN PICTURES,

AMBROTYPES, &c.

Executed in the Very Best Style.

Old Daguerreotypes copied in any size, and Colored if desired.

J. W. WATSON,

Fayetteville Street, Raleigh, N. C.

LEFT & FAR LEFT: *Branson's North Carolina Business Directories* for 1866 and 1867 published these two business notices for Watson's photography enterprise. Directories courtesy State Library of North Carolina.

of the City of Raleigh, North Carolina, 1887, 194; *Directory of the City of Raleigh, 1888*, 144; *Historical and Descriptive Review*, 96–97; *News and Observer* (Raleigh), Apr. 3, 1889; *State Chronicle* (Raleigh), Apr. 5, 1889; Wake County Register of Deaths (A&H); *Craig's Daguerreian Registry*, 3:596; Green, *A New Bern Album*, 14; Haynes, *Catching Shadows*, 116.

WATTS, _____: active 1924–1925 with Carolina Photo Company, Patton Ave., Asheville, in partnership with Joseph H. Howard.

SOURCE: Miller, *Asheville, N.C. City Directory, 1924–1925.*

WEAR, J. S. (b. ca. 1810): itinerant daguerreotyper; active 1846–1857; in Wilmington (1846) in room on Front St., adjoining room of Samuel D. Humphrey; in Columbia, S.C. (1847); worked as dentist in New York City (1850); in Sumter and Georgetown, S.C. (1852); in Fayetteville (1853–1857), periodically on Hay St., above J. M. Beasley's store (J. D. Nott succeeded Wear in Fayetteville, 1856); itinerant portrait painter and daguerreotyper in Salem (1855, 1857) in rooms at Zevely's Hotel (1855) and above store formerly occupied by Boner & Clinard on Main St. (1857); in Fayetteville (1856) in partnership with R. D. Green, who was a watchmaker and jeweler; in Wytheville, Va. (1857).

SOURCES: *Fayetteville Observer*, June 16, 1846, Dec. 19, 24, 1853, Apr. 14, Aug. 26, 1856; *North Carolina Argus* (Fayetteville), Nov. 1, 4, 1854; Feb. 1, June 30–Sept. 22, 1855; *People's Press* (Salem), Aug. 31, 1855, July 24, 1857; Teal, *Partners with the Sun*, 32; Seventh Census, 1850: New York, Pop. Sch., New York City, 15th Ward; *Craig's Daguerreian Registry*, 3:597; Rinhart and Rinhart, *The American Daguerreotype*, 413.

WEARN, RICHARD (d. 1874): active 1854–1874; in Anderson, S.C. (1854); in Abbeville, S.C. (1856); in Newberry, S.C. (1858); in Columbia (1859–1874); published stereograph of N.C. mountains in association with W. P. Hix.

SOURCES: Teal, *Partners with the Sun*, 143; *Craig's Daguerreian Registry*, 3:597.

WEATHERMAN, MILTON H. ("MILT") (b. ca. 1868): native of N.C.; active 1919–1921; in Celo (1919); in Micaville (1921).

SOURCES: State Auditor's Records, Sch. B; Fourteenth Census, 1920: Yancey County, Pop. Sch., Crabtree Township, E.D. 193; information provided by Paul E. Kardulis Jr., Burnsville.

WEAVER, _____: active early 1910s; in Wilson (1910–1911) in partnership with a Mr. Woody; in Tarboro (1910s) as Weaver Studio.

SOURCE: *N.C. Year Book*, 1910, 1911.

WEAVER, RALPH C.: active 1930, West Asheville.

SOURCE: *Miller's Asheville Directory*, 1930; information provided by staff of Pack Memorial Public Library, Asheville.

WEBB, C. E.: active 1932, Reidsville; operated Webb's Studio.

SOURCE: *Hill's Reidsville Directory*, 1932.

WEBB, JAMES C. (1876–1938): active 1899–1938; in Washington County (1899–1900); in Washington (ca. 1900–1903, ca. 1910s–1920s) as manager of American Traveling Photograph Company of North Carolina; produced postcard views of eastern N.C.; in Rocky Mount (ca. 1910–1920s); in Wilson (1916–1917) as operator of Webb's Studio, E. Nash St.; in Kinston (n.d.); published postcard scenes of S.C. towns, including Manning (1908) and Mullins (ca. 1920); in Sanford (1921–1922); in Charlotte (1927–1928) as operator of Webb's Studio, E. Trade St.; in Durham (1932) as operator of Webb's Studio, W. Main St.; in Lumberton (1935–1938), in association with William M. Hughes.

SOURCES: Registry of Licenses to Trade, Washington County, 1883–1902 (A&H); *N.C. Year Book*, 1902, 1903; State Auditor's Records, Sch. B; Hill, *Wilson, N.C. Directory, 1916–'17*; Teal, *Partners with the Sun*, 247; Miller, *Charlotte Directory, 1927–1928*; Hill, *Durham, N.C. Directory, 1932*; Photographic Examiners Records, Baldwin, *Lumberton City Directory, 1938*; Vital Records, death certificates, Book 2069, p. 412 (A&H).

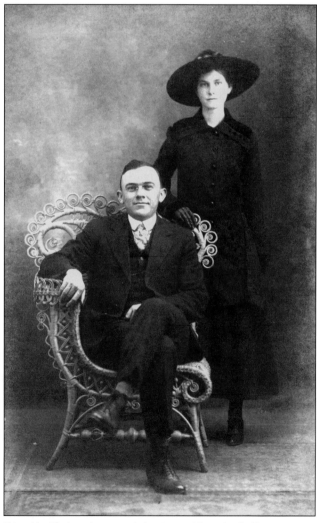

This unidentified couple appears to be at ease while posing for Kinston photographer James C. Webb about 1920. The portrait was reproduced in postcard format so that the couple could share the picture with others. Courtesy of the compiler.

WEBB, LLOYD EDGAR (1879–1937): native of N.C.; active 1904–1930s, Morganton; received training under direction of F. W. Tyler; operated Webb's Studio; president of N.C. Division of Master Photo Finishers of America; talented musician and dealer in stringed musical instruments; George A. Sebren purchased studio in 1938.

SOURCES: Photographic Examiners Records; *Mercantile Agency Reference Book*, 1904; *N.C. Year Book*, 1904–1907, 1910–1916; State Auditor's Records, Sch. B; *Bradstreet's*, 1925; Fifteenth Census, 1930: Burke County, Pop. Sch., Morganton, E.D. 12-15; *Mercantile Reference Book*, 1931; *News and Observer* (Raleigh), Nov. 19, 1937. Phifer, *Burke County*, 301.

WEBSTER, D. F.: active 1913–1916, Hertford.

SOURCE: *N.C. Year Book*, 1913–1916.

WEBSTER, J. S.: active 1919, Asheville.

SOURCE: State Auditor's Records, Sch. B.

WEBSTER, W.: active 1910–1912, Hertford.

SOURCE: *N.C. Year Book*, 1910–1912.

WEEKS, B. B.: active 1916, Sanford.

SOURCE: State Auditor's Records, Sch. B.

WEEKS, GEORGE H.: itinerant daguerreotyper, 1849–1850s; in Newark, N.J. (1849–1856); in partnership with a Mr. Griffin, Farmville, Va. (Jan. 1851); in Raleigh (Feb.–May 1851), where they operated a "locomotive daguerrean gallery" at rear of Pomeroy & O'Neal's bookstore and later moved to courthouse square; in Greensboro (Mar.–May 1851), where they operated a "sky-light gallery" at Col. Gott's hotel; in Salisbury (ca. May–July 1851), where they produced "ivory daguerreotypes"; sole operator in Greeneville, Tenn. (Sept. 1851) and in Philadelphia (1854–1856).

SOURCES: *Raleigh Register* (semi-weekly), Feb. 12, May 10, 1851; *Greensborough Patriot*, Mar. 15, Apr. 12, 1851; *Carolina Watchman* (Salisbury), Apr. 17, May 22, 1851; *Craig's Daguerreian Registry*, 3:600; Eskind, *Index to American Photographic Collections*, 1027; Rinhart and Rinhart, *The American Daguerreotype*, 413; Ries and Ruby, *Directory of Pennsylvania Photographers*, 293.

WEILL, BLANCHE B. (ca. 1876–1911): native of N.C.; active late 1890s–early 1900s, Charlotte; daughter of Henry Baumgarten, with whom she worked as a photographer.

SOURCES: Tenth Census, 1880: Mecklenburg County, Pop. Sch., Charlotte, E.D. 107; Thirteenth Census, 1910: Mecklenburg County, Pop. Sch., Charlotte, E.D. 101; *Charlotte Observer*, Mar. 3, 1911; Vital Records, death certificates, Book D-18, p. 142 (A&H); information provided by Shelia Bumgarner, Public Library of Charlotte and Mecklenburg County.

WEISS, MYRON M.: active 1933–1936, Charlotte; vice-president and manager, Bon-Art Studio, S. Tryon St.

SOURCE: *Hill's Charlotte Directory*, 1933–1936.

WELCH, J. M.: active 1916–1920, Bryson City.

SOURCES: *N.C. Year Book*, 1916; State Auditor's Records, Sch. B.

WELDON, ALPHEUS: active mid-nineteenth century, Browntown (Davidson County).

SOURCE: Joyce, *Clark's Collection of Historical Remembrances*, 190.

WELFARE, ALANSON E. (1824–1883): native of N.C.; active 1857–1870s, Salem; daguerreotyper and maker of ambrotypes; mechanical genius; missionary to Indians in western United States; worked as a jeweler by 1880; portraits of Welfare are housed at MESDA in Winston-Salem.

SOURCES: *Zell's U.S. Business Directory*, 1875; *People's Press* (Salem), June 24, 1857, May 10, 1883; Eighth Census, 1860: Forsyth County, Pop. Sch., Salem; Ninth Census, 1870: Forsyth County, Pop. Sch., Salem; Tenth Census, 1880: Forsyth County, Pop. Sch., Salem, E.D. 85; Branson, *NCBD*, 1869, 1872; Forsyth County Estates Records (A&H); information provided by Jennifer Bean Bower, MESDA.

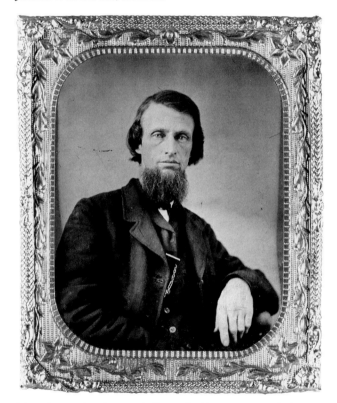

Salem photographer Alanson E. Welfare sat for this tintype portrait in the 1860s. Photograph courtesy MESDA.

WEST, APRIOR (b. ca. 1875): native of N.C.; active as itinerant in Fayetteville (by 1910).

SOURCE: Thirteenth Census, 1910: Cumberland County, Pop. Sch., Fayetteville, E.D. 50.

WEST, CHARLES MONROE (b. ca. 1869): native of N.C.; active 1915–1921, West Asheville.

SOURCES: Miller, *Asheville, N.C. City Directory*, 1915, 1917; State Auditor's Records, Sch. B; Fourteenth Census, 1920: Buncombe County, Pop. Sch., Asheville, E.D. 12; information provided by staff of Pack Memorial Public Library, Asheville.

WEST, DAVID F. (1847–1923): native of N.C.; active 1885–1906; itinerant statewide (1885–1886); in Burlington (by 1900); in tent in Siler City and Chatham County (1900); on E. Ramseur St., Durham (1902–1906).

SOURCES: State Auditor's Records, Ledgers, 1869–1899, Vol. 18, p. 127 (A&H); Twelfth Census, 1900: Alamance County, Pop. Sch., Burlington, E.D. 13; *Messenger* (Siler City), July 4, 1900; Adams, *Directory of Greater Durham, North Carolina, 1902*, 294; Hill, *Durham, N.C. Directory, 1905*, 302; *www.familysearch.org.*

WEST, FREDERICK C. *See* West-Dempster Company.

WEST, W. J.: active 1919, Duke (Harnett County).

SOURCE: State Auditor's Records, Sch. B.

WEST-DEMPSTER COMPANY: active 1929–1941, High Point; U. S. Newsom, manager (1929–1933). Frederick C. West (1874–1955) was president and Thomas Dempster Jr. was vice-president of this Grand Rapids, Mich., company that established an office in High Point as the furniture-manufacturing business moved south. The company specialized in photographing finished furniture for advertising purposes.

SOURCES: Miller, *High Point Directory*, 1929–1931; *Hill's High Point Directory*, 1933; Photographic Examiners Records; Tinder list of Mich. photographers.

WHARTON, CYRUS P. (1852–1929): native of N.C.; active 1873–ca.1911; in Forsyth County (1873–1874); in Graham (1875); in Raleigh (ca. 1875), with John W. Watson; in Salisbury (1876) in gallery located above a bookstore; in Chapel Hill (1878–1879); advertised photograph of faculty of the University of North Carolina; in Greensboro (by 1880–1886); in Raleigh (1886–1911) as Wharton's Gallery, Fayetteville St.; operated one of the largest and best-equipped studios in the state; purchased Raleigh studio of William H. Riggsbee (1892); in Carthage (briefly, 1896) at Shaw Hotel, in partnership with W. L. Moore; in Raleigh in partnership with Manly W. Tyree (1906–1911); served as vice-president of Photographers' Association of Virginia and North Carolina.

SOURCES: Treasurer's and Comptroller's Records, County Settlements with the State, Box 41, Forsyth-Franklin, Forsyth County List of Traders Licensed in Said County, 1873 (A&H); *Alamance Gleaner* (Graham), June 8, 1875; *Carolina Watchman* (Salisbury), Mar. 2, 16, 1876; *Weekly Ledger* (Chapel Hill), May 11, 1878; *Chapel Hill Ledger*, Sept. 20, 1879; Tenth Census, 1880: Guilford County, Pop. Sch., Gilmer Township, Greensboro, E.D. 127; *Chataigne's N.C. Directory and Gazetteer, 1883–'84*; *State Chronicle* (Raleigh), Oct. 13, 1887; *Directory of the City of Raleigh, North Carolina, 1887*, 194; *Directory of the*

City of Raleigh, 1888, 144; Branson, *NCBD*, 1890; *Daily State Chronicle* (Raleigh), Sept. 7, 1890, Apr. 2, 1892; *Carthage Blade*, Sept. 8, 1896; Separk, *Directory of the City of Raleigh, N.C., 1896–'97*, 354; *News and Observer* (Raleigh), Aug. 24, 1899, Nov. 26, 1929; Twelfth Census, 1900: Wake County, Pop. Sch., Raleigh, E.D. 141; *Maloney's 1901 Raleigh Directory*, 5:393; *N.C. Year Book*, 1902–1911; *Mercantile Agency Reference Book*, 1904; *Bradstreet's*, 1908; Sprange, *Blue Book*, 289; Vital Records, death certificates, Book 1337, p. 190 (A&H).

WHEELAN STUDIO: active 1936–1940s with Efird's Department Store, Charlotte, and Myers Department Store, Greensboro.

SOURCE: Photographic Examiners Records.

WHEELER, _____: active ca. 1920s, as operator of Wheeler Studio, Reidsville.

SOURCE: photograph bearing name "Wheeler."

WHEELER, W. M.: active 1860s in unidentified location in N.C.

SOURCE: Witham, *Catalogue of Civil War Photographers*, 60.

WHILLY, _____ (b. ca. 1887): native of Del.; active by 1910, Charlotte.

SOURCE: Thirteenth Census, 1910: Mecklenburg County, Pop. Sch., Charlotte, E.D. 103.

WHITAKER, LOUIS HENRY (b. 1858): native of N.C.; active by 1900–1907, Enfield.

SOURCES: Twelfth Census, 1900: Halifax County, Pop. Sch., E. Enfield Township, E.D. 29; *N.C. Year Book*, 1906, 1907; *www.familysearch.org.*

WHITAKER, S. D. (b. 1856): native of N.C.; active 1905, Andrews.

SOURCES: information provided by Jerry R. Roughton, Kenansville; *www.familysearch.org.*

WHITE, E. J.: active 1908–1915, Harbor Beach, Mich. (1908–1909); in Lumberton (1910–1915).

SOURCES: Tinder list of Mich. photographers; *N.C. Year Book*, 1910–1915.

WHITE, GEORGE E.: active 1916–1917, Elizabeth City.

SOURCES: *N.C. Year Book*, 1916; State Auditor's Records, Sch. B, Taxes; *Bradstreet's*, 1917.

WHITE, H. C. *See* H. C. White Company.

WHITE, HUGH DIXON (1887–1964): active 1933–1941, Guilford College; active after World War II with William A. Roberts in Greensboro.

SOURCES: Photographic Examiners Records; *Hill's Greensboro Directory*, 1938–1941; *www.familysearch.org.*

WHITE, JAMES E.: active 1937–1940 as manager, Hollywood Studio, Shelby.

SOURCE: *Miller's Shelby City Directory*, 1937–1940.

WHITE, K. G.: active ca. 1895, Goldsboro.

SOURCE: Sprange, *Blue Book*, 289.

WHITE, LEWIS GEORGE (b. 1863): active 1925–1940s with White Studio, Dunn.

SOURCE: Photographic Examiners Records.

WHITE, ROBERT GRAHAM (1863–1911): native of N.C.; active 1888–1910, Greensboro, in association with O. D. Prince (1888) in gallery on W. Market St., second door from the courthouse; sole proprietor in subsequent years.

SOURCES: *North Carolina Prohibitionist* (Greensboro), Oct. 19, 1888; *Turner's Annual Directory of the City of Greensboro for the Years 1890–'91*; *Greensboro City Directory, 1892–'93*; Brenizer, *A Directory of the City of Greensboro, N.C. for 1896–'97*; *Maloney's 1899–1900 Greensboro Directory*; Hill, *Greensboro, N.C. Directory, 1905–1910*; Twelfth Census, 1900: Guilford County, Pop. Sch., Greensboro, E.D. 52; *N.C. Year Book*, 1902–1907, 1910, 1911; Guilford County Wills (A&H); *Daily Record* (Greensboro), May 17, 1911; Vital Records, death certificates, Book D-21, p. 141 (A&H).

WHITEHEAD, PAUL: active 1907, Enfield.

SOURCE: *N.C. Year Book*, 1907.

WHITEHURST, JESSE HARRISON (ca. 1820–1875): native of Va.; active ca. 1842–1864; one of the earliest daguerreotypers in the South; in Charleston, S.C. (1844), in association with a Mr. Manning; operated chain of galleries in New York City, Baltimore, Washington, Richmond, Norfolk, Lynchburg, Petersburg, and Wilmington, N.C.; located in Baltimore between 1849 and 1864; obtained talented operators and secured good agents for the studios; awarded numerous gold and silver medals at fairs and expositions for superior work; in Wilmington (1853–1855); operated Whitehurst's Gallery in Mozart Hall above Hart & Polley's store on Front St.—the first permanent gallery in the state (Benjamin F. Harrison and William T. Harrison, Whitehurst's cousins, operated the establishment for Whitehurst and advertised stereographic daguerreotypes); secured the services of C. P. Wilhelm (ca. 1853–1854) and M. M. Mallon (1854) to operate the gallery during 1853–1854 period; gallery closed in Jan. 1855.

SOURCES: *Democratic Pioneer* (Elizabeth City), Sept. 17, 1850, Oct. 5, 1852, Mar. 7, 1854; *Wilmington Journal*, Jan. 14, July 1, Aug. 5, Sept. 16, Dec. 2, 1853, Jan. 27, July 28, Sept. 22, Oct. 20, 1854; *Craig's Daguerreian Registry*, 3:612–615; Palmquist, *The Daguerreian Annual, 1990*, 198–199; Rinhart and Rinhart, *The American Daguerreotype*, 414–415; Teal, *Partners with the Sun*, 17; Kelbaugh, *Directory of Maryland Photographers*, 58, 100, 102; information provided by Lynn and Mark White, Hightstown, N.J.

WHITENER, KATHRYN (Mrs. S. C. Whitener) (1902–1981): active 1940–1941 with Hardin Studio, Hickory; daughter of Charles M. Hardin; active after World War II.

SOURCES: Photographic Examiners Records; *www.familysearch.org*.

WHITESIDE, W. D. (b. ca. 1884): native of Tenn.; active by 1930, Littleton.

SOURCE: Fifteenth Census, 1930: Halifax County, Pop. Sch., Littleton, E.D. 42-16.

WHITFORD, REID: active ca. 1900, New Bern.

SOURCE: Green, *A New Bern Album*, 15.

WHITLEY, ATOSSA (b. 1900): active 1929–1936 with Camera Craft Studio, Durham; wife of F. Gilbert Whitley.

SOURCE: Photographic Examiners Records.

WHITLEY, FRANK GILBERT (b. 1887): active ca. 1913–1940s with Camera Craft Studio, Durham (1925–1940s); husband of Atossa Whitley.

SOURCES: Photographic Examiners Records; *Mercantile Reference Book*, 1931.

WHITLEY, T. G.: active 1916 as operator of T. G. Whitley & Company, North Wilkesboro.

SOURCE: State Auditor's Records, Sch. B.

WHITLOCK, MARTIN A. (b. ca. 1873): native of N.C.; active 1908–1916, Albemarle; in partnership with a Mr. Lowder as Whitlock & Lowder (1908); in partnership with a Mr. Tower as Whitlock & Tower (1916).

SOURCES: information provided by Jerry R. Roughton, Kenansville; Thirteenth Census, 1910: Stanly County, Pop. Sch., Albemarle, E.D. 115; State Auditor's Records, Sch. B.

WHITSETT, JERRE CALDWELL (b. 1902): active 1934–1940s with Whitsett Photo Company, Charlotte.

SOURCES: Photographic Examiners Records; *Hill's Charlotte Directory*, 1935–1941; *Mercantile Agency Reference Book*, 1943.

WHITTEMORE, F. C.: active 1919, Reidsville.

SOURCE: State Auditor's Records, Sch. B.

WHITTINGTON, _____: active 1880s, Wilson, in partnership with P. C. Setszer.

SOURCE: Cotten list of N.C. photographers.

WHORLEY, _____: active early 1900s, Leaksville, as proprietor of Whorley's Studio.

SOURCE: photograph bearing name "Whorley's Studio," in possession of Jerry R. Roughton, Kenansville.

WHYNOT COPYING HOUSE: active 1901, Whynot (Randolph County); sent flyers to many area post offices in an attempt to get a person in each town to represent the firm.

SOURCE: information provided by Harvey S. Teal, Columbia, S.C.

WICKER, B. J.: active 1875–1886; at Company Shops (1875) to erect permanent gallery; itinerant in Cameron (1878) in partnership with Montraville P. Stone; in Carthage (in tent with Stone); in Pittsboro (1879); in Carthage (1880); in Randolph County (1885–1886) in partnership with a Mr. Jones.

SOURCES: *Alamance Gleaner* (Graham), June 15, 22, 1875; *Carthaginian* (Carthage), Mar. 7, 1878; *Chatham Record* (Pittsboro), Mar. 27, 1879; *Moore Index* (Carthage), Mar. 18, 1880; Treasurer's and Comptroller's Records, County Settlements with the State, Box 74, Randolph County (A&H).

WICKER, WILLIAM T. (b. ca. 1883): native of N.C.; active 1909–1913; in Rockingham (1909–1913); in Roberdel (1910).

SOURCES: *Post* (Rockingham), Nov. 18, 1909; Thirteenth Census, 1910: Richmond County, Pop. Sch., Roberdel, E.D. 105; *N.C. Year Book*, 1910–1913.

WICKS, METTA W. (Mrs. A. J. Wicks) (1899–1979): purchased Zimmerman Studio, Durham, in 1936; active 1936–1941 with Wicks' Studio, W. Main St., Durham.

SOURCES: Photographic Examiners Records; Hill, *Durham, N.C. Directory, 1941*; *www.familysearch.org*.

WIGHT, GRANT: active ca. 1912–1917, Asheville, in partnership with a Mr. Donnahoe; affiliated with Robinson Kodak Store.

SOURCE: information provided by staff of Pack Memorial Public Library, Asheville.

WILCOX, H. P.: active 1908–1909, E. Nash St., Wilson.

SOURCE: *Wilson, N.C. Directory, 1908–1909.*

WILD, JOSEPH S. (b. ca. 1880): native of Tenn.; active early twentieth century; photographed logging operations and lumbering camps in Transylvania County.

SOURCE: Fourteenth Census, 1920: Transylvania County, Pop. Sch., Cathey's Creek Township, E.D. 186; information provided by Jan Plemmons, Amelia Island, Fla.

WILDE, JOHN W. F. (ca. 1803–after 1870): native of Md.; itinerant daguerreotyper, active 1848–1870; in unidentified location (ca. 1848); in Hillsborough (1849, 1851) in rooms at Major Howerton's hotel (1849) and at Orange County Courthouse (1851); in Baltimore, Md. (1851–1856); in Greensboro (1851); in Charlotte (1852, 1853) in rooms above Trotter's jewelry store (1852), on Granite Row (1853); in Asheville (1853) in rooms at Buncombe County Courthouse; in Yorkville, S.C. (1853–1854), in partnership with William P. Hughes; in Savannah, Ga. (1854–1856); in Selma, Ala. (1858–1861, 1868); in Talladega, Ala. (1868); in Demopolis, Ala. (1870), in association with his daughter Augusta, late 1840s–early 1850s—very likely the first father-daughter

This pair of daguerreotypes is believed to feature likenesses of Asheville brothers James Alfred Patton (1831–1864) and William Augustus Patton (1835–1863), members of a prominent Buncombe County family. Maryland photographer John W. F. Wilde and his daughter Augusta made the portraits while on a visit to Asheville in 1853. The words "Dr. Wilde and Daughter" are printed beneath one of the cased images. Photographs courtesy Mary Parker, Asheville.

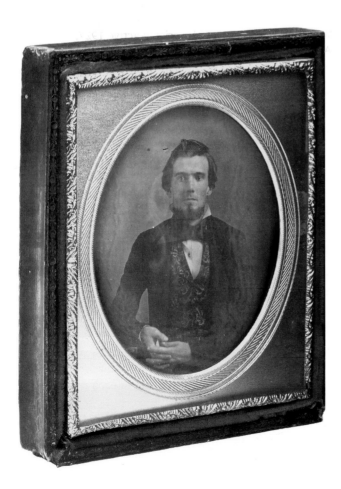

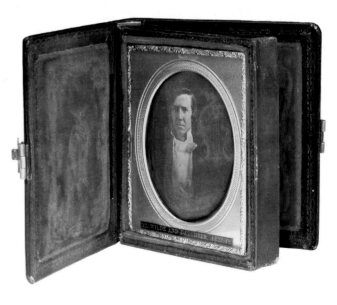

team in N.C. (*see* Augusta W. Mosher); her son, Jonathan ("John") T. Mosher, was photographer in Ala. in 1860s and 1870s.

SOURCES: *Hillsborough Recorder*, Dec. 5, 1849, Jan. 22, 1851; *Greensborough Patriot*, Mar. 15, 1851; *North Carolina Whig* (Charlotte), Feb. 18, 1852, Apr. 6, 1853; *Western Democrat* (Charlotte), Dec. 17, 1852, Jan. 28, 1853; *Asheville News*, July 28, 1853; Seventh Census, 1850: City of Baltimore, Md., Pop. Sch., Third Ward; *Craig's Daguerreian Registry*, 3:619; Rinhart and Rinhart, *The American Daguerreotype*, 415; Kelbaugh, *Directory of Maryland Photographers*, 34, 58; Robb list of Ala. photographers.

WILDER, ARTHUR E. (1889–1965): native of N.C.; active by 1920–1930s, Greensboro.

SOURCES: Fourteenth Census, 1920: Guilford County, Pop. Sch., Greensboro, E.D. 144; *Hill's Greensboro Directory*, 1935; *www.familysearch.org.*

WILEY, JAMES: active 1919, Raleigh.

SOURCE: State Auditor's Records, Sch. B.

WILHELM, C. P.: active 1850s–1860s; in Wilmington (ca. 1853–1854) with Whitehurst's Gallery, above Hart & Polley's store on Front St.; in Edenton (ca. 1866–1867) in partnership with Dr. H. R. Phillips.

SOURCES: Palmquist, *The Daguerreian Annual, 1990*, 199; photograph made in Edenton bearing names of Wilhelm and Phillips.

WILHELMS, _____: active ca. 1918, Camp Greene; associated with Sackett & Wilhelms Corp., Brooklyn, N.Y.; received permission to take photographs at the camp.

SOURCES: National Army Camps, Camp Greene, Charlotte, N.C., RG 393, Box 20, National Archives; information provided by Jane Johnson, Charlotte.

WILKINS, J.: active 1895, Poindexter St., Elizabeth City.

SOURCE: *North Carolinian* (Elizabeth City), Feb. 27, 1895 (includes illustration of studio).

WILKINSON, NEAL (NEIL) (ca. 1829–1863): daguerreotyper; active 1855–1862; in Charlotte (1855–early 1860s) in rooms located above Trotter and Son's jewelry store; also proprietor of private boardinghouse (1860); enlisted in Company B, Fifty-third Regiment, N.C. State Troops, Mar. 8, 1862; killed at Gettysburg, July 3, 1863.

SOURCES: *Western Democrat* (Charlotte), Feb. 9, 1855, Aug. 4, 1863; Eighth Census, 1860: Mecklenburg County, Pop. Sch., Charlotte; *Greensborough Patriot*, July 16, 1863; Manarin and Jordan, *N.C. Troops*, 13:87.

WILLARD, _____: active 1889, Wilmington, in partnership with a Mr. Freeburger; occupied Yates' Gallery on or about Apr. 8; prepared to produce photographs, oil, crayon, and pastel portraits.

SOURCES: *Messenger* (Wilmington), Mar. 31, 1889; Reaves list of Wilmington photographers.

WILLAUER, WILLIAM J.: active 1925, Charlotte.

SOURCE: Miller, *Charlotte Directory*, 1925.

WILLETT, W. F.: of N.Y.; active 1887 on Patton Ave., Asheville, with Edward E. Brown.

SOURCE: *Country Homes* (Asheville), Aug. 1887.

WILLIAMS, _____: of New Bern; active 1909, Newport.

SOURCE: New Bern *Weekly Journal*, Feb. 26, 1909.

WILLIAMS, CARLYLE: active twentieth century, Wallace; father of Shubert Williams.

SOURCE: information provided by Sarah Robinson, Jacksonville, Fla.

WILLIAMS, ELY (b. ca. 1886): native of N.C.; active by 1910, Greensboro.

SOURCE: Thirteenth Census, 1910: Guilford County, Pop. Sch., Greensboro, E.D. 104.

WILLIAMS, ISAAC N. (b. ca. 1865): native of Pa.; active as itinerant by 1910, Lilesville.

SOURCE: Thirteenth Census, 1910: Anson County, Pop. Sch., Lilesville, E.D. 10.

WILLIAMS, J. E.: active (obtained license to practice) 1911, Durham.

SOURCE: Record of Special Licenses Issued, Durham County, 1910–1911 (A&H).

WILLIAMS, J. W.: African American; active 1927, Asheville.

SOURCE: Miller, *Asheville, N.C. City Directory, 1927*.

WILLIAMS, JAMES EDWARD ("JACK") (1910–1989): active 1937–1950s, Durham; formed studio on Corcoran St. with Thomas N. Daniel (1937); operated Daniel & Smith Studio (1939–1941); sole proprietor after World War II; on W. Main St. by late 1940s; secretary, N.C. Photographers' Association; died in Va.

SOURCES: Photographic Examiners Records; Hill, *Durham City Directory*, 1938–1941; *Mercantile Agency Reference Book*, 1943; *www.familysearch.org.*

WILLIAMS, LUMIS ADOLPHUS (b. 1892): active 1922–1930s; with Taylor's Studio, Hamlet (1922–1924); with Hollywood Studio in Forest City (1934), Shelby (1934 and afterward), and Kings Mountain (1935 and afterward) in association with wife; son-in-law of John B. Taylor.

SOURCE: Photographic Examiners Records.

WILLIAMS, LUMIS A. (Mrs.) (b. 1900); active 1922–1930s; with Taylor's Studio, Hamlet (1922–1924), and with Hollywood Studio in Forest City (1934), Shelby (1934 and afterward), and Kings Mountain (1935 and afterward) in association with husband; daughter of John B. Taylor.

SOURCE: Photographic Examiners Records.

WILLIAMS, M. T.: active 1869–1872, Shelby.
SOURCE: Branson, *NCBD*, 1869, 1872.

WILLIAMS, N. (M.) P.: of Gettysburg, Pa.; active ca. 1918, Camp Greene; received permission to take photographs at the camp.
SOURCES: National Army Camps, Camp Greene, Charlotte, N.C., RG 393, Box 20, National Archives; information provided by Jane Johnson, Charlotte.

WILLIAMS, P. N.: active early twentieth century, Salem.
SOURCES: information from the files of MESDA; photograph bearing his name.

WILLIAMS, R. S.: active 1919, Fayetteville.
SOURCE: State Auditor's Records, Sch. B.

WILLIAMS, ROSA E. (Mrs.) (b. 1911): active 1935–1939 with Preston Studio, Asheville; operator of Shields' Studio after World War II. *See also* Shields, Rosa E.
SOURCE: Photographic Examiners Records.

WILLIAMS, SHUBERT (1920–1993): active twentieth century, Wallace; son of Carlyle Williams; died in Ga.
SOURCES: information provided by Sarah Robinson, Jacksonville, Fla.; *www.familysearch.org*.

WILLIS, FLOYD M. (1910–1973): active 1938–1940s, Shelby.
SOURCES: Photographic Examiners Records; *www.familysearch.org*.

WILLS, JOHN Q.: active 1916–1917; proprietor of Branagan Studio, Pack Square, Asheville.
SOURCES: State Auditor's Records, Sch. B; Miller, *Asheville, N.C. City Directory, 1917*; information provided by staff of Pack Memorial Public Library, Asheville.

WILSON, BLANCHE EDNA (b. 1905): active 1932–1940s; with Stone Studio, High Point (1932–1934); sole proprietor in Burlington of Wilson's Studio (1934–1940s).
SOURCES: Photographic Examiners Records; *Hill's Burlington Directory*, 1935; *Mercantile Agency Reference Book*, 1943.

WILSON, C. C.: active 1903, Greenville.
SOURCE: *N.C. Year Book*, 1903.

WILSON, ERNEST G. (1890–1971): native of N.C.; active 1914–1940s, Asheville; with John G. Robinson (1914–1916); with Carolina Photo Company (1916–1921); with Ray's Studio (1921–1930); sole proprietor, Wilson's Studio (1930–1940s); father of Juanita E. Wilson.
SOURCES: Photographic Examiners Records; *Mercantile Reference Book*, 1931; *Mercantile Agency Reference Book*, 1943; *Miller's Asheville Directory*, 1932, 1936–1937; information provided by staff of Pack Memorial Public Library, Asheville.

WILSON, FRANCES (Miss): active 1922–1926, Statesville.
SOURCE: Miller, *Statesville, N.C. City Directory*, 1922–23, 1925–1926.

WILSON, J. B.: active 1916–1921; in Asheville (1916–1919); in Belmont (1921).
SOURCE: State Auditor's Records, Sch. B.

WILSON, JUANITA E. (1919–1976): native of N.C.; active ca. 1933–1960s, Asheville; official photographer for Civil Air Patrol in N.C. (n.d.); joined her father, Ernest G. Wilson, in his studio in 1937.
SOURCES: Photographic Examiners Records; information provided by staff of Pack Memorial Public Library, Asheville; *www.familysearch.org*.

WILSON, T. J.: active 1866–1867, Hay St., Fayetteville.
SOURCE: *Branson & Farrar's NCBD*, 1866–1867.

WILSON, WILLIAM: active (obtained license to practice) 1903–1904, Alleghany County.
SOURCE: Registry of Licenses to Trade, Alleghany County, 1874–1906 (A&H).

WILSON, WILLIS JAMES (1871–1947): native of N.C.; active by 1910–1915, Raleigh.
SOURCES: Thirteenth Census, 1910: Wake County, Pop. Sch., Raleigh, E.D. 119; Hill, *Raleigh Directory*, 1913–1914; *N.C. Year Book*, 1914, 1915; Vital Records, death certificates, Book 16A, p. 306 (A&H); *News and Observer* (Raleigh), July 29, 1947.

WINBURN, J. T.: active ca. 1871–1898; itinerant in tent (1870s–1880s); in S.C. (ca. 1870s–1880s); operated Winburn's Gallery, Fayetteville (1887–1898), above A. E. Rankin & Company's store on Person St.; specialized in baby photographs; T. T. McGilvary took over as proprietor of the studio in Oct. 1898; George E. Paton purchased studio (ca. 1898).
SOURCES: Information on photograph suggests that Winburn was an itinerant operator in a tent; *Evening News* (Fayetteville), Aug. 2, 1887; *Fayetteville Observer*, Trade Issue, June 27, 1889; *Home-Florist* (Fayetteville), spring 1890; Sprange, *Blue Book*, 289; Branson, *NCBD*, 1896, 1897; *News and Observer* (Raleigh), Aug. 24, 1899; Teal, *Partners with the Sun*, 268.

WINDHORST, A. M.: active 1921, Elizabeth City.
SOURCE: State Auditor's Records, Sch. B.

WINEBURGER, E. M. (W.): of Trade, Tenn.; active 1919–1921; in Ashe County (1919); in Spruce Pine (1921).
SOURCE: State Auditor's Records, Sch. B.

WINNER, JOSEPH LLOYD (ca. 1836–1902): native of Pa.; active ca. 1861–1879; at Camp Parole Station, Md. (Civil War period); in Shickshinny, Pa. (1860s–ca. 1870); in Elizabeth City (periodically by 1870–1879), in gallery located above Dr. James M. Butt's drugstore on Road St.; also engaged as jeweler; jeweler and photographer

Photographer Joseph L. Winner of Elizabeth City applied for and received two patents relating to his profession. Shown here is a drawing of Winner's "Improvement in Apparatus for Fumigating Photographic Paper," patented May 30, 1871. Patent courtesy U.S. Patent Office, Washington, D.C.

J.T. Winburn of Fayetteville produced this pleasing likeness of an unidentified young man who visited his studio about 1890. Courtesy of the compiler.

on Main St., Washington (ca. 1876–1878); by 1880 relocated to Wilmington and was employed primarily as a jeweler; while a resident of Elizabeth City in 1871, Winner was issued two patents: for improvement in apparatus for fumigating photographic paper and for improvement in corners for photographic plate holders; perhaps brother of W. H. Winner.

SOURCES: Witham, *Catalogue of Civil War Photographers*, 33; Ries and Ruby, *Directory of Pennsylvania Photographers*, 305; Ninth Census, 1870: Pasquotank County, Pop. Sch., Elizabeth City; Tenth Census, 1880: New Hanover County, Pop. Sch., Wilmington; *North Carolinian* (Elizabeth City), Feb. 16, 1871; *Economist* (Elizabeth City), Sept. 13, 1876; *North State Press* (Washington), Nov. 12, 1878; United States Patent Office, No. 120 and 141, Oct. 17, 1871, No. 115 and 554, May 30, 1871; New Hanover County Wills, Book 326, p. 244 (A&H).

WINNER, W. H.: active 1872–1875, Edenton; perhaps brother of Joseph L. Winner.

SOURCES: Branson, *NCBD*, 1872; *Zell's U.S. Business Directory*, 1875.

WINSTEAD, ALONZO G. (1877–1910): native of N.C.; active by 1900, Wilson; son of Francis M. Winstead.

SOURCES: Twelfth Census, 1900: Wilson County, Pop. Sch., Wilson, E.D. 126; Howell, *Wilson County, North Carolina Cemeteries*, 2:129.

WINSTEAD, FRANCIS MARION (1850–1914): native of N.C.; active 1880–ca.1908; on Nash St., Wilson, in partnership with Sydney R. Alley (1880–1886) as A & W Photo Gallery; sole proprietor (1887–ca. 1890s), Winstead's Photograph Gallery, above Wells' store, corner of Nash and Tarboro Streets; C. R. Tyson took over operation of gallery (1896–1897); in Tarboro (1884–1886); in New Bern (ca. late 1890s); returned to Wilson in 1898 and worked there for the remainder of his career in studio above Woodard's and Godwin's store; father of Alonzo G. Winstead.

SOURCES: Cotten list of N.C. photographers; *Weekly Brief* (Wilson), July 13, 1886; *Wilson Mirror*, Sept. 13, 1887, June 6, 1888; *State Chronicle* (Raleigh), Wilson Edition, May 31, 1889; *Great Sunny South* (Snow Hill), Aug. 19, 1898; Twelfth Census, 1900: Wilson County, Pop. Sch., Wilson, E.D. 126; *Mercantile*

A military unit marches past Francis M. Winstead's photograph gallery, situated on the northwest corner of Pollock and Middle Streets in New Bern. This photograph (late 1890s) was taken from a building situated across the street from the gallery. Photograph courtesy A&H.

Agency Reference Book, 1904; *Bradstreet's*, 1908; Green, *A New Bern Album*, 117; Howell, *Wilson County, North Carolina Cemeteries*, 2:130; Sprange, *Blue Book*, 289; Vital Records, death certificates, Book 53, p. 468 (A&H).

WINSTON, JOHN D. (b. ca. 1888): native of N.C.; African American; active 1922–1930; resided in Henderson (1922); worked in Granville County (1922); active as street photographer in Durham (by 1930).
SOURCES: State Auditor's Records, Sch. B; Fifteenth Census, 1930: Durham County, Pop. Sch., Durham, E.D. 32-9.

WINTER, CLARA M.: active 1906–1909 with Winter's Studio, Asheville.
SOURCES: Hill, *Asheville, N.C. City Directory, 1906–'07*; Miller, *Asheville, N.C. City Directory, 1907–1909*.

WISEMAN, W. H.: active 1850s–1860s; practiced in New York City (ca. 1850s); in Salisbury (1857) as itinerant; operated picture gallery opposite Mansion Hotel; in Charlotte (1866–1867); in Newberry, S.C. (1868–1877).
SOURCES: *Carolina Watchman* (Salisbury), May 26, 1857; *Branson & Farrar's NCBD*, 1866–1867; Eskind, *Index to American Photographic Collections*, 1045; Teal, *Partners with the Sun*, 156.

WITHERSPOON, H. K.: active 1937, Raleigh; took photographs of Herbert H. Brimley at State Museum of Natural History.
SOURCE: Herbert H. Brimley Photograph Collection (N.C. Department of Agriculture, Museum of Natural Sciences).

WOLCOTT, J. C.: active ca. 1920s–1940s; in Ridgecrest (1920s–1930s); in Black Mountain (1930s–1940s), in association with June Glenn Jr.
SOURCES: postcard bearing his name; Photographic Examiners Records.

WOLFE, FRANK CECIL (1888–1956): active 1911, Pack Square, Asheville, in partnership with Newton W. Blough; thought to be a brother of Asheville author Thomas Wolfe; an Asheville city directory includes a listing for a Frank W. Wolfe: either the middle initial is incorrect or the directory may refer to another brother, Frederick William Wolfe.
SOURCES: Miller, *Asheville, N.C. City Directory, 1911*; information provided by staff of Pack Memorial Public Library, Asheville.

WOLFF, FRED: active 1940 and afterward, Wilmington; left Wilmington *Star-News* and became associated with

Edward L. K. Gruehn in Wolfe-Gruehn Studio on Princess St.; slogan "In the Modern Manner."

SOURCE: Reaves list of Wilmington photographers.

WOMBLE, LILLIAN RUTH ("LOUISE") (Miss) (b. 1905): native of Va.; active 1926–1940s with Clement Studio, Goldsboro; became partner by 1936; in Chapel Hill (1930).

SOURCES: Photographic Examiners Records; Fifteenth Census, 1930: Orange County, Pop. Sch., Chapel Hill, E.D. 56-6.

WOOD, C. H.: native of England; studied photography in Europe, Canada, and the U.S.; active as itinerant who operated from tent; at Davidson College (early 1880s); offered to undertake outdoor photography, as well as stereographs; in Hyde County (1884–1885); in Stonewall (1885), where windstorm demolished his tent; in Aurora (1885).

SOURCES: Registry of Licenses to Trade, Hyde County, 1881–1903 (A&H); broadside advertisement in the James Harwell Papers (A&H); *New Berne Weekly Journal*, Jan. 22, 1885.

This broadside advertises the services of English itinerant photographer C. H. Wood, who erected his tent at Davidson College during the fall season in the early 1880s. Broadside courtesy A&H.

WOOD, HUGH D.: active early twentieth century, New Bern vicinity; important amateur photographer; Office of Archives and History holds copy negatives of a number of his prints, many of which are of African American subjects.

SOURCE: Green, *A New Bern Album*, 15.

WOOD, JOHN (b. ca. 1902): native of N.C.; active by 1930, High Point.

SOURCE: Fifteenth Census, 1930: Guilford County, Pop. Sch., High Point, E.D. 41-50.

WOOD, WILLIAM: active 1919–1920, Goldsboro.

SOURCE: State Auditor's Records, Sch. B.

WOODALL, NATHAN B. (b. ca. 1900): native of N.C.; active by 1930, High Point.

SOURCE: Fifteenth Census, 1930: Guilford County, Pop. Sch., High Point, E.D. 41-52.

WOODARD, BENJAMIN T. (1883–1932): active 1916, Lucama (Wilson County).

SOURCES: *N.C. Year Book*, 1916; Howell, *Wilson County, North Carolina Cemeteries*, 1:111.

WOODARD, WESTLEY: active 1916, Princeton.

SOURCE: *N.C. Year Book*, 1916.

WOODBRIDGE, JOHN S.: active 1848–1857; in New Bern as itinerant daguerreotyper from New York City (1848, 1850, 1851); occupied rooms in Durand's building on Craven St. (1848, 1850); operated skylight daguerrean gallery in building formerly occupied by H. Latimer on Craven St. (1851); in Columbus, Ga. (1854–1858) in partnership with a Mr. Popkins (1856–1858); in Baltimore, Md. (1855–1856); in Cincinnati, Ohio (1856); operated studios in Cincinnati, Baltimore, and St. Louis (1857) in partnership with S. P. Harris.

SOURCES: *Newbernian* (New Bern), Mar. 28, Apr. 11, May 9, 23, 1848, Feb. 26, Apr. 16, 1850; *Newbernian and North Carolina Advocate*, Nov. 19, 1850, Jan. 21, 1851; *Craig's Daguerreian Registry*, 3:632; Green, *A New Bern Album*, 13; Rinhart and Rinhart, *The American Daguerreotype*, 416; Gagel, *Ohio Photographers*, 32, 109; information provided by Bruce S. Cheeseman, King Ranch, Kingsville, Tex.

WOODS, J. C.: active 1919, Badin (Stanly County).

SOURCE: State Auditor's Records, Sch. B.

WOODY, _____: active 1910–1911, Wilson, in partnership with a Mr. Weaver.

SOURCE: *N.C. Year Book*, 1910, 1911.

WOODY, JULIAN CARR (1885–1957): native of N.C.; active 1910s–1920s, Badin, Greensboro, and Durham; photographed construction of Badin Lake and dam; later settled in Person County and worked for Collins

and Aikman; photograph of Woody on file at N.C. Office of Archives and History.

SOURCE: information provided by Leigh H. Gunn, Timberlake.

WOOLWINE, C. W. C. (b. ca. 1851): native of Va.; active 1879–1880, Salisbury.

SOURCES: Tenth Census, 1880; Rowan County, Pop. Sch., Salisbury, E.D. 246; Cotten list of N.C. photographers.

WOOTTEN, MARY BAYARD (1875–1959): native of N.C.; active ca. 1905–1950s; received early training from Edward Gerock of New Bern; also studied under Ignatius W. Brock of Asheville; in association with John L. Grant (1905–1906); sole proprietor of studio in New Bern (ca. 1906–1910s); in partnership with half brother, George C. Moulton, as Wootten-Moulton Studio (ca. 1912–1940s); at Fort Bragg (1921–ca. 1930) as Wootten-Moulton Studio; studio burned in 1930; in Chapel Hill (1928–1954) as Wootten-Moulton Studio; at Camp Butner (early 1940s) as Wootten-Moulton Studio; obtained notoriety as photographer at Camp Glenn, a state guard camp near Morehead City; likely the first female to take aerial views in the state (1914);

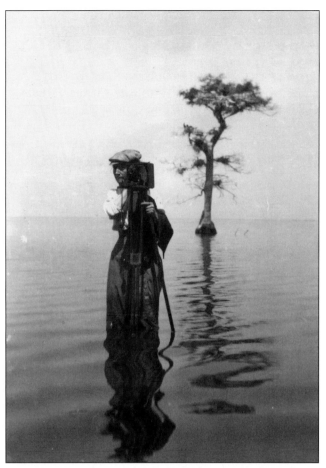

Here Wootten stands ankle-deep in the waters of Great Lake in Craven County to take pictures of birdlife in May 1911. Herbert H. Brimley, head of the State Museum of Natural History, likely took the photograph of Wootten peering from behind her camera. Photograph courtesy A&H.

publisher of numerous picture postcards; worked as a "pictorialist" in photography field, striving to inject artistic elements into her images at a time when realistic photography dominated the medium; became state's leading female photographer and one of the South's best camera artists; some of the state's foremost photographers of the mid-twentieth century received their training at the Wootten-Moulton Studio; provided photographs for numerous books and had works exhibited in other states; active in Women's Federation of the Photographers' Association; active in N.C. Photographers' Association; daughter of

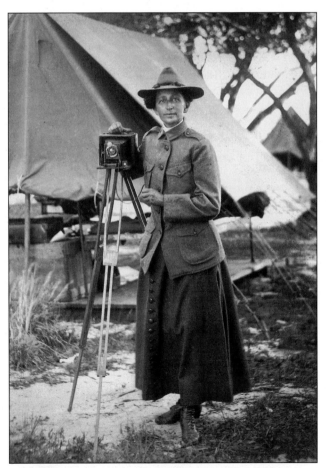

Bayard Wootten poses proudly about 1908 in her uniform at Camp Glenn, a state guard facility near Morehead City. She subsequently served as the official "camp photographer" for several years and was issued her own uniform. Photograph courtesy North Carolina Collection, Wilson Library, UNC-CH.

OPPOSITE, TOP: Many of Wootten's Camp Glenn photographs were made into picture postcards. An example is this view of soldiers practicing on a firing range in August 1908. Courtesy of the compiler. **OPPOSITE, BOTTOM:** In November 1911 Wootten captured this unique image of aviator Charles "Bird Man" Witmer flying a Curtis biplane at the Craven County Agricultural Stock Exhibit and Aviation Meet near the John L. Roper Lumber Company of New Bern. Postcard courtesy Micky Weeks, Cary.

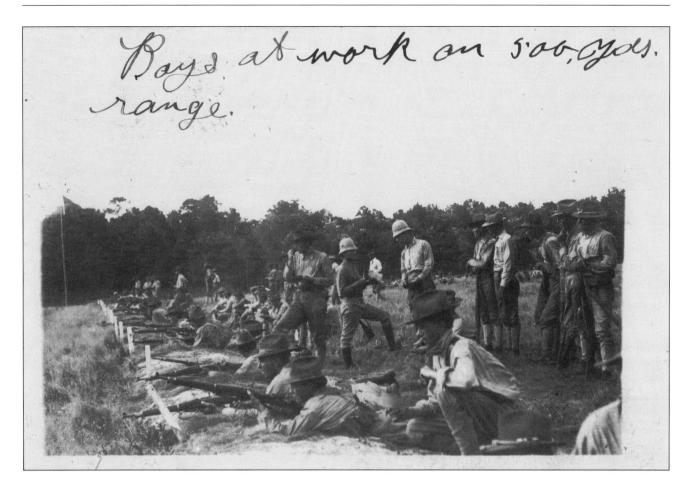

Boys at work on 500 yds. range.

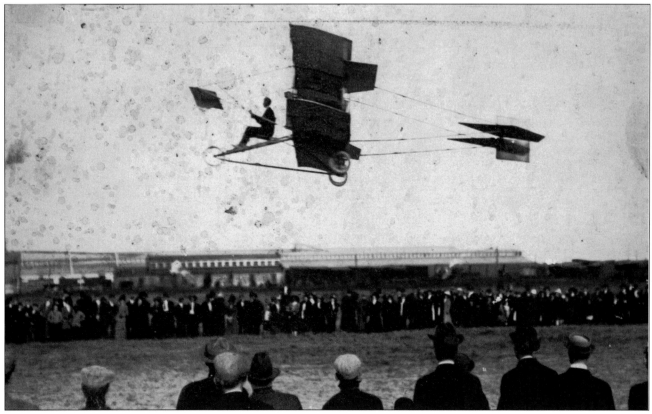

Rufus Morgan, one of the state's most talented stereographic artists; half-sister of Celia Moulton Lively; many of her original photographs are housed at the Photographic Services Division, North Carolina Collection, Wilson Library, UNC-CH.

SOURCES: Photographic Examiners Records; *Illustrated City of New Bern*, 7; *N.C. Year Book*, 1910–1916; State Auditor's Records, Sch. B; *Bradstreet's*, 1917, 1921, 1925; *Mercantile Reference Book*, 1931; *Mercantile Agency Reference Book*, 1943; Hill, *New Bern Directory*, 1907–1908, 1911–1912, 1914–1915, 1918–1921, 1926; *Baldwin's New Bern Directory*, 1937, 1941; *Daily Journal* (New Bern), May 29, 1914; *Greensboro Daily News*, Aug. 1, 1926; *News and Observer* (Raleigh), Dec. 5, 1937, Oct. 9, 1949, July 8, 1951; Apr. 7, 1959; Weaver, "N.C. Guard's Only Woman General," *Uplift*, Nov. 1, 1941, pp. 14–16 (reprinted from Weaver's article in *Charlotte Observer*); DNCB, s.v. "Wootten, Mary Bayard"; Cotten, *Light and Air*; Green, *A New Bern Album*, 15; Busbee, "North Carolina through the Camera," *North Carolina Teacher* 9 (Oct. 1932): 56, 77; information provided by Mary M. Barden, New Bern; information provided by Roy Parker Jr., Fayetteville.

WORD, HENRY: active 1919, Charlotte.
SOURCE: State Auditor's Records, Sch. B.

WORD, S. A.: active 1921, Rosman (Transylvania County).
SOURCE: State Auditor's Records, Sch. B.

WORMELL, E. S. (b. ca. 1838): native of Maine; active 1860s–1880s; in Portland, Maine (Civil War era); operated Wormell's Picture Gallery on Craven St., New Bern (1871–1878); also agent for Singer Sewing Machine Company (1876–1877); in Washington (ca. 1870s); in Tarboro (by 1880); producer of stereographs.
SOURCES: *Republican and Courier* (New Bern), Nov. 25, 1871; Branson, *NCBD*, 1872; *Chataigne's Raleigh Directory*, 1875, 204; State Auditor's Records, Sch. B, Box 1, Folder 1874–1876 (A&H); *Beveridge and Co.'s N.C. Directory*, 1877–'78, 266; Tenth Census, 1880: Edgecombe County, Pop. Sch., Tarboro, E.D. 59; Darrah, *World of Stereographs*, 202; Witham, *Catalogue of Civil War Photographers*, 31; *Zell's U.S. Business Directory*, 1875; George Eastman House Photographers Database; information provided by Stephen M. Rowe, Raleigh.

WORTH, G. B. (B. G.): itinerant daguerreotyper; active 1844–1846; in Raleigh (1844–1845); occupied rooms on third story of Benjamin B. Smith's brick building; in Hillsborough (1846); occupied rooms at Nichols' hotel.
SOURCES: *Raleigh Register and North Carolina Gazette*, Nov. 22, 1844, Jan. 28, 1845; *Hillsborough Recorder*, Sept. 10, 1846.

WORTH, STEPHEN G. (ca. 1854–1929): native of N.C.; active late nineteenth century; not a commercial photographer; employed by U.S. Department of Fisheries; also businessman and newpaper owner; documented turpentine industry in Sampson County; photographic negatives of his work are on file at N.C. Office of Archives and History.

SOURCE: *News and Observer* (Raleigh), Apr. 27, 1929.

WORTHAM, GEORGE: active 1930s, Oxford.
SOURCE: Photographic Examiners Records.

WORTMAN, WILLIAM ANDREW (1855–1921): native of N.C.; active ca. 1895, Morganton; at time of death he was employed as a jeweler and watch repairman; died in Gaston County; buried in Burke County.
SOURCES: Sprange, *Blue Book*, 289; Vital Records, death certificates, Book 661, p. 218 (A&H).

WORTTEN (WORTHEN), BASCUM E. (b. ca. 1893): native of N.C.; active by 1910, Gastonia.
SOURCE: Thirteenth Census, 1910: Gaston County, Pop. Sch., Gastonia, E.D. 59.

WREN, JOHN A. (b. ca. 1840): native of Va.; active 1866–1890; in Clinton, Laurens, and Abbeville, S.C. (1866); in Newberry, S.C. (1867–1868); in Negaunee, Mich. (1867); in Salisbury (by 1870); operated Maxwell Gallery in Anderson, S.C. (1887, 1889–1890); published book of views of Anderson in 1890.
SOURCES: Ninth Census, 1870: Rowan County, Pop. Sch., Salisbury; Teal, *Partners with the Sun*, 127, 153; Tinder list of Mich. photographers.

WRIGHT, ARTHUR (b. ca. 1877): native of England; active by 1910, Durham.
SOURCE: Thirteenth Census, 1910: Durham County, Pop. Sch., Durham, E.D. 36.

WRIGHT, ED: active 1922, High Point.
SOURCE: State Auditor's Records, Sch. B.

WRIGHT, JAMES (b. 1868): native of N.C.; active by 1900, Fayetteville.
SOURCE: Twelfth Census, 1900: Cumberland County, Pop. Sch., Fayetteville, E.D. 23.

WRIGHT, S. R.: active late 1860s or early 1870s, Hillsborough.
SOURCE: name on back of cartes-de-visite.

WRIGHT, _____: active ca. 1910s, Troy, in partnership with Daniel Frank Morgan.
SOURCE: photograph bearing name "Wright."

WYATT, W. G.: active 1903–1918; in Greensboro (1903–1905); in Durham (1917–1918).
SOURCES: Hill, *Greensboro, N.C. Directory, 1903–'04*; *N.C. Year Book*, 1905; Record of Special Licenses Issued, Durham County, 1917–1918 (A&H).

Y

YANCEY, RUBY STONE (Mrs.) (b. 1909): active 1922–1940s; in Mount Airy (1922–1923) with husband, J. Lee Stone; in Salisbury (1923–1930s) with husband; with Stone Studio, High Point (1930s) with husband.

SOURCES: Photographic Examiners Records; *Mercantile Agency Reference Book*, 1943.

YARBOROUGH, HOBART H. (b. ca. 1908): native of N.C.; active 1930–1931 as proprietor of Art Studio, Thomasville; brother of Vestal Yarborough.

SOURCES: Fifteenth Census, 1930: Davidson County, Pop. Sch., Thomasville, E.D. 29-24; Miller, *Thomasville City Directory, 1930–'31*; *Mercantile Reference Book*, 1931.

YARBOROUGH, VESTAL (b. ca. 1910): native of N.C.; active by 1930 in Thomasville; brother of Hobart H. Yarborough.

SOURCE: Fifteenth Census, 1930: Davidson County, Pop. Sch., Thomasville, E.D. 29-24.

YATES, CHARLES W. (1839–1915): native of N.C.; active 1868–1890s; member, Company E., Forty-first Regiment, N.C. State Troops; active for entire career in Wilmington; purchased photograph gallery of Thomas S. Hansley, Market St. (1868); in partnership with John J. Conoley prior to 1875; operated C. W. Yates & Company (1875 and afterward) in partnership with DeWitt C. Love (not a photographer); business also became a seller of musical instruments and a leading book and stationery store; in partnership with Alexander Orr Jr. (ca. 1879–1883); the two men published stereographs of Wilmington and vicinity (J. F. Lardner operated the gallery in 1883); in partnership with William P. Hughes as Hughes & Yates (n.d.); in partnership with Sidney L. Alderman (1880s); Nat W. Taylor operated Yates' Gallery (1888–1889); Yates closed his photography business in the 1890s.

SOURCES: *Star* (Wilmington), Mar. 22, Apr. 18, Oct. 29, 1868; *Morning Star* (Wilmington), June 11, 1869, Apr. 11, 1915; Ninth Census, 1870: New Hanover County, Pop. Sch., Wilmington; Branson, *NCBD*, 1869, 1877–'78, 1884, 1890; *Haddock's Wilmington Directory, 1870–'71*; *Chataigne's Raleigh Directory*, 1875, 229; *Sheriff's Wilmington Directory, 1877–8*; *Directory of the City of Wilmington, 1889*; *Chataigne's N.C. Directory and Gazetteer, 1883–'84*; *Zell's U.S. Business Directory*, 1887, 1889; *Curtin's United States Business Directory, 1890*, 1400; Sprange, *Blue Book*, 289; Vital Records, death certificates, Book 96, p. 419 (A&H); Cotten list of N.C. photographers; Reaves list of Wilmington photographers; photograph bearing Yates's name, owned by Bill Bennett, Rocky Mount.

YELTON, _____: active 1913–1914, Caroleen, in partnership with a Mr. Dobbins (1913).

SOURCE: *N.C. Year Book*, 1913, 1914.

Partners Charles W. Yates and Alexander Orr Jr. collaborated to produce this stereograph of a tightrope walker entertaining a crowd on Market Street in Wilmington on February 7, 1879. Photograph courtesy Cape Fear Museum, Wilmington.

YOKELY, K. M.: active 1919, Asheboro.

SOURCE: State Auditor's Records, Sch. B.

YORK, A. HENRY (b. 1869): native of N.C.; active by 1900, Ramseur.

SOURCES: Twelfth Census, 1900: Randolph County, Pop. Sch., Ramseur, E.D. 84; photograph bearing his name, in possession of Jerry R. Roughton, Kenansville.

YOSKELL, B. J.: active 1920–1921, Wilmington.

SOURCE: State Auditor's Records, Sch. B

YOST, JAMES OGATHA (1883–1957): native of N.C.; active 1902–1940s, Hamlet (1907–1940s); industrial and commercial photographer; out of business because of ill health (1935–1936); resumed career in 1937.

SOURCES: Photographic Examiners Records; *www.familysearch.org*.

YOUNG, ROBERT W.: African American; active 1939–1940s, Asheville; operated Young's Studio.

SOURCES: *Miller's Asheville Directory*, 1939–1941; *Mercantile Agency Reference Book*, 1943.

YOW, J. W.: active 1916, Ramseur.

SOURCE: *N.C. Year Book*, 1916.

Z

ZACHARY, _____: active late nineteenth century, Burlington, in partnership with a Mr. Thomas.

SOURCE: photograph bearing name "Zachary."

ZANGWELL, SAMUEL: active 1911, Patton Ave., Asheville.

SOURCE: Miller, *Asheville, N.C. City Directory, 1911.*

ZIMMERMAN, EDWARD KOSSUTH (1871–1938): native of Pa.; active 1907–1936; in Durham (1907–1929, 1935–1936); operated Zimmerman Studio, E. Main St.; in Clinton (1919–1920, 1929–1935); Metta W. Wicks purchased the Durham studio in 1936.

SOURCES: Registry of Licenses to Trade, Durham County, 1881–1913 (A&H); *Bradstreet's*, 1908, 1917, 1921, 1925; Thirteenth Census, 1910: Durham County, Pop. Sch., Durham, E.D. 37; Record of Special Licenses Issued, Durham County, 1914–1916 (A&H); *N.C. Year Book*, 1916; Hill, *Durham, N.C. Directory*, 1923–1938; *Mercantile Reference Book*, 1931; Photographic Examiners Records; State Auditor's Records, Sch. B; Vital Records, death certificates, Book 2007, p. 34 (A&H); *News and Observer* (Raleigh), Feb. 15, 1938.

ZION, OSKUS: active 1916, Elizabeth City.

SOURCE: State Auditor's Records, Sch. B.

ZOELLER, WILLIAM HENRY (1864–1936): native of N.C.; active 1883–1930s; apprenticed at Bachrach's Studio, Washington, D.C.; in Greenville (1884–1886) in partnership with John F. Engle; in Snow Hill (1886); in Edenton (1889) in partnership with Engle; in Elizabeth City (1889) in partnership with Engle; gallery located above Harrison & Nash's store; in Tarboro (1890–1891); in Elizabeth City (1892–1930s); in partnership with Charles A. Morgan (ca. 1895) as Zoeller, Morgan & Company; later as Zoeller Photographic Company, and later Zoeller's Studio; in Tarboro (ca. 1895); associated with son-in-law, Harley A. Dartt (1928–1933), near end of his career; collection of his negatives are housed at Museum of the Albemarle in Elizabeth City; portraits of Zoeller are on file at N.C. Office of Archives and History.

SOURCES: *Historical and Descriptive Review*, 216; *Eastern Reflector* (Greenville), Apr. 21, 1886, Apr. 13, July 20, 1887; *Economist* (Elizabeth City), Feb. 26, 1889; *Fisherman and Farmer* (Edenton), July 26, 1889; Sprange, *Blue Book*, 289; Registry of Licenses to Trade, Washington County, 1883–1902 (1900–1901) (A&H); Twelfth Census, 1900: Pasquotank County, Pop. Sch., Elizabeth City, E.D. 77; *N.C. Year Book*, 1902–1907, 1910–1916; *Mercantile Agency Reference Book*, 1904; *Bradstreet's*, 1908, 1917, 1921, 1925; *Mercantile Reference Book*, 1931; Photographic Examiners Records; State Auditor's Records, Sch. B; Miller, *Elizabeth City, N.C. City Directory*, 1923–'24; *Daily Advance* (Elizabeth City), June 1, 3, 1936;

Elizabeth City photographer William H. Zoeller has donned a robe and hat and is wearing a sign to advertise a two-day special price for photographs made at his studio. He probably devised this "walking billboard" in the late 1910s. Photograph courtesy Museum of the Albemarle, Elizabeth City.

Vital Records, Deaths, Pasquotank County, Book 23, p. 72 (A&H); Pasquotank County Wills, Book R, p. 410 (A&H); Cotten list of N.C. photographers; information provided by Museum of the Albemarle, Elizabeth City.

ZOOLEK, T. A.: active 1921, Rockingham.

SOURCE: State Auditor's Records, Sch. B.

ZUKY, ANTHONY K.: native of Hungary; active 1850s as itinerant daguerreotyper; in New York City (1853–1854); exhibited works at the Crystal Palace during World's Fair (1853); in Saratoga, N.Y. (n.d.); in Elizabeth City (1853–1854); in Athens, Ga. (1854).

SOURCES: *Old North State* (Elizabeth City), Nov. 5, Dec. 10, 1853; *Craig's Daguerreian Registry*, 3:640; Rinhart and Rinhart, *The American Daguerreotype*, 416.

This photograph by Zoeller and partner Charles A. Morgan shows construction on the Dismal Swamp Canal in northeastern North Carolina about 1895. Photograph courtesy A&H.

UNIDENTIFIED daguerreotyper: active 1844, Fayetteville; offered colored daguerreotype miniatures.

SOURCE: *Fayetteville Observer*, Apr. 3, 1844.

UNIDENTIFIED daguerreotyper: from Orange County, N.Y.; active 1846–1847, Edenton, Williamston, Washington, Greenville; departed N.Y. aboard schooner *Belle*, Oct. 20, 1846; arrived in Edenton via Norfolk, Portsmouth, Va., late Oct.; in Edenton, resided at inn of Samuel T. Bond, clerk of Chowan County Superior Court; made daguerreotypes at courthouse, apparently in clerk's office; Chowan County Court of Pleas and Quarter Sessions subsequently directed that Bond not allow his office to be used for a private purpose; Bond refused to obey and was fined $25 for contempt of court; unidentified daguerreotyper departed Edenton on Nov. 30, traveling to Williamston, where he stopped at residence of one William A. Wattres and "set up taking pictures"; after making $17 on Christmas day, he departed Williamston for Washington on Dec. 28; on Jan. 3, 1847, he traveled to Greenville, where he set up his equipment at the Pitt County Courthouse; while in Greenville the artist was "annoyed with gangs a-coming in and wanting to set to see how they would look."

SOURCES: Minutes of the Chowan County Court of Pleas and Quarter Sessions, 1843–1853, pp. 151–152 (A&H); unpublished diary of unidentified daguerreotyper owned by Richard McGrath; information provided by John S. Craig, Torrington, Conn.

UNIDENTIFIED daguerreotyper: active 1848, Hillsborough; occupied room at Union Hotel.

SOURCE: *Hillsborough Recorder*, June 7, 1848.

UNIDENTIFIED daguerreotyper: active ca. 1856, Fayetteville; advertised daguerreotype apparatus for sale at F. T. Ward's.

SOURCE: *Fayetteville Observer*, Jan. 27, 1856.

UNIDENTIFIED PHOTOGRAPHER: active 1878, Wilmington; advertised a "daguerreotype gallery" located on third floor of No. 34 Market St.

SOURCES: *Star* (Wilmington), Sept. 4, 1878; Reaves list of Wilmington photographers.

SOURCES

PUBLISHED WORKS

Adams, Samuel L., comp. *Directory of Greater Durham, North Carolina*, Vol. 5: *1902*. Durham: the compiler, 1902.

Aheron, Piper. *From Avalon to Eden: A Postcard Tour of Rockingham County.* Dover, N.H.: Arcadia Publishing, 1997.

Albemarle, North Carolina City Directory, 1937 and 1940. Charleston, S.C.: Baldwin Directory Company, 1937, 1940.

Albright, Alex. "The Early North Carolina Movies." *State* 54 (July 1986).

Aldridge, Bryan K., et al., comps. *McDowell County, North Carolina Cemetery Records*, Vol. 3. N.p., 1995.

Alexander, Tom, Jr., and Jane Alexander, eds. *Mountain Fever: Tom Alexander.* Asheville: Bright Mountain Books, 1995.

American Legion North Carolina Fayetteville City Directory, 1928. Fayetteville: Burkhead-DeVane Printing Company, 1928.

Asheville, North Carolina City Directory, 1887. N.p.: Southern Directory Company Publishers, 1902.

Asheville, North Carolina City Directory, 1899–1900. Atlanta: Maloney Directory Company, 1899.

Asheville, North Carolina City Directory, 1901. Atlanta: Maloney Directory Company, 1901.

Asheville, North Carolina City Directory, 1902–'03, 1904–'05, 1906–'07. Richmond, Virginia: Hill Directory Company, 1902, 1904, 1906.

Asheville, North Carolina City Directory, 1935. Charleston, S.C.: Baldwin Directory Company and the Asheville Advocate, 1935.

Atlanta City Directory, 1923–1924, Vol. 46. Atlanta: Atlanta City Directory Company, 1923.

Baldwin & Times' Thomasville, North Carolina City Directory, 1935. Charleston, S.C.: Baldwin Directory Company, 1935.

Baldwin's Concord City Directory, 1938 and 1940. Charleston, S.C.: Baldwin Directory Company, 1938, 1940.

Baldwin's Goldsboro City Directory, 1938. Charleston, S.C.: Baldwin City Directory Company, 1938.

Baldwin's New Bern, North Carolina City Directory, 1937 and 1941. Charleston, S.C.: Baldwin Directory Company, 1937, 1941.

Baldwin's Washington, North Carolina City Directory, 1937. Charleston, S.C.: Baldwin Directory Company, 1937.

Barber, Jody, and Louise Bailey. *Hendersonville and Henderson County: A Pictorial History.* Norfolk/Virginia Beach: Donning Company, 2d printing, 1995.

Baty, Laurie A. "On the Trail of Nahum S. Bennett." In Peter E. Palmquist, ed., *The Daguerreian Annual, 1990.* Eureka, Calif.: Daguerreian Society and Eureka Printing Company, 1990.

Beasley & Emerson's Charlotte Directory For 1875–76. Charlotte: Beasley & Emerson Publishers, 1875.

Belvin, Lynne, and Harriette Riggs, eds. *The Heritage of Wake County, North Carolina, 1983.* Raleigh: Wake County Genealogical Society, 1983.

Benjamin, W. S. *The Great Epidemic in New Berne and Vicinity, September and October, 1864. By One Who Passed Through It.* New Berne: George Mills Joy, 1865.

Beveridge & Co.'s North Carolina State Directory, 1877–'78. . . . Richmond, Va.: William H. Beveridge, 1877.

Bizzell, Oscar M., Jr., ed. *The Heritage of Sampson County, North Carolina.* Winston-Salem: Hunter Publishing Company for the Sampson County Historical Society, 1983.

Black, Russell C., Jr., and Irene Clanton Black, eds. *Iredell County North Carolina Cemeteries*, Vol. Seven: *Glenwood Memorial Park and Willow Valley Cemetery, Mooresville.* Mooresville: privately printed by the editors, 1999.

Block, Susan Taylor. *Wilmington through the Lens of Louis T. Moore.* Wilmington: Lower Cape Fear Historical Society and New Hanover County Public Library, 2001.

_____, comp. *Along the Cape Fear.* Dover, N.H.: Arcadia Publishing, 1998.

Bradstreet's Book of Commerical Ratings, North Carolina, July, 1908. New York: Bradstreet Company, 1908. Cited in text as *Bradstreet's*, 1908.

Bradstreet's Book of Commercial Ratings, 1914. New York: Bradstreet Company, 1914. Cited in text as *Bradstreet's*, 1914.

Bradstreet's Book of Commercial Ratings of Bankers, Merchants, Manufacturers, etc. In a Portion of the United States Selected Under Specific Agreement From the General Volume Which Is Copyrighted, Vol. 197 (Mar. 1917); Vol. 212 (Jan. 1921); and Vol. 228 (Jan. 1925). New York: Bradstreet Company, 1917, 1921, 1925. Cited in text as *Bradstreet's*, with appropriate year(s).

Branson & Farrar's North Carolina Business Directory For 1866–'67. Raleigh: Branson & Farrar, Publishers, 1866.

Branson, Rev. L., ed. *North Carolina Business Directory, 1872.* Raleigh: J. A. Jones, Publisher, 1872.

_____. *The North Carolina Business Directory for 1877 and 1878.* Raleigh: L. Branson Publisher and Bookseller, 1878.

_____. *Branson's North Carolina Business Directory for 1884.* Raleigh: Levi Branson Office Publisher, 1884.

Branson, Levi., comp. *Directory of the Business and Citizens of Durham City For 1887.* Raleigh: Edwards and Broughton, 1887.

_____., ed. *North Carolina Business Directory, 1890*, Vol. VII. Raleigh: Levi Branson, Office Publisher, 1889.

Branson's Directory of Raleigh, N.C., 1891. Raleigh: Levi Branson, Office Publisher, 1891.

Branson's North Carolina Business Directory for 1867-8. Raleigh: Branson & Jones, Publishers, 1867.

Branson's North Carolina Business Directory for 1869. Raleigh: J. A. Jones, Publisher, 1869.

Branson's North Carolina Busniess Directory, 1896, Vol. 8. Raleigh: Levi Branson, Office Publisher, 1896. Cited in text as Branson, *NCBD*, 1896.

Branson's North Carolina Business Directory, 1897, Vol. 9. Raleigh: Levi Branson, Office Publisher, 1897. Cited in text as Branson, *NCBD*, 1897.

Brawley, James S. *The Rowan Story, 1753–1953: A Narrative History of Rowan County, North Carolina*. Salisbury: Rowan Printing Company, 1953.

Brenizer, Charles. *A Directory of the City of Greensboro, North Carolina For 1896–97*. Charlotte: Observer Printing and Publishing House, 1896.

Brey, William, and Marie Brey. *Philadelphia Photographers, 1840–1900*. Cherry Hill, N.J.: Willowdale Press, 1992.

Broecker, William L., ed. *International Center of Photography Encyclopedia of Photography*. New York: Pound Press, Crown Publishers, 1984.

Brown, Marvin A. *Our Enduring Past: A Survey of 235 Years of Life and Architecture in Lincoln County, N.C.* Lincolnton: Lincoln County Historical Properties Commission, 1986.

Brunk, Robert S., ed. *May We All Remember Well*, Vol. 1. Asheville: Robert S. Brunk Auction Services, 1997.

Busbee, Mrs. Jacques. "North Carolina Through the Camera." *North Carolina Teacher* 9 (Oct. 1932).

Butler, Lindley S. *Our Proud Heritage: A Pictorial History of Rockingham County, N.C.* Bassett, Va: Bassett Printing Corporation, 1971.

Caldwell County North Carolina Cemeteries, Vol. 1. Lenoir: Caldwell County Genealogical Society, 1985.

Carter & Snyder's General Directory of Mount Airy, North Carolina, 1913–1914. N.p.: 1913.

Casada, Jim. "George Masa: Musings on a Man of Mystery." *Smoky Mountain Living* 1 (fall 2001).

Catawba County Cemeteries, Vol. 6. Hickory: Catawba County Genealogical Society, 1990.

Catlett, J. Stephen. *Martin's and Miller's Greensboro*. Charleston, S.C.: Arcadia Publishing, second printing, 2000.

Cemeteries of Burke County, Vols. 1, 2, 3. Morganton: Burke County Genealogical Society, 1995.

Charles Emerson & Company's Newbern Directory, 1880–'81. Raleigh: Edwards, Broughton & Company, 1880.

Charles Emerson & Company's Raleigh Directory, 1880–'81. . . . Raleigh: Edwards, Broughton & Company, 1879.

Charles Emerson & Company's Winston, Salem and Greensboro, North Carolina Directory, 1879–'80. Raleigh: Edwards, Broughton & Company, Printers and Binders, 1879.

Chataigne, J. H. *Chataigne's Raleigh City Directory Containing A General Directory of the Cities of Raleigh, Durham, Fayetteville, Greensboro, New Bern and Wilmington, etc.* Washington, D.C.: Library of Congress, 1875.

_____, comp. *Chataigne's North Carolina State Directory and Gazetteer, 1883–'84*. Raleigh: Alfred Williams, 1883.

Clark, David L., comp. *The Roving Artist: A Biographical Sketch*. High Point: by the author, 1895.

Concord, North Carolina City Directory, 1902. Charlotte: Interstate Directory Company, 1902.

Concord, North Carolina City Directory, 1908, 1913–'14, 1916–'17, 1920–'21. Asheville: Piedmont Directory Company, 1908, 1913, 1916, 1920.

Concord, North Carolina City Directory, 1922–'23. N.p.: Commercial Service Company, 1922.

Corey, Jane. "Hugh Morton's Favorite Ten." *State* 36 (Oct. 1, 1968).

Cotten, Jerry W. *Light and Air: The Photography of Bayard Wootten*. Chapel Hill and London: University of North Carolina Press, 1998.

Country Homes (Asheville) 2 (Aug. 1887).

Craig, John S., comp. *Craig's Daguerreian Registry*, Vol. 1: *The Overview*. Torrington, Conn.: privately printed, 1994.

_____. *Craig's Daguerreian Registry*, Vol. 2: *Pioneers and Progress, Abbott to Lytle*. Torrington, Conn.: privately printed, 1996.

_____. *Craig's Daguerreian Registry*, Vol. 3: *Pioneers and Progress, MacDonald to Zuky*. Torrington, Conn.: privately printed, 1996.

Crow, Terrell Armistead, and Mary Moulton Barden, eds. *Live Your Own Life: The Family Papers of Mary Bayard Clarke, 1854–1886*. Columbia: University of South Carolina Press, 2003.

Curtin, H. A., comp. *Curtin's United States Business Directory, 1890*. New York: the compiler, 1890.

Czach, Marie. *A Directory of Early Illinois Photographers: Preliminary Investigations into Photography as Practiced in Illinois, Excluding Chicago, from 1846 to 1914*. McComb, Ill.: Western Illinois University, 1977.

Darrah, William C. *The World of Stereographs*. Gettysburg, Pa.: W. C. Darrah, 1977.

Davidson, J. D., comp. *Asheville, North Carolina City Directory, 1883–'84*. Asheville: Baughman Brothers Printers, 1883.

Dictionary of American Biography, s.v. "Morley, Margaret Warner."

A Directory of the City of Charlotte, North Carolina For 1896 and 1897. Charlotte: Charlotte Directory Company, 1896.

Directory of the City of Raleigh, North Carolina, 1887. Raleigh: Edwards Broughton & Company, 1887.

Directory of the City of Raleigh, North Carolina, 1888. Raleigh: Observer Printing Company, 1888.

Directory of the City of Wilmington, North Carolina, 1889. Published by Julius A. Bonitz. Wilmington: Messenger Steam Presses, 1889.

A Directory of Greensboro, Salem and Winston and Gazetteer of Forsyth and Guilford Counties, 1884. Atlanta: Interstate Directory Company, 1884.

Dixon, Penelope. *Photographers of the Farm Security Administration: An Annotated Bibliography, 1930–1980*. New York and London: Garland Publishing, Inc., 1983.

Dozier, Rebecca Leach. *Town Leaders, Littleton, North Carolina, 1790–1920*. Spartanburg, S.C.: Reprint Company, 1996.

Dudley, Jack. *Morehead City: A Walk through Time*. Morehead City: the author, 2003.

Dumont, N., ed. *North Carolina As a Place For Investment, Manufactures, Mining, Stock Raising, Fruit and Farming: What Northern Residents in North Carolina Say of it as a Place to Live In*. Raleigh: Observer State Printer and Binder, 1879.

Dun, R. G., and Company. *The Mercantile Agency Reference Book (and Key) For the States Within; States Corrected Up to September, 1875.* New York: Dun, Barlow & Company, 1875.

_____. *The Mercantile Agency Reference Book (and Key) Containing Ratings of the Merchants, Manufacturers and Traders Generally Throughout the Southern States, January, 1878–,* Vol. 39. New York: Dun, Barlow & Company, 1877.

_____. *The Mercantile Agency Reference Book and Key Containing Ratings of the Merchants, Manufacturers and Traders Generally Throughout the Southern States, July, 1890–,* Vol. 87. New York: R. G. Dun & Company, 1890.

_____. *The Mercantile Agency Reference Book and Key Containing Ratings of the Merchants, Manufacturers and Traders Generally Throughout the Southern States, January, 1891,* Vol. 91. New York: R. G. Dun & Company, 1890.

_____. *The Mercantile Agency Reference Book and Key Containing Ratings of the Merchants, Manufacturers and Traders Generally Throughout the Southern States, January, 1892,* Vol. 96. New York: R. G. Dun & Company, 1891.

_____. *The Mercantile Agency Reference Book (and Key) Containing Ratings of Merchants, Manufacturers and Traders Generally Throughout the Following Southern States, January 1904,* Vol. 143. New York: R. G. Dun & Company, 1903. Cited in text as *Mercantile Agency Reference Book, 1904.*

_____. *The Mercantile Reference Book (and Key) Containing Ratings of Merchants, Manufacturers and Traders Generally Throughout the United States, March, 1931–,* Vol. 252. New York: R. G. Dun & Company, 1931. Cited in text as *Mercantile Reference Book, 1931.*

Dunn, Rachel Warlick. *Daniel Warlick of Lincoln County and His Descendants: A Genealogy of the Warlick Family From Palatinate, Germany, 1729–1993,* 2d ed. N.p, n.d.

Durham, North Carolina Directory, 1903–'04, 1905–'06, 1907–'08. Richmond, Va: Hill Directory Company, 1903, 1905, 1907.

Early Architectural Photography of North Carolina by Frances Benjamin Johnston and Bayard Wootten. Raleigh: Preservation North Carolina, 1994.

Encyclopedia of World Biography, 2d ed., Vol. 11. Detroit, New York, Toronto, and London: Gale Research, 1998.

Eskind, Andrew H., ed. *Index to American Photographic Collections, Third Enlarged Edition Compiled at the International Museum of Photography At George Eastman House.* New York: G. K. Hall & Company, 1996.

Evans, Virginia Fraser, comp. *Iredell County Landmarks: A Pictorial History of Iredell County.* Statesville: Iredell County American Revolution Bicentennial Commission, 1976.

Fayetteville, North Carolina Directory, 1909–'10. Fayetteville, N.C., and Richmond, Va.: Hill Directory Company, 1909.

Fields, Orville T. *Cemeteries of Carter County, Tennessee.* N.p.: privately published, 1976.

Fowler, Don D. *The Western Photographs of John K. Hillers: Myself in the Water.* Washington, D.C., and London: Smithsonian Institution Press, 1989.

Freel, Margaret Walker. *Our Heritage: The People of Cherokee County, North Carolina, 1540–1955.* Asheville: Miller Printing Company, 1956.

Fulenweider, Harry W., comp. *Asheville, North Carolina City Directory, 1890.* N.p.: Walker, Evans & Cogswell Company, 1890.

Fuller, Sue Elizabeth. "Checklist of Connecticut Photographers by Town: 1839–1889 and Alphabetical Index to Connecticut Photographers: 1839–1889." *Connecticut Historical Society Bulletin* 47 (winter 1982).

Gagel, Diane VanSkiver, comp. *Ohio Photographers, 1839–1900.* Nevada City, Calif.: Carl Mautz Publishing, 1998.

Gardiner, Charles S., comp. *Dunn, North Carolina City Directory, 1918–'19.* Florence, S.C.: the compiler, 1918.

_____. *Fayetteville, North Carolina City Directory, 1915–1916.* Florence, S.C.: the compiler, 1915.

_____. *Goldsboro, North Carolina City Directory, 1916–1917.* Florence, S.C.: the compiler, 1916.

_____. *Lexington, North Carolina City Directory, 1916–'17.* Florence, S.C.: Gardiner's Directory Company, 1916.

Garrett, Franklin Miller, ed. *Atlanta and Environs: A Chronicle of its People and Events, Family and Personal History,* Vol. 3. New York: Lewis Historical Publishing Company, 1954.

Gastonia, North Carolina City Directory, 1910–'11 and 1913–14. Asheville: Piedmont Directory Company, 1910, 1913.

Gastonia, North Carolina City Directory, 1918–'19, 1921–'22, 1923–'24, 1927–'28. n. p.: Commercial Service Company, 1918, 1921, 1923, 1927.

Ginsberg, Louis. *Photographers in Virginia, 1839–1900: A Checklist.* Petersburg, Va.: Privately printed, 1986.

Green, John B., III. *A New Bern Album.* New Bern: Tryon Palace Commission, 1985.

Greensboro City Directory for 1887. Newburgh, N.Y.: Thompson, Breed & Crofutt, 1887.

Greensboro City Directory, 1892–'93. Greensboro: Stone and Kendall, 1892.

Greensboro, North Carolina Directory, 1903–'04, 1905–'06, 1907–'08, 1909–'10, 1912–'13, 1913–'14, 1915–'16, 1917, 1918–'19, 1920. Greensboro, N.C., and Richmond, Va.: Hill Directory Company, 1903, 1905, 1907, 1909, 1912, 1913, 1915, 1917, 1918, 1920. Cited in text as Hill, *Greensboro Directory,* with appropriate year(s).

Hackney & Moale's Canton, North Carolina City Directory, 1906–'07. N.p.: Hackney & Moale, 1906.

Haddock's Wilmington, N.C. Directory and General Advertiser, Containing a General and Business Directory of the City, 1870–'71. Compiled by T. M. Haddock. Wilmington: J. A. Engelhard, Steam Power Press Print, 1871.

Hadley, Wade, Doris Goerch Horton, and Nell Craig Strowd. *Chatham County, 1771–1971.* N.p.: Moore Publishing Company, n.d.

Harris, Mary Emma. *The Arts at Black Mountain College.* Cambridge: MIT Press, 1987.

Hatchett & Watson, comps. *Business Directory of the City of New Berne, North Carolina.* Raleigh: Edwards & Broughton Printers, 1893.

Hawthorne, Ann, ed. *The Picture Man: Photographs by Paul Buchanan.* Chapel Hill and London: University of North Carolina Press, 1993.

Haynes, David. *Catching Shadows: A Directory of Nineteeth-Century Texas Photographers.* Austin, Texas: Texas State Historical Association, 1993.

Haywood County Heritage, North Carolina, Vol. 1: *1994*. Marceline, Mo.: Walsworth Publishing Company for the Haywood County Heritage Book Committee, 1994.

Hendersonville City Directory, 1937–38. Asheville: Southern Directory Company, 1937.

Hendersonville, North Carolina City Directory, 1915. N.p.: I. E. Maxwell, 1915.

Hewitt, Janet B., ed. *The Roster of Confederate Soldiers, 1861–1865*, 16 vols. Wilmington: Broadfoot Publishing Company, 1996.

Hickory, North Carolina City Directory, 1920–21. Statesville: Brady Printing Company, 1920.

Hickory, North Carolina City Directory, 1935. N.p. Home Directory Company, 1935.

Hill Directory Company's Fayetteville, North Carolina City Directory, 1924. Richmond, Va.: Hill Directory Company, 1924.

Hill Directory Company's Greensboro, North Carolina City Directory, 1921–1923. Richmond, Va.: Hill Directory Company, 1921–1923.

Hill Directory Company's New Bern, North Carolina City Directory, 1920–'21, 1926. Richmond, Va.: Hill Directory Company, 1920, 1926.

Hill Directory Co.'s Raleigh, N.C. City Directory, 1921–22, 1922–23, 1923–24, 1924, 1925, 1926. Richmond, Va.: Hill Directory Co., 1922–1926. Cited in text as Hill, *Raleigh Directory*, with appropriate year(s).

Hill Directory Company's Wilmington, North Carolina Directory, 1922, 1924, 1926, 1928, 1930, 1932, 1934, 1938, 1940. Richmond, Va.: Hill Directory Company, 1922, 1924, 1926, 1928, 1930, 1932, 1934, 1938, 1940. Cited in text as Hill, *Wilmington Directory*, with appropriate year(s).

Hill Directory Co.'s Wilson, N.C. City Directory, 1922–23. Richmond, Va.: Hill Directory Co., 1922.

Hill Directory Co.'s Wilson, N.C. City Directory, 1925. Richmond, Va.: Hill Directory Co., 1925.

Hill's Belmont City Directory, 1941. Richmond, Va.: Hill Directory Company, 1941.

Hill's Burlington City Directory, 1935. Richmond, Va.: Hill Directory Company, 1935.

Hill's Charlotte, North Carolina City Directory, 1932–1941. Richmond, Va.: Hill Directory Company, 1932–1941. Cited in text as *Hill's Charlotte Directory*, with appropriate year(s).

Hill's Fayetteville City Directory, 1937, 1939, 1941. Richmond, Va.: Hill Directory Company, 1937, 1939, 1941.

Hill's Gastonia City Directory, 1934 and 1936. Richmond, Va.: Hill Directory Company, 1934, 1936.

Hill's Goldsboro City Directory, 1934. Richmond, Va.: Hill Directory Company, 1934.

Hill's Goldsboro, North Carolina City Directory, 1928. Richmond, Va.: Hill Directory Company, 1928.

Hill's Greensboro, North Carolina City Directory, 1928–1931 and 1934–1941. Richmond, Va.: Hill Directory Company, 1928–1931, 1934–1941.

Hill's High Point, North Carolina City Directory, 1933, 1940. Richmond, Va.: Hill Directory Company, 1933, 1940. Cited in text as *Hill's High Point Directory*, with appropriate year(s).

Hill's Raleigh, N.C. City Directory, 1927, 1928, 1929, 1930, 1931, 1932, 1933, 1934, 1935, 1936, 1937, 1938, 1939, 1940, 1941.

Richmond, Va.: Hill Directory Co., 1927–1941. Cited in text as Hill, *Raleigh Directory*, with appropriate year(s).

Hill's Reidsville City Directory, 1932. Richmond, Va.: Hill Directory Company, 1932.

Hill's Rocky Mount City Directory, 1912–'13, 1925, 1930, 1934. Richmond, Va.: Hill Directory Company, 1912, 1925, 1930, 1934.

Hill's Wilson, N.C. City Directory, 1917, 1920, 1922–1923, 1925, 1930, 1941. Richmond, Va.: Hill Directory Co., 1917, 1920, 1922–1923, 1925, 1930, 1941.

Historical and Descriptive Review of the State of North Carolina Including the Manufacturing and Mercantile Industries of the Towns of Durham, Fayetteville, Henderson, Oxford and Raleigh, and Sketches of Their Leading Men and Business Houses, 2nd Volume of N.C. Charleston, S.C.: Empire Publishing Company, 1885.

Hobbs, Robert. *Elliott Daingerfield: Retrospective Exhibition* (catalog). N.p.: Mint Museum, Charlotte, and North Carolina Museum of Art, Raleigh, 1971.

Horton, Clarence E., Jr., ed. *A Bicentennial History of Concord from the Pages of* Progress *Magazine*. Charlotte: Delmar Printing & Publishing Company, 1996.

Howell, Joan L., comp. *Wilson County, North Carolina Cemeteries*, Vols. 1 and 2. Wilson: Wilson County Genealogical Society, 1993.

The Hugh Mangum Museum of Photography: The Packhouse at West Point on the Eno (undated brochure from McCown-Mangum House, Durham County).

Illustrated City of New Bern, North Carolina, 1914. N.p., 1914.

J. L. Hill Printing Co.'s Directory of Wilmington, N.C., 1897. Richmond, Va.: J. L. Hill Printing Company, 1897.

Jackson County Heritage, North Carolina, Vol. 1, *1992*. Marceline, Mo.: Walsworth Publishing Company and the Jackson County Genealogical Society, 1992.

Jenkins, Reese V. *Images & Enterprise: Technology and the American Photographic Industry, 1839–1925*. Baltimore: The Johns Hopkins University Press, 1975.

Jones, H. G. *North Carolina Illustrated, 1524–1984*. Chapel Hill: University of North Carolina Press, 1983.

Joyce, Mary Lib Clark. *Clark's Collection of Historical Remembrances*. High Point: Privately published, n.d.

Kallam, Lemuel Wallace, comp. *Kallam Cemetery Book 2, Surry County, North Carolina, 1983–*. Dobson: Surry County Genealogical Association, 1983.

Kelbaugh, Ross J., comp. *Directory of Maryland Photographers, 1839–1900*. Baltimore: Privately published by the compiler, 1988.

Kelley's Wilmington Directory to Which is Added a Business Directory for 1860–61. Compiled by T. Tuther, Jr. and Published by George H. Kelley. Wilmington: Fulton and Price Steam Power Press Printers, [1861].

Khoury, Angel Ellis. *Manteo: A Roanoke Island Town*. Virginia Beach, Va.: Donning Company, 1999.

Kirk, Stephen. *First in Flight: The Wright Brothers in North Carolina*. Winston-Salem: John F. Blair Publisher, 1995.

Kluttz, Ralph Dean, comp. *The Descendants of Johann Jacob Klotz in America, 1690–1990*. Charlotte: privately printed by Delmar Company, 1990.

Leebrick, Gil. "George Masa." In *Coming to Light: The Western North Carolina Re-Photographic Project*. Asheville: Asheville Museum of Art, 1994.

Lentz, Ralph E., II. *W. R. Trivett, Appalachian Picture Man: Photographer of a Bygone Time*. Jefferson, N.C.: McFarland and Company, 2001.

Lexington City Directory, 1937. Charleston, S.C.: Baldwin Directory Company, 1937.

Lindau, Betsy. *The 1st Hundred Years of Southern Pines, North Carolina*. Southern Pines: Town of Southern Pines, 1987.

Lindsey & Brown's Descriptive Catalogue of Photographic Views of the Land of the Sky of Beauties of Western North Carolina. Asheville: N.p., n.d.

Lumberton City Directory, 1938. Charleston, S.C.: Baldwin Directory Company, 1938.

Lumberton, North Carolina City Directory, 1916–'17. Florence, S.C.: Gardiner's Directory Company, 1916.

McCaslin, Richard B. *Portraits of Conflict: A Photographic History of North Carolina in the Civil War*. Fayetteville, Ark.: University of Arkansas Press, 1997.

McHenry, Robert. *Liberty's Women*. Springfield, Mass.: G. & C. Merriam Company, n.d.

McIlwaine, J. S. *Asheville, North Carolina City Directory, 1896–'7*. N.p.: Franklin Printers & Publishing Company, 1896.

Maloney's Charlotte 1897–'98 City Directory. Atlanta: Maloney Directory Company, 1897.

Maloney's 1899–1900 Charlotte City Directory. Atlanta: Maloney Directory Company, 1899.

Maloney's 1899–1900 Greensboro, North Carolina City Directory. Atlanta: Maloney Directory Company, 1899.

Maloney's 1901 Greensboro City Directory. Atlanta: Maloney Directory Company, 1901.

Maloney's 1901 Raleigh City Directory. Atlanta: Maloney Directory Company, 1901.

Manarin, Louis H., and Weymouth T. Jordan Jr., comps. *North Carolina Troops, 1861–1865: A Roster*, 15 vols. to date. Raleigh: Division (now Office) of Archives and History, North Carolina Department of Cultural Resources, 1966–.

Mangum, D. C., comp. *Mangum's Directory of Durham and Suburbs*. Durham: Educator Company, 1897.

Mann, Albert W. *History of the Forty-Fifth Regiment Massachusetts Volunteer Militia, "The Cadet Regiment."* Jamaica Plain, Mass: Brookside Printing Company, 1908.

Massengill, Stephen E. *Around Southern Pines, A Sandhills Album: Photographs by E. C. Eddy*. Charleston, S.C.: Arcadia Publishing, 1998.

_____. "One Man's View." *State* 61 (May 1994).

_____. *The Photographs of Frank Marchant, Commercial Photographer, Hamlet, North Carolina, 1907–1930s*. Laurinburg: privately printed by the author, 1989.

_____. " 'Portraits by the Sunlight Made': Daguerrean Artists in North Carolina, 1842–1861." *Carolina Comments* 41 (Sept. 1993).

_____. " 'To Secure A Faithful Likeness': A Roster of Photographers Active in North Carolina, 1865–1900," parts 1 and 2. *Carolina Comments* 44 (Jan., Mar. 1996).

_____. *Western North Carolina: A Visual Journey through Stereo Views and Photographs*. Charleston, S.C.: Arcadia Publishing, 1999.

Massengill, Stephen E., and Robert M. Topkins. "Letters Written from San Diego County, 1879–1880 by Rufus Morgan, North Carolina Apiarist and Photographer." *Journal of San Diego History* 40 (fall 1994): 142–177.

The Mercantile Agency Reference Book, Book No. 7, January, 1943, Vol. 321. New York: Dun and Bradstreet, 1942. Cited in text as *Mercantile Agency Reference Book*, 1943.

Miller, Charles W., comp. *Miller's Thomasville, North Carolina City Directory, 1941–42*. N.p.: the compiler, 1941.

Miller, Ernest H., comp. *Asheville, North Carolina City Directory, 1907–'08–1927, 1931–1932*. Asheville: Piedmont Directory Company, 1907–1927, 1931–1932.

_____. *Burlington, North Carolina City Directory, 1909–'10*. Asheville: Piedmont Directory Company, 1909.

_____. *Charlotte, North Carolina City Directory, 1911–1918, 1920–1930*. Asheville: Piedmont Directory Company, 1911–1918, 1920–1930. Cited in text as Miller, *Charlotte Directory*, with appropriate year(s).

_____. *Concord, North Carolina City Directory, 1924–25, 1929–30*. Asheville: Piedmont Directory Company, 1924–25, 1929–30.

_____. *Elizabeth City, North Carolina City Directory, 1923–24*. Asheville: Piedmont Directory Company, 1923.

_____. *Flat Rock City Directory, 1926–27*. Asheville: Piedmont Directory Company, 1926.

_____. *Gastonia, North Carolina City Directory, 1930–31*. Asheville: Piedmont Directory Company, 1930.

_____. *Greenville, North Carolina City Directory, 1916–'17, 1926–27*. Asheville: Piedmont Directory Company, 1916, 1926.

_____. *Hendersonville, North Carolina City Directory, 1921–22, 1924–25, 1926–27*. Asheville: Piedmont Directory Company, 1921, 1924, 1926.

_____. *Hickory, North Carolina City Directory, 1925–26, 1928–29, 1930–31*. Asheville: Piedmont Directory Company, 1925, 1928, 1930.

_____. *High Point, North Carolina City Directory, 1908, 1910–11, 1913*. Asheville: Piedmont Directory Company, 1908, 1910, 1913. Cited in text as Miller, *High Point Directory*, with appropriate year(s).

_____. *High Point, North Carolina City Directory, 1919–1931*. Asheville: Commercial Service Company, 1919–1931.

_____. *Lenoir, North Carolina City Directory, 1930–31*. Asheville: Piedmont Directory Company, 1930.

_____. *Lexington, North Carolina City Directory, 1925–26*. Asheville: Piedmont Directory Company, 1925.

_____. *Monroe, North Carolina City Directory, 1922–23*. Asheville: Piedmont Directory Company, 1922.

_____. *Mount Airy, North Carolina City Directory, 1928–29*. Asheville: Piedmont Directory Company, 1928.

_____. *Reidsville, North Carolina City Directory, 1929*. Asheville: Piedmont Directory Company, 1929.

_____. *Salisbury, North Carolina City Directory, 1907–'08, 1913–1917, 1919–'20, 1922–1923, 1924–1929*. Asheville: Piedmont Directory Company, 1907, 1913–1917, 1919, 1922–1929. Cited in text as Miller, *Salisbury Directory*, with appropriate year(s).

_____. *Statesville City Directory, 1932–33*. Asheville: Carolina Directory Company, 1932.

_____. *Statesville, North Carolina City Directory, 1909–'10,* 1916–'17, 1922–'23, 1925–'26, 1928–1931. Asheville: Piedmont Directory Company, 1909, 1916, 1922, 1925, 1928–1930.

_____. *Thomasville City Directory, 1928–1931 and 1933–34.* Asheville: Piedmont Directory Company, 1928, 1930, 1933.

_____. *Washington, North Carolina City Directory, 1916–'17.* Asheville: Piedmont Press, 1916.

Miller, Mildred J., ed. *The Heritage of Iredell County, 1980.* Statesville: Genealogical Society of Iredell County, 1980.

Miller's Asheboro City Directory, 1937–1942. Asheville: Piedmont Directory Company, 1937, 1939, 1941.

Miller's Asheville City Directory, 1928–1930 and 1936–1941. Asheville: Piedmont Directory Company, 1928–1930, 1936–1941.

Miller's Burlington City Directory, 1920–'21, 1924–'25, 1927–1930. Asheville: Piedmont Directory Company, 1920, 1924, 1927–1930.

Miller's Canton City Directory, 1937–38. Asheville: Piedmont Directory Company, 1937.

Miller's Dunn City Directory, 1926–'27. Asheville: Piedmont Directory, 1926.

Miller's Elizabeth City City Directory, 1936–1939. Asheville: Southern Directory Company, 1936, 1938.

Miller's Greenville, North Carolina City Directory, 1936–1941. Asheville: Southern Directory Company, 1936, 1938, 1940.

Miller's Henderson City Directory, 1938–1941. Asheville: Piedmont Directory Company, 1938, 1940.

Miller's Hendersonville City Directory, 1939–1942. Asheville: Piedmont Directory Company, 1939, 1941.

Miller's Hickory City Directory, 1937–38. Asheville: Piedmont Directory Company, 1937.

Miller's Lenoir City Directory, 1937–1940. Asheville: Piedmont Directory Company, 1937, 1939.

Miller's Lexington City Directory, 1941–42. Asheville: Piedmont Directory Company, 1941.

Miller's Marion City Directory, 1940–41. Asheville: Piedmont Directory Company, 1940.

Miller's Mooresville City Directory, 1939–40. Asheville: Piedmont Directory Company, 1939.

Miller's Morganton City Directory, 1939–1942. Asheville: Piedmont Directory Company, 1939, 1941.

Miller's North Wilkesboro City Directory, 1939–40. Asheville: Piedmont Directory Company, 1939.

Miller's Reidsville City Directory, 1941–42. Asheville: Piedmont Directory Company, 1941.

Miller's Shelby City Directory, 1937–1940. Asheville: Piedmont Directory Company, 1937, 1939.

Miller's Statesville City Directory, 1938–1941; Asheville: Piedmont Directory Company, 1938, 1940.

Modern Progress Blue Book. N.p., 1915.

Montgomery, Lizzie Wilson. *Sketches of Old Warrenton, North Carolina, Traditions and Reminiscences of the Town and People Who Made It.* Raleigh: Edwards & Broughton Printing Company, 1924.

Morton, Hugh. *Hugh Morton's North Carolina.* Chapel Hill and London: University of North Carolina Press, 2003.

Moss, Bobby Gilmer. *The Old Iron District: A Study of the Development of Cherokee County, 1780–1897.* Blacksburg, S.C.: Scotia-Hibernia Press, 1972.

Movers & Makers: Doris Ulmann's Portraits of the Craft Revival in Appalachia. N.p. [2003].

New Bern, North Carolina Directory, 1904–'05, 1907–'08, 1911–'12, 1914–'15, 1918–'19. Richmond, Va.: Hill Directory Company, 1904, 1907, 1911, 1914, 1918.

Newhall, Beaumont. *The Daguerreotype in America,* 3d rev. ed. New York: Dover Publications, 1976.

_____. *The History of Photography: From 1839 to the Present Day.* New York: Museum of Modern Art, 1982.

The North Carolina Year Book and Business Directory, 1902–1916. Raleigh: News and Observer, 1902–1916. Cited in text as *N.C. Year Book,* with appropriate year(s).

Oates, John Alexander. *The Story of Fayetteville and the Upper Cape Fear.* N.p., n.d., 1950.

Odum, Eugene P., ed. *A North Carolina Naturalist, H. H. Brimley: Selections from His Writings.* Chapel Hill: University of North Carolina Press, 1949.

Page, Reid A., Jr., ed. *Tales of Pinehurst,* Vol. 1. Pinehurst: Gazette Newspaper, 1988.

Palmquist, Peter E., ed. *The Daguerreian Annual, 1990.* Eureka, Calif.: Daguerreian Society and Eureka Printing Company, 1990.

Paul, Hiram V. *History of the Town of Durham, N.C., Embracing Biographical Sketches and Engravings of Leading Business Men, and a Carefully Compiled Business Directory of Durham.* Raleigh: Edwards Broughton & Company, 1884.

Peacock, Mary Reynolds. *Silversmiths of North Carolina, 1696–1860,* 2d. rev. ed. Raleigh: North Carolina Department of Cultural Resources, Division (now Office) of Archives and History, 1984.

Phifer, Edward William, Jr. *Burke: The History of a North Carolina County, 1777–1920.* Morganton: privately published, 1977.

Photographic Art Journal, ser. 1. Ed. Henry Hunt Snelling. Vol. 2 (1850).

Pinehurst Outlook, Vol. 4 (Nov. 9, 1900); Vol. 5 (Nov. 15, 1901); Vol. 18 (1914–1915).

Polito, Ronald, ed. *A Directory of Massachusetts Photographers, 1839–1900.* Camden, Maine: Picton Press, 1993.

Porter, Benjamin. "Re-Photographing Herbert Pelton's Panoramas." In *Coming to Light: The Western North Carolina Re-Photographic Project.* Asheville: Asheville Museum of Art, 1994.

Powell, William S., gen. ed. *Dictionary of North Carolina Biography.* Six Volumes. Chapel Hill and London: University of North Carolina Press, 1979–1996. Cited in text as *DNCB.*

Proceedings of the Fiftieth Annual Convocation of the M.E. Grand Royal Arch Chapter of North Carolina Held in Raleigh Tuesday and Wednesday, May 17 and 18, 1898. Durham: Educator Company, 1898.

Raleigh City Directory for the Year 1886. Raleigh: Turner, McLean & Losee Directory Company, 1886.

Raleigh, N.C. Directory, 1905–06, 1907, 1908, 1909–10, 1911–12, 1913–14, 1915–16, 1917, 1918–19, 1919–20. Richmond, Va.: Hill Directory Company, 1906–1920. Cited in text as Hill, *Raleigh Directory,* with appropriate year(s).

Ramsey, N. A. *Durham Almanac for the Year of Our Lord, 1894.* Durham: N. A. Ramsey, 1894.

Ramsey's Durham Directory for the Year 1892. Durham: N. A. Ramsey, 1892.

Reference Book of the Mercantile Association of the Carolinas for the States of North Carolina and South Carolina, January, 1890. Wilmington: Jackson & Bell, 1890.

Reference Book of the Mercantile Association of the Carolinas for the States of North Carolina and South Carolina, January, 1891. Wilmington: Jackson & Bell, 1891.

Reference Book of the Mercantile Association of the Carolinas for the States of North Carolina and South Carolina, July, 1892. Wilmington: Jackson & Bell, 1892.

Reidsville City Directory, 1935. Charleston, S.C.: Baldwin Directory Company, 1935.

Richards, James. *Raleigh City Directory, 1883.* Raleigh: Edwards, Broughton & Company, 1883.

Ries, Linda A., and Jay W. Ruby, comps. and eds. *Directory of Pennsylvania Photographers, 1839–1900.* [Harrisburg]: Pennsylvania Historical and Museum Commission, 1999.

Rinhart, Floyd, and Marion Rinhart. *The American Daguerreotype.* Athens: University of Georgia Press, 1981.

_____. *Victorian Florida: America's Last Frontier.* Atlanta: Peachtree Publishers Ltd., 1986.

Ritzenthaler, Mary Lynn, Gerald J. Munoff, and Margery S. Long. *Archives & Manuscripts: Administration of Photographic Collections.* Chicago: Society of American Archivists, 1984.

Robbins, D. P. *Descriptive Sketch of Winston-Salem Its Advantages and Surroundings, Kernersville, etc.* Winston: Sentinel Job Print, 1888.

Rowan County Cemeteries, Vol. 6. Salisbury: Genealogical Society of Rowan County, n.d.

Salisbury City Directory, 1935. Charleston, S.C.: Baldwin Directory Company, 1935.

Sandweiss, Martha A., ed. *Photography in Nineteenth-Century America.* Fort Worth, Texas: Amon Carter Museum, 1991.

Separk, Charles. A., comp. *Directory of the City of Raleigh, N.C., 1896–'97.* Raleigh: Raleigh Stationery Company, 1896.

Sharpe, Bill. "Photos by Morton." *State* 18 (Dec. 2, 1950).

Sheriff's Wilmington, N.C. Directory and General Advertiser for 1877–8. Compiled and published by Benjamin R. Sheriff. Wilmington: the compiler, 1877.

Sky-Land 1(Sept. 1914).

Smaw's Wilmington Directory Comprising a General and City Business Directory, 1866–1867. Compiled and published by Frank D. Smaw Jr. Wilmington: the compiler, [1866].

Smith, Eddie C., and Ben Patrick. *Voices from the Field: A Pictorial History of Camp Butner.* Butner: Camp Butner 50th Anniversary Planning Committee, 1992.

Smith, Harry Clyde, comp. *The Darnall, Darnell Family, with Allied Families*, Vol. 1. Los Angeles, Calif.: American Offset Printers, 1954.

Sprange, Walter, ed. *The Blue Book for Amateur Photographers, American Edition, 1895.* N.p., 1895. Cited in text as Sprange, *Blue Book.*

St. Amand, Jeanette Cox, comp. *Pitt County Gravestone Records*, Vol. 3. Wilmington: n.p., 1960.

Stephenson, E. Frank. *Murfreesboro, North Carolina: 200 Years on the Meherrin River.* Murfreesboro: privately published by the author, 1987.

Stokes, Durward T. *Auction and Action: Historical Highlights of Graham, North Carolina.* Graham: City of Graham, 1985.

Swicegood, Frank, and Marie L. Hinson, eds. *Cemetery Records of Davidson County, North Carolina*, Vol. 5. Lexington: Genealogical Society of Davidson County, 1987.

Taft, Robert. *Photography and the American Scene: A Social History, 1839–1889.* New York: Macmillan, 1938; reprinted Mineola, N.Y.: Dover Publications, 1964.

Talbot, William Henry Fox. *The Pencil of Nature.* New York: Da Capo Press, 1969.

Taylor, James P., Alfred A. Taylor, and Hugh L. Taylor. *Life and Career of Senator Robert Love Taylor (Our Bob).* Nashville, Tenn.: Bob Taylor Publishing Company, 1923.

Teal, Harvey S. *Partners with the Sun: South Carolina Photographers, 1840–1940.* Columbia: University of South Carolina Press, 2001.

Tessier, Mitzi. "Asheville and Herbert W. Pelton." In *Coming to Light: The Western North Carolina Re-Photographic Project.* Asheville: Asheville Museum of Art, 1994.

Thomson's Mercantile and Professional Directory, 1851–'52. Baltimore: William Thomson, 1851.

Townsend, Peggy T., comp. *Vanishing Ancestors: Cemetery Records of Robeson County, North Carolina*, Vol. Three. Red Springs: privately published by the compiler, 1992.

Turner & Company's Durham Directory for the years 1889 and 1890. Danville, Va.: E. F. Turner & Company, 1889.

Turner & Company's Winston and Salem City Directory for the Years, 1889 & 1890. Danville, Va.: E. F. Turner & Company, 1889.

Turner's Annual Directory of the City of Greensboro for the Years 1890–'91. Danville, Va.: E. F. Turner & Company, 1890.

Turner's Fifth Annual Winston and Salem City Directory for the Years 1891 and 1892. Danville, Va.: E. F. Turner & Company, 1891.

Turner's Sixth Annual Winston and Salem City Directory for the Years 1894 and 1895. Danville, Va.: E. F. Turner & Company, 1894.

Walsh's Directory of the Cities of Winston and Salem, N.C. for 1902–'03, 1904–'05. Charleston, S.C.: W. H. Walsh Directory Company, 1902, 1904.

Walsh's Directory of the City of Charlotte for 1902–1910. Charleston, S.C.: W. H. Walsh Directory Company, 1901, 1903, 1904, 1905, 1907, 1908, 1909, 1910.

Walsh's Winston-Salem, North Carolina City Directory for 1906, 1907, 1908. Charleston, S.C.: Walsh Directory Company, 1906, 1907, 1908.

Ward, Doris Cline, ed. *The Heritage of Old Buncombe County, North Carolina*, Vol. 2. Asheville: Old Buncombe County Genealogical Society, 1987.

Weaver, Bill Rhodes. "N.C. Guard's Only Woman General is Official U.N.C. Photographer." *Uplift*, Nov. 1, 1941.

Weaver, Clarence E., ed. *Winston-Salem, North Carolina, City of Industry.* Winston-Salem: Winston Printing Company, n.d.

Weeks' 1899 Charlotte City Directory. Charlotte: Southern Industrial Publishing Company, 1899.

Weinstein, Robert A., and Larry Booth. *Collection, Use, and Care of Historical Photographs*. Nashville: American Association for State and Local History, 1977.

White, Alice D., ed. *The Heritage of Cherokee County, North Carolina*, Vol. 1: *1887*. Winston-Salem: Hunter Publishing Company, 1987.

Whiteside, Tom, producer and director. "The Cameraman Has Visited Our Town" (documentary videotape). Durham, 1989.

Who Was Who in America, Vol. 1: *1897–1942*. Chicago: A. N. Marquis Company, fifth printing, 1962.

Willis, Dixie T., comp. *Pamlico County, North Carolina Cemeteries*. Baltimore: Gateway Press, 1983.

Wilmington Directory Including a General and City Business Directory for 1865–66. Compiled by Frank D. Smaw Jr. Wilmington: Fulton and Price Steam Power Press Printers, 1865.

Wilmington, North Carolina Directory, 1905, 1907, 1909–10, 1911–12, 1913–14, 1917, 1918, 1919–20: Richmond, Va.: Hill Directory Company, 1905, 1907, 1909, 1911, 1913, 1917, 1918, 1920.

Wilson, Charles Reagan, and William Ferris, eds. *Encyclopedia of Southern Culture*. Chapel Hill and London: University of North Carolina Press, 1989.

Wilson, N.C. Directory, 1908–1909. Richmond, Va.: Hill Directory Co., 1908.

Wilson, N.C. Directory, 1912–13. Richmond, Va.: Hill Directory Co., 1912.

Wilson, N.C. Directory, 1916–17. Richmond, Va. Hill Directory Company, 1916.

Winston-Salem, North Carolina City Directory, 1910–1913, 1915–1916, 1918, 1920–1923. Asheville: Piedmont Directory Company, 1910, 1911, 1912, 1915, 1916, 1918, 1920, 1921, 1922, 1923 (published after 1921 as the Piedmont Series by Miller Press). Cited in text as *Winston-Salem Directory*, with appropriate year(s).

Witham, George F., comp. *Catalogue of Civil War Photographers, 1861–1865: A Listing of Civil War Photographers' Imprints*, 2d. ed. Memphis, Tenn: Privately printed by the compiler, 1988.

Year Book, Vol. 1 (1954–1955). Elizabeth City: Pasquotank Historical Society, n.d.

Zell's Classified United States Business Directory for 1883. Philadelphia: United States Directory Company Limited, 1883.

Zell's Classified United States Business Directory for 1884. Philadelphia: United States Publishing Company, 1884.

Zell's Classified United States Business Directory for 1885. New York: American Reporter Company, 1885.

Zell's Classified United States Business Directory for 1887. New York: American Reporter Company, 1887.

Zell's United States Business Directory for 1875. Philadelphia: T. Ellwood Zell, 1875.

Zell's United States Business Directory for 1881. Philadelphia: United States Directory Company, 1881.

Zell's United States Business Directory for 1889. New York: H. A. Curtin, 1889.

FEDERAL RECORDS

Appalachian National Park Association Collection (North Carolina Office of Archives and History).

Seventh Census of the United States, 1850. Population Schedules. Maryland and North Carolina.

Eighth Census of the United States, 1860. Population Schedules. North Carolina.

Ninth Census of the United States, 1870. Population Schedules. North Carolina.

Tenth Census of the United States, 1880. Population Schedules. Alabama and North Carolina.

Twelfth Census of the United States, 1900. Population Schedules. Georgia and North Carolina.

Thirteenth Census of the United States, 1910. Population Schedules. North Carolina.

Fourteenth Census of the United States, 1920. Population Schedules. North Carolina.

Fifteenth Census of the United States, 1930. Population Schedules. North Carolina.

National Army Camps, Camp Greene, Charlotte, N.C. (National Archives).

United States Patent Office Records.

WPA Cemetery Index (Office of Archives and History).

PUBLISHED FEDERAL RECORDS

Seventh Census of the United States, 1850, Embracing a Statistical View of the States and Territories. Washington: Robert Armstrong, Public Printer, 1853.

Population of the United States in 1860, Compiled from the Original Returns of the Eighth Census. Washington: Government Printing Office, 1864.

Ninth Census of the United States, Population and Social Statistics, 1870. Washington: Department of Interior, Census Office, 1872.

Tenth Census of the United States, 1880, Population and Social Statistics. Washington: Department of Interior, Census Office, 1883.

Eleventh Census of the United States, Miscellaneous Statistics, Part III, 1890. Washington: Government Printing Office, Department of Interior, Census Office, 1897.

Twelfth Census of the United States, 1900, Population, Census Reports, Vol. 2, Part 2. Washington: United States Census Office, 1902.

Thirteenth Census of the United States Taken in the Year 1910, Vol. 4: *Population 1910, Occupation Statistics*. Washington: Department of Commerce, Bureau of Census, Government Printing Office, 1914.

Fourteenth Census of the United States Taken in the Year 1920, Vol. 5: *Population 1920, Occupations*. Washington: Department of Commerce, Bureau of the Census, Government Printing Office, 1923.

Fifteenth Census of the United States: 1930. Population. Vol. 4: *Occupations, by States*. . . . Washington: U.S. Government Printing Office, 1933.

Sixteenth Census of the United States: 1940. Census of Business. Vol. 3: *Service Establishments, Places of Amusement, Hotels,*

Tourist Courts and Tourist Camps, 1939. Washington: U.S. Government Printing Office, 1942.

Sixteenth Census of the United States: 1940. Population. Vol. 3: *The Labor Force. . . . Part 4: Nebraska-Oregon.* Washington: U.S. Government Printing Office, 1943.

STATE RECORDS

Division of Health Services
Vital Records (death certificates).

N.C. Department of Agriculture, Museum of Natural Sciences
Herbert H. Brimley Photograph Collection.

Office of Archives and History
Blue Ridge Parkway Photograph Collection.
Herbert H. Brimley Photograph Collection.
Carolina Power and Light Company Photograph Collection.
Civil War Pension Applications.
State Department of Conservation and Development Records.
Charles A. and Anne M. Farrell Photograph Collection.
Nontextual Materials Unit Photographic Files.
N.C. Museum of History Photograph Collection.

Office of State Auditor
Account Book, 1872–1880, Aud. II, Vol. 33.
Account Book, 1888–1893, Aud. II, Vol. 34.
Ledgers, 1869–1899, Aud. II, Vols. 14–23, Tax on Itinerant Photographers Tax Returns, 1868–1927 (by county). Cited in text as Ledgers, 1869–1899, with appropriate volume and page number(s).
Miscellaneous Tax Group (1868–1932), Box 3, Artists' and Photographers' Privilege Licenses, 1877–1887.
Schedule B, Taxes, 1869–1888, 1914–1922 (by county). Cited in text as State Auditor's Records, Sch. B.

State Board of Photographic Examiners Records, 1935–1949. Cited in text as Photographic Examiners Records.

Supreme Court Records

Treasurer's and Comptroller's Records
County Settlements with the State, Boxes 15–92.

PUBLISHED STATE RECORDS

Consolidated Statutes of North Carolina . . . 1917 . . . and . . . 1919. . . , 2 vols. Raleigh: Edwards & Broughton Printing Company, State Printers, 1920, Vol. 2.

Executive and Legislative Documents of the State of North Carolina, Session 1883. Document No. 18. Raleigh: Ashe & Gatling, State Printers and Binders, 1883.

Guide to Research Materials in the North Carolina State Archives: State Agency Records. Raleigh: Department of Cultural Resources, Division of Archives and History, 1995.

Illustrations of the North Carolina State Exposition, Raleigh, October, 1884. Raleigh: Department of Agriculture, 1884.

Laws and Resolutions of the State of North Carolina Passed by the General Assembly At Its Session 1876–'77. Raleigh: News Publishing Company, State Printer and Binder, 1877.

Laws and Resolutions of the State of North Carolina Passed by the General Assembly At Its Session of 1883. Raleigh: Ashe & Gatling, State Printers and Binders, 1883.

Laws and Resolutions of the State of North Carolina Passed by the General Assembly At Its Session of 1885. Raleigh: P. M. Hale, State Printer and Binder, 1885.

Laws and Resolutions of the State of North Carolina Passed by the General Assembly At Its Session of 1887, 1889, and 1891. Raleigh: Josephus Daniels, State Printer and Binder, 1887, 1889, 1891.

The North Carolina Code of 1931. . . . Charlottesville, Va.: Michie Company, 1931.

The North Carolina Code of 1935. . . . Charlottesville, Va.: Michie Company, 1935.

The North Carolina Code of 1939. . . . Charlottesville, Va.: Michie Company, 1939.

Public Laws and Resolutions of the State of North Carolina Passed by the General Assembly at Its Session of 1899. Raleigh: Edwards & Broughton and E. M. Uzzell, State Printers and Binders, 1899.

Public Laws and Resolutions Together With the Private Laws of the State of North Carolina Passed by the General Assembly at Its Session 1872–'73. Raleigh: Stone & Uzzell, State Printers and Binders, 1873.

Public Laws of the State of North-Carolina Passed by the General Assembly At Its Session of 1856–'57 and 1858–'9. Raleigh: Holden & Wilson, Printers to the State, 1857, 1859.

Public Laws of the State of North Carolina Passed by the General Assembly At Its Session of 1866–'67. Raleigh: William E. Pell, State Printer, 1867.

Public Laws of the State of North Carolina Passed by the General Assembly At Its Session 1868–'69. Raleigh: M. S. Littlefield, State Printer & Binder, 1869.

Public Laws of the State of North Carolina Passed by the General Assembly At Its Session 1869–'70. Raleigh: Joseph W. Holden, State Printer and Binder, 1870.

COUNTY RECORDS (A&H)

Alamance County Wills
Alleghany County Registry of Licenses to Trade
Anson County Estates Records
Anson County Wills
Beaufort County Vital Records
Bertie County Estates Records
Buncombe County Deed Records
Buncombe County Estates Records
Buncombe County Wills
Carteret County Estates Records

Carteret County Wills
Minutes of the Chowan County Court of Pleas and
 Quarter Sessions
Chowan County Deed Records
Clay County Registry of Licenses to Trade
Columbus County Registry of Licenses to Trade
Craven County Estates Records
Cumberland County Marriage Records
Cumberland County Tax Records
Cumberland County Wills
Davidson County Estates Records
Davidson County Registry of Licenses to Trade
Davidson County Tax Records
Davie County Tax Records
Durham County Record of Special Licenses Issued
Durham County Registry of Licenses to Trade
Forsyth County Estates Records
Forsyth County Wills
Granville County Estates Records
Granville County Tax Records
Greene County Registry of Licenses to Trade
Guilford County Wills
Hyde County Estates Records
Hyde County Registry of Licenses to Trade
Iredell County Estates Records
Jackson County Registry of Licenses to Trade
Johnston County Marriage Records
Jones County Registry of Licenses to Trade
Lincoln County Estates Records
Lincoln County Wills
Macon County Estates Records
Mecklenburg County Estates Records
Mecklenburg County Wills
Mitchell County Registry of Licenses to Trade
New Hanover County Estates Records
New Hanover County Registry of Licenses to Trade
New Hanover County Wills
Northampton County Tax Records
Orange County Tax Records
Pasquotank County Tax Records
Pasquotank County Vital Records
Pasquotank County Wills
Pender County Registry of Licenses to Trade
Perquimans County Registry of Licenses to Trade
Person County Registry of Licenses to Trade
Polk County Registry of Licenses to Trade
Richmond County Deed Records
Richmond County Registry of Licenses to Trade
Richmond County Tax Records
Robeson County Estates Records
Rockingham County Wills
Rutherford County Estates Records
Stanly County Registry of Licenses to Trade
Union County Estates Records
Wake County Deed Records
Wake County Estates Records
Wake County Register of Deaths
Wake County Wills
Washington County Registry of Licenses to Trade
Wayne County Registry of Licenses to Trade
Wayne County Tax Records

PRIVATE COLLECTIONS

**Duke University Rare Book, Manuscript, and Special
Collections Library:**
Edward Featherston Small Papers

Georgia State Archives:
Georgia Family and Children Services, Confederate Soldiers'
 Home Record: Register of Inmates

Mars Hill College:
William A. Barnhill Photograph Collection

Museum of the Albemarle (Elizabeth City):
Cox-Northern Collection

**North Carolina Collection, Wilson Library, University of
North Carolina at Chapel Hill:**
Broadside advertisement for N. J. Reid, Oct. 18, 1890

North Carolina Office of Archives and History:
Mary Eliza Battle Papers
Joseph A. Engelhard Papers
James Harwell Papers
Delia Hyatt Papers
Glennie Tomlinson Miller Papers
John L. Patterson Papers
Gertrude Weil Papers

**Southern Highlands Research Center, D. Hiden Ramsey
Library, University of North Carolina at Asheville:**
Ewart M. Ball Photograph Collection
Henry Scadin Photograph Collection

**Southern Historical Collection, Wilson Library, University
of North Carolina at Chapel Hill:**
Col. Leonidas Campbell Jones Diary

Miscellaneous:
Minute Book of Meetings, St. John's (Masonic) Lodge,
 Wilmington

DIARIES, JOURNALS, AND PRIVATE PAPERS

Handwritten journal of E. C. Eddy, in possession of
 Ellennore Eddy Smith, Southern Pines
Holeman Family Papers, in possession of Leigh Holeman
 Gunn, Timberlake
Diary of Lucy Morgan, in possession of Louise Morgan,
 Brevard
Private correspondence of members of Peace family, in
 possession of Laura Peace, Henderson

NEWSPAPERS

Advance (Wilson), Nov. 11, 1897

Alamance Gleaner (Graham), June 8, 15, 22, Oct. 5, 1875

Albemarle Southern (Murfreesboro), Apr. 5, 1860

American (Statesville), Nov. 14, 1865

American Advocate (Kinston), Aug. 30, 1855; Feb. 28, Aug. 21, 1856; Apr. 16, 30, Sept. 17, 24, 1857; Nov. 3, 1858

American Eagle (Louisburg), Feb. 26, 1859

Ancient City (St. Augustine, Fla.), Jan. 26, 1850

Ansonian (Polkton), Apr. 15, 1875; Feb. 2, 1876

Argus (Lumberton), Aug. 28, Dec. 25, 1902

Asheville Citizen, July 6, 1885; Feb. 2, July 21, 1927; Dec. 23, 1931; June 22, 1933; Apr. 2, 1934; Aug. 8, 1934; Jan. 13, Mar. 1, 1936; Aug. 27, 28, 1937; June 7, 1938; June 8, 1942; Dec. 14, 1949; Feb. 1, Nov. 9, 1950; Oct. 25, 1960; June 9, 1964; June 24, 1966

Asheville Daily Advocate, July 7, 1885

Asheville Daily Gazette, Apr. 12, May 18, June 3, 13, 1902

Asheville News, July 28, 1853; June 22, 29, 1854; Aug. 23, 1855; Mar. 20, Nov. 20, 1856; Jan. 21, July 15, Aug. 5, 1858; Jan. 6, Apr. 7, Sept. 22, Nov. 24, 1859; Jan. 2, 1862; Nov. 16, 1865

Asheville News and Mountain Farmer, Aug. 20, Sept. 10, 1869

Asheville Pioneer, May 14, 1868; Aug. 26, 1869

Asheville Spectator, Sept. 3, 1858

Atlantic Methodist (Wilmington), Feb. 17, 1892

Beaufort Eagle, July 29, 1876

Beaufort Journal, July 1, 15, 1857

Biblical Recorder (Raleigh), Apr. 16, 1879

Border Review (Henderson), Mar. 24, 1879

Cape Fear Banner (Fayetteville), June 22, 1880

Carolina Banner (Tarboro), July 19, 1889

Carolina Messenger (Goldsboro), Jan. 3, 6, Nov. 30, 1873; Sept, 9, 1875; Jan. 8, June 22, 1877

Carolina Republican (Lincolnton), Aug. 24, 1849

Carolina Watchman (Salisbury), Apr. 20, 1848; June 13, 1850; Apr. 17, May 22, Aug. 17, Sept. 25, 1851; Apr. 22, July 1, Sept. 2, 1852; Jan. 13, Apr. 21, Aug. 18, 1853; Feb. 22, Nov. 13, 1855; Mar. 25, June 24, July 22, Nov. 28, 1856; May 26, July 21, 1857; July 12, 1859; Mar. 7, 1864; Jan. 20, Mar. 2, 16, 1876; Dec. 17, 1885; Jan. 7, Mar. 11, 1886; Oct. 13, 1887; Apr. 19, Aug. 23, Oct. 25, 1888; Feb. 28, July 25, 1889; Jan. 2, Feb. 27, 1890; Oct. 8, Dec. 3, 1891; May 25, 1893; Jan. 28, 1897

Carthage Blade, June 21, 1888; Oct. 3, 24, 1893; Feb. 11, Sept. 8, 1896; Apr. 6, May 11, 1897

Carthaginian (Carthage), Mar. 7, 1878

Central Express (Sanford), Oct. 5, 1889

Central Times (Dunn), May 7, 1891

Chapel Hill Ledger, Sept. 20, 1879

Chapel Hill Weekly Gazette, May 16, 1857

Charlotte Democrat, Dec. 19, 1879

Charlotte Journal, Feb. 2, May 18, 1849

Charlotte News, Feb. 22, 1932

Charlotte Observer, Nov. 1, 1904; Mar. 3, 1911; Apr. 1, 8, 1918; Aug. 13, 1930; May 25, 26, 1932; Feb. 17, 1935; Feb. 11, 1942; May 6, 1943; Aug. 7, 1948; July 1, 1949; Aug. 22, 1959

Chatham Record (Pittsboro), Mar. 27, 1879; Apr. 3, 1890; Nov. 26, 1891

Chronicle (Wilmington), Feb. 4–Apr. 1, 1846; Feb. 5, 1847; Jan. 5, 1848

Clayton Bud, June 17, 1885

Commercial (Wilmington), Nov. 2, 1847; Jan. 1, 1848

Concord Sun, Aug. 14, 1880

Concord Weekly Gazette, June 21, 28, July 5, 12, 26, Aug. 2, Nov. 15, Dec. 12, 1856; Jan. 10, 1857

County Union (Dunn), Apr. 10, 1895

Courier (Louisburg), Oct. 2, 1874

Courier (Roxboro), Jan. 10, 1900

Daily Advance (Elizabeth City), June 1, 3, 1936

Daily Evening Crescent (Raleigh), Aug. 25, 1874

Daily Journal (New Bern), Jan. 25, 1888; Feb. 8, 1894; Jan. 8, May 29, 1914

Daily News (Goldsboro), Dec. 2, 1865

Daily News (Raleigh), Feb. 25, 1875

Daily North Carolina Standard (Raleigh), Oct. 5, 9, 1865

Daily Nut Shell (New Bern), Aug. 13, 1878

Daily Observer (Charlotte), Jan. 25, 1869

Daily Record (Greensboro), May 17, 1911

Daily Reflector (Greenville), June 12, 1908; Mar. 3, 1911; Feb. 3, 1941

Daily Reporter (Durham), June 5, 1885; May 7, 1886; May 14, 1887

Daily Review (Wilmington), May 24, 1883

Daily Rocket (Rockingham), Sept. 26, 1894

Daily Southern Citizen (Greensboro), Aug. 12, 1864

Daily State Chronicle (Raleigh), Mar. 20, Sept. 7, 1890

Daily State Journal (Raleigh), Mar. 11, 1863

Daily Waynesville Courier, Aug. 8, 1906

Dan Valley Echo (Leaksville), Oct. 13, 1887

Danbury Reporter, Mar. 21, 1872, June 8, 1876

Davidson Dispatch (Lexington), Apr. 18, 1888

Democratic Pioneer (Elizabeth City), Sept. 17, 1850; Oct. 5, 1852; Mar. 7, 1854; Aug. 11, 1857

Dispatch (Lexington), Dec. 10, 1997

Dispatch (Wilmington), May 20, Oct. 29, 1898; Sept. 19, Nov. 17, 1899; Aug. 18, 1902; July 13, 1909; July 1, 1911; Apr. 9, 1914; Sept. 15, 1922

Dunn Signboard, Dec. 9, 1887

Duplin Record (Magnolia), Oct. 30, 1874

Durham Herald, June 14, 1876

Durham Morning Herald, Oct. 25, 1964; Apr. 3, 1968; Mar. 19, Nov. 28, 1986

Durham Recorder, Mar. 31, 1881; May 30, June 13, 1883; June 3, 1885; Jan. 19, 1899

Durham Sun, Aug. 28, 1974

Durham Tobacco Plant, Feb. 14, 1872; Jan. 19, Apr. 12, Sept. 27, Oct. 3, 18, 1876; Oct. 9, 1877; Apr. 20, 1880

Eagle (Fayetteville), Nov. 18, 1869; Oct. 19, Dec. 21, 1871; Jan. 25, Feb. 1, Mar. 14, 1872

Eastern Carolina News (Kenansville), May 29, 1908

Eastern Courier (Hertford), May 22, June 6, Aug. 7, 1895; Jan. 9, 1896

Eastern Intelligencer (Washington), June 1, 1869

New Bern Weekly Progress, Jan. 8, 1861; July–Aug. 1862

New Berne Weekly Journal, Jan. 22, 1885

New Era (Goldsboro), Oct. 27, 1853

New Era and Commercial Advertiser (New Bern), Aug.–Dec. 1858

New York Times, Dec. 15, 1923

Newbern Daily Progress, Aug. 11, 1862

Newbern Journal of Commerce, Feb. 23, 1869

Newbernian (New Bern), Nov. 25, 1843; Nov. 23, 1847; Jan. 18, Mar. 28, Apr. 11, May 9, 23, 1848; Feb. 26, Apr. 16, 1850; Sept. 14, 1852; Feb. 22, 1879; Apr. 24, May 1, 1880

Newbernian and North Carolina Advocate (New Bern), Nov. 15, 1850; Jan. 21, 1851; Jan. 11, 1853

News-Dispatch (Wilmington), Dec. 11, 1924

News and Farm (Kernersville), Oct. 2, 1887; Jan. 20, 1888

News and Observer (Raleigh), Jan. 20, 1880; Apr. 3, 1889; Aug. 24, 1899; Mar. 27, 1902; June 22, 1904; Feb. 18, Mar. 11, 1908; Mar. 4, 1911; Jan. 2, 1916; June 7, 1924; Oct. 16, 1927; Apr. 27, Nov. 26, 1929; Oct. 7, 1931; Jan. 8, Oct. 26, 1932; May 16, 1934; Apr. 26, Aug. 13, 1936; Nov. 19, Dec. 5, 1937; Feb. 15, 1938; Apr. 25, Nov. 15, 1939; Mar. 21, July 23, 1940; May 10, Aug. 26, Nov. 3, 1942; Jan. 23, 1943; Apr. 5, 1946; Jan. 25, July 29, Oct. 3, 1947; Oct. 12, 1948; Oct. 9, 1949; July 8, Aug. 30, 1951; Nov. 8, 1953; Apr. 7, 1959; May 28, 1960; Nov. 2, 1965; Apr. 3, 1966; Apr. 15, 1984; Apr. 9, Nov. 9, 10, 1993; Apr. 19, 1995; Jan. 28, 1998; Mar. 3, 2002; Oct. 24, Dec. 13, 2003

Newton Enterprise, Jan. 26, 1884

North Carolina Argus (Fayetteville), Nov. 1, 4, 1854; Feb. 1, June 30–Sept. 22, Nov. 10, 1855; Oct. 20, 1856

North Carolina Argus (Wadesborough), Sept. 23, 1858; Jan. 6, Feb. 17, Aug. 25, 1859; Sept. 20, 27, 1860

North Carolina Citizen (Asheville), Aug. 3, 1874

North Carolina Gazette (Fayetteville), Dec. 21, 1876

North Carolina Presbyterian (Fayetteville), Nov. 24, 1860; Feb. 10, 17, 1869; Jan. 31, Mar. 27, 1872; July 23, 1873; Jan. 14, 1874

North Carolina Prohibitionist (Greensboro), Oct. 19, 1888

North Carolina Republican (Raleigh), Mar. 19, 1880

North Carolina Standard (Raleigh), Nov. 18, 1846; Aug. 30, 1851

North Carolina Whig (Charlotte), Feb. 18, 1852; Apr. 6, 1853

North Carolinian (Elizabeth City), Feb. 16, 1871; July 14, 1886; Apr. 19, 1893; Feb. 27, 1895

North State Press (Washington), Nov. 12, 1878; Mar. 2, July 6, 1880; July 20, 1881

North State Whig (Washington), Apr. 3, May 1, Nov. 13, 1850; Feb. 10, 1852; Feb. 23, Mar. 29, Apr. 13, 1853

North Wilkesboro News, Sept. 21, 1893

Observer and Gazette (Fayetteville), Nov. 19, 1885

Old Constitution (Danbury), June 3, 1870

Old North State (Beaufort), Dec. 15, 1864; Jan. 7, 1865

Old North State (Elizabeth City), June 16, 1849; Aug. 10, 1850; June 7, 1851; Nov. 5, Dec. 10, 1853

Oxford Public Ledger, Apr. 25, 1939

Oxford Torchlight, Sept. 5, 1876; June 20, 1882; Apr. 7, 1885

Patriot and Flag (Greensborough), Mar. 8, Apr. 10–Oct. 9, 1857; Mar. 5, Apr. 30, 1858

Pee Dee Herald (Wadesboro), Dec. 6, 1876

People's Press (Salem), Jan. 17, 1852; May 21, 1853; Aug. 31, 1855; June 5, 24, July 24, 1857; May 10, 1883; Feb. 12, 1891

Perquimans Record (Hertford), Dec. 10, 1890; May 11, June 1, Nov. 23, 1892

Piedmont Press (Hickory), June 20, 1875

Pilot (Southern Pines), Aug. 1, 1979

Public Ledger (Oxford), Jan. 24, Feb. 14, 1890

Raleigh Register (semi-weekly), Nov. 24, 1846; Nov. 24, Dec. 1, 1847; Feb. 12, Apr. 26, 30, May 10, 1851

Raleigh Register & North Carolina Gazette, Nov. 16, Dec. 30, 1842; Jan. 10–Mar. 10, Nov. 25, Dec. 5, 1843; Apr. 2, Nov. 22, 1844; Jan. 28, 1845; Sept. 29, Nov. 20, 1846; Nov. 24, 1847; May 24, Sept. 16, 1848

Randolph Regulator (Asheboro), Nov. 15, 22, 1876

Red Springs Comet, Mar. 9, 1892

Republican and Courier (New Bern), Nov. 25, 1871

Review (High Point), Jan. 9, 1913; Mar. 18, 1915

Richmond Rocket (Rockingham), Apr. 3, 1884; Jan. 22, 1885

Roanoke Advocate and States' Rights Banner (Halifax), May 2, 11, 1842

Roanoke Beacon (Plymouth), June 28, Aug. 16, Sept. 20, Oct. 18, 1889; Nov. 4, 1898

Roanoke Cresset (Plymouth), Feb. 9, 1861

Roanoke News (Weldon), Sept. 15, 1887

Robesonian (Lumberton), June 20, Nov. 20, 1872; Feb. 5, Aug. 20, 1873; Jan. 9, 1903

Rocket (Rockingham), Feb. 19, July 17, Oct. 15, 1891; July 19, 1894

Rutherford County News (Rutherfordton), Apr. 19, 1928

Rutherford Star and West-Carolina Record (Rutherfordton), June 13, 1874

Rutherfordton Sun, Apr. 19, 1903

Salisbury Banner, July 26, 1859

Sandhill Citizen (Southern Pines), Oct. 7, 1981

Sanford Express, Jan. 12, Mar. 2, 1906; Mar. 29, Apr. 5, July 12, Sept. 6, 27, 1907; Feb. 21, May 9, 24, June 12, 26, Sept. 25, 1908; July 1, 1910; Feb. 17, Mar. 17, 31, 1911; Apr. 19, Nov. 15, 1912; Jan. 13, May 9, 1913; Jan. 6, Nov. 13, 1914; Feb. 5, 1915; June 17, 1921

Semi-Weekly Index (Henderson), Feb. 9, 1869

Semi-Weekly Newbernian (New Bern), Apr. 14, 1851; Sept. 14, 1852

Semi-Weekly News (Warrenton), Feb. 5, 1856

Semi-Weekly Raleigh Register, Feb. 18, 1854; Nov. 17, 1855; Feb. 4, Apr. 25, Sept. 19, Dec. 16, 1857; Oct. 28, Dec. 25, 1858

Sentinel (Raleigh), May 3, 1871

Shelby Star, Oct. 11, 1984

Smithfield Herald, May 24, 1894; Sept. 15, 1899

Southern Pines Tourist, May 23, 1913

Southerner (Tarborough), Jan. 7, 1854; Nov. 24, 1855; Mar. 14, Apr. 4, 18, May 23, 1857; Jan. 9, 23, Mar. 16, June 19, 26, Dec. 18, 1858; Jan. 15, Feb. 19, Oct. 8, 1859; Mar. 3, 1860

Spirit of the Age (Raleigh), Jan. 18, 1854; Aug. 10, 1859

Spirit of the South (Rockingham), July 1, 1876

Standard (Concord), Oct. 5, 1888; Oct. 18, 1889

Star (Wilmington), Mar. 22, Apr. 18, Oct. 29, 1868; May 6, 1870; Dec. 5, 1876; Sept. 4, 1878; May 24, 1883; Dec. 25, 1888; Nov. 2, 1889; May 15, 1891; Aug. 16, 1895; Mar. 29,

1896; Mar. 9, June 3, July 28, Nov. 9, 1898; Jan. 16, 1901; Mar. 30, 1907; Nov. 26, 1932; Dec. 1, 1940; June 24, 1943; Dec. 3, 1984

State Chronicle (Raleigh), Apr. 26, 1884; Sept. 11, 1885; Nov. 18, 1886; Aug. 25, Oct. 13, 1887; Mar. 2, 1888; Apr. 5, 19, May 31 (Wilson Edition), 1889; Mar. 20, 1890; Apr. 2, May 21, June 18, Oct. 29, 1892

Statesville American, July 1, 1872

Sun (Fayetteville), Sept. 26, Oct. 3, 1883

Swain County Herald (Bryson City), June 13, 27, July 18, Nov. 28, 1889

Tar Heel (Elizabeth City), June 6, 13, Aug. 2, 1902

Tarboro Southerner, Apr. 6, 1871

Tarborough Press, Oct. 25, 1851

Taylorsville Index, May 22, June 12, 1890

Temperance Herald (Concord), June 16, 1881

Times (Dunn), Jan. 23, 1895

Times (Greensboro), Dec. 11, 1858; June 11, 1859

Times (Wilson), Aug. 23, 1897

Times-News (Hendersonville), Jan. 26, 2001

Torch-Light (Oxford), Feb. 24, July 14, 17, 1874; May 11, 25, 1875; Oct. 22, 1878

Torchlight (Oxford), Apr. 13, Aug. 24, 1886; May 30, 1888

Transylvania Hustler (Brevard), Nov. 2, 1893

Tri-Weekly Examiner (Salisbury), Sept. 10, 1869

Twin-City Sentinel (Winston-Salem), Sept. 25, 1923; Oct. 24, 1925; Nov. 12, 1960

Union (New Bern), June 4–Nov. 24, 1856; Jan. 19, Sept. 2, Dec. 10, 17, 1857

Union Republican (Winston), Jan. 15, 1891

Warrenton News, Aug. 29, 1850; Mar. 24, 1853; Sept. 21, 1860

Washington Dispatch, Dec. 23, 1857; July 12, 1859; Sept. 17, 1861

Washington Gazette, Sept. 26, 1889

Washington Progress, Aug. 27, 1914

Washington Whig, Apr. 3, 1850

Watauga Democrat (Boone), Aug. 15, 1907; Sept. 26, 1918; Apr. 24, 1919

Waynesville Courier, Jan. 3, 1908

Webster's Dollar Weekly (Reidsville), Jan. 30, 1883

Webster's Weekly (Reidsville), Jan. 26, 1892

Weekly Brief (Wilson), July 13, 1886

Weekly Index (Henderson), May 21, 1869

Weekly Ledger (Chapel Hill), May 11, 1878

Weekly News (Louisburg), Feb. 10, 1855

Weekly News (New Bern), Feb. 5, Nov. 5, 1853

Weekly North Carolina Standard (Raleigh), Nov. 27, 1850

Weekly Pioneer (Asheville), Nov. 24, 1870; Sept. 28, 1871; June 6, Aug. 15, 1872; Aug. 22, 1874

Weekly Raleigh Register and North Carolina Gazette, Feb. 12, 1851

Weekly Standard (Raleigh), Mar. 7, 1860; July 15, 1863

Weekly Star (Wilmington), Apr. 29, Aug. 5, 1892

Weldon Patriot, May 7, 1857

West-Carolina Record (Rutherfordton), Apr. 26, May 17, 1873

Western Carolina Advocate (Asheville), Jan. 5, 1893

Western Democrat (Charlotte), Dec. 17, 1852; Jan. 28, 1853; Aug. 4, Nov. 17, 1854; Feb. 9, 1855; Sept. 23, 1856; May 12–Aug. 11, Oct. 20, 1857; May 3, 1859; Aug. 4, 1863; Aug. 1, 1865

Western North Carolina Times (Hendersonville), June 2, 1911

Western Sentinel (Winston), June 24, 1859; June 1, 1866

Western Vindicator (Rutherfordton), May 31, 1869; Apr. 14, 1898

Wide Awake (Fayetteville), July 19, 1876

Wilmington Daily Journal, Apr. 1, 1861

Wilmington Journal, Feb. 6, Dec. 25, 1846; June 23, 1848; Dec. 4, 1848–Jan. 7, 1849; Dec. 20, 1850; Feb. 28, Apr. 14, 1851; Jan. 16, Apr. 9, 1852; Jan. 14, July 1, 22, Aug. 5, Sept. 16, Dec. 2, 1853; Jan. 27, July 28, Aug. 4, Sept. 22, Oct. 20, 1854; Nov. 12, 1858

Wilmington Morning Star, Feb. 1, 1951

Wilson Advance, Apr. 19, 1878; Apr. 6, 1883; May 20, June 6, 1884; Nov. 17, 1887; May 26, 1899

Wilson Daily Times, Aug. 21, 1993

Wilson Mirror, Sept. 13, 1887; June 6, 1888

Wilson Times, Aug. 18, 1899

Windsor Ledger, Feb. 13, 1895; Nov. 5, 1896; May 11, 1905

Windsor Public Ledger, Oct. 19, 1887

Winston-Salem Journal, Oct. 25, 1924; Dec. 31, 1932; Dec. 2, 1939; Oct. 8, 1940

GENERAL INFORMATION SOURCES

Cedar Grove Cemetery, New Bern, inscriptions on tombstones

Elmwood Cemetery, Henderson, inscription on tombstone

Greensboro Public Library, biographical information file

Institute for Photographic Research, Bryan, Texas

Lee County Genealogical and Historical Society, Sanford

List of Alabama photographers compiled by Frances Osborn Robb, Huntsville. Cited in text as Robb list of Ala. photographers

List of Indiana photographers compiled by James A. Marusek, Bloomfield. Cited in text as Marusek list of Ind. photographers

List of Michigan photographers compiled by David V. Tinder, Dearborn. Cited in text as Tinder list of Mich. photographers

List of North Carolina photographers compiled by Jerry Cotten, North Carolina Collection. Cited in text as Cotten list of N.C. photographers

List of Wake County photographers compiled by Elizabeth Reid Murray, Raleigh. Cited in text as Murray list of Wake County photographers

List of Wilmington photographers compiled by William R. Reaves, New Hanover County Museum, Wilmington. Cited in text as Reaves list of Wilmington photographers

Records of Maplewood Cemetery, Durham

Oakdale Cemetery, Wilmington, inscription on tombstone

Records of Oakwood Cemetery, Raleigh

Person County Museum, Roxboro

Photographers' Database, George Eastman House, Rochester, N.Y.

"Reference Guide to Farm Security Administration/Office of War Information Photographs" (undated in-house finding aid, Library of Congress, Prints and Photographs Division, Washington, D.C.). Cited in text as "Reference Guide to FSA/OWI Photographs."

Smithsonian Institution, U.S. Naval Imaging Command, Washington, D.C.

St. John's Lodge, Wilmington, Minute Book of Meetings, 1863, 1875–1877.

Tufts Archives, Given Memorial Public Library, Pinehurst, biographical files.

www.familysearch.org (genealogical reference site of Church of Jesus Christ of Latter-day Saints).

www.getty.edu/art/collections/bio (Web site of J. Paul Getty Museum, Los Angeles).

www.photocollect.com (online biography of Lewis Hine).

INDEX